BAKING

The Ultimate Cookbook

13-Digit ISBN: 978-1-64643-216-5
10-Digit ISBN: 1-64643-216-9

This book may be ordered by mail from the publisher. Please include $5.99 for postage and handling.
Please support your local bookseller first!

Books published by Cider Mill Press Book Publishers are available at special discounts for bulk purchases in the United States by corporations, institutions, and other organizations. For more information, please contact the publisher.

Cider Mill Press Book Publishers
"Where good books are ready for press"
501 Nelson Place
Nashville, Tennessee 37214

cidermillpress.com

Typography: Adobe Garamond, Brandon Grotesque, Lastra, Sackers English Script
Front cover image: Chocolate Cake with Berries & Cocoa Crumble, see page 131
Back cover image: Beignets, see page 330
Front endpaper image: Strawberry Rhubarb Pie, see page 251
Back endpaper image: Canelés, see page 304

Printed in China

23 24 25 26 27 TYC 6 5 4 3 2

BAKING

The Ultimate Cookbook

ROBERT GONZALEZ & DAN CREAN

CIDER MILL PRESS

BOOK PUBLISHERS

CONTENTS

INTRODUCTION: MEET THE CHEFS

From the early mornings to the late nights, we have been on this culinary journey together for over 10 years. Our paths crossed while working in fine dining restaurants in Boston, most notably Cultivar, where I was working as Pastry Chef and brought Dan on as Sous Chef. During our time there, we formed part of the team that won Boston's Best New Restaurant in 2018.

We then tackled a James Beard dinner in New York City, and now run the bakery and kitchen at the Concord Market in Concord, Massachusetts, where we strive to bring the taste and feel of homemade goods to everyday folks while sourcing only the best ingredients New England has to offer. Our passion for baking, for perfection, and for pushing the envelope in terms of what desserts can be is a large part of what drives us every day.

While the industry can be brutal, we've discovered that it can be very rewarding when filled with passion, the right people, and proper routines. We were always taught that if we love what we do, we will never work a day in our lives. Now the time has come for us to share that love with you, and pass along the lessons we have learned and taught to so many others who have crossed our paths over these last 10 years.

That said, baking is not without its share of disappointment. It is an exact and unforgiving science—one minor oversight, and the results can be disastrous. I view each day in the kitchen as a series of lab experiments. Each recipe is a formula teeming with possible discoveries and secrets. Once we find these, the only limit is our imagination. This combination of theory, practice, and play forms the crux of our success.

Dan discovered his love for baking while cooking alongside his great-grandmother. Those times fostered a belief that baking has the power to tell stories, revive memories, evoke emotions, and even transport one through time. Even within the simplest recipe, magic resides. Believe that, and your baked goods can't help but improve.

Baking may be unforgiving, and it may test our patience. But it is in these moments that we learn our greatest lessons. Embracing our passion for baking and pastries has allowed us to find our calling, to find lifelong friends, and ultimately find out who we are. No matter where we are or what language we speak, baking is one common language. When we open ourselves to this language, we open a world of endless possibilities.

Robert Gonzalez & Dan Crean

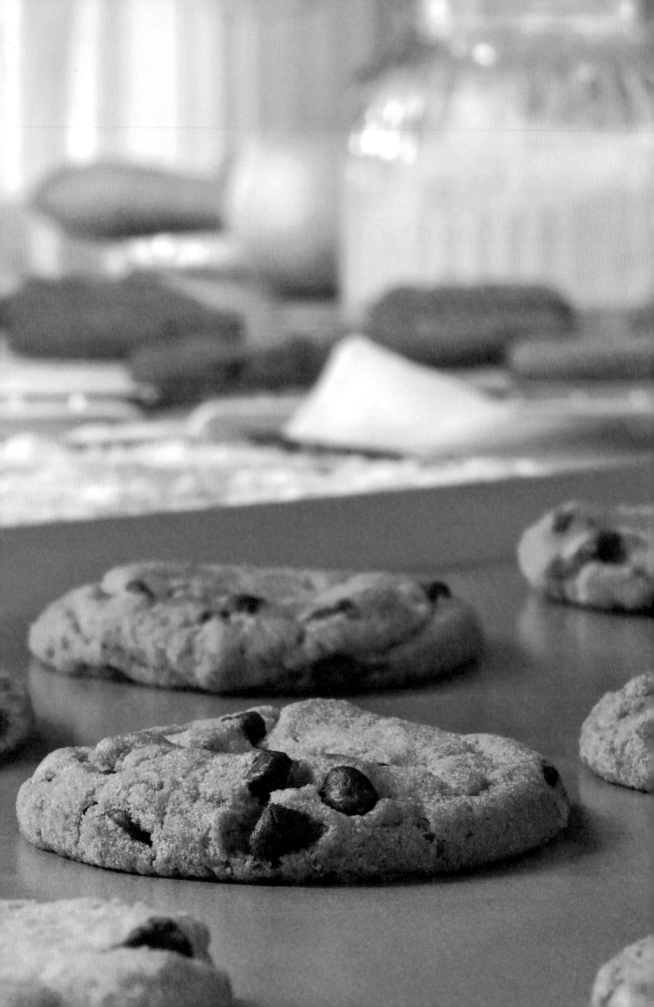

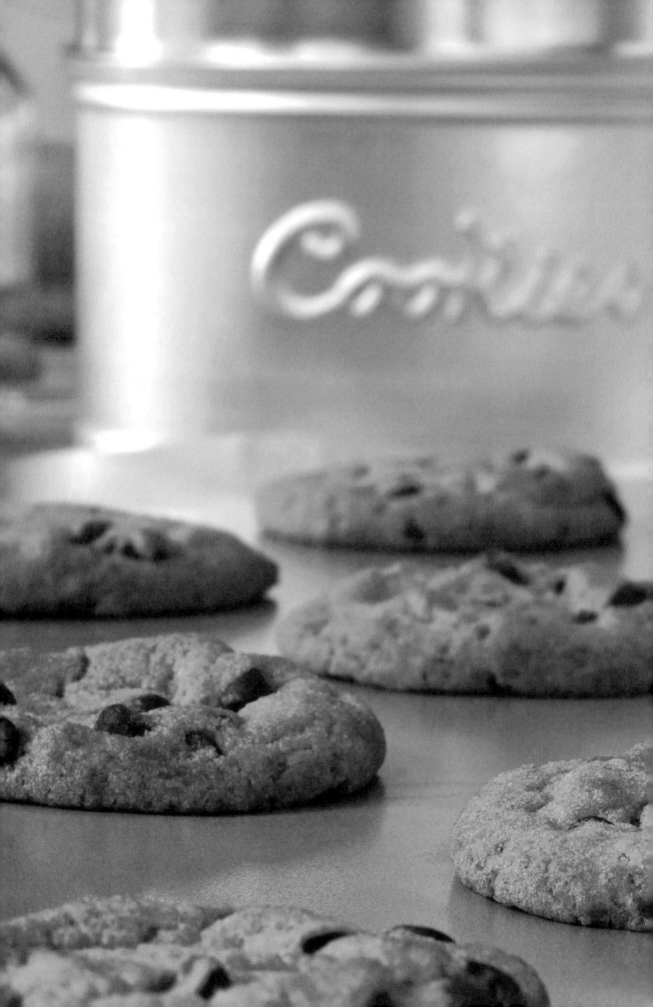

A BRIEF HISTORY
OF BAKING

The roots of baking, a process of preparing foods using dry heat, can be traced back more than 12,000 years ago to the Neolithic Age. Archeological evidence from this time points to people soaking and mashing grains in water to form a paste that was then poured on hot, flat stones, and subsequently onto hot ashes to produce rudimentary flatbreads. From there baking gradually evolved to ovens—the oldest one so far discovered dates back 6,500 years, and was found in Croatia.

Baking as we know it really began to take shape during the Roman Empire. They baked breads made from flour ground in their own mills in chimney ovens, and the craft became so popular that a baker's guild was established in 168 BCE in Rome, and pastry cooks gained respect for their occupation due to the decadent nature of their creations. By 1 CE, there were over 300 pastry chefs in Rome, revered for their great number of breads, pretzels, tortes, and sweet cakes. As the empire expanded throughout Europe and eastern Asia, so did the art of baking spread. By the dawn of the thirteenth century, baking had become so well established in London that it was regulated to set quality standards.

It was the ancient Egyptians who introduced yeast, which they were using to brew beer, to baking. Other leavening agents, such a baking soda, were introduced to baking in the nineteenth century as baking expanded into a commercial industry featuring automation, developments that enabled mass production and distribution.

Lost in this commercial craze were the unique aromas and textures of freshly baked goods, a characterization that no amount of labeling on commercial products could elicit. As the pace of the world quickened and the wide availability of baked goods made spending time before the oven increasingly less appealing, the craft and its benefits became almost entirely forgotten.

This unfortunate turn has recently started to reverse, however. A renewed interest in all things artisan has revived the craft, a renaissance that extends from celebrated talents like Nancy Silverton and Christina Tosi to exceptional local bakeries and passionate home bakers. This surge in popularity even provided one of the few bright spots of the COVID-19 pandemic, as people who never fancied themselves bakers began drilling into the complex process of making sourdough bread, sharing and celebrating their results on social media.

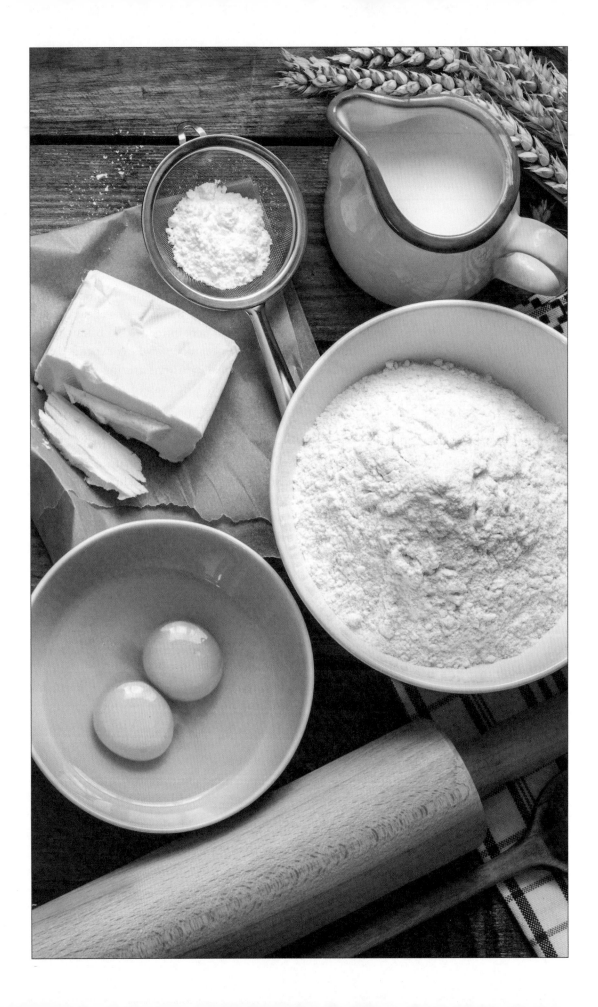

THE FUNDAMENTALS OF FLAVOR

FLOUR

Technically, flour derives from the grinding of seeds, nuts, or roots. The most commonly used flour comes from wheat, but flours from other grains, or cereals, are also very common.

Hearty and able to be processed into an affordable staple that can then be made into a dizzying variety of foodstuffs, wheat is the world's most widely grown cereal, accounting for nearly one-third of the global cereal harvest as of 2017.

Wheat seeds consist of a large, starchy endosperm and an oily germ, which are enclosed in an outer layer of bran. The fibers are primarily in the bran, while the endosperm is where the starches and most of the proteins are stored. Fats are stocked in the germ of the wheat kernel, and this part is also rich in vitamins.

Wheat and other cereals can be ground into flours featuring varying degrees of fineness. Coarse flours, like semolina, are best suited for pasta making. Fine flours, like the widely used all-purpose flour, are ideal for baking. And if you want to make a pastry with a feathery texture, you need to look for superfine flour, which is silky to the touch and confers that elegant feel to the baked goods it produces.

Research shows that wheat flour's ability to absorb water increases with a reduction in particle size. Dough development time and stability also grow as the flour increases in fineness.

This is due to the tendency of flour proteins to be more readily available in the finest fractions of milled flour. A dough made with finer flour is also more extensible, allowing for easier shaping. In all, this results in baked goods with higher volumes, lighter textures, and better colors compared to those made with coarser flours.

In order to obtain an even lighter and airier consistency in baked goods made from wheat flour, the bran is either partially or totally eliminated, or sifted out. Bran removal, which has been done since antiquity, now relies on increasingly sophisticated milling and sifting techniques.

Based on the amount of bran present in wheat flour, different labels are applied, such as whole wheat, sifted, unbleached white, and white (i.e., bleached).

Whole wheat flour is obtained when all the bran contained in the wheat kernel is included in the milled flour. However, not all whole wheat flours are the same. Most whole wheat flours available at the store are not made by grinding the whole seed at once. Instead, the bran, which was previously removed, is added back to the refined flour. The resulting flour, which is called whole wheat, will not truly include the whole ground wheat kernel, but only the endosperm and bran fractions. In fact, the vitamin-rich wheat germ is not included

in most industrially produced whole wheat flours.

Unbleached white flour is obtained via roller mill technology. This sophisticated method involves mechanically isolating the endosperm from the bran and the wheat germ and milling only the endosperm. This results in a flour that is lighter and whiter than that which can be produced by sifting. Unbleached white flour is extremely versatile and has a long shelf life, but the term does not mean that the flour is necessarily free from chemical additives. A very common additive in unbleached white flour is potassium bromate, which improves performance in the oven by strengthening the dough and allowing it to rise higher. However, this additive has been cited as a possible carcinogen, and is banned in the United Kingdom, Canada, and the European Union. Because of this, you may want to seek out unbleached white flour that is also unbromated.

If you see flour that is identified as "white flour" and does not specify being unbleached, this might mean that the flour has been bleached. Bleaching is done to increase whiteness and improve performance in the oven. Through bleaching, the flour is oxidized, which can mimic the natural aging of flour.

Unbleached flours are significantly denser and coarser in texture, and the final product has an almost ivory color compared to its bleached version. Traditionally you will find unbleached flours in bread and high-protein flour blends which can be worked more vigorously, and thus they are used in yeasted breads and laminated doughs.

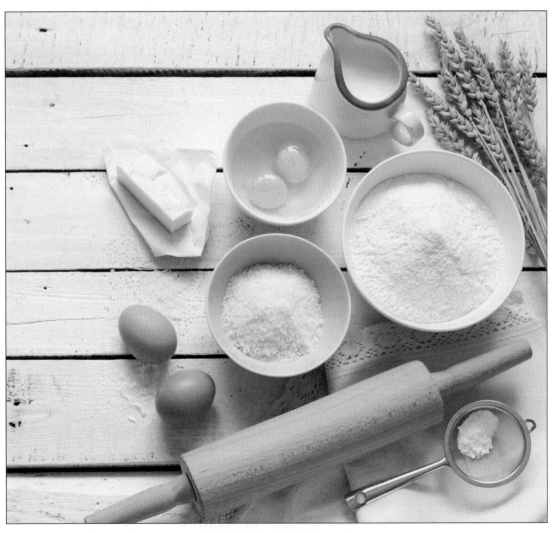

FLOURS USED IN BAKING

All-purpose flour: A versatile white flour that can be relied upon to produce outstanding results in nearly every baking preparation. It is generally a combination of flour from hard (bronze-colored wheat that has a higher protein, and thus higher gluten, content) and soft wheat (wheat with a light golden color; also referred to as "white wheat"). It is overwhelmingly the most frequently recommended flour in this book.

Pastry flour: A superfine white wheat flour with a relatively low protein content (around 9 percent) that is ideal for light, flaky baked goods. It is not a must, and the results it achieves can be duplicated with an all-purpose flour with a protein content on the lower end of the spectrum, but some baking enthusiasts swear by it for piecrusts, tarts, and croissants.

Cake flour: Another smooth, superfine white wheat flour, and its protein content is even lower (ranging from 6 to 8 percent) than pastry flour. It lends baked goods the tender texture and high rise that is particularly desirable for cakes and biscuits.

Bread flour: A white flour with a high protein content, which is ideal for bread baking, since the extra-elastic dough it produces can capture and hold more carbon dioxide than recipes using cake or pastry flour. Generally obtained from hard wheat, it is to be avoided when making desserts, as its high protein content will result in cakes and cookies that are far tougher and denser than anyone is in the market for.

High-gluten flour: A flour made from hard wheat that contains the highest protein content, ranging from 13.5 to 14.5 percent. This supercharged protein content increases the amount of gluten and possible gluten development. It is best when used to produce baked goods where chewiness is desired, such as bagels, sourdough bread, and pizza crusts.

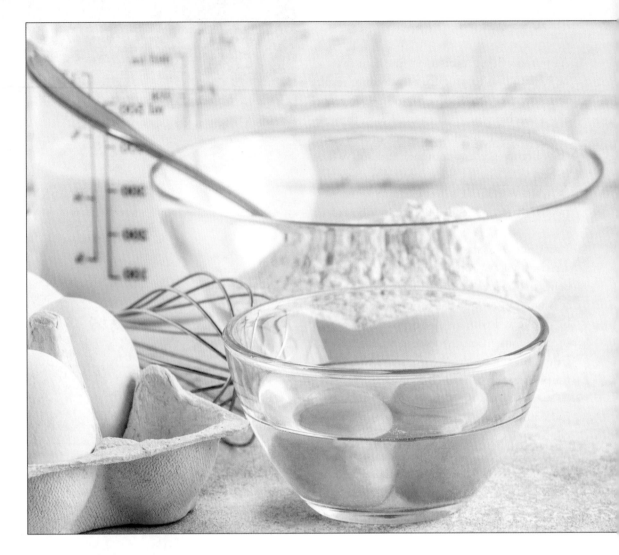

SALT

Contrary to what most nonbakers think, the primary reason to add salt to a dough is not for taste. Although salt does improve the taste, the other functions it serves are far more important.

Baking without salt will result in flat baked goods that in no way resemble the airy delights you were envisioning when you set out. The presence of salt in dough also slows down the activity of yeasts, bacteria, and enzymes, reducing acidity and allowing more time for the sweet, flavorful sugars to develop.

Salt also helps the dough create a better structure by making gluten (the protein that holds together baked goods) more robust and more effective at keeping the gasses in, produc-

ing results that are higher in volume and feature a more open crumb.

Salt absorbs water; thus, a dough containing salt will be drier and more elastic, and less difficult to work with during handling and shaping.

Keep in mind that salt stiffens the dough, which is why you should generally try to add it during the last phases of mixing/kneading rather than at the beginning, so as not to make the dough too tough too early.

In this book, fine sea salt and kosher salt are called for. Fine sea salt should be used in any baking recipe that does not specify a kind of salt. Where kosher salt is suggested, the Diamond Crystal brand should be used.

EGGS

For the purpose of making glorious desserts, it is best to secure the highest-quality eggs available.

Eggs provide more protein, which, when combined with the gluten, enhances the structure of a dough, making it elastic, soft, and easier to roll out without tearing.

It is important to use eggs that have a vibrantly orange yolk, as it is a sign of a healthy, happy, and well-fed chicken. Egg yolks get their color from carotenoids, which are also responsible for strengthening the chicken's immune system. Because chickens only hatch eggs if they have sufficient levels of carotenoids, the yolks possess hues of dark gold and orange. Paler yolks are often a result of chickens feeding on

barley or white cornmeal, which don't nourish them as well as a diet based on yellow corn and marigold petals.

Using brown or white eggs is up to personal preference, since they have the same nutritional profiles and taste. However, there are good arguments for buying brown eggs. Brown eggs come from larger breeds that eat more, take longer to produce their eggs, and produce eggs with thicker protective shells, which prevents internal moisture loss over time and helps them maintain their freshness.

Eggs in the United States are graded according to the thickness of their shell and the firmness of their white. Large egg producers can

assess the quality of each individual egg and efficiently sort the eggs by size, weight, and quality. With almost scientific precision, eggs are graded AA (top quality), A (good quality, found in most supermarkets), and B (substandard eggs with thin shells and watery whites that don't reach consumers but are used commercially and industrially). They are also further categorized by size: medium, large (the most common size), and extra large.

The past decade or so has seen a rise in the popularity of free-range and organic eggs. The chickens that produce these eggs are fed organic feed and are caged with slightly more space at their disposal than those raised at conventional chicken farms. The jury is still out on whether free-range eggs taste better, but they constitute an additional, and perhaps politically oriented, option for aspiring bakers.

SUGAR

The standards—granulated sugar (which is simply called "sugar" in the recipes), confectioners' sugar (which is the same as powdered sugar), and brown sugar—will be required in almost all of the recipes in this book. But in your endeavors you may come across a recipe that calls for one of the following sugars, which are less common.

Caster sugar: A superfine sugar with a consistency that sits somewhere between granulated sugar and confectioners' sugar. Since it can

dissolve without heat, unlike granulated sugar, it is most commonly called for in recipes where the sugar needs to melt or dissolve quickly, as in meringues. This ease can come with a hefty price tag that scares some people off, but you can easily make caster sugar at home with nothing more than a food processor or a blender and some granulated sugar. Place the granulated sugar in the food processor or blender and pulse until the consistency is superfine, but short of powdery. Let the sugar settle in the food processor, transfer it to a container, and label it to avoid future confusion.

Demerara sugar: A large-grained raw sugar that originated in Guyana and is now produced in a number of countries around the globe. It is commonly referred to as a "brown sugar" due to its color, but brown sugar is refined white sugar that has been bathed in molasses. Demer-

ara has a natural caramel flavor that comes through in any dish it is added to. Famous for the depth and complexity it can lend to recipes, it is worth experimenting with if a certain recipe is falling short of your ideal flavor. Demerara's large grains also pack a pleasant crunchy quality, making it perfect for sprinkling on muffins, cakes, and cookies.

Turbinado sugar: Very similar to demerara sugar, possessing the large, crunchy grains and rich flavor that have made demerara fashionable of late. If you're going to give either of these sugars a try, keep in mind that they contain more moisture than granulated sugar. This probably won't be a problem in preparations featuring a moist batter, such as brownies. But in recipes that are on the arid side, like pastry and cookie doughs, substituting demerara or turbinado might take you wide of the mark.

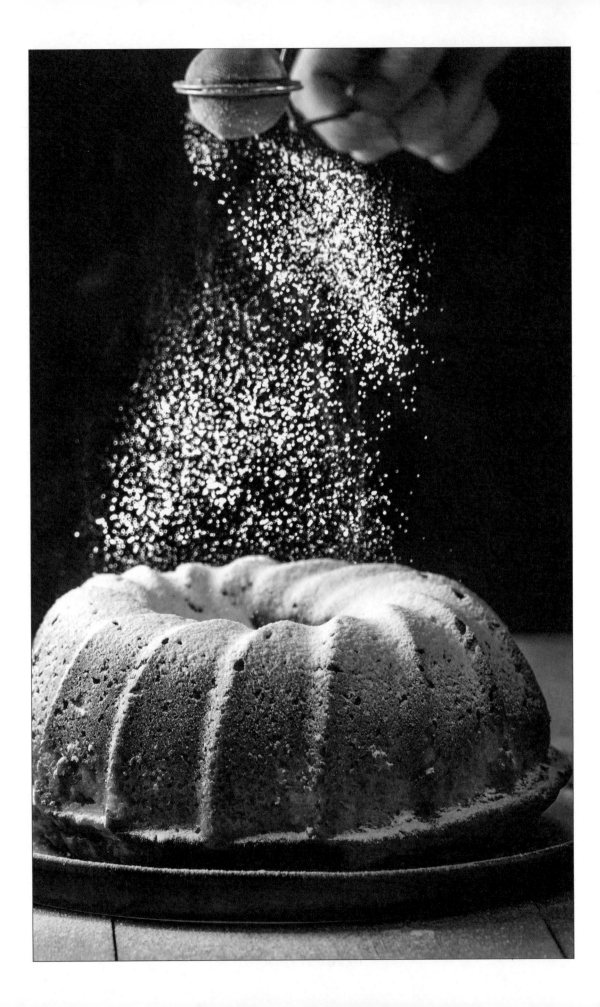

Muscovado sugar: A cane sugar with a very moist texture and a molasses-forward flavor. It is best suited to savory dishes, but it may be worth incorporating into preparations where you're after something other than standard sweetness. As with demerara and turbinado, you want to keep moisture in mind whenever you're thinking of utilizing it in a recipe.

Sanding sugar: A larger-crystal sugar used for decorating and finishing baked goods. Due to the larger size of its grains, sanding sugar will not fully melt in the oven, giving cookies and piecrusts a shiny and slightly crusty topping.

SUGAR SUBSTITUTES

As far as sugar alternatives go, substituting an equivalent amount of a combination of maple syrup and honey is probably the easiest route when baking. Agave nectar is another option, but it will affect the tenderness and flavor of baked goods. If you want to use agave nectar, swap it for the suggested amount of sugar and add ¼ cup flour to your preparation.

For those who have blood sugar concerns, stevia is the best bet to approximate the effect sugar would provide. Avoid saccharin (which will leave a strong aftertaste) and aspartame.

CARAMELIZING SUGAR

Caramelizing sugar is a key weapon in any confectioner's arsenal, as it lends desserts rich aromas and deep, complex flavors, but it's often perceived to be daunting and a little dangerous. Here's what you'll need to stick the landing the next time you're asked to make caramel.

Like many aspects of desserts, caramelizing sugar is a matter of basic chemistry. Applying heat to the combination of water and sugar leads us to a simple syrup. Continuing to heat the syrup causes the evaporation of water, which leads to a higher concentration of sugar in the solution. That higher concentration causes a more intricate structure as the mixture cools. There is a range of caramel, from the weakest stage at 235°F to full caramelization at 338°F.

When cooking or caramelizing sugar, the "wet" method is strongly preferred, as it slows

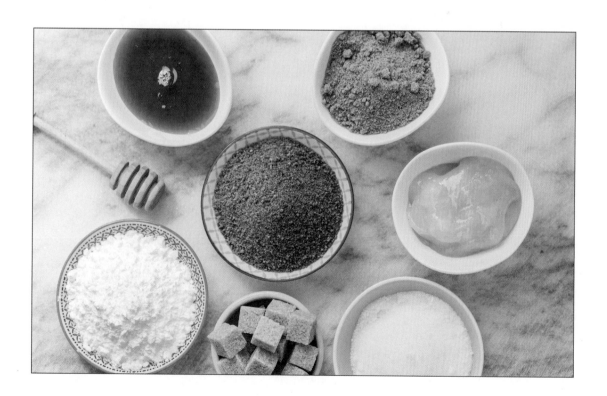

down the speed at which the sugar cooks and minimizes the chance that the caramel will burn. To employ this method, combine water and sugar in a saucepan and bring to a boil. When the sugar and water are combined, swirl the pan to distribute the water, run your finger under cold water, and wipe the sides of the pot clean of any granules of sugar. This prevents the sugar that has not been incorporated from cooking too quickly and burning on the side of the pot. It is also recommended that you keep a pastry brush and a bowl of cold water nearby when making caramel, so that you can carefully brush the sides of the pot with the cold water and control the sugar's cooking speed, maintaining the proper balance needed to make caramel.

BUTTER

In this book, the majority of the recipes call for unsalted butter. Salted butter is not the preferred choice because the salt content in each stick of butter varies, making it hard to exercise the necessary control over the amount of salt in your desserts.

For a few preparations, cultured butter is called for. Though widely available in Europe, it is something of a specialty item in the United States. Its higher percentage of butterfat is essential for light but rich pastries like croissants. Made from fresh pasteurized cream instead of sweet cream like most butters in the United States, cultured butter also has live bacterial cultures added to it after it has been pasteurized, lending the final product a unique tang. Despite being a less common ingredient in American kitchens, cultured butter can be found in many large supermarkets.

CHOCOLATE

Whether it be milk or dark, sweet, bitter, or white, the array of flavors that chocolate provides, and the number of desserts this versatility can carry, causes people all across the globe to be powerless against its sweet song.

The rare ingredient that is as comfortable playing with others as it is standing on its own, it's quite possible that chocolate is responsible for putting more smiles on people's faces than any other food.

No one is certain exactly when chocolate started to be a crave-worthy ingredient the world over, but it is believed that the Olmec civilization, which inhabited present-day Mexico, used cacao in a bitter, ceremonial drink, a hypothesis borne out by traces of theobromine—a stimulant that is found in chocolate and tea—being found on ancient Olmec pots and vessels.

While the exact role of chocolate in Olmec culture is impossible to pin down because they kept no written history, it appears that they passed on their reverence for it to the Mayans, who valued chocolate to the point that cocoa beans were used as currency in certain transactions. It is interesting that access to this precious resource wasn't restricted to the wealthy among the Mayans, but was available enough that a beverage consisting of chocolate mixed with honey or chili peppers could be enjoyed with every meal in a majority of Mayan households.

The next great Mexican civilization, the Aztecs, carried things even further. They saw cocoa as more valuable than gold, and the mighty Aztec ruler Montezuma II supposedly drank gallons of chocolate each day, believing that it provided him with considerable energy and also served as a potent aphrodisiac.

No one is certain exactly which explorer brought this New World tradition back

to Europe, with some crediting Christopher Columbus and others Hernán Cortés. Whoever is responsible, they created a sensation on the continent. Chocolate-based beverages that were sweetened with cane sugar or spruced up with spices such as cinnamon became all the rage, and fashionable houses where the wealthy congregated and indulged began popping up all over Europe by the early seventeenth century.

Chocolate remained in the hands of Europe's elite until a Dutch chemist named Coenraad Johannes van Houten discovered how to treat cacao beans with alkaline salts to produce a powdered chocolate that was more soluble. This "Dutch cocoa" made cocoa affordable for all and opened the door for mass production.

The first chocolate bar was produced by the British chocolatier J. S. Fry and Sons, though the amalgamation of sugar, chocolate liqueur, and cocoa butter was far chewier, and less sweet, than the bars turned out for the modern palate.

Swiss chocolatier Daniel Peter is widely credited as the individual who added dried milk powder to chocolate to create milk chocolate in 1876. Peter then teamed with his friend Henri Nestlé to create the company that brought milk chocolate to the masses.

In order to produce chocolate, the seeds of the cacao tree are harvested, heaped into piles to ferment, dried in the sun, and roasted at low temperatures to develop the beguiling flavors. The shells of the beans are then removed, and the resulting nibs are ground into cocoa mass (which is also called cocoa liquor) and placed under extremely high pressure to produce cocoa powder and cocoa butter. From there, the cocoa powder and cocoa butter are partnered with sugar to produce dark chocolate, and sugar and milk powder to produce milk chocolate.

Dark chocolate has a minimum of 55 percent cocoa and can go all the way to 100 percent, which is extremely bitter, though it carries a highly complex flavor. The dark chocolate you'll use in your desserts will tend to land in the 55 to 70 percent range.

Milk chocolate usually ranges from 38 to 42 percent cocoa and contains milk or heavy cream, along with cocoa beans and sugar. The lower cocoa content creates a creamier and silkier chocolate that is preferred by many.

Now for the question that continues to burn hotly in the minds of many: Is white chocolate chocolate? It depends. It does not contain the cocoa mass that is produced by grinding the roasted nibs of the cacao bean finely, so some do not consider white chocolate to be a true chocolate. Some apocryphal tales assert that white chocolate is the result of cocoa beans that have not been roasted; that is far from the case. White chocolate is instead made with cocoa butter (a product resulting from roasted cocoa beans), sugar, and milk powder.

Cocoa powder is pulverized, unsweetened cocoa mass that provides any dessert an intense injection of chocolatey flavor. The amount of cocoa liquor in cocoa powder varies from 88 to 100 percent, with the remainder being supplied by dried cocoa butter.

VANILLA

While it is synonymous with the bland and flavorless, for a large group of people, vanilla is anything but boring. Equal parts smooth and sweet, vanilla has an unmatched ability to both soothe and dazzle the taste buds. Any skeptics out there should talk to their favorite baker about the crucial role vanilla plays in a number of desserts, adding a luscious aroma and lightness whose absence would be glaring, rendering the finished confection unacceptable to anyone who had experienced it previously.

Vanilla is typically categorized according to where the orchid that produces the bean is grown, and, as those who are devotees of the vanilla bean know, there is plenty of variation in its flavor across the globe. Madagascar Bour-

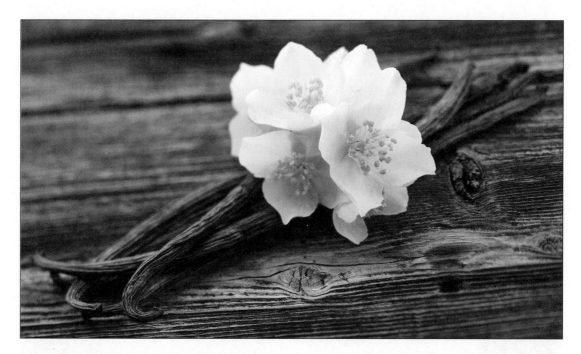

bon vanilla has nothing to do with American whiskey—though, to be fair, it's an understandable mistake given that many bourbons do carry strong notes of vanilla. Instead, it refers to Bourbon Island (now known as Reunion), an island east of Madagascar in the Indian Ocean, after which the vanilla that grows in the region was named. The sweet, creamy flavor of these beans is what comes to mind when most think of vanilla, as its incredible versatility has made it ubiquitous. Mexican vanilla adds a bit of nutmeg-y spice to vanilla's famously sweet and creamy quality, which makes it a wonderful addition to those cinnamon- and nutmeg-heavy desserts that show up around the holidays, and it can also be used to dress up a barbecue sauce. Indonesian vanilla beans carry a smoky, woody flavor and aroma that are particularly welcome in cookies and chocolate-rich desserts. Tahitian vanilla possesses a floral flavor that carries hints of stone fruit and anise, making Tahitian vanilla a perfect match for fruit-based desserts, as well as ice creams and custards. It is interesting to note that Tahitian vanilla is a different species of orchid than the one that produces the other three, and its beans are noticeably plumper.

This appellation tendency does not apply to French vanilla. Instead, this name refers to the traditional French method for making ice cream, which utilizes a rich egg custard base. Those eggs, some claim, give vanilla a richness and depth that the bean can't attain on its own, forming such a memorable match that the flavor, which carries caramel and floral notes, resides in a category all its own. This classification begs the question: What of vanilla ice cream made without eggs? Ice cream prepared in this manner is referred to as "Philadelphia style."

Using pure vanilla extract as opposed to the seeds of a vanilla bean will not affect the taste of your preparation, so don't be wary of any recipe that recommends the former. Ultimately, vanilla extract is made by macerating vanilla beans in a combination of water and alcohol. It is the more common recommendation due to its lower price and the ease of selling larger amounts. While using vanilla bean in place of extract won't do much to the taste, those dark little flecks do add an aesthetic element that the extract cannot, giving any dessert that utilizes the seeds an air of sophistication. If you want to take advantage of this in any recipe that recommends vanilla extract, simply substitute the seeds of 1 vanilla bean for every 1 tablespoon of vanilla extract.

LEAVENING AGENTS

Baking powder: A mix of baking soda and cornstarch that enables a baker to go without the acidic components needed to activate regular baking soda to react and leaven. The first reaction occurs when a liquid reacts with the baking soda. The second occurs when heat is added to the equation.

Baking soda: Sodium bicarbonate, which reacts when combined with acid and heat. Common acidic ingredients in baking are buttermilk, brown sugar, cocoa powder, citrus juice, vinegar, cream of tartar, sour cream, and yogurt.

Active dry yeast: A dormant, living organism that is used as a natural leavening agent. Dry yeast is activated when dissolved in lukewarm water (90 to 110°F) or kneaded into dough where the friction of the kneading process awakens the dormant yeast.

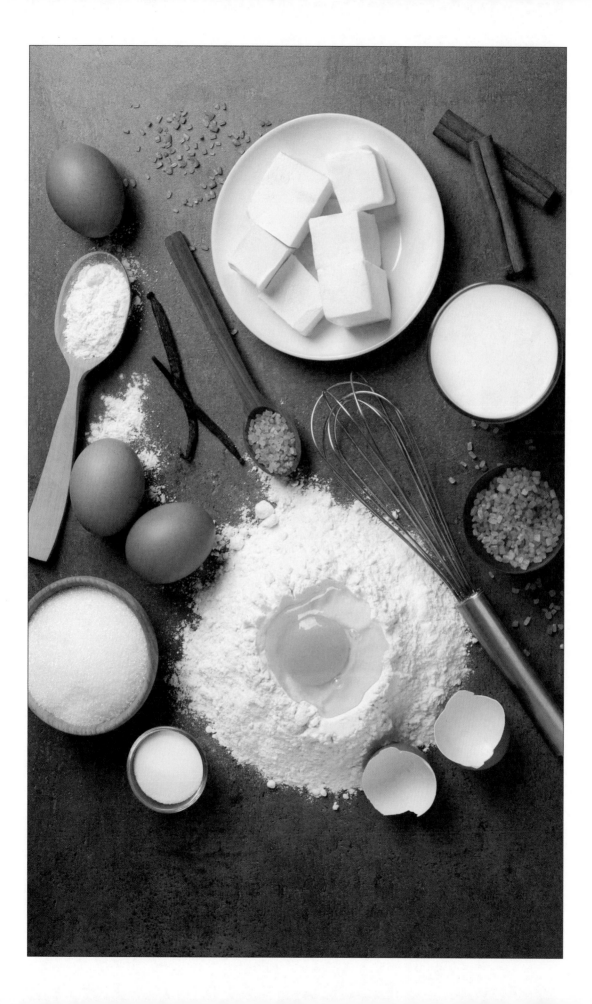

TIPS ON EQUIPMENT & TECHNIQUES

ACCURACY IS THE NAME OF THE BAKING GAME

Precision is important in all forms of cooking, but it is crucial when it comes to baking in particular. The beloved taste and texture of your favorite baked goods hinge on a delicate balance of flavors and interactions between ingredients, meaning that, most often, getting the results you desire means a commitment to measuring the components by weight, especially for ingredients such as flour.

If you and a friend were both to measure a cup of flour and place the flour on a scale, the weights would be different. This discrepancy occurs because of inconsistencies that arise when packing and filling a cup of flour. This goes for any ingredient measured using spoons or cups. These dry measuring cups and measuring spoons do not have a universal standard and can vary from brand to brand. But no matter where you are or what you are measuring, weight is weight. Four ounces for one person in France will be four ounces for another in Wichita, Kansas.

Throughout this book, weights will be given for a number of ingredients, particularly in the recipes that will be baked. A liquid in ounces should be measured by volume unless otherwise specified. Liquids such as water have a density of 1, which means they have a 1:1 ratio of weight to volume—i.e., they can be weighed on a scale or measured by volume and produce the same

result. Dry ingredients labeled by ounce should be measured on a scale.

Aside from assuring consistency and quality, weighing ingredients also saves time. Instead of readying an array of measuring cups that will all have to be cleaned afterward, you simply place a bowl on the scale, tare it, and begin adding ingredients. Another benefit of weighing ingredients is that it becomes easier to double or halve a recipe.

TAKE YOUR TEMPERATURE

Temperature is very important for certain ingredients, as most recipes call for you to emulsify items with different densities and structures. Having these various items at a similar temperature allows them to come together in a smooth and cohesive manner. Let us take butter that has softened at room temperature, for example.

The creaming method is the process of combining butter and sugar until airy, light, and fluffy. This process is only possible when the butter is warm enough that the friction from beating it opens up small pockets, which trap air as the sugar is being incorporated. As more air enters the mixture, it grows lighter, almost fluffy.

Eggs are another ingredient where various temperatures make a big difference in the final product. As a general rule, take your eggs out of

the refrigerator at least one hour before starting your preparation.

You want everything to be at room temperature for baked goods intended to have a lighter, more delicate texture. Any dough or batter that must rest at room temperature or be refrigerated before going in the oven does not need to be made with room-temperature ingredients.

If you're short on time, there are a few things that can be done to warm up said ingredients. Butter, milk, water, and sour cream can be gradually heated in a microwave until they reach room temperature. Conversely, if your kitchen is cold and your metal mixing bowl is chilling your product too quickly, you can lightly run the flame of a kitchen torch over the outside of the bowl to help maintain the higher temperature of the mixture inside.

SIFTING

Sifting is another important step in many recipes. This process allows one to separate the flour particles, which lightens the mix and allows other ingredients to be evenly distributed, resulting in baked goods with a lighter, fluffier texture. It's wise to have a small and a large sifter on hand. A small sifter is good for dusting and decorating. A larger sifter is best for aerating mixes that use cake flour, baking powder, baking soda, and cocoa powder.

READ THE RECIPE. THEN READ IT AGAIN.

One of the most common and detrimental mistakes in cooking is starting preparations without reading the recipe all the way through. Take the time to read the recipe, so you can see how much time you will need, what ingredients are

required, what items need to be at room temperature, etc. Reading the recipe carefully allows you to get organized, so that you can focus on executing it properly when the time comes. It's easy to leave something out or miss a key step when you're rushing to grab items and containers as you go. It's also much harder to pay attention to how a certain batter feels, or how a cookie smells as it turns toward the last minute of baking, hindering the sixth sense that is essential for overcoming the inevitable changes in conditions and ingredients.

PREPARE BAKING PANS

Getting your baking pans ready before starting a particular preparation is another good habit to develop, as it enables you to save time between finishing mixing a dough or batter and putting it in the oven. Baking is all about timing—just consider that most leavening agents, especially when used in a cake batter, start to lose their power the moment they are moistened and mixed. Reducing the amount of time a leavening agent has to work without the aid of heat will pay off big in the final result.

DO NOT OPEN THE OVEN!

The temptation to open the oven and take a closer look to ensure that whatever's in there is baking properly is overwhelming. Resist the temptation, especially when there's a cake in the oven, for at least three-quarters of the suggested baking time. A drop in temperature could cause the final product to deflate slightly, nullifying all the work you did to mix the dough or batter properly.

STAND MIXER

One of the keys to producing beautiful baked goods is emulsification. Emulsification is the combination of liquids that normally would not easily blend, e.g., butter and sugar. These ingredients tend to have different chemical structures and different densities, and that is where a stand mixer comes into play. When a product is properly emulsified, air becomes trapped in small pockets that lighten and aerate the finished products.

For proper emulsification to occur, ingredients are best at room temperature. This goes for items that are refrigerated as well as those that have been toasted or melted, like chocolate and nuts—they will have to be at room temperature before being added to the mixes.

Most recipes begin with the creaming of butter and sugar. This requires us to use the paddle attachment, which creates enough friction that air becomes trapped in the butter's fat.

Scraping the sides of the mixing bowl between additions of ingredients such as eggs is also crucial to the final product. The paddle and whisk attachments of a stand mixer leave a small gap between the bowl and the attachment, which prevents some of the mixture from being properly emulsified. Scraping down the bowl ensures we are evenly distributing our ingredients.

When it comes to adding dry ingredients, such as flour to a dough or batter, consider placing the dry ingredients on parchment paper or a narrow container, as this allows us to add them gradually. It is generally important to control the rate at which products get added to the work bowl of the stand mixer, as it ensures even distribution and prevents overworking of the mix. Overworking the mixture may flatten it or heat it up too much. When recipes call for the alternating of wet and dry ingredients, always end with a dry ingredient.

Whipping egg whites is crucial to many recipes, such as sponge cakes, meringues, buttercreams, macarons, and light cakes. Before separating your egg whites, ensure that the whisk attachment and bowl are clean, oil free, and dry.

Room-temperature egg whites retain a better structure when whipped at medium speed. Adding salt or cream of tartar to the mix provides extra stability and structure, and any sugar must be added gradually so as not to destabilize this structure. Once all the sugar has been added, we increase the speed to high and allow the egg whites to whip until glossy, stiff peaks are formed. These stiff peaks occur when the whisk attachment is held horizontally and the mixture does not droop.

FOLDING

Folding is a technique used to combine light and airy ingredients such as eggs or egg whites with heavier ingredients, such as a ganache. As folding requires a gentle touch, a rubber spatula is essential. Once you have that in hand, simply combine the two mixtures and turn it over and over itself until smooth and emulsified.

KNEADING

Kneading is the process of developing a smooth and elastic dough. When flour and moisture are combined, strands of the gluten protein begin to form. This protein becomes tougher the more friction is applied, which results in more gas retention and volume in the final product.

Properly developed gluten allows yeasted doughs to stretch and expand as it rises. Kneading can be done either by hand or with a stand mixer. In most instances in this book, we use the stand mixer to begin the dough and finish on a flour-dusted work surface by hand, as this is the best way to get a feel for bread and dough.

To finish kneading a dough by hand, fold the dough in half toward you. Then, with the heel of your hand, push the dough down and away from you. Give the dough a quarter turn and repeat this folding, pushing, and turning until the dough is smooth and elastic. Add flour only if the dough becomes too sticky.

Dough will toughen up the more you work it. We recommend letting dough relax for at least a few minutes if it becomes too tough to work. You can do this by placing the dough in a covered bowl, to prevent it from drying out.

To know when your dough has been kneaded enough, do the "window" test. Take a golf ball–sized piece of dough and use your thumbs and index fingers to gently stretch it. If it stretches to the point that you can almost see through it, it is ready. If the dough rips easily, it does not have enough gluten development and we must continue kneading for another 2 minutes before testing it again.

COOKIES

Our love of cookies is tied to the memory, to the mind. The sight of them on a tiered stand around the holidays, piled high with the bounty of a recent cookie swap. An afternoon spent making drop cookies with a loved one, trading turns licking the spoon. Sneaking into a kitchen to grab a chocolate chip cookie just out of the oven to savor the pillowy warmth at its peak.

This magic that lingers is due in some part to the cookie's unique ability to be crisp but still moist, rich without also being heavy. But there's also plenty of room for mystery within that mystique, which makes sense to those who have experienced the alchemy that takes place when an unbelievably simple to prepare dough is put in the oven.

CHOCOLATE CHIP COOKIES

YIELD: 24 COOKIES / **ACTIVE TIME:** 20 MINUTES / **TOTAL TIME:** 2 HOURS

By far the king of all cookies. We prefer ours slightly undercooked and just a touch gooey, and we're convinced that this recipe will win you over to our side.

1. In the work bowl of a stand mixer fitted with the paddle attachment, cream the butter, sugar, dark brown sugar, salt, and baking soda on medium until the mixture is very light and fluffy, about 5 minutes. Scrape down the work bowl and then beat for another 5 minutes.

2. Reduce the speed to low and incorporate the eggs one at a time, scraping down the work bowl as needed. Add the vanilla, beat to incorporate, raise the speed to medium, and beat for 1 minute.

3. Add the flour and semisweet chocolate chips, reduce the speed to low, and beat until the mixture comes together as a dough.

4. Scoop 2-oz. portions of the mixture onto parchment-lined baking sheets, making sure to leave enough space between the portions. Place the baking sheets in the refrigerator and let the dough firm up for 1 hour.

5. Preheat the oven to 350°F.

6. Place the cookies in the oven and bake until they are lightly golden brown at their edges, 10 to 12 minutes. Make sure not to let the cookies fully brown or they will be too crispy.

7. Remove from the oven and let the cookies cool on the baking sheets for a few minutes. Transfer them to wire racks and let them cool for 20 to 30 minutes before enjoying.

INGREDIENTS:

8	OZ. UNSALTED BUTTER, SOFTENED
8	OZ. SUGAR
8	OZ. DARK BROWN SUGAR
1½	TEASPOONS KOSHER SALT
1	TEASPOON BAKING SODA
2	EGGS
1½	TEASPOONS PURE VANILLA EXTRACT
14.5	OZ. ALL-PURPOSE FLOUR
14	OZ. SEMISWEET CHOCOLATE CHIPS

SNICKERDOODLES

YIELD: 24 COOKIES / **ACTIVE TIME:** 20 MINUTES / **TOTAL TIME:** 2 HOURS

The cinnamon is essential to these classic cookies, so make sure to use a top-quality offering.

1. In the work bowl of a stand mixer fitted with the paddle attachment, cream the butter, sugar, dark brown sugar, salt, and baking soda on medium until the mixture is very light and fluffy, about 5 minutes. Scrape down the work bowl and then beat for another 5 minutes.

2. Reduce the speed to low and incorporate the eggs one at a time, scraping down the work bowl as needed. Add the vanilla, beat to incorporate, raise the speed to medium, and beat for 1 minute.

3. Add the flour, reduce the speed to low, and beat until the mixture comes together as a dough.

4. Scoop 2-oz. portions of the mixture onto parchment-lined baking sheets, making sure to leave enough space between the portions. Place the baking sheets in the refrigerator and let the dough firm up for 1 hour.

5. Preheat the oven to 350°F.

6. Toss the scoops of cookie dough in the Cinnamon Sugar and return them to the baking sheet. Place the cookies in the oven and bake until they are lightly golden brown around the edges, 10 to 12 minutes.

7. Remove from the oven and let the cookies cool on the baking sheets for a few minutes. Transfer them to wire racks and let them cool for another 20 to 30 minutes before enjoying.

INGREDIENTS:

8 OZ. UNSALTED BUTTER, SOFTENED

8 OZ. SUGAR

8 OZ. DARK BROWN SUGAR

1½ TEASPOONS KOSHER SALT

1 TEASPOON BAKING SODA

2 EGGS

1½ TEASPOONS PURE VANILLA EXTRACT

14.5 OZ. ALL-PURPOSE FLOUR

 CINNAMON SUGAR (SEE RECIPE)

CINNAMON SUGAR

1 CUP SUGAR

1 TABLESPOON CINNAMON

CINNAMON SUGAR

1. Combine the ingredients in a mixing bowl and use as indicated.

MATCHA RICE KRISPIES TREATS

YIELD: 12 BARS / **ACTIVE TIME:** 15 MINUTES / **TOTAL TIME:** 1 HOUR AND 15 MINUTES

The earthiness of matcha is a perfect match for the sweetness of a marshmallow bar.

1. Line a 13 x 9–inch baking pan with parchment paper and coat it with nonstick cooking spray.

2. Fill a small saucepan halfway with water and bring it to a simmer. Place the marshmallow creme, butter, matcha powder, and salt in a heatproof mixing bowl, place it over the simmering water, and stir the mixture with a rubber spatula until the butter has melted and the mixture is thoroughly combined. Remove the bowl from heat, add the cereal, and fold until combined. Add the vanilla and white chocolate chips and fold until evenly distributed.

3. Transfer the mixture to the baking pan and spread it with a rubber spatula. Place another piece of parchment over the mixture and pack it down with your hand until it is flat and even. Remove the top piece of parchment.

4. Place the pan in the refrigerator for 1 hour.

5. Run a knife along the edge of the pan and turn the mixture out onto a cutting board. Cut into squares and enjoy.

INGREDIENTS:

12	OZ. MARSHMALLOW CREME
4.5	OZ. UNSALTED BUTTER
2	TABLESPOONS MATCHA POWDER
¾	TEASPOON FINE SEA SALT
9	CUPS RICE KRISPIES
¾	TEASPOON PURE VANILLA EXTRACT
2½	CUPS WHITE CHOCOLATE CHIPS

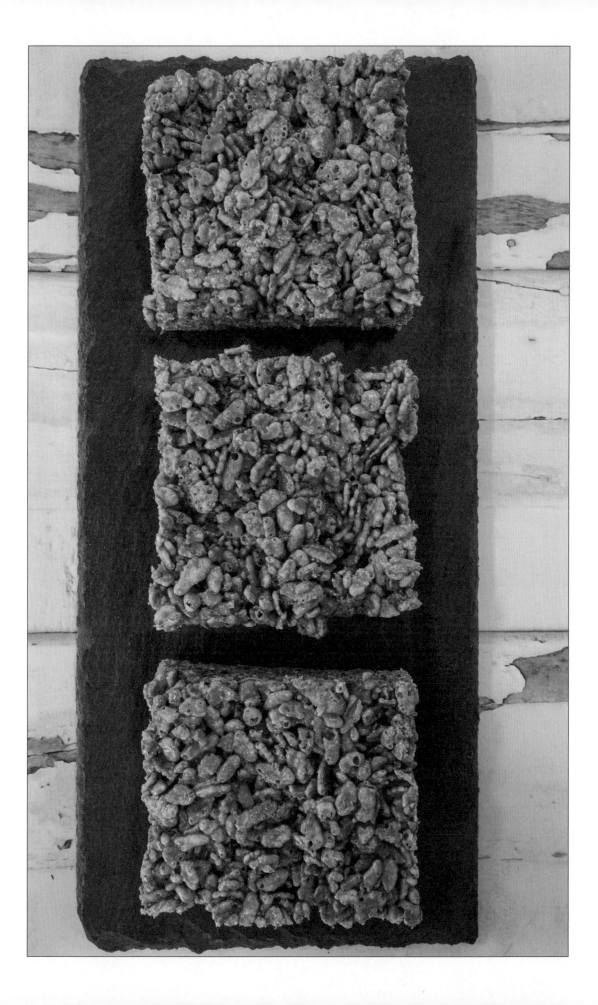

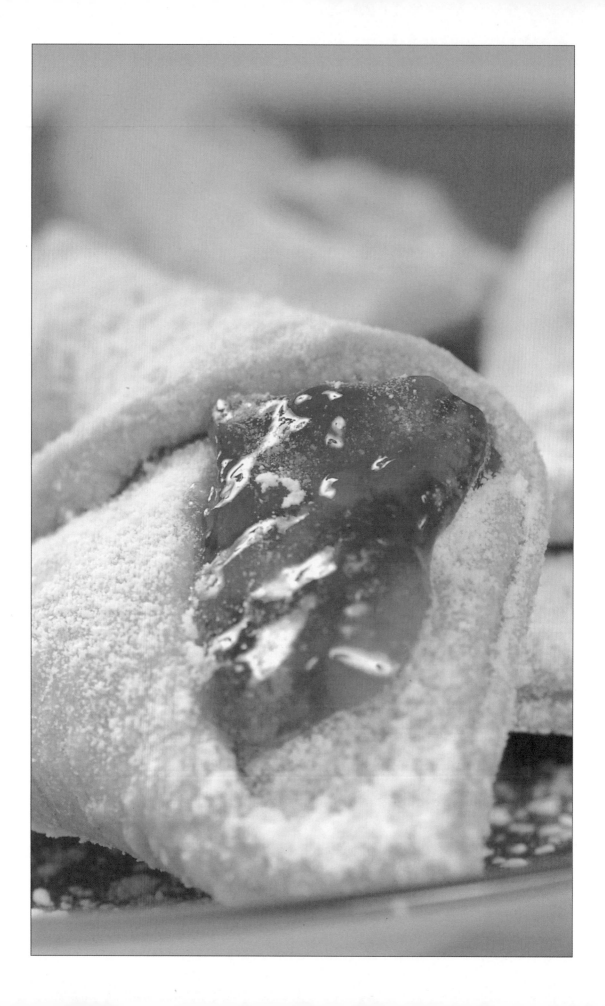

APRICOT KOLACHES

YIELD: 32 COOKIES / **ACTIVE TIME:** 30 MINUTES / **TOTAL TIME:** 2 HOURS AND 30 MINUTES

You can nestle any fruit in this dough, but none will be lovelier than the sweet and tart apricot.

1. Place the dried apricots in a saucepan and cover with water. Bring the water to a boil over medium-high heat and cook until the apricots are soft, adding more water if too much evaporates. Add the sugar and reduce the heat so that the mixture simmers. Cook, stirring to dissolve the sugar, until the liquid thickens into a syrup. Transfer the mixture to a blender or food processor and puree until smooth. Let it stand until cool.

2. Sift the flour and salt into a mixing bowl. In the work bowl of a stand mixer fitted with the paddle attachment, beat the cream cheese and butter on high until the mixture is fluffy. Gradually add the dry mixture to the wet mixture and beat to incorporate. Divide the dough into two balls and cover loosely with plastic wrap. Flatten each ball to about ¾ inch thick and refrigerate until the dough is firm, about 2 hours.

3. Preheat the oven to 375°F and line a large baking sheet with parchment paper. Place one of the balls of dough on a flour-dusted work surface and roll it out into a ⅛-inch-thick square. Cut the dough into as many 1½-inch squares as possible.

4. Place approximately 1 teaspoon of the apricot mixture in the center of each square. Gently lift two opposite corners of each square and fold one over the other. Gently press down to seal, and transfer to the baking sheet. Repeat until all of the squares have been used.

5. Place the cookies in the oven and bake for 12 to 14 minutes, until the cookies are golden brown. Remove, briefly let them cool on the baking sheets, and transfer to wire racks to cool completely. Repeat with the remaining ball of dough. When all of the kolaches have been baked and cooled, dust with the confectioners' sugar.

INGREDIENTS:

- 8 OZ. DRIED APRICOTS
- 3.5 OZ. SUGAR
- 2.8 OZ. ALL-PURPOSE FLOUR, PLUS MORE AS NEEDED
- ¼ TEASPOON FINE SEA SALT
- 2 OZ. CREAM CHEESE, SOFTENED
- 4 OZ. UNSALTED BUTTER, SOFTENED
- ¼ CUP CONFECTIONERS' SUGAR, FOR DUSTING

CLASSIC SUGAR COOKIES

YIELD: 48 COOKIES / **ACTIVE TIME:** 40 MINUTES / **TOTAL TIME:** 3 HOURS

These seem to abound around the holidays, but they are wonderful at any time of year—particularly when made with a loved one.

1. In the work bowl of a stand mixer fitted with the paddle attachment, cream the butter and brown sugar on medium until the mixture is very light and fluffy, about 5 minutes. Scrape down the work bowl and then beat the mixture for another 5 minutes.

2. Reduce the speed to low, add the egg, and beat until incorporated. Scrape down the work bowl and beat the mixture for 1 minute on medium.

3. Add the remaining ingredients, reduce the speed to low, and beat until the mixture comes together as a dough. Form the dough into a ball and then flatten it into a disk. Cover the dough completely with plastic wrap and refrigerate for 2 hours.

4. Preheat the oven to 350°F and line two baking sheets with parchment paper.

5. Remove the dough from the refrigerator and let it sit on the counter for 5 minutes.

6. Place the dough on a flour-dusted work surface and roll it out until it is approximately ¼ inch thick. Use cookie cutters to cut the dough into the desired shapes and place them on the baking sheets. Form any scraps into a ball, roll it out, and cut into cookies. If the dough becomes too sticky or warm, place it back in the refrigerator for 15 minutes to firm up.

7. Place the cookies in the oven and bake until they are lightly golden brown at their edges, 8 to 10 minutes. Remove the cookies from the oven, transfer to wire racks, and let them cool for 10 minutes before enjoying or decorating.

INGREDIENTS:

- 8 OZ. UNSALTED BUTTER, SOFTENED
- 7 OZ. LIGHT BROWN SUGAR
- 1 EGG
- 12 OZ. ALL-PURPOSE FLOUR, PLUS MORE AS NEEDED
- 1 TEASPOON BAKING POWDER
- ½ TEASPOON KOSHER SALT

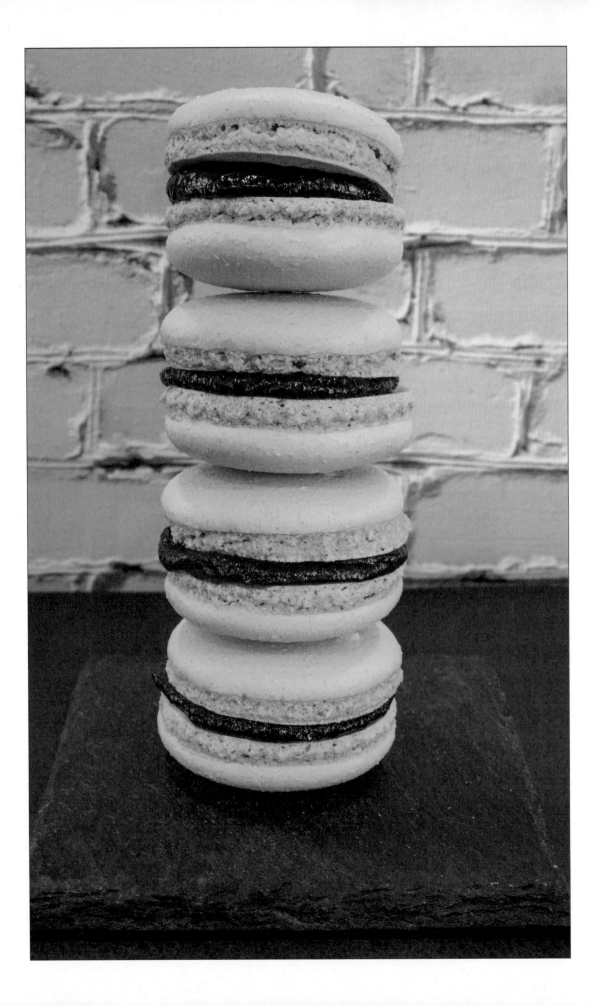

MACARONS

YIELD: 30 MACARONS / **ACTIVE TIME:** 1 HOUR / **TOTAL TIME:** 4 HOURS

Featuring a crispy outside and a cloud-like center, these confections are, for once, entirely worth the hype. For ideas on what to fill them with, see the Essential Accompaniments chapter.

1. Place the almond flour and confectioners' sugar in a food processor and blitz for about 1 minute, until the mixture is thoroughly combined and has a fine texture. Place the mixture in a mixing bowl, add three of the egg whites and the salt, and stir with a rubber spatula until the mixture is almost a paste. Set the mixture aside.

2. Place the sugar and water in a small saucepan. Place a candy thermometer in the saucepan and cook the mixture over high heat.

3. While the syrup is coming to a boil, place the remaining egg whites in the work bowl of a stand mixer fitted with the whisk attachment, and whip on medium until they hold firm peaks.

4. Cook the syrup until it is 245°F. Remove the pan from heat and carefully add the syrup to the whipped egg whites, slowly pouring it down the side of the work bowl. When all of the syrup has been added, whip the mixture until it is glossy, holds stiff peaks, and has cooled slightly. If desired, stir in the food coloring.

5. Add half of the meringue to the almond flour mixture and fold to incorporate. Fold in the remaining meringue. When incorporated, the batter should be smooth, very glossy, and not too runny.

6. Fit a piping bag with a plain tip and fill it with the batter. Pipe evenly sized rounds onto baking sheets lined with Silpat silicone baking mats, leaving an inch of space between each round. You want the rounds to be about the size of a silver dollar (approximately 2 inches wide) when you pipe them onto the sheet; they will spread slightly as they sit.

7. Gently tap each baking sheet to smooth the tops of the macarons.

8. Let the macarons sit at room temperature, uncovered, for 1 hour. This allows a skin to form on them.

9. Preheat the oven to 325°F.

10. Place the macarons in the oven and bake for 10 minutes. Rotate the baking sheet and let them bake for another 5 minutes. Turn off the oven, crack the oven door, and let the macarons sit in the oven for 5 minutes.

11. Remove from the oven and let the cookies sit on a cooling rack for 2 hours. When the macarons are completely cool, fill them as desired.

INGREDIENTS:

11	OZ. FINE ALMOND FLOUR
11	OZ. CONFECTIONERS' SUGAR
8	EGG WHITES
	PINCH OF FINE SEA SALT
11	OZ. SUGAR
½	CUP WATER
2–3	DROPS OF GEL FOOD COLORING (OPTIONAL)

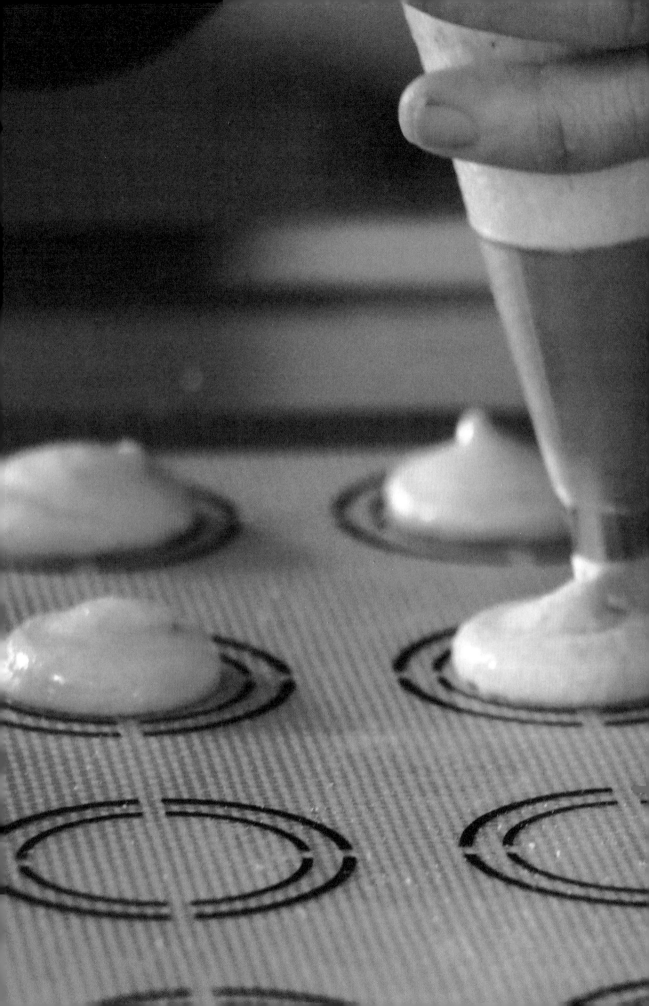

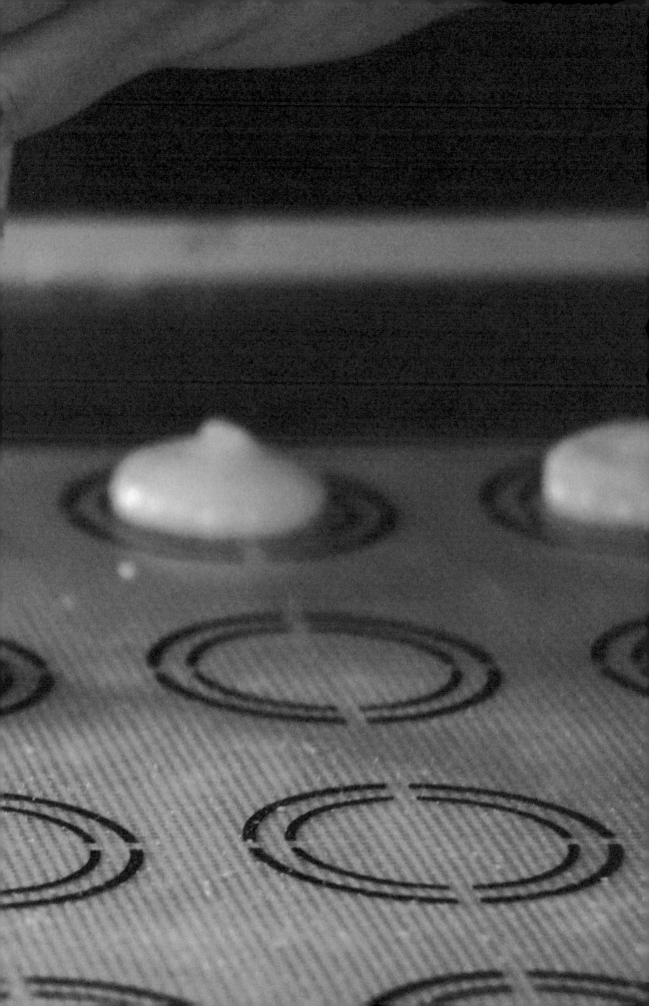

MADELEINES

YIELD: 30 MADELEINES / **ACTIVE TIME:** 40 MINUTES / **TOTAL TIME:** 3 HOURS AND 30 MINUTES

Thanks to the unmatched brilliance of Marcel Proust, this just may be the world's most famous cookie.

1. In the work bowl of a stand mixer fitted with the paddle attachment, beat the sugar, egg whites, and lemon zest on medium until the mixture is light and fluffy. Add the flours and beat until incorporated. Set the mixture aside.

2. Place the butter in a small saucepan and melt it over low heat.

3. Set the mixer to low speed and slowly pour the melted butter into the mixer. When the butter has been incorporated, add the vanilla and beat until incorporated.

4. Place the madeleine batter into two piping bags. Place the bags in the refrigerator to set the batter, about 2 hours.

5. Coat your madeleine pans with nonstick cooking spray. Pipe about 1 tablespoon of batter in the center of each seashell mold.

6. Place the pans in the oven and bake until the edges of the madeleines turn golden brown, about 10 minutes. Remove the cookies from the oven, immediately remove the cookies from the pans, transfer them onto a cooling rack, and let them cool completely.

7. Once cool, lightly dust the tops of the madeleines with confectioners' sugar.

INGREDIENTS:

8	OZ. SUGAR
8	OZ. EGG WHITES
	ZEST OF 1 LEMON
3.2	OZ. FINE ALMOND FLOUR
3.2	OZ. ALL-PURPOSE FLOUR
7	OZ. UNSALTED BUTTER
1	TEASPOON PURE VANILLA EXTRACT
	CONFECTIONERS' SUGAR, FOR DUSTING

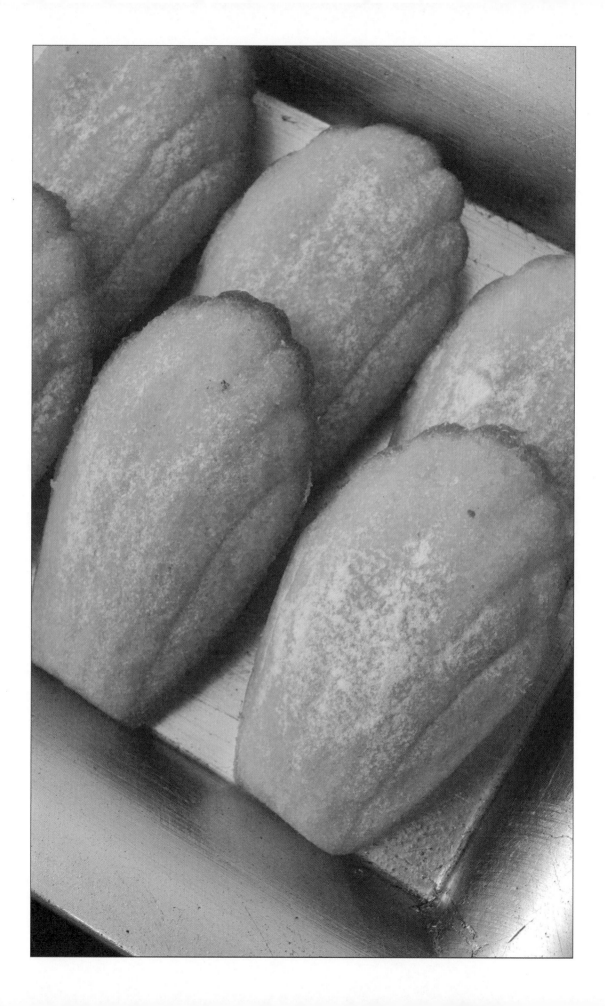

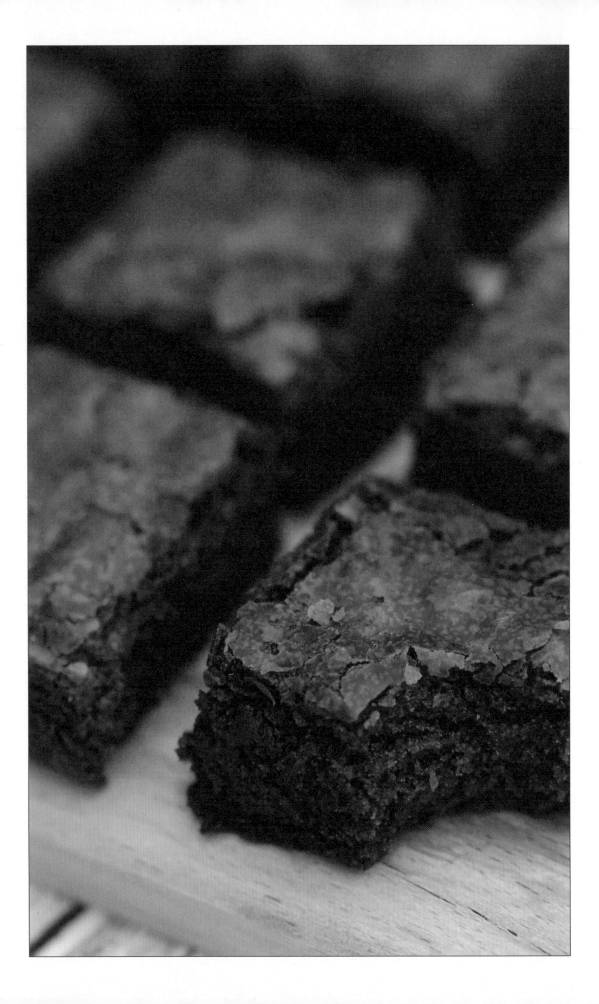

BROWNIES FROM SCRATCH

YIELD: 12 BROWNIES / **ACTIVE TIME:** 30 MINUTES / **TOTAL TIME:** 3 HOURS

Toss aside those store-bought mixes for good, as this recipe for homemade brownies has it all.

1. Preheat the oven to 350°F. Line a 13 x 9–inch baking pan with parchment paper and coat it with nonstick cooking spray.

2. Fill a small saucepan halfway with water and bring it to a simmer. Place the dark chocolate and butter in a heatproof bowl, place it over the simmering water, and stir until they have melted and been combined. Remove the bowl from heat and set aside.

3. In a separate mixing bowl, whisk the sugar, brown sugar, cocoa powder, and salt, making sure to break up any clumps. Whisk in the eggs, vanilla, and melted dark chocolate mixture and then gradually add the flour, whisking to thoroughly incorporate before adding the next bit.

4. Pour the batter into the baking pan and use a rubber spatula to even out the top. Lightly tap the baking pan on the counter to remove any air bubbles.

5. Place the brownies in the oven and bake until a cake tester comes out clean after being inserted, 30 to 40 minutes.

6. Remove the brownies from the oven, transfer the brownies to a cooling rack, and let them cool completely. Once they are cool, transfer them to the refrigerator and chill for 1 hour.

7. Run a paring knife along the sides of the pan, cut the brownies into squares, and enjoy.

INGREDIENTS:

- 7.5 OZ. DARK CHOCOLATE (55 TO 65 PERCENT)
- 12 OZ. UNSALTED BUTTER
- 12 OZ. SUGAR
- 12 OZ. LIGHT BROWN SUGAR
- ¼ CUP COCOA POWDER, PLUS 1 TABLESPOON
- 1 TEASPOON KOSHER SALT
- 5 EGGS
- 1½ TABLESPOONS PURE VANILLA EXTRACT
- 9.5 OZ. ALL-PURPOSE FLOUR

COCONUT MACAROONS

YIELD: 12 MACAROONS / **ACTIVE TIME**: 45 MINUTES / **TOTAL TIME**: 3 HOURS

Coconut can be divisive, but for coconut lovers, these sweet, pillowy, and slightly crispy treats are the jewel of their obsession.

1. Line a baking sheet with parchment paper. In a mixing bowl, mix the sweetened condensed milk, shredded coconut, salt, and vanilla with a rubber spatula until combined. Set the mixture aside.

2. In the work bowl of a stand mixer fitted with the whisk attachment, whip the egg whites until they hold stiff peaks. Add the whipped egg whites to the coconut mixture and fold to incorporate.

3. Scoop 2-oz. portions of the mixture onto the lined baking sheet, making sure to leave enough space between them. Place the baking sheet in the refrigerator and let the dough firm up for 1 hour.

4. Preheat the oven to 350°F.

5. Place the cookies in the oven and bake until they are lightly golden brown, 20 to 25 minutes.

6. Remove from the oven, transfer the cookies to a cooling rack, and let them cool for 1 hour.

7. Dip the bottoms of the macaroons into the ganache and then place them back on the baking sheet. If desired, drizzle some of the ganache over the tops of the cookies. Refrigerate until the chocolate is set, about 5 minutes, before serving.

INGREDIENTS:

1 (14 OZ.) CAN SWEETENED CONDENSED MILK

7 OZ. SWEETENED SHREDDED COCONUT

7 OZ. UNSWEETENED SHREDDED COCONUT

¼ TEASPOON KOSHER SALT

½ TEASPOON PURE VANILLA EXTRACT

2 EGG WHITES

CHOCOLATE GANACHE (SEE PAGE 664), WARM

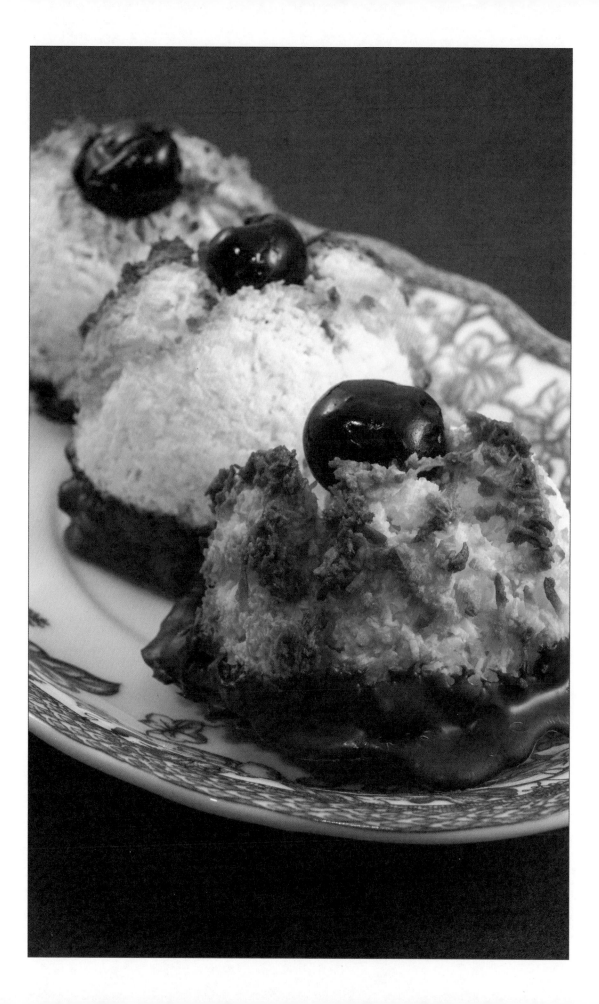

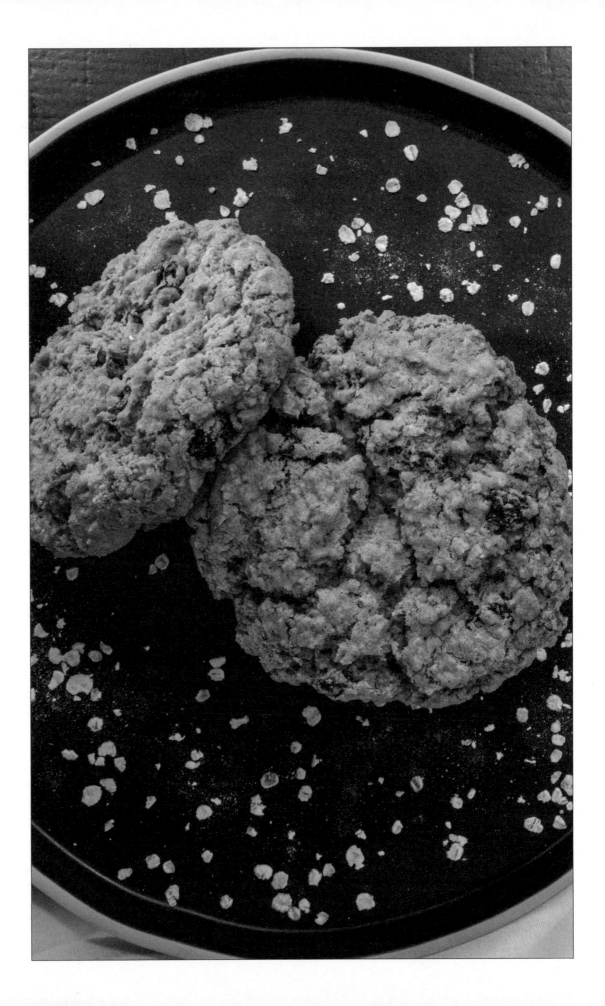

OATMEAL RAISIN COOKIES

YIELD: 24 COOKIES / **ACTIVE TIME:** 20 MINUTES / **TOTAL TIME:** 2 HOURS

A classic that reached its vaunted status by being more than the sum of its parts.

1. In the work bowl of a stand mixer fitted with the paddle attachment, cream the butter, sugar, brown sugar, salt, cinnamon, ginger, and cardamom on medium until the mixture is very light and fluffy, about 5 minutes. Scrape down the work bowl and then beat for another 5 minutes.

2. Reduce the speed to low and incorporate the egg, scraping down the work bowl as needed. Add the vanilla, beat to incorporate, raise the speed to medium, and beat for 1 minute.

3. Add the flour, baking soda, oats, and raisins, reduce the speed to low, and beat until the mixture comes together as a dough.

4. Scoop 2-oz. portions of the mixture onto parchment-lined baking sheets, making sure to leave enough space between the portions. Place the baking sheets in the refrigerator and let the dough firm up for 1 hour.

5. Preheat the oven to 350°F.

6. Place the cookies in the oven and bake until they are lightly golden brown around the edges, 10 to 12 minutes.

7. Remove from the oven and let the cookies cool on the baking sheets for a few minutes. Transfer them to wire racks and let them cool for another 20 to 30 minutes before enjoying.

INGREDIENTS:

9	OZ. UNSALTED BUTTER, SOFTENED
6	OZ. SUGAR
6	OZ. LIGHT BROWN SUGAR
½	TEASPOON KOSHER SALT
2¼	TEASPOONS CINNAMON
1½	TEASPOONS GROUND GINGER
½	TEASPOON CARDAMOM
1	EGG
¾	TEASPOON PURE VANILLA EXTRACT
8	OZ. ALL-PURPOSE FLOUR
1¼	TEASPOONS BAKING SODA
10	OZ. OLD-FASHIONED OATS
7	OZ. RAISINS

ALFAJORES

YIELD: 36 COOKIES / **ACTIVE TIME:** 1 HOUR / **TOTAL TIME:** 3 HOURS

These melt-in-your-mouth cookies are traditional to Spain. If you're a fan of dulce de leche and you get a moment, take a look at some of the delicious iterations that have sprung up around the globe.

1. In the work bowl of a stand mixer fitted with the paddle attachment, cream the butter, sugar, salt, vanilla, and lemon zest on medium until the mixture is very light and fluffy, about 5 minutes. Scrape down the work bowl and then beat the mixture for another 5 minutes.

2. Reduce the speed to low, add the egg yolks, and beat until incorporated. Scrape down the work bowl and beat the mixture for 1 minute on medium.

3. Add the cornstarch, flour, and baking soda, reduce the speed to low, and beat until the dough comes together. Form the dough into a ball and then flatten it into a disk. Cover the dough completely with plastic wrap and refrigerate for 2 hours.

4. Preheat the oven to 350°F and line two baking sheets with parchment paper.

5. Remove the dough from the refrigerator and let it sit on the counter for 5 minutes.

6. Place the dough on a flour-dusted work surface and roll it out until it is approximately ¼ inch thick. Use a 2-inch ring cutter to cut cookies out of the dough, and place them on the baking sheets. Form any scraps into a ball, roll it out, and cut into cookies. If the dough becomes too sticky or warm, place it back in the refrigerator for 15 minutes to firm up.

7. Place the cookies in the oven and bake until they are lightly golden brown at their edges, about 8 minutes. Remove the cookies from the oven, transfer them to a wire rack, and let them cool for 10 minutes.

8. Place about a teaspoon of dulce de leche on half of the cookies and use the other cookies to assemble the sandwiches. Dust with confectioners' sugar and enjoy.

INGREDIENTS:

8.9	OZ. UNSALTED BUTTER, SOFTENED
5.4	OZ. SUGAR
½	TEASPOON KOSHER SALT
1	TABLESPOON PURE VANILLA EXTRACT
	ZEST OF 1 LEMON
4	EGG YOLKS
10.7	OZ. CORNSTARCH
7.1	OZ. ALL-PURPOSE FLOUR, PLUS MORE AS NEEDED
1	TEASPOON BAKING SODA
12	OZ. DULCE DE LECHE
1	CUP CONFECTIONERS' SUGAR, FOR DUSTING

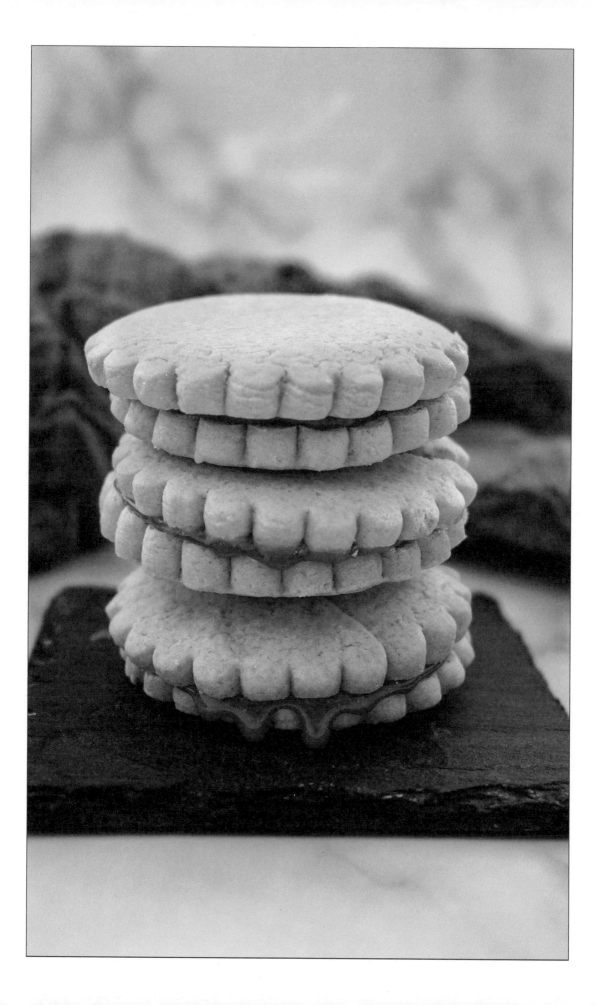

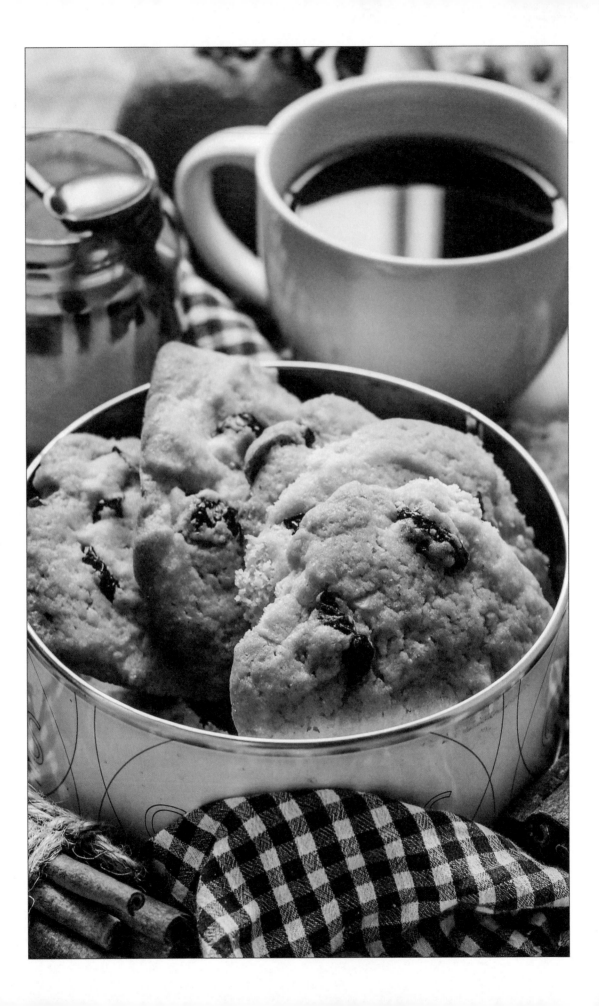

WHITE CHOCOLATE & CRANBERRY COOKIES

YIELD: 48 COOKIES / **ACTIVE TIME:** 15 MINUTES / **TOTAL TIME:** 3 HOURS

An improbably good cookie, with the dried cranberries adding an extra bit of chewiness that proves irresistible.

1. Place the flour, baking soda, and salt in a large mixing bowl and whisk to combine. Place the butter, brown sugar, and sugar in the work bowl of a stand mixer fitted with the paddle attachment and beat at medium speed until pale and fluffy, scraping down the sides of the work bowl as needed. Reduce the speed to low and incorporate the eggs one at a time. Add the vanilla and beat to incorporate.

2. With the mixer running on low, gradually add the dry mixture to the wet mixture and beat until a smooth dough forms. Add the white chocolate chips and dried cranberries and fold until evenly distributed. Cover the dough with plastic wrap and refrigerate for 2 hours.

3. Preheat the oven to 350°F and line two large baking sheets with parchment paper. Drop tablespoons of the dough onto the baking sheets and, working with one baking sheet at a time, place the cookies in the oven and bake for about 10 minutes, until lightly browned. Remove from the oven and let the cookies cool on the baking sheets for 5 minutes before transferring them to wire racks to cool completely.

INGREDIENTS:

13.2	OZ. ALL-PURPOSE FLOUR
1	TEASPOON BAKING SODA
1	TEASPOON FINE SEA SALT
8	OZ. UNSALTED BUTTER, SOFTENED
7	OZ. LIGHT BROWN SUGAR
3.5	OZ. SUGAR
2	LARGE EGGS, AT ROOM TEMPERATURE
2	TEASPOONS PURE VANILLA EXTRACT
1½	CUPS WHITE CHOCOLATE CHIPS
1	CUP SWEETENED DRIED CRANBERRIES

CHOCOLATE CRINKLE COOKIES

YIELD: 20 COOKIES / **ACTIVE TIME:** 45 MINUTES / **TOTAL TIME:** 2 HOURS AND 30 MINUTES

Somewhere between a brownie and a cookie, these are an ideal blend of chocolatey and chewy.

1. Line two baking sheets with parchment paper. Bring water to a simmer in a small saucepan over low heat. Place the dark chocolate in a heatproof bowl and place the bowl over the simmering water. Occasionally stir the chocolate until it is melted. Remove the bowl from heat and set aside.

2. In the work bowl of a stand mixer fitted with the paddle attachment, cream the butter, dark brown sugar, and vanilla on medium until the mixture is very light and fluffy, about 5 minutes. Scrape down the work bowl and then beat the mixture for another 5 minutes.

3. Reduce the speed to low, add the melted chocolate, and beat until incorporated, scraping down the work bowl as needed.

4. Add the eggs one at a time and beat until incorporated, again scraping down the work bowl as needed. When both eggs have been incorporated, beat for 1 minute.

5. Add the flour, cocoa powder, baking powder, and salt and beat until the mixture comes together as a smooth dough.

6. Drop 2-oz. portions of the dough on the baking sheets, making sure to leave enough space between the portions. Place the baking sheets in the refrigerator and let the dough firm up for 1 hour.

7. Preheat the oven to 350°F. Place the confectioners' sugar in a mixing bowl, toss the dough balls in the sugar until they are completely coated, and then place them back on the baking sheets.

8. Place the cookies in the oven and bake until a cake tester comes out clean after being inserted, 12 to 14 minutes.

9. Remove from the oven, transfer the cookies to a cooling rack, and let them cool for 20 to 30 minutes before enjoying.

INGREDIENTS:

9	OZ. DARK CHOCOLATE (55 TO 65 PERCENT)
4.5	OZ. UNSALTED BUTTER, SOFTENED
7	OZ. DARK BROWN SUGAR
¾	TEASPOON PURE VANILLA EXTRACT
2	EGGS
7	OZ. ALL-PURPOSE FLOUR
2.5	OZ. COCOA POWDER
2	TEASPOONS BAKING POWDER
1	TEASPOON KOSHER SALT
2	CUPS CONFECTIONERS' SUGAR, FOR COATING

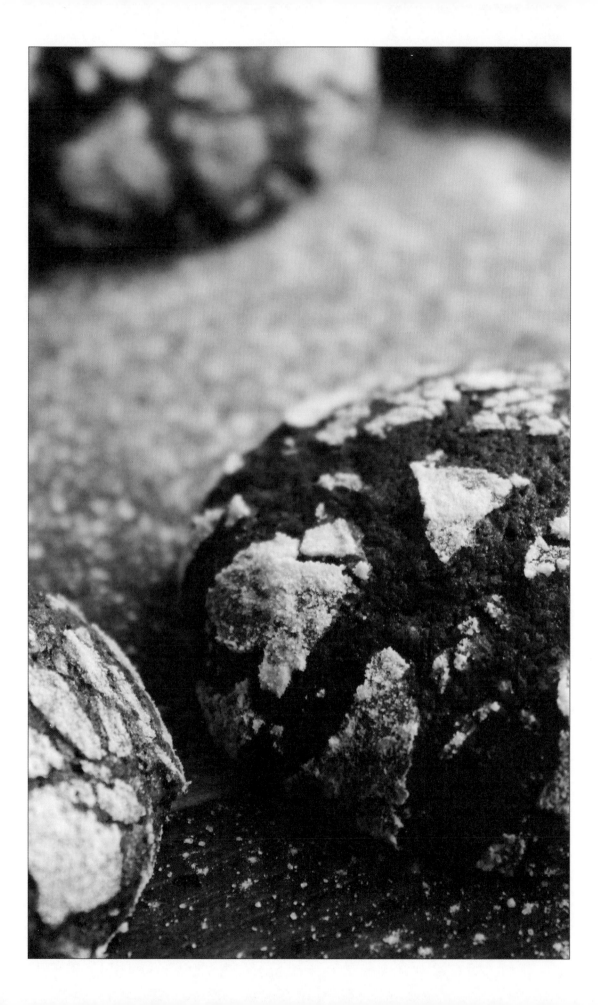

FLORENTINES

YIELD: 40 FLORENTINES / **ACTIVE TIME:** 25 MINUTES / **TOTAL TIME:** 1 HOUR

These cookies are believed to have royal bloodlines, as it is thought that a chef in King Louis XIV's court created the confection.

1. Preheat the oven to 350°F and position a rack in the center.

2. In the work bowl of a stand mixer fitted with the paddle attachment, cream the butter and confectioners' sugar on medium until light and fluffy, about 5 minutes.

3. Add the coconut flakes, almond flour, currants, flour, and salt and beat until the mixture comes together as a dough.

4. Scoop 1-oz. portions of the mixture onto parchment-lined baking sheets, making sure to leave 3 inches between the portions.

5. Place the cookies in the oven and bake until they are lightly golden brown around the edges, 8 to 10minutes.

6. Remove from the oven, transfer the cookies to wire racks, and let them cool completely.

7. Fill a small saucepan halfway with water and bring it to a simmer. Place the dark chocolate in a heatproof bowl, set it over the simmering water, and stir until it is melted and smooth.

8. Brush the undersides of the cooled florentines with the melted chocolate, place the cookies on sheets of parchment paper, and let the chocolate set before enjoying.

INGREDIENTS:

2	OZ. UNSALTED BUTTER, SOFTENED
6	OZ. CONFECTIONERS' SUGAR
1	OZ. UNSWEETENED COCONUT FLAKES
4	OZ. ALMOND FLOUR
4	OZ. DRIED CURRANTS
2	OZ. ALL-PURPOSE FLOUR
½	TEASPOON KOSHER SALT
8	OZ. DARK CHOCOLATE (55 TO 65 PERCENT)

CHEWY GINGER COOKIES

YIELD: 24 COOKIES / **ACTIVE TIME:** 30 MINUTES / **TOTAL TIME:** 2 HOURS

These rich and chewy cookies are a great, grown-up spin on the gingerbread men we know and love.

1. Line two baking sheets with parchment paper. In the work bowl of a stand mixer fitted with the paddle attachment, cream the butter and sugar on medium until the mixture is very light and fluffy, about 5 minutes. Scrape down the work bowl and then beat the mixture for another 5 minutes.

2. Reduce the speed to low, add the molasses, and beat to incorporate. Add the eggs one at a time and beat until incorporated, again scraping down the work bowl as needed. When both eggs have been incorporated, scrape down the work bowl, add the vinegar, raise the speed to medium, and beat for 1 minute.

3. Add the flour, baking soda, ginger, cinnamon, nutmeg, and salt, reduce the speed to low, and beat until the dough comes together.

4. Drop 2-oz. portions of the dough on the baking sheets, making sure to leave enough space between the portions. Place the baking sheets in the refrigerator and let the dough firm up for 1 hour.

5. Preheat the oven to 350°F.

6. Place the cookies in the oven and bake until they are lightly golden brown around the edges, 10 to 12 minutes. Do not allow the cookies to fully brown or they will come out too crispy.

7. Remove from the oven, transfer the cookies to a cooling rack, and let them cool for 20 to 30 minutes before enjoying.

INGREDIENTS:

6.5	OZ. UNSALTED BUTTER, SOFTENED
18	OZ. SUGAR
6.5	OZ. MOLASSES
2	EGGS
1½	TABLESPOONS WHITE VINEGAR
23	OZ. ALL-PURPOSE FLOUR
2	TEASPOONS BAKING SODA
2	TEASPOONS GROUND GINGER
1	TEASPOON CINNAMON
½	TEASPOON FRESHLY GRATED NUTMEG
½	TEASPOON KOSHER SALT

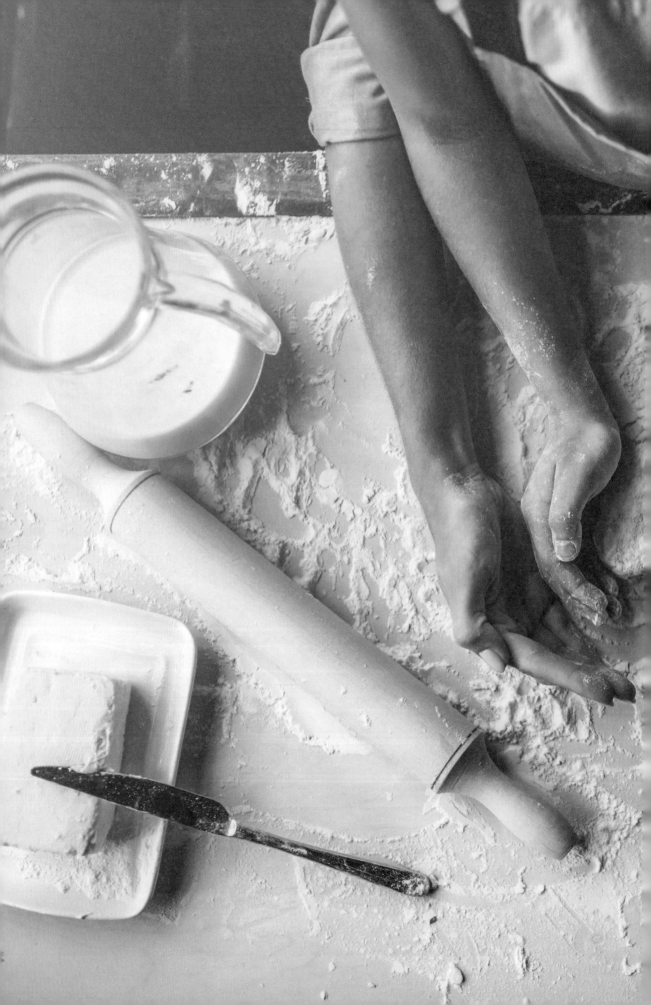

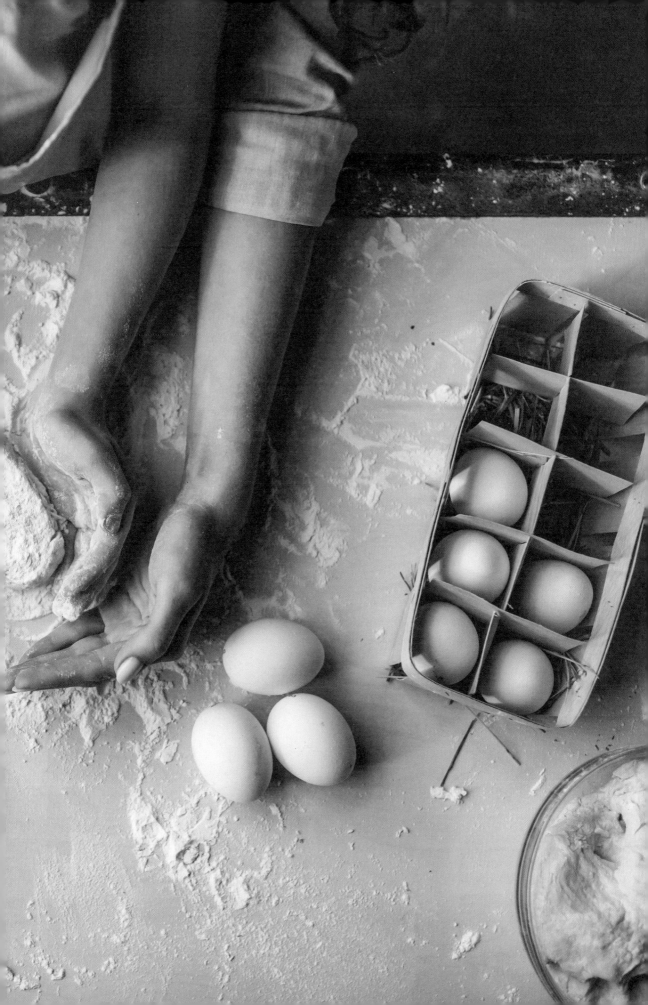

VANILLA TUILES

YIELD: 24 COOKIES / **ACTIVE TIME:** 45 MINUTES / **TOTAL TIME:** 3 HOURS

These thin, delicate cookies can be molded into tubes, cups, and small bowls while still warm, and filled with whipped cream, berries, puddings, or a custard.

1. Sift the flour into a small bowl and set aside.

2. In a medium bowl, whisk the egg whites, confectioners' sugar, and vanilla and set aside.

3. In a small saucepan, melt the butter over low heat. Stir it into the egg white mixture, add the sifted flour, and whisk until the mixture is a smooth batter. Cover the bowl with plastic wrap and refrigerate for 2 hours.

4. Preheat the oven to 400°F.

5. Line an 18 x 13–inch baking sheet with a silicone baking mat. Place 2-teaspoon portions of the batter about 5 inches apart from one another. Use a small, offset spatula to spread the batter into 4-inch circles. Tap the pan lightly on the counter to remove any air bubbles and level the circles.

6. Place the tuiles in the oven and bake until the edges begin to color, 4 to 5 minutes. Remove from the oven. Working quickly, carefully remove the tuiles with the offset spatula and either shape them as desired or transfer them to a cooling rack.

7. Repeat until all of the batter has been used.

INGREDIENTS:

3.5	OZ. ALL-PURPOSE FLOUR
5	EGG WHITES
4.5	OZ. CONFECTIONERS' SUGAR
½	TEASPOON PURE VANILLA EXTRACT
5.3	OZ. UNSALTED BUTTER

MEYER LEMON CRINKLE COOKIES

YIELD: 24 COOKIES / **ACTIVE TIME:** 45 MINUTES / **TOTAL TIME:** 2 HOURS AND 30 MINUTES

The perfect cookie for the spring. The Meyer lemons bring a floral touch to an already light and sweet treat.

1. Line two baking sheets with parchment paper. In the work bowl of a stand mixer fitted with the paddle attachment, cream the butter, sugar, and lemon zest on medium until the mixture is very light and fluffy, about 5 minutes. Scrape down the work bowl and then beat the mixture for another 5 minutes.

2. Add the eggs one at a time and beat until incorporated, again scraping down the work bowl as needed. When both eggs have been incorporated, scrape down the work bowl, add the lemon juice and food coloring, and beat for 1 minute. Add the flour, baking powder, baking soda, and salt and beat until the mixture comes together as a smooth dough.

3. Drop 2-oz. portions of the dough on the baking sheets, making sure to leave enough space between the portions. Place the baking sheets in the refrigerator and let the dough firm up for 1 hour.

4. Preheat the oven to 350°F. Place the confectioners' sugar in a mixing bowl, toss the dough balls in the sugar until they are completely coated, and then place them back on the baking sheets.

5. Place the cookies in the oven and bake until a cake tester comes out clean after being inserted, 12 to 14 minutes.

6. Remove from the oven, transfer the cookies to a cooling rack, and let them cool for 20 to 30 minutes before enjoying.

INGREDIENTS:

8	OZ. UNSALTED BUTTER, SOFTENED
1	LB. SUGAR
	ZEST AND JUICE OF 2 MEYER LEMONS
2	EGGS
2–3	DROPS OF LEMON-YELLOW GEL FOOD COLORING
15	OZ. ALL-PURPOSE FLOUR
½	TEASPOON BAKING POWDER
¼	TEASPOON BAKING SODA
½	TEASPOON FINE SEA SALT
2	CUPS CONFECTIONERS' SUGAR, FOR COATING

PEANUT BUTTER & CHOCOLATE CHIP COOKIES

YIELD: 24 COOKIES / **ACTIVE TIME:** 30 MINUTES / **TOTAL TIME:** 2 HOURS

As we know, no combo can compete with peanut butter and chocolate. These cookies are as buttery as they are sweet, and certain to satisfy.

1. Line two baking sheets with parchment paper. In the work bowl of a stand mixer fitted with the paddle attachment, cream the butter, peanut butter, sugar, dark brown sugar, salt, and baking soda on medium until the mixture is very light and fluffy, about 5 minutes. Scrape down the work bowl and then beat the mixture for another 5 minutes.

2. Add the eggs one at a time and beat until incorporated, again scraping down the work bowl as needed. When both eggs have been incorporated, scrape down the work bowl, add the vanilla, and beat for 1 minute. Add the flour and semisweet chocolate chips and beat until the mixture comes together as a dough.

3. Drop 2-oz. portions of the dough on the baking sheets, making sure to leave enough space between the portions. Place the baking sheets in the refrigerator and let the dough firm up for 1 hour.

4. Preheat the oven to 350°F.

5. Place the cookies in the oven and bake until they are lightly golden brown around the edges, 10 to 12 minutes. Do not let the cookies become fully brown or they will end up being too crispy.

6. Remove from the oven, transfer the cookies to a cooling rack, and let them cool for 20 to 30 minutes before enjoying.

INGREDIENTS:

4	OZ. UNSALTED BUTTER, SOFTENED
4	OZ. SMOOTH PEANUT BUTTER
8	OZ. SUGAR
8	OZ. DARK BROWN SUGAR
1½	TEASPOONS KOSHER SALT
1	TEASPOON BAKING SODA
2	EGGS
1½	TEASPOONS PURE VANILLA EXTRACT
14.5	OZ. ALL-PURPOSE FLOUR
14	OZ. SEMISWEET CHOCOLATE CHIPS

ORANGE & PISTACHIO BISCOTTI

YIELD: 24 BISCOTTI / **ACTIVE TIME:** 1 HOUR / **TOTAL TIME:** 4 HOURS AND 30 MINUTES

Feel free to swap in your favorite fruits and nuts for the pistachios and cranberries here.

1. Line a baking sheet with parchment paper. In the work bowl of a stand mixer fitted with the paddle attachment, cream the butter, orange zest, sugar, and vanilla on medium until the mixture is very light and fluffy, about 5 minutes. Scrape down the work bowl and then beat the mixture for another 5 minutes.

2. Add the eggs one at a time and beat on low until incorporated, again scraping down the work bowl as needed. When both eggs have been incorporated, scrape down the work bowl and beat on medium for 1 minute.

3. Add the remaining ingredients, reduce the speed to low, and beat until the mixture comes together as a dough.

4. Place the dough on the baking sheet and form it into a log that is the length of the pan and anywhere from 3 to 4 inches wide. Place the dough in the refrigerator for 1 hour.

5. Preheat the oven to 350°F.

6. Place the biscotti dough in the oven and bake until it is golden brown and a cake tester comes out clean when inserted into the center, 25 to 30 minutes. Remove from the oven, transfer the biscotti to a cooling rack, and let it cool completely before refrigerating for 2 hours.

7. Preheat the oven to 250°F. Cut the biscotti to the desired size, place the pieces on their sides, and bake for 10 minutes. Remove from the oven, turn them over, and bake for another 6 minutes. Remove from the oven and let the biscotti cool completely before enjoying.

INGREDIENTS:

4	OZ. UNSALTED BUTTER, SOFTENED
	ZEST OF 1 ORANGE
7	OZ. SUGAR
¾	TEASPOON PURE VANILLA EXTRACT
2	EGGS
10	OZ. ALL-PURPOSE FLOUR
½	TEASPOON BAKING SODA
½	TEASPOON BAKING POWDER
½	TEASPOON FINE SEA SALT
4	OZ. SHELLED PISTACHIOS, TOASTED
1	CUP DRIED CRANBERRIES

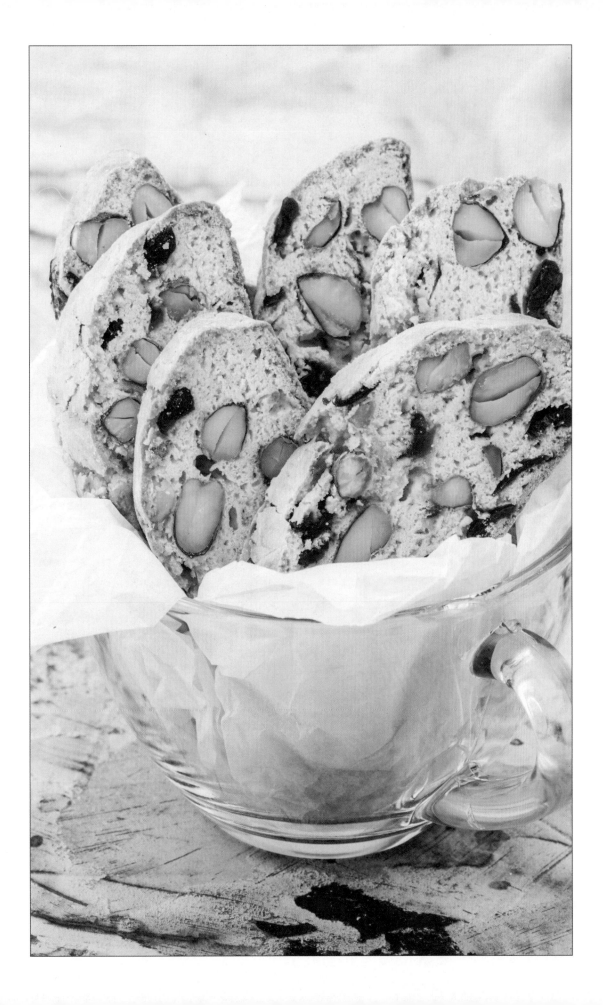

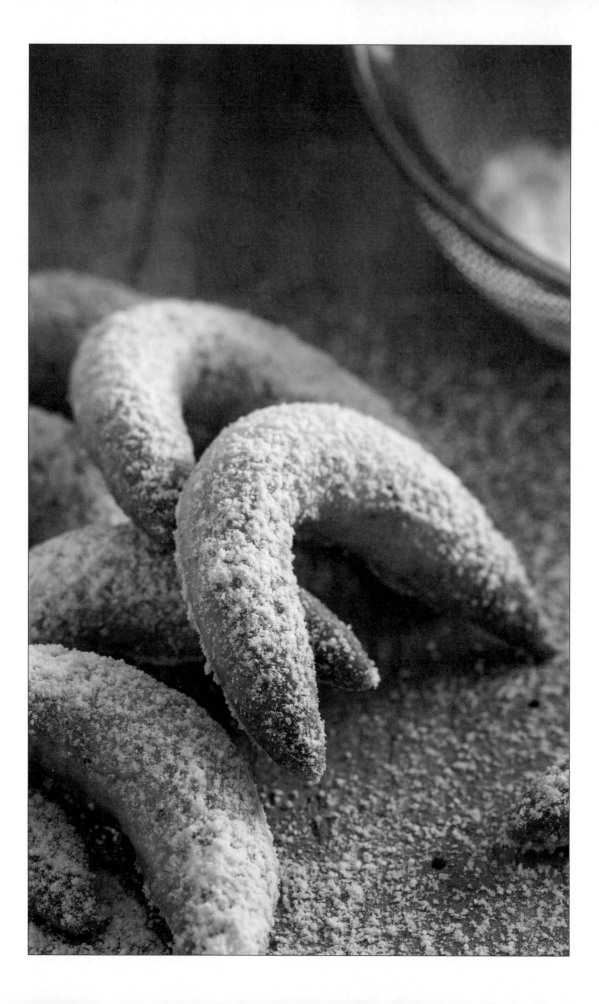

KIPFERL BISCUITS

YIELD: 12 COOKIES / **ACTIVE TIME**: 40 MINUTES / **TOTAL TIME**: 2 HOURS

A heavy dusting of confectioners' sugar is the traditional topping for these beautiful, crescent-shaped cookies. Some Caramelized White Chocolate (see page 705) would be another good option.

1. Place all of the ingredients, except for the white chocolate chips, in the work bowl of a stand mixer fitted with the paddle attachment and beat at medium speed until the mixture comes together as a soft dough. Flatten the dough into a disk, cover it completely with plastic wrap, and refrigerate for 1 hour.

2. Preheat the oven to 350°F and line two large baking sheets with parchment paper. Remove the dough from the refrigerator and let it stand at room temperature for 5 minutes. Roll the dough into a ¾-inch-thick log, cut it into 2-inch-long pieces, and roll the pieces into cylinders with your hands, while tapering and curling the ends to create crescent shapes. Place them on the baking sheets.

3. Place the cookies in the oven and bake for about 15 minutes, until set and firm. Remove from the oven and transfer the cookies to wire racks to cool.

4. Fill a small saucepan halfway with water and bring it to a gentle simmer. Place the white chocolate chips in a heatproof bowl, place it over the simmering water, and stir until melted. Drizzle the melted chocolate over the cooled biscuits and let it set before serving.

INGREDIENTS:

- 6.7 OZ. ALL-PURPOSE FLOUR, PLUS MORE AS NEEDED
- 1.5 OZ. COCOA POWDER
- ½ TEASPOON INSTANT ESPRESSO POWDER
- ¼ TEASPOON FINE SEA SALT
- 8 OZ. UNSALTED BUTTER, SOFTENED AND DIVIDED INTO TABLESPOONS
- 3 OZ. CONFECTIONERS' SUGAR, SIFTED
- 2.5 OZ. FINE ALMOND FLOUR
- 1 TEASPOON PURE VANILLA EXTRACT
- ½ CUP WHITE CHOCOLATE CHIPS

OREO COOKIES

Finally, a way to make everyone's favorite sandwich cookie at home.

1. Line two baking sheets with parchment paper. In the work bowl of a stand mixer fitted with the paddle attachment, cream the butter and sugar on medium until the mixture is light and fluffy, about 5 minutes. Scrape down the work bowl with a rubber spatula and beat the mixture for another 5 minutes.

2. Reduce the speed to low, add the eggs one at a time, and beat until incorporated, again scraping down the work bowl as needed. When both eggs have been incorporated, scrape down the work bowl, add the vanilla, and beat for 1 minute.

3. Add the flour, cocoa powder, baking soda, baking powder, and salt and beat on low until the dough comes together.

4. Drop 1-oz. portions of the dough on the baking sheets, making sure to leave enough space between the portions. Place the baking sheets in the refrigerator and let the dough firm up for 1 hour.

5. Preheat the oven to 350°F.

6. Place the cookies in the oven and bake until they are starting to firm up, about 8 minutes.

7. Remove from the oven, transfer the cookies to a cooling rack, and let them cool for 20 to 30 minutes.

8. Place the filling in a piping bag and pipe about 1 tablespoon of filling on half of the cookies. Use the other halves to assemble the sandwiches.

INGREDIENTS:

8	OZ. UNSALTED BUTTER, SOFTENED
1	LB. SUGAR
2	EGGS
¾	TEASPOON PURE VANILLA EXTRACT
9.5	OZ. ALL-PURPOSE FLOUR
4.5	OZ. COCOA POWDER
1½	TEASPOONS BAKING SODA
½	TEASPOON BAKING POWDER
¾	TEASPOON KOSHER SALT
1	CUP BUTTERFLUFF FILLING (SEE PAGE 667)

PRALINE BARS

YIELD: 12 BARS / **ACTIVE TIME:** 30 MINUTES / **TOTAL TIME:** 1 HOUR

A wonderful translation of the beloved Southern confection.

1. Preheat the oven to 350°F. Line a 13 x 9–inch baking pan with parchment paper and coat it with nonstick cooking spray.

2. To begin preparations for the crust, melt the butter in a small saucepan over medium-low heat and set aside.

3. In a mixing bowl, combine the graham cracker crumbs, sugar, and flour. Add the melted butter and fold to incorporate. Place the mixture in the baking pan and press down on it so that it is flat and even. Set aside.

4. To prepare the filling, whisk the dark brown sugar and eggs in a mixing bowl until there are no clumps left, about 2 minutes. Add the graham cracker crumbs, salt, baking powder, and vanilla and whisk until thoroughly incorporated. Pour the filling over the crust and evenly distribute the pecans on top, pressing down so they adhere.

5. Place the bars in the oven and bake until the top is golden brown, 25 to 30 minutes. Remove from the oven, transfer them to a cooling rack, and let them cool. When cool, cut them into bars.

INGREDIENTS:

FOR THE CRUST

9	OZ. UNSALTED BUTTER
4	CUPS GRAHAM CRACKER CRUMBS
3	TABLESPOONS SUGAR
¼	CUP ALL-PURPOSE FLOUR, PLUS 1 TABLESPOON

FOR THE FILLING

4½	CUPS DARK BROWN SUGAR
6	EGGS
1	CUP GRAHAM CRACKER CRUMBS
1½	TEASPOONS KOSHER SALT
¾	TEASPOON BAKING POWDER
1	TABLESPOON PURE VANILLA EXTRACT
1½	CUPS CHOPPED PECANS

FLOURLESS FUDGE BROWNIES

YIELD: 12 BROWNIES / **ACTIVE TIME:** 30 MINUTES / **TOTAL TIME:** 2 HOURS AND 45 MINUTES

Flourless fudge brownies are the ultimate gluten-free guilty pleasure.

1. Preheat the oven to 350°F. Line a 13 x 9–inch baking pan with parchment paper and coat it with nonstick cooking spray.

2. Fill a small saucepan halfway with water and bring it to a simmer. Place the dark chocolate and butter in a heatproof bowl, place it over the simmering water, and stir until they have melted and been combined. Remove the bowl from heat and set aside.

3. In a separate mixing bowl, whisk the sugar, brown sugar, cocoa powder, and salt, making sure to break up any clumps. Whisk in the eggs, vanilla, and melted chocolate mixture. Pour the batter into the baking pan and use a rubber spatula to even out the top. Lightly tap the baking pan on the counter to remove any air bubbles.

4. Place the brownies in the oven and bake until a cake tester comes out clean after being inserted, 30 to 40 minutes.

5. Remove the brownies from the oven, transfer them to a cooling rack, and let them cool completely. Once they are cool, refrigerate for 1 hour.

6. Run a paring knife along the sides of the pan and cut the brownies into squares.

INGREDIENTS:

1	LB. DARK CHOCOLATE (55 TO 65 PERCENT)
8	OZ. UNSALTED BUTTER
12	OZ. SUGAR
4	OZ. LIGHT BROWN SUGAR
¼	CUP COCOA POWDER
¾	TEASPOON KOSHER SALT
6	EGGS
1½	TEASPOONS PURE VANILLA EXTRACT

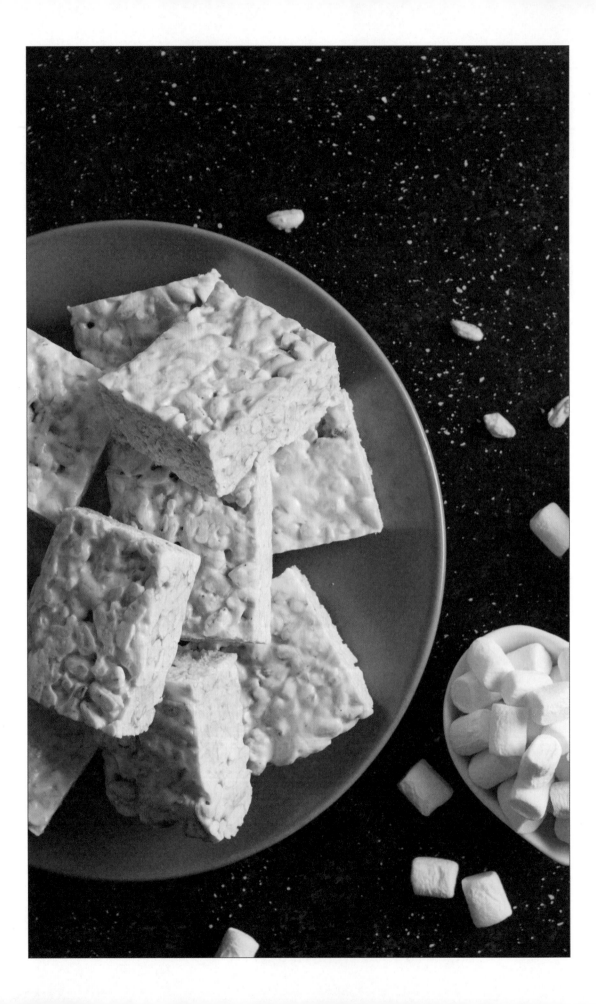

RICE KRISPIES TREATS

YIELD: 12 BARS / **ACTIVE TIME:** 30 MINUTES / **TOTAL TIME:** 1 HOUR AND 30 MINUTES

Some sweets connoisseurs may view these as a retro dessert, but their appeal is eternal.

1. Line a 13 x 9–inch baking pan with parchment paper and coat it with nonstick cooking spray.

2. Fill a small saucepan halfway with water and bring it to a simmer. Place the marshmallow creme, butter, and salt in a heatproof mixing bowl over the simmering water and stir the mixture with a rubber spatula until the butter has melted and the mixture is thoroughly combined. Remove the bowl from heat, add the cereal and vanilla, and fold until combined. If desired, add the chocolate chips or M&M's and fold until evenly distributed.

3. Transfer the mixture to the baking pan and spread it with a rubber spatula. Place another piece of parchment over the mixture and pack it down with your hands until it is flat and even. Remove the top piece of parchment and refrigerate for 1 hour.

4. Run a knife along the edge of the pan, turn the mixture out onto a cutting board, and cut into squares.

INGREDIENTS:

12 OZ. MARSHMALLOW CREME

4.5 OZ. UNSALTED BUTTER

¾ TEASPOON FINE SEA SALT

9 CUPS RICE KRISPIES

¾ TEASPOON PURE VANILLA EXTRACT

2½ CUPS CHOCOLATE CHIPS OR M&M'S (OPTIONAL)

LEMON & ALMOND BISCOTTI

YIELD: 24 BISCOTTI / **ACTIVE TIME:** 1 HOUR / **TOTAL TIME:** 4 HOURS AND 30 MINUTES

A light biscotti that is as beautiful as it is delicious. Unless you have considerable willpower, make sure you only whip these up when company is coming over.

1. Line a baking sheet with parchment paper. In the work bowl of a stand mixer fitted with the paddle attachment, cream the butter, lemon zest, sugar, and vanilla on medium until the mixture is very light and fluffy, about 5 minutes. Scrape down the work bowl and then beat the mixture for another 5 minutes.

2. Add the eggs one at a time and beat on low until incorporated, again scraping down the work bowl as needed. When both eggs have been incorporated, scrape down the work bowl and beat on medium for 1 minute.

3. Add the remaining ingredients, reduce the speed to low, and beat until the mixture comes together as a dough.

4. Place the dough on the baking sheet and form it into a log that is the length of the pan and anywhere from 3 to 4 inches wide. Refrigerate the dough for 1 hour.

5. Preheat the oven to 350°F.

6. Place the dough in the oven and bake until it is golden brown and a cake tester comes out clean when inserted into the center, 25 to 30 minutes. Remove the biscotti from the oven, transfer it to a cooling rack, and let it cool completely before refrigerating for 2 hours.

7. Preheat the oven to 250°F. Cut the biscotti to the desired size, place the pieces on their sides, and bake for 10 minutes. Remove from the oven, turn them over, and bake for another 6 minutes. Remove from the oven and let the biscotti cool completely before enjoying.

INGREDIENTS:

8 OZ. UNSALTED BUTTER, SOFTENED

ZEST OF 1 LEMON

7 OZ. SUGAR

¾ TEASPOON PURE VANILLA EXTRACT

2 EGGS

10 OZ. ALL-PURPOSE FLOUR

½ TEASPOON BAKING SODA

½ TEASPOON BAKING POWDER

½ TEASPOON FINE SEA SALT

8 OZ. SLIVERED ALMONDS, TOASTED

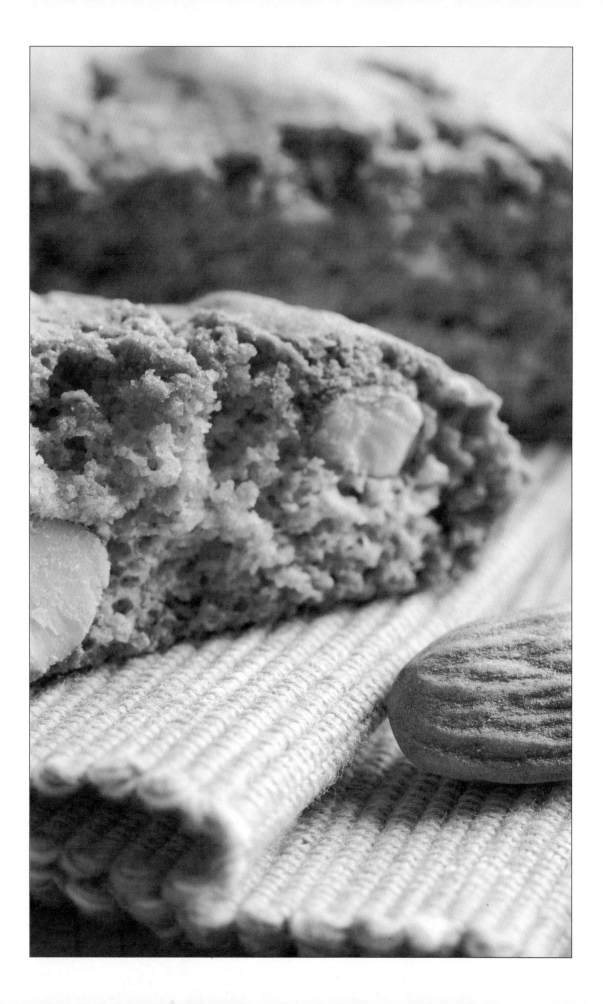

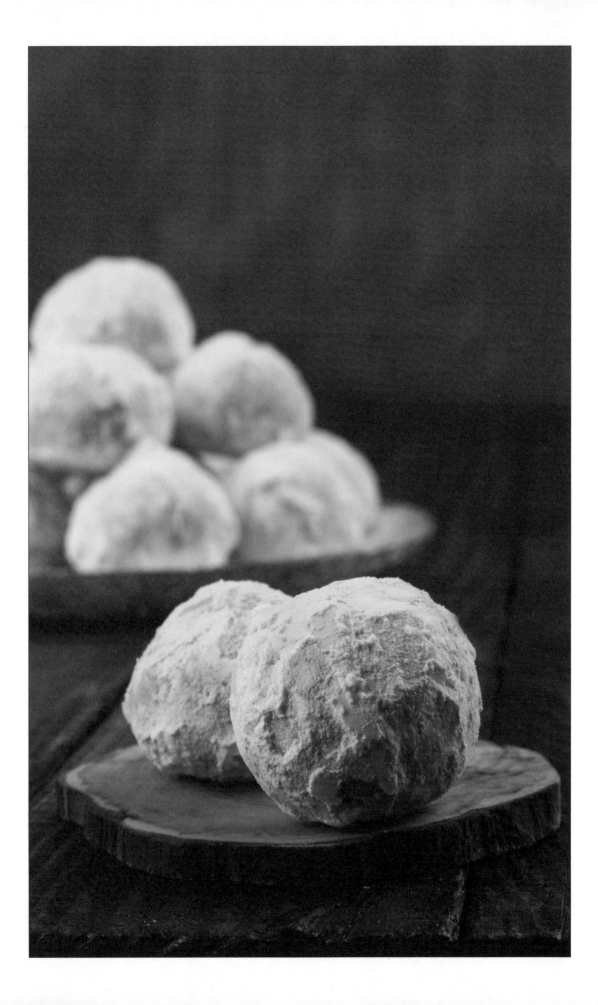

POLVORONES

YIELD: 36 COOKIES / **ACTIVE TIME:** 20 MINUTES / **TOTAL TIME:** 1 HOUR

Taking its name from the Spanish word polvo, meaning "powder," these confections are also popularly known as Mexican wedding cookies. But they originated in medieval Arabia, and were brought to Spain by the Moors when they took over Andalusia during the eighth century.

1. Preheat the oven to 350°F and line two baking sheets with parchment paper. Place the butter and 5 oz. of the confectioners' sugar in the work bowl of a stand mixer fitted with the paddle attachment and beat at medium speed until light and fluffy. Add the flours, almonds, and vanilla and beat until the dough is just combined and very stiff. Add a few drops of warm water, if necessary, to make it pliable.

2. Remove tablespoons of the dough and roll them into balls. Place the balls on the baking sheets and flatten them slightly with the bottom of a glass that has been dipped in flour. Place the cookies in the oven and bake until they are lightly browned, about 10 minutes. Remove from the oven.

3. Sift the remaining sugar into a shallow bowl and use a spatula to transfer the cookies to the bowl. Roll the cookies in the sugar until they are evenly coated and then transfer them to wire racks to cool completely.

INGREDIENTS:

8 OZ. UNSALTED BUTTER, SOFTENED

7 OZ. CONFECTIONERS' SUGAR

4 OZ. CAKE FLOUR, PLUS MORE FOR DUSTING

5 OZ. SELF-RISING FLOUR

1 CUP ALMONDS, BLANCHED AND MINCED

½ TEASPOON PURE VANILLA EXTRACT

WARM WATER (110°F), AS NEEDED

WHITE CHOCOLATE CHIP & MACADAMIA COOKIES

YIELD: 24 COOKIES / **ACTIVE TIME:** 20 MINUTES / **TOTAL TIME:** 2 HOURS

As far as nuts go, macadamias are the most buttery, making them an ideal pairing with creamy white chocolate.

1. Line two baking sheets with parchment paper. In the work bowl of a stand mixer fitted with the paddle attachment, cream the butter, sugar, dark brown sugar, salt, and baking soda on medium until the mixture is very light and fluffy, about 5 minutes. Scrape down the work bowl and then beat the mixture for another 5 minutes.

2. Reduce the speed to low, add the eggs one at a time, and beat until incorporated, again scraping down the work bowl as needed. When both eggs have been incorporated, scrape down the work bowl, add the vanilla, raise the speed to medium, and beat for 1 minute.

3. Add the flour, macadamia nuts, and white chocolate chips, reduce the speed to low, and beat until the dough comes together.

4. Drop 2-oz. portions of the dough on the baking sheets, making sure to leave enough space between the portions. Place the baking sheets in the refrigerator and let the dough firm up for 1 hour.

5. Preheat the oven to 350°F.

6. Place the cookies in the oven and bake until they are lightly golden brown around the edges, 10 to 12 minutes. Remove from the oven, transfer the cookies to a cooling rack, and let them cool for 20 to 30 minutes before enjoying.

INGREDIENTS:

- 8 OZ. UNSALTED BUTTER, SOFTENED
- 8 OZ. SUGAR
- 8 OZ. DARK BROWN SUGAR
- 1½ TEASPOONS KOSHER SALT
- 1 TEASPOON BAKING SODA
- 2 EGGS
- 1½ TEASPOONS PURE VANILLA EXTRACT
- 14.5 OZ. ALL-PURPOSE FLOUR
- 7 OZ. MACADAMIA NUTS, TOASTED
- 7 OZ. WHITE CHOCOLATE CHIPS

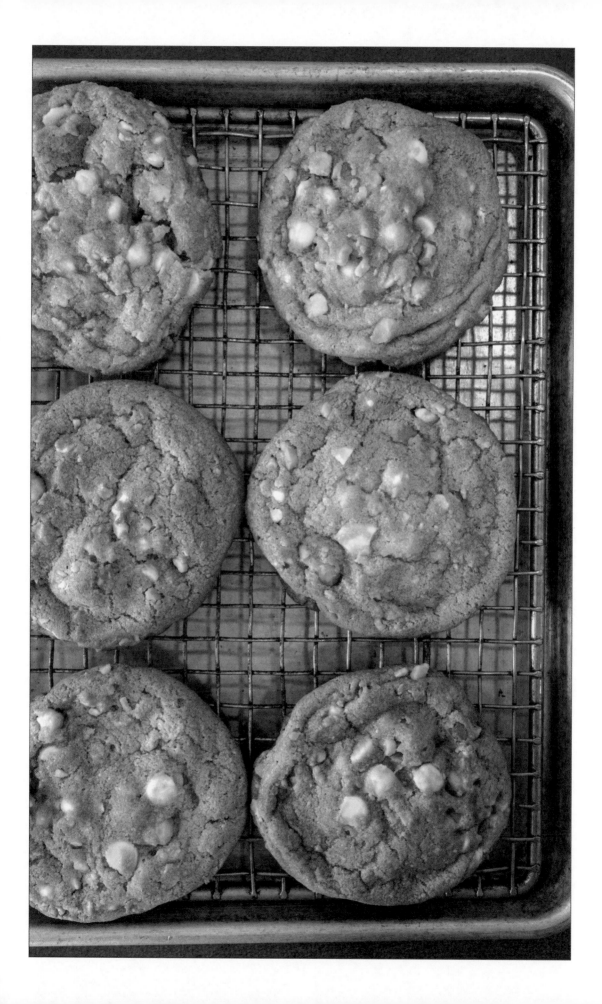

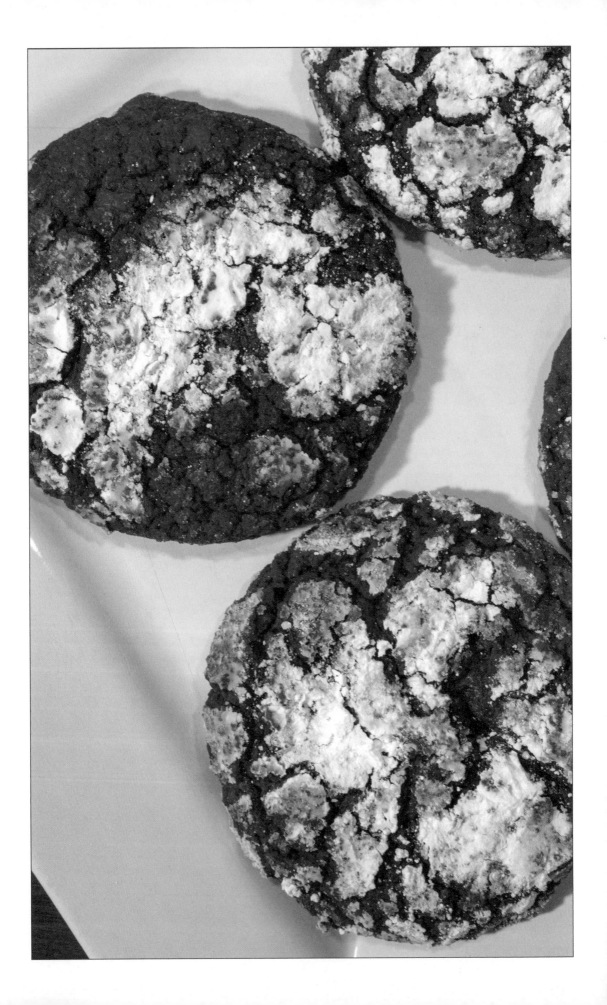

RED VELVET CRINKLE COOKIES

YIELD: 24 COOKIES / **ACTIVE TIME:** 45 MINUTES / **TOTAL TIME:** 2 HOURS AND 30 MINUTES

This crinkle cookie goes out to all those red velvet cake lovers out there.

1. Line two baking sheets with parchment paper. In a mixing bowl, whisk together the flour, cocoa powder, baking powder, and salt and set aside.

2. In the work bowl of a stand mixer fitted with the paddle attachment, cream the butter, sugar, and brown sugar on medium until the mixture is very light and fluffy, about 5 minutes. Scrape down the work bowl and then beat the mixture for another 5 minutes.

3. Add the eggs one at a time and beat until incorporated, again scraping down the work bowl as needed. When both eggs have been incorporated, scrape down the work bowl, add the vanilla and food coloring, and beat for 1 minute. Add the dry mixture and beat until the mixture comes together as a smooth dough.

4. Drop 2-oz. portions of the dough on the baking sheets, making sure to leave enough space between the portions. Place the baking sheets in the refrigerator and let the dough firm up for 1 hour.

5. Preheat the oven to 350°F. Place the confectioners' sugar in a mixing bowl, toss the dough balls in the sugar until they are completely coated, and then place them back on the baking sheets.

6. Place the cookies in the oven and bake until a cake tester comes out clean after being inserted, 12 to 14 minutes.

7. Remove from the oven, transfer the cookies to a cooling rack, and let them cool for 20 to 30 minutes before enjoying.

INGREDIENTS:

- 9 OZ. ALL-PURPOSE FLOUR
- 2 TABLESPOONS COCOA POWDER
- 1½ TEASPOONS BAKING POWDER
- ½ TEASPOON KOSHER SALT
- 4 OZ. UNSALTED BUTTER, SOFTENED
- 4 OZ. SUGAR
- 5 OZ. LIGHT BROWN SUGAR
- 2 EGGS
- 2 TEASPOONS PURE VANILLA EXTRACT
- 2–3 DROPS OF RED GEL FOOD COLORING, PLUS MORE AS NEEDED
- 2 CUPS CONFECTIONERS' SUGAR, FOR COATING

SPRITZ COOKIES

YIELD: 24 COOKIES / ACTIVE TIME: 20 MINUTES / TOTAL TIME: 2 HOURS

The combination of spritz's buttery blast and nutty finish has made them a holiday staple the world over.

1. In the work bowl of a stand mixer fitted with the paddle attachment, cream the butter and confectioners' sugar on medium until the mixture is very light and fluffy, about 5 minutes. Scrape down the work bowl and beat for another 5 minutes.

2. Reduce the speed to low, add the egg whites, vanilla, and almond extract gradually and beat until incorporated. Scrape down the work bowl and beat on medium for 1 minute.

3. Add the flour and salt and beat on low until the mixture comes together as a smooth dough. Transfer it to a piping bag fit with a #847 star tip. Pipe 2-inch-wide roses onto parchment-lined baking sheets, making sure to leave ½ inch between each cookie. Place the baking sheets in the refrigerator for 1 hour.

4. Preheat the oven to 350°F.

5. Using a pastry brush, gently brush all of the cookies with the egg.

6. Place the jam in a piping bag and cut a ½-inch slit in it. Pipe ½ teaspoon of jam in the center of each cookie.

7. Place the cookies in the oven and bake until the edges are a light golden brown, 15 to 20 minutes.

8. Remove from the oven, transfer the cookies to a wire rack, and let them cool completely before enjoying.

INGREDIENTS:

8	OZ. UNSALTED BUTTER
6	OZ. CONFECTIONERS' SUGAR
2	EGG WHITES
1	TEASPOON PURE VANILLA EXTRACT
1	TEASPOON ALMOND EXTRACT
10	OZ. ALL-PURPOSE FLOUR
½	TEASPOON KOSHER SALT
1	EGG, BEATEN
1	CUP RASPBERRY JAM (SEE PAGE 691)

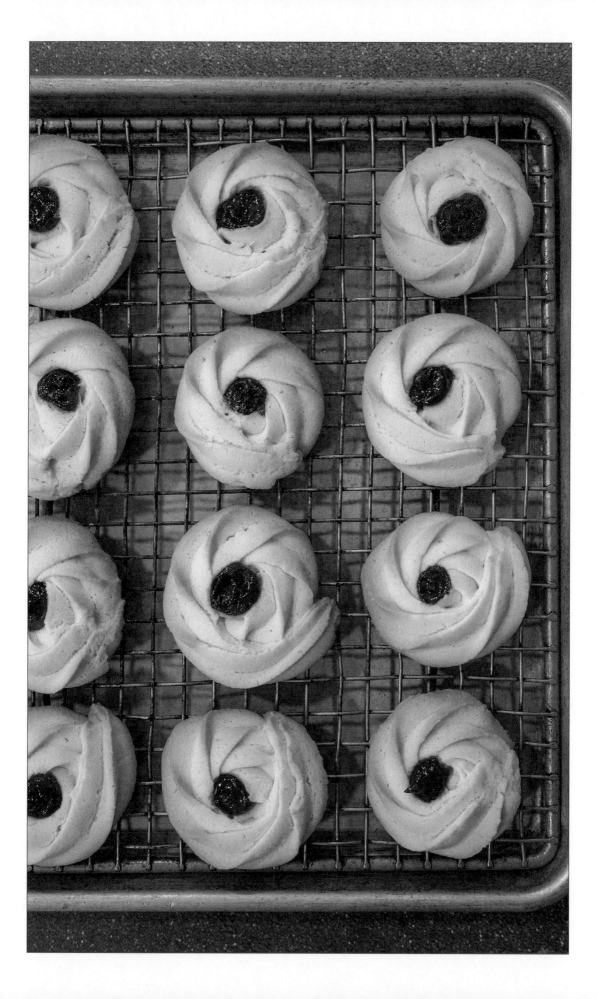

CHOCOLATE TUILES

YIELD: 24 COOKIES / **ACTIVE TIME:** 45 MINUTES / **TOTAL TIME:** 3 HOURS

For an extra-special treat in the summer, place thin, 5-inch circles of batter on a baking sheet, bake them at 475°F for 2 minutes, and roll them around a wooden citrus reamer to form them into ice cream cones.

1. Sift the flour and cocoa powder into a small bowl and set aside.

2. In a medium bowl, whisk the egg whites, confectioners' sugar, and vanilla and set aside.

3. In a small saucepan, melt the butter over low heat. Stir it into the egg white mixture, add the flour mixture, and whisk until the mixture is a smooth batter. Cover the bowl with plastic wrap and refrigerate for 2 hours.

4. Preheat the oven to 400°F.

5. Line an 18 x 13–inch baking sheet with a silicone baking mat. Place 2-teaspoon portions of the batter about 5 inches apart from one another. Use a small, offset spatula to spread the batter into 4-inch circles. Tap the pan lightly on the counter to remove any air bubbles and level the circles.

6. Place the tuiles in the oven and bake until the edges begin to curl up, 4 to 5 minutes. Remove from the oven. Working quickly, carefully remove the tuiles with the offset spatula and either shape them as desired or transfer them to a cooling rack.

7. Repeat until all of the batter has been used.

INGREDIENTS:

2.5	OZ. ALL-PURPOSE FLOUR
2	TABLESPOONS COCOA POWDER
5	EGG WHITES
4.5	OZ. CONFECTIONERS' SUGAR
½	TEASPOON PURE VANILLA EXTRACT
5.3	OZ. UNSALTED BUTTER

SCOTTISH SHORTBREAD

YIELD: 24 COOKIES / **ACTIVE TIME:** 20 MINUTES / **TOTAL TIME:** 2 HOURS AND 30 MINUTES

The only shortbread recipe you'll ever need.

1. Preheat the oven to 325°F. Grate the butter into a bowl and place it in the freezer for 30 minutes.

2. Place the 3.5 oz. of sugar, flour, salt, and frozen butter in the work bowl of a stand mixer fitted with the paddle attachment and beat slowly until it is fine like sand. Be careful not to overwork the mixture.

3. Press the mixture into a square, 8-inch baking pan and bake for 1 hour and 15 minutes.

4. Remove from the oven and sprinkle the remaining sugar over the top. Let it cool and then cut the shortbread into bars or circles.

INGREDIENTS:

10 OZ. UNSALTED BUTTER

3.5 OZ. SUGAR, PLUS 2 TABLESPOONS

12.5 OZ. ALL-PURPOSE FLOUR

1 TEASPOON FINE SEA SALT

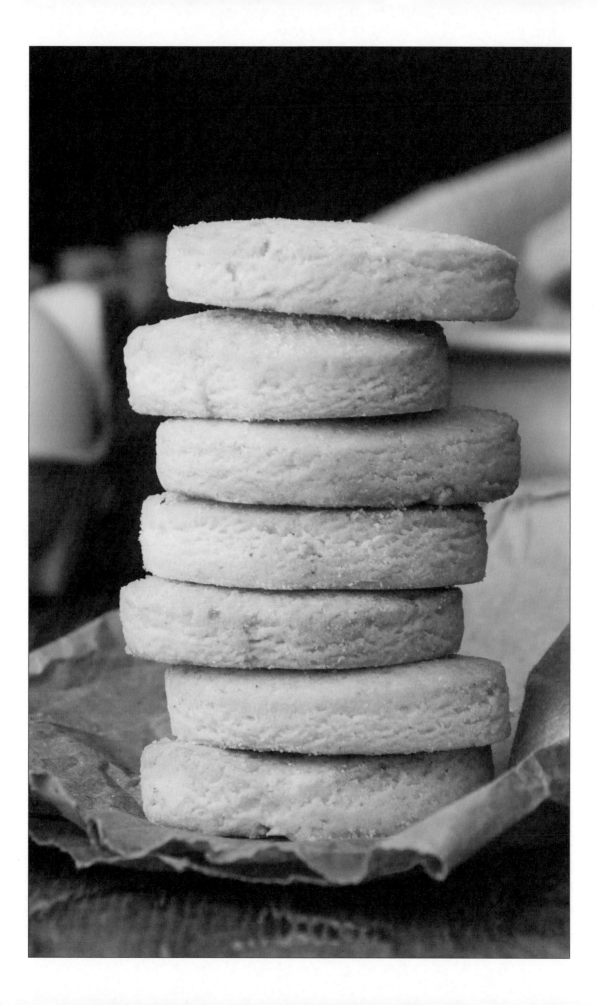

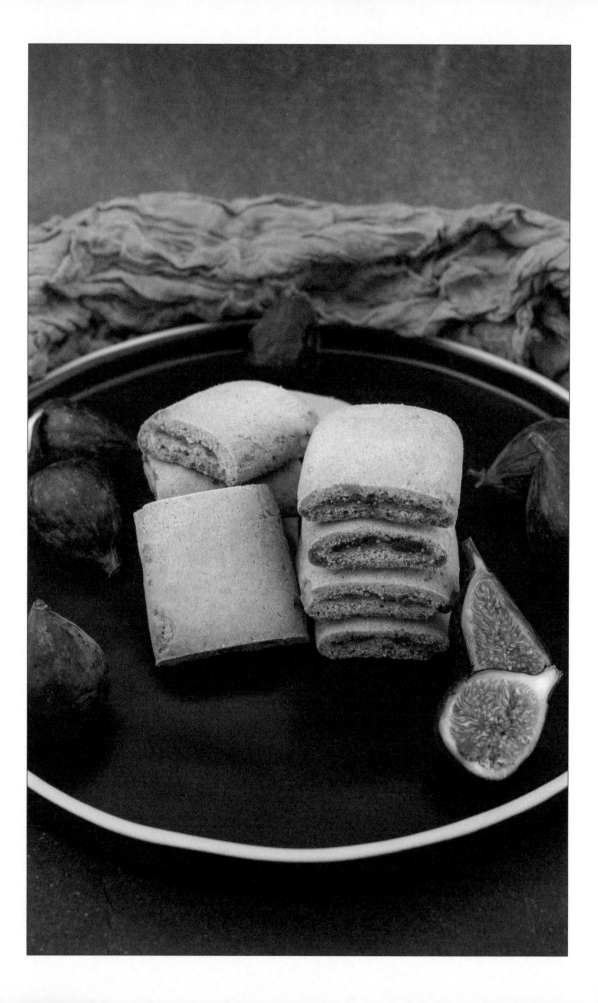

FIG NEWTONS

YIELD: 60 COOKIES / ACTIVE TIME: 1 HOUR / TOTAL TIME: 2 HOURS AND 30 MINUTES

I f you get nostalgic thinking about eating store-bought versions of these, get ready to create a whole new set of sweet memories with these scrumptious homemade ones.

1. In the work bowl of a stand mixer fitted with the paddle attachment, cream the butter, brown sugar, honey, and orange zest on medium until the mixture is very light and fluffy, about 5 minutes. Scrape down the work bowl and then add the egg yolks and orange juice. Beat until combined, add the flour, baking soda, cinnamon, and salt, and beat until the dough comes together.

2. Place the dough on a flour-dusted work surface and divide it into two 6-inch squares. Cover each piece completely with plastic wrap and refrigerate for 1 hour.

3. Preheat the oven to 350°F and line two baking sheets with parchment paper. Place one piece of dough on a flour-dusted work surface and roll it out until it is a 15-inch square. Cut the dough into 3-inch-wide strips.

4. Place the preserves or jam in a piping bag and pipe a strip of filling down the center of each strip, leaving 1 inch on either side.

5. Gently fold the dough over the filling so that it is sealed. Flip the strip over so that the seam is facing down. Transfer the strips to one of the baking sheets, place them back in the refrigerator, and let them chill for 10 minutes.

6. Cut the strips into 2-inch squares and place them back on one of the baking sheets, leaving 1 inch between each square.

7. Place the cookies in the oven and bake until they are golden brown, 10 to 12 minutes. Remove from the oven, transfer them to a wire rack to cool, and repeat with the other piece of dough.

INGREDIENTS:

10	OZ. UNSALTED BUTTER, SOFTENED
8	OZ. LIGHT BROWN SUGAR
2	OZ. HONEY
	ZEST OF 1 ORANGE
6	EGG YOLKS
1	OZ. ORANGE JUICE
21	OZ. ALL-PURPOSE FLOUR, PLUS MORE AS NEEDED
1¼	TEASPOONS BAKING SODA
½	TEASPOON CINNAMON
½	TEASPOON KOSHER SALT
6	CUPS FIG PRESERVES OR JAM

DOUBLE SHOT COOKIES

YIELD: 18 COOKIES / **ACTIVE TIME:** 30 MINUTES / **TOTAL TIME:** 2 HOURS

Illy espresso powder, available at stores around the country, is the best choice for these cookies, and for all your baking needs.

1. Line two baking sheets with parchment paper. Fill a small saucepan halfway with water and bring it to a simmer. Place the dark chocolate and butter in a heatproof bowl, place it over the simmering water, and stir until they have melted and been combined. Remove the bowl from heat and whisk in the eggs, sugar, and vanilla.

2. Add the flour, baking powder, salt, and espresso powder and whisk until the dough comes together. Add the chocolate chips and fold until evenly distributed.

3. Drop 2-oz. portions of the dough on the baking sheets, making sure to leave enough space between them. Place the baking sheets in the refrigerator and let the dough firm up for 1 hour.

4. Preheat the oven to 350°F.

5. Place the cookies in the oven and bake until a cake tester comes out clean after being inserted, 12 to 14 minutes.

6. Remove from the oven, transfer the cookies to a cooling rack, and let them cool for 20 to 30 minutes before enjoying.

INGREDIENTS:

7.7 OZ. DARK CHOCOLATE (55 TO 65 PERCENT)

1.1 OZ. UNSALTED BUTTER, SOFTENED

2 EGGS

3.6 OZ. SUGAR

¾ TEASPOON PURE VANILLA EXTRACT

1.25 OZ. ALL-PURPOSE FLOUR

¼ TEASPOON BAKING POWDER

¼ TEASPOON KOSHER SALT

¼ CUP ESPRESSO POWDER

6 OZ. CHOCOLATE CHIPS

MEXICAN CHOCOLATE CRINKLE COOKIES

YIELD: 20 COOKIES / **ACTIVE TIME:** 30 MINUTES / **TOTAL TIME:** 2 HOURS

Spicy, sweet, chocolatey, crunchy, and moist. In other words, a cookie for those who won't rest until they have it all.

1. Line two baking sheets with parchment paper. Fill a small saucepan halfway with water and bring it to a simmer. Place the Mexican chocolate in a heatproof bowl, place it over the simmering water, and stir until melted. Remove the bowl from heat and set aside.

2. In the work bowl of a stand mixer fitted with the paddle attachment, cream the butter, brown sugar, and vanilla on medium until the mixture is very light and fluffy, about 5 minutes. Scrape down the work bowl and then beat the mixture for another 5 minutes.

3. Reduce the speed to low, add the melted chocolate, and beat until incorporated.

4. Add the eggs one at a time and beat until incorporated, again scraping down the work bowl as needed. When both eggs have been incorporated, scrape down the work bowl. Set the speed to medium and beat for 1 minute.

5. Add the flour, cocoa powder, baking powder, cinnamon, ancho chile powder, and salt, reduce the speed to low, and beat until the mixture comes together as a dough.

6. Drop 2-oz. portions of the dough on the baking sheets, making sure to leave enough space between the portions. Place the baking sheets in the refrigerator and let the dough firm up for 1 hour.

7. Preheat the oven to 350°F. Place the confectioners' sugar in a mixing bowl, toss the dough balls in the sugar until they are completely coated, and then place them back on the baking sheets.

8. Place the cookies in the oven and bake until a cake tester comes out clean after being inserted, 12 to 14 minutes.

9. Remove from the oven, transfer the cookies to a cooling rack, and let them cool for 20 to 30 minutes before enjoying.

INGREDIENTS:

9	OZ. MEXICAN CHOCOLATE
4.5	OZ. UNSALTED BUTTER, SOFTENED
7	OZ. DARK BROWN SUGAR
¾	TEASPOON PURE VANILLA EXTRACT
2	EGGS
7	OZ. ALL-PURPOSE FLOUR
2.5	OZ. COCOA POWDER
2	TEASPOONS BAKING POWDER
½	TEASPOON CINNAMON
¼	TEASPOON ANCHO CHILE POWDER
1	TEASPOON KOSHER SALT
2	CUPS CONFECTIONERS' SUGAR, FOR COATING

BAKLAVA

YIELD: 48 PIECES / **ACTIVE TIME:** 30 MINUTES / **TOTAL TIME:** 1 HOUR

As with pizza, fried chicken, and ice cream, there is no such thing as bad baklava.

1. Place the walnuts, 3.5 oz. of the sugar, cinnamon, and cloves in a food processor. Pulse until very fine and set aside.

2. Preheat the oven to 375°F and coat an 18 x 13–inch baking sheet with nonstick cooking spray. Place the phyllo sheets on a plate and cover them with plastic wrap or a damp paper towel to keep them from drying out. Place 1 sheet of phyllo on the baking sheet and brush it with some of the melted butter. Repeat with 7 more sheets, and then spread one-third of the walnut mixture on top. Place 4 more sheets of phyllo dough on top, brushing each with melted butter. Spread half of the remaining walnut mixture on top, and then repeat. Top the last of the walnut mixture with the remaining sheets of phyllo dough, brushing each one with melted butter. Trim the edges to make a neat rectangle.

3. Cut the pastry into squares or triangles, taking care not to cut through the bottom crust. Place the baklava in the oven and bake for 25 to 30 minutes, until the top layer of phyllo is brown.

4. While the pastry is cooking, combine the remaining sugar, water, honey, lemon, and cinnamon stick in a saucepan. Bring to a boil over medium heat while stirring occasionally. Reduce the heat to low and simmer for 5 minutes. Strain the syrup and keep it hot while the pastry finishes baking.

5. Remove the baklava from the oven and pour the hot syrup over the pastry. Place the pan on a wire rack, allow it to cool to room temperature, and then cut through the bottom crust. If desired, garnish with chopped pistachios before serving.

INGREDIENTS:

3½	CUPS WALNUTS, TOASTED
17.5	OZ. SUGAR
1	TEASPOON CINNAMON
¼	TEASPOON GROUND CLOVES
1	LB. FROZEN PHYLLO SHEETS, THAWED
12	OZ. UNSALTED BUTTER, MELTED
1½	CUPS WATER
½	CUP HONEY
½	LEMON, SLICED THIN
1	CINNAMON STICK
	PISTACHIOS, CHOPPED, FOR GARNISH (OPTIONAL)

KUDOS BARS

YIELD: 12 KUDOS BARS / **ACTIVE TIME:** 30 MINUTES / **TOTAL TIME:** 2 HOURS AND 30 MINUTES

Consider dipping these bars into the Coating Chocolate (see page 711), instead of just drizzling the Chocolate Ganache over the top.

1. Line a 13 x 9–inch baking pan with parchment paper and coat it with nonstick cooking spray. Place the cereal, oats, and 2 cups of the chocolate chips in a mixing bowl and stir to combine. Set the mixture aside.

2. In a medium saucepan, combine the brown sugar, butter, honey, corn syrup, and salt. Bring to a boil over medium heat and cook for another 2 minutes. Remove the pan from heat, whisk in the vanilla, and then pour it over the cereal mixture. Stir with a rubber spatula until combined.

3. Transfer the mixture to the baking pan and press down on it until it is flat and even. Sprinkle the remaining chocolate chips over the mixture and gently press them down into it. Refrigerate for 2 hours.

4. Remove from the refrigerator and cut the mixture into bars.

5. Drizzle the ganache over the bars and enjoy.

INGREDIENTS:

6	CUPS CRISPY RICE CEREAL
3	CUPS ROLLED OATS
4	CUPS CHOCOLATE CHIPS
1	CUP DARK BROWN SUGAR
¾	CUP UNSALTED BUTTER
¾	CUP HONEY
¼	CUP LIGHT CORN SYRUP
4	TEASPOONS KOSHER SALT
2	TABLESPOONS PURE VANILLA EXTRACT
2	CUPS CHOCOLATE GANACHE (SEE PAGE 664), WARM

LEMON BARS

YIELD: 12 BARS / **ACTIVE TIME:** 40 MINUTES / **TOTAL TIME:** 5 HOURS

A confection for those who prefer a fruit-based dessert, and those who aren't afraid of a little tartness at the end of the day.

1. Preheat the oven to 325°F. Line a 13 x 9–inch baking pan with parchment paper and coat it with nonstick cooking spray. To prepare the crust, place all of the ingredients in a mixing bowl and work the mixture with your hands until combined, soft, and crumbly.

2. Firmly press the crust into the baking pan, making sure it is flat and even. Place it in the oven and bake until the crust begins to brown at the edges, about 20 minutes. Remove from the oven and place it on a cooling rack.

3. To prepare the filling, place the sugar, flour, lemon zest, and salt in a mixing bowl and whisk until combined. Add the eggs and lemon juice, whisk until incorporated, and spread the mixture over the baked crust.

4. Place it in the oven and bake until the center is set, 20 to 25 minutes.

5. Remove from the oven, transfer it to a cooling rack, let it cool for 2 hours, and then refrigerate for an additional 2 hours.

6. Cut the bars, dust them with confectioners' sugar, and store them in the refrigerator until ready to serve.

INGREDIENTS:

FOR THE CRUST

10	OZ. ALL-PURPOSE FLOUR
4	OZ. SUGAR
¼	TEASPOON KOSHER SALT
8	OZ. UNSALTED BUTTER, SOFTENED

FOR THE FILLING

1	LB. SUGAR
¾	CUP ALL-PURPOSE FLOUR
	ZEST OF 2 LEMONS
¼	TEASPOON KOSHER SALT
5	EGGS
1	CUP FRESH LEMON JUICE
1	CUP CONFECTIONERS' SUGAR, FOR DUSTING

GINGERBREAD COOKIES

YIELD: 24 COOKIES / **ACTIVE TIME:** 30 MINUTES / **TOTAL TIME:** 2 HOURS

Most know it as a Christmas classic, but gingerbread's roots as a foundational piece of celebrations seem to date all the way back to the ancient Greeks and Egyptians, who featured a rudimentary form of the cookie at various ceremonies.

1. In the work bowl of a stand mixer fitted with the paddle attachment, cream the butter and brown sugar on medium until light and fluffy, about 5 minutes.

2. Reduce the speed to low, add the eggs and molasses, and beat until incorporated. Scrape down the work bowl and beat on medium for 1 minute.

3. Add the flour, ginger, cinnamon, baking soda, baking powder, and salt and beat on low until the mixture comes together as a smooth dough. Form it into a ball and then flatten the dough into a disk. Cover it with plastic wrap and refrigerate for 1 to 2 hours, until firm enough to roll out.

4. Preheat the oven to 350°F. Remove the dough from the refrigerator and allow it to sit on the counter for 5 minutes.

5. Place the dough on a flour-dusted work surface and roll it out to about ¼ inch thick. Use a gingerbread man cookie cutter to cut the dough, and place the cookies on parchment-lined baking sheets. The scraps can be formed into a ball, rolled out, and cut into additional cookies. If the dough becomes too sticky or warm, place it back in the refrigerator for 15 minutes to firm up.

6. Place the cookies in the oven and bake until they are golden brown at the edges, 9 to 11 minutes. Remove from the oven, transfer the cookies to wire racks, and let them cool for 10 minutes before enjoying.

INGREDIENTS:

8	OZ. UNSALTED BUTTER, SOFTENED
10.5	OZ. LIGHT BROWN SUGAR
2	EGGS
1	CUP MOLASSES
30	OZ. ALL-PURPOSE FLOUR, PLUS MORE AS NEEDED
1	TABLESPOON GROUND GINGER
1	TABLESPOON CINNAMON
¾	TEASPOON BAKING SODA
¼	TEASPOON BAKING POWDER
¼	TEASPOON KOSHER SALT

BUTTERSCOTCH TOFFEE PECAN COOKIES

YIELD: 20 COOKIES / **ACTIVE TIME:** 40 MINUTES / **TOTAL TIME:** 2 HOURS

Toasting the pecans draws their oils to the surface, leading to a richer flavor that stands toe-to-toe with the toffee.

1. Preheat the oven to 350°F and line two baking sheets with parchment paper.

2. Place the pecans on a separate baking sheet, place them in the oven, and bake until they are toasted and fragrant, about 10 minutes. Remove from the oven and let them cool for 15 minutes before chopping them. Turn the oven off.

3. In the work bowl of a stand mixer fitted with the paddle attachment, cream the butter, sugar, and brown sugar on medium until the mixture is very light and fluffy, about 5 minutes. Scrape down the work bowl and then beat the mixture for another 5 minutes.

4. Reduce the speed to low, add the eggs one at a time, and beat until incorporated, again scraping down the work bowl as needed. When both eggs have been incorporated, scrape down the work bowl and then beat for 1 minute on medium. Add the flour, baking soda, salt, toffee bits, butterscotch chips, and pecans and beat until the mixture comes together as a dough.

5. Drop 2-oz. portions of the dough on the baking sheets, making sure to leave enough space between the portions. Place the baking sheets in the refrigerator and let the dough firm up for 1 hour.

6. Preheat the oven to 350°F.

7. Place the cookies in the oven and bake until their edges are a light golden brown, 10 to 12 minutes.

8. Remove from the oven, transfer the cookies to a cooling rack, and let them cool for 20 to 30 minutes before enjoying.

INGREDIENTS:

8	OZ. PECANS
8	OZ. UNSALTED BUTTER, SOFTENED
3.5	OZ. SUGAR
6.5	OZ. LIGHT BROWN SUGAR
2	EGGS
12	OZ. ALL-PURPOSE FLOUR
½	TEASPOON BAKING SODA
½	TEASPOON KOSHER SALT
4	OZ. TOFFEE BITS
10	OZ. BUTTERSCOTCH CHIPS

PEPPERMINT BARS

YIELD: 12 BARS / **ACTIVE TIME:** 1 HOUR / **TOTAL TIME:** 3 HOURS AND 30 MINUTES

In the universe of sweets, the combination of chocolate and mint stands right behind that of chocolate and peanut butter.

1. Preheat the oven to 350°F. Line a 13 x 9–inch baking pan with parchment paper and coat it with nonstick cooking spray. To begin preparations for the crust, fill a small saucepan halfway with water and bring it to a simmer. Place the chocolate and butter in a heat-proof bowl, place it over the simmering water, and stir until they are melted and combined. Remove the bowl from heat and set aside.

2. In a mixing bowl, whisk the sugar, brown sugar, cocoa powder, and salt, making sure to break up any clumps. Add the eggs and vanilla, whisk to incorporate, and then add the melted chocolate mixture. Whisk to incorporate, pour the batter into the baking pan, and even the surface with a rubber spatula. Lightly tap the baking pan on the counter to settle the batter and remove any air bubbles.

3. Place it in the oven and bake until a cake tester comes out clean after being inserted, 20 to 30 minutes. Remove from the oven and transfer the pan to a cooling rack.

4. To prepare the topping, place the confectioners' sugar, butter, and heavy cream in the work bowl of a stand mixer fitted with the paddle attachment and cream on low until the mixture comes together. Raise the speed to medium and beat until light and fluffy. Add the peppermint candies and beat until just incorporated.

5. Spread the mixture over the baked crust, using an offset spatula to even it out. Transfer the pan to the refrigerator and chill until the topping is set, about 2 hours.

6. Run a sharp knife along the edge of the pan and carefully remove the bars. Place them on a cutting board and cut them to the desired size. Drizzle the ganache over the bars, sprinkle the additional peppermint candies on top, and store in the refrigerator until ready to serve.

INGREDIENTS:

FOR THE CRUST

8	OZ. DARK CHOCOLATE (55 TO 65 PERCENT)
4	OZ. UNSALTED BUTTER
6	OZ. SUGAR
2	OZ. LIGHT BROWN SUGAR
2	TABLESPOONS COCOA POWDER
¼	TEASPOON KOSHER SALT
3	EGGS
¾	TEASPOON PURE VANILLA EXTRACT

FOR THE TOPPING

28.5	OZ. CONFECTIONERS' SUGAR
3	OZ. UNSALTED BUTTER, SOFTENED
4	OZ. HEAVY CREAM
2	CUPS PEPPERMINT CANDY PIECES, PLUS 1 CUP FOR GARNISH
2	CUPS CHOCOLATE GANACHE (SEE PAGE 664), WARM

CAKES

They are universal symbols of celebration. Their presence forces one to acknowledge that something grand is underway, that a transformation has taken place. Birthdays, weddings, graduations, farewells—all of the momentous days of our lives seem to incline toward a gleaming, ornately appointed cake.

This ability to signal distinctiveness is what allowed the elaborate cakes accessible to all today to spread from their exclusive origins in the kitchens of royalty. At present, anyone with a bit of attention and determination can turn out a cake worthy of rejoicing over, whether it be a humble but satisfying pound cake, a beguiling soufflé, or the eye-catching complexity of the Opera Torte (see page 184).

VANILLA CAKE

YIELD: 1 CAKE / **ACTIVE TIME:** 1 HOUR / **TOTAL TIME:** 3 HOURS AND 30 MINUTES

An updated classic, with the buttermilk providing a lovely, unexpected tanginess.

1. Preheat the oven to 350°F. Line three round 8-inch cake pans with parchment paper and coat them with nonstick cooking spray.

2. In a medium bowl, whisk together the cake flour, baking powder, and salt. Sift this mixture into another mixing bowl and set aside.

3. In the work bowl of a stand mixer fitted with the paddle attachment, cream the butter, canola oil, and sugar until the mixture is smooth and creamy, about 5 minutes.

4. Incorporate the eggs one at a time, scraping down the sides of the work bowl with a rubber spatula as needed.

5. Reduce the speed to low, add the dry mixture and beat until combined.

6. Gradually add the milk, buttermilk, and vanilla. When they have been thoroughly incorporated, pour 1½ cups of batter into each cake pan. Bang the pans on the countertop to spread the batter evenly and to dissolve any air bubbles.

7. Place the cakes in the oven and bake until they are lightly golden brown and baked through, 25 to 30 minutes. Insert a cake tester in the center of each cake to check for doneness.

8. Remove from the oven and place the cakes on a cooling rack. Let them cool completely.

9. Trim a thin layer off the top of each cake to create a flat surface. Transfer 2 cups of the buttercream to a piping bag and cut a ½-inch slit in it.

10. Place one cake on a cake stand and pipe one ring of buttercream around the edge. Place 1 cup of the Butterfluff Filling in the center and level it with an offset spatula. Place the second cake on top and repeat the process with the buttercream and filling. Place the last cake on top. Place 1½ cups of the buttercream on the cake and frost the top and sides of the cake using an offset spatula. Refrigerate the cake for at least 1 hour before slicing and serving.

INGREDIENTS:

13	OZ. CAKE FLOUR
2	TEASPOONS BAKING POWDER
¼	TEASPOON KOSHER SALT
8	OZ. UNSALTED BUTTER, SOFTENED
½	CUP CANOLA OIL
3	CUPS SUGAR
5	EGGS
½	CUP MILK
½	CUP BUTTERMILK
1	TABLESPOON PURE VANILLA EXTRACT
	ITALIAN BUTTERCREAM (SEE PAGE 715)
	BUTTERFLUFF FILLING (SEE PAGE 667)

TRIPLE CHOCOLATE CAKE

YIELD: 1 CAKE / **ACTIVE TIME:** 1 HOUR / **TOTAL TIME:** 3 HOURS AND 30 MINUTES

The only chocolate cake recipe you will ever need, moist and fudgy, but also, somehow, cloud-like.

1. Preheat the oven to 350°F. Line three round 8-inch cake pans with parchment paper and coat them with nonstick cooking spray.

2. To begin preparations for the cakes, sift the sugar, flour, cocoa powder, baking soda, baking powder, and salt into a medium bowl. Set aside.

3. In the work bowl of a stand mixer fitted with the whisk attachment, combine the sour cream, canola oil, and eggs on medium.

4. Reduce the speed to low, add the dry mixture, and whisk until combined. Scrape down the sides of the work bowl with a rubber spatula as needed. Add the hot coffee and whisk until thoroughly incorporated.

5. Pour 1½ cups of batter into each cake pan. Bang the pans on the countertop to spread the batter and to remove any air bubbles.

6. Place the cakes in the oven and bake until they are lightly golden brown and baked through, 25 to 30 minutes. Insert a cake tester in the center of each cake to check for doneness.

7. Remove from the oven and place the cakes on a cooling rack. Let them cool completely.

8. To prepare the filling, place 2 cups of the butterfluff and the cocoa powder in a small bowl and whisk to combine.

9. To prepare the frosting, place the buttercream and cocoa powder in another mixing bowl and whisk until combined. Set aside.

10. Trim a thin layer off the top of each cake to create a flat surface. Transfer 2 cups of the frosting to a piping bag

11. Place one cake on a cake stand and pipe one ring of frosting around the edge. Place 1 cup of the filling in the center and level it with an offset spatula. Place the second cake on top and repeat the process with the frosting and filling. Place the last cake on top, place 1½ cups of the frosting on the cake, and frost the top and sides of the cake using an offset spatula. Refrigerate the cake for at least 1 hour.

12. Carefully spoon some the ganache over the edge of the cake so that it drips down. Spread any remaining ganache over the center of the cake.

13. Place the cake in the refrigerator for 30 minutes so that the ganache hardens. To serve, sprinkle the shaved chocolate over the top and slice.

INGREDIENTS:

FOR THE CAKES

20	OZ. SUGAR
13	OZ. ALL-PURPOSE FLOUR
4	OZ. COCOA POWDER
1	TABLESPOON BAKING SODA
1½	TEASPOONS BAKING POWDER
1½	TEASPOONS KOSHER SALT
1½	CUPS SOUR CREAM
¾	CUP CANOLA OIL
3	EGGS
1½	CUPS BREWED COFFEE, HOT

FOR THE FILLING

BUTTERFLUFF FILLING (SEE PAGE 667)

¼	CUP COCOA POWDER

FOR THE FROSTING

ITALIAN BUTTERCREAM (SEE PAGE 715)

1	CUP COCOA POWDER

FOR THE TOPPING

CHOCOLATE GANACHE (SEE PAGE 664), WARM

CHOCOLATE, SHAVED

ANGEL FOOD CAKE

YIELD: 1 CAKE / **ACTIVE TIME:** 30 MINUTES / **TOTAL TIME:** 2 HOURS

It's not just a clever nickname: this light and airy cake is heavenly with some Chantilly Cream (see page 668) or Strawberry Preserves (see page 688).

1. Preheat the oven to 325°F. Coat a 10-inch Bundt pan with non-stick cooking spray.

2. Sift the cake flour and ½ cup of the sugar into a medium bowl.

3. In the work bowl of a stand mixer fitted with the whisk attachment, whip the egg whites and salt on high until soft peaks begin to form. Reduce the speed to low and add the remaining sugar a few tablespoons at a time until all of it has been incorporated. Add the vanilla, raise the speed back to high, and whisk the mixture until it holds stiff peaks.

4. Remove the work bowl from the mixer and gently fold in the dry mixture. Pour the batter into the prepared Bundt pan.

5. Place in the oven and bake until the cakes are lightly golden brown and a cake tester comes out clean after being inserted, 45 to 55 minutes.

6. Remove the cake from the oven and transfer it to a cooling rack. Let it cool for 30 minutes.

7. Invert the cake onto a cake stand or serving tray, dust the top with confectioners' sugar, and serve with the preserves.

INGREDIENTS:

1	CUP CAKE FLOUR
1½	CUPS SUGAR
12	EGG WHITES, AT ROOM TEMPERATURE
¼	TEASPOON KOSHER SALT
1	TEASPOON PURE VANILLA EXTRACT
	CONFECTIONERS' SUGAR, FOR DUSTING
	STRAWBERRY PRESERVES (SEE PAGE 688), FOR SERVING

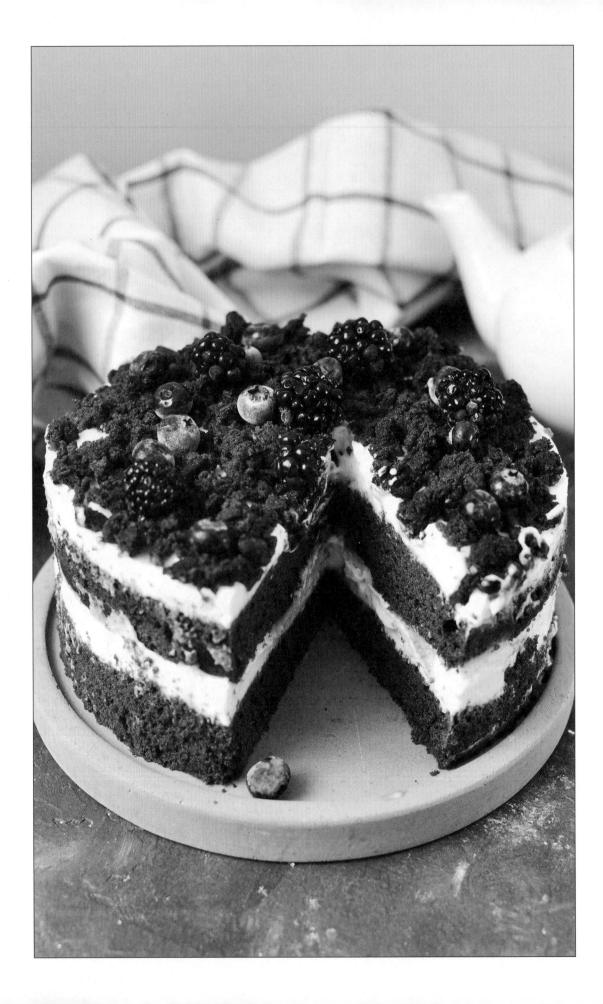

CHOCOLATE CAKE
WITH BERRIES & COCOA CRUMBLE

YIELD: 1 CAKE / **ACTIVE TIME:** 1 HOUR / **TOTAL TIME:** 3 HOURS AND 30 MINUTES

You can use any berries you'd like for this cake, but black raspberries and blueberries will hold up best against its richness.

1. Preheat the oven to 350°F. Line two round 8-inch cake pans with parchment paper and coat them with nonstick cooking spray.

2. To begin preparations for the cakes, sift the sugar, flour, cocoa powder, baking soda, baking powder, and salt into a medium bowl. Set the mixture aside.

3. In the work bowl of a stand mixer fitted with the whisk attachment, combine the sour cream, canola oil, and eggs on medium.

4. Reduce the speed to low, add the dry mixture, and whisk until combined. Scrape down the sides of the work bowl with a rubber spatula as needed. Add the hot coffee and whisk until thoroughly incorporated.

5. Divide the batter between the cake pans. Bang the pans on the counter to spread the batter and to remove any possible air bubbles.

6. Place the cakes in the oven and bake until they are lightly golden brown and baked through, 25 to 30 minutes. Insert a cake tester in the center of each cake to check for doneness.

7. Remove from the oven and place the cakes on a cooling rack. Let them cool completely.

8. Trim a thin layer off the top of each cake to create a flat surface. Transfer the Butterfluff Filling to a piping bag and cut a ½-inch slit in it.

9. Place one cake on a cake stand and pipe one ring of filling around the edge. Place 1 cup of the filling in the center and level it with an offset spatula. Place the second cake on top and repeat the process with the filling. Refrigerate the cake for at least 1 hour.

10. Preheat the oven to 350°F. To begin preparations for the topping, sift the flour and cocoa powder into a bowl. Add the sugar and butter and work the mixture with your hands until it resembles coarse bread crumbs. Spread the mixture on a parchment-lined baking sheet, place it in the oven, and bake until dry to the touch, about 10 minutes.

11. Sprinkle the crumble over the cake, top it with berries, and enjoy.

INGREDIENTS:

FOR THE CAKES

13.2	OZ. SUGAR
8.6	OZ. ALL-PURPOSE FLOUR
2.6	OZ. COCOA POWDER
2	TEASPOONS BAKING SODA
1	TEASPOON BAKING POWDER
1	TEASPOON KOSHER SALT
1	CUP SOUR CREAM
½	CUP CANOLA OIL
2	EGGS
1	CUP BREWED COFFEE, HOT

FOR THE FILLING

BUTTERFLUFF FILLING (SEE PAGE 667)

FOR THE TOPPING

½	CUP ALL-PURPOSE FLOUR
3	TABLESPOONS COCOA POWDER
¼	CUP SUGAR
⅓	CUP UNSALTED BUTTER
	FRESH BERRIES

COFFEE CAKE

YIELD: 1 CAKE / **ACTIVE TIME:** 20 MINUTES / **TOTAL TIME:** 2 HOURS AND 30 MINUTES

Like the beloved beverage that lends its name to this confection, this cake is great at any time of day.

1. Preheat the oven to 350°F. Coat a round 9-inch cake pan with nonstick cooking spray.

2. Place the flour, baking powder, baking soda, and salt in a mixing bowl and whisk to combine.

3. In the work bowl of a stand mixer fitted with the paddle attachment, cream the butter and sugar on medium until it is light and fluffy, about 5 minutes.

4. Reduce the speed to low and incorporate the eggs one at a time, scraping down the work bowl as needed. Add the sour cream, raise the speed to medium, and beat to incorporate. Add the dry mixture, reduce the speed to low, and beat until the mixture is a smooth batter.

5. Pour half of the batter into the cake pan and spread it into an even layer. Sprinkle 1 cup of the topping over the batter. Pour the remaining batter over the topping and spread it into an even layer. Sprinkle the remaining topping over the top of the cake.

6. Place the cake in the oven and bake until a cake tester inserted into the center comes out clean, 45 to 55 minutes.

7. Remove from the oven and place the pan on a wire rack to cool for 1 hour. Remove the cake from the pan, dust the top with confectioners' sugar, and enjoy.

INGREDIENTS:

1	LB. ALL-PURPOSE FLOUR
1	TEASPOON BAKING POWDER
1½	TEASPOONS BAKING SODA
½	TEASPOON KOSHER SALT
8	OZ. UNSALTED BUTTER, SOFTENED
11	OZ. SUGAR
4	EGGS
2	CUPS SOUR CREAM
	COFFEE CAKE TOPPING (SEE PAGE 701)
	CONFECTIONERS' SUGAR, FOR DUSTING

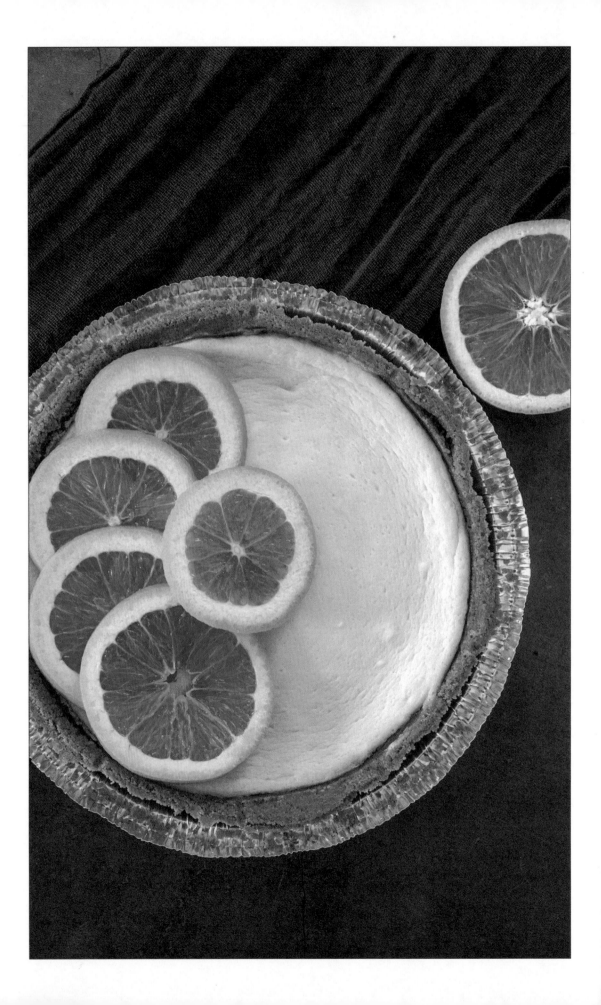

CHEESECAKE WITH CITRUS & BRIE

YIELD: 1 CHEESECAKE / **ACTIVE TIME:** 1 HOUR / **TOTAL TIME:** 8 HOURS

A light and tangy cheesecake that benefits greatly from the Grand Marnier and a triple-cream Brie.

1. Preheat the oven to 350°F. Bring 8 cups of water to a boil in a small saucepan.

2. In the work bowl of a stand mixer fitted with the paddle attachment, cream the cream cheese, Brie, sugar, salt, and orange zest on high until the mixture is fluffy, about 10 minutes. Scrape down the sides of the work bowl as needed.

3. Reduce the speed of the mixer to medium and incorporate one egg at a time, scraping down the work bowl as needed. Add the vanilla and Grand Marnier and mix until incorporated.

4. Pour the mixture into the crust, place the cheesecake in a large baking pan with high sides, and gently pour the boiling water into the baking pan until it reaches halfway up the sides of the spring-form pan.

5. Cover the baking pan with aluminum foil, place it in the oven, and bake until the cheesecake is set and only slightly jiggly in the center, 50 minutes to 1 hour.

6. Turn off the oven and leave the oven door cracked. Allow the cheesecake to rest in the cooling oven for 45 minutes.

7. Remove the cheesecake from the oven and transfer it to a cooling rack. Let it sit at room temperature for 1 hour.

8. Transfer the cheesecake to the refrigerator and let it cool for at least 4 hours before serving and slicing. To serve, top each slice with a heaping spoonful of the Strawberry Preserves.

INGREDIENTS:

1.5 LBS. CREAM CHEESE, SOFTENED

8 OZ. TRIPLE-CREAM BRIE CHEESE, RIND REMOVED

⅔ CUP SUGAR

¼ TEASPOON KOSHER SALT

ZEST OF 1 ORANGE

4 EGGS

1 TABLESPOON PURE VANILLA EXTRACT

2 TABLESPOONS GRAND MARNIER

1 GRAHAM CRACKER CRUST (SEE PAGE 222), IN A SPRINGFORM PAN

STRAWBERRY PRESERVES (SEE PAGE 688)

CARROT CAKE

YIELD: 1 CAKE / **ACTIVE TIME:** 30 MINUTES / **TOTAL TIME:** 2 HOURS

An ideal way to use your carrot trimmings—so make sure you save yours in the freezer. Once you have enough, reward yourself with this cake.

1. Preheat the oven to 350°F. Line three round 8-inch cake pans with parchment paper and coat them with nonstick cooking spray.

2. Place the flour, baking soda, cinnamon, ginger, and salt in a mixing bowl and whisk to combine. Set the mixture aside.

3. In the work bowl of a stand mixer fitted with the whisk attachment, combine the sugar, canola oil, eggs, carrots, and coconut and whip on medium for 5 minutes.

4. Reduce the speed to low, add the dry mixture, and whisk until combined. Scrape down the sides of the work bowl with a rubber spatula as needed.

5. Pour 1½ cups of batter into each cake pan. Bang the pans on the countertop to spread the batter and to remove any possible air bubbles.

6. Place the cakes in the oven and bake until they are lightly golden brown and baked through, 22 to 26 minutes. Insert a cake tester in the center of each cake to check for doneness.

7. Remove from the oven and place the cakes on a cooling rack. Let them cool completely.

8. Trim a thin layer off the top of each cake to create a flat surface.

9. Place one cake on a cake stand. Place 1 cup of the frosting in the center and level it with an offset spatula. Place the second cake on top and repeat the process with the frosting. Place the last cake on top, place 2 cups of the frosting on the cake, and frost the top and sides of the cake using an offset spatula. Refrigerate the cake for at least 1 hour before enjoying.

INGREDIENTS:

9 OZ. ALL-PURPOSE FLOUR

2 TEASPOONS BAKING SODA

1 TABLESPOON CINNAMON

1½ TEASPOONS GROUND GINGER

1 TEASPOON KOSHER SALT

14 OZ. SUGAR

1¼ CUPS CANOLA OIL

4 EGGS

3 LARGE CARROTS, PEELED AND GRATED

½ CUP SWEETENED SHREDDED COCONUT

CREAM CHEESE FROSTING (SEE PAGE 716)

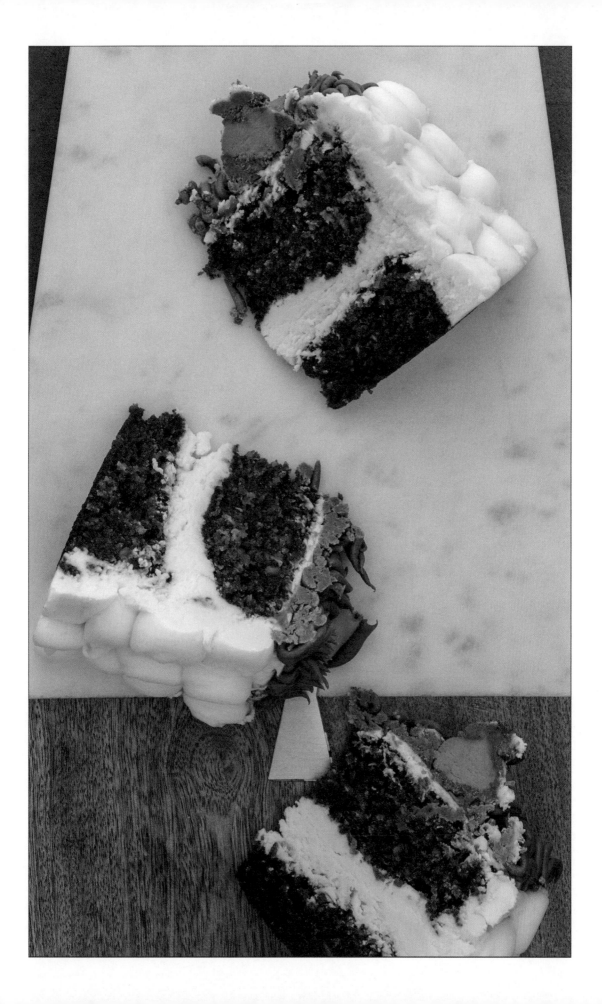

LEMON YOGURT POUND CAKE

YIELD: 1 CAKE / **ACTIVE TIME:** 20 MINUTES / **TOTAL TIME:** 2 HOURS

Adding enough of the Lemon Syrup so that it seeps into the cake is the key to making it top shelf.

1. Preheat the oven to 350°F. Coat an 8 x 4–inch loaf pan with nonstick cooking spray.

2. Place the flour, baking powder, salt, and 5 oz. of the sugar in a mixing bowl and whisk to combine. Set aside.

3. In the work bowl of a stand mixer fitted with the paddle attachment, beat the eggs, canola oil, remaining sugar, lemon zest, lemon juice, and vanilla on medium for 5 minutes. Add the dry mixture, reduce the speed to low, and beat until the mixture comes together as a smooth batter. Add the yogurt and beat to incorporate.

4. Pour the batter into the prepared loaf pan, place it in the oven, and bake until a cake tester inserted into the center of the cake comes out clean, 60 to 70 minutes.

5. Remove the pan from the oven and place it on a wire rack to cool. Generously brush the cake with the syrup and let it cool completely before serving.

LEMON SYRUP

1. Place the lemon juice and sugar in a small saucepan and cook over medium heat, stirring to dissolve the sugar. Remove the pan from heat and let the syrup cool before using or storing.

INGREDIENTS:

8	OZ. ALL-PURPOSE FLOUR
1½	TEASPOONS BAKING POWDER
¾	TEASPOON KOSHER SALT
10	OZ. SUGAR
3	EGGS
5	OZ. CANOLA OIL
	ZEST AND JUICE OF 2 LEMONS
1½	TEASPOONS PURE VANILLA EXTRACT
7	OZ. FULL-FAT YOGURT
	LEMON SYRUP (SEE RECIPE)

LEMON SYRUP

½	CUP FRESH LEMON JUICE
½	CUP SUGAR

COCONUT CAKE

YIELD: 1 CAKE / **ACTIVE TIME:** 1 HOUR / **TOTAL TIME:** 3 HOURS

Coconut cake is a sweet and incredibly soft and fluffy cake with an unmatched coconut flavor.

1. Preheat the oven to 350°F. Line three round 8-inch cake pans with parchment paper and coat them with nonstick cooking spray.

2. To begin preparations for the cakes, place the flour, baking powder, and salt in a mixing bowl and whisk to combine. Set the mixture aside.

3. In the work bowl of a stand mixer fitted with the paddle attachment, cream the butter and sugar on medium for 5 minutes.

4. Reduce the speed to low and incorporate the eggs one at a time, scraping down the work bowl as needed.

5. Add the dry mixture, beat until combined, and then add the remaining ingredients. Beat until incorporated.

6. Pour 1½ cups of batter into each cake pan. Bang the pans on the countertop to spread the batter and to remove any possible air bubbles.

7. Place the cakes in the oven and bake until they are lightly golden brown and baked through, 20 to 25 minutes. Insert a cake tester in the center of each cake to check for doneness.

8. Remove from the oven and place the cakes on a cooling rack. Let them cool completely.

9. To begin preparations for the frosting, place the buttercream and coconut extract in a mixing bowl and whisk until combined. Set the frosting aside.

10. Trim a thin layer off the top of each cake to create a flat surface.

11. Place one cake on a cake stand. Place 1 cup of the buttercream in the center and level it with an offset spatula. Place the second cake on top and repeat the process with the buttercream. Place the last cake on top and spread 1 cup of the buttercream over the entire cake using an offset spatula. Sprinkle the coconut over the top and side of the cake.

12. Refrigerate the cake for at least 1 hour before slicing and serving.

INGREDIENTS:

FOR THE CAKES

8	OZ. CAKE FLOUR
2¼	TEASPOONS BAKING POWDER
½	TEASPOON KOSHER SALT
6	OZ. UNSALTED BUTTER, SOFTENED
11	OZ. SUGAR
3	EGGS
1	TEASPOON PURE VANILLA EXTRACT
2	TEASPOONS COCONUT EXTRACT
1	CUP COCONUT MILK
½	CUP SWEETENED SHREDDED COCONUT

FOR THE FROSTING

	AMERICAN BUTTERCREAM (SEE PAGE 712)
1	TEASPOON COCONUT EXTRACT
2	CUPS SWEETENED SHREDDED COCONUT

GLUTEN-FREE ALMOND TORTE

YIELD: 1 CAKE / ACTIVE TIME: 40 MINUTES / TOTAL TIME: 2 HOURS

Thanks to this torte's crispy outside, moist and chewy interior, and homemade almond syrup, even gluten evangelists would be wise to give this one a try.

1. Preheat the oven to 375°F. Line a round 9-inch cake pan with parchment paper and coat it with nonstick cooking spray.

2. In a medium bowl, whisk together the flour, xanthan gum, baking powder, and salt. Set aside.

3. In the work bowl of a stand mixer fitted with the paddle attachment, cream the almond paste, butter, sugar, vanilla, and almond extract on high until the mixture is smooth and fluffy, about 10 minutes. Reduce the speed to low and incorporate the eggs one at a time. Scrape down the sides of the work bowl with a rubber spatula between each addition. Add the dry mixture, beat until combined, and raise the speed to high. Beat the mixture for 2 minutes to thicken it.

4. Pour the batter into the prepared cake pan. Bang the pan on the countertop to evenly distribute the batter and remove any air bubbles. Sprinkle the slivered almonds over the batter and place it in the oven.

5. Bake the cake until it is lightly golden brown and a cake tester comes out clean after being inserted, 20 to 25 minutes. Remove from the oven, transfer the cake to a cooling rack, and let it cool completely.

6. Gently brush the syrup over the torte and dust with confectioners' sugar before slicing and serving.

ALMOND SYRUP

1. Place the water and sugar in a small saucepan and bring to a boil over medium heat, stirring to dissolve the sugar.

2. Remove the saucepan from heat, stir in the almond extract, and let the syrup cool completely before using.

INGREDIENTS:

2.5	OZ. GLUTEN-FREE FLOUR
¼	TEASPOON XANTHAN GUM
¾	TEASPOON BAKING POWDER
¼	TEASPOON KOSHER SALT
4	OZ. ALMOND PASTE
4	OZ. UNSALTED BUTTER, SOFTENED
4.7	OZ. SUGAR
¼	TEASPOON PURE VANILLA EXTRACT
¼	TEASPOON ALMOND EXTRACT
3	EGGS
½	CUP SLIVERED ALMONDS
	ALMOND SYRUP (SEE RECIPE)
	CONFECTIONERS' SUGAR, FOR DUSTING

ALMOND SYRUP

½	CUP WATER
½	CUP SUGAR
¼	TEASPOON ALMOND EXTRACT

STRAWBERRY RHUBARB RICOTTA CAKES

YIELD: 4 SMALL CAKES / **ACTIVE TIME:** 30 MINUTES / **TOTAL TIME:** 1 HOUR AND 15 MINUTES

An exciting twist on the classic combination of strawberry and rhubarb.

1. Preheat the oven to 350°F and coat a 9 x 5–inch loaf pan with nonstick cooking spray. Place the butter and sugar in the work bowl of a stand mixer fitted with the paddle attachment and beat on high until the mixture is smooth and a pale yellow. Reduce the speed to medium, add the eggs one at a time, and beat until incorporated. Add the vanilla, lemon zest, and ricotta cheese and beat until the mixture is smooth.

2. Place the flour, baking powder, and salt in a mixing bowl and whisk to combine. Reduce the speed of the mixer to low, add the dry mixture to the wet mixture, and beat until incorporated. Scrape the mixing bowl as needed while mixing the batter.

3. Add the strawberries and fold to incorporate. Place the batter in the loaf pan, place it in the oven, and bake until a cake tester inserted into the center comes out clean, about 35 minutes. Remove from the oven and let the cake cool to room temperature in the pan.

4. Remove the cooled cake from the pan and cut it into 8 equal pieces. Spread some of the jam over four of the pieces. Cover the jam with some of the meringue and then place the unadorned pieces of cake on top. Spread more meringue on top, garnish with additional strawberries, and serve.

RHUBARB JAM

1. Place the rhubarb, water, sugar, and salt in a saucepan and cook over high heat, stirring occasionally to prevent sticking, until nearly all of the liquid has evaporated.

2. Add the pectin and stir the mixture for 1 minute. Transfer to a sterilized mason jar and allow it to cool completely before applying the lid and placing it in the refrigerator, where the jam will keep for up to 1 week.

INGREDIENTS:

4	OZ. UNSALTED BUTTER, SOFTENED
3.5	OZ. SUGAR
2	EGGS
¼	TEASPOON PURE VANILLA EXTRACT
	ZEST OF 1 LEMON
¾	CUP RICOTTA CHEESE
3.75	OZ. ALL-PURPOSE FLOUR
1	TEASPOON BAKING POWDER
½	TEASPOON KOSHER SALT
½	CUP MINCED STRAWBERRIES, PLUS MORE FOR GARNISH
½	CUP RHUBARB JAM (SEE RECIPE)
	ITALIAN MERINGUE (SEE PAGE 737)

RHUBARB JAM

4	CUPS CHOPPED RHUBARB
1	CUP WATER
¾	CUP SUGAR
½	TEASPOON FINE SEA SALT
1	TEASPOON PECTIN

CHOCOLATE SOUFFLES

YIELD: 6 SOUFFLES / **ACTIVE TIME:** 30 MINUTES / **TOTAL TIME:** 1 HOUR

A rich cake with multiple textures—the first layer is crispy, the center is thick, molten chocolate, and the bottom layer is akin to chocolate mousse.

1. Preheat the oven to 375°F. Coat the insides of six 8 oz. ramekins with nonstick cooking spray. Place 2 tablespoons of sugar in each ramekin and spread it to evenly coat the insides of the dishes. Knock out any excess sugar and set the ramekins aside.

2. Place the dark chocolate and butter in a large, heatproof bowl. Add 2 inches of water to a small saucepan and bring it to a simmer. Place the bowl on top and melt the butter and chocolate together.

3. In a medium saucepan, bring the water and heavy cream to a simmer and then whisk in the chocolate-and-butter mixture. Remove the saucepan from heat.

4. Place the egg yolks and sour cream in a mixing bowl and whisk until combined. Gradually incorporate the cream-and-chocolate mixture, while whisking constantly. Set aside.

5. In the work bowl of a stand mixer fitted with the whisk attachment, whip the egg whites and cream of tartar on high until the mixture holds stiff peaks. Reduce the speed to medium and gradually incorporate the 9 oz. of sugar. Once all of the sugar has been incorporated, raise the speed back to high and whip until it is a glossy, stiff meringue.

6. Working in three increments, add the meringue to the chocolate base, folding gently with a rubber spatula.

7. Spoon the souffle base to the rims of the ramekins. Gently tap the bottoms of the ramekins with the palm of your hand to remove any air bubbles, but not so hard as to deflate the meringue.

8. Place in the oven and bake until the souffles have risen significantly and have set on the outside, but are still jiggly at the center, 25 to 27 minutes. Remove from the oven and serve immediately.

INGREDIENTS:

9	OZ. SUGAR, PLUS MORE FOR COATING RAMEKINS
20	OZ. DARK CHOCOLATE (55 TO 65 PERCENT)
4	OZ. UNSALTED BUTTER
19	OZ. WATER, PLUS MORE AS NEEDED
2	OZ. HEAVY CREAM
11	EGGS, SEPARATED
1.5	OZ. SOUR CREAM
½	TEASPOON CREAM OF TARTAR

ORANGE & CARDAMOM COFFEE CAKE

YIELD: 1 CAKE / **ACTIVE TIME:** 20 MINUTES / **TOTAL TIME:** 2 HOURS AND 30 MINUTES

The floral notes of cardamom can brighten the darkest mornings.

1. Preheat the oven to 350°F. Coat a round 9-inch cake pan with nonstick cooking spray.

2. Place the flour, baking powder, baking soda, cardamom, cinnamon, and salt in a mixing bowl and whisk to combine.

3. In the work bowl of a stand mixer fitted with the paddle attachment, cream the butter, sugar, and orange zest on medium until it is light and fluffy, about 5 minutes.

4. Reduce the speed to low and incorporate the eggs one at a time, scraping down the work bowl as needed. Add the sour cream, raise the speed to medium, and beat to incorporate. Add the dry mixture, reduce the speed to low, and beat until the mixture is a smooth batter.

5. Pour half of the batter into the cake pan and spread it into an even layer. Sprinkle 1 cup of the topping over the batter. Pour the remaining batter over the topping and spread it into an even layer. Sprinkle the remaining topping over the top of the cake.

6. Place the cake in the oven and bake until a cake tester inserted into the center comes out clean, 45 to 55 minutes.

7. Remove from the oven and place the pan on a wire rack to cool for 1 hour. Remove the cake from the pan, dust the top with confectioners' sugar, and enjoy.

INGREDIENTS:

1	LB. ALL-PURPOSE FLOUR
1	TEASPOON BAKING POWDER
1½	TEASPOONS BAKING SODA
2	TEASPOONS CARDAMOM
½	TEASPOON CINNAMON
½	TEASPOON KOSHER SALT
8	OZ. UNSALTED BUTTER, SOFTENED
11	OZ. SUGAR
	ZEST OF 2 ORANGES
4	EGGS
2	CUPS SOUR CREAM
	COFFEE CAKE TOPPING (SEE PAGE 701)
	CONFECTIONERS' SUGAR, FOR DUSTING

BLACK FOREST CAKE

YIELD: 1 CAKE / **ACTIVE TIME:** 1 HOUR / **TOTAL TIME:** 3 HOURS AND 30 MINUTES

Don't be afraid—this improbably moist layered cake is certain to reward the time and energy expended on preparing it.

1. Preheat the oven to 350°F. Line three round 8-inch cake pans with parchment paper and coat them with nonstick cooking spray.

2. In a medium bowl, sift the sugar, flour, cocoa powder, baking soda, baking powder, and salt into a mixing bowl and set aside.

3. In the work bowl of a stand mixer fitted with the whisk attachment, combine the sour cream, canola oil, and eggs on medium. Reduce the speed to low, add the dry mixture, and beat until combined. Scrape down the sides of the work bowl with a rubber spatula as needed.

4. With the mixer running on low, gradually add the hot coffee and beat until fully incorporated. Pour 1½ cups of batter into each cake pan. Bang the pans on the counter to distribute the batter evenly and remove any air bubbles.

5. Place the cakes in the oven and bake until they are browned and a cake tester comes out clean after being inserted, 25 to 30 minutes. Remove the cakes from the oven, transfer them to a cooling rack, and let them cool completely.

6. Trim a thin layer off the top of each cake to create a flat surface. Transfer 2 cups of the Chantilly Cream into a piping bag.

7. Place one cake on a cake stand and pipe one ring of cream around the edge. Place 1 cup of the cherry jam in the center and level it with an offset spatula. Place the second cake on top and repeat the process with the cream and cherry jam. Place the last cake on top and spread 1½ cups of the cream over the entire cake using an offset spatula. Refrigerate the cake for at least 1 hour.

8. Carefully spoon some the ganache over the edge of the cake so that it drips down. Spread any remaining ganache over the center of the cake.

9. Place the cake in the refrigerator for 30 minutes so that the ganache hardens.

10. Garnish the cake with the shaved chocolate and fresh cherries before slicing and serving.

INGREDIENTS:

20	OZ. SUGAR
13	OZ. ALL-PURPOSE FLOUR
4	OZ. COCOA POWDER
1	TABLESPOON BAKING SODA
1½	TEASPOONS BAKING POWDER
1½	TEASPOONS KOSHER SALT
1½	CUPS SOUR CREAM
¾	CUP CANOLA OIL
3	EGGS
1½	CUPS BREWED COFFEE, HOT
2	BATCHES OF CHANTILLY CREAM (SEE PAGE 668)
2	CUPS CHERRY JAM
	CHOCOLATE GANACHE (SEE PAGE 664), MADE WITH DARK CHOCOLATE, WARM
	DARK CHOCOLATE, SHAVED, FOR GARNISH
2	CUPS FRESH RED CHERRIES, FOR GARNISH

RED VELVET CAKE

YIELD: 1 CAKE / **ACTIVE TIME:** 1 HOUR / **TOTAL TIME:** 3 HOURS

It's gorgeous, yes. But the piquant flavor provided by the buttermilk is what has really ushered this cake into the pantheon of great desserts.

1. Preheat the oven to 350°F. Line three round 8-inch cake pans with parchment paper and coat them with nonstick cooking spray.

2. In a medium bowl, whisk together the cake flour, cocoa powder, salt, and baking soda. Set aside.

3. In the work bowl of a stand mixer fitted with the paddle attachment, cream the butter and sugar on high until the mixture is creamy and fluffy, about 5 minutes. Reduce the speed to low, add the eggs two at a time, and beat until incorporated, scraping down the sides of the work bowl with a rubber spatula between additions. Add the vinegar, beat until incorporated, and then add the dry mixture. Beat until thoroughly incorporated, add the buttermilk, vanilla, and food coloring, and beat until they have been combined.

4. Pour 1½ cups of batter into each cake pan. Bang the pans on the counter to distribute the batter evenly and remove any air bubbles.

5. Place the cakes in the oven and bake until set and cooked through and a cake tester comes out clean after being inserted, 26 to 28 minutes. Remove the cakes from the oven, transfer them to a cooling rack, and let them cool completely.

6. Trim a thin layer off the top of each cake to create a flat surface. Transfer 2 cups of the frosting into a piping bag.

7. Place one cake on a cake stand and place 1 cup of the frosting in the center and level it with an offset spatula. Place the second cake on top and repeat the process with the frosting. Place the last cake on top and spread 2 cups of the frosting over the entire cake using an offset spatula. Refrigerate the cake for at least 1 hour before slicing and serving.

INGREDIENTS:

12.7	OZ. CAKE FLOUR
1	OZ. COCOA POWDER
½	TEASPOON KOSHER SALT
1	TEASPOON BAKING SODA
13.4	OZ. UNSALTED BUTTER, SOFTENED
14.5	OZ. SUGAR
6	EGGS
1	TEASPOON WHITE VINEGAR
2.5	OZ. BUTTERMILK
1	TEASPOON PURE VANILLA EXTRACT
2	TEASPOONS RED FOOD COLORING
	CREAM CHEESE FROSTING (SEE PAGE 716)

CONCHAS

YIELD: 42 CONCHAS / **ACTIVE TIME:** 1 HOUR AND 30 MINUTES / **TOTAL TIME:** 13 HOURS

Conchas are a traditional Mexican sweet bread that get their name from the striped shell "pasta" or crunchy topping.

1. To begin preparations for the dough, place the milk, sugar, and yeast in the work bowl of a stand mixer fitted with the dough hook attachment and stir gently to combine. Let the mixture sit until it is foamy, about 10 minutes.

2. Add the eggs and stir gently to incorporate. Add the vanilla, flour, salt, and cardamom and work the mixture until it comes together as a scraggly dough.

3. Knead the dough on medium for about 3 minutes. Add the butter in four increments and work the mixture for 2 minutes after each addition, scraping down the work bowl as needed.

4. Increase the mixer's speed and knead the dough until it can be lifted cleanly out of the bowl, about 10 minutes.

5. Place the dough on a flour-dusted work surface and lightly flour your hands and the top of the dough. Fold the edges of the dough toward the middle and gently press them into the dough. Carefully turn the dough over and use your palms to shape the dough to form a tight ball. Carefully pick up the dough and place it in a mixing bowl. Let it rise in a naturally warm place until it has doubled in size, about 1 hour.

6. Place the dough on a flour-dusted work surface and press down gently to deflate the dough with your hands. Fold in the edges toward the middle and press them in. Carefully flip the dough over and tighten the dough into a ball with a smooth, taut surface.

7. Place the dough back in the mixing bowl, cover it with plastic wrap, and chill in the refrigerator for 8 hours.

8. Divide the dough into 2.6-oz. portions and form them into balls. Place the balls on parchment-lined baking sheets, cover them with kitchen towels, and let them rise at room temperature for 2 hours.

9. To begin preparations for the topping, place all of the ingredients in the work bowl of a stand mixer fitted with the paddle attachment and beat until the mixture comes together as a smooth dough.

INGREDIENTS:

FOR THE DOUGH

2	CUPS WARMED MILK (90°F)
2	CUPS SUGAR
2	OZ. ACTIVE DRY YEAST
18	OZ. EGGS
	SEEDS OF 1 VANILLA BEAN
45	OZ. ALL-PURPOSE FLOUR, PLUS MORE AS NEEDED
½	OZ. FINE SEA SALT
⅛	TEASPOON (SCANT) CARDAMOM
1	LB. UNSALTED BUTTER, SOFTENED

FOR THE TOPPING

6	OZ. ALL-PURPOSE FLOUR
6	OZ. CONFECTIONERS' SUGAR
4.8	OZ. UNSALTED BUTTER, SOFTENED

10. Divide the topping into ⅓-oz. portions. Line a tortilla press with plastic, place a piece of the topping mixture on top, and top with another piece of plastic. Flatten the mixture, place it on one of the proofed conchas, and make small cuts in the topping that are the same shape as the top of an oyster shell. Repeat with the remaining topping mixture and let the conchas rest for 10 minutes.

11. Place in the oven and bake for 10 minutes. Rotate the pans, lower the oven's temperature to 300°F, and bake for an additional 2 minutes. Remove and let them cool before enjoying.

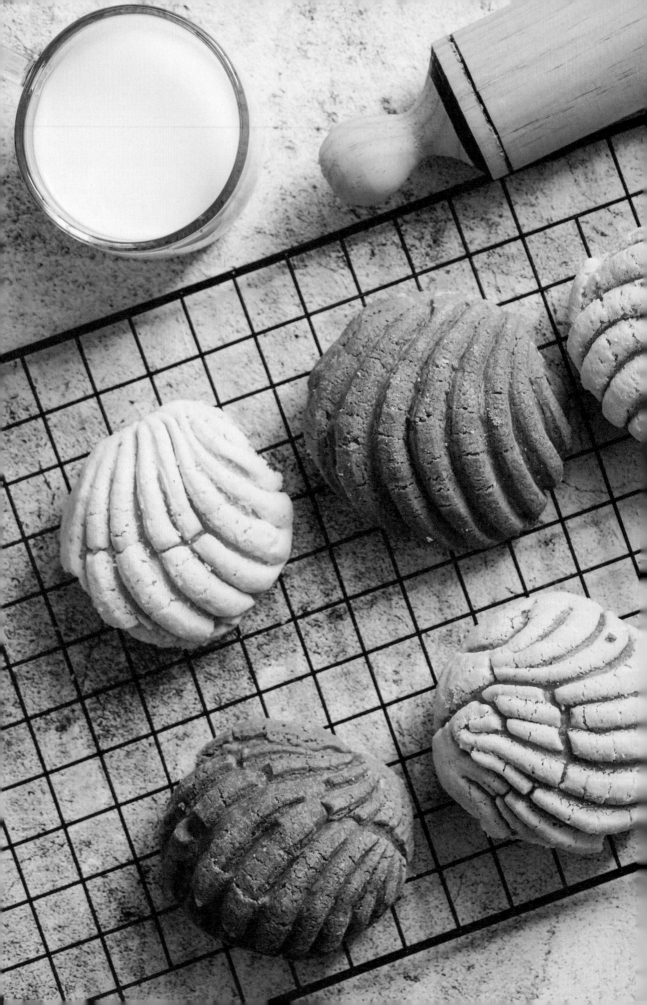

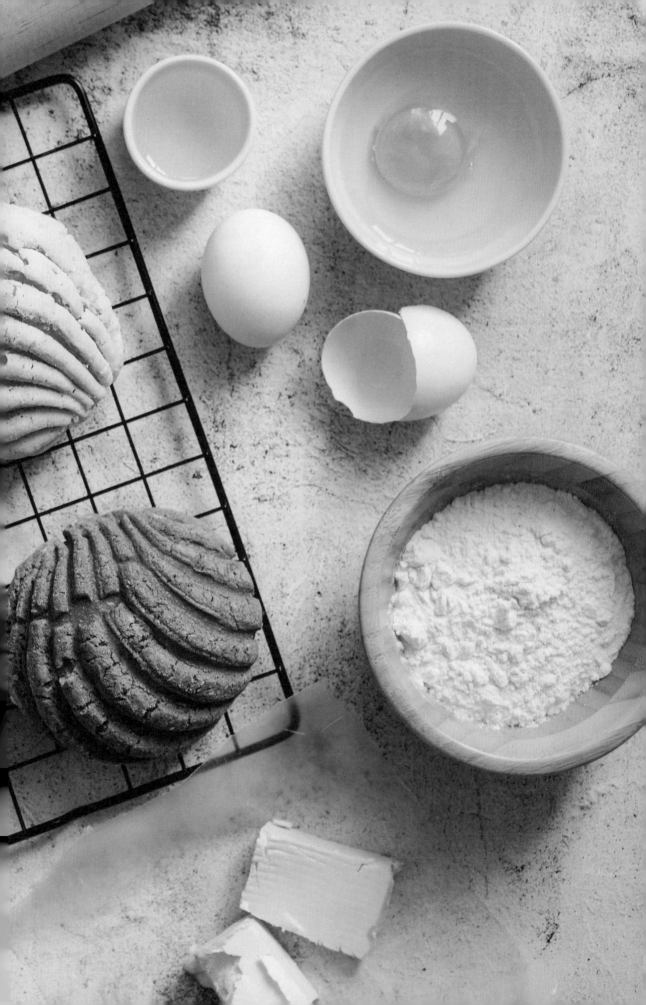

TRES LECHES CAKE

YIELD: 1 CAKE / **ACTIVE TIME:** 45 MINUTES / **TOTAL TIME:** 3 HOURS AND 15 MINUTES

A recipe that appeared on cans of Nestlé condensed milk during the 1940s is believed to be responsible for the proliferation of this simple, delicious cake.

1. Preheat the oven to 350°F. Line a 13 x 9–inch baking pan with parchment paper and coat it with nonstick cooking spray.

2. Sift the flour, baking powder, and salt into a medium bowl and set aside.

3. In the work bowl of a stand mixer fitted with the paddle attachment, cream the butter, sugar, and orange zest on medium until the mixture is smooth and creamy, about 5 minutes.

4. Incorporate the eggs two at a time, scraping down the sides of the work bowl with a rubber spatula between each addition.

5. Reduce the speed of the mixer to low, add the dry mixture, and beat until combined. Incorporate the vanilla and then pour the batter into the prepared pan. Gently tap the pan on the countertop to evenly distribute the batter and remove any air bubbles.

6. Place the cake in the oven and bake until it is golden brown and a cake tester comes out clean after being inserted, 30 to 35 minutes. Remove the cake from the oven and transfer to a cooling rack. Let it cool for 1 hour.

7. While the cake is cooling, combine the evaporated milk, sweetened condensed milk, milk, and heavy cream in a small bowl.

8. Once the cake has cooled for 1 hour, poke holes in it using a fork. Slowly pour the milk mixture over the entire top of the cake. Refrigerate the cake for at least 1 hour, allowing the cake to soak up the milk.

9. Spread the Chantilly Cream over the top of the cake, slice it into squares, and serve with the sliced strawberries.

INGREDIENTS:

14	OZ. ALL-PURPOSE FLOUR
1	TEASPOON BAKING POWDER
½	TEASPOON KOSHER SALT
8	OZ. UNSALTED BUTTER, SOFTENED
1	LB. SUGAR
	ZEST OF 1 ORANGE
10	EGGS
1½	TEASPOONS PURE VANILLA EXTRACT
1	(12 OZ.) CAN EVAPORATED MILK
1	(14 OZ.) CAN SWEETENED CONDENSED MILK
½	CUP MILK
½	CUP HEAVY CREAM
	CHANTILLY CREAM (SEE PAGE 668)
	FRESH STRAWBERRIES, SLICED, FOR SERVING

FLOURLESS CHOCOLATE TORTE

YIELD: 1 CAKE / **ACTIVE TIME:** 30 MINUTES / **TOTAL TIME:** 3 HOURS AND 30 MINUTES

This flourless torte is rich and decadent, sure to assuage any chocolate lover's yearning.

1. Preheat the oven to 375°F. Line a round 9-inch cake pan with parchment paper and coat it with nonstick cooking spray.

2. Fill a small saucepan halfway with water and bring it to a gentle simmer. In a heatproof medium bowl, combine the dark chocolate and butter. Place the bowl over the simmering water and stir the mixture with a rubber spatula until it has melted. Remove the mixture from heat and set aside.

3. In another small saucepan, bring the water, salt, and sugar to a boil over medium heat. Pour the mixture into the melted chocolate and whisk to combine. Incorporate the eggs and vanilla and then pour the batter into the prepared cake pan.

4. Place the cake in the oven and bake until set and the internal temperature reaches 200°F, 25 to 30 minutes. Remove the cake from the oven and let it cool on a wire rack for 30 minutes.

5. Place the torte in the refrigerator for 2 hours.

6. Run a paring knife along the edge of the pan and invert the torte onto a serving plate. Dust the top of the torte with confectioners' sugar and garnish with fresh raspberries.

INGREDIENTS:

- 9 OZ. DARK CHOCOLATE (55 TO 65 PERCENT)
- 4 OZ. UNSALTED BUTTER
- ¼ CUP WATER, PLUS MORE AS NEEDED
- PINCH OF KOSHER SALT
- 3 OZ. SUGAR
- 3 EGGS
- ½ TEASPOON PURE VANILLA EXTRACT
- CONFECTIONERS' SUGAR, FOR DUSTING
- FRESH RASPBERRIES, FOR GARNISH

EGGNOG CUPCAKES

YIELD: 24 CUPCAKES / **ACTIVE TIME:** 30 MINUTES / **TOTAL TIME:** 1 HOUR AND 30 MINUTES

These deliciously light cupcakes are perfect for the holidays.

1. Preheat the oven to 350°F. Line a 24-well cupcake pan with liners.

2. To begin preparations for the cupcakes, whisk the flour, sugar, baking powder, and kosher salt in a medium bowl. Set aside.

3. In the work bowl of a stand mixer fitted with the paddle attachment, combine the butter, egg whites, vanilla, and nutmeg on medium. The batter will look separated and broken. Reduce the speed to low, add the dry mixture, and beat until incorporated, scraping down the sides of the work bowl with a rubber spatula as needed.

4. Gradually add the heavy cream and milk until the mixture comes together as a smooth cake batter. Pour approximately ¼ cup of the batter into each cupcake liner.

5. Place in the oven and bake until the cupcakes are lightly golden brown and a cake tester comes out clean after being inserted, 16 to 20 minutes.

6. Remove from the oven and place the cupcakes on a cooling rack.

7. To prepare the frosting, place the buttercream in the work bowl of a stand mixer fitted with a paddle attachment and add the nutmeg. Beat on medium until combined. Spoon the frosting into a piping bag, frost the cupcakes, and top each one with a little more nutmeg.

INGREDIENTS:

FOR THE CUPCAKES

11.4	OZ. ALL-PURPOSE FLOUR
9.5	OZ. SUGAR
1¾	TEASPOONS BAKING POWDER
½	TEASPOON KOSHER SALT
8	OZ. UNSALTED BUTTER, SOFTENED
4	EGG WHITES
½	TEASPOON PURE VANILLA EXTRACT
2¾	TEASPOONS FRESHLY GRATED NUTMEG
1	CUP HEAVY CREAM
⅓	CUP MILK

FOR THE FROSTING

	AMERICAN BUTTERCREAM (SEE PAGE 712)
1	TABLESPOON FRESHLY GRATED NUTMEG, PLUS MORE FOR GARNISH

ELDERFLOWER SOUFFLES

YIELD: 4 SOUFFLES / **ACTIVE TIME:** 30 MINUTES / **TOTAL TIME:** 2 HOURS

St-Germain liqueur, which brings notes of lychee, sweet blossoms, and peach nectar, is the overwhelming preference for the elderflower liqueur used here.

1. Coat four 8 oz. ramekins with nonstick cooking spray. Place 2 tablespoons of sugar in each ramekin and spread it to evenly coat the insides of the dishes. Knock out any excess sugar and set the ramekins aside.

2. In a small bowl, whisk together the cornstarch and cold water. Set aside.

3. Bring the milk and lemon zest to a boil over medium heat in a medium saucepan. Gradually pour in the cornstarch mixture while continually whisking. Continue to whisk until the mixture has thickened and has boiled for 30 seconds. Immediately remove the pan from heat and whisk in the elderflower liqueur.

4. Transfer the souffle base to a medium bowl. Take plastic wrap and place it directly on the mixture so that no air can get to it. This will prevent a skin from forming. Place the bowl in the refrigerator until it reaches room temperature, about 1 hour.

5. Preheat the oven to 375°F. In the work bowl of a stand mixer fitted with the whisk attachment, whip the egg whites and cream of tartar on high until the mixture holds stiff peaks. Reduce the speed to medium and gradually incorporate the sugar. Once all of the sugar has been incorporated, raise the speed back to high and whip until it is a glossy, stiff meringue.

6. Working in three increments, add the meringue to the souffle base, folding gently with a rubber spatula.

7. Spoon the souffle base to the rims of the ramekins. Gently tap the bottoms of the ramekins with the palm of your hand to remove any air bubbles, but not so hard as to deflate the meringue.

8. Place in the oven and bake until the souffles have risen significantly and set on the outside, but are still jiggly at the center, 22 to 25 minutes. Remove from the oven and serve immediately.

INGREDIENTS:

3.5	OZ. SUGAR, PLUS MORE FOR COATING RAMEKINS
2	TABLESPOONS CORNSTARCH
¼	CUP COLD WATER
10.5	OZ. MILK
	ZEST OF ½ LEMON
2	OZ. ELDERFLOWER LIQUEUR
4	EGG WHITES
¼	TEASPOON CREAM OF TARTAR

STRAWBERRY SHORTCAKE

YIELD: 1 CAKE / **ACTIVE TIME:** 45 MINUTES / **TOTAL TIME:** 2 HOURS AND 30 MINUTES

Thanks to a lighter and fluffier cake, the strawberry no longer has to carry its cohorts, and can simply shine.

INGREDIENTS:

4	OZ. CAKE FLOUR
3.5	OZ. SUGAR, PLUS 7 OZ.
12	EGG WHITES, AT ROOM TEMPERATURE
¼	TEASPOON KOSHER SALT
1	TEASPOON PURE VANILLA EXTRACT
	CHANTILLY CREAM (SEE PAGE 668)
3	CUPS HALVED STRAWBERRIES
	STRAWBERRY PRESERVES (SEE PAGE 688)

1. Preheat the oven to 350°F. Line three round 8-inch cake pans with parchment paper and coat them with nonstick cooking spray.

2. Sift the flour and 3.5 oz. of sugar into a mixing bowl. Set the mixture aside.

3. In the work bowl of a stand mixer fitted with the whisk attachment, whip the egg whites and salt on high until the mixture begins to form soft peaks.

4. Reduce the speed to low and incorporate the remaining 7 oz. of sugar a few tablespoons at a time. Add the vanilla, raise the speed to high, and whip the mixture until it holds stiff peaks.

5. Remove the bowl from the mixer and gently fold in the dry mixture.

6. Divide the batter among the cake pans. Bang the pans on the countertop to spread the batter and to remove any possible air bubbles.

7. Place the cakes in the oven and bake until they are lightly golden brown and baked through, 15 to 20 minutes. Insert a cake tester in the center of each cake to check for doneness.

8. Remove from the oven and place the cakes on a cooling rack. Let them cool completely and then remove them from the pans.

9. Trim a thin layer off the top of each cake to create a flat surface.

10. Place one cake on a cake stand. Place 1 cup of the Chantilly Cream in the center and spread it to within ½ inch of the cake's edge. Arrange 1 cup of the strawberries on top in an even layer. Place the second cake on top and repeat the process with the cream and strawberries. Place the last cake on top and spread 1 cup of the cream over the top.

11. Refrigerate the cake for at least 1 hour before slicing and serving. Garnish each slice with some of the preserves and remaining strawberries.

LAVENDER & LEMON CUPCAKES

YIELD: 24 CUPCAKES / **ACTIVE TIME:** 30 MINUTES / **TOTAL TIME:** 1 HOUR AND 30 MINUTES

Lavender has a lovely, but very powerful, flavor. Pairing it with another strong flavor, such as lemon, is the key to getting the most out of it when using it in a dessert.

1. Preheat the oven to 350°F and line a 24-well cupcake pan with liners.

2. In a medium bowl, whisk together the flour, baking powder, salt, and lavender. Set aside.

3. In the work bowl of a stand mixer fitted with the paddle attachment, cream the butter, sugar, and lemon zest on high until the mixture is light and fluffy, about 5 minutes. Reduce the speed to low and gradually incorporate the egg whites, scraping down the sides of the work bowl with a rubber spatula as needed. Add the dry mixture and beat until incorporated.

4. Add the milk and beat until the mixture is a smooth batter. Pour approximately ¼ cup of batter into each cupcake liner, place the pan in the oven, and bake until the cupcakes are lightly golden brown, 15 to 18 minutes.

5. Remove the cupcakes from the oven and transfer them to a cooling rack. Let them cool completely.

6. Place the buttercream and violet gel food coloring in the work bowl of a stand mixer fitted with the paddle attachment and beat until combined. Place the frosting in a piping bag and frost the cupcakes. Place the cupcakes in the refrigerator and let the frosting set before garnishing with the dried lavender buds.

INGREDIENTS:

14	OZ. ALL-PURPOSE FLOUR
1	TABLESPOON BAKING POWDER, PLUS 2 TEASPOONS
½	TEASPOON KOSHER SALT
1	TABLESPOON GROUND DRIED LAVENDER
8	OZ. UNSALTED BUTTER, SOFTENED
15	OZ. SUGAR
	ZEST OF 2 LEMONS
7	EGG WHITES
¾	CUP MILK
	AMERICAN BUTTERCREAM (SEE PAGE 712)
1–2	DROPS OF VIOLET GEL FOOD COLORING
	DRIED LAVENDER BUDS, FOR GARNISH

OLIVE OIL CAKE

YIELD: 1 CAKE / **ACTIVE TIME:** 30 MINUTES / **TOTAL TIME:** 1 HOUR AND 30 MINUTES

The olive oil will keep this cake moist for an alarming amount of time, making this a good option for the summer, when people are less likely to keep to a set schedule.

1. Preheat the oven to 325°F. Coat a round 9-inch cake pan with nonstick cooking spray.

2. Place the lemon juice and ½ cup of sugar in a small sauce-pan and bring the mixture to a boil, stirring to dissolve the sugar. Remove from heat and let it cool.

3. Sift the flour, baking soda, and baking powder into a small bowl and set the mixture aside.

4. In a medium bowl, whisk the lemon zest, 7 oz. sugar, salt, yogurt, olive oil, and eggs until the mixture is smooth and combined. Add the dry mixture and whisk until a smooth batter forms.

5. Pour the batter into the prepared cake pan, place it in the oven, and bake until the cake is lightly golden brown and a cake tester comes out clean after being inserted, 45 minutes to 1 hour.

6. Remove the cake from the oven, transfer it to a cooling rack, and gently pour the lemon syrup over the hot cake. Let the cake cool completely.

7. Carefully remove the cake from the pan, transfer it to a serving plate, dust it with confectioners' sugar, and serve.

INGREDIENTS:

ZEST AND JUICE OF 3 LEMONS

½ CUP SUGAR, PLUS 7 OZ.

7 OZ. ALL-PURPOSE FLOUR

1 TEASPOON BAKING SODA

1 TEASPOON BAKING POWDER

½ TEASPOON KOSHER SALT

¾ CUP FULL-FAT PLAIN YOGURT

¾ CUP EXTRA-VIRGIN OLIVE OIL

3 EGGS

CONFECTIONERS' SUGAR, FOR DUSTING

CHOCOLATE BEET CAKE

YIELD: 1 CAKE / **ACTIVE TIME:** 45 MINUTES / **TOTAL TIME:** 3 HOURS AND 15 MINUTES

Their detractors will say their taste is too earthy to even be considered for use in a dessert, but devotees understand that beets' sweetness makes them a natural.

1. Preheat the oven to 350°F. Coat a round 9-inch cake pan with nonstick cooking spray.

2. Place the beets in a large saucepan, cover them with water, and bring to a boil. Cook the beets until they are very tender when poked with a knife, about 1 hour. Drain and let the beets cool. When cool enough to handle, place the beets under cold, running water and rub off their skins. Cut the beets into 1-inch chunks, place them in a food processor, and puree. Set aside.

3. Whisk the flour, cocoa powder, baking powder, and salt together in a small bowl. Set aside.

4. Bring a small saucepan filled halfway with water to a gentle simmer. Add the dark chocolate and butter to a heatproof mixing bowl and set it over the simmering water until the mixture melts, stirring occasionally. Remove the bowl from heat and set aside.

5. Heat the milk in a clean saucepan, warm it over medium-low heat until it starts to steam, and pour it into the chocolate mixture. Stir to combine, add the eggs and sugar, and whisk until incorporated. Add the beet puree, stir to incorporate, and add the dry mixture. Whisk until the mixture comes together as a smooth batter.

6. Pour the batter into the prepared cake pan, place it in the oven, and bake until baked through and a cake tester comes out clean after being inserted, 40 to 45 minutes. Remove from the oven, transfer the cake to a cooling rack, and let it cool completely.

7. Carefully remove the cake from the pan and transfer it to a serving plate.

8. Spread the warm ganache over the top of the cake, garnish with blackberries, and serve.

INGREDIENTS:

2	MEDIUM RED BEETS, RINSED
4.5	OZ. ALL-PURPOSE FLOUR
3	TABLESPOONS COCOA POWDER
1¼	TEASPOONS BAKING POWDER
¼	TEASPOON KOSHER SALT
7	OZ. DARK CHOCOLATE (55 TO 65 PERCENT)
7	OZ. UNSALTED BUTTER
¼	CUP MILK
5	EGGS
7	OZ. SUGAR
1	CUP CHOCOLATE GANACHE (SEE PAGE 664), WARM
	FRESH BLACKBERRIES, FOR GARNISH

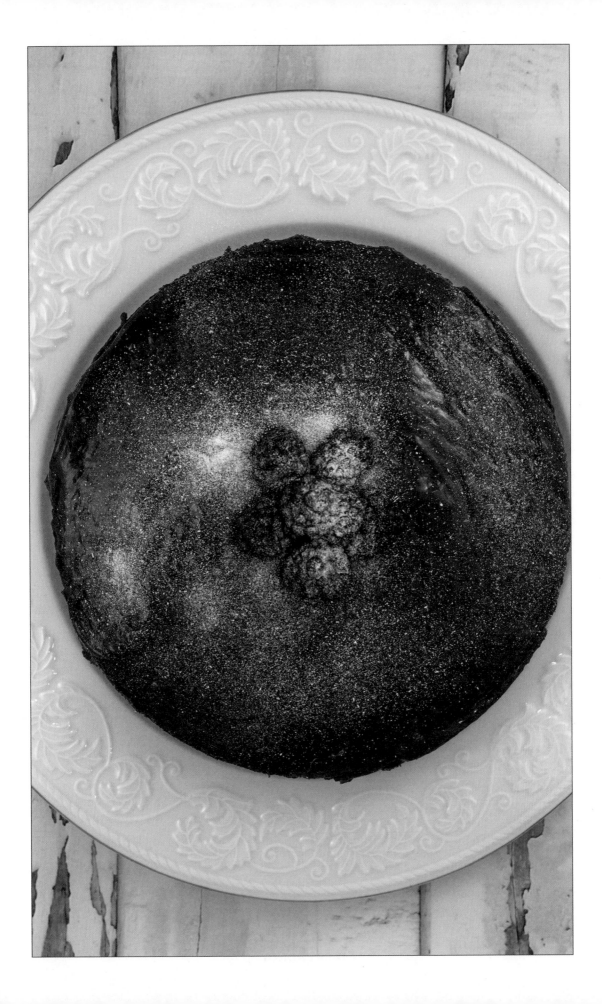

BROWN BUTTER CAKE

YIELD: 1 CAKE / **ACTIVE TIME:** 1 HOUR / **TOTAL TIME:** 3 HOURS AND 30 MINUTES

Browning butter caramelizes the milk solids in butterfat, giving it a unique, nutty taste that is wonderful in a number of desserts. If you like this cake, don't hesitate to experiment with brown butter in your favorite confections.

1. Preheat the oven to 350°F. Line three round 8-inch cake pans with parchment paper and coat them with nonstick cooking spray.

2. Sift the flour, baking powder, and salt into a medium bowl and set aside.

3. In the work bowl of a stand mixer fitted with the paddle attachment, cream the butter and sugar on high until the mixture is smooth and creamy, about 5 minutes.

4. Incorporate the eggs two at a time, scraping down the sides of the work bowl with a rubber spatula between each addition. Reduce the speed to low, add the dry mixture, and beat until combined.

5. Pour 1½ cups of batter into each cake pan. Bang the pans on the countertop to evenly distribute the batter and remove any air bubbles.

6. Place the cakes in the oven and bake until they are lightly golden brown, 35 to 40 minutes. Remove from the oven, transfer them to a cooling rack, and let the cakes cool completely.

7. While the cakes cool, place the buttercream and 1 cup of the caramel in the work bowl of a stand mixer fitted with the paddle attachment and beat on medium until combined. Set aside.

8. Trim a thin layer off the top of each cake to create a flat surface. Place one cake on a cake stand and pipe one ring of cream around the edge. Place 1 cup of the frosting in the center and level it with an offset spatula. Place the second cake on top and repeat the process with the frosting. Place the last cake on top and spread 1½ cups of the frosting over the entire cake using an offset spatula.

9. Gently spoon some of the remaining caramel over the edge of the cake and let it drip down the side. Spread ½ cup of the caramel over the top of the cake.

10. Place the cake in the refrigerator for 1 hour before slicing and serving.

INGREDIENTS:

18	OZ. ALL-PURPOSE FLOUR
1	TABLESPOON BAKING POWDER
2	TEASPOONS KOSHER SALT
1	LB. BROWN BUTTER (SEE RECIPE)
1	LB. SUGAR
8	EGGS
	AMERICAN BUTTERCREAM (SEE PAGE 712)
	CARAMEL SAUCE (SEE PAGE 702)

BROWN BUTTER

INGREDIENTS:

1.5 LBS. UNSALTED BUTTER

1. Place the butter in a large saucepan and melt it over medium heat, stirring frequently, until the butter gives off a nutty smell and turns golden brown (let your nose lead the way here, as you frequently waft the steam toward you).

2. Remove the pan from heat and strain the butter through a fine sieve. Let the butter cool and solidify before using it in this preparation.

AUTUMN SPICE CAKE

YIELD: 1 CAKE / *ACTIVE TIME:* 1 HOUR / *TOTAL TIME:* 3 HOURS AND 30 MINUTES

Fall spices have started to be categorized as "basic." But when done right, they produce results as magical as the season.

1. Preheat the oven to 350°F. Line three round 8-inch cake pans with parchment paper and coat them with nonstick cooking spray.

2. To begin preparations for the cakes, sift the flour, baking soda, baking powder, cinnamon, cloves, nutmeg, ginger, and salt into a mixing bowl. Set aside.

3. In the work bowl of a stand mixer fitted with the whisk attachment, beat the eggs, sugar, brown sugar, pumpkin puree, canola oil, and vanilla on medium until combined. Add the buttermilk and melted butter and beat until incorporated.

4. Reduce the speed to low, add the dry mixture, and whisk until a smooth batter forms. Pour 1½ cups of batter into each cake pan. Bang the pans on the counter to evenly distribute the batter and to remove any air bubbles.

5. Place the cakes in the oven and bake until they are lightly golden brown and a cake tester comes out clean after being inserted, 35 to 45 minutes. Remove from the oven, transfer the cakes to a cooling rack, and let them cool completely.

6. To prepare the frosting, combine the butterfluff and maple extract in a mixing bowl. In a separate bowl, whisk the cinnamon and the buttercream together. Set both aside.

7. Trim a thin layer off the top of each cake to create a flat surface. Place 2 cups of the cinnamon buttercream in a piping bag and cut a ½-inch slit in it. Place one cake on a cake stand and pipe one ring of buttercream around the edge. Place 1 cup of the maple butterfluff in the center and level it with an offset spatula. Place the second cake on top and repeat the process with the buttercream and butterfluff. Place the last cake on top and spread 1½ cups of the buttercream over the entire cake. Dust the top of the cake with additional cinnamon and refrigerate for 1 hour before slicing and serving.

INGREDIENTS:

FOR THE CAKE

14	OZ. ALL-PURPOSE FLOUR
2	TEASPOONS BAKING SODA
1	TABLESPOON BAKING POWDER
2	TEASPOONS CINNAMON
2	TEASPOONS GROUND CLOVES
2	TEASPOONS FRESHLY GRATED NUTMEG
1	TEASPOON GROUND GINGER
1	TEASPOON KOSHER SALT
8	EGGS
12	OZ. SUGAR
3	OZ. LIGHT BROWN SUGAR
12	OZ. PUMPKIN PUREE
1	CUP CANOLA OIL
2	TEASPOONS PURE VANILLA EXTRACT
4	OZ. BUTTERMILK
12	OZ. UNSALTED BUTTER, MELTED

FOR THE FROSTING

	BUTTERFLUFF FILLING (SEE PAGE 667)
1	TABLESPOON MAPLE EXTRACT
2	TABLESPOONS CINNAMON, PLUS MORE FOR DUSTING
	ITALIAN BUTTERCREAM (SEE PAGE 715)

CHOCOLATE CAKE ROLL

YIELD: 10 TO 12 SERVINGS / **ACTIVE TIME:** 45 MINUTES / **TOTAL TIME:** 3 HOURS

Rolling up a light chocolate sponge cake with a sweet, airy filling and drizzling ganache over the top ushers this childhood favorite into maturity.

1. Preheat the oven to 350°F. Line an 18 x 13–inch baking sheet with parchment paper and coat it with nonstick cooking spray.

2. Sift the flour, cocoa powder, 7 oz. of the sugar, salt, and baking powder into a small bowl. Set aside.

3. In a medium bowl, whisk the canola oil, eggs, and water until combined. Add the dry mixture and whisk until combined.

4. In the work bowl of a stand mixer fitted with the whisk attachment, whip the egg whites and cream of tartar on high until soft peaks begin to form. Reduce the speed to low and add the remaining sugar a few tablespoons at a time. When all of the sugar has been incorporated, raise the speed back to high and whip until the mixture holds stiff peaks.

5. Remove the work bowl from the mixer. Gently fold half of the meringue into the cake batter. Add the remaining meringue and fold until no white streaks remain. Spread the cake batter over the baking sheet, place it in the oven, and bake until the center of the cake springs back when poked with a finger and a cake tester comes out clean after being inserted, 10 to 12 minutes. Remove the cake from the oven and immediately dust the top with cocoa powder. Turn the cake onto a fresh piece of parchment paper. Peel the parchment away from the bottom side of the cake. Place a fresh piece of parchment on the bottom of the cake and turn it over so that the cocoa-dusted side of the cake is facing up.

6. Using a rolling pin, gently roll the cake up into a tight roll, starting with a narrow end. Let the cake cool to room temperature while coiled around the rolling pin.

7. Gently unroll the cake and spread the filling evenly over the top, leaving an approximately ½-inch border around the edges. Carefully roll the cake back up with your hands (do not use the rolling pin). Place the cake roll on a cooling rack that has parchment paper beneath it.

8. Pour the ganache over the cake roll. Refrigerate for at least 1 hour to let the chocolate set before slicing and serving.

INGREDIENTS:

7.5	OZ. ALL-PURPOSE FLOUR
1.8	OZ. COCOA POWDER, PLUS MORE AS NEEDED
12	OZ. SUGAR
1½	TEASPOONS KOSHER SALT
¾	TEASPOON BAKING POWDER
5	OZ. CANOLA OIL
5	EGGS
5	OZ. WATER
7	EGG WHITES
½	TEASPOON CREAM OF TARTAR
	BUTTERFLUFF FILLING (SEE PAGE 667)
	CHOCOLATE GANACHE (SEE PAGE 664), WARM

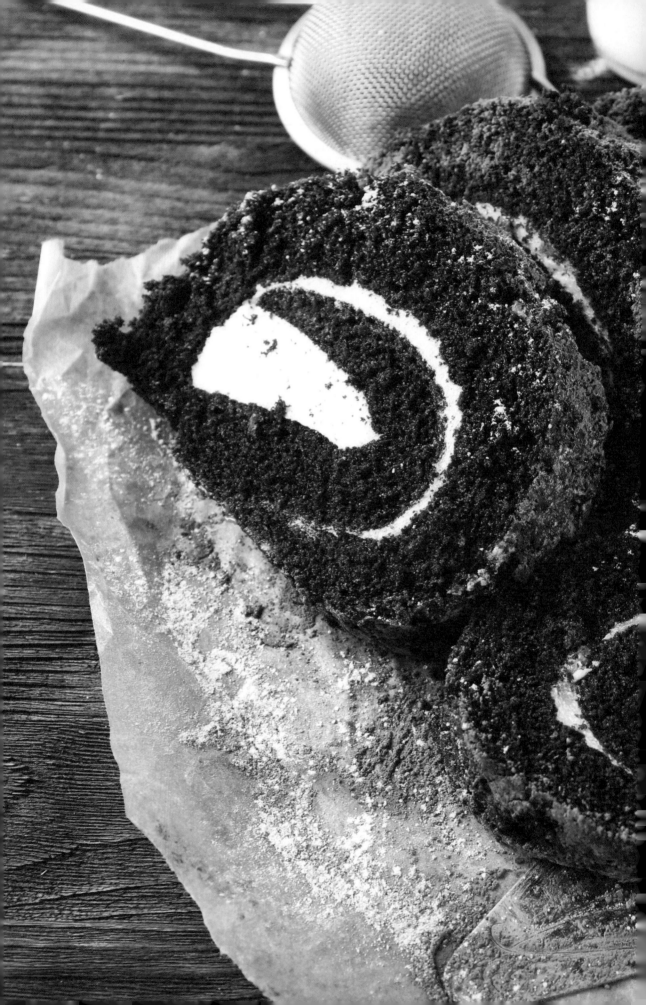

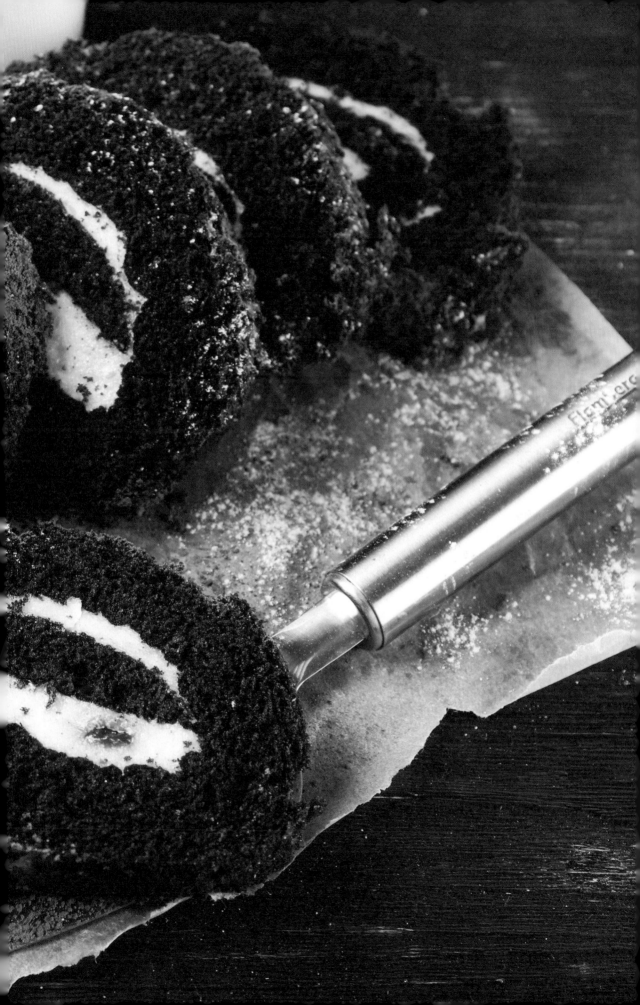

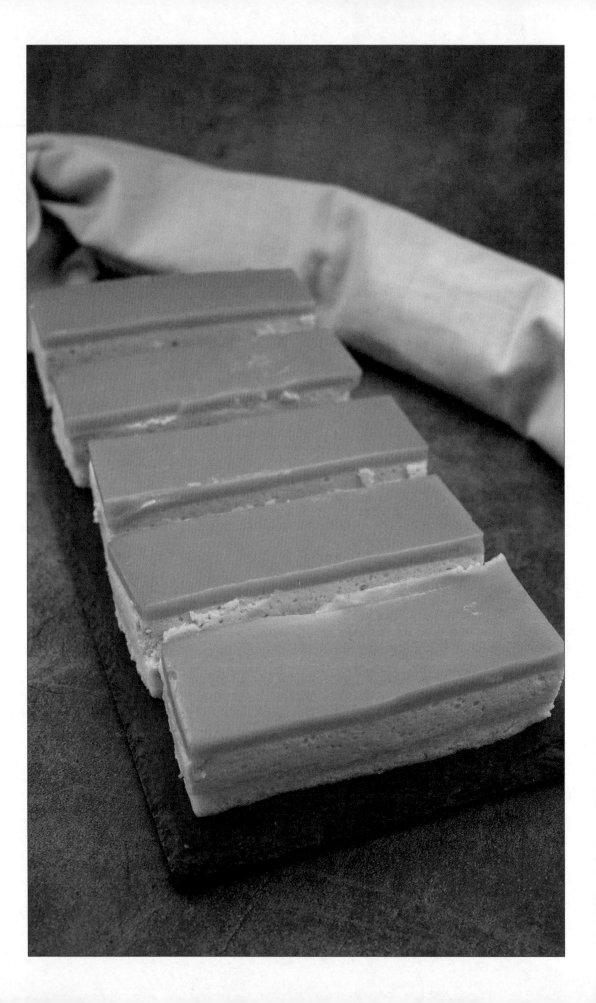

MANGO SHORTCAKE

YIELD: 1 CAKE / **ACTIVE TIME:** 1 HOUR AND 30 MINUTES / **TOTAL TIME:** 8 HOURS

Don't hesitate to serve the mango mousse on its own, or as the filling for a pie.

1. Preheat the oven to 325°F. Coat a 13 x 9–inch baking pan with nonstick cooking spray.

2. To begin preparations for the cake, sift the flour and ¼ cup of the sugar into a mixing bowl. Set aside.

3. In the work bowl of a stand mixer fitted with the whisk attachment, whip the egg whites and salt on high until soft peaks begin to form. Reduce the speed to low and add the remaining sugar a few tablespoons at a time. When all of the sugar has been incorporated, add the vanilla, raise the speed back to high, and whip until the mixture holds stiff peaks.

4. Remove the work bowl from the mixer and gently fold in the dry mixture. Pour the batter into the prepared pan, place it in the oven, and bake until the cake is lightly golden brown and a cake tester comes out clean after being inserted, 20 to 25 minutes. Remove the cake from the oven, transfer it to a cooling rack, and let it cool completely.

5. To prepare the mango mousse, place the gelatin sheets in a small bowl, and add 1 cup of ice and enough cold water to cover the sheets. In a small saucepan, bring the mango puree, confectioners' sugar, and lime zest to a simmer over medium heat. Immediately remove the pan from heat. Remove the gelatin from the ice bath and squeeze out as much water as possible. Whisk the gelatin into the mango mixture until fully dissolved. Let the mixture cool to room temperature.

6. Place the heavy cream in the work bowl of a stand mixer fitted with the paddle attachment and whip on high until soft peaks form. Fold the whipped cream into the mousse base.

7. Pour the mousse over the cake and use a rubber spatula to spread it evenly. Refrigerate for 4 hours.

8. To prepare the mango gelee, place the gelatin sheets in a small bowl, and add 1 cup of ice and enough cold water to cover the sheets. Place the water, mango puree, and sugar in a small saucepan and bring to a simmer over medium heat.

9. Remove the pan from heat. Remove the gelatin from the ice bath and squeeze out as much water as possible. Whisk the gelatin into the mango mixture until fully dissolved. Let the gelee cool to room temperature.

10. Pour the gelee over the mousse layer and refrigerate the cake for 2 hours.

11. To serve, cut the shortcake into bars.

INGREDIENTS:

FOR THE CAKE
½	CUP CAKE FLOUR
¾	CUP SUGAR
6	EGG WHITES, ROOM TEMPERATURE
⅛	TEASPOON KOSHER SALT
½	TEASPOON PURE VANILLA EXTRACT

FOR THE MANGO MOUSSE
4	SHEETS OF SILVER GELATIN
1¼	CUPS MANGO PUREE
2.6	OZ. CONFECTIONERS' SUGAR
	ZEST OF 1 LIME
1¼	CUPS HEAVY CREAM

FOR THE MANGO GELEE
4	SHEETS OF SILVER GELATIN
½	CUP WATER
1¼	CUPS MANGO PUREE
2	TABLESPOONS SUGAR

OPERA TORTE

YIELD: 1 CAKE / **ACTIVE TIME:** 3 HOURS / **TOTAL TIME:** 3 HOURS AND 45 MINUTES

A classic French dessert that beautifully marries chocolate, coffee, and almond. This cake is a bit of a process to put together, but a wonderful project for some winter weekend.

1. Preheat the oven to 400°F. Coat two 13 x 9–inch baking pans with nonstick cooking spray.

2. To begin preparations for the joconde, sift the almond flour, confectioners' sugar, and flour into a large bowl. Add the eggs and whisk until combined. Set aside.

3. In the work bowl of a stand mixer fitted with the whisk attachment, whip the egg whites and salt on high until soft peaks begin to form. Reduce the speed to low and gradually incorporate the sugar. Raise the speed back to high and continue to whip until stiff peaks form. Add the meringue to the dry mixture and fold until thoroughly incorporated. Divide the batter between the two prepared pans, place them in the oven, and bake until they are set and lightly browned, 8 to 10 minutes. Remove from the oven, transfer them to a cooling rack, and let them cool completely.

4. To prepare the coffee syrup, place the water, sugar, and espresso in a small saucepan and bring to a simmer over medium heat while stirring frequently to dissolve the sugar and espresso. Remove from heat and let the syrup cool completely.

5. To prepare the hazelnut and praline crunch, bring a small saucepan filled halfway with water to a gentle simmer. Place the dark chocolate in a small heatproof bowl, place it over the simmering water, and stir until the chocolate is melted. Remove the bowl from heat, stir in the praline paste and the feuilletine flakes, and spread the mixture over the two joconde. Place the cakes in the refrigerator.

6. To begin preparations for the mocha cream, place the sugar and water in a small saucepan over high heat. Cook until the mixture reaches 245°F on a candy thermometer.

7. While the sugar and water are heating up, place the egg yolks and espresso powder in the work bowl of a stand mixer fitted with the whisk attachment and whip the mixture on high.

INGREDIENTS:

FOR THE JOCONDE
5 OZ. FINE ALMOND FLOUR
5 OZ. CONFECTIONERS' SUGAR
1 OZ. ALL-PURPOSE FLOUR
5 EGGS
5 EGG WHITES
¼ TEASPOON KOSHER SALT
2 TABLESPOONS SUGAR

FOR THE COFFEE SYRUP
½ CUP WATER
½ CUP SUGAR
1 TABLESPOON GROUND ESPRESSO

FOR THE HAZELNUT & PRALINE CRUNCH
4 OZ. DARK CHOCOLATE (55 TO 65 PERCENT)
4 OZ. PRALINE PASTE
3 OZ. FEUILLETINE FLAKES

FOR THE MOCHA CREAM
1 CUP SUGAR
¼ CUP WATER
6 EGG YOLKS
3 TABLESPOONS ESPRESSO POWDER
8 OZ. UNSALTED BUTTER, SOFTENED

FOR THE TOPPING
CHOCOLATE GANACHE (SEE PAGE 664), AT ROOM TEMPERATURE

8. When the syrup reaches the correct temperature, gradually add it to egg yolk mixture. Continue to whip on high until the mixture cools slightly. Reduce the speed to low and gradually add the softened butter. When all of the butter has been incorporated, raise the speed back to high and whip the mixture until smooth and fluffy. Set aside.

9. Remove both cakes from the refrigerator and carefully remove them from the pans. Place one cake on a serving tray with the coated layer facing down. Brush the cake with some of the coffee syrup and spread half of the mocha cream over the top. Lay the second cake on top so that the mocha and hazelnut layers are touching. Brush the top of this cake with the remaining coffee syrup and then spread the remaining mocha cream over the cake.

10. Place the cake in the refrigerator for 30 minutes. Spread the Chocolate Ganache over the cake and let it sit for 10 minutes. To serve, use a hot knife to cut the cake into rectangles.

NOTE: Feuilletine flakes are a crispy confection made from thin, sweetened crepes. They can be found at many baking shops, and are also available online.

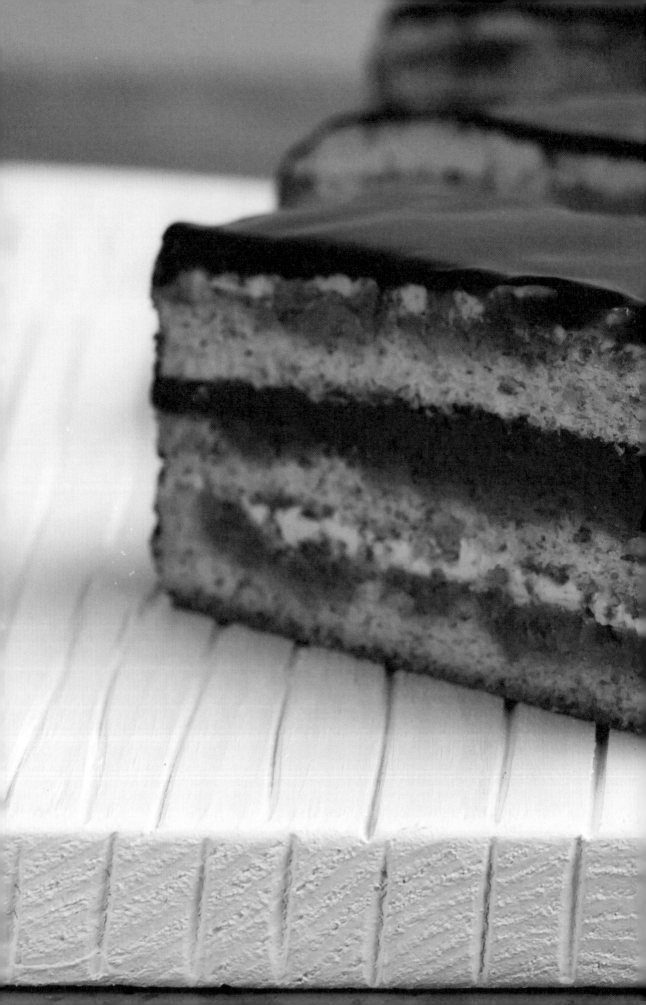

HOSTESS CUPCAKES

YIELD: 24 CUPCAKES / **ACTIVE TIME:** 40 MINUTES / **TOTAL TIME:** 2 HOURS

An American classic that almost every child continually pined for.

1. Preheat the oven to 350°F. Line a 24-well cupcake pan with liners.

2. In a medium bowl, whisk together the sugar, flour, cocoa powder, baking soda, baking powder, and salt. Sift the mixture into a separate bowl and set aside.

3. In the work bowl of a stand mixer fitted with the whisk attachment, combine the sour cream, canola oil, and eggs on medium.

4. Reduce the speed to low, add the dry mixture, and beat until incorporated, scraping down the sides of the work bowl with a rubber spatula as needed. Gradually add the hot coffee and beat until thoroughly incorporated. Pour about ¼ cup of batter into each cupcake liner.

5. Place the cupcakes in the oven and bake until they are browned and a cake tester comes out clean after being inserted, 18 to 22 minutes. Remove from the oven and place the cupcakes on a cooling rack until completely cool.

6. Using an apple corer or a sharp paring knife, carefully remove the center of each cupcake. Place 2 cups of the Butterfluff Filling in a piping bag and fill the centers of the cupcakes with it.

7. While the ganache is warm, dip the tops of the cupcakes in the ganache and place them on a baking sheet. Refrigerate the cupcakes for 20 minutes so that the chocolate will set.

8. Place 1 cup of the butterfluff in a piping bag fit with a thin, plain tip and pipe decorative curls on top of each cupcake. Allow the curls to set for 10 minutes before serving.

INGREDIENTS:

20	OZ. SUGAR
13	OZ. ALL-PURPOSE FLOUR
4	OZ. COCOA POWDER
1	TABLESPOON BAKING SODA
1½	TEASPOONS BAKING POWDER
1½	TEASPOONS KOSHER SALT
1½	CUPS SOUR CREAM
¾	CUP CANOLA OIL
3	EGGS
1½	CUPS BREWED COFFEE, HOT
	BUTTERFLUFF FILLING (SEE PAGE 667)
	CHOCOLATE GANACHE (SEE PAGE 664), WARM

BLUEBERRY & LEMON CHEESECAKE

YIELD: 1 CHEESECAKE / **ACTIVE TIME:** 1 HOUR / **TOTAL TIME:** 8 HOURS

Swirling the blueberry and lemon mixtures as recommended produces a stunning cake, but will have no impact on the final flavor if your style is more staid.

1. Preheat the oven to 350°F. Bring 8 cups of water to a boil in a medium saucepan.

2. In a small saucepan, cook the blueberries, water, and sugar over medium heat until the blueberries burst and start to become fragrant, about 5 minutes. Remove the pan from heat.

3. In the work bowl of a stand mixer fitted with the paddle attachment, cream the cream cheese, sugar, and salt on high until the mixture is soft and airy, about 10 minutes. Scrape down the sides of the work bowl with a rubber spatula as needed.

4. Reduce the speed of the mixer to medium and incorporate the eggs one at a time, scraping down the work bowl as needed. Add the vanilla and mix until incorporated.

5. Divide the mixture between two mixing bowls. Add the blueberry mixture to one bowl and whisk to combine. Whisk the lemon juice into the mixture in the other bowl.

6. Starting with the lemon mixture, add 1 cup to the Graham Cracker Crust. Add 1 cup of the blueberry mixture, and then alternate between the mixtures until all of them have been used.

7. If desired, use a paring knife to gently swirl the blueberry and lemon mixtures together, making sure not to overmix.

8. Place the cheesecake in a large baking pan with high sides. Gently pour the boiling water into the pan until it reaches halfway up the sides of the cheesecake pan. Cover the baking pan with aluminum foil and place it in the oven. Bake until the cheesecake is set and only slightly jiggly in the center, 50 minutes to 1 hour.

9. Turn off the oven and leave the oven door cracked. Allow the cheesecake to rest in the cooling oven for 45 minutes.

10. Remove the cheesecake from the oven and transfer the springform pan to a cooling rack. Let it sit at room temperature for 1 hour.

11. Transfer the cheesecake to the refrigerator and let it cool for at least 4 hours before slicing and serving.

INGREDIENTS:

2	PINTS OF BLUEBERRIES
1	TABLESPOON WATER
2	TABLESPOONS SUGAR
2	LBS. CREAM CHEESE, SOFTENED
⅔	CUP SUGAR
¼	TEASPOON KOSHER SALT
4	EGGS
1	TEASPOON PURE VANILLA EXTRACT
2	TABLESPOONS FRESH LEMON JUICE
1	GRAHAM CRACKER CRUST (SEE PAGE 222), IN A SPRINGFORM PAN

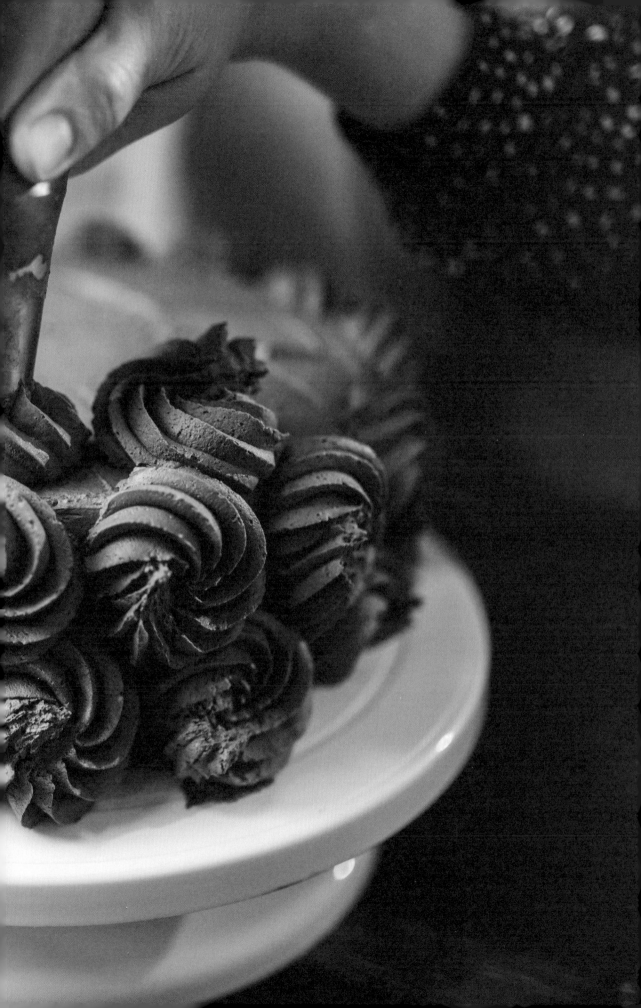

CHERRY AMARETTO SOUFFLES

YIELD: 6 SOUFFLES / **ACTIVE TIME:** 30 MINUTES / **TOTAL TIME:** 2 HOURS

The richness and acidity provided by the cherries are balanced by the sweetness and nuttiness of the amaretto.

1. Preheat the oven to 375°F. Coat six 8 oz. ramekins with nonstick cooking spray. Place 2 tablespoons of sugar in each ramekin and spread it to evenly coat the insides of the dishes. Knock out any excess sugar and set the ramekins aside.

2. In a small bowl, whisk together the cornstarch and cold water. Set aside.

3. Bring the cherry puree and milk to a boil over medium heat in a medium saucepan. Gradually pour in the cornstarch slurry while continually whisking. Continue to whisk until the mixture has thickened and has boiled for 30 seconds. Immediately remove the pan from heat and whisk in the amaretto.

4. Transfer the cherry mixture to a medium bowl. Cover it with plastic wrap, placing the wrap directly on the mixture so that no air can get to it. This will prevent a skin from forming. Place the bowl in the refrigerator until it reaches room temperature, about 1 hour.

5. In the work bowl of a stand mixer fitted with a whisk attachment, whip the egg whites and cream of tartar on high until the mixture holds stiff peaks. Reduce the speed to medium and gradually incorporate the sugar. Once all of the sugar has been added, raise the speed back to high and whip until it is a glossy, stiff meringue.

6. Working in three increments, add the meringue to the cherry base, folding gently with a rubber spatula.

7. Spoon the souffle base to the rims of the ramekins. Gently tap the bottoms of the ramekins with the palm of your hand to remove any air bubbles, but not so hard as to deflate the meringue.

8. Place in the oven and bake until the souffles have risen significantly and set on the outside, but are still jiggly at the center, 25 to 27 minutes. Remove from the oven and serve immediately.

INGREDIENTS:

8	OZ. SUGAR, PLUS MORE FOR COATING RAMEKINS
5	TABLESPOONS CORNSTARCH
½	CUP COLD WATER
10	OZ. MORELLO CHERRIES, PUREED
10	OZ. MILK
2	OZ. AMARETTO LIQUEUR
8	EGG WHITES
½	TEASPOON CREAM OF TARTAR

BUTTERSCOTCH SOUFFLES

YIELD: 4 SOUFFLES / **ACTIVE TIME:** 30 MINUTES / **TOTAL TIME:** 2 HOURS

Butterscotch is created by boiling butter and brown sugar together, a process that manages to approximate the flavor of a rich caramel astonishingly well.

1. Preheat the oven to 375°F. Coat four 8 oz. ramekins with nonstick cooking spray. Place 2 tablespoons of sugar in each ramekin and spread it to evenly coat the insides of the dishes. Knock out any excess sugar and set the ramekins aside.

2. In a medium bowl, whisk together the cornstarch and egg. Set aside.

3. Bring the milk, dark brown sugar, and butter to a boil over medium heat in a medium saucepan.

4. Gradually add the heated milk mixture into the egg-and-cornstarch mixture while whisking constantly. When fully incorporated, transfer the tempered mixture back into the saucepan.

5. Cook the mixture over medium heat, whisking until the mixture has thickened. Immediately remove the saucepan from heat and whisk in the vanilla.

6. Take plastic wrap and place it directly on the mixture so that no air can get to it. This will prevent a skin from forming. Place the bowl in the refrigerator until it reaches room temperature, about 1 hour.

7. In the work bowl of a stand mixer fitted with the whisk attachment, whip the egg whites and cream of tartar on high until the mixture holds stiff peaks. Reduce the speed to medium and gradually incorporate the sugar. Once all of the sugar has been incorporated, raise the speed back to high and whip until it is a glossy, stiff meringue.

8. Working in three increments, add the meringue to the souffle base, folding gently with a rubber spatula.

9. Spoon the souffle base to the rims of the ramekins. Gently tap the bottoms of the ramekins with the palm of your hand to remove any air bubbles, but not so hard as to deflate the meringue.

10. Place in the oven and bake until the souffles have risen significantly and set on the outside, but are still jiggly at the center, 22 to 25 minutes. Remove from the oven and serve immediately.

INGREDIENTS:

3	OZ. SUGAR, PLUS MORE FOR COATING RAMEKINS
2	TABLESPOONS CORNSTARCH
1	EGG
10.5	OZ. MILK
3	OZ. DARK BROWN SUGAR
1	OZ. UNSALTED BUTTER
½	TEASPOON PURE VANILLA EXTRACT
4	EGG WHITES
¼	TEASPOON CREAM OF TARTAR

DARK CHOCOLATE ENTREMET

YIELD: 1 CAKE / **ACTIVE TIME:** 3 HOURS / **TOTAL TIME:** 15 HOURS

An entremet is a layered cake that features as many different textures and flavors as any dessert in the world.

1. Preheat the oven to 350°F. Coat a round 6-inch cake pan with nonstick cooking spray.

2. To begin preparations for the cake, sift the flour, cocoa powder, almond flour, and confectioners' sugar into a medium bowl. Set the mixture aside.

3. In the work bowl of a stand mixer fitted with the whisk attachment, whip the egg whites and salt on high until soft peaks begin to form. Reduce the speed to low and gradually incorporate the sugar. Raise the speed to high and whip the mixture until it holds stiff peaks.

4. Fold the meringue into the dry mixture until fully incorporated and then pour the batter into the prepared cake pan.

5. Place the cake in the oven and bake until set and a cake tester comes out clean after being inserted, 10 to 12 minutes. Remove the cake from the oven and set it on a wire rack to cool completely. Once cool, remove the cake from the pan and set aside.

6. To begin preparations for the gelee, place the gelatin sheets in a small bowl, and add 1 cup of ice and enough cold water to cover the sheets. Place the water, passion fruit puree, and sugar in a small saucepan and bring to a simmer over medium heat.

7. Prepare a 6-inch ring mold by wrapping plastic wrap tightly over the bottom. Set the ring mold on a small baking sheet.

8. Remove the pan from heat. Remove the gelatin from the ice bath and squeeze out as much water as possible. Whisk the gelatin into the passion fruit mixture until fully dissolved. Let the gelee cool to room temperature and then pour it into the ring mold. Place the cake ring in the freezer for at least 4 hours to fully freeze.

9. To begin preparations for the mousse, place the gelatin sheets in a small bowl, and add 1 cup of ice and enough cold water to cover the sheets.

10. Prepare an 8-inch ring mold by wrapping plastic wrap tightly over the bottom. Set the ring mold on a small baking sheet.

Continued . . .

INGREDIENTS:

FOR THE CAKE
1	OZ. ALL-PURPOSE FLOUR
1	TABLESPOON COCOA POWDER
2	OZ. ALMOND FLOUR
2.4	OZ. CONFECTIONERS' SUGAR
3	EGG WHITES
¼	TEASPOON KOSHER SALT
2	TABLESPOONS SUGAR

FOR THE GELEE
2	SHEETS OF SILVER GELATIN
¼	CUP WATER
7	OZ. PASSION FRUIT PUREE
3	TABLESPOONS SUGAR

FOR THE MOUSSE
2	SHEETS OF SILVER GELATIN
1	LB. DARK CHOCOLATE (55 TO 65 PERCENT)
14	OZ. HEAVY CREAM, PLUS ½ CUP
½	CUP MILK
2	EGG YOLKS
2	TABLESPOONS SUGAR

FOR THE GLAZE
5	SHEETS OF SILVER GELATIN
9	OZ. SUGAR
5	OZ. WATER
3	OZ. COCOA POWDER
3	OZ. SOUR CREAM
2	OZ. DARK CHOCOLATE

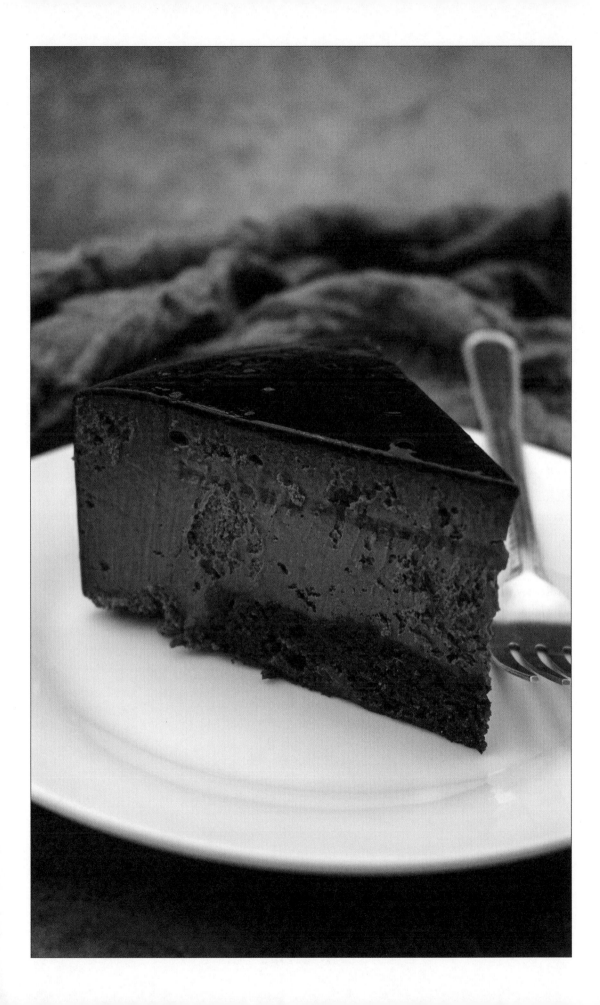

11. Fill a small saucepan halfway with water and bring it to a gentle simmer. Place the dark chocolate in a heatproof bowl, place the bowl over the simmering water, and stir with a rubber spatula until the chocolate has melted. Remove the chocolate from heat and set aside.

12. In the work bowl of a stand mixer fitted with the whisk attachment, whip 14 oz. of the heavy cream on high until soft peaks form. Place the whipped cream in the refrigerator.

13. In a small saucepan, combine the milk and remaining heavy cream and bring to a boil over medium heat.

14. Place the egg yolks and sugar in a small bowl and whisk to combine. Gradually add the heated milk mixture into the egg-and-sugar mixture while whisking constantly. When fully incorporated, transfer the tempered mixture back into the saucepan.

15. Cook the mixture over medium heat, whisking until the mixture has thickened slightly and reads 175°F on an instant-read thermometer. Remove the pan from heat, remove the gelatin from the ice bath, and squeeze out as much water as possible. Whisk the gelatin into the warm mousse until fully dissolved.

16. Pour the mixture over the melted chocolate and stir to combine.

17. Remove the whipped cream from the refrigerator and, working in two increments, fold it into the mixture.

18. Pour 2 cups of the mousse into the 8-inch ring mold. Spread it into an even layer with an offset spatula.

19. Remove the passion fruit gelee from the freezer, carefully remove the plastic wrap, and remove the gelee from the cake ring. Place the gelee in the center of the mousse and press down.

20. Add more of the mousse until it reaches about ½ inch from the top of the ring mold.

21. Place the chocolate cake in the mousse, top side down, and push down gently until the cake and mousse are level with each other.

22. Transfer the entremet to the freezer and chill for at least 4 hours.

23. To begin preparations for the glaze, place the gelatin sheets in a small bowl, and add 1 cup of ice and enough cold water to cover the sheets.

24. In a medium saucepan, combine the sugar, water, cocoa powder, and sour cream and warm over low heat, stirring continuously until the mixture begins to steam. Take care to not let the mixture come to a boil, as it can burn easily.

25. Remove the pan from heat, remove the gelatin from the ice bath, and squeeze out as much water as possible. Whisk the gelatin into the warm mixture until fully dissolved.

26. Add the dark chocolate and stir until the mixture is smooth. Let the glaze cool to 95°F.

27. Remove the entremet from the freezer and peel off the plastic wrap from the bottom. Using a kitchen torch, lightly heat the sides of the ring mold to loosen the entremet.

28. Place a wire rack on a piece of parchment paper. Flip the entremet over so that the cake is bottom side up.

29. Pour the glaze carefully and evenly over the top in a circular motion, starting from the center and working out toward the edge. Allow the glaze to fall over the side and cover the entirety of the cake. Use an offset spatula to spread the glaze as needed. If there are any air bubbles, carefully go over them with a kitchen torch, as a smooth, shiny finish is a key piece of a successful entremet.

30. Using a spatula, transfer the glazed cake to a serving tray and refrigerate for 4 hours to allow the glaze to set and the center of the cake to thaw. When ready to serve, use a hot knife to cut the cake.

CLASSIC CHEESECAKE

YIELD: 1 CHEESECAKE / **ACTIVE TIME:** 30 MINUTES / **TOTAL TIME:** 8 HOURS

Many who would not tolerate another form of this rich, cheesy treat would be nonplussed if asked to identify what produces the famed dense and satiny texture. That beloved attribute is the result of little more than time, patience, and plenty of perfectly touched-up cream cheese.

1. Preheat the oven to 350°F. Bring 8 cups of water to a boil in a small saucepan.

2. In the work bowl of a stand mixer fitted with the paddle attachment, cream the cream cheese, sugar, and salt on high until the mixture is fluffy, about 10 minutes. Scrape down the sides of the work bowl as needed.

3. Reduce the speed of the mixer to medium and incorporate one egg at a time, scraping down the work bowl as needed. Add the vanilla and beat until incorporated.

4. Pour the mixture into the Graham Cracker Crust, place the cheesecake in a large baking pan with high sides, and gently pour the boiling water into the baking pan until it reaches halfway up the sides of the springform pan.

5. Cover the baking pan with aluminum foil, place it in the oven, and bake until the cheesecake is set and only slightly jiggly in the center, 50 minutes to 1 hour.

6. Turn off the oven and leave the oven door cracked. Allow the cheesecake to rest in the cooling oven for 45 minutes.

7. Remove the cheesecake from the oven and transfer it to a cooling rack. Let it sit at room temperature for 1 hour.

8. Transfer the cheesecake to the refrigerator and let it cool for at least 4 hours before serving and slicing. To serve, top each slice with a heaping spoonful of the compote.

INGREDIENTS:

2 LBS. CREAM CHEESE, SOFTENED

⅔ CUP SUGAR

¼ TEASPOON KOSHER SALT

4 EGGS

1 TABLESPOON PURE VANILLA EXTRACT

1 GRAHAM CRACKER CRUST (SEE PAGE 222), IN A SPRINGFORM PAN

 SUMMER BERRY COMPOTE (SEE PAGE 676), FOR SERVING

RASPBERRY CHIFFON CAKE

YIELD: 1 CAKE / **ACTIVE TIME:** 30 MINUTES / **TOTAL TIME:** 2 HOURS AND 30 MINUTES

A light and rich cake that is a cross between a moist, buttery treat and an airy, fluffy sponge cake.

1. Preheat the oven to 325°F. Place a 10-inch tube pan with a removable bottom near your workspace. Do not grease the pan.

2. Sift the cake flour, 6 oz. of the sugar, salt, and baking powder into a small bowl. Set aside.

3. In a medium bowl, whisk together the canola oil, eggs, pureed raspberries, and vanilla. Add the dry mixture and whisk until thoroughly incorporated.

4. In the work bowl of a stand mixer fitted with the whisk attachment, whip the egg whites and cream of tartar on high until soft peaks begin to form. Decrease the speed to low and add the remaining sugar a few tablespoons at a time. When all of the sugar has been incorporated, raise the speed back to high and whip until the mixture holds stiff peaks.

5. Remove the work bowl from the mixer and gently fold half of the meringue into the cake batter base. Add the remaining meringue and fold the mixture until no white streaks remain. Pour the batter into the tube pan, place it in the oven, and bake until the cake is lightly golden brown and a cake tester comes out clean after being inserted, about 1 hour.

6. Remove the cake from the oven and let it cool completely.

7. Run a long metal spatula around the inside of the tube pan and center. Turn the cake out onto a serving platter, dust the top with confectioners' sugar, and serve with the Chantilly Cream and fresh raspberries.

INGREDIENTS:

6	OZ. CAKE FLOUR
10	OZ. SUGAR
½	TEASPOON KOSHER SALT
1½	TEASPOONS BAKING POWDER
¼	CUP CANOLA OIL
2	EGGS
¾	CUP PUREED RASPBERRIES
1½	TEASPOONS PURE VANILLA EXTRACT
6	EGG WHITES
¼	TEASPOON CREAM OF TARTAR
	CONFECTIONERS' SUGAR, FOR DUSTING
	CHANTILLY CREAM (SEE PAGE 668), FOR SERVING
	FRESH RASPBERRIES, FOR SERVING

MOLTEN LAVA CAKES

YIELD: 6 SMALL CAKES / **ACTIVE TIME:** 20 MINUTES / **TOTAL TIME:** 40 MINUTES

Yes, originally this was probably the result of a miscue in the kitchen. But it is also proof that mistakes can be a portal to genius.

1. Preheat the oven to 425°F. Spray six 6 oz. ramekins with nonstick cooking spray and coat each one with cocoa powder. Tap out any excess cocoa powder and set the ramekins aside.

2. Sift the flour and salt into a small bowl and set aside.

3. Fill a small saucepan halfway with water and bring it to a gentle simmer. Place the dark chocolate and butter in a heatproof mixing bowl and place it over the simmering water. Stir occasionally until the mixture is melted and completely smooth. Remove the bowl from heat and set aside.

4. In another mixing bowl, whisk together the eggs, egg yolks, and sugar. Add the chocolate mixture and whisk until combined. Add the dry mixture and whisk until a smooth batter forms.

5. Pour approximately ½ cup of batter into each of the ramekins. Place them in the oven and bake until the cakes look firm and are crested slightly at the top, 12 to 15 minutes. Remove from the oven and let them cool for 1 minute.

6. Invert each cake onto a plate (be careful, as the ramekins will be very hot). Dust the cakes with confectioners' sugar and serve.

INGREDIENTS:

1	CUP COCOA POWDER, PLUS MORE AS NEEDED
3	OZ. ALL-PURPOSE FLOUR
¼	TEASPOON KOSHER SALT
8	OZ. DARK CHOCOLATE (55 TO 65 PERCENT)
4	OZ. UNSALTED BUTTER
3	EGGS
3	EGG YOLKS
4	OZ. SUGAR
	CONFECTIONERS' SUGAR, FOR DUSTING

COCONUT TRES LECHES

YIELD: 1 CAKE / **ACTIVE TIME:** 1 HOUR / **TOTAL TIME:** 4 HOURS

A particularly tropical and toothsome variation on the beloved classic.

1. Preheat the oven to 325°F. Coat a baking pan with nonstick cooking spray. To begin preparations for the sponge cake, place the egg whites and sugar in the work bowl of a stand mixer fitted with the whisk attachment and whip to full volume.

2. Combine the flour, sea salt, and baking powder in a separate bowl.

3. Incorporate the egg yolks into the meringue one at a time. Add one-third of the meringue into the dry mixture along with the water and vanilla and beat until incorporated. Add another one-third of the meringue and fold to combine. Add the remaining one-third and carefully fold until incorporated.

4. Transfer the batter into the baking pan and gently spread until it is even. Place in the oven and bake until a knife inserted into the center comes out clean, about 40 minutes.

5. While the cake is in the oven, prepare the soaking liquid. Place all of the ingredients in a saucepan and warm it over medium heat, stirring to combine. When the mixture starts to steam and all of the sugar has dissolved, remove the pan from heat.

6. Pour the soaking liquid over the cake and chill it in the refrigerator for 2 hours.

7. To serve, top slices with the berries and enjoy.

INGREDIENTS:

FOR THE SPONGE CAKE

16	EGGS, SEPARATED
28.2	OZ. SUGAR
28.9	OZ. ALL-PURPOSE FLOUR, SIFTED
⅔	TEASPOON FINE SEA SALT
¼	CUP BAKING POWDER
4.6	OZ. WATER
5	TEASPOONS MEXICAN VANILLA EXTRACT
	FRESH BERRIES, FOR SERVING

FOR THE SOAKING LIQUID

2	(14 OZ.) CANS SWEETENED CONDENSED MILK
2	(12 OZ.) CANS EVAPORATED MILK
½	CUP HEAVY CREAM
1¾	CUPS COCONUT MILK
½	CUP SUGAR

DAN'S ORANGE MERINGUE CHEESECAKE

YIELD: 1 CHEESECAKE / ACTIVE TIME: 30 MINUTES / TOTAL TIME: 2 HOURS

An incredibly airy no-bake cheesecake that gets its mousse-like texture from the addition of whipped cream.

1. In the work bowl of a stand mixer fitted with the whisk attachment, whip the heavy cream until it forms soft peaks. Transfer the whipped cream to a bowl and store it in the refrigerator.

2. Wipe out the work bowl of the stand mixer and fit it with the paddle attachment. Place the cream cheese, sugar, and orange zest in the work bowl and beat on high until the mixture is fluffy, about 10 minutes. Scrape down the sides of the work bowl as needed.

3. Add the confectioners' sugar, sour cream, orange juice, lemon juice, and vanilla and beat until incorporated.

4. Remove the bowl from the stand mixer. Add the whipped cream and fold gently until thoroughly incorporated.

5. Pour the mixture into the Graham Cracker Crust and place the cheesecake in the refrigerator to chill for 1 hour.

6. Remove the cheesecake from the refrigerator and spread 1 cup of the Swiss Meringue over the top. Use a kitchen torch to lightly torch the meringue.

7. Place the cheesecake in the refrigerator and chill for 30 minutes before slicing and serving.

INGREDIENTS:

3 OZ. HEAVY CREAM

12 OZ. CREAM CHEESE, SOFTENED

2 OZ. SUGAR

ZEST AND JUICE OF 1 ORANGE

1½ TEASPOON CONFECTIONERS' SUGAR

2 TABLESPOONS SOUR CREAM

1 TEASPOON FRESH LEMON JUICE

1 TEASPOON PURE VANILLA EXTRACT

1 GRAHAM CRACKER CRUST (SEE PAGE 222), IN A SPRINGFORM PAN

SWISS MERINGUE (SEE PAGE 734)

COOKIES 'N' CREAM CHEESECAKE

YIELD: 1 CHEESECAKE / **ACTIVE TIME:** 30 MINUTES / **TOTAL TIME:** 8 HOURS

The cookie crust made here will serve you well in a number of other preparations, so don't hesitate to try it out with your favorites.

1. Preheat the oven to 350°F. To begin preparations for the crust, place the cookies in a food processor and pulse until finely ground. Transfer to a medium bowl and combine with the melted butter.

2. Transfer the mixture to a 9-inch pie plate and press it into the bottom and side in an even layer. Use the bottom of a dry measuring cup to help flatten the bottom of the crust. Use a paring knife to trim away any excess crust and create a flat and smooth edge.

3. Place the pie plate on a baking sheet and bake until it is firm, 8 to 10 minutes. Remove from the oven, transfer the crust to a cooling rack, and let it cool for at least 2 hours.

4. Preheat the oven to 350°F.

5. To begin preparations for the filling, place the cookies in a food processor and pulse until finely ground. Set aside.

6. Bring 8 cups of water to a boil in a small saucepan.

7. In the work bowl of a stand mixer fitted with the paddle attachment, cream the cream cheese, sugar, and salt on high until the mixture is fluffy, about 10 minutes. Scrape down the sides of the work bowl as needed.

8. Reduce the speed of the mixer to medium and incorporate one egg at a time, scraping down the work bowl as needed. Add the vanilla and beat until incorporated. Remove the work bowl from the mixer and fold in the cookie crumbs.

9. Pour the mixture into the crust, place the cheesecake in a large baking pan with high sides, and gently pour the boiling water into the baking pan until it reaches halfway up the sides of the pie plate.

10. Cover the baking pan with aluminum foil, place it in the oven, and bake until the cheesecake is set and only slightly jiggly in the center, 50 minutes to 1 hour.

11. Turn off the oven and leave the oven door cracked. Allow the cheesecake to rest in the cooling oven for 45 minutes.

12. Remove the cheesecake from the oven and transfer it to a cooling rack. Let it sit at room temperature for 1 hour.

13. Refrigerate the cheesecake for at least 4 hours before serving and slicing. To serve, top each slice with a heaping spoonful of Chantilly Cream.

INGREDIENTS:

FOR THE CRUST

24 OREO COOKIES (SEE PAGE 84 FOR HOMEMADE)

3 OZ. UNSALTED BUTTER, MELTED

FOR THE FILLING

15 OREO COOKIES

2 LBS. CREAM CHEESE, SOFTENED

⅔ CUP SUGAR

¼ TEASPOON KOSHER SALT

4 EGGS

1 TEASPOON PURE VANILLA EXTRACT

CHANTILLY CREAM (SEE PAGE 668), FOR SERVING

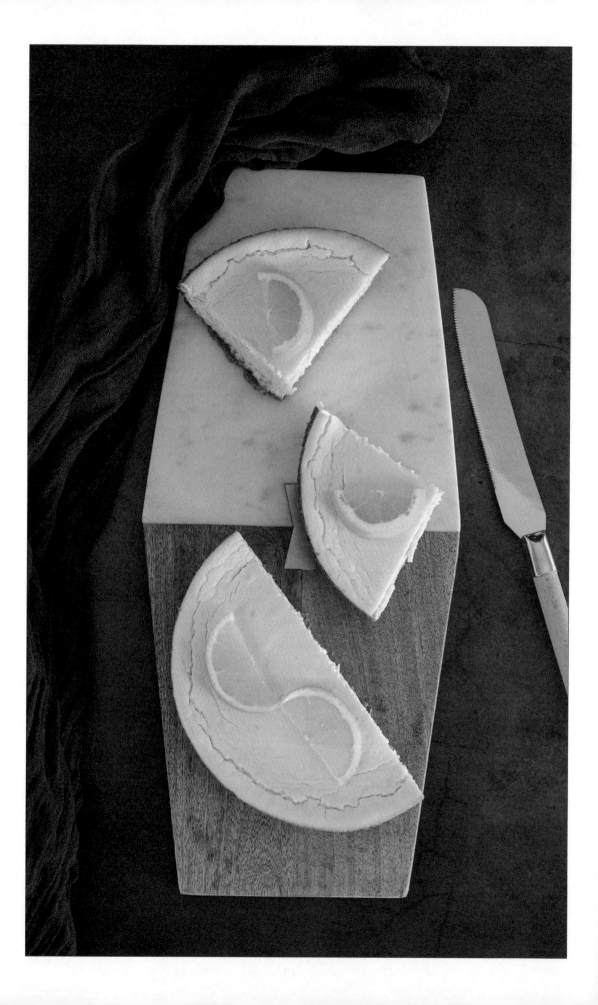

LEMON RICOTTA CHEESECAKE

YIELD: 1 CHEESECAKE / **ACTIVE TIME:** 1 HOUR / **TOTAL TIME:** 8 HOURS

Whole milk ricotta is a must for this (and, really, any dessert that calls for ricotta cheese). When shopping, keep an eye out for BelGioioso's offering, as it provides the best results.

1. Preheat the oven to 350°F. Bring 8 cups of water to a boil in a medium saucepan.

2. In the work bowl of a stand mixer fitted with the paddle attachment, cream the ricotta, cream cheese, sugar, and lemon zest on high until the mixture is soft and airy, about 10 minutes. Scrape down the work bowl with a rubber spatula as needed. Reduce the speed of the mixer to medium and incorporate the egg, scraping down the work bowl as needed. Add the lemon juice and vanilla and mix until incorporated. Add the cornstarch and flour and beat until incorporated. Reduce the speed to low, add the melted butter and sour cream, and beat until the mixture is very smooth.

3. Pour the mixture into the crust, place the cheesecake in a large baking pan with high sides, and gently pour the boiling water into the baking pan until it reaches halfway up the sides of the springform pan.

4. Cover the baking pan with aluminum foil, place it in the oven, and bake until the cheesecake is set and only slightly jiggly in the center, 50 minutes to 1 hour.

5. Turn off the oven and leave the oven door cracked. Allow the cheesecake to rest in the cooling oven for 45 minutes.

6. Remove the cheesecake from the oven and transfer it to a cooling rack. Let it sit at room temperature for 1 hour.

7. Transfer the cheesecake to the refrigerator and let it cool for at least 4 hours before serving and slicing. To serve, top each slice with a dollop of the Chantilly Cream.

INGREDIENTS:

- 8 OZ. WHOLE MILK RICOTTA CHEESE
- 8 OZ. CREAM CHEESE, SOFTENED
- 6 OZ. SUGAR
- ZEST AND JUICE OF 1 LEMON
- 1 EGG
- ¼ TEASPOON PURE VANILLA EXTRACT
- 1 TABLESPOON CORNSTARCH, PLUS 1½ TEASPOONS
- 1½ TABLESPOONS ALL-PURPOSE FLOUR
- 1 OZ. UNSALTED BUTTER, MELTED
- 1 CUP SOUR CREAM
- 1 GRAHAM CRACKER CRUST (SEE PAGE 222), IN A SPRINGFORM PAN
- CHANTILLY CREAM (SEE PAGE 668), FOR TOPPING

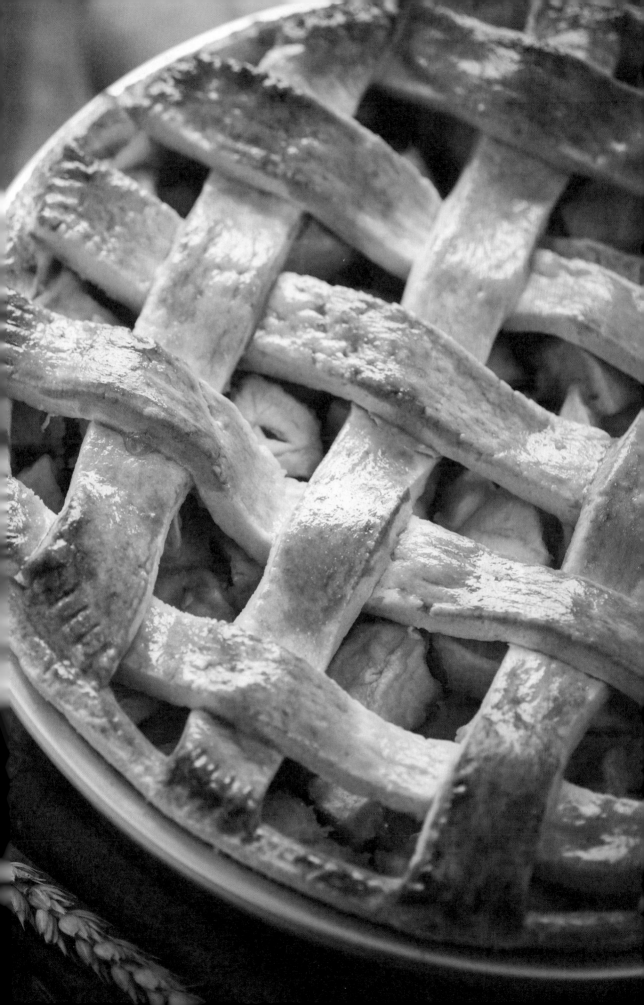

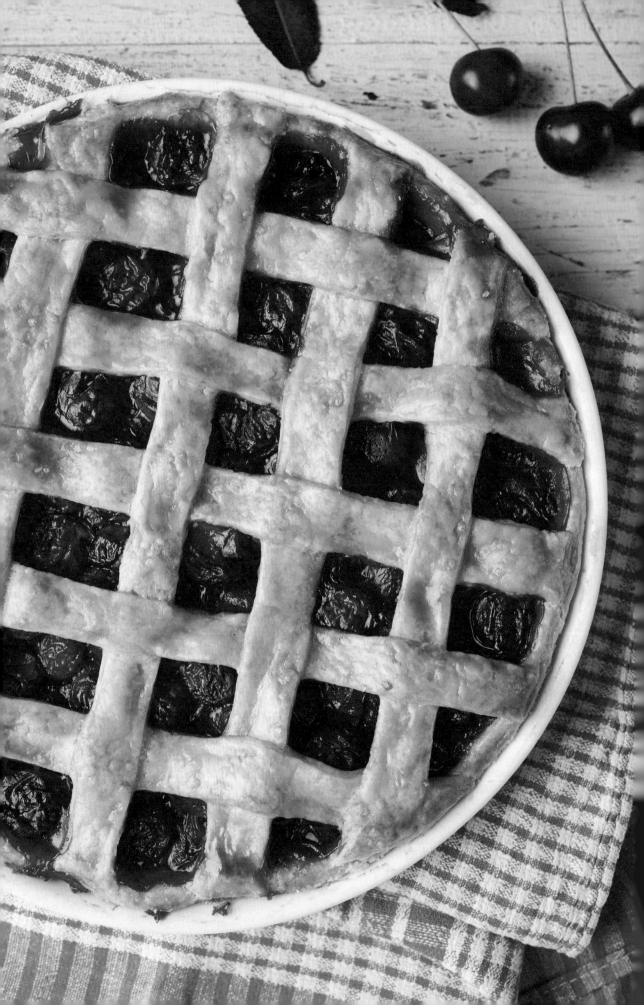

PIES, TARTS & QUICHE

"Anytime is a good time for pie."

When Maria de Medeiros's Fabienne offered this response after Bruce Willis's Butch questioned her choice of blueberry pie for breakfast in the 1994 film *Pulp Fiction*, it was easy to imagine millions nodding along.

Simply put, pie, though frequently grouped behind other beloved treats like cake, cookies, and ice cream, has the most fervent devotees in the dessert game. As far as these folks are concerned, nothing else will do when the time comes for a treat. Dubious? Consider, for a minute, the apple pie's place as a stand-in for what is good about the American way of life—clearly, pie has attained a level few foods ever reach.

Cherry, blueberry, and strawberry rhubarb in the summer. Pumpkin during the holidays. Chocolate or banana cream at the diner after a late-night meal with a loved one. The presence of pie signals that something special is happening, and the warm memories we hold of our encounters with our favorites indicate that this communication comes through loud and clear.

Pie's humbler, but no less delicious, cousins, tarts and quiche, can also be found in this chapter.

PERFECT PIECRUSTS

YIELD: 2 (9-INCH) PIECRUSTS / **ACTIVE TIME:** 15 MINUTES / **TOTAL TIME:** 2 HOURS AND 15 MINUTES

Perfect buttery, flaky crusts that will serve you well no matter how you use them.

1. Transfer the butter to a small bowl and place it in the freezer.

2. Place the flour, salt, and sugar in a food processor and pulse a few times until combined.

3. Add the chilled butter and pulse until the mixture is crumbly, consisting of pea-sized clumps.

4. Add the water and pulse until the mixture comes together as a dough.

5. Place the dough on a flour-dusted work surface and fold it over itself until it is a ball. Divide the dough in two and flatten each piece into a 1-inch-thick disk. Cover each piece completely with plastic wrap and place the dough in the refrigerator for at least 2 hours before rolling it out to fit your pie plate.

INGREDIENTS:

8 OZ. UNSALTED BUTTER, CUBED

12.5 OZ. ALL-PURPOSE FLOUR, PLUS MORE AS NEEDED

½ TEASPOON KOSHER SALT

4 TEASPOONS SUGAR

½ CUP ICE WATER

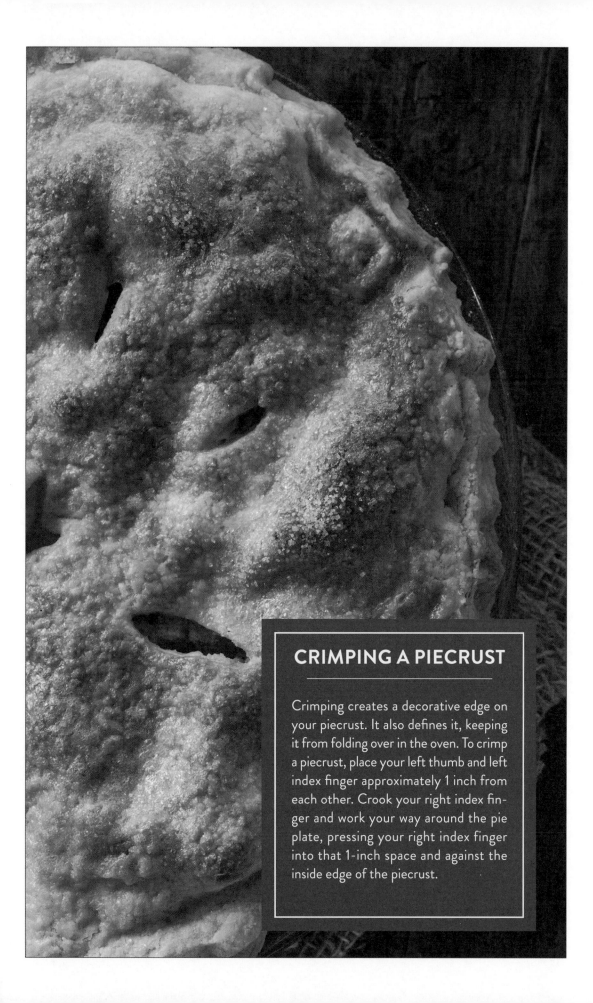

CRIMPING A PIECRUST

Crimping creates a decorative edge on your piecrust. It also defines it, keeping it from folding over in the oven. To crimp a piecrust, place your left thumb and left index finger approximately 1 inch from each other. Crook your right index finger and work your way around the pie plate, pressing your right index finger into that 1-inch space and against the inside edge of the piecrust.

PÂTÉ SUCRÉE

YIELD: 2 (9-INCH) CRUSTS / **ACTIVE TIME:** 15 MINUTES / **TOTAL TIME:** 2 HOURS AND 15 MINUTES

If you want a sweet piecrust, this is your best bet. It also makes a wonderful tart shell.

1. In the work bowl of a stand mixer fitted with the paddle attachment, cream the butter, sugar, and salt on medium until the mixture is creamy, light, and fluffy, about 5 minutes.

2. Add the egg and egg yolks and beat until incorporated. Add the flour and beat until the mixture comes together as a dough.

3. Place the dough on a flour-dusted work surface and fold it over itself until it is a ball. Divide the dough in two and flatten each piece into a 1-inch-thick disk. Cover each piece completely with plastic wrap and place the dough in the refrigerator for at least 2 hours before rolling it out to fit your pie plate.

INGREDIENTS:

8	OZ. UNSALTED BUTTER, SOFTENED
8	OZ. SUGAR
¼	TEASPOON KOSHER SALT
1	EGG
2	EGG YOLKS
1	LB. ALL-PURPOSE FLOUR, PLUS MORE AS NEEDED

GRAHAM CRACKER CRUST

YIELD: 1 (9-INCH) CRUST / **ACTIVE TIME:** 10 MINUTES / **TOTAL TIME:** 1 HOUR

Whether you're intent on making a cheesecake to remember or putting a twist on your favorite pie, your quest starts here.

1. Preheat the oven to 375°F. Place the graham cracker crumbs and sugar in a large mixing bowl and stir to combine. Add the maple syrup and 5 tablespoons of the melted butter and stir until thoroughly combined.

2. Grease a 9-inch pie plate with the remaining butter. Pour the crust into the pie plate and gently press into shape. Line the crust with aluminum paper, fill with uncooked rice, dried beans, or pie weights, and bake for about 10 minutes, until the crust is firm.

3. Remove from the oven, discard the aluminum foil and weights, and allow the crust to cool completely before filling.

INGREDIENTS:

1½ CUPS GRAHAM CRACKER
 CRUMBS

2 TABLESPOONS SUGAR

1 TABLESPOON REAL MAPLE
 SYRUP

3 OZ. UNSALTED BUTTER,
 MELTED

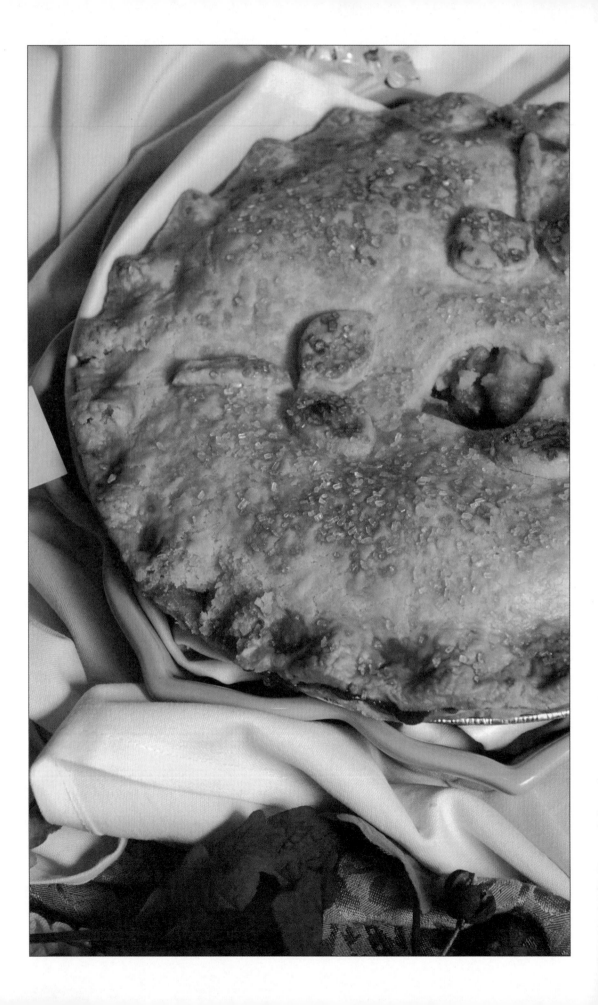

APPLE PIE

YIELD: 1 PIE / **ACTIVE TIME:** 30 MINUTES / **TOTAL TIME:** 1 HOUR AND 45 MINUTES

The combination of Granny Smith and Honeycrisp provides the most balanced flavor. However, those who have access to the Northern Spy, which prefers cooler climes, should give it a try, as a strong contingent identifies it as the very best option.

1. Preheat the oven to 375°F. Coat a 9-inch pie pan with nonstick cooking spray and place one of the crusts in it.

2. Place the apples, sugar, brown sugar, cornstarch, cinnamon, nutmeg, cardamom, lemon zest, lemon juice, and salt in a mixing bowl and toss until the apples are evenly coated.

3. Fill the crust with the apple filling, lay the other crust over the top, and crimp the edge to seal. Brush the top crust with the egg and sprinkle the sanding sugar over it. Cut several slits in the top crust.

4. Place the pie in the oven and bake until the filling is bubbly and has thickened, about 50 minutes. Remove from the oven and let the pie cool completely before serving.

INGREDIENTS:

2	PERFECT PIECRUSTS (SEE PAGE 218), ROLLED OUT
3	HONEYCRISP APPLES, PEELED, CORED, AND SLICED
3	GRANNY SMITH APPLES, PEELED, CORED, AND SLICED
½	CUP SUGAR
¼	CUP LIGHT BROWN SUGAR
1½	TABLESPOONS CORNSTARCH
1	TEASPOON CINNAMON
½	TEASPOON FRESHLY GRATED NUTMEG
¼	TEASPOON CARDAMOM
	ZEST AND JUICE OF 1 LEMON
¼	TEASPOON KOSHER SALT
1	EGG, BEATEN
	SANDING SUGAR, FOR TOPPING

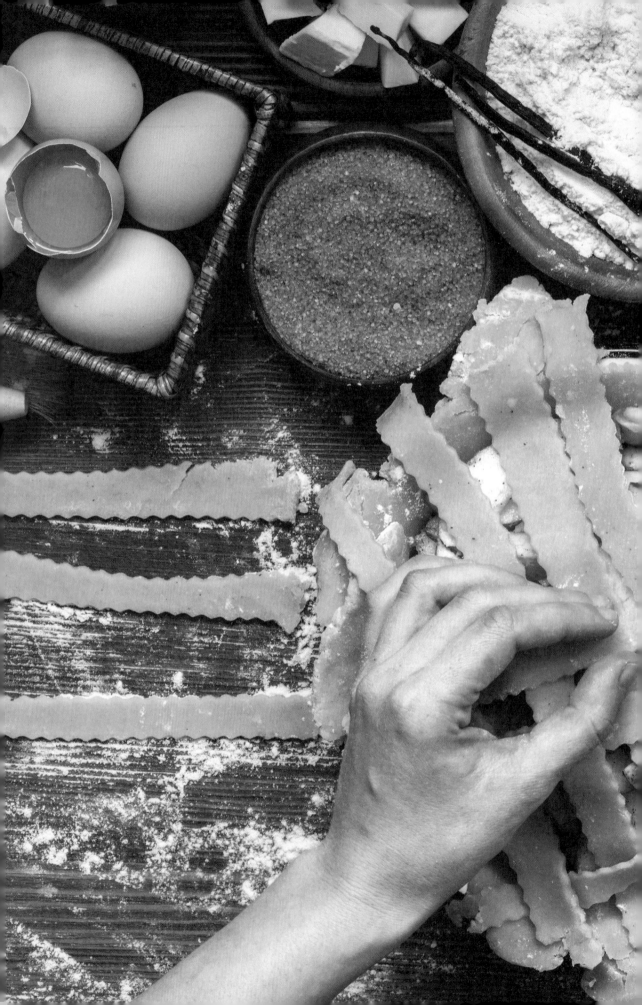

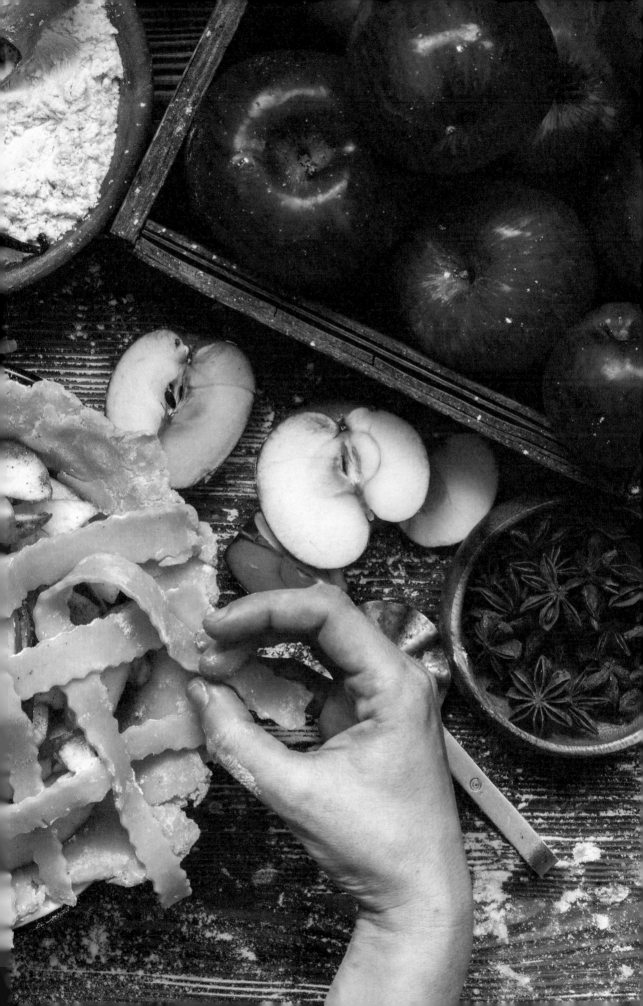

WILD MAINE BLUEBERRY PIE

YIELD: 1 PIE / **ACTIVE TIME:** 30 MINUTES / **TOTAL TIME:** 1 HOUR AND 30 MINUTES

An All-American dessert that has been honored with its own day: April 28 is National Blueberry Pie Day. Interestingly, this is far too early for those who live in Maine—where blueberry pie is the official state dessert—to enjoy a slice made with fresh berries, since blueberry season in the New England state typically runs from July to September.

1. Preheat the oven to 350°F. Place the blueberries, sugar, cornstarch, nutmeg, lemon juice, lemon zest, and salt in a large mixing bowl and stir to combine.

2. Place one of the crusts in a greased 9-inch pie plate and fill it with the blueberry mixture. Place the other crust over the mixture and crimp the edge to seal.

3. Brush the top crust with the egg white and then sprinkle sugar over it. Cut 4 or 5 slits in the middle, place the pie in the oven, and bake until the top crust is golden brown and the filling is bubbling, about 40 minutes.

4. Remove the pie from the oven and let it cool before serving.

INGREDIENTS:

6	CUPS FRESH BLUEBERRIES
1	CUP SUGAR, PLUS MORE TO TASTE
2	TABLESPOONS CORNSTARCH
½	TEASPOON FRESHLY GRATED NUTMEG
1	TABLESPOON FRESH LEMON JUICE
1	TEASPOON LEMON ZEST
¼	TEASPOON FINE SEA SALT
2	PERFECT PIECRUSTS (SEE PAGE 218), ROLLED OUT
1	EGG WHITE

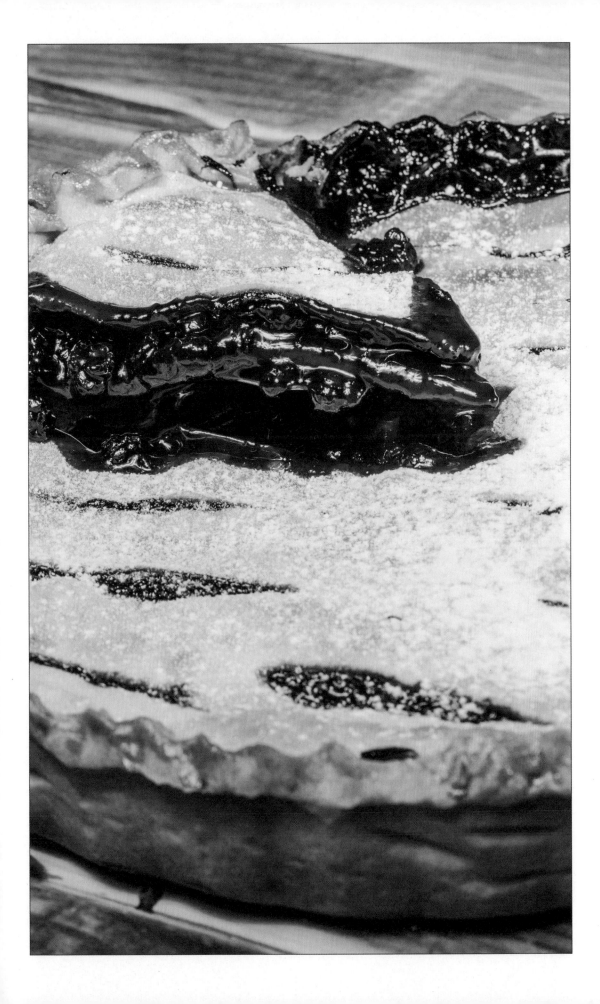

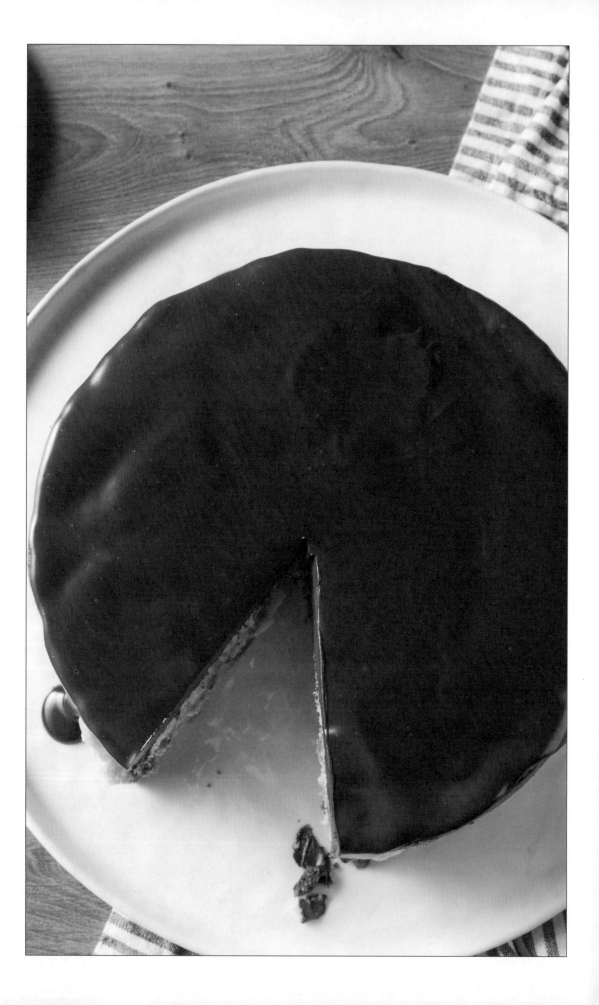

BOSTON CREAM PIE

YIELD: 1 PIE / **ACTIVE TIME:** 45 MINUTES / **TOTAL TIME:** 2 HOURS AND 30 MINUTES

Is this, in all likelihood, actually a cake? Sure. But when you're this luscious, you get to call yourself whatever you want.

1. Preheat the oven to 350°F. Line two round 9-inch cake pans with parchment paper and coat with nonstick cooking spray.

2. Sift the flour, baking powder, and salt into a bowl. Set the mixture aside.

3. In the work bowl of a stand mixer fitted with the whisk attachment, whip the eggs and sugar on high until the mixture is pale and thick, about 5 minutes.

4. Reduce the speed to low, add the dry mixture, and beat until incorporated.

5. Combine the milk and butter in a small saucepan and warm over medium heat until the butter has melted. Whisk in the vanilla and remove the pan from heat. With the mixer running on low, add the milk mixture to the work bowl and beat the mixture until it comes together as a smooth batter.

6. Divide the batter between the cake pans. Bang the pans on the countertop to spread the batter and to remove any possible air bubbles.

7. Place the cakes in the oven and bake until they are lightly golden brown and baked through, 35 to 40 minutes. Insert a cake tester in the center of each cake to check for doneness.

8. Remove from the oven and place the cakes on a cooling rack. Let them cool completely.

9. Trim a thin layer off the top of each cake to create a flat surface.

10. Place one cake on a cake stand. Place 1 cup of the Pastry Cream in the center and spread it with an offset spatula. Place the second cake on top.

11. Combine the heavy cream and corn syrup in a saucepan and bring it to a boil, stirring to dissolve the corn syrup. Remove the pan from heat and add the dark chocolate. Stir until the chocolate has melted and the mixture is smooth. Let the ganache cool for 10 minutes.

12. Pour the ganache over the cake and spread it to the edge, allowing some ganache to drip down the side. Let the cake rest for 20 minutes before slicing.

INGREDIENTS:

6.5	OZ. ALL-PURPOSE FLOUR
1½	TEASPOONS BAKING POWDER
½	TEASPOON KOSHER SALT
3	EGGS
8	OZ. SUGAR
½	CUP MILK
3	OZ. UNSALTED BUTTER
2	TEASPOONS PURE VANILLA EXTRACT
	PASTRY CREAM (SEE PAGE 671)
½	CUP HEAVY CREAM
1	TABLESPOON LIGHT CORN SYRUP
4	OZ. DARK CHOCOLATE (55 TO 65 PERCENT)

WHOOPIE PIES

YIELD: 20 WHOOPIE PIES / **ACTIVE TIME:** 30 MINUTES / **TOTAL TIME:** 1 HOUR

This has been categorized as a cookie, cake, sandwich, and pie. Pennsylvania, Maine, Massachusetts, Virginia, and New Hampshire have proclaimed themselves the birthplace of this treat. In the interest of avoiding controversy, we'll simply say this: it is uniquely delicious, and deserving of its growing following.

1. Preheat the oven to 350°F and line two baking sheets with parchment paper. Sift the all-purpose flour, cocoa powder, baking soda, and salt into a mixing bowl. Set the mixture aside.

2. In the work bowl of a stand mixer fitted with the paddle attachment, cream the butter and sugar on medium until the mixture is very light and fluffy, about 5 minutes. Scrape down the work bowl with a rubber spatula and then beat the mixture for another 5 minutes.

3. Reduce the speed to low, add the egg, and beat until incorporated. Scrape down the work bowl, raise the speed to medium, and beat the mixture for 1 minute.

4. Reduce the speed to low, add the vanilla and the dry mixture, and beat until it comes together as a smooth batter. Add the buttermilk in a slow stream and beat to incorporate.

5. Scoop 2-oz. portions of the batter onto the baking sheets, making sure to leave 2 inches between each portion. Tap the bottom of the baking sheets gently on the counter to remove any air bubbles and let the portions spread out slightly.

6. Place in the oven and bake until a cake tester inserted at the centers of the whoopie pies comes out clean, 10 to 12 minutes.

7. Remove the whoopie pies from the oven and let them cool completely on the baking sheets.

8. Carefully remove the whoopie pies from the parchment paper. Scoop about 2 oz. of the Butterfluff Filling on half of the whoopie pies and then create sandwiches by topping with the remaining half.

INGREDIENTS:

9 OZ. ALL-PURPOSE FLOUR

1.8 OZ. COCOA POWDER

1½ TEASPOONS BAKING SODA

½ TEASPOON KOSHER SALT

4 OZ. UNSALTED BUTTER, SOFTENED

8 OZ. SUGAR

1 EGG

1 TEASPOON PURE VANILLA EXTRACT

1 CUP BUTTERMILK

2 CUPS BUTTERFLUFF FILLING (SEE PAGE 667)

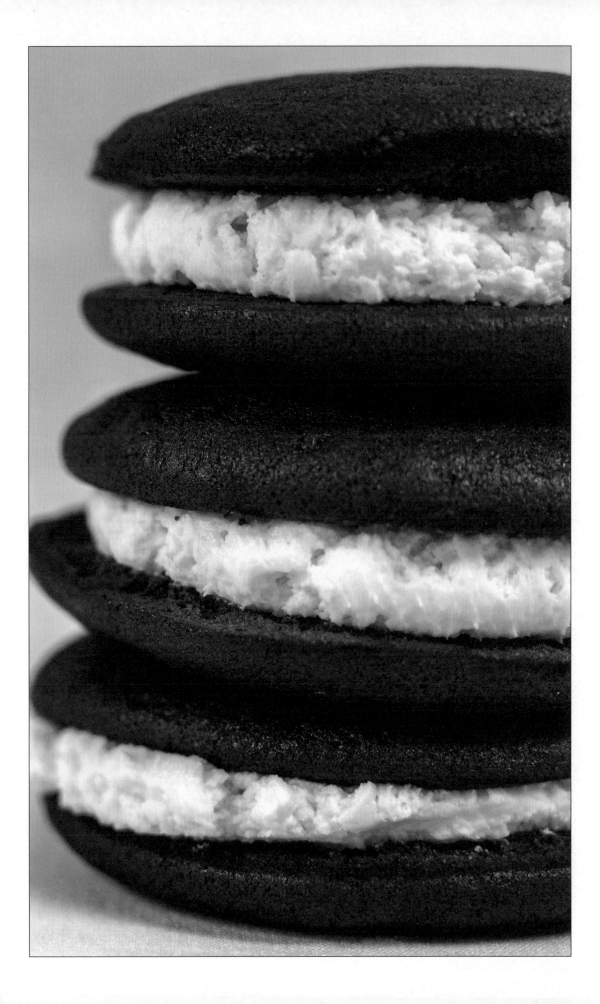

CLASSIC FRUIT TART

YIELD: 1 TART / **ACTIVE TIME:** 15 MINUTES / **TOTAL TIME:** 30 MINUTES

A perfect preparation for those weekday evenings when you require something sweet.

1. Spread the Pastry Cream over the bottom of the tart shell. Arrange the strawberries around the outside edge of the shell. Arrange the blackberries in a ring just inside the strawberries and then pile the raspberries in the center.

2. Gently brush the fresh fruit with the glaze. Place the fruit tart in the refrigerator and let it chill for 15 minutes before slicing and serving.

INGREDIENTS:

2 CUPS PASTRY CREAM (SEE PAGE 671)

1 PÂTÉ SUCRÉE (SEE PAGE 221), BLIND BAKED

2 CUPS HULLED AND SLICED STRAWBERRIES

2 CUPS BLACKBERRIES, SLICED LENGTHWISE

1 CUP RASPBERRIES

 APRICOT GLAZE (SEE PAGE 681)

LINZER TART

YIELD: 1 TART / **ACTIVE TIME:** 30 MINUTES / **TOTAL TIME:** 2 HOURS AND 45 MINUTES

Toasting the almond flour is key to getting the crust to where its crumbly, subtly flavored loveliness allows the preserves to shine.

1. Preheat the oven to 250°F. Place the almond flour on a baking sheet, place it in the oven, and toast for 5 minutes. Remove from the oven and set aside.

2. In the work bowl of a stand mixer fitted with the paddle attachment, combine the sugar, butter, and lemon zest and beat on medium until the mixture is pale and fluffy.

3. Incorporate two of the eggs one at a time, scraping down the work bowl as needed.

4. Place the flour, almond flour, cinnamon, cloves, cocoa powder, and salt in a separate bowl and whisk to combine. Gradually add this mixture to the wet mixture and beat until the mixture comes together as a dough. Divide the dough in half, envelop each piece in plastic wrap, and refrigerate for 1 hour.

5. Preheat the oven to 350°F and coat a 9-inch tart pan with non-stick cooking spray. Place the pieces of dough on a flour-dusted work surface and roll them out to fit the tart pan. Place one piece of dough in the pan and then cut the other piece of dough into ¾-inch-wide strips.

6. Fill the crust in the pan with the jam. Lay some of the strips over the tart and trim any excess. To make a lattice crust, lift every other strip and fold back so you can place another strip across those strips that remain flat. Lay the folded strips back down over the cross-strip. Fold back the strips that you laid the cross-strip on top of and repeat until the lattice covers the surface of the tart. Beat the remaining egg until scrambled and brush the strips with it, taking care not to get any egg on the filling.

7. Place the tart in the oven and bake for about 45 minutes, until the lattice crust is golden brown. Remove from the oven and let it cool before serving.

INGREDIENTS:

3.3 OZ. FINE ALMOND FLOUR

7 OZ. SUGAR

6 OZ. UNSALTED BUTTER, SOFTENED

1 TEASPOON LEMON ZEST

3 EGGS

6.25 OZ. ALL-PURPOSE FLOUR, PLUS MORE AS NEEDED

½ TEASPOON CINNAMON

¼ TEASPOON GROUND CLOVES

1 TABLESPOON UNSWEETENED COCOA POWDER

¼ TEASPOON KOSHER SALT

1½ CUPS RASPBERRY JAM (SEE PAGE 691)

GOLDEN PEACH PIE

YIELD: 1 PIE / **ACTIVE TIME:** 30 MINUTES / **TOTAL TIME:** 6 HOURS

Fresh peach pie filling and a flaky crust—nothing beats this summertime favorite.

1. Preheat the oven to 375°F. Coat a 9-inch pie plate with nonstick cooking spray and place one of the crusts in it.

2. Place the peaches, brown sugar, cornstarch, cinnamon, ginger, nutmeg, lemon zest, lemon juice, and salt in a mixing bowl and toss until the peaches are evenly coated.

3. Using a pizza cutter or chef's knife, cut the other crust into 14 to 16 strips that are about ½ inch wide. Lay half of the strips over the filling and trim any excess. To make a lattice crust, lift every other strip and fold back so you can place another strip across those strips that remain flat. Lay the folded strips back down over the cross-strip. Fold back the strips that you laid the cross-strip on top of and repeat until the lattice covers the surface of the pie.

4. Brush the strips with the egg, taking care not to get any egg on the filling. Sprinkle sanding sugar over the pie, place it in the oven and bake until the filling has thickened and starts to bubble, 75 to 90 minutes.

5. Remove the pie from the oven, place it on a wire rack, and let it cool for 4 hours before serving.

INGREDIENTS:

2 PERFECT PIECRUSTS (SEE PAGE 218), ROLLED OUT

8 RIPE PEACHES, PITTED AND SLICED

1 CUP LIGHT BROWN SUGAR

2 TABLESPOONS CORNSTARCH

½ TEASPOON CINNAMON

½ TEASPOON GROUND GINGER

¼ TEASPOON FRESHLY GRATED NUTMEG

 ZEST AND JUICE OF 1 LEMON

¼ TEASPOON KOSHER SALT

1 EGG, BEATEN

 SANDING SUGAR, FOR TOPPING

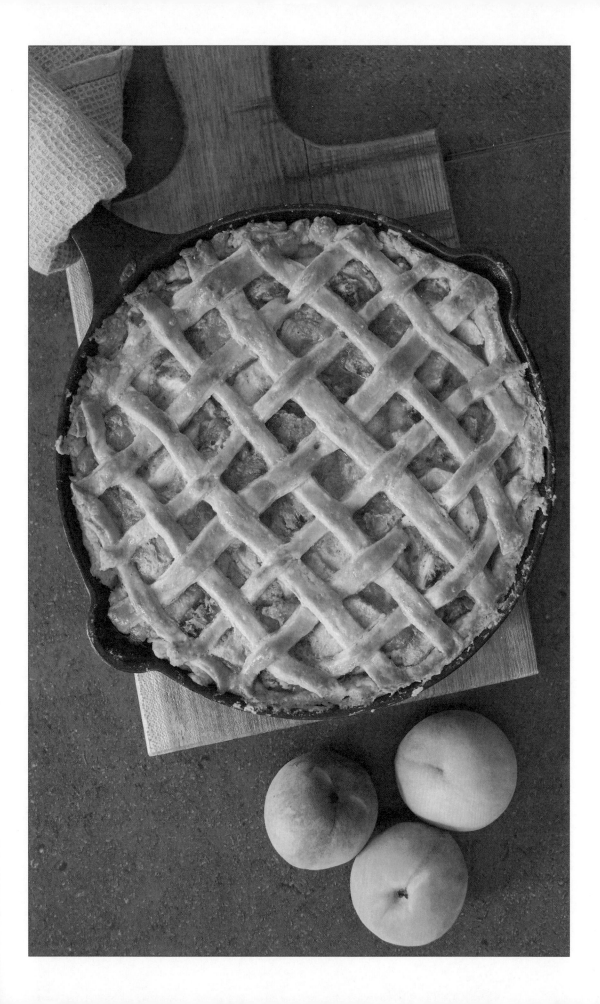

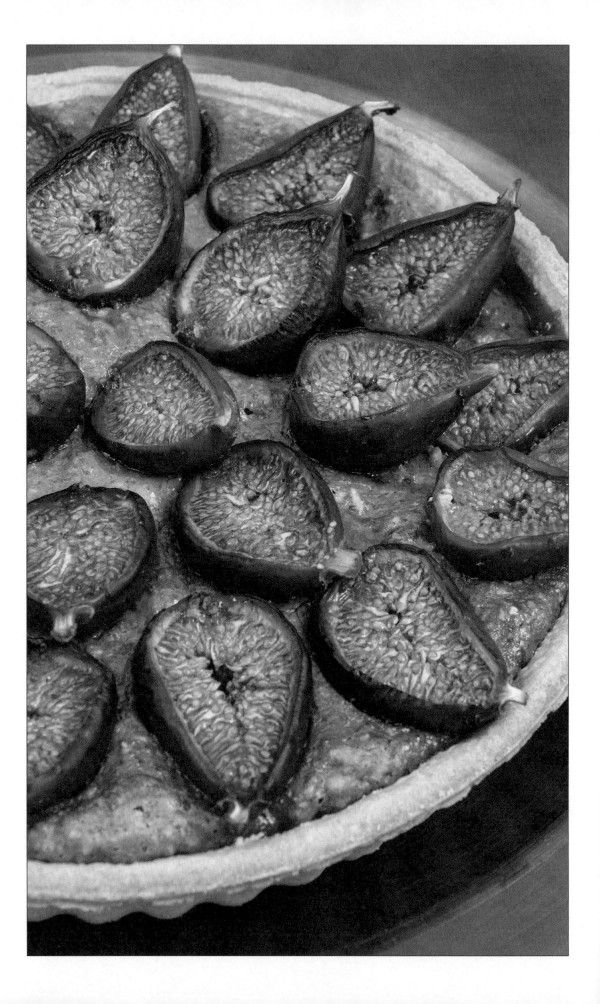

FIG & PECAN TART

YIELD: 1 TART / **ACTIVE TIME:** 25 MINUTES / **TOTAL TIME:** 1 HOUR AND 15 MINUTES

A sweet and earthy tart that provides a perfect introduction to baking with the underutilized and underrated fig.

1. Preheat the oven to 350°F. Place the pecans, dark brown sugar, vanilla, and egg whites in a food processor and pulse until the pecans are finely ground.

2. Pour the mixture into the tart shell and lay the sliced figs over the top. Place the tart in the oven and bake until the filling has set and the figs have caramelized, about 30 minutes. Remove from the oven and let the tart cool completely before slicing and serving.

INGREDIENTS:

1½	CUPS PECANS
⅔	CUP DARK BROWN SUGAR
1	TEASPOON PURE VANILLA EXTRACT
2	EGG WHITES
1	PÂTÉ SUCRÉE (SEE PAGE 221), BLIND BAKED IN A TART PAN
6	FIGS, SLICED

FUNFETTI WHOOPIE PIES

YIELD: 20 WHOOPIE PIES / **ACTIVE TIME:** 30 MINUTES / **TOTAL TIME:** 1 HOUR AND 45 MINUTES

Too much fun, and too delicious, for you to bother trying to act like you're above it.

1. Preheat the oven to 350°F and line two baking sheets with parchment paper. Sift the flour, baking soda, baking powder, and salt into a mixing bowl and set the mixture aside.

2. In the work bowl of a stand mixer fitted with the paddle attachment, cream the butter and sugar on medium until the mixture is very light and fluffy, about 5 minutes. Scrape down the work bowl and then beat the mixture for another 5 minutes.

3. Add the egg and vanilla, reduce the speed to low, and beat until incorporated, again scraping down the work bowl as needed.

4. Add the dry mixture and beat on low until the batter comes together. Gradually add in the buttermilk and beat until incorporated. When all of the buttermilk has been combined, add the sprinkles and fold the mixture until they are evenly distributed.

5. Drop 2-oz. portions of the dough on the baking sheets, making sure to leave 2 inches of space between the portions.

6. Place in the oven and bake until a cake tester inserted into the centers of the cakes comes out clean, about 12 minutes. Remove from the oven and let the cakes cool completely.

7. Spread the filling on half of the cakes and use the other cakes to assemble the whoopie pies.

INGREDIENTS:

12	OZ. ALL-PURPOSE FLOUR
1	TEASPOON BAKING SODA
¾	TEASPOON BAKING POWDER
¾	TEASPOON KOSHER SALT
4	OZ. UNSALTED BUTTER, SOFTENED
9	OZ. SUGAR
1	EGG
1½	TEASPOONS PURE VANILLA EXTRACT
⅔	CUP BUTTERMILK
½	CUP RAINBOW SPRINKLES
2	CUPS BUTTERFLUFF FILLING (SEE PAGE 667)

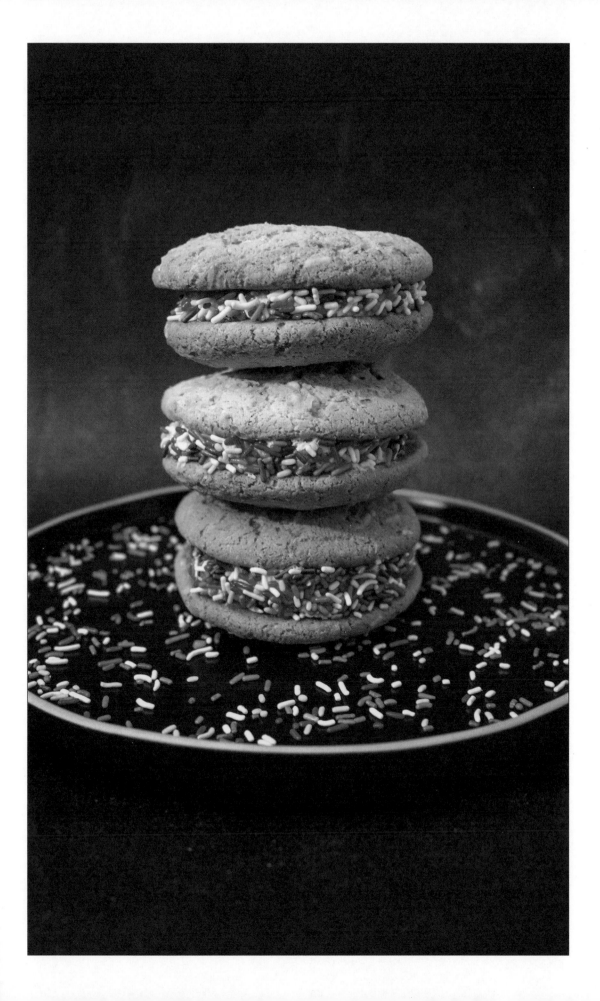

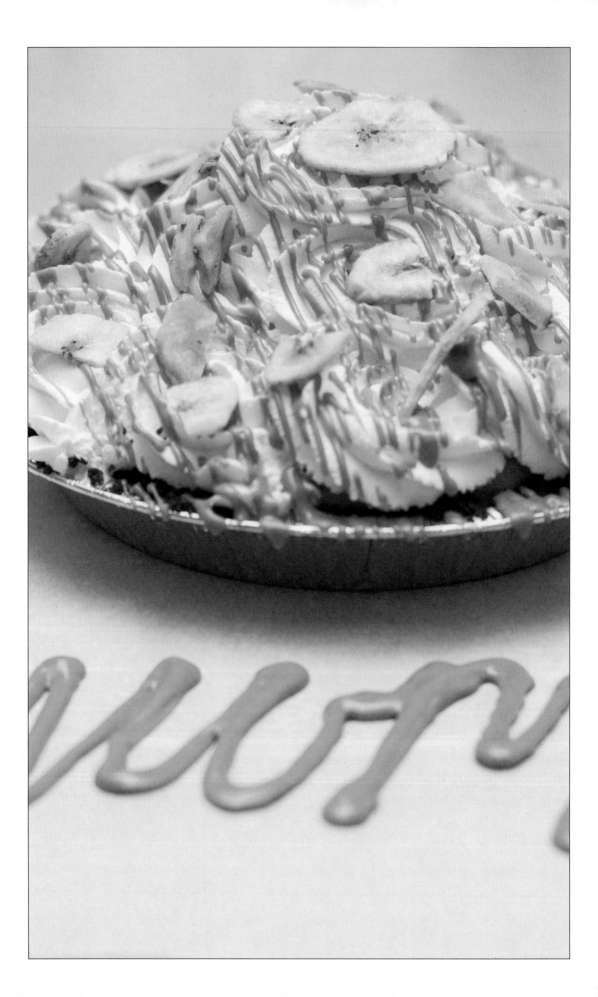

GRACELAND PIE

The trio of bacon, peanut butter, and banana is a strange one, but as any fan of Elvis will tell you, it's fit for a King.

1. Place the sugar, flour, and salt in a saucepan and whisk to combine. Whisk the milk into the mixture and bring to a simmer, while stirring constantly, over medium heat. Simmer, while stirring, for 2 minutes and then remove the pan from heat.

2. While whisking constantly, stir a small amount of the warmed mixture into the beaten egg yolks. Add the tempered egg yolks to the saucepan, place the pan back over medium heat, and cook until the mixture thickens and starts bubbling, while whisking constantly. Remove from heat, add the butter and vanilla, and stir until combined. Add half of the sliced bananas, stir to coat, and let the mixture cool.

3. While the mixture is cooling, place the peanut butter in a saucepan and warm over medium heat until it starts to melt.

4. Place the remaining bananas in the piecrust and then pour the cooled banana cream over the bananas. Cover with the Chantilly Cream, drizzle the peanut butter over it, and arrange the dehydrated banana chips and bacon pieces (if desired) on top.

INGREDIENTS:

¾ CUP SUGAR

⅓ CUP ALL-PURPOSE FLOUR

¼ TEASPOON FINE SEA SALT

2 CUPS WHOLE MILK

3 EGG YOLKS, BEATEN

1 OZ. UNSALTED BUTTER

1¼ TEASPOONS PURE VANILLA EXTRACT

4 BANANAS, SLICED

½ CUP CREAMY NATURAL PEANUT BUTTER

1 GRAHAM CRACKER CRUST (SEE PAGE 222), MADE WITH CHOCOLATE GRAHAM CRACKERS

CHANTILLY CREAM (SEE PAGE 668)

DEHYDRATED BANANA CHIPS, FOR GARNISH

¼ CUP CRISPY, CHOPPED BACON, FOR GARNISH (OPTIONAL)

NECTARINE PIE

YIELD: 1 PIE / **ACTIVE TIME:** 30 MINUTES / **TOTAL TIME:** 1 HOUR AND 45 MINUTES

Whenever you come across ripe nectarines, the temptation is to buy as many as you can. This pie turns that impulse into a prudent play.

1. Preheat the oven to 375°F. Coat a 9-inch pie plate with nonstick cooking spray and place one of the crusts in it.

2. Place the nectarines, sugar, brown sugar, cornstarch, cinnamon, nutmeg, lemon zest, lemon juice, and salt in a mixing bowl and toss until the nectarines are evenly coated.

3. Fill the crust with the nectarine mixture, lay the other crust over the top, and crimp the edge to seal. Brush the top crust with the egg and sprinkle the sanding sugar over it. Cut several slits in the top crust.

4. Place the pie in the oven and bake until the filling is bubbly and has thickened, about 50 minutes. Remove from the oven and let the pie cool completely before serving.

INGREDIENTS:

2	PERFECT PIECRUSTS (SEE PAGE 218), ROLLED OUT
7	NECTARINES, PITTED AND SLICED
½	CUP SUGAR
½	CUP LIGHT BROWN SUGAR
3	TABLESPOONS CORNSTARCH
¼	TEASPOON CINNAMON
¼	TEASPOON FRESHLY GRATED NUTMEG
	ZEST AND JUICE OF 1 LEMON
¼	TEASPOON KOSHER SALT
1	EGG, BEATEN
	SANDING SUGAR, FOR TOPPING

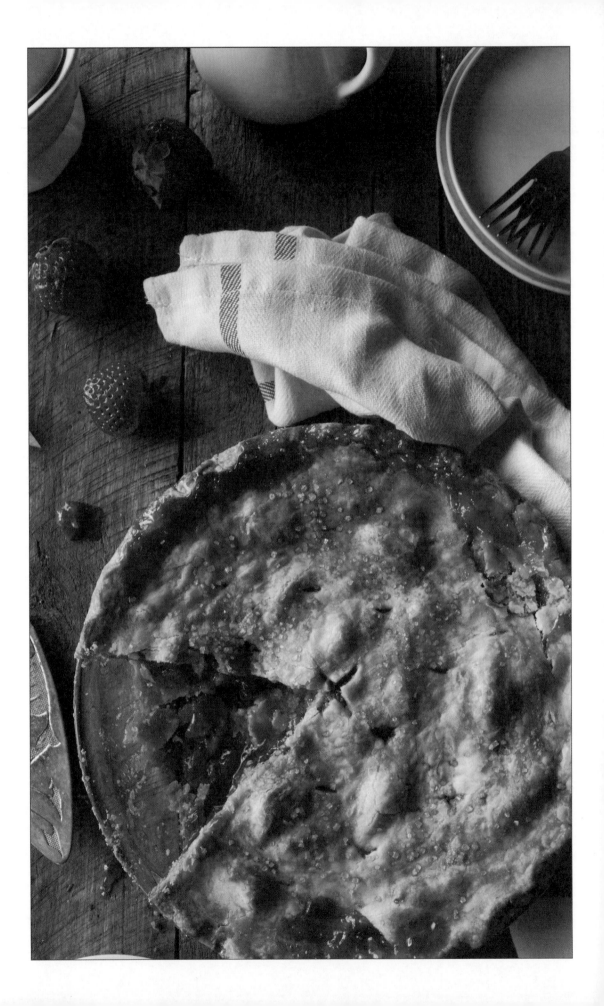

STRAWBERRY RHUBARB PIE

YIELD: 1 PIE / **ACTIVE TIME:** 30 MINUTES / **TOTAL TIME:** 1 HOUR AND 45 MINUTES

The floral aspect of the cardamom and the brightness added by the orange zest lift this classic combination to all-new heights.

1. Preheat the oven to 375°F. Coat a 9-inch pie plate with nonstick cooking spray and place one of the crusts in it.

2. Place the strawberries, rhubarb, sugar, cornstarch, cardamom, orange zest, and salt in a mixing bowl and toss until the strawberries and rhubarb are evenly coated.

3. Fill the crust with the strawberry mixture, lay the other crust over the top, and crimp the edge to seal. Brush the top crust with the egg and sprinkle the sanding sugar over it. Cut several slits in the top crust.

4. Place the pie in the oven and bake until the filling is bubbly and has thickened, about 50 minutes. Remove from the oven and let the pie cool completely before serving.

INGREDIENTS:

2 PERFECT PIECRUSTS (SEE PAGE 218), ROLLED OUT

3 CUPS STRAWBERRIES, HULLED AND QUARTERED

3 CUPS CHOPPED RHUBARB

1 CUP SUGAR

2 TABLESPOONS CORNSTARCH

¼ TEASPOON CARDAMOM

ZEST OF 2 ORANGES

¼ TEASPOON KOSHER SALT

1 EGG, BEATEN

SANDING SUGAR, FOR TOPPING

BANANA CREAM PIE

YIELD: 1 PIE / **ACTIVE TIME**: 30 MINUTES / **TOTAL TIME**: 2 HOURS AND 30 MINUTES

Rich and silky, decadent and irresistibly beautiful, this may be the optimal use of the banana.

1. Place the bananas, milk, heavy cream, and vanilla in a blender and puree until smooth.

2. Place the puree in a medium saucepan and bring to a boil over medium heat. Remove the pan from heat once it comes to a boil.

3. While the puree is coming to a boil, place the sugar, salt, cornstarch, and egg whites in a small bowl and whisk for 2 minutes.

4. While whisking constantly, incorporate small amounts of the puree into the egg white mixture. When half of the puree has been incorporated, add the tempered mixture to the saucepan and place it over medium heat. While whisking continually, cook until the mixture thickens and begins to bubble. Remove the pan from heat, add the butter, and whisk until incorporated.

5. Strain the custard through a fine mesh strainer and into a small bowl. Pour the strained custard into the crust and place plastic wrap directly onto the custard to prevent a skin from forming. Place the pie in the refrigerator for 2 hours.

6. Spread the Chantilly Cream over the filling, slice the pie, and enjoy.

INGREDIENTS:

2	BANANAS, PEELED AND SLICED
1½	CUPS MILK
1	CUP HEAVY CREAM
¾	TEASPOON PURE VANILLA EXTRACT
4	OZ. SUGAR
½	TEASPOON KOSHER SALT
¼	CUP CORNSTARCH
4	EGG WHITES
1	OZ. UNSALTED BUTTER, SOFTENED
1	GRAHAM CRACKER CRUST (SEE PAGE 222)
	CHANTILLY CREAM (SEE PAGE 668)

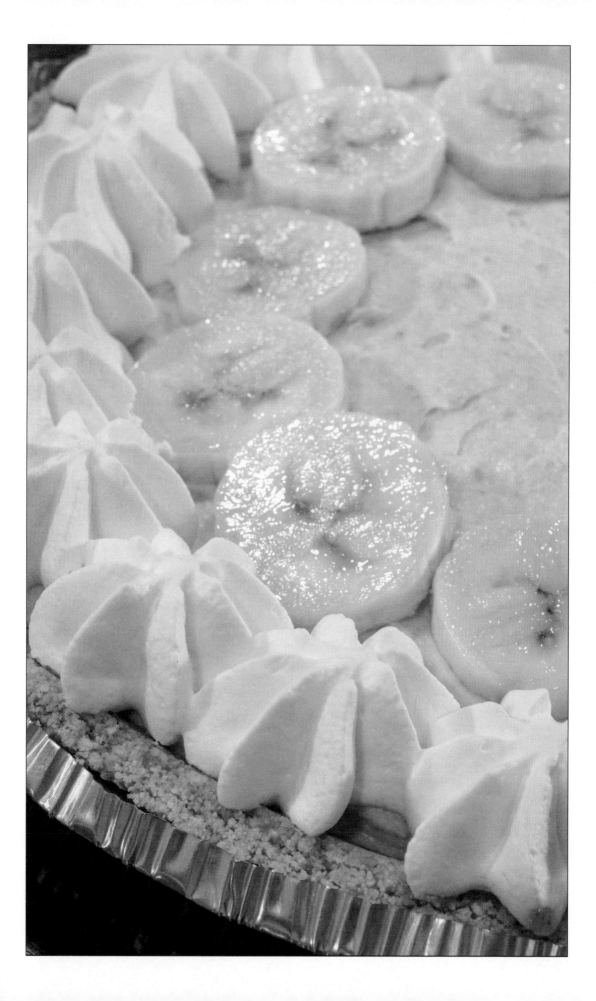

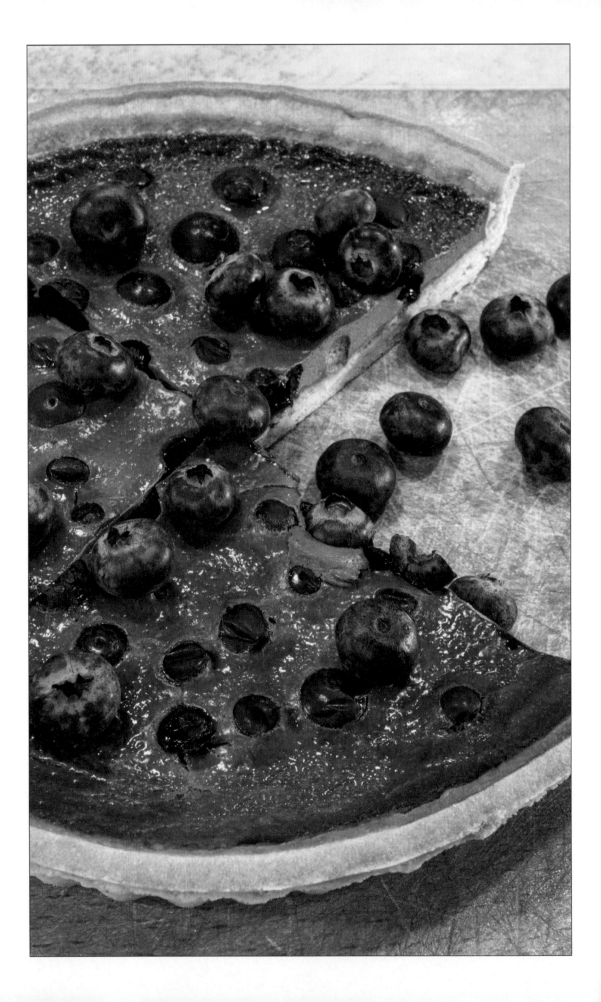

WILD BLUEBERRY TART

YIELD: 1 TART / **ACTIVE TIME:** 30 MINUTES / **TOTAL TIME:** 5 HOURS

The beauty of the blueberry custard will catch everyone's eye, and its taste will prove worthy of the attention.

1. Line a fluted, 9-inch tart pan with nonstick cooking spray. Remove the dough from the refrigerator and let it rest at room temperature for 30 minutes.

2. Place the dough on a flour-dusted work surface and roll it out to 12 inches. Carefully transfer the dough to the tart pan and press it firmly against the bottoms and sides, taking care not to tear the dough. Use a paring knife to trim away any excess dough. Cover the pan with plastic wrap and refrigerate for 30 minutes.

3. Preheat the oven to 350°F.

4. Remove the pan from the refrigerator and poke holes all over the bottom of the dough with a fork. Place a sheet of aluminum foil directly on the dough and fill it with your preferred weight.

5. Place the pan in the oven and bake the crust for 15 minutes. Remove it from the oven, remove the weight and aluminum foil, and return the crust to the oven. Bake until the center of the crust just begins to color. Remove the crust from the oven, place the pan on a wire rack, and let it cool completely.

6. Place half of the blueberries in a blender and puree until smooth. Transfer the puree to a small bowl, add the eggs, heavy cream, lemon zest, and salt and stir until combined.

7. Pour the mixture into the prepared tart shell and sprinkle the remaining blueberries over the top.

8. Place the tart in the oven and bake until the custard has puffed up around on the edges and the center has set, 20 to 25 minutes.

9. Remove the tart from the oven and place it on a cooling rack. Let it cool at room temperature for 1 hour and then transfer the tart to the refrigerator for 2 hours before slicing and serving.

INGREDIENTS:

1	PÂTÉ SUCRÉE (SEE PAGE 221)
	ALL-PURPOSE FLOUR, AS NEEDED
2	PINTS OF FRESH BLUEBERRIES
2	EGGS
3	OZ. HEAVY CREAM
	ZEST OF ½ LEMON
	PINCH OF KOSHER SALT

ROASTED STRAWBERRY HANDPIES

YIELD: 8 HANDPIES / **ACTIVE TIME:** 40 MINUTES / **TOTAL TIME:** 2 HOURS

Roasting the strawberries caramelizes the sugars and concentrates the flavor, guaranteeing that these seemingly small pockets are extremely deep.

1. Preheat the oven to 400°F. Place the strawberries on a baking sheet, place it in the oven, and roast until they start to darken and release their juice, about 20 to 30 minutes. If you prefer, you can roast them for up to an hour. Cooking the strawberries for longer will caramelize the sugars and lend them an even richer flavor.

2. Remove the strawberries from the oven and place them in a saucepan with the sugar and lemon juice. Bring to a simmer over medium heat and cook for 20 minutes, until the mixture has thickened slightly.

3. Place the cornstarch and water in a small cup and stir until there are no lumps in the mixture. Add to the saucepan and stir until the mixture is syrupy. Remove the pan from heat.

4. Divide the ball of piecrust dough into two pieces, place them on a flour-dusted work surface, roll them out into squares that are about ⅛ inch thick, and then cut each square into quarters. Spoon some of the strawberry mixture into the center of each quarter.

5. Take a bottom corner of each pie and fold to the opposite top corner. Press down to ensure that none of the mixture leaks out and then use a fork to seal the edge. Place the pies on a baking sheet and brush them with the beaten egg. Place in the oven and bake until they are golden brown, about 20 to 30 minutes.

6. While the pies are cooking, place the confectioners' sugar, milk, and cinnamon in a bowl and stir until well combined.

7. Remove the pies from the oven, brush them with the sugar-and-cinnamon glaze, and allow them to cool before serving.

INGREDIENTS:

3	QUARTS OF FRESH STRAWBERRIES, HULLED AND SLICED
1	CUP SUGAR
2	TEASPOONS FRESH LEMON JUICE
1	TABLESPOON CORNSTARCH
½	TABLESPOON WATER
1	BALL OF PERFECT PIECRUST DOUGH (SEE PAGE 218)
	ALL-PURPOSE FLOUR, AS NEEDED
2	EGGS, BEATEN
1½	CUPS SIFTED CONFECTIONERS' SUGAR
3	TABLESPOONS WHOLE MILK
1	TEASPOON CINNAMON

SOUR CHERRY CRUMBLE PIE

YIELD: 1 PIE / **ACTIVE TIME:** 30 MINUTES / **TOTAL TIME:** 1 HOUR AND 45 MINUTES

The morello cherry is more acidic than its family members, lending it a vibrant sour taste that will linger in the mind long after you've left the table.

1. Preheat the oven to 375°F. Coat a 9-inch pie plate with nonstick cooking spray and place the crust in it.

2. Place the cherries, sugar, cornstarch, ginger, lemon zest, lemon juice, and salt in a mixing bowl and toss until the cherries are evenly coated.

3. Fill the crust with the cherry mixture and sprinkle the topping over it.

4. Place the pie in the oven and bake until the filling is bubbly and has thickened, about 50 minutes. Remove from the oven and let the pie cool completely before serving.

INGREDIENTS:

1 PERFECT PIECRUST (SEE PAGE 218), ROLLED OUT

6 CUPS MORELLO CHERRIES, PITTED AND HALVED

½ CUP SUGAR

3 TABLESPOONS CORNSTARCH

¼ TEASPOON GROUND GINGER

 ZEST AND JUICE OF 1 LEMON

¼ TEASPOON KOSHER SALT

 STREUSEL TOPPING (SEE PAGE 698)

PUMPKIN PIE

YIELD: 1 PIE / **ACTIVE TIME:** 3 MINUTES / **TOTAL TIME:** 5 HOURS

Don't believe the hype: while using anything other than fresh pumpkin is verboten in contemporary cooking cliques, the actual difference appears to exist only in the mind. For almost every preparation, fresh is better than canned. Not so for this one, yet another way that pumpkin pie defies convention.

1. Preheat the oven to 350°F. In a mixing bowl, whisk together the pumpkin puree, evaporated milk, eggs, brown sugar, cinnamon, ginger, nutmeg, cloves, and salt. When the mixture is smooth, pour it into the crust.

2. Place the pie in the oven and bake until the filling is just set, about 40 minutes. Remove from the oven and let the pie cool at room temperature for 30 minutes before transferring it to the refrigerator. Chill the pie for 3 hours.

3. Slice the pie, top each piece with a dollop of the Chantilly Cream, and serve.

INGREDIENTS:

- 1 (15 OZ.) CAN PUMPKIN PUREE
- 1 (12 OZ.) CAN EVAPORATED MILK
- 2 EGGS
- 6 OZ. LIGHT BROWN SUGAR
- 1 TEASPOON CINNAMON
- 1 TEASPOON GROUND GINGER
- ½ TEASPOON FRESHLY GRATED NUTMEG
- ¼ TEASPOON GROUND CLOVES
- ½ TEASPOON KOSHER SALT
- 1 PERFECT PIECRUST (SEE PAGE 218), BLIND BAKED

 CHANTILLY CREAM (SEE PAGE 668)

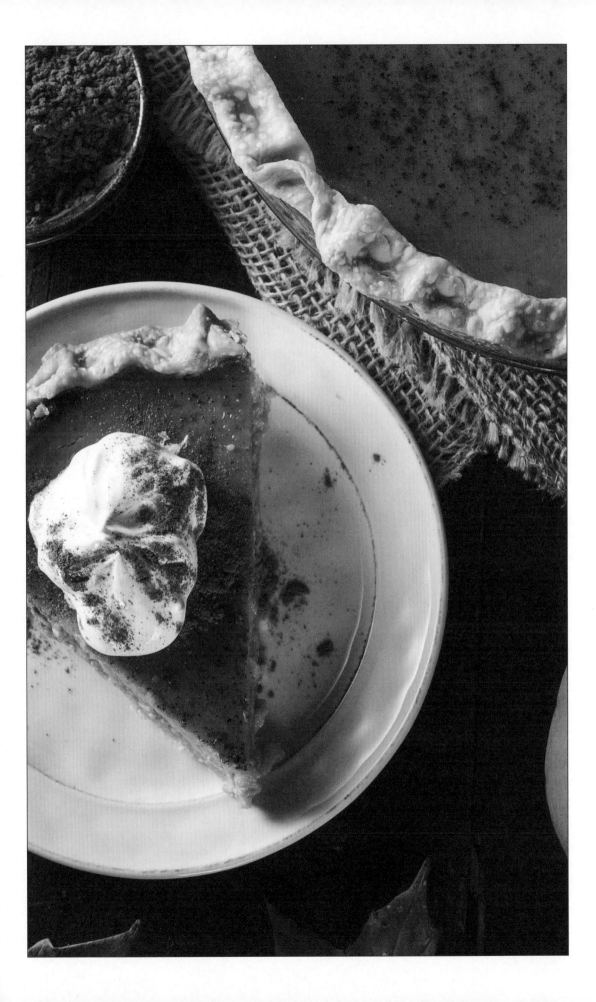

PEAR & FRANGIPANE TART

YIELD: 1 TART / **ACTIVE TIME:** 30 MINUTES / **TOTAL TIME:** 2 HOURS AND 15 MINUTES

A classic French pastry that features ingenuously spiced poached pears and a lush almond cream.

1. Preheat the oven to 375°F. In a medium saucepan, combine the water, sugar, cinnamon sticks, star anise, vanilla, lemon zest, and lemon juice and bring the mixture to a simmer over medium heat.

2. Peel the pears and slice them in half lengthwise. Core the pears and gently lay them in the simmering poaching liquid. Let them simmer until tender, about 15 minutes. Transfer the poached pears to a paper towel–lined plate and let them cool to room temperature. When the pears are cool enough to handle, slice them into ⅛-inch-wide strips. Set the pears aside.

3. Spread the Frangipane evenly over the bottom of the tart shell and arrange the pears over it, making sure the thinnest parts are pointing toward the center. Place the tart in the oven and bake until the Frangipane has risen up around the pears and is golden brown. Remove from the oven and let the tart cool for 1 hour before dusting with confectioners' sugar and slicing.

INGREDIENTS:

6	CUPS WATER
2	CUPS SUGAR
2	CINNAMON STICKS
1	STAR ANISE POD
1	TABLESPOON PURE VANILLA EXTRACT
	ZEST AND JUICE OF 1 LEMON
3	ANJOU PEARS
2	CUPS FRANGIPANE (SEE PAGE 730)
1	PÂTÉ SUCRÉE (SEE PAGE 221), BLIND BAKED IN A TART PAN
	CONFECTIONERS' SUGAR, FOR DUSTING

ROBERT'S KEY WEST KEY LIME PIE

YIELD: 1 PIE / **ACTIVE TIME:** 40 MINUTES / **TOTAL TIME:** 4 HOURS AND 30 MINUTES

When selecting key limes, keep in mind that the green ones are actually unripe. They will have higher levels of acidity and tartness, which can be fine in some preparations, but for desserts you'll want to seek out yellow key limes, as they are sweeter.

1. Preheat the oven to 350°F. In a mixing bowl, whisk together the condensed milk, egg yolks, key lime juice, salt, and vanilla. When the mixture is smooth, pour it into the crust.

2. Place the pie in the oven and bake until the filling is just set, about 16 minutes. Remove from the oven and let the pie cool at room temperature for 30 minutes before transferring it to the refrigerator. Chill the pie for 3 hours.

3. Place the meringue in a piping bag fit with a star tip. Pipe the meringue around the border of the pie and lightly brown it with a kitchen torch. Slice and serve.

INGREDIENTS:

1 (14 OZ.) CAN SWEETENED CONDENSED MILK

4 EGG YOLKS

½ CUP FRESH KEY LIME JUICE

¼ TEASPOON KOSHER SALT

½ TEASPOON PURE VANILLA EXTRACT

1 GRAHAM CRACKER CRUST (SEE PAGE 222)

 SWISS MERINGUE (SEE PAGE 734)

PLUM GALETTE

YIELD: 1 GALETTE / ACTIVE TIME: 20 MINUTES / TOTAL TIME: 1 HOUR

It should be illegal for something this beautiful to be so simple.

1. Preheat the oven to 400°F. Place the ball of Perfect Piecrust dough on a flour-dusted work surface, roll it out to 9 inches, and place it on a parchment-lined baking sheet.

2. Place the plums, ½ cup of sugar, lemon juice, cornstarch, and salt in a mixing bowl and stir until the plums are evenly coated.

3. Spread the jam over the crust, making sure to leave a 1½-inch border. Distribute the plum mixture on top of the jam and fold the crust over it. Brush the folded-over crust with the beaten egg and sprinkle it with the remaining sugar.

4. Put the galette in the oven and bake until the crust is golden brown and the filling is bubbly, about 35 to 40 minutes. Remove from the oven and allow it to cool before serving.

INGREDIENTS:

1	BALL OF PERFECT PIECRUST DOUGH (SEE PAGE 218)
	ALL-PURPOSE FLOUR, AS NEEDED
5	PLUMS, PITTED AND SLICED
½	CUP SUGAR, PLUS 1 TABLESPOON
	JUICE OF ½ LEMON
3	TABLESPOONS CORNSTARCH
	PINCH OF FINE SEA SALT
2	TABLESPOONS BLACKBERRY JAM
1	EGG, BEATEN

CHOCOLATE & BOURBON PECAN PIE

YIELD: 1 PIE / **ACTIVE TIME:** 30 MINUTES / **TOTAL TIME:** 2 HOURS AND 30 MINUTES

The deep, complex flavor of bourbon adds dimension to this exceptionally sweet treat.

1. Preheat the oven to 375°F. Coat a 9-inch pie plate with nonstick cooking spray and place the piecrust in it. Trim away any excess and crimp the edge.

2. Place the pecans on a parchment-lined baking sheet, place them in the oven, and toast until fragrant, 8 to 10 minutes. Remove the pecans from the oven and let them cool.

3. Place the eggs, dark brown sugar, corn syrup, vanilla, salt, and bourbon in a mixing bowl and whisk until combined.

4. Cover the bottom of the piecrust with the semisweet chocolate chips. Arrange the toasted pecans on top of the chocolate chips and then pour the filling into the crust.

5. Place the pie in the oven and bake until the center of the pie is set, 55 to 60 minutes.

6. Remove the pie from the oven, place it on a cooling rack, and let it cool for 1 to 2 hours before slicing and serving.

INGREDIENTS:

1	PERFECT PIECRUST (SEE PAGE 218), ROLLED OUT
8	OZ. LARGE PECAN HALVES
3	EGGS
6	OZ. DARK BROWN SUGAR
1	CUP LIGHT CORN SYRUP
1	TEASPOON PURE VANILLA EXTRACT
½	TEASPOON KOSHER SALT
2	TABLESPOONS BOURBON
5	OZ. SEMISWEET CHOCOLATE CHIPS

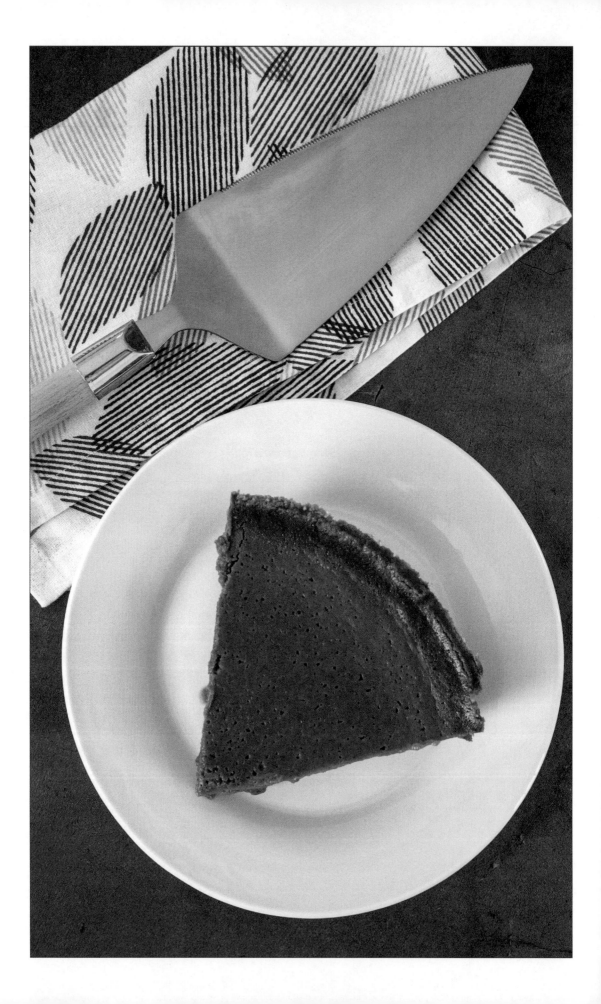

SWEET POTATO PIE

YIELD: 1 PIE / **ACTIVE TIME:** 20 MINUTES / **TOTAL TIME:** 4 HOURS AND 30 MINUTES

A Southern favorite that, when executed by a practiced hand, will win over even those who wrinkle their noses at the thought of sweet potatoes.

1. Preheat the oven to 350°F. Place the sweet potato puree, eggs, heavy cream, brown sugar, cinnamon, nutmeg, ginger, vanilla, and salt in a mixing bowl and whisk until smooth.

2. Pour the filling into the crust, place the pie in the oven, and bake until the filling is just set, about 30 minutes.

3. Remove from the oven, place the pie on a cooling rack, and let it sit for 30 minutes.

4. Place the pie in the refrigerator and chill for 3 hours.

5. To serve, top each slice with a dollop of Chantilly Cream.

INGREDIENTS:

15 OZ. SWEET POTATO PUREE

2 EGGS

½ CUP HEAVY CREAM

1 CUP DARK BROWN SUGAR

1 TEASPOON CINNAMON

½ TEASPOON FRESHLY GRATED NUTMEG

¼ TEASPOON GROUND GINGER

½ TEASPOON PURE VANILLA EXTRACT

¼ TEASPOON KOSHER SALT

1 GRAHAM CRACKER CRUST (SEE PAGE 222)

CHANTILLY CREAM (SEE PAGE 668), FOR SERVING

NUTTY CARAMEL & CRANBERRY PIE

YIELD: 1 PIE / **ACTIVE TIME:** 45 MINUTES / **TOTAL TIME:** 3 HOURS

With a bedeviling texture, considerable lusciousness, and a complex play of flavors, this simple pie is far more than the sum of its parts.

1. Preheat the oven to 375°F. Coat a 9-inch pie plate with nonstick cooking spray and place the Perfect Piecrust in it.

2. Place the almonds and cashews on a parchment-lined baking sheet, place them in the oven, and toast until they are fragrant and starting to brown, 8 to 10 minutes. Remove from the oven and let them cool. Leave the oven on.

3. In a medium saucepan, bring the sugar and water to a boil over high heat. Cook, swirling the pan occasionally, until the mixture is a deep amber color. Remove the pan from heat.

4. Whisk the butter, vanilla, and salt into the caramel, taking care as the mixture may splatter. Let the caramel cool.

5. Place the toasted nuts and cranberries in a mixing bowl and toss to combine. Place the mixture in the piecrust and pour the caramel over it until the crust is filled. Save any remaining caramel for another preparation.

6. Place the pie in the oven and bake until the filling is set at the edge and the center barely jiggles when you shake the pie plate, about 1 hour. Remove from the oven and let the pie cool completely before slicing and serving.

INGREDIENTS:

1 PERFECT PIECRUST (SEE PAGE 218), ROLLED OUT

1 CUP SLIVERED ALMONDS

1 CUP CASHEWS, CHOPPED

1⅓ CUPS SUGAR

½ CUP WATER

6 TABLESPOONS BUTTER

1 TEASPOON PURE VANILLA EXTRACT

¼ TEASPOON KOSHER SALT

1½ CUPS FRESH CRANBERRIES

SHOOFLY PIE

YIELD: 1 PIE / **ACTIVE TIME:** 15 MINUTES / **TOTAL TIME:** 1 HOUR AND 15 MINUTES

This pie originated in Pennsylvania Dutch country during the late nineteenth century, when it was seen as the ideal accompaniment to a powerful cup of coffee first thing in the morning.

1. Preheat the oven to 350°F. Place the molasses, baking soda, and boiling water in a large mixing bowl and stir to combine. Evenly distribute the mixture in the piecrust.

2. Place the flour, brown sugar, cinnamon, nutmeg, and salt in a large mixing bowl and stir to combine. Add the butter and work the mixture with your hands until it is sticking together in clumps. Distribute the mixture over the pie.

3. Place the pie in the oven and bake until the crust is golden brown and the topping is dry to the touch, about 45 minutes. Remove from the oven and let it cool before serving.

INGREDIENTS:

1	CUP MOLASSES
1	TEASPOON BAKING SODA
¾	CUP BOILING WATER
1	PÂTÉ SUCRÉE (SEE PAGE 221), ROLLED OUT
1½	CUPS ALL-PURPOSE FLOUR
½	CUP PACKED DARK BROWN SUGAR
½	TEASPOON CINNAMON
	PINCH OF FRESHLY GRATED NUTMEG
	PINCH OF FINE SEA SALT
4	OZ. UNSALTED BUTTER, CHILLED AND DIVIDED INTO TABLESPOONS

HAM & CHEESE QUICHE

YIELD: 1 QUICHE / **ACTIVE TIME:** 15 MINUTES / **TOTAL TIME:** 2 HOURS

This quiche is a great spot for ham left over from a holiday dinner.

1. Preheat the oven to 350°F. Place the eggs, heavy cream, salt, and pepper in a mixing bowl and whisk until combined. Set the mixture aside.

2. Lay two slices of the cheese in the bottom of the crust, followed by two slices of the ham. Alternate layers of cheese and ham until all of the slices have been used.

3. Pour the egg mixture into the crust, stopping when it reaches the top.

4. Place the quiche in the oven and bake until the center is set and the filling is lightly golden brown, 35 to 45 minutes.

5. Remove the quiche from the oven, transfer it to a wire rack, and let it cool for 1 hour before serving. The quiche will be enjoyable warm, at room temperature, or cold.

INGREDIENTS:

8	EGGS
1	CUP HEAVY CREAM
1	TEASPOON KOSHER SALT
¼	TEASPOON BLACK PEPPER
8	SLICES OF SWISS CHEESE
1	PERFECT PIECRUST (SEE PAGE 218), BLIND BAKED
8	SLICES OF SMOKED HAM

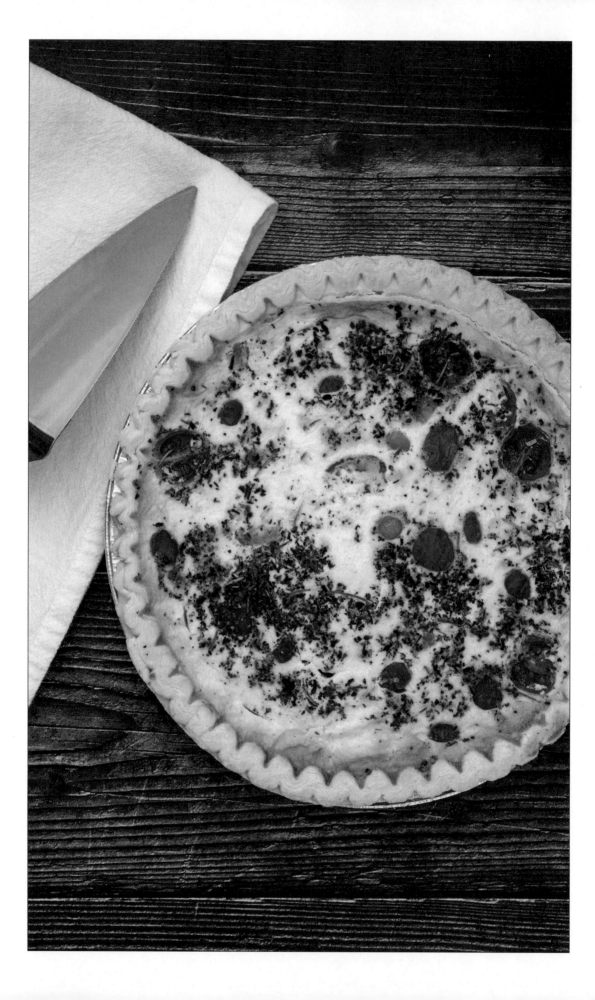

TOMATO, FETA & HERB QUICHE

YIELD: 1 QUICHE / **ACTIVE TIME:** 15 MINUTES / **TOTAL TIME:** 2 HOURS

The herbs bridge the gap between the subtle acidity of the tomatoes and the savory feta, resulting in a lovely, bright quiche.

1. Preheat the oven to 350°F. Place the eggs, heavy cream, salt, pepper, and herbes de Provence in a mixing bowl and whisk until combined. Set the mixture aside.

2. Sprinkle the feta over the bottom of the crust and evenly distribute the cherry tomatoes over the top. Pour the egg mixture into the crust, stopping when it reaches the top.

3. Place the quiche in the oven and bake until the center is set and the filling is lightly golden brown, 35 to 45 minutes.

4. Remove the quiche from the oven, transfer it to a wire rack, and let it cool for 1 hour before serving. The quiche will be enjoyable warm, at room temperature, or cold.

INGREDIENTS:

8	EGGS
1	CUP HEAVY CREAM
1	TEASPOON KOSHER SALT
¼	TEASPOON BLACK PEPPER
1	TEASPOON HERBES DE PROVENCE
1	CUP CRUMBLED FETA CHEESE
1	PERFECT PIECRUST (SEE PAGE 218), BLIND BAKED
1	PINT OF CHERRY TOMATOES, HALVED

BUTTERNUT SQUASH QUICHE

YIELD: 1 QUICHE / **ACTIVE TIME:** 30 MINUTES / **TOTAL TIME:** 2 HOURS AND 30 MINUTES

Save this one for those crisp and impossibly bright mornings that the fall specializes in.

1. Preheat the oven to 350°F. Place the eggs, heavy cream, salt, and pepper in a mixing bowl and whisk until combined. Set the mixture aside.

2. Place the olive oil in a large skillet and warm it over medium-high heat. Working in batches if necessary to avoid crowding the pan, add the butternut squash and cook, stirring occasionally, until it is nearly cooked through, about 10 minutes.

3. Add the garlic, spinach, and rosemary to the pan and cook until the spinach has wilted, about 2 minutes. Remove the pan from heat and let the vegetable mixture cool.

4. Sprinkle the goat cheese over the bottom of the crust and evenly distribute the vegetable mixture over the top. Pour the egg mixture into the crust, stopping when it reaches the top.

5. Place the quiche in the oven and bake until the center is set and the filling is lightly golden brown, 35 to 45 minutes.

6. Remove the quiche from the oven, transfer it to a cooling rack, and let it cool for 1 hour. The quiche will be enjoyable warm, at room temperature, or cold.

INGREDIENTS:

8	EGGS
1	CUP HEAVY CREAM
1	TEASPOON KOSHER SALT
¼	TEASPOON BLACK PEPPER
1	TABLESPOON EXTRA-VIRGIN OLIVE OIL
2	CUPS DICED BUTTERNUT SQUASH (½-INCH DICE)
2	GARLIC CLOVES, MINCED
1	CUP FRESH SPINACH
1	TEASPOON MINCED FRESH ROSEMARY
½	CUP CRUMBLED GOAT CHEESE
1	PERFECT PIECRUST (SEE PAGE 218), BLIND BAKED

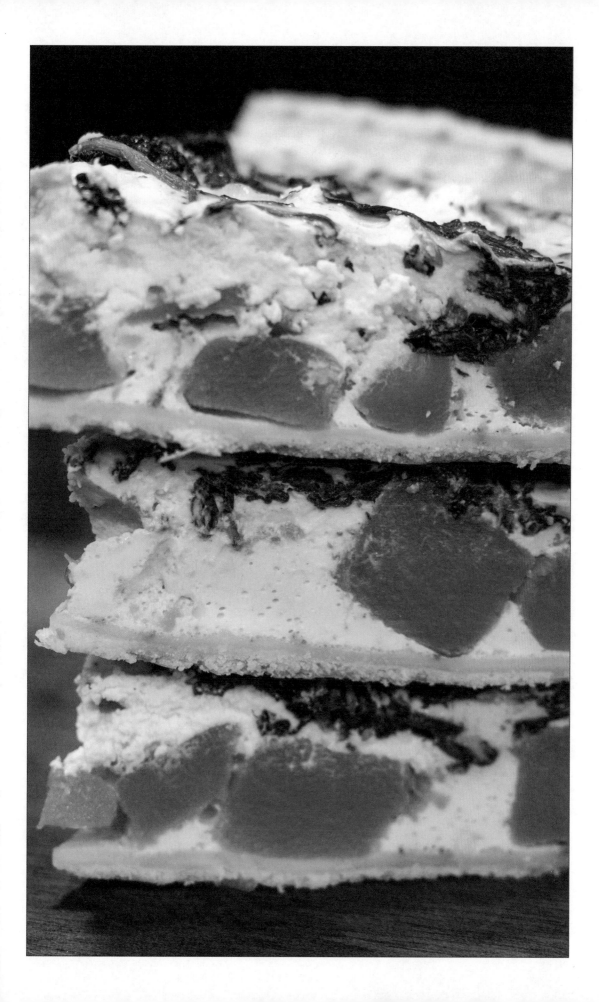

ROASTED SUMMER SQUASH QUICHE

YIELD: 1 QUICHE / **ACTIVE TIME:** 30 MINUTES / **TOTAL TIME:** 2 HOURS AND 30 MINUTES

Try to track down the sharpest cheddar cheese you can when you get a hankering for this one.

1. Preheat the oven to 400°F. Place the eggs, heavy cream, half of the salt, and the ¼ teaspoon of pepper in a mixing bowl and whisk until combined. Set the mixture aside.

2. Place the squash, zucchini, olive oil, and remaining salt and pepper in a mixing bowl and toss to coat. Transfer the mixture to a baking sheet, place it in the oven, and roast until the vegetables are tender and lightly browned, about 15 minutes. Remove from the oven and let it cool. Lower the oven's temperature to 350°F.

4. Sprinkle the cheddar cheese over the bottom of the crust and evenly distribute the roasted vegetable mixture over the top. Pour the egg mixture into the crust, stopping when it reaches the top.

5. Place the quiche in the oven and bake until the center is set and the filling is lightly golden brown, 35 to 45 minutes.

6. Remove the quiche from the oven, transfer it to a cooling rack, and let it cool for 1 hour. The quiche will be enjoyable warm, at room temperature, or cold.

INGREDIENTS:

8 EGGS

1 CUP HEAVY CREAM

1 TEASPOON KOSHER SALT

¼ TEASPOON BLACK PEPPER, PLUS 1 PINCH

1 YELLOW SQUASH, SLICED THIN

1 ZUCCHINI, SLICED THIN

1 TABLESPOON EXTRA-VIRGIN OLIVE OIL

1 CUP SHREDDED SHARP CHEDDAR CHEESE

1 PERFECT PIECRUST (SEE PAGE 218), BLIND BAKED

GARDEN VEGETABLE QUICHE

YIELD: 1 QUICHE / **ACTIVE TIME:** 30 MINUTES / **TOTAL TIME:** 2 HOURS AND 30 MINUTES

The savory, meaty mushrooms allow this versatile quiche to facilitate whatever other vegetables are growing in your garden, or available at the farmers market.

1. Preheat the oven to 350°F. Place the eggs, heavy cream, salt, and pepper in a mixing bowl and whisk until combined. Set the mixture aside.

2. Place the olive oil in a large skillet and warm it over medium-high heat. Add the mushrooms, onion, and broccoli and cook, stirring occasionally, until they start to soften, about 5 minutes.

3. Add the garlic and spinach and cook until the spinach has wilted, about 2 minutes. Remove the pan from heat and let the vegetable mixture cool.

4. Sprinkle the gouda cheese over the bottom of the crust and evenly distribute the vegetable mixture over the top. Pour the egg mixture into the crust, stopping when it reaches the top.

5. Place the quiche in the oven and bake until the center is set and the filling is lightly golden brown, 35 to 45 minutes.

6. Remove the quiche from the oven, transfer it to a cooling rack, and let it cool for 1 hour. The quiche will be enjoyable warm, at room temperature, or cold.

INGREDIENTS:

8	EGGS
1	CUP HEAVY CREAM
1	TEASPOON KOSHER SALT
¼	TEASPOON BLACK PEPPER
1	TABLESPOON EXTRA-VIRGIN OLIVE OIL
½	CUP SLICED MUSHROOMS
½	RED ONION, SLICED THIN
½	CUP BROCCOLI FLORETS, CHOPPED
3	GARLIC CLOVES, MINCED
½	CUP SPINACH
1	CUP SHREDDED SMOKED GOUDA CHEESE
1	PERFECT PIECRUST (SEE PAGE 218), BLIND BAKED

CHICKEN POT PIE

YIELD: 1 PIE / **ACTIVE TIME:** 30 MINUTES / **TOTAL TIME:** 1 HOUR AND 30 MINUTES

Classic comfort food. If you're feeling industrious, make a few and store them in the freezer. They'll come in handy on those winter nights when the weather is foreboding.

1. Preheat the oven to 400°F. Place the olive oil in a large skillet and warm it over medium-high heat. Add the onions, carrots, and celery and cook, stirring occasionally, until tender, about 8 minutes.

2. Add the thyme, pepper, salt, chicken, and flour and stir until incorporated.

3. Add the stock and heavy cream, stirring to prevent any lumps from forming. Reduce the heat to medium-low and cook until the sauce has thickened, about 10 minutes.

4. Pour the mixture into a 9-inch pie plate, add the frozen vegetables, and let the mixture cool.

5. Place the piecrust over the filling and trim away any excess. Crimp the edge to seal, cut four small slits in the crust, and brush it with the beaten egg.

6. Place the pie in the oven and bake until the crust is golden brown, 45 to 50 minutes.

7. Remove the pie from the oven, place it on a cooling rack, and let it cool for 15 minutes before slicing and serving.

CHICKEN STOCK

1. Place the chicken bones in a stockpot and cover with cold water. Bring to a simmer over medium-high heat, and use a ladle to skim off any impurities that rise to the surface. Add the vegetables, thyme, peppercorns, and bay leaf, reduce the heat to low, and simmer for 5 hours, while skimming to remove any impurities that rise to the surface.

2. Strain, allow it to cool slightly, and transfer to the refrigerator. Leave uncovered and allow it to cool completely. Remove the layer of fat and cover. The stock will keep in the refrigerator for 3 to 5 days, and in the freezer for up to 3 months.

INGREDIENTS:

2	TABLESPOONS EXTRA-VIRGIN OLIVE OIL
½	CUP DICED ONIONS
½	CUP DICED CARROTS
½	CUP DICED CELERY
2	TEASPOONS DRIED THYME
½	TEASPOON BLACK PEPPER
1	TEASPOON KOSHER SALT
2	CUPS SHREDDED COOKED CHICKEN
½	CUP ALL-PURPOSE FLOUR
2	CUPS CHICKEN STOCK (SEE RECIPE)
½	CUP HEAVY CREAM
1	CUP FROZEN PEAS
½	CUP FROZEN CORN
1	PERFECT PIECRUST (SEE PAGE 218), ROLLED OUT
1	EGG, BEATEN

CHICKEN STOCK

7	LBS. CHICKEN BONES, RINSED
4	CUPS CHOPPED YELLOW ONIONS
2	CUPS CHOPPED CARROTS
2	CUPS CHOPPED CELERY
3	GARLIC CLOVES, CRUSHED
3	SPRIGS OF FRESH THYME
1	TEASPOON BLACK PEPPERCORNS
1	BAY LEAF

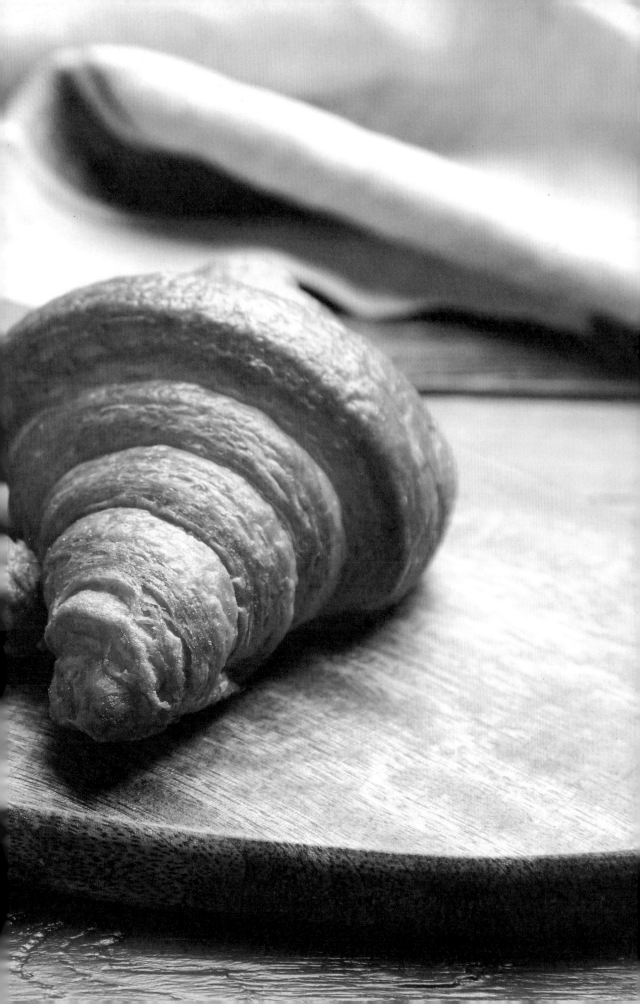

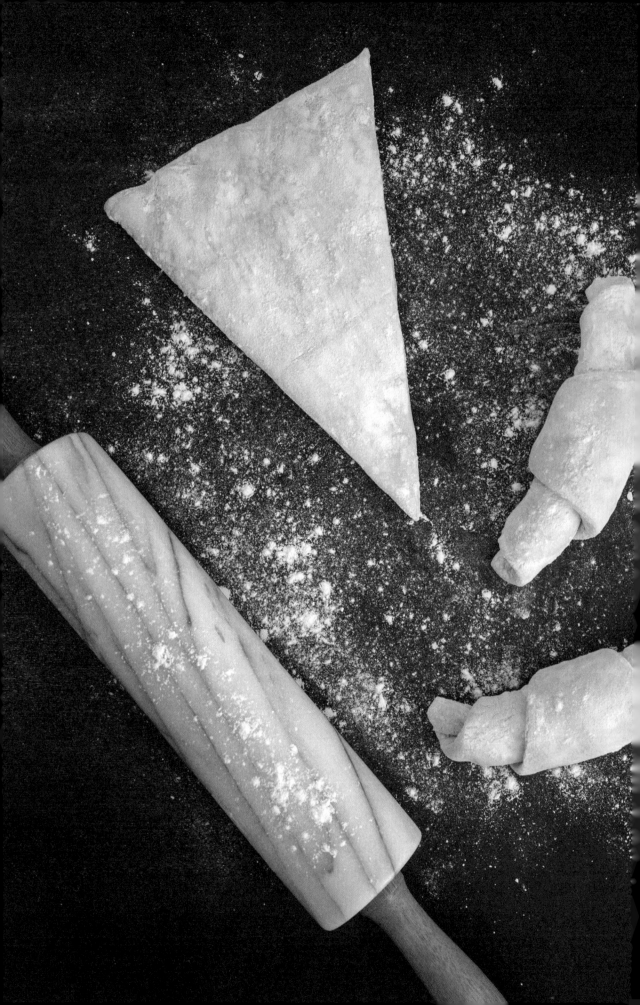

PASTRIES

*M*any a foodie will tell you that a pastry was their first love. One day, while accompanying a parent to the store in order to pick up things for dinner, they caught an unimaginably beautiful and promising sight out of the corner of their eye. A delicate, golden beauty, sequestered behind glass. They held their breath, feeling wonder but also pain, sure that this wonder could never be theirs. Try as they may to forget, it remained front of mind, growing in force until, eventually, they could no longer remain apart from it. And, somehow, the actual experience managed to match the ideal that had been fashioned.

This section offers considerable opportunities to create similarly lovely collisions for those you love. These recipes also offer a chance to stretch yourself in the kitchen once you've cut your teeth on some of the more rudimentary preparations in this book. So when it is time to really dazzle someone, or you've got one of those precious weekends with no plans and snow coming in, pass your time composing one of the confections in this chapter. You won't regret it.

CROISSANT DOUGH

YIELD: DOUGH FOR 16 CROISSANTS / **ACTIVE TIME:** 2 HOURS / **TOTAL TIME:** 12 HOURS

The mother of all laminated doughs. This recipe is for a base dough that will be used to make all your favorite croissant flavors and variations. One last thing: should you find that this recipe is not quite hitting the mark, try using cultured butter—some bakers swear it is the only option when making croissants.

1. To begin preparations for the dough, place the yeast, water, and milk in the work bowl of a stand mixer fitted with the dough hook, gently stir, and let the mixture sit until it starts to foam, about 10 minutes.

2. Add the sugar, flour, and salt and knead the mixture on low until it comes together as a dough, about 5 minutes. Add the butter, continue to knead on low for 2 minutes, and then raise the speed to medium. Knead until the dough is smooth and the butter has been entirely incorporated, 6 to 7 minutes.

3. Spray a mixing bowl with nonstick cooking spray. Transfer the dough to the bowl, cover it with plastic wrap, and chill in the refrigerator for 3 hours.

4. While the croissant dough is resting, prepare the butter block. Fit the stand mixer with the paddle attachment, add the butter and flour, and beat the mixture until smooth. Transfer the mixture to a silicone baking mat that is in a baking sheet. Use a small spatula to spread the mixture into a 7 x 10–inch rectangle. Place the baking sheet in the refrigerator for 30 minutes to 1 hour. You want the butter block to be firm but pliable. If the butter block is too firm for the following steps, let the butter sit at room temperature for a few minutes.

5. Remove the dough from the refrigerator, place it on a flour-dusted work surface, and roll it into a 10 x 20–inch rectangle.

6. Place the butter block in the center of the dough. Fold the dough over the butter block like a letter, folding a third of the dough from the left side of the dough and a third from the right so that they meet in the center. Pinch the seam to seal.

7. Turn the dough 90 degrees clockwise and flip it over so that the seam is facing down. Roll out the dough into a 10 x 20–inch rectangle. Make another letter fold of the dough, place the dough on the Silpat mat, and cover it with plastic wrap. Chill in the refrigerator for 1 hour.

INGREDIENTS:

FOR THE DOUGH

2	TABLESPOONS ACTIVE DRY YEAST
8	OZ. WATER
8	OZ. MILK
2	OZ. SUGAR
29	OZ. ALL-PURPOSE FLOUR, PLUS MORE AS NEEDED
1	TABLESPOON KOSHER SALT, PLUS 1 TEASPOON
11	OZ. UNSALTED BUTTER, SOFTENED

FOR THE BUTTER BLOCK

1	LB. UNSALTED BUTTER, SOFTENED
¼	CUP ALL-PURPOSE FLOUR

8. Place the dough on a flour-dusted work surface, roll it into a 10 x 20–inch rectangle, and fold the dough like a letter, lengthwise. Pinch the seam to seal, turn the dough 90 degrees clockwise, and flip the dough over so that the seam is facing down. Place the dough back on the baking sheet, cover it in plastic wrap, and refrigerate for 1 hour.

9. Place the dough on a flour-dusted work surface, roll it into a 10 x 20–inch rectangle, and fold the dough like a letter, lengthwise. Pinch the seam to seal, turn the dough 90 degrees clockwise, and flip the dough over so that the seam is facing down. Place the dough back on the baking sheet, cover it in plastic wrap, and refrigerate for 4 hours. After this period of rest, the dough will be ready to make croissants with.

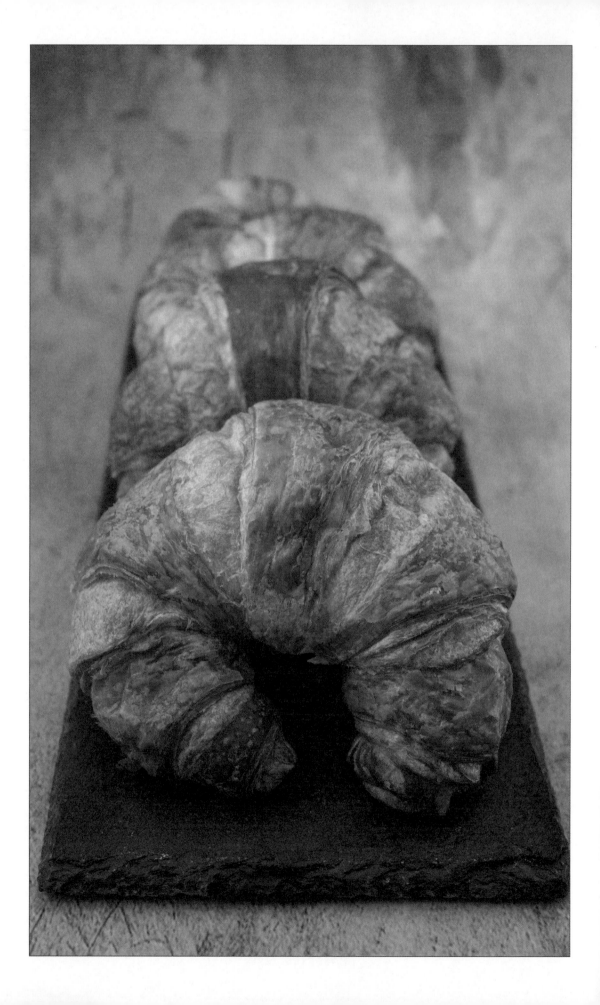

CLASSIC CROISSANTS

YIELD: 16 CROISSANTS / **ACTIVE TIME:** 30 MINUTES / **TOTAL TIME:** 2 HOURS

The perfectly flaky and buttery croissants everyone dreams of leaving it all behind and moving to Paris for.

1. Line two baking sheets with parchment paper.

2. Place the dough on a flour-dusted work surface and roll it into an 8 x 20–inch rectangle. Using a pizza cutter or chef's knife, cut the dough horizontally in the center so that you have two 4 x 20–inch rectangles. Cut each rectangle vertically into strips that are 5 inches wide.

3. Cut each rectangle diagonally, yielding 16 triangles.

4. Gently roll out each triangle until it is 8 inches long. Roll the croissants up tight, moving from the wide side of the triangle to the tip. Tuck the tips under the croissants and slightly bend the ends inward to give the croissants their iconic crescent shape. Place eight croissants on each of the baking sheets.

5. Cover the baking sheets with plastic wrap and let the croissants rest at room temperature for 1 hour.

6. Preheat the oven to 400°F.

7. Remove the plastic wrap and brush the croissants with the beaten egg.

8. Place the croissants in the oven and bake until they are golden brown, 20 to 22 minutes.

9. Remove the croissants from the oven and place them on wire racks. Let them cool slightly before serving.

INGREDIENTS:

CROISSANT DOUGH (SEE PAGE 294)

ALL-PURPOSE FLOUR, AS NEEDED

1 EGG, BEATEN

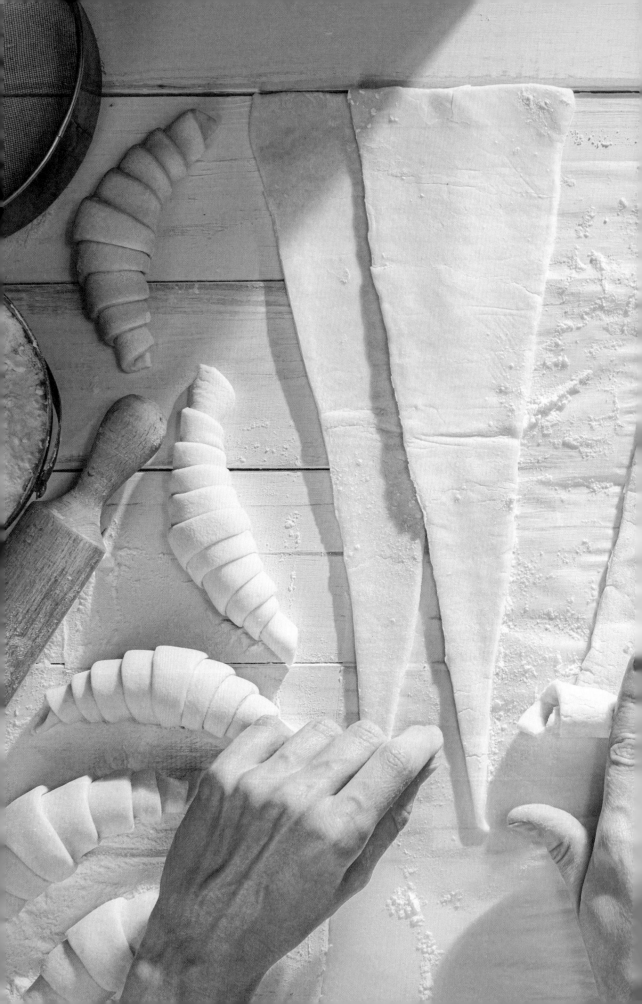

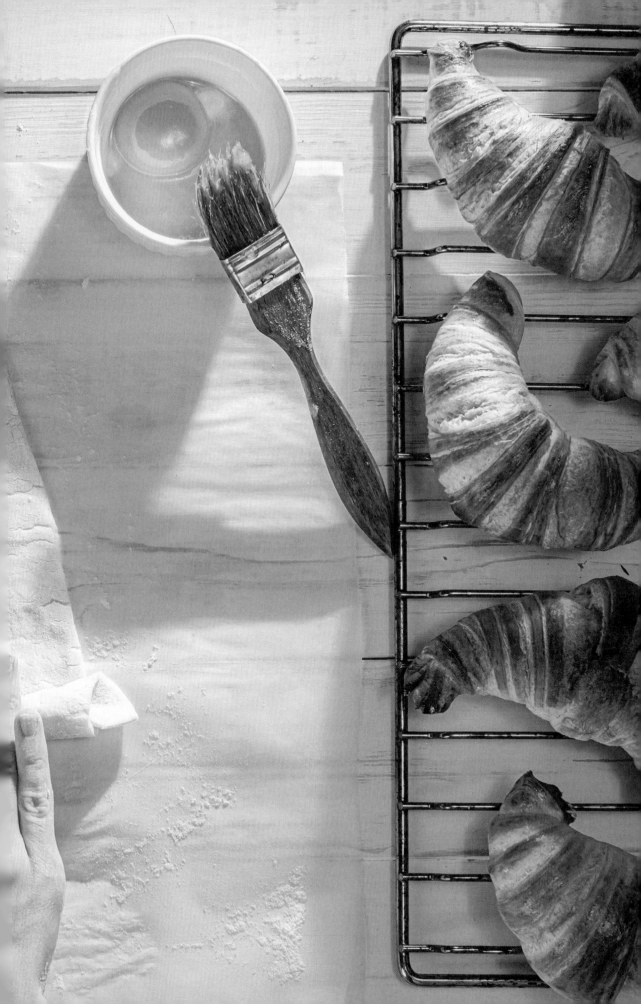

ECLAIRS

YIELD: 12 ECLAIRS / **ACTIVE TIME:** 40 MINUTES / **TOTAL TIME:** 1 HOUR AND 30 MINUTES

Adecadent dessert that manages to return everyone to the excitement they felt as a child, when procuring something sweet was the primary focus.

1. Preheat the oven to 425°F and line two baking sheets with parchment paper. In a medium saucepan, combine the water, butter, salt, and sugar and warm the mixture over medium heat until the butter is melted.

2. Add the flour to the pan and use a rubber spatula or wooden spoon to fold the mixture until it comes together as a thick, shiny dough, taking care not to let the dough burn.

3. Transfer the dough to the work bowl of a stand mixer fitted with the paddle attachment and beat on medium until the dough is no longer steaming and the bowl is just warm to the touch, at least 10 minutes.

4. Incorporate the eggs two at a time, scraping down the work bowl between each addition. Transfer the dough to a piping bag fit with a plain tip. Pipe 12 eclairs onto the baking sheets, leaving 1½ inches between them. They should be approximately 5 inches long.

5. Place the eclairs in the oven and bake for 10 minutes. Lower the oven's temperature to 325°F and bake until they are golden brown and a cake tester inserted into their centers comes out clean, 20 to 25 minutes. Remove from the oven and let them cool on wire racks.

6. Fill a piping bag fitted with a plain tip with the Pastry Cream.

7. Using a paring knife, cut 3 small slits on the undersides of the eclairs and fill them with the Pastry Cream.

8. Carefully dip the top halves of the eclairs in the ganache, or drizzle the ganache over the pastries. Allow the chocolate to set before serving.

INGREDIENTS:

17 OZ. WATER

8.5 OZ. UNSALTED BUTTER

1 TEASPOON FINE SEA SALT

2.4 OZ. SUGAR

12.5 OZ. ALL-PURPOSE FLOUR

6 EGGS

PASTRY CREAM (SEE PAGE 671)

CHOCOLATE GANACHE (SEE PAGE 664), WARM

CHOCOLATE CAKE DOUGHNUTS

YIELD: 12 DOUGHNUTS / **ACTIVE TIME:** 1 HOUR / **TOTAL TIME:** 24 HOURS

For those who prize tenderness while tending to their sweet tooth, these doughnuts are a godsend.

1. In the work bowl of a stand mixer fitted with the paddle attachment, cream the sugar and butter on medium until light and fluffy, about 5 minutes.

2. Incorporate the egg yolks one at a time, scraping down the work bowl as needed. When all of the egg yolks have been incorporated, add the sour cream and beat until incorporated. Add the flour, cocoa powder, baking powder, and salt and beat until the mixture comes together as a dough.

3. Coat a medium heatproof bowl with nonstick cooking spray, transfer the dough to the bowl, and cover it with plastic wrap. Refrigerate overnight.

4. Place the canola oil in a Dutch oven fitted with a candy thermometer and warm the oil to 350°F over medium heat. Set a cooling rack in a rimmed baking sheet beside the stove.

5. Remove the dough from the refrigerator and place it on a flour-dusted work surface. Roll the dough out until it is ½ inch thick. Cut out the donuts using a round, 4-inch cookie cutter, and then use a round, 1-inch cookie cutter to cut out the centers.

6. Transfer the doughnuts to the wire rack and let them sit at room temperature for 10 minutes.

7. Working in batches, carefully place the doughnuts in the oil and fry, turning them once, until they are browned and cooked through, about 4 minutes. A cake tester inserted into the center of the doughnuts should come out clean. Transfer the cooked doughnuts to the wire rack to drain and cool.

8. When cool, dip the doughnuts in the glaze, place them on a piece of parchment paper, and let the glaze set before enjoying.

INGREDIENTS:

- 6 OZ. SUGAR
- 1 OZ. UNSALTED BUTTER, SOFTENED
- 3 EGG YOLKS
- 10.8 OZ. SOUR CREAM
- 11.4 OZ. ALL-PURPOSE FLOUR, PLUS MORE AS NEEDED
- 2.9 OZ. COCOA POWDER
- 2 TEASPOONS BAKING POWDER
- 1 TABLESPOON KOSHER SALT
- 4 CUPS CANOLA OIL
- HONEY GLAZE (SEE PAGE 678)

CANELÉS

YIELD: 18 CANELÉS / **ACITVE TIME:** 1 HOUR / **TOTAL TIME:** 2 DAYS

A bit of infrastructure is needed here if you want your canelés to achieve their highest form—expensive (though beautiful) copper molds to conduct the heat well enough to get the proper level of caramelization, as well as beeswax to coat them.

1. To begin preparations for the pastries, place the milk and butter in a saucepan. If using the vanilla bean, halve it, scrape the seeds into the saucepan, and add the pod as well. If using extract, stir it in. Place the pan over medium heat and bring the mixture to a simmer. Immediately remove the pan from heat and let it sit for 10 minutes.

2. In a large mixing bowl, whisk the flour, sugar, and salt together. Set the mixture aside. Place the eggs and egg yolks in a heatproof mixing bowl and whisk to combine, making sure not to add any air to the mixture.

3. While whisking the egg mixture, add the milk mixture in small increments. When all of the milk mixture has been thoroughly incorporated, whisk in the rum or Cognac.

4. Remove the vanilla bean pod and reserve. While whisking, add the tempered eggs to the dry mixture and whisk until just combined, taking care not to overwork the mixture. Strain the custard through a fine sieve. If the mixture is still warm, place the bowl in an ice bath until it has cooled.

5. Add the vanilla bean pod to the custard, cover it with plastic wrap, and refrigerate for at least 24 hours; however, 48 hours is strongly recommended.

6. Preheat the oven to 500°F. To prepare the molds, grate the beeswax into a mason jar and add the butter. Place the jar in a saucepan filled with a few inches of water and bring the water to a simmer. When the beeswax mixture is melted and combined, pour it into one mold, immediately pour it back into the jar, and set the mold, right side up, on a wire rack to drain. When all of the molds have been coated, place them in the freezer for 15 minutes. Remove the custard from the refrigerator and let it come to room temperature.

7. Pour the custard into the molds so that they are filled about 85 percent of the way. Place the filled molds, upside down, on a baking sheet, place them in the oven, and bake for 10 minutes. Reduce the oven's temperature to 375°F and bake until they are a deep brown, about 40 minutes. Turn the canelés out onto a wire rack and let them cool completely before enjoying. Reheat the beeswax mixture and let the molds cool before refilling them with the remaining batter.

INGREDIENTS:

FOR THE PASTRIES

17.1 OZ. WHOLE MILK

1.75 OZ. CULTURED BUTTER, SOFTENED

1 VANILLA BEAN OR 1 TABLESPOON PURE VANILLA EXTRACT

3.5 OZ. ALL-PURPOSE FLOUR

7 OZ. SUGAR

PINCH OF FINE SEA SALT

2 EGGS

2 EGG YOLKS

1.75 OZ. DARK RUM OR COGNAC

FOR THE MOLDS

1.75 OZ. BEESWAX

1.75 OZ. UNSALTED BUTTER

PARIS-BREST

YIELD: 6 PASTRIES / **ACTIVE TIME:** 50 MINUTES / **TOTAL TIME:** 2 HOURS

A classic French pastry that was created in 1910 to commemorate the Paris-Brest-Paris bicycle race, with its circular shape representing a wheel.

1. Preheat the oven to 425°F and line two baking sheets with parchment paper. In a medium saucepan, combine the water, butter, salt, and sugar and warm the mixture over medium heat until the butter is melted.

2. Add the flour to the pan and use a rubber spatula or wooden spoon to fold the mixture until it comes together as a thick, shiny dough, taking care not to let the dough burn.

3. Transfer the dough to the work bowl of a stand mixer fitted with the paddle attachment and beat on medium until the dough is no longer steaming and the bowl is just warm to the touch, at least 10 minutes.

4. Incorporate six of the eggs two at a time, scraping down the work bowl between each addition. Transfer the dough to a piping bag fitted with a #867 tip (this will be called a "French Star Tip" on occasion).

5. Pipe a 5-inch ring of dough onto a baking sheet and then pipe another ring inside the first ring. Pipe another ring atop the seam between the first two rings. Repeat until all of the dough has been used.

6. In a small bowl, whisk the remaining egg and brush the tops of the dough with it. Arrange the almonds on top and gently press them down to ensure they adhere.

7. Place the pastries in the oven and bake for 10 minutes. Lower the oven's temperature to 300°F and bake until they are golden brown and a cake tester inserted into each one comes out clean, 30 to 35 minutes. Remove from the oven and let them cool on a wire rack.

8. Fill a piping bag fit with a plain tip with the mousseline. Using a serrated knife, slice the pastries in half along their equators. Pipe rosettes of the mousseline around the inside. Place the top half of the pastries on top, dust them with confectioners' sugar, and enjoy.

INGREDIENTS:

17	OZ. WATER
8.5	OZ. UNSALTED BUTTER
1	TEASPOON FINE SEA SALT
2.4	OZ. SUGAR
12.5	OZ. ALL-PURPOSE FLOUR
7	EGGS
1	CUP SLIVERED ALMONDS
	HAZELNUT MOUSSELINE (SEE RECIPE)
	CONFECTIONERS' SUGAR, FOR DUSTING

HAZELNUT MOUSSELINE

1. Place the sugar, egg yolks, and cornstarch in a mixing bowl and whisk for 2 minutes, so that the mixture is thoroughly combined. Set aside.

2. Place the milk in a medium saucepan and bring to a simmer over medium heat. While whisking continually, gradually add the warm milk to the egg yolk mixture until it has all been incorporated.

3. Pour the tempered egg yolks into the saucepan and cook over medium heat, stirring constantly. When the custard has thickened and begins to simmer, cook for another 30 seconds, and then remove the pan from heat.

4. Whisk in the remaining ingredients, strain the mousseline into a bowl through a fine-mesh sieve, and place plastic wrap directly on the top to keep a skin from forming. Place the mousseline in the refrigerator and chill for 2 hours before using. The mousseline will keep in the refrigerator for 5 days.

HAZELNUT PRALINE PASTE

1. Place the hazelnuts in a large, dry skillet and toast over medium heat until they just start to brown, about 5 minutes. Transfer the nuts to a clean, dry kitchen towel, fold the towel over the nuts, and rub them together until the skins have loosened. Place the toasted nuts on a parchment-lined baking sheet and discard the skins.

2. Place the sugar and water in a small saucepan and warm over medium heat, swirling the pan occasionally instead of stirring the mixture. Cook until the mixture is a deep golden brown and then pour it over the toasted hazelnuts. Let the mixture sit at room temperature until it has set.

3. Break the hazelnut brittle into pieces, place them in a blender, and add the canola oil and salt. Puree until the mixture is a smooth paste, and use as desired. The paste will keep in the refrigerator for up to 1 month.

INGREDIENTS:

HAZELNUT MOUSSELINE

½	CUP SUGAR
6	EGG YOLKS
3	TABLESPOONS CORNSTARCH
2	CUPS WHOLE MILK
¼	TEASPOON KOSHER SALT
1½	TEASPOONS PURE VANILLA EXTRACT
2	OZ. UNSALTED BUTTER, SOFTENED
¼	CUP HAZELNUT PRALINE PASTE (SEE RECIPE)

HAZELNUT PRALINE PASTE

2	CUPS HAZELNUTS
1	CUP SUGAR
3	TABLESPOONS WATER
2	TEASPOONS CANOLA OIL
¼	TEASPOON FINE SEA SALT

FRENCH CRULLERS

YIELD: 12 CRULLERS / **ACTIVE TIME:** 1 HOUR / **TOTAL TIME:** 1 HOUR AND 30 MINUTES

Made from choux pastry, these doughnuts are dangerously light and airy.

1. In a medium saucepan, combine the water, butter, salt, and sugar and warm the mixture over medium heat until the butter has melted.

2. Add the flour to the pan and use a rubber spatula or wooden spoon to fold the mixture until it comes together as a thick, shiny dough, taking care not to let the dough burn.

3. Transfer the dough to the work bowl of a stand mixer fitted with the paddle attachment and beat on medium until the dough is no longer steaming and the bowl is just warm to the touch, at least 10 minutes.

4. Incorporate the eggs two at a time, scraping down the work bowl between each addition. Transfer the dough to a piping bag fitted with a star tip.

5. Cut parchment paper into a dozen 4-inch squares, place them on a baking sheet, and coat them with nonstick cooking spray. Pipe a 4-inch circle of dough onto each parchment square, and place the baking sheet in the refrigerator for 30 minutes.

6. Place the canola oil in a Dutch oven fitted with a candy thermometer and warm the oil to 350°F over medium heat. Set a cooling rack in a rimmed baking sheet beside the stove.

7. Working in batches, carefully lower the dough, with the parchment attached, into the hot oil. Cook for 2 minutes, turn them over, and use tongs to remove the parchment paper. Cook until the crullers are a deep golden brown and then transfer them to the wire rack to drain and cool.

8. When the crullers are cool, dip them in the glaze and let it set before enjoying.

INGREDIENTS:

17	OZ. WATER
8.5	OZ. UNSALTED BUTTER
1	TEASPOON FINE SEA SALT
2.4	OZ. SUGAR
12.5	OZ. ALL-PURPOSE FLOUR
6	EGGS
4	CUPS CANOLA OIL
	HONEY GLAZE (SEE PAGE 678)

PAIN AU CHOCOLAT

YIELD: 16 CROISSANTS / **ACTIVE TIME:** 30 MINUTES / **TOTAL TIME:** 2 HOURS

Patience is a virtue—but don't let these linger too long after pulling them from the oven, as they are best warm.

1. Line two baking sheets with parchment paper.

2. Place the dough on a flour-dusted work surface and roll it into an 8 x 20–inch rectangle. Using a pizza cutter or chef's knife, cut the dough horizontally in the center so that you have two 4 x 20–inch rectangles. Cut each rectangle vertically into strips that are 5 inches wide.

3. Cut each rectangle in half at its equator, yielding 16 rectangles. Gently roll out each rectangle until it is 8 inches long.

4. Place 2 tablespoons of chocolate on one end of each rectangle and roll them up tightly.

5. Place eight croissants on each of the baking sheets. Cover the baking sheets with plastic wrap and let the croissants rest at room temperature for 1 hour.

6. Preheat the oven to 375°F.

7. Remove the plastic wrap and brush the croissants with the beaten egg.

8. Place the croissants in the oven and bake until they are golden brown, 20 to 22 minutes.

9. Remove the croissants from the oven and place them on wire racks. Let the croissants cool slightly before dusting them with confectioners' sugar and enjoying.

INGREDIENTS:

CROISSANT DOUGH (SEE PAGE 294)

ALL-PURPOSE FLOUR, AS NEEDED

2 CUPS DARK CHOCOLATE COINS (55 PERCENT), CHOPPED

1 EGG, BEATEN

CONFECTIONERS' SUGAR, FOR DUSTING

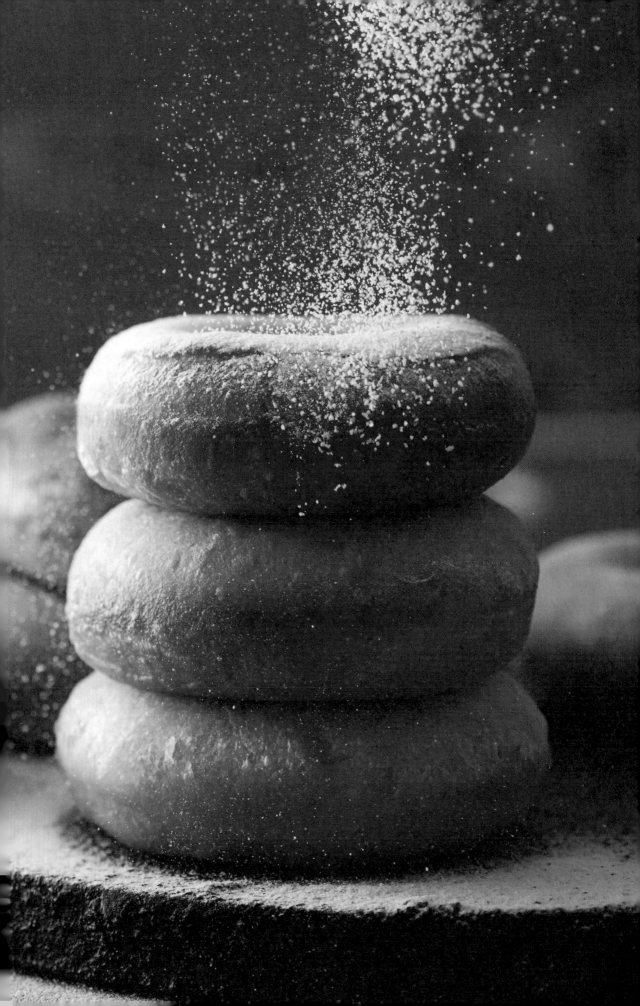

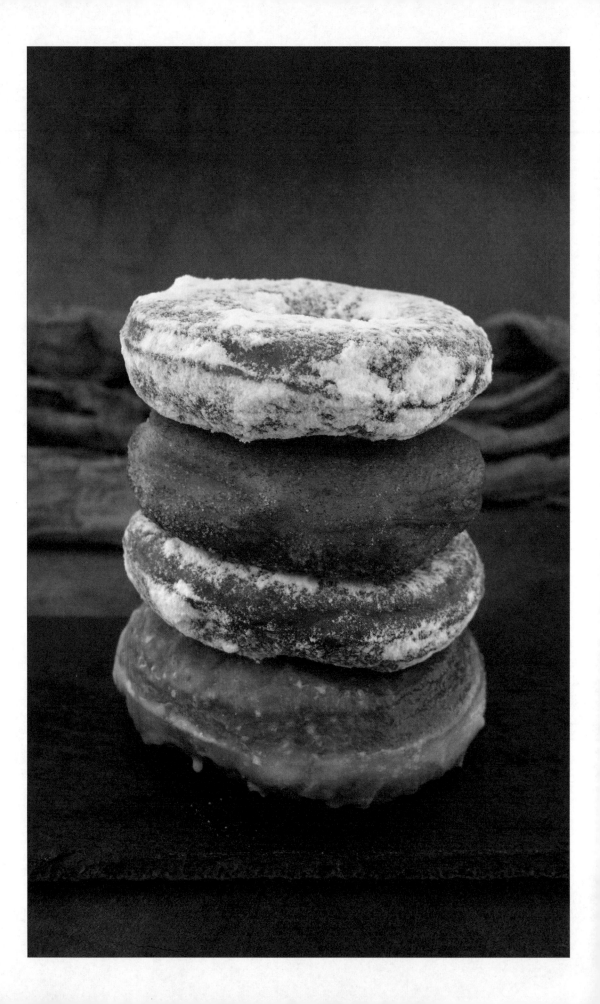

BRIOCHE DOUGHNUTS

YIELD: 15 DOUGHNUTS / **ACTIVE TIME:** 1 HOUR / **TOTAL TIME:** 24 HOURS

The preparation here is for the classic, centerless treats coated in a simple sweet glaze, but if you want to fill them with jam, Meyer Lemon Curd (see page 354), or Pastry Cream (see page 671), make sure you keep the centers intact.

1. In the work bowl of a stand mixer, combine the milk, water, yeast, sugar, nutmeg, egg, and egg yolk.

2. Add the flour and salt, fit the mixer with the dough hook, and knead on low for 5 minutes.

3. Gradually add the butter and knead to incorporate. When all of the butter has been incorporated, knead on low for 5 minutes.

4. Raise the speed to medium and knead until the dough starts to pull away from the sides of the work bowl, about 6 minutes. Cover the bowl with plastic wrap and place it in the refrigerator overnight.

5. Place the canola oil in a Dutch oven fitted with a candy thermometer and warm the oil to 350°F over medium heat. Set a cooling rack in a rimmed baking sheet beside the stove.

6. Remove the dough from the refrigerator and place it on a flour-dusted work surface. Roll the dough out until it is ½ inch thick. Cut out the donuts using a round, 4-inch cookie cutter, and then use a round, 1-inch cookie cutter to cut out the centers. If you want to fill the doughnuts, leave the centers in the rounds.

7. Transfer the doughnuts to the cooling rack and let them sit at room temperature for 10 minutes.

8. Working in batches, carefully place the doughnuts in the oil and fry, turning them once, until they are browned and cooked through, 2 to 4 minutes. Transfer the cooked doughnuts to the wire rack to drain and cool.

9. When the doughnuts have cooled, coat them in the glaze and let it set before enjoying.

INGREDIENTS:

1	CUP MILK
1	CUP WATER
2	TABLESPOONS ACTIVE DRY YEAST
4	OZ. SUGAR
¼	TEASPOON FRESHLY GRATED NUTMEG
1	EGG
1	EGG YOLK
28	OZ. BREAD FLOUR, PLUS MORE AS NEEDED
1	TEASPOON KOSHER SALT
3	OZ. UNSALTED BUTTER, SOFTENED
4	CUPS CANOLA OIL
	HONEY GLAZE (SEE PAGE 678)

APPLE STRUDEL

YIELD: 6 SERVINGS / **ACTIVE TIME:** 25 MINUTES / **TOTAL TIME:** 1 HOUR AND 30 MINUTES

In a traditional Austrian strudel, the apples will be one of the more tart varieties, and grated. We're not so specific here, but those looking to dig into the origins of their favorite preparations would do well to keep this in mind.

1. Preheat the oven to 350°F and line a baking sheet with parchment paper. Place the apples, lemon zest, lemon juice, sugar, cinnamon, ginger, and a pinch of salt in a large mixing bowl and toss until the apples are evenly coated. Place the mixture in a skillet and cook over medium heat until the apples begin to release their liquid. Remove the pan from heat and let it cool for 10 minutes before draining the mixture.

2. Place the melted butter in a bowl and stir in the remaining salt.

3. Brush a sheet of phyllo dough with some of the salted butter and lightly dust it with some of the confectioners' sugar. Repeat with the remaining sheets of phyllo dough, stacking them on top of one another after they have been dressed.

4. Place the apple mixture in the center of the phyllo sheets, leaving a 2-inch border of dough on the sides. Fold the border over the filling so that they overlap and gently press down to seal.

5. Place the strudel on the baking sheet, place it in the oven, and bake, rotating the sheet halfway through, until the strudel is golden brown, 30 to 40 minutes. Remove from the oven, transfer to a cutting board, and let it cool slightly. Slice into desired portions and dust with additional confectioners' sugar before serving.

INGREDIENTS:

12 OZ. APPLES, PEELED, CORED, AND CHOPPED

¼ TEASPOON LEMON ZEST

1 TEASPOON FRESH LEMON JUICE

1½ TABLESPOONS SUGAR

DASH OF CINNAMON

¼ TEASPOON GROUND GINGER

2 PINCHES OF FINE SEA SALT

2 OZ. UNSALTED BUTTER, MELTED

7 SHEETS OF FROZEN PHYLLO DOUGH, THAWED

1 TABLESPOON CONFECTIONERS' SUGAR, PLUS MORE FOR DUSTING

ALMOND CROISSANTS

YIELD: 16 CROISSANTS / **ACTIVE TIME:** 30 MINUTES / **TOTAL TIME:** 2 HOURS

Toasting the sliced almonds in a dry skillet for a minute or two is a nice touch, assuming you have any patience left after preparing the dough.

1. Line two baking sheets with parchment paper. Place the Frangipane in a piping bag and set aside.

2. Place the dough on a flour-dusted work surface and roll it into an 8 x 20–inch rectangle. Using a pizza cutter or chef's knife, cut the dough horizontally in the center so that you have two 4 x 20–inch rectangles. Cut each rectangle vertically into strips that are 5 inches wide.

3. Cut each rectangle diagonally, yielding 16 triangles. Gently roll out each triangle until it is 8 inches long.

4. Cut a hole in the piping bag and pipe about 3 tablespoons of Frangipane toward the wide side of each triangle. Spread the filling out a bit with an offset spatula.

5. Roll the croissants up tight, moving from the wide side of the triangle to the tip. Tuck the tip under the croissants. Place eight croissants on each of the baking sheets.

6. Cover the baking sheets with plastic wrap and let the croissants rest at room temperature for 1 hour.

7. Preheat the oven to 375°F.

8. Remove the plastic wrap and brush the croissants with the beaten egg. Sprinkle the almonds over the croissants and press them down gently so that they adhere.

9. Place the croissants in the oven and bake until they are golden brown, 20 to 22 minutes.

10. Remove the croissants from the oven and place them on wire racks. Let the croissants cool slightly before dusting them with confectioners' sugar and enjoying.

INGREDIENTS:

FRANGIPANE (SEE PAGE 730)

CROISSANT DOUGH (SEE PAGE 294)

ALL-PURPOSE FLOUR, AS NEEDED

1 EGG, BEATEN

2 CUPS SLICED ALMONDS

CONFECTIONERS' SUGAR, FOR DUSTING

APPLE CIDER DOUGHNUTS

YIELD: 12 DOUGHNUTS / **ACTIVE TIME:** 1 HOUR / **TOTAL TIME:** 24 HOURS

The only thing that can distract one from the glory of fall in the Northeast is the smell of a fresh batch of these doughnuts carrying on the air.

1. In the work bowl of a stand mixer fitted with the paddle attachment, combine the apple cider, eggs, egg yolk, butter, and brown sugar and beat on medium for 2 minutes.

2. Add the baking powder, baking soda, salt, ½ teaspoon of cinnamon, nutmeg, cardamom, allspice, and the flours and beat until the mixture comes together as a dough, about 5 minutes.

3. Coat a medium heatproof bowl with nonstick cooking spray, transfer the dough to the bowl, and cover it with plastic wrap. Refrigerate overnight.

4. Place the canola oil in a Dutch oven fitted with a candy thermometer and warm the oil to 350°F over medium heat. Set a cooling rack in a rimmed baking sheet beside the stove.

5. Remove the dough from the refrigerator and place it on a flour-dusted work surface. Roll the dough out until it is ½ inch thick. Cut out the donuts using a round, 4-inch cookie cutter and then use a round, 1-inch cookie cutter to cut out the centers.

6. Transfer the doughnuts to the wire rack and let them sit at room temperature for 10 minutes.

7. Working in batches, carefully place the doughnuts in the oil and fry, turning them once, until they are browned and cooked through, 2 to 4 minutes. Transfer the cooked doughnuts to the wire rack to drain and cool.

8. Place the sugar and remaining cinnamon in a small bowl and stir to combine.

9. When the doughnuts have cooled, toss them in the cinnamon sugar and serve.

INGREDIENTS:

1¼	CUPS APPLE CIDER
2	EGGS
1	EGG YOLK
4	OZ. UNSALTED BUTTER, MELTED
6	OZ. LIGHT BROWN SUGAR
2½	TEASPOONS BAKING POWDER
1	TEASPOON BAKING SODA
1	TEASPOON KOSHER SALT
½	TEASPOON CINNAMON, PLUS 1 TABLESPOON
½	TEASPOON FRESHLY GRATED NUTMEG
½	TEASPOON CARDAMOM
½	TEASPOON ALLSPICE
19	OZ. ALL-PURPOSE FLOUR, PLUS MORE AS NEEDED
1.4	OZ. WHOLE WHEAT FLOUR
4	CUPS CANOLA OIL
2	CUPS SUGAR

MILLE-FEUILLE

YIELD: 6 SERVINGS / **ACTIVE TIME:** 20 MINUTES / **TOTAL TIME:** 45 MINUTES

An impressive, delicious dessert that will have company thinking you're some kind of preternaturally gifted maker of confections.

1. Preheat the oven to 400°F and line two baking sheets with parchment paper. Roll out the sheets of puff pastry and place each one on a baking sheet. Dust the sheets generously with confectioners' sugar, place them in the oven, and bake for 12 to 15 minutes, until they are golden brown. Remove from the oven, transfer to a wire rack, and let them cool.

2. Place the Pastry Cream in a bowl, add the orange zest and Grand Marnier, and fold to incorporate. Transfer the mixture into a piping bag fitted with a plain tip, and place it in the refrigerator to chill while the puff pastry continues to cool.

3. Divide each sheet of the cooled puff pastry into 3 equal portions. Remove the piping bag from the refrigerator and place a thick layer of cream on one of the pieces of puff pastry. Dot the edges of the cream with raspberries and press down on them gently. Fill the space between the raspberries with more of the cream and place another piece of puff pastry on top. Repeat the process with the cream and raspberries, and then place the last piece of puff pastry on top. Carefully cut into the desired number of portions and serve.

INGREDIENTS:

2 SHEETS OF FROZEN PUFF PASTRY, THAWED

 CONFECTIONERS' SUGAR, FOR DUSTING

 PASTRY CREAM (SEE PAGE 671)

 ZEST OF 1 ORANGE

1 TABLESPOON GRAND MARNIER

1 PINT OF FRESH RASPBERRIES

DANISH DOUGH

YIELD: DOUGH FOR 20 DANISHES / ACTIVE TIME: 2 HOURS / TOTAL TIME: 12 HOURS

Danish dough is very similar to croissant dough, only it is even richer, as it incorporates eggs.

1. To begin preparations for the dough, place the milk and yeast in the work bowl of a stand mixer fitted with the dough hook, gently stir, and let the mixture sit until it starts to foam, about 10 minutes.

2. Add the eggs, sugar, flour, and salt and knead the mixture on low until it comes together as a smooth dough, about 5 minutes.

3. Spray a mixing bowl with nonstick cooking spray. Transfer the dough to the bowl, cover it with plastic wrap, and chill in the refrigerator for 3 hours.

4. While the dough is resting, prepare the butter block. Fit the stand mixer with the paddle attachment, add the butter and flour, and beat the mixture until smooth. Transfer the mixture to a silicone baking mat that is in a baking sheet. Use a small spatula to spread the mixture into a 7 x 10–inch rectangle. Place the baking sheet in the refrigerator for 30 minutes to 1 hour. You want the butter block to be firm but pliable. If the butter block is too firm for the following steps, let the butter sit at room temperature for a few minutes.

5. Remove the dough from the refrigerator, place it on a flour-dusted work surface, and roll it into a 10 x 20–inch rectangle.

6. Place the butter block in the center of the dough. Fold the dough over the butter block like a letter, folding a third of the dough from the left side of the dough and a third from the right so that they meet in the center. Pinch the seam to seal.

7. Turn the dough 90 degrees clockwise and flip it over so that the seam is facing down. Roll out the dough into a 10 x 20–inch rectangle. Make another letter fold of the dough, place the dough on the Silpat mat, and cover it with plastic wrap. Chill in the refrigerator for 1 hour.

8. Place the dough on a flour-dusted work surface, roll it into a 10 x 20–inch rectangle, and fold the dough like a letter, lengthwise. Pinch the seam to seal, turn the dough 90 degrees clockwise, and flip the dough over so that the seam is facing down. Place the dough back on the baking sheet, cover it in plastic wrap, and refrigerate for 1 hour.

INGREDIENTS:

FOR THE DOUGH

11	OZ. MILK
1	TABLESPOON ACTIVE DRY YEAST
2	EGGS
2	OZ. SUGAR
22	OZ. ALL-PURPOSE FLOUR, PLUS MORE AS NEEDED
1	TABLESPOON KOSHER SALT

FOR THE BUTTER BLOCK

1	LB. UNSALTED BUTTER, SOFTENED
¼	CUP ALL-PURPOSE FLOUR

9. Place the dough on a flour-dusted work surface, roll it into a 10 x 20–inch rectangle, and fold the dough like a letter, lengthwise. Pinch the seam to seal, turn the dough 90 degrees clockwise, and flip the dough over so that the seam is facing down. Place the dough back on the baking sheet, cover it in plastic wrap, and refrigerate for 4 hours. After this period of rest, the dough will be ready to make danish with.

CINNAMON APPLE DANISH

YIELD: 16 DANISH / **ACTIVE TIME:** 30 MINUTES / **TOTAL TIME:** 2 HOURS

This danish is wonderful anytime, but it is absolutely heavenly on a bright fall morning.

1. Line two baking sheets with parchment paper. Place the apples in a small bowl with the brown sugar and cinnamon and toss to coat.

2. Place the dough on a flour-dusted work surface and roll it into a 12-inch square. Using a pizza cutter or chef's knife, slice the dough into sixteen 3-inch squares.

3. To make the classic, frame-shaped danish, fold the squares into triangles. Make two diagonal cuts about ¼ inch inside from the edge of the triangles' short sides.

4. Open the triangle, take one edge of the "frame," and fold it over to the cut on the opposite side. Repeat with the other edge of the frame.

5. Place eight danish on each baking sheet. Place 2 tablespoons of Pastry Cream in the center of each danish and top the cream with 4 to 5 slices of apple.

6. Cover the baking sheets with plastic wrap and let the danish rest at room temperature for 45 minutes.

7. Preheat the oven to 375°F.

8. Brush the danish with the beaten egg, place them in the oven, and bake until they are golden brown, 15 to 20 minutes.

9. Remove the danish from the oven and place them on wire racks to cool for 10 minutes. Brush the tops of the danish with the glaze and let it set before enjoying.

INGREDIENTS:

4	GRANNY SMITH APPLES, PEELED, CORED, AND SLICED
1	TABLESPOON LIGHT BROWN SUGAR
2	TEASPOONS CINNAMON
	DANISH DOUGH (SEE PAGE 326)
	ALL-PURPOSE FLOUR, AS NEEDED
	PASTRY CREAM (SEE PAGE 671)
1	EGG, BEATEN
	APRICOT GLAZE (SEE PAGE 681)

BEIGNETS

YIELD: 15 BEIGNETS / **ACTIVE TIME:** 1 HOUR / **TOTAL TIME:** 24 HOURS

While these originated in France, beignets are now most commonly associated with New Orleans, where their alchemical interaction with a café au lait lends a considerable amount to that city's mystique.

1. In the work bowl of a stand mixer fitted with the paddle attachment, combine the milk, eggs, egg yolks, sugar, and butter and beat on medium for 2 minutes.

2. Add the yeast, flour, and salt and beat until the mixture comes together as a dough, about 5 minutes.

3. Coat a medium heatproof bowl with nonstick cooking spray, transfer the dough to the bowl, and cover it with plastic wrap. Refrigerate overnight.

4. Place the canola oil in a Dutch oven fitted with a candy thermometer and warm the oil to 350°F over medium heat. Set a paper towel–lined baking sheet beside the stove.

5. Remove the dough from the refrigerator and place it on a flour-dusted work surface. Roll the dough out until it is ½ inch thick. Cut the dough into 2-inch squares.

6. Working in batches, carefully place the beignets in the oil and fry, turning them once, until they are browned and cooked through, 2 minutes. Transfer the cooked doughnuts to the baking sheet to drain and cool.

7. When the beignets have cooled, dust them generously with confectioners' sugar and enjoy.

INGREDIENTS:

1½	CUPS MILK
2	EGGS
2	EGG YOLKS
½	CUP SUGAR
4	OZ. UNSALTED BUTTER, MELTED
2	TABLESPOONS ACTIVE DRY YEAST
25	OZ. ALL-PURPOSE FLOUR, PLUS MORE AS NEEDED
1¼	TEASPOONS KOSHER SALT
4	CUPS CANOLA OIL
1	CUP CONFECTIONERS' SUGAR, FOR DUSTING

CANNOLI

YIELD: 10 CANNOLI / **ACTIVE TIME:** 45 MINUTES / **TOTAL TIME:** 4 HOURS

At the end of the day, few things in this world deliver on the promise of their appearance as well as the cannoli.

1. Line a colander with three pieces of cheesecloth and place it in sink. Place the ricotta in the colander, form the cheesecloth into a pouch, and twist to remove as much liquid as possible from the ricotta. Keep the pouch taut and twisted, place it in a baking dish, and place a cast-iron skillet on top. Weight the skillet down with 2 large, heavy cans and place in the refrigerator for 1 hour.

2. Discard the drained liquid and transfer the ricotta to a mixing bowl. Add the mascarpone, half of the grated chocolate, the confectioners' sugar, vanilla, and salt and stir until well combined. Cover the bowl and refrigerate for at least 1 hour. The mixture will keep in the refrigerator for up to 24 hours.

3. Line an 18 x 13–inch baking sheet with parchment paper. Fill a small saucepan halfway with water and bring it to a gentle simmer. Place the remainder of the chocolate in a heatproof mixing bowl, place it over the simmering water, and stir until it is melted. Add the remaining grated chocolate and stir until melted.

4. Dip the ends of the cannoli shells in chocolate, let the excess drip off, and transfer them to the baking sheet. Let the shells sit until the chocolate is firm, about 1 hour.

5. Place the cannoli filling in a piping bag and cut a ½-inch slit in it. Pipe the filling into the shells, working from both ends in order to ensure they are filled evenly. When all of the cannoli have been filled, dust them with confectioners' sugar and enjoy.

INGREDIENTS:

12	OZ. WHOLE MILK RICOTTA CHEESE
12	OZ. MASCARPONE CHEESE
4	OZ. CHOCOLATE, GRATED
¾	CUP CONFECTIONERS' SUGAR, PLUS MORE FOR DUSTING
1½	TEASPOONS PURE VANILLA EXTRACT
	PINCH OF FINE SEA SALT
10	CANNOLI SHELLS

GOLDEN PEACH & ALMOND DANISH

YIELD: 16 DANISH / **ACTIVE TIME:** 30 MINUTES / **TOTAL TIME:** 2 HOURS

When you use ripe, in-season peaches, this danish absolutely bursts with country-fresh flavor.

1. Line two baking sheets with parchment paper. Place the dough on a flour-dusted work surface and roll it into a 12-inch square. Using a pizza cutter or chef's knife, slice the dough into sixteen 3-inch squares.

2. To make the square danish, fold the corners of the squares into the center and press down to seal. Place eight danish on each baking sheet.

3. Place 2 tablespoons of Frangipane in the center of each danish and top with 3 to 4 overlapping slices of peach.

4. Cover the baking sheets with plastic wrap and let the danish rest at room temperature for 45 minutes.

5. Preheat the oven to 375°F.

6. Brush the danish with the beaten egg, sprinkle the almonds over them, and gently press them down so that they adhere.

7. Place the danish in the oven and bake until they are golden brown, 15 to 20 minutes.

8. Remove the danish from the oven and place them on a wire rack to cool for 10 minutes. Brush the tops of the danish with the glaze and let it set before enjoying.

INGREDIENTS:

DANISH DOUGH (SEE PAGE 326)

ALL-PURPOSE FLOUR, AS NEEDED

FRANGIPANE (SEE PAGE 730)

4 GOLDEN PEACHES, PEELED, PITTED, AND SLICED

1 EGG, BEATEN

2 CUPS SLICED ALMONDS

APRICOT GLAZE (SEE PAGE 681)

ZEPPOLE

YIELD: 18 ZEPPOLE / **ACTIVE TIME:** 30 MINUTES / **TOTAL TIME:** 1 HOUR

A treat concocted to celebrate Saint Joseph's Day, a Catholic feast day. You should treat these as you would a doughnut: either sprinkle them with sugar, roll them in cinnamon, or inject them with your favorite filling.

1. Combine the flour, sugar, yeast, baking powder, and salt in a large bowl and whisk in the warm water and vanilla. Cover the bowl with plastic wrap and let the batter rest at room temperature until it doubles in size, 15 to 25 minutes.

2. Add oil to a Dutch oven until it is about 1½ inches deep, and warm to 350°F over medium heat.

3. Using a greased tablespoon, add six heaping tablespoons of the batter to the oil and fry until the zeppole are golden brown and cooked through, 2 to 3 minutes, turning halfway through. Make sure the oil remains around 350°F while frying the zeppole.

4. Transfer the cooked zeppole to a paper towel–lined plate. When all of the zeppole have been cooked, dust them with confectioners' sugar (if desired) and serve.

INGREDIENTS:

6.7 OZ. ALL-PURPOSE FLOUR

1 TABLESPOON SUGAR

2 TEASPOONS INSTANT YEAST

1 TEASPOON BAKING POWDER

½ TEASPOON FINE SEA SALT

1 CUP WARM WATER (105°F)

½ TEASPOON PURE VANILLA EXTRACT

CANOLA OIL, AS NEEDED

CONFECTIONERS' SUGAR, FOR DUSTING (OPTIONAL)

RASPBERRY DANISH

YIELD: 16 DANISH / **ACTIVE TIME**: 30 MINUTES / **TOTAL TIME**: 2 HOURS

A straightforward pastry that gets away with its simplicity because of the concord between the tart raspberries and sweet, vanilla-spiked glaze.

1. Line two baking sheets with parchment paper. Place the dough on a flour-dusted work surface and roll it into a 12-inch square. Using a pizza cutter or chef's knife, slice the dough into sixteen 3-inch squares.

2. To make pinwheeled-shaped danish, make four cuts of equal length, starting from the corners and moving toward the center. Make sure to not cut all the way through the center. Make two diagonal cuts about ¼ inch inside from the edges of the triangles' short sides.

3. Fold the point of every other half toward the center and press down to seal. Place eight danish on each baking sheet. Place 1 tablespoon of jam in the center of each danish.

4. Cover the baking sheets with plastic wrap and let the danish rest at room temperature for 45 minutes.

5. Preheat the oven to 375°F.

6. Brush the danish with the beaten egg, place them in the oven, and bake until they are golden brown, 15 to 20 minutes.

7. Remove the danish from the oven and place them on wire racks to cool for 10 minutes. Brush the tops of the danish with the glaze and let it set before enjoying.

INGREDIENTS:

DANISH DOUGH (SEE PAGE 326)

ALL-PURPOSE FLOUR, AS NEEDED

RASPBERRY JAM (SEE PAGE 691)

1 EGG, BEATEN

VANILLA GLAZE (SEE PAGE 682)

OREJAS

YIELD: 12 OREJAS / ACTIVE TIME: 15 MINUTES / TOTAL TIME: 1 HOUR

These crispy, sugary pastries treats are known worldwide by many different names. Orejas, which means "ears," is the Mexican version.

1. Preheat the oven to 425°F and line a baking sheet with parchment paper. Brush the puff pastry with some of the egg white.

2. Combine the cinnamon and sugar in a bowl and then sprinkle the mixture all over the puff pastry. Fold the short edges of the pastry inward until they meet in the middle. Brush lightly with the egg white and fold in half again until sealed together. Chill in the refrigerator for 15 to 20 minutes.

3. Cut the pastry into ½-inch-thick slices. Place the slices on the baking sheet, cut side up so you can see the folds.

4. Place the orejas in the oven and bake until they are golden brown, 8 to 12 minutes. Remove from the oven and let them cool on wire racks before enjoying.

INGREDIENTS:

1	SHEET OF FROZEN PUFF PASTRY, THAWED
1	EGG WHITE, BEATEN
1	TEASPOON CINNAMON
½	CUP SUGAR

CHURROS

YIELD: 75 CHURROS / **ACTIVE TIME:** 25 MINUTES / **TOTAL TIME:** 30 MINUTES

Churros are the most popular Mexican sweet, no doubt because they are completely irresistible. This preparation is for a big batch, most of which you will have to freeze, but you can also enjoy a few straight out of the fryer.

1. Add canola oil to a Dutch oven until it is about 2 inches deep and warm to 350°F. Place the milk, water, sugar, and salt in a large saucepan and bring it to a boil.

2. Gradually add the flours and cook, stirring constantly, until the mixture pulls away from the sides of the pan.

3. Place the mixture in the work bowl of a stand mixer fitted with the paddle attachment and beat until the dough is almost cool. Incorporate the eggs one at a time, scraping down the work bowl as needed.

4. Place the dough in a piping bag fitted with a star tip. Pipe 6-inch lengths of dough into the oil and fry until they are golden brown. Place them on paper towel–lined plates to drain and cool slightly. Toss in cinnamon sugar and enjoy, or store the churros in the freezer.

5. To serve frozen churros, preheat the oven to 450°F. Remove the churros from the freezer and toss them in cinnamon sugar until coated. Place them in the oven and bake for 5 minutes. Remove, toss them in cinnamon sugar again, and serve with the ganache.

INGREDIENTS:

	CANOLA OIL, AS NEEDED
35.25	OZ. MILK
81.1	OZ. WATER
2.8	OZ. SUGAR, PLUS MORE TO TASTE
1.4	OZ. SALT
38.8	OZ. "00" FLOUR
38.8	OZ. ALL-PURPOSE FLOUR
32	EGGS
	CINNAMON, TO TASTE
	CHOCOLATE GANACHE (SEE PAGE 664), WARM, FOR SERVING

BUÑUELOS

YIELD: 12 PASTRIES / **ACTIVE TIME:** 20 MINUTES / **TOTAL TIME:** 1 HOUR

This take on fried dough came to Mexico via the Spanish. It can be topped with almost anything you like, but confectioners' sugar is the traditional choice.

1. In a large mixing bowl, combine the flour, baking powder, sugar, and salt. Add the egg, melted butter, and vanilla and work the mixture until it resembles coarse bread crumbs.

2. Incorporate water 1 tablespoon at a time until the mixture comes together as a soft, smooth dough. Cover the mixing bowl with plastic wrap and let it rest for 30 minutes.

3. Divide the dough into 12 portions and roll them out as thin as possible, without breaking them, on a flour-dusted work surface.

4. Add canola oil to a Dutch oven until it is about 2 inches deep and warm it to 350°F. Working in batches to avoid crowding the pot, gently slip the buñuelos into the oil and fry until they are crispy and golden brown, about 2 minutes. Transfer to a paper towel–lined plate and let them drain before enjoying.

INGREDIENTS:

2 CUPS ALL-PURPOSE FLOUR, PLUS MORE AS NEEDED

1 TEASPOON BAKING POWDER

1 TABLESPOON SUGAR

½ TEASPOON KOSHER SALT

1 EGG

1 TABLESPOON UNSALTED BUTTER, MELTED AND COOLED

1 TEASPOON MEXICAN VANILLA EXTRACT

WATER, AS NEEDED

CANOLA OIL, AS NEEDED

RED VELVET DOUGHNUTS

YIELD: 12 DOUGHNUTS / **ACTIVE TIME:** 1 HOUR / **TOTAL TIME:** 24 HOURS

I f you're a red velvet fanatic and find that the flavor of these doughnuts isn't quite hitting the mark, try substituting a little buttermilk for a portion of the sour cream.

1. In the work bowl of a stand mixer fitted with the paddle attachment, cream the sugar and butter on medium until light and fluffy, about 5 minutes.

2. Incorporate the egg yolks one at a time, scraping down the work bowl as needed. When all of the egg yolks have been incorporated, add the sour cream and beat until incorporated. Add the flour, cocoa powder, baking powder, salt, and food coloring and beat until the mixture comes together as a dough.

3. Coat a medium heatproof bowl with nonstick cooking spray, transfer the dough to the bowl, and cover it with plastic wrap. Refrigerate overnight.

4. Place the canola oil in a Dutch oven fitted with a candy thermometer and warm the oil to 350°F over medium heat. Set a cooling rack in a rimmed baking sheet beside the stove.

5. Remove the dough from the refrigerator and place it on a flour-dusted work surface. Roll the dough out until it is ½ inch thick. Cut out the donuts using a round, 4-inch cookie cutter and then use a round, 1-inch cookie cutter to cut out the centers.

6. Transfer the doughnuts to the wire rack and let them sit at room temperature for 10 minutes.

7. Working in batches, carefully place the doughnuts in the oil and fry, turning them once, until they are browned and cooked through, about 4 minutes. A cake tester inserted into the center of the doughnuts should come out clean. Transfer the cooked doughnuts to the wire rack to drain and cool.

8. When cool, spread the frosting over the doughnuts and enjoy.

INGREDIENTS:

6 OZ. SUGAR

1 OZ. UNSALTED BUTTER, SOFTENED

3 EGG YOLKS

10.8 OZ. SOUR CREAM

12.9 OZ. ALL-PURPOSE FLOUR, PLUS MORE AS NEEDED

1.5 OZ. COCOA POWDER

2 TEASPOONS BAKING POWDER

1 TABLESPOON KOSHER SALT

4 DROPS OF RED GEL FOOD COLORING

4 CUPS CANOLA OIL

CREAM CHEESE FROSTING (SEE PAGE 716)

BRAIDED BLUEBERRY & CREAM CHEESE DANISH

YIELD: 2 LARGE DANISH / **ACTIVE TIME:** 30 MINUTES / **TOTAL TIME:** 2 HOURS AND 30 MINUTES

An irresistible breakfast danish braid with sweet cream cheese custard and fresh blueberries.

1. Line two baking sheets with parchment paper. Remove the dough from the refrigerator and cut it in half. Cover one of the halves in plastic wrap and place it back in the refrigerator.

2. Place the dough on a flour-dusted work surface and roll it into an 8 x 12–inch rectangle. Transfer the dough to one of the baking sheets.

3. Spread 1 cup of the filling down the center of the dough, in a strip that is about 3 inches wide. Spread half of the blueberries over the filling.

4. Cut 10 slanting strips that are about 1 inch wide on each side of the filling. Fold the strips over each other, alternating between the sides. Fold the ends of the danish inward, so that they are under the braid, and place the danish on one of the baking sheets.

5. Repeat the steps above with the second piece of dough.

6. Cover the baking sheets with plastic wrap and let the danish rest at room temperature for 45 minutes.

7. Place the danish in the refrigerator for 30 minutes. Preheat the oven to 375°F.

8. Gently brush the tops of the danish with the egg and sprinkle pearl sugar generously over them.

9. Place the danish in the oven and bake for 20 to 24 minutes or until they are golden brown.

10. Remove the danish from the oven and place them on a wire rack to cool for 10 minutes before slicing and serving.

INGREDIENTS:

DANISH DOUGH (SEE PAGE 326)

ALL-PURPOSE FLOUR, AS NEEDED

2 PINTS OF BLUEBERRIES

CREAM CHEESE DANISH FILLING (SEE PAGE 728)

1 EGG, BEATEN

PEARL OR SANDING SUGAR, FOR TOPPING

CUSTARDS, CANDIES
& OTHER CONFECTIONS

ustards and candies made from scratch may seem to be something from the past, but a quick scan of the ingredients required will reveal something important—everything you need to prepare them is probably already in the house, and many are a wonderful landing spot for odds and ends left over from other preparations—egg yolks, milk, bread, and fruit.

Cutting down on waste and costs and getting to treat yourself—sounds like something worth investing a bit of time in.

MEYER LEMON CURD

YIELD: 3 CUPS / **ACTIVE TIME:** 25 MINUTES / **TOTAL TIME:** 2 HOURS

The floral quality present in the Meyer lemon makes this recipe an easy but unique take on the sumptuous classic.

1. Fill a small saucepan halfway with water and bring it to a gentle simmer.

2. Place the lemon juice in a small saucepan and warm it over low heat.

3. Combine the eggs, sugar, salt, and vanilla in a metal mixing bowl. Place the bowl over the simmering water and whisk the mixture continually until it is 135°F on an instant-read thermometer.

4. When the lemon juice comes to a simmer, gradually add it to the egg mixture while whisking constantly.

5. When all of the lemon juice has been incorporated, whisk the curd until it has thickened and is 155°F. Remove the bowl from heat, add the butter, and stir until thoroughly incorporated.

6. Transfer the curd to a mason jar and let it cool. Once cool, store the curd in the refrigerator, where it will keep for up to 2 weeks.

INGREDIENTS:

¾ CUP FRESH MEYER LEMON JUICE

4 EGGS

¾ CUP SUGAR

⅛ TEASPOON KOSHER SALT

¼ TEASPOON PURE VANILLA EXTRACT

4 OZ. UNSALTED BUTTER, SOFTENED

CRÈME BRÛLÉE

YIELD: 4 SERVINGS / **ACTIVE TIME:** 1 HOUR / **TOTAL TIME:** 10 HOURS

Originating in France in 1691, this luscious dessert disappeared shortly after and lay dormant until the 1980s, when it was resurrected as a symbol of that decade's emphasis on lavish living.

1. Place the egg yolks in a mixing bowl and set aside.

2. Place the heavy cream, milk, 3 oz. of sugar, and salt in a saucepan and bring to a boil over medium heat. Remove the pan from heat and stir in the vanilla.

3. While whisking, gradually add the hot milk mixture to the egg yolks. When all of the milk has been incorporated, place plastic wrap directly on the surface of the custard, place it in the refrigerator, and chill for at least 4 hours. Crème brûlée is best when cooked chilled.

4. Preheat the oven to 325°F. Bring 8 cups of water to a boil and then set aside.

5. Fill four 8 oz. ramekins three-quarters of the way with custard. Place the ramekins in a 13 x 9–inch baking dish and pour the boiling water into the pan until it reaches halfway up the sides of the ramekins. Place the pan in the oven and bake until the custards are set at their edges and jiggle slightly at their centers, 30 to 40 minutes. Remove from the oven and carefully transfer the ramekins to a wire rack. Let them cool for 1 hour.

6. Place the ramekins in the refrigerator and chill for 4 hours.

7. Divide the remaining 2 oz. of sugar among the ramekins and spread evenly on top. Use a kitchen torch to caramelize the sugar and serve.

INGREDIENTS:

12	EGG YOLKS
14	OZ. HEAVY CREAM
4	OZ. MILK
3	OZ. SUGAR, PLUS 2 OZ.
¼	TEASPOON KOSHER SALT
¾	TEASPOON PURE VANILLA EXTRACT

CHOCOLATE POTS DE CRÈME

YIELD: 6 SERVINGS / **ACTIVE TIME:** 30 MINUTES / **TOTAL TIME:** 6 HOURS AND 30 MINUTES

A loose, easy-to-prepare custard that occupies the space between a mousse and a pudding.

1. Preheat the oven to 325°F. Bring 8 cups of water to a boil and then set aside.

2. Place the chocolate in a heatproof mixing bowl. Place the heavy cream in a saucepan and bring it to a simmer over medium heat. Pour the cream over the chocolate and whisk until the chocolate has melted and the mixture is combined. Set aside.

3. In the work bowl of a stand mixer fitted with the whisk attachment, combine the sugar, egg yolks, liqueur, and salt and whip on high until the mixture is pale yellow and ribbony, about 10 minutes.

4. Pour the mixture into the chocolate mixture and fold to incorporate.

5. Fill six 8 oz. ramekins three-quarters of the way with the custard.

6. Place the ramekins in a 13 x 9–inch baking pan and pour the boiling water into the pan until it reaches halfway up the sides of the ramekins. Place the pan in the oven and bake until the custards are set at their edges and jiggle slightly at their centers, about 50 minutes. Remove from the oven and carefully transfer the ramekins to a wire rack. Let them cool for 1 hour.

7. Place the ramekins in the refrigerator and chill for 4 hours before enjoying.

INGREDIENTS:

5	OZ. CHOCOLATE
2	CUPS HEAVY CREAM
4	OZ. SUGAR
4	EGG YOLKS
1	TABLESPOON CHOCOLATE LIQUEUR
¼	TEASPOON KOSHER SALT

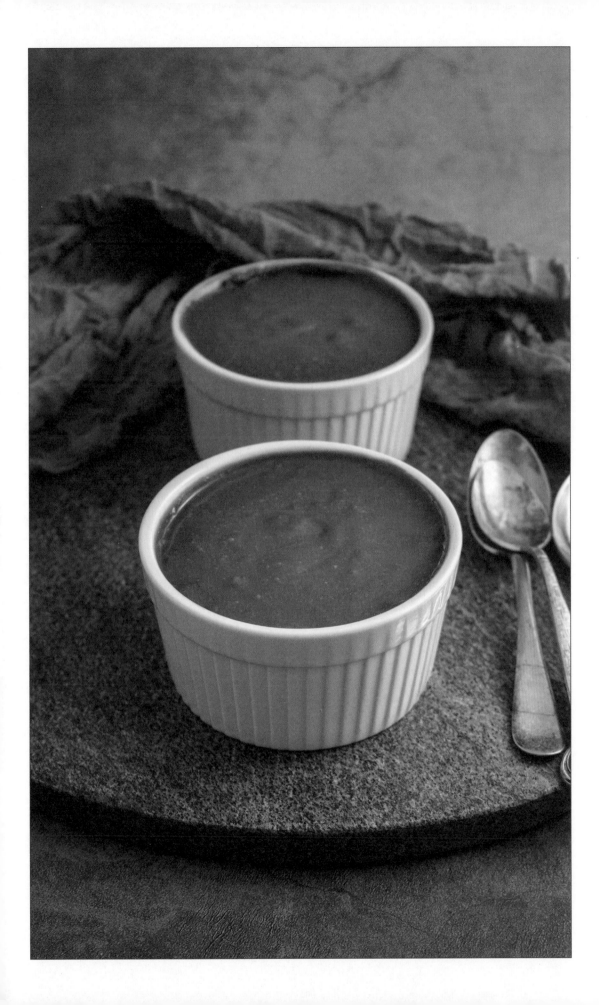

QUICK CHOCOLATE MOUSSE

YIELD: 3 CUPS / **ACTIVE TIME:** 15 MINUTES / **TOTAL TIME:** 15 MINUTES

Great on its own, but also wonderful when used as a filling for cakes.

1. Place the heavy cream in the work bowl of a stand mixer fitted with a whisk attachment and whip it on medium until the cream holds stiff peaks.

2. Fill a small saucepan halfway with water and bring it to a gentle simmer.

3. Combine the chocolate, water, cocoa powder, confectioners' sugar, vanilla, and salt in a heatproof mixing bowl. Place the bowl over the simmering water and whisk until the chocolate has melted and the mixture is smooth.

4. Remove the bowl from heat, add the whipped cream, and fold until incorporated. Transfer the mousse to ramekins or a piping bag if using it as a cake filling. If not using immediately, place the mousse in an airtight container and store it in the refrigerator, where it will keep for up to 2 weeks.

INGREDIENTS:

1½	CUPS HEAVY CREAM
8	OZ. CHOCOLATE
½	CUP WATER
2	TABLESPOONS COCOA POWDER
1	TABLESPOON CONFECTIONERS' SUGAR
1	TEASPOON PURE VANILLA EXTRACT
	PINCH OF KOSHER SALT

LEMON POSSET

YIELD: 6 SERVINGS / **ACTIVE TIME:** 30 MINUTES / **TOTAL TIME:** 4 HOURS

An English classic that allows us to appreciate all the good that is available when you keep things simple in the kitchen.

1. Place the heavy cream, sugar, and lemon zest in a saucepan and bring the mixture to a simmer over medium heat, stirring constantly. Cook until the sugar has dissolved and the mixture has reduced slightly, about 10 minutes.

2. Remove the saucepan from heat and stir in the lemon juice. Let the mixture stand until a skin forms on the top, about 20 minutes. Strain the mixture through a fine sieve and transfer it to the refrigerator. Chill until set, about 3 hours.

3. About 10 minutes before you are ready to serve the posset, remove the mixture from the refrigerator and let it come to room temperature. Cover the bottom of the serving dishes with the Chantilly Cream and then alternate layers of the posset and Chantilly Cream. Top each serving with a generous amount of blueberries and enjoy.

INGREDIENTS:

2 CUPS HEAVY CREAM

⅔ CUP SUGAR

1 TABLESPOON LEMON ZEST

6 TABLESPOONS FRESH LEMON JUICE

2 CUPS CHANTILLY CREAM (SEE PAGE 668)

FRESH BLUEBERRIES, FOR TOPPING

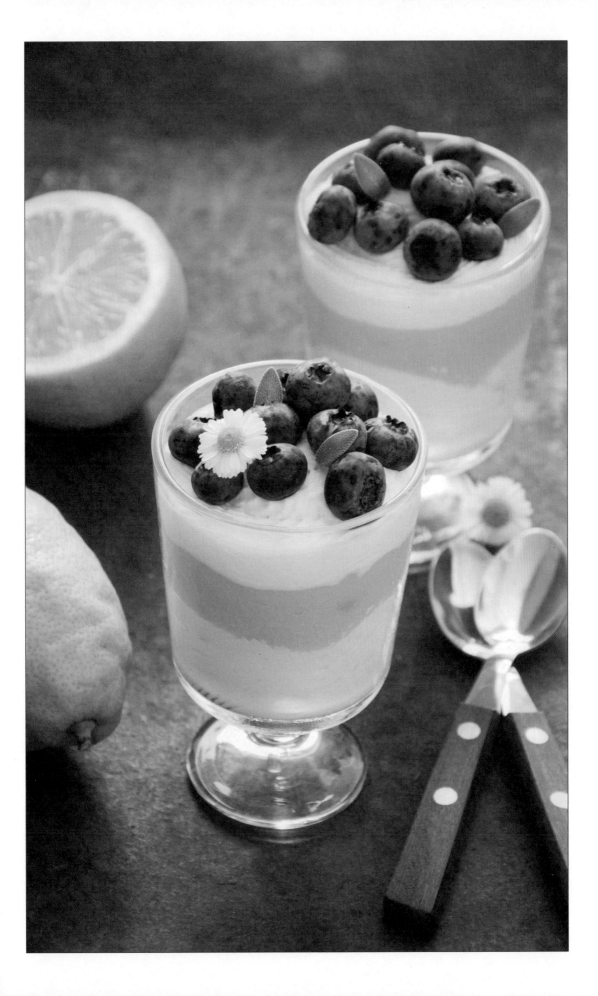

PASSION FRUIT CURD

YIELD: 3 CUPS / **ACTIVE TIME:** 25 MINUTES / **TOTAL TIME:** 2 HOURS

A t once, tangy, floral, and sweet, passion fruit is one of the world's most underappreciated fruits. Serving this curd to loved ones will help change that.

1. Fill a small saucepan halfway with water and bring it to a gentle simmer.

2. Place the passion fruit juice in a small saucepan and warm it over low heat.

3. Combine the eggs, sugar, salt, and vanilla in a metal mixing bowl. Place the bowl over the simmering water and whisk the mixture continually until it is 135°F on an instant-read thermometer.

4. When the passion fruit juice comes to a simmer, gradually add it to the egg mixture while whisking constantly.

5. When all of the lemon juice has been incorporated, whisk the curd until it has thickened and is 155°F. Remove the bowl from heat, add the butter, and stir until thoroughly incorporated.

6. Transfer the curd to a mason jar and let it cool. Once cool, store the curd in the refrigerator, where it will keep for up to 2 weeks.

INGREDIENTS:

¾ CUP PASSION FRUIT JUICE

4 EGGS

½ CUP SUGAR

⅛ TEASPOON KOSHER SALT

¼ TEASPOON PURE VANILLA EXTRACT

4 OZ. UNSALTED BUTTER, SOFTENED

MAPLE POTS DE CRÈME

YIELD: 4 SERVINGS / **ACTIVE TIME**: 30 MINUTES / **TOTAL TIME**: 6 HOURS AND 30 MINUTES

Using maple sugar instead of maple syrup allows this custard to retain the lightness you want in a pot de crème.

1. Preheat the oven to 325°F. Bring 8 cups of water to a boil and then set aside.

2. Place the heavy cream, two-thirds of the maple sugar, and the salt in a saucepan and bring it to a simmer over medium heat.

3. Place the egg yolks and remaining maple sugar in a mixing bowl and whisk until the sugar has dissolved.

4. Whisking constantly, gradually add the warm mixture to the egg yolk mixture. When all of the warm mixture has been incorporated, pour the custard into four 8 oz. ramekins until they are three-quarters full.

5. Place the ramekins in a 13 x 9–inch baking pan and pour the boiling water into the pan until it reaches halfway up the sides of the ramekins. Place the pan in the oven and bake until the custards are set at their edges and jiggle slightly at their centers, about 50 minutes. Remove from the oven and carefully transfer the ramekins to a wire rack. Let them cool for 1 hour.

6. Place the ramekins in the refrigerator and chill for 4 hours before enjoying.

INGREDIENTS:

18	OZ. HEAVY CREAM
6	OZ. MAPLE SUGAR
¼	TEASPOON KOSHER SALT
5	EGG YOLKS

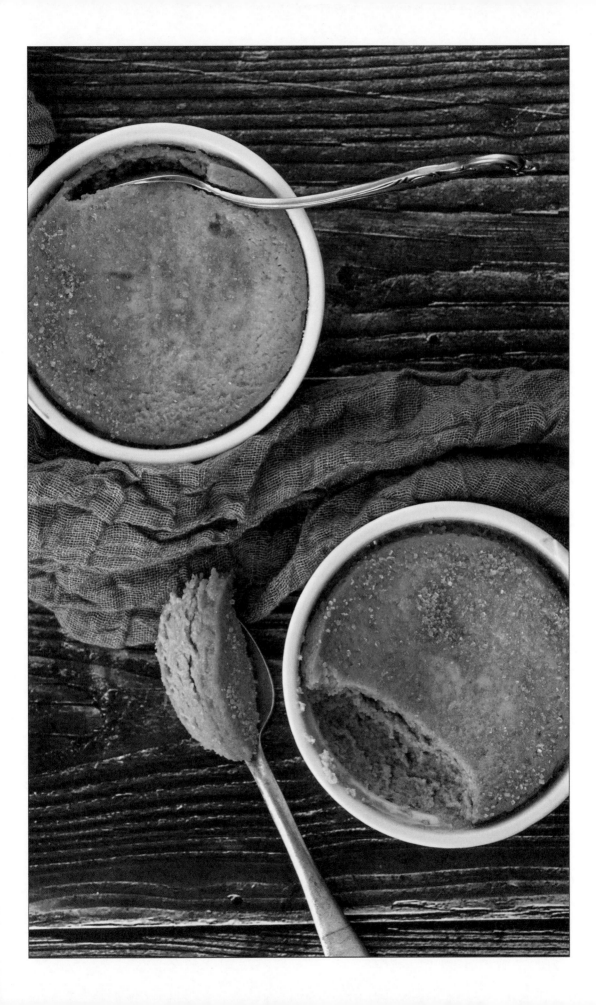

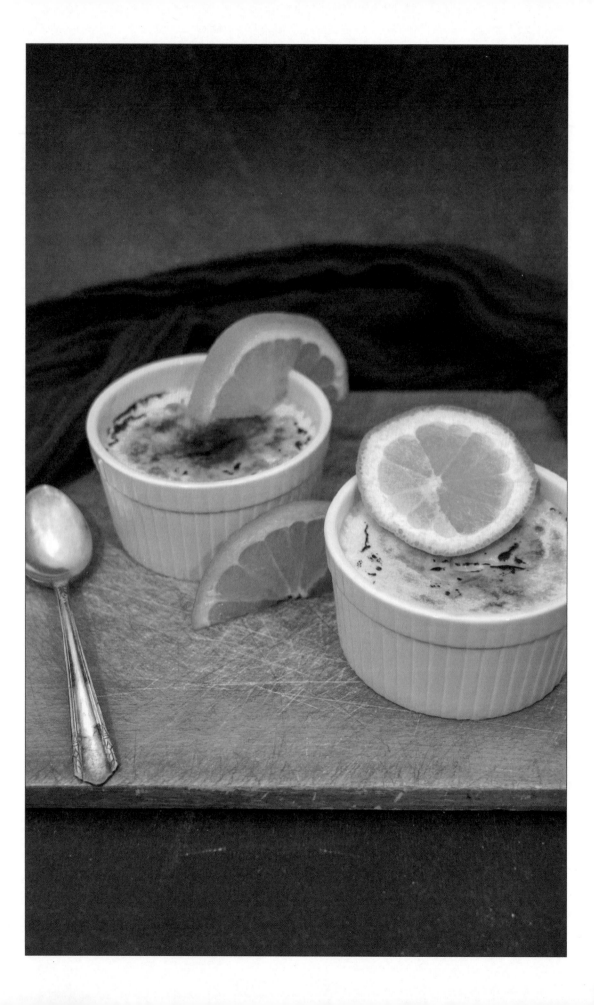

CREMA CATALANA

YIELD: 4 SERVINGS / **ACTIVE TIME:** 30 MINUTES / **TOTAL TIME:** 6 HOURS AND 30 MINUTES

This is the Spanish version of Crème Brûlée, made with a touch more milk and the zest of an orange.

1. Place the egg yolks in a mixing bowl, whisk to combine, and set aside.

2. Combine the heavy cream, milk, vanilla seeds, three-quarters of the sugar, orange zest, and salt in a saucepan and bring the mixture to a simmer. Remove the pan from heat and strain the mixture into a clean bowl through a fine-mesh sieve.

3. Whisking constantly, gradually add the warm mixture to the egg yolk mixture. When all of the warm mixture has been incorporated, place the custard in the refrigerator and chill for 4 hours.

4. Preheat the oven to 325°F. Bring 8 cups of water to a boil and then set aside.

5. Fill four 8 oz. ramekins three-quarters of the way with the custard.

6. Place the ramekins in a 13 x 9–inch baking pan and pour the boiling water into the pan until it reaches halfway up the sides of the ramekins. Place the pan in the oven and bake until the custards are set at their edges and jiggle slightly at their centers, about 50 minutes. Remove from the oven and carefully transfer the ramekins to a wire rack. Let them cool for 1 hour.

7. Place the ramekins in the refrigerator and chill for 4 hours.

8. Divide the remaining sugar among the ramekins and spread evenly on top. Use a kitchen torch to caramelize the sugar and serve.

INGREDIENTS:

8	EGG YOLKS
12	OZ. HEAVY CREAM
7	OZ. MILK
	SEEDS OF ½ VANILLA BEAN
1	CUP SUGAR
	ZEST OF ½ ORANGE
¼	TEASPOON KOSHER SALT

DARK CHOCOLATE MOUSSE

YIELD: 6 SERVINGS / **ACTIVE TIME:** 45 MINUTES / **TOTAL TIME:** 2 HOURS AND 45 MINUTES

With its perfect balance of bitter and sweet and silky texture, this is a dish that will never go out of style.

1. Fill a small saucepan halfway with water and bring it to a simmer. Place the dark chocolate in a heatproof mixing bowl and place it over the simmering water. Stir until the chocolate is melted and then set aside.

2. In the work bowl of a stand mixer fitted with the whisk attachment, whip 15 oz. of the heavy cream until it holds soft peaks. Transfer the whipped cream to another bowl and place it in the refrigerator.

3. Place the egg yolks and sugar in a mixing bowl, whisk to combine, and set the mixture aside.

4. In a small saucepan, combine the milk, salt, and remaining cream and bring the mixture to a simmer. Remove the pan from heat.

5. Whisking constantly, gradually add the warm mixture to the egg yolk mixture. When all of the warm mixture has been incorporated, add the tempered egg yolks to the saucepan and cook over low heat, stirring constantly, until the mixture thickens enough to coat the back of a wooden spoon.

6. Remove the pan from heat, pour the mixture into the melted chocolate, and whisk until thoroughly combined. Add half of the whipped cream, fold until incorporated, and then fold in the rest of the whipped cream.

7. Divide the mousse between six 8 oz. ramekins and lightly tap the bottom of each one to settle the mousse and to remove any air bubbles. Transfer the mousse to the refrigerator and chill for 2 hours.

8. To serve, top each mousse with Chantilly Cream.

INGREDIENTS:

17	OZ. DARK CHOCOLATE (55 TO 65 PERCENT)
19	OZ. HEAVY CREAM
2	EGG YOLKS
1	OZ. SUGAR
½	CUP WHOLE MILK
¼	TEASPOON KOSHER SALT
	CHANTILLY CREAM (SEE PAGE 668). FOR SERVING

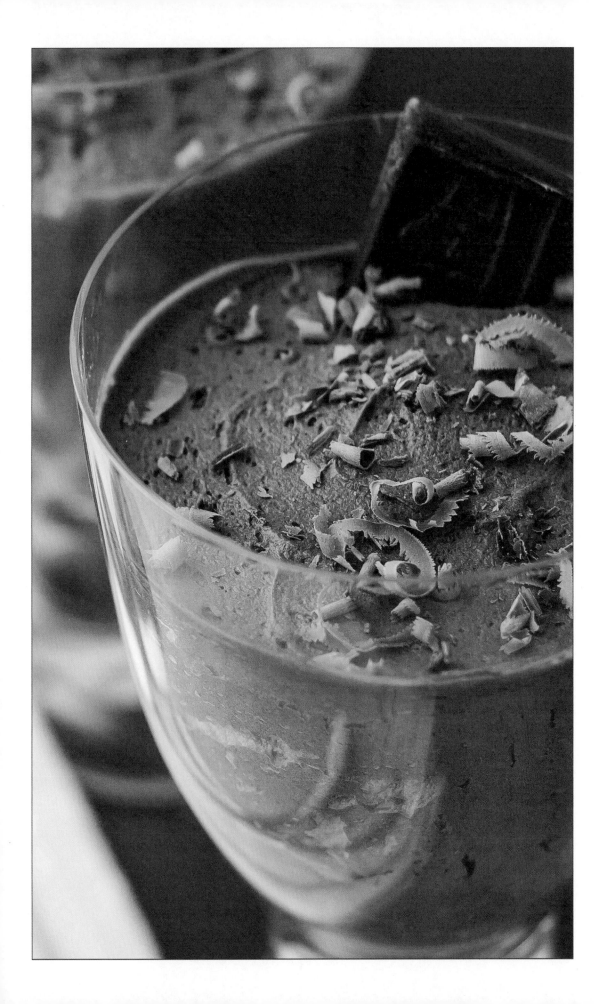

TIRAMISU

YIELD: 8 TO 10 SERVINGS / **ACTIVE TIME:** 20 MINUTES / **TOTAL TIME:** 3 HOURS AND 30 MINUTES

To be blunt: the ladyfingers available at the grocery store are a travesty. If you want this coffee-laced dessert, you'll want to use the homemade version provided here.

1. Place the espresso, 1 tablespoon of the sugar, and the Kahlúa in a bowl and stir to combine. Set the mixture aside.

2. Place two inches of water in a saucepan and bring to a simmer. Place the remaining sugar and egg yolks in a metal mixing bowl and set the bowl over the simmering water. Whisk the mixture continually until it has nearly tripled in size, approximately 10 minutes. Remove from heat, add the mascarpone, and fold to incorporate.

3. Pour the heavy cream into a separate bowl and whisk until soft peaks start to form. Gently fold the whipped cream into the mascarpone mixture.

4. Place the Ladyfingers in the espresso mixture and briefly submerge them. Place an even layer of the soaked Ladyfingers on the bottom of a 13 x 9–inch baking pan. This will use up approximately half of the Ladyfingers. Spread half of the mascarpone mixture on top of the Ladyfingers and then repeat until the Ladyfingers and mascarpone have been used up.

5. Cover with plastic and place in the refrigerator for 3 hours. Sprinkle the cocoa powder over the top before serving.

INGREDIENTS:

2	CUPS FRESHLY BREWED ESPRESSO
½	CUP GRANULATED SUGAR, PLUS 1 TABLESPOON
3	TABLESPOONS KAHLÚA
4	LARGE EGG YOLKS
2	CUPS MASCARPONE CHEESE
1	CUP HEAVY CREAM
30	LADYFINGERS (SEE RECIPE)
2	TABLESPOONS COCOA POWDER, FOR TOPPING

LADYFINGERS

1. Preheat the oven to 300°F. Line two baking sheets with parchment paper and dust with flour. Shake to remove any excess.

2. Place the egg yolks in a mixing bowl and gradually incorporate the sugar, using a handheld mixer at high speed. When the mixture is thick and a pale yellow, whisk in the vanilla.

3. In the work bowl of a stand mixer fitted with the whisk attachment, beat the egg whites and salt until the mixture holds soft peaks. Scoop one-quarter of the whipped egg whites into the egg yolk mixture and sift one-quarter of the flour on top. Fold to combine and repeat until all of the egg whites and flour have been incorporated and the mixture is light and airy.

4. Spread the batter in 4-inch-long strips on the baking sheets, leaving 1 inch between them. Sprinkle the confectioners' sugar over the top and place them in the oven.

5. Bake until they are lightly golden brown and just crispy, about 20 minutes. Remove from the oven and transfer the ladyfingers to a wire rack to cool completely before using.

INGREDIENTS:

LADYFINGERS

3.3 OZ. ALL-PURPOSE FLOUR, PLUS MORE AS NEEDED

3 EGGS, SEPARATED

3.5 OZ. SUGAR, PLUS 1 TABLESPOON

1 TEASPOON PURE VANILLA EXTRACT

PINCH OF FINE SEA SALT

3 OZ. CONFECTIONERS' SUGAR

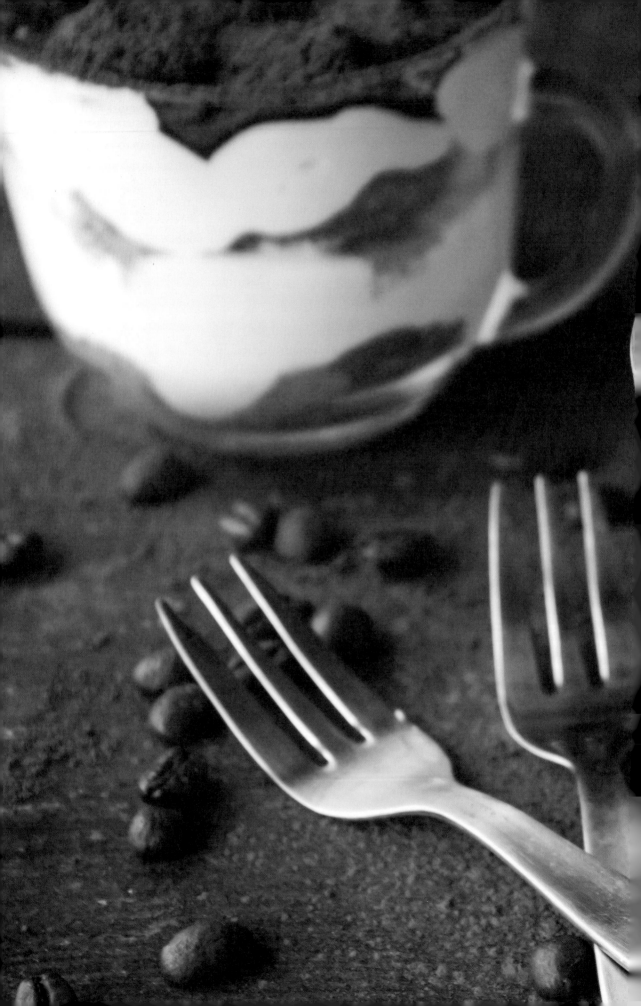

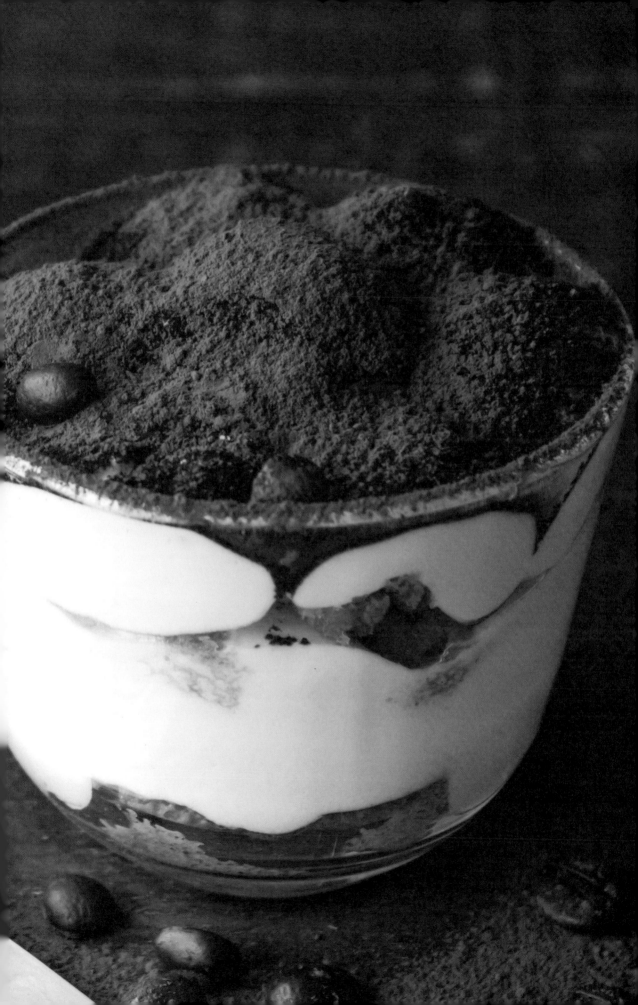

VANILLA PANNA COTTA

YIELD: 4 SERVINGS / **ACTIVE TIME:** 30 MINUTES / **TOTAL TIME:** 4 HOURS AND 30 MINUTES

This eggless custard, which translates to "cooked cream" in Italian, is great on its own, or with fresh berries on top.

1. Place the gelatin sheets in a small bowl. Add 1 cup of ice and water until the sheets are submerged. Let the mixture rest.

2. Combine the heavy cream, milk, sugar, and vanilla seeds and pod in a saucepan and bring to a simmer. Cook for 15 minutes and then remove the pan from heat. Remove the vanilla bean pod and discard.

3. Remove the bloomed gelatin from the ice water. Squeeze to remove as much water from the sheets as possible, add them to the warm mixture, and whisk until they have completely dissolved.

4. Strain the mixture into a bowl through a fine-mesh sieve and divide it among four 8 oz. ramekins, leaving about ½ inch of space at the top. Carefully transfer the ramekins to the refrigerator and chill until the panna cottas are fully set, about 4 hours.

INGREDIENTS:

3½ SHEETS OF SILVER GELATIN

13 OZ. HEAVY CREAM

13 OZ. MILK

3.5 OZ. SUGAR

SEEDS AND POD OF ½ VANILLA BEAN

BEET PANNA COTTA

YIELD: 4 SERVINGS / **ACTIVE TIME:** 30 MINUTES / **TOTAL TIME:** 4 HOURS AND 30 MINUTES

A gorgeous variation on the traditional Italian panna cotta, with the goat cheese cutting beautifully against the sweetness of the beets.

1. Place the gelatin sheets in a small bowl. Add 1 cup of ice and water until the sheets are submerged. Let the mixture rest.

2. Combine the heavy cream, milk, sugar, honey, and beets in a saucepan and bring to a simmer. Cook for 15 minutes and then remove the pan from heat.

3. Remove the bloomed gelatin from the ice water. Squeeze to remove as much water from the sheets as possible, add them to the warm mixture, and whisk until they have completely dissolved.

4. Transfer the mixture to a blender, add the goat cheese, and puree until emulsified, about 45 seconds.

5. Strain the mixture into a bowl through a fine-mesh sieve and divide it among four 8 oz. ramekins, leaving about ½ inch of space at the top. Carefully transfer the ramekins to the refrigerator and chill until the panna cottas are fully set, about 4 hours.

INGREDIENTS:

4	SHEETS OF SILVER GELATIN
13	OZ. HEAVY CREAM
9	OZ. MILK
4	OZ. SUGAR
1.8	OZ. HONEY
12	OZ. RED BEETS, PEELED AND FINELY DICED
4	OZ. GOAT CHEESE, CRUMBLED

PUMPKIN MOUSSE

YIELD: 6 SERVINGS / **ACTIVE TIME:** 30 MINUTES / **TOTAL TIME:** 2 HOURS AND 30 MINUTES

If someone around your house just can't take the plunge on pumpkin pie, try warming them up a little with this brilliant, in taste and appearance, mousse.

1. Place the pumpkin puree, 1 cup of the heavy cream, and the sugar in a saucepan and bring to a simmer, stirring to combine. Remove the pan from heat, pour the mixture into a heatproof bowl, and set aside.

2. In the work bowl of a stand mixer fitted with the whisk attachment, add the cinnamon, nutmeg, cloves, vanilla, and remaining heavy cream and whip on medium until the mixture holds medium peaks.

3. Transfer the whipped cream to the bowl containing the pumpkin mixture and fold to incorporate.

4. Divide the mousse among six 8 oz. ramekins and lightly tap the bottom of each one to settle the mousse and to remove any air bubbles. Transfer the mousse to the refrigerator and chill for 2 hours.

5. To serve, top each mousse with additional cinnamon.

INGREDIENTS:

15 OZ. PUMPKIN PUREE

3 CUPS HEAVY CREAM

¾ CUP SUGAR

1 TABLESPOON CINNAMON, PLUS MORE FOR SERVING

1 TEASPOON FRESHLY GRATED NUTMEG

1 TEASPOON GROUND CLOVES

1 TABLESPOON PURE VANILLA EXTRACT

CHOCOLATE & SOURDOUGH BREAD PUDDING

YIELD: 16 SERVINGS / **ACTIVE TIME**: 45 MINUTES / **TOTAL TIME**: 24 HOURS

Using sourdough in bread pudding gives this humble offering a bit more texture and tanginess.

1. Place the bread in a mixing bowl and let it rest overnight at room temperature, uncovered, to dry out.

2. Place the chocolate chips in a heatproof mixing bowl. Place the milk, butter, sugar, heavy cream, cinnamon, nutmeg, and salt in a medium saucepan and bring to a simmer. Remove the pan from heat, pour the mixture over the chocolate chips, and stir until the chocolate has melted and the mixture is combined.

3. Place the eggs and vanilla in a heatproof mixing bowl and whisk to combine. Whisking constantly, gradually add the melted chocolate mixture until all of it has been incorporated.

4. Coat a 13 x 9–inch baking pan with cooking spray and then distribute the bread pieces in it. Slowly pour the custard over the bread and gently shake the pan to ensure it is evenly distributed. Press down on the bread pieces with a rubber spatula so that they soak up the custard. Cover the baking dish with aluminum foil, place it in the refrigerator, and chill for 2 hours.

5. Preheat the oven to 350°F.

6. Place the baking pan in the oven and bake for 45 minutes. Remove the aluminum foil and bake until the bread pudding is golden brown on top, about 15 minutes. Remove from the oven and let the bread pudding cool slightly before slicing and serving.

INGREDIENTS:

8	CUPS SOURDOUGH BREAD PIECES
2	CUPS CHOCOLATE CHIPS
3	CUPS WHOLE MILK
3	TABLESPOONS UNSALTED BUTTER
2¼	CUPS SUGAR
¾	CUP HEAVY CREAM
1½	TEASPOONS CINNAMON
½	TEASPOON FRESHLY GRATED NUTMEG
¼	TEASPOON KOSHER SALT
3	EGGS
1½	TEASPOONS PURE VANILLA EXTRACT

COCONUT PUDDING PANCAKES

YIELD: 30 PANCAKES / **ACTIVE TIME:** 20 MINUTES / **TOTAL TIME:** 50 MINUTES

This is a take on a very popular street food in Thailand that is known as khanom krok, or "candy bowl," because of its traditional shape and sweetness. To make the perfectly spherical cakes found on the streets of Bangkok, you will need to purchase a khanom krok pan, which is similar to the aebleskiver pan used here.

1. Preheat the oven to 350°F and coat an aebleskiver pan with nonstick cooking spray.

2. Place the coconut milk, 1 cup of the rice flour, the coconut, 1 tablespoon of the sugar, and the salt in a bowl and whisk vigorously until the sugar has dissolved. Set the mixture aside.

3. Place the coconut cream, remaining rice flour, remaining sugar, and tapioca starch or cornstarch in another bowl and whisk until the starch has dissolved. Add this mixture to the coconut milk mixture and stir until combined.

4. Fill the wells of the aebleskiver pan with the batter and top with some of the corn, if using.

5. Place the pan in the oven and bake until the pancakes are firm, 15 to 20 minutes. Remove from the oven, transfer the cooked pancakes to a platter, and tent it with aluminum foil to keep warm. Repeat Steps 4 and 5 with any remaining batter.

INGREDIENTS:

1½ CUPS COCONUT MILK

1½ CUPS RICE FLOUR

½ CUP SWEETENED
 SHREDDED COCONUT

5 TABLESPOONS CASTER
 SUGAR

½ TEASPOON FINE SEA SALT

1 CUP COCONUT CREAM

½ TABLESPOON TAPIOCA
 STARCH OR CORNSTARCH

¼ CUP CORN KERNELS
 (OPTIONAL)

GINGERBREAD MOUSSE

YIELD: 6 SERVINGS / **ACTIVE TIME:** 30 MINUTES / **TOTAL TIME:** 2 HOURS AND 45 MINUTES

The earthy sweetness of molasses is the perfect companion to all of the baking spice in this mousse.

1. Fill a small saucepan halfway with water and bring it to a simmer. Place the white chocolate in a heatproof mixing bowl and place it over the simmering water. Stir until the chocolate is melted and then set aside.

2. In the work bowl of a stand mixer fitted with the whisk attachment, whip the heavy cream until it holds soft peaks. Transfer the whipped cream to another bowl and place it in the refrigerator.

3. Wipe out the work bowl of the stand mixer, add the molasses, confectioners' sugar, egg yolks, eggs, vanilla, cinnamon, allspice, cardamom, nutmeg, and ginger and whip until the mixture has doubled in size and is pale, about 15 minutes. Transfer the mixture to a mixing bowl. Add the chocolate and whisk to incorporate. Add the whipped cream and fold to incorporate.

4. Divide the mousse among six 8 oz. ramekins and lightly tap the bottom of each one to settle the mousse and to remove any air bubbles. Transfer the mousse to the refrigerator and chill for 2 hours.

5. To serve, top each mousse with Chantilly Cream.

INGREDIENTS:

10.5 OZ. WHITE CHOCOLATE

14 OZ. HEAVY CREAM

2 OZ. MOLASSES

1 OZ. CONFECTIONERS' SUGAR

2 EGG YOLKS

2 EGGS

1 TEASPOON PURE VANILLA EXTRACT

1 TEASPOON CINNAMON

1 TEASPOON ALLSPICE

1 TEASPOON CARDAMOM

1 TEASPOON FRESHLY GRATED NUTMEG

½ TEASPOON GROUND GINGER

2 CUPS CHANTILLY CREAM (SEE PAGE 668), TO SERVE

THE PERFECT FLAN

YIELD: 6 SERVINGS / **ACTIVE TIME:** 30 MINUTES / **TOTAL TIME:** 6 HOURS AND 30 MINUTES

Listen Mamet, you're a great writer, but you're wrong about this: there most definitely *is* a difference between good and bad flan.

1. Preheat the oven to 350°F. Bring 8 cups of water to a boil and set aside.

2. Place 1 cup of the sugar and the water in a small saucepan and bring to a boil over high heat, swirling the pan instead of stirring. Cook until the caramel is a deep golden brown, taking care not to burn it. Remove the pan from heat and pour the caramel into a round 8-inch cake pan. Place the cake pan on a cooling rack and let it sit until it has set.

3. Place the egg yolks, eggs, cream cheese, remaining sugar, condensed milk, evaporated milk, heavy cream, almond extract, and vanilla in a blender and puree until emulsified.

4. Pour the mixture over the caramel and place the cake pan in a roasting pan. Pour the boiling water into the roasting pan until it reaches halfway up the side of the cake pan.

5. Place the flan in the oven and bake until it is just set, 60 to 70 minutes. The flan should still be jiggly without being runny. Remove from the oven, place the cake pan on a cooling rack, and let it cool for 1 hour.

6. Place the flan in the refrigerator and chill for 4 hours.

7. Run a knife along the edge of the pan and invert the flan onto a plate so that the caramel layer is on top. Slice the flan and serve.

INGREDIENTS:

2	CUPS SUGAR
¼	CUP WATER
5	EGG YOLKS
5	EGGS
5	OZ. CREAM CHEESE, SOFTENED
1	(14 OZ.) CAN SWEETENED CONDENSED MILK
1	(12 OZ.) CAN EVAPORATED MILK
1½	CUPS HEAVY CREAM
½	TEASPOON ALMOND EXTRACT
½	TEASPOON PURE VANILLA EXTRACT

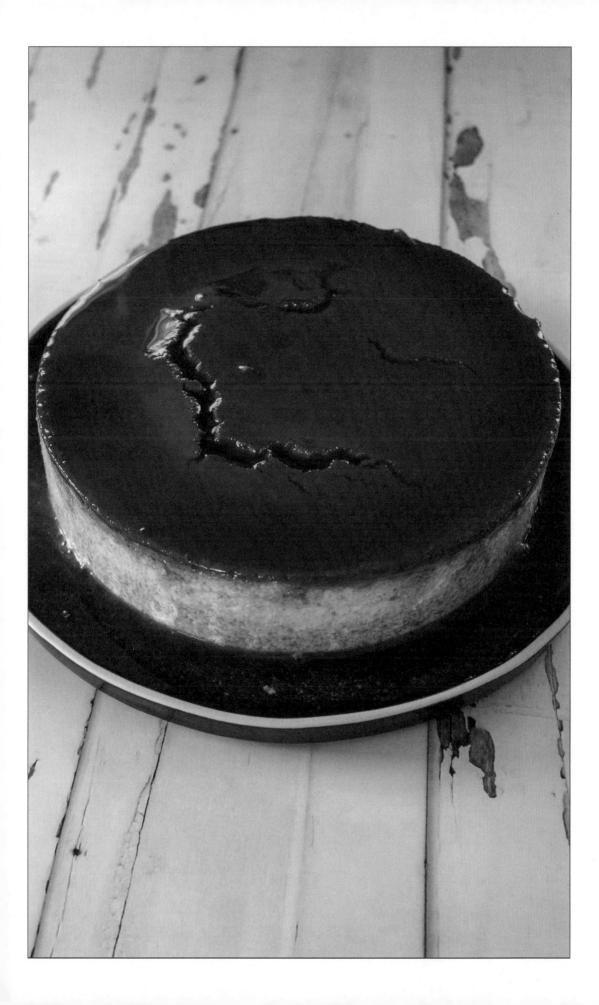

CHERRY CLAFOUTIS

YIELD: 4 SERVINGS / **ACTIVE TIME:** 10 MINUTES / **TOTAL TIME:** 40 MINUTES

A French classic. The cherries here are pitted for convenience, but Julia Child insisted they remain in her version, claiming they added a welcome hint of almond.

1. Preheat the oven to 350°F. Coat four 8 oz. ramekins with nonstick cooking spray. Divide the cherries among the ramekins and set aside.

2. Place the eggs, flour, vanilla, almond extract, 3.5 oz. of the sugar, and milk in a blender and puree until the mixture is a smooth batter.

3. Divide the batter among the ramekins and sprinkle the remaining sugar over each portion.

4. Place the ramekins in the oven and bake until the custard is lightly browned and a cake tester inserted into the center of each clafoutis comes out clean, about 20 minutes.

5. Remove from the oven and let the clafoutis cool slightly on a wire rack. Dust each one lightly with confectioners' sugar and serve warm.

INGREDIENTS:

2	CUPS SWEET CHERRIES, PITTED
3	EGGS
2.5	OZ. ALL-PURPOSE FLOUR
1	TEASPOON PURE VANILLA EXTRACT
¼	TEASPOON ALMOND EXTRACT
3.5	OZ. SUGAR, PLUS 2 OZ.
12	OZ. MILK
½	CUP CONFECTIONERS' SUGAR, FOR TOPPING

ZABAGLIONE

YIELD: 6 SERVINGS / **ACTIVE TIME:** 20 MINUTES / **TOTAL TIME:** 20 MINUTES

Any sweet wine can be substituted for the Marsala in this classic Italian dessert, which is thought to date back to the fifteenth century.

1. Fill a small saucepan halfway with water and bring it to a gentle simmer. Combine the egg yolks and sugar in a heatproof bowl and place it over the simmering water. Whisk the mixture until it is pale yellow and creamy.

2. While whisking continually, slowly add the Marsala. The mixture will begin to foam, and then it will swell considerably. Whisk until it is very soft, with a number of gentle peaks and valleys. Ladle the zabaglione into serving dishes and garnish with fresh raspberries.

INGREDIENTS:

4 EGG YOLKS

¼ CUP SUGAR

½ CUP DRY MARSALA WINE

 FRESH RASPBERRIES, FOR
 GARNISH

EGGNOG MOUSSE

YIELD: 6 SERVINGS / **ACTIVE TIME:** 30 MINUTES / **TOTAL TIME:** 2 HOURS AND 30 MINUTES

Heavy desserts tend to reign around the holidays, making this light and fluffy offering a welcome sight on the dessert table.

1. In the work bowl of a stand mixer fitted with the whisk attachment, whip the egg whites on high until they hold stiff peaks. Transfer the egg whites to another bowl and place it in the refrigerator.

2. Wipe out the work bowl of the stand mixer, add the heavy cream, confectioners' sugar, vanilla, nutmeg, cinnamon, and ginger, and whip until the mixture holds stiff peaks.

3. Transfer the whipped cream to a mixing bowl. Add the whipped egg whites and fold to incorporate.

4. Divide the mousse between six 8 oz. ramekins and lightly tap the bottom of each one to settle the mousse and to remove any air bubbles. Transfer the mousse to the refrigerator and chill for 2 hours.

5. To serve, top each mousse with Chantilly Cream.

INGREDIENTS:

4 EGG WHITES

4 CUPS HEAVY CREAM

1 CUP CONFECTIONERS' SUGAR

2 TEASPOONS PURE VANILLA EXTRACT

2 TABLESPOONS FRESHLY GRATED NUTMEG, OR TO TASTE

2 TABLESPOONS CINNAMON

1 TABLESPOON GROUND GINGER, OR TO TASTE

2 CUPS CHANTILLY CREAM (SEE PAGE 668), FOR SERVING

CARAMEL BREAD PUDDING

YIELD: 16 SERVINGS / **ACTIVE TIME:** 45 MINUTES / **TOTAL TIME:** 24 HOURS

A classic bread pudding that elects to omit the raisins that so often make their way into the preparation. If you find yourself missing their sweetness and chewiness, toss in anywhere from ¼ to ½ cup.

1. Place the bread in a mixing bowl and let it rest overnight at room temperature, uncovered, to dry out.

2. Place the cream, milk, cinnamon, cloves, sugar, and salt in a medium saucepan and bring the mixture to a simmer. Remove the pan from heat.

3. Place the eggs and vanilla in a heatproof mixing bowl and whisk to combine. Whisking constantly, gradually add the warm mixture. When half of the warm mixture has been incorporated, add the tempered eggs to the saucepan and whisk to combine.

4. Coat a 13 x 9–inch baking pan with cooking spray and then distribute the bread pieces in it. Slowly pour the custard over the bread and gently shake the pan to ensure it is evenly distributed. Press down on the bread pieces with a rubber spatula so that they soak up the custard. Cover the baking dish with aluminum foil, place it in the refrigerator, and chill for 2 hours.

5. Preheat the oven to 350°F.

6. Place the baking pan in the oven and bake for 45 minutes. Remove the aluminum foil and bake until the bread pudding is golden brown on top, about 15 minutes. Remove from the oven and let the bread pudding cool slightly before slicing and serving with the toffee sauce.

INGREDIENTS:

8 CUPS TORN CHALLAH OR BRIOCHE

9 OZ. HEAVY CREAM

3 OZ. MILK

1 TEASPOON CINNAMON

¼ TEASPOON GROUND CLOVES

3 OZ. SUGAR

¼ TEASPOON KOSHER SALT

3 EGGS

½ TEASPOON PURE VANILLA EXTRACT

2 CUPS BOURBON TOFFEE SAUCE (SEE PAGE 724)

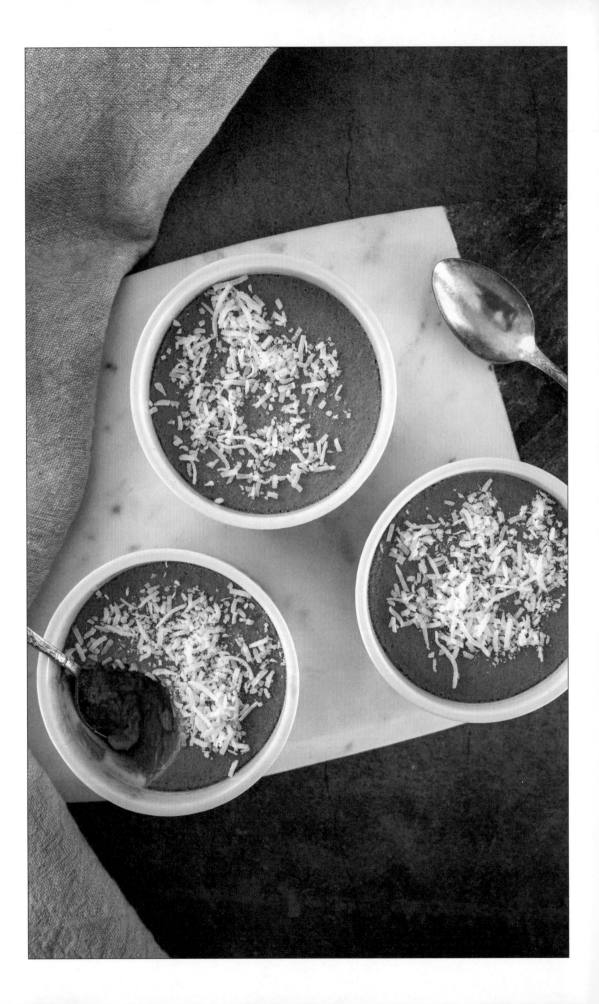

COCONUT FLAN

YIELD: 6 SERVINGS / **ACTIVE TIME:** 30 MINUTES / **TOTAL TIME:** 6 HOURS AND 30 MINUTES

Feel free to top this flan with some fresh tropical fruit, such as fresh mango, passion fruit, or lychee.

1. Preheat the oven to 350°F. Bring 8 cups of water to a boil and set aside.

2. Place the sugar and water in a small saucepan and bring to a boil over high heat, swirling the pan instead of stirring. Cook until the caramel is a deep golden brown, taking care not to burn it. Remove the pan from heat and add the evaporated milk a little at a time, whisking constantly to prevent the sugar from seizing. When all of the evaporated milk has been added, incorporate the coconut milk and condensed milk in the same fashion.

3. Whisk the eggs, egg yolks, vanilla, and salt into the mixture. Divide the mixture among six 8 oz. ramekins, filling each one about three-quarters of the way.

4. Place the ramekins in a 13 x 9–inch roasting pan. Pour the boiling water into the roasting pan until it reaches halfway up the sides of the ramekins.

5. Place the pan in the oven and bake the flan is just set, 45 to 50 minutes. The flan should still be jiggly without being runny. Remove from the oven, place the roasting pan on a cooling rack, and let it cool for 1 hour.

6. Place the flan in the refrigerator and chill for 4 hours before serving.

INGREDIENTS:

½	CUP SUGAR
2	TABLESPOONS WATER
12	OZ. EVAPORATED MILK
14	OZ. COCONUT MILK
14	OZ. SWEETENED CONDENSED MILK
3	EGGS
3	EGG YOLKS
1½	TEASPOONS PURE VANILLA EXTRACT
½	TEASPOON KOSHER SALT

MANGO CON CHILE PÂTE DE FRUIT

YIELD: 60 CANDIES / **ACTIVE TIME:** 25 MINUTES / **TOTAL TIME:** 3 HOURS AND 30 MINUTES

Putting the sublime combination of mango and chile into a candy tuned out to be a fruitful gamble.

1. Line a baking sheet with a silicone baking mat and place a silicone candy mold on it. Place the pectin and a little bit of the sugar in a mixing bowl and stir to combine. Add the citric acid to the water and let it dissolve.

2. Place the puree in a saucepan and warm it to 120°F. Add the pectin-and-sugar mixture and whisk to prevent any clumps from forming. Bring the mixture to a boil and let it cook for 1 minute.

3. Stir in the corn syrup and remaining sugar and cook the mixture until it is 223°F. The mixture should have thickened and should cool quickly and hold its shape when a small portion of it is dropped from a rubber spatula.

4. Stir in the lime zest and citric acid-and-water mixture and cook for another minute or so. Remove the pan from heat, strain the mixture, and pour it into the candy mold.

5. Let it cool for at least 3 hours before cutting into the desired shapes. Toss in Tajín seasoning, sugar, and salt and enjoy.

INGREDIENTS:

3	TABLESPOONS APPLE PECTIN
20.1	OZ. SUGAR, PLUS MORE TO TASTE
1½	TEASPOONS CITRIC ACID
1½	TEASPOONS WATER
17.6	OZ. MANGO PUREE
3½	OZ. CORN SYRUP
	PINCH OF LIME ZEST
	TAJÍN SEASONING, TO TASTE
	SALT, TO TASTE

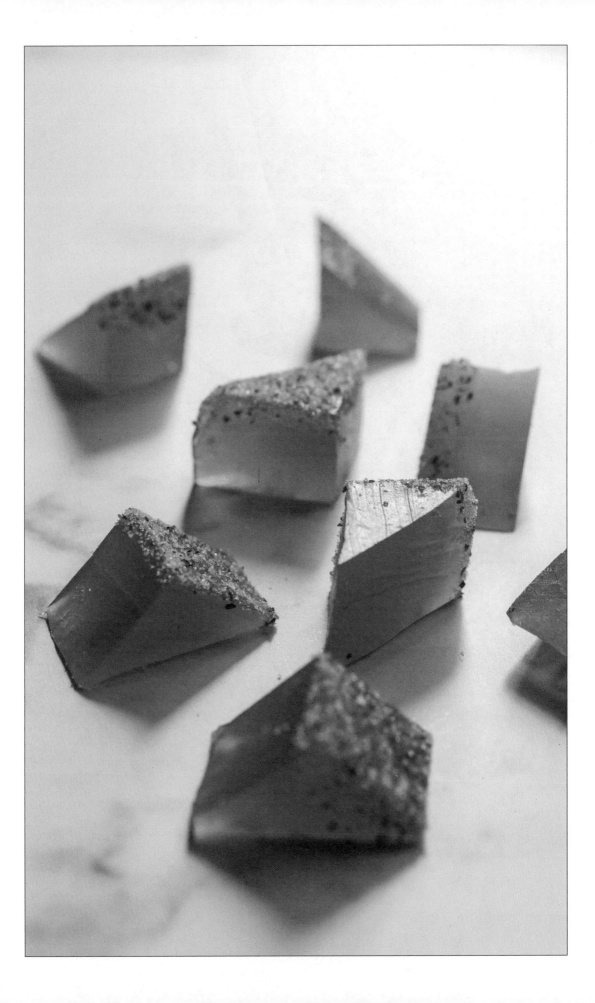

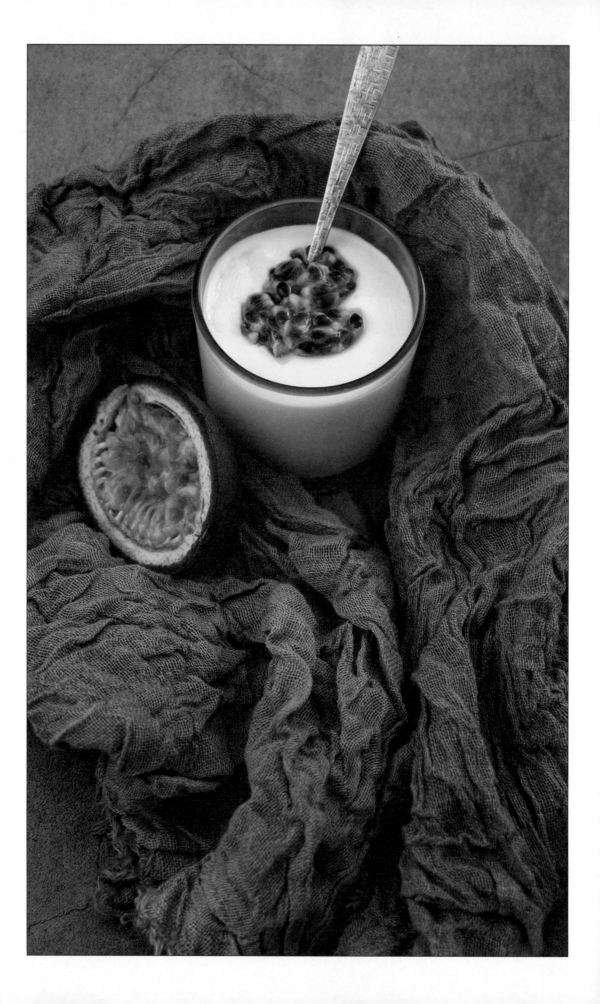

ORANGE & COCONUT PANNA COTTA

YIELD: 6 SERVINGS / **ACTIVE TIME:** 30 MINUTES / **TOTAL TIME:** 4 HOURS AND 30 MINUTES

A tropically inspired panna cotta that will keep you cool all summer long.

1. Place the gelatin sheets in a small bowl. Add 1 cup of ice and water until the sheets are submerged. Let the mixture rest.

2. Combine the heavy cream, coconut milk, confectioners' sugar, orange juice, orange zest, vanilla seeds, and half of the vanilla bean pod in a saucepan and bring to a simmer. Cook for 15 minutes and then remove the pan from heat. Remove the vanilla bean pod and discard it.

3. Remove the bloomed gelatin from the ice water. Squeeze to remove as much water from the sheets as possible, add them to the warm mixture, and whisk until they have completely dissolved.

4. Strain the mixture into a bowl through a fine-mesh sieve and divide it among four 8 oz. ramekins, leaving about ½ inch of space at the top. Carefully transfer the ramekins to the refrigerator and chill until the panna cottas are fully set, about 4 hours.

5. Split the passion fruits in half and scoop the insides into a small bowl to remove their seeds and juice. Garnish the top of each panna cotta with about 1 tablespoon of passion fruit juice and seeds, and chill the panna cottas in the refrigerator until ready to serve.

INGREDIENTS:

4	SHEETS OF SILVER GELATIN
2½	CUPS HEAVY CREAM
1	CUP COCONUT MILK
4.5	OZ. CONFECTIONERS' SUGAR
1¼	CUPS ORANGE JUICE
	ZEST OF 1 ORANGE
	SEEDS OF 1 VANILLA BEAN, POD RESERVED
6	FRESH PASSION FRUITS, FOR GARNISH

SWEET & SPICY PECANS

YIELD: 4 CUPS / **ACTIVE TIME:** 30 MINUTES / **TOTAL TIME:** 1 HOUR AND 30 MINUTES

These frosted nuts make a wonderful addition to a cheese plate or charcuterie board.

1. Preheat the oven to 350°F. Place the pecans on a parchment-lined baking sheet, place them in the oven, and toast until fragrant, about 15 minutes.

2. Remove the pecans from the oven, set the pan on a cooling rack, and let the pecans cool. Leave the oven on.

3. In the work bowl of a stand mixer fitted with the whisk attachment, whip the egg whites and salt on high until the mixture holds stiff peaks.

4. Reduce the speed to medium and gradually incorporate the sugar. When all of the sugar has been added, raise the speed to high, and whip until the meringue is glossy, about 2 minutes. Reduce the speed to low, add the cinnamon, nutmeg, and cayenne pepper, and beat until incorporated.

5. Remove the work bowl from the mixer, add the toasted pecans, and fold until evenly distributed in the meringue.

6. Line an 18 x 13–inch baking sheet with a silicone baking mat. Place the frosted pecans on the baking sheet in a single layer, place them in the oven, and bake for 30 minutes, removing the pan from the oven every 10 minutes to stir the pecans and ensure that they cook evenly.

7. Remove the pecans from the oven and let them cool completely before enjoying.

INGREDIENTS:

4	CUPS PECANS HALVES
2	EGG WHITES
	PINCH OF KOSHER SALT
¾	CUP SUGAR
½	TEASPOON CINNAMON
¼	TEASPOON FRESHLY GRATED NUTMEG
⅛	TEASPOON CAYENNE PEPPER

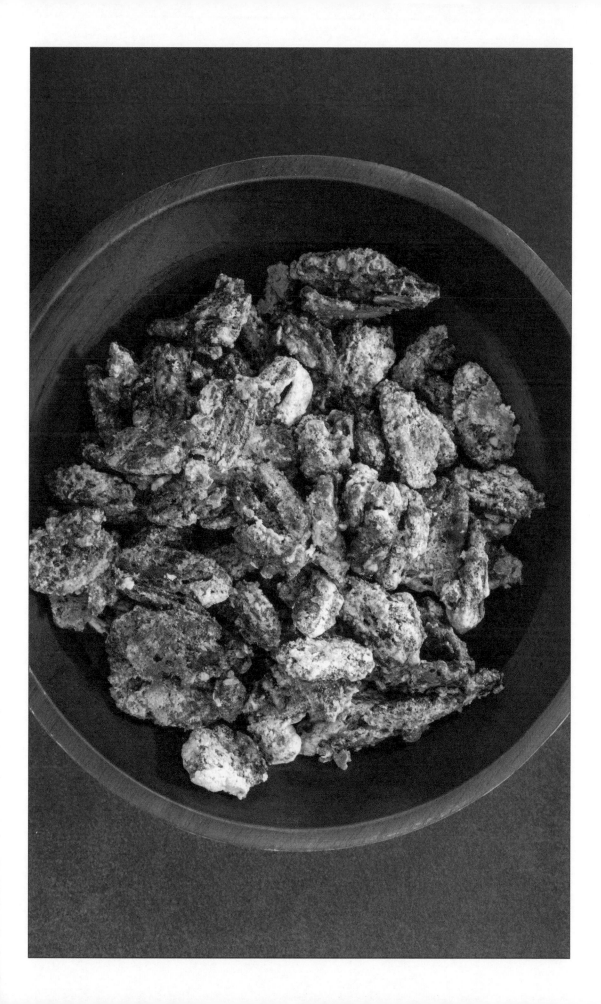

STRAWBERRY FRUIT LEATHER

YIELD: 40 SERVINGS / **ACTIVE TIME:** 30 MINUTES / **TOTAL TIME:** 4 HOURS AND 30 MINUTES

A grown-up take on Fruit Roll-Ups that is just as fun and enjoyable as the original.

1. Preheat the oven to 180°F. Line an 18 x 13–inch baking sheet with a silicone baking mat.

2. Place the strawberries, confectioners' sugar, and lemon juice in a blender and puree until smooth.

3. Spread the strawberry puree over the silicone mat. It should be an even layer that is about ⅛ inch thick.

4. Place in the oven and bake until the leather is tacky but no longer sticky, about 3 hours.

5. Remove the pan from the oven and place it on a wire rack to cool completely.

6. Carefully remove the fruit leather from the silicone mat and place it on a piece of parchment paper. Use a pizza cutter to cut the leather into the desired shapes and sizes. The fruit leather can be stored in an airtight container at room temperature for up to 1 week.

INGREDIENTS:

8 OZ. STRAWBERRIES, HULLED AND STEMMED

2 TABLESPOONS CONFECTIONERS' SUGAR

1 TEASPOON FRESH LEMON JUICE

TANG YUAN DANGO

YIELD: 4 TO 6 SERVINGS / **ACTIVE TIME:** 30 MINUTES / **TOTAL TIME:** 2 HOURS

A sweet rice dumpling that is both beautiful and bursting with flavor, thanks to the freeze-dried berries.

1. Place the strawberries and sugar in a glass mixing bowl and stir to combine. Place 1 inch of water in a small saucepan and bring it to a boil. Cover the bowl with plastic wrap, place it over the saucepan, and let cook for 1 hour. Check the water level every 15 minutes and add more if it has evaporated. After 1 hour, turn off the heat and let the syrup cool. When cool, strain and discard the solids.

2. Bring water to a boil in a large saucepan. Place the flour, water, and ¾ cup of the syrup in a large mixing bowl and use a fork to work the mixture until it is combined and very dry. Remove 2 tablespoons of the mixture and roll each tablespoon into a ball. Place the balls in the boiling water and cook until they float to the surface and double in size, about 5 minutes. Return the balls to the mixture, add the canola oil, and use the fork to incorporate.

3. Bring the water back to a boil and prepare an ice water bath. Place the mixture on a flour-dusted work surface and knead until it is a smooth and slightly tacky dough. If the dough is too dry or too sticky, incorporate water or flour as needed.

4. Divide the dough into 18 pieces, roll them into balls, and use a slotted spoon to gently lower them into the pot. Gently stir to keep them from sticking to the bottom, and then cook until they float to the surface and double in size, about 8 minutes. Remove with a slotted spoon, refresh in the ice water bath, drain, and place 3 balls on each of the skewers. Garnish with the freeze-dried strawberries, drizzle some of the remaining syrup over the top, and enjoy.

INGREDIENTS:

- 4 CUPS FRESH STRAWBERRIES, HULLED AND CHOPPED
- 8.75 OZ. SUGAR
- 8.5 OZ. SWEET RICE FLOUR (GLUTINOUS RICE FLOUR), PLUS MORE AS NEEDED
- ⅓ CUP WATER, PLUS MORE AS NEEDED
- 2 TABLESPOONS CANOLA OIL
- 6 WOODEN SKEWERS

 FREEZE-DRIED STRAWBERRIES, FOR GARNISH

MACADAMIA BRITTLE

YIELD: 24 SERVINGS / **ACTIVE TIME:** 40 MINUTES / **TOTAL TIME:** 2 HOURS AND 30 MINUTES

Brittle is great with any nut, but becomes transcendent with the buttery macadamia. This is great at a holiday party, or as a small gift.

1. Preheat the oven to 350°F. Line a baking sheet with parchment paper and place the macadamia nuts on it. Place the nuts in the oven and roast until they are golden brown and fragrant, about 15 minutes. Remove the nuts from the oven and let them cool for 30 minutes.

2. Place the nuts in a food processor and pulse until roughly chopped.

3. Make sure all of the ingredients are measured out, as you must work quickly once the sugar caramelizes. Place two 18 x 13–inch silicone baking mats on the counter, along with one rolling pin and a cooling rack.

4. In a large saucepan fitted with a candy thermometer, combine the butter, corn syrup, brown sugar, sugar, and salt and cook over medium heat, swirling the pan occasionally, until the caramel reaches 248°F.

5. Remove the pan from heat and carefully whisk in the water and vanilla.

6. Add the baking soda and toasted macadamia nuts and work quickly, whisking the mixture to deflate the bubbling caramel.

7. Pour the mixture over one of the mats, using a rubber spatula to remove all the caramel from the pan. Place the second silicone mat on top. Using the rolling pin, roll the caramel out until it is the length and width of the mats.

8. Carefully transfer the mats to the cooling rack. Allow the brittle to set for at least an hour before breaking it up.

INGREDIENTS:

1½	CUPS MACADAMIA NUTS
1	TABLESPOON UNSALTED BUTTER, SOFTENED
½	CUP LIGHT CORN SYRUP
3.5	OZ. BROWN SUGAR
1	LB. SUGAR
½	TEASPOON KOSHER SALT
½	CUP WATER
½	TEASPOON PURE VANILLA EXTRACT
¾	TEASPOON BAKING SODA

PRALINES

YIELD: 24 PRALINES / **ACTIVE TIME:** 30 MINUTES / **TOTAL TIME:** 1 HOUR AND 30 MINUTES

Originating in France and initially containing almonds, the praline came into its own in Louisiana, where the plentiful pecan lent its natural sweetness to the treat. The transformation proved to be addictive, and they became so popular that they were being hawked on the streets of New Orleans as far back as the 1860s, a time when markets and vendors were largely concerned with providing the necessities of everyday life.

1. Preheat the oven to 350°F. Place the pecans on a parchment-lined baking sheet, place them in the oven, and toast until fragrant, about 15 minutes. Remove from the oven and let the pecans cool.

2. Line an 18 x 13–inch baking sheet with a silicone baking mat.

3. Combine the sugar, dark brown sugar, baking soda, salt, milk, and heavy cream in a medium saucepan fitted with a candy thermometer and cook over medium-high heat, stirring occasionally, until the thermometer reads 242°F. Remove the pan from heat, stir in the butter and bourbon, and then add the pecans. Fold until the pecans are completely coated and evenly distributed.

4. Scoop 2-oz. portions of the mixture onto the silicone mat, leaving ½ inch between each praline. Place the baking sheet on a wire rack and let the pralines set for 1 hour before enjoying.

INGREDIENTS:

3	CUPS PECANS
10	OZ. SUGAR
¾	CUP DARK BROWN SUGAR
½	TEASPOON BAKING SODA
¼	TEASPOON KOSHER SALT
3	OZ. MILK
3	OZ. HEAVY CREAM
1	OZ. UNSALTED BUTTER
1	TABLESPOON BOURBON

RASPBERRY FRUIT LEATHER

YIELD: 40 SERVINGS / **ACTIVE TIME:** 30 MINUTES / **TOTAL TIME:** 4 HOURS AND 30 MINUTES

Due to the relatively high acidity of raspberries, this will be tangier than it appears at first sight.

1. Preheat the oven to 180°F. Line an 18 x 13–inch baking sheet with a silicone baking mat.

2. Place the raspberries, confectioners' sugar, and lemon juice in a blender and puree until smooth.

3. Spread the raspberry puree over the silicone mat. It should be an even layer that is about ⅛ inch thick.

4. Place in the oven and bake until the leather is tacky but no longer sticky, about 3 hours.

5. Remove the pan from the oven and place it on a wire rack to cool completely.

6. Carefully remove the fruit leather from the silicone mat and place it on a piece of parchment paper. Use a pizza cutter to cut the leather into the desired shapes and sizes. The fruit leather can be stored in an airtight container at room temperature for up to 1 week.

INGREDIENTS:

2 PINTS OF RASPBERRIES

2 TABLESPOONS CONFECTIONERS' SUGAR

1 TEASPOON LEMON JUICE

APPLE CHIPS

YIELD: 1 CUP / **ACTIVE TIME:** 1 HOUR / **TOTAL TIME:** 8 HOURS

Apple chips are a wonderful snack, but don't hesitate to adorn ice cream, cakes, and mousses with them.

1. Combine the water, sugar, cinnamon sticks, and lemon juice in a small saucepan and bring the mixture to a boil, stirring to dissolve the sugar. Remove the pan from heat and set aside.

2. Using a mandoline, cut the apples horizontally into approximately ⅛-inch-thick slices.

3. Place the apple slices in a heat-resistant container and pour the hot syrup over the apples. Let the mixture sit until completely cool, about 2 hours.

4. Preheat the oven to 200°F. Line an 18 x 13–inch baking sheet with a silicone baking mat.

5. Remove the apple slices one at a time from the syrup. Shake off the excess liquid and lay the apples on the silicone mat.

6. Place the apples in the oven and bake until they are tacky but no longer sticky, 2 to 3 hours.

7. Remove the apple chips from the oven and set the pan on a wire rack to cool. Let the apple chips cool completely before enjoying or storing.

INGREDIENTS:

2	CUPS WATER
2	CUPS SUGAR
2	CINNAMON STICKS
2	TABLESPOONS FRESH LEMON JUICE
2	HONEYCRISP APPLES

CLASSIC CHOCOLATE TRUFFLES

YIELD: 36 TRUFFLES / **ACTIVE TIME:** 20 MINUTES / **TOTAL TIME:** 24 HOURS

It's important to use the best possible ingredients here, as compromises have nowhere to hide.

1. Break the chocolate into small pieces, place it in a food processor, and blitz until it is finely chopped. Place it in a heatproof bowl and add the salt.

2. Place the cream in a saucepan and bring to a simmer over medium heat, stirring frequently. Pour the warm cream over the chocolate and whisk until it has melted and the mixture is smooth. Transfer the chocolate to a square 9-inch baking pan and let it cool completely. Cover it with plastic wrap and refrigerate overnight.

3. Line two baking sheets with parchment paper and place the cocoa powder in a shallow bowl. Form heaping tablespoons of the chocolate mixture into balls and roll them in the cocoa powder. Place them on the baking sheets and refrigerate for 30 minutes before serving.

INGREDIENTS:

1 LB. DARK CHOCOLATE (55 TO 65 PERCENT)

 PINCH OF FINE SEA SALT

1¼ CUPS HEAVY CREAM

½ CUP COCOA POWDER

MERINGUE KISSES

YIELD: 50 KISSES / **ACTIVE TIME:** 30 MINUTES / **TOTAL TIME:** 1 HOUR AND 30 MINUTES

Y ou'll savor each one.

1. Preheat the oven to 200°F and line two baking sheets with parchment paper.

2. Fill a small saucepan halfway with water and bring it to a gentle simmer. In the work bowl of a stand mixer, combine the egg whites, sugar, and salt. Place the work bowl over the simmering water and whisk continually until the sugar has dissolved. Remove the bowl from heat and return it to the stand mixer.

3. Fit the mixer with the whisk attachment and whip the mixture on high until it holds stiff peaks. If using food coloring or vanilla, add it now and whisk to incorporate.

4. Transfer the meringue to a piping bag fit with a round tip.

5. Pipe the meringue onto the baking sheets, leaving about 1 inch between the meringues. Place the sheets in the oven and bake the meringues until they can be pulled off the parchment cleanly and are no longer sticky in the center, about 1 hour. If the meringues need a little longer, crack the oven door and continue cooking. This will prevent the meringues from browning.

6. Remove from the oven and enjoy immediately.

INGREDIENTS:

4 EGG WHITES

7 OZ. SUGAR

 PINCH OF KOSHER SALT

1–2 DROPS OF GEL FOOD
 COLORING (OPTIONAL)

1 TEASPOON PURE VANILLA
 EXTRACT (OPTIONAL)

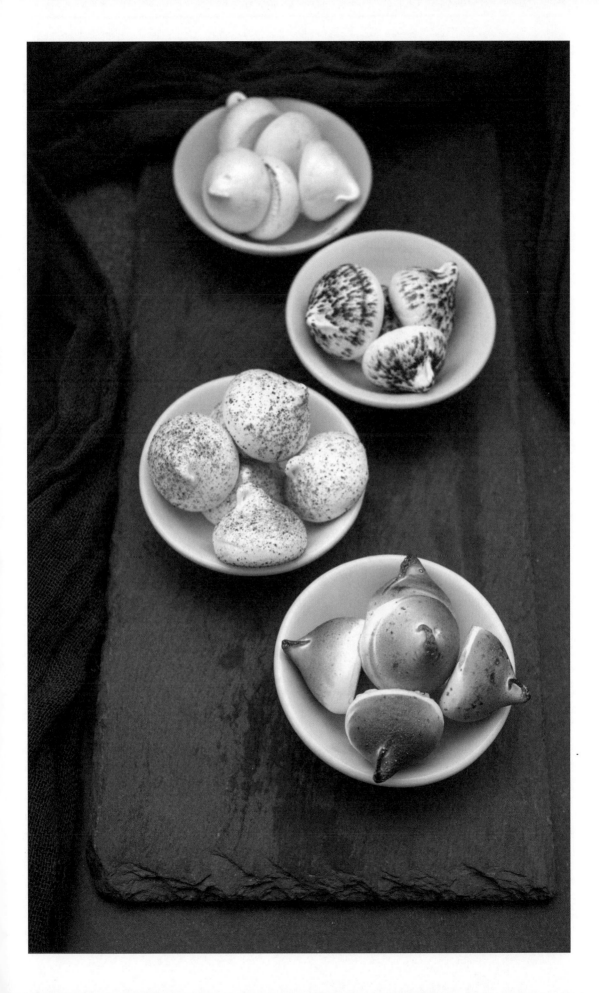

RASPBERRY PÂTE DE FRUIT

YIELD: 6 SERVINGS / **ACTIVE TIME:** 45 MINUTES / **TOTAL TIME:** 3 HOURS

A sweet French gummy that is positively bursting with fresh flavor.

1. Line a 13 x 9–inch baking pan with parchment paper and coat it with nonstick cooking spray.

2. Place the pectin and ¼ cup of the sugar in a mixing bowl and whisk to combine.

3. In a large saucepan fitted with a candy thermometer, combine the raspberry puree and water and warm the mixture over high heat. While whisking continually, gradually add the pectin mixture and bring the mixture to a boil.

4. Once boiling, add 4 cups of the sugar and whisk until dissolved. Lower the heat to medium and cook the mixture until it is 230°F.

5. Remove the pan from heat and carefully pour the mixture into the prepared baking pan. Transfer the pan to a cooling rack and let it sit at room temperature until cool and set, about 2 hours.

6. Dust a cutting board with sugar, transfer the candy onto the board, and cut it into 1-inch squares.

7. Place the remaining sugar in a medium bowl, add the candies, and toss until coated.

INGREDIENTS:

1 OZ. APPLE PECTIN

6¼ CUPS SUGAR, PLUS MORE
 AS NEEDED

14.2 OZ. RASPBERRIES, PUREED

28.5 OZ. WATER

CINNAMON & HONEY PARFAITS

YIELD: 4 SERVINGS / **ACTIVE TIME:** 10 MINUTES / **TOTAL TIME:** 10 MINUTES

A delicious and healthy treat suitable for any time of year. Best of all, it can be prepared with incredible alacrity.

1. Place the yogurt, honey, confectioners' sugar, salt, and cinnamon in a mixing bowl and whisk until combined.

2. Divide 1 cup of the Granola among four mason jars. Top the Granola with ½ cup of the yogurt mixture. Top the yogurt with the remaining Granola and the blueberries. Top each portion with the cream, dust each parfait with additional cinnamon, and serve.

INGREDIENTS:

2	CUPS GREEK YOGURT
¼	CUP HONEY
¼	CUP CONFECTIONERS' SUGAR
¼	TEASPOON KOSHER SALT
1	TABLESPOON CINNAMON, PLUS MORE TO TASTE
2	CUPS GRANOLA (SEE PAGE 431)
1	PINT OF FRESH BLUEBERRIES
2	CUPS CHANTILLY CREAM (SEE PAGE 668)

BAKED APPLES

YIELD: 6 SERVINGS / **ACTIVE TIME:** 15 MINUTES / **TOTAL TIME:** 1 HOUR

A sweet-tart, crisp apple such as the Pink Lady is what you'll want to use in this recipe.

1. Preheat the oven to 350°F. Slice the tops off of the apples and set aside. Use a paring knife to cut out the apples' cores and then scoop out the centers, leaving a ½-inch-thick cavity inside each apple.

2. Rub the inside and outside of the apples with some of the melted butter. Place the jam and goat cheese in a mixing bowl and stir to combine. Fill the apples' cavities with the mixture, place the tops back on the apples, and set aside.

3. Coat a baking pan with the remaining butter and then arrange the apples in the pan. Place in the oven and bake until tender, 25 to 30 minutes. Remove from the oven and let them cool briefly before serving.

INGREDIENTS:

- 6 APPLES
- 3 TABLESPOONS UNSALTED BUTTER, MELTED
- 6 TABLESPOONS BLACKBERRY JAM
- 2 OZ. GOAT CHEESE, AT ROOM TEMPERATURE, CUT INTO 6 ROUNDS

BLUEBERRY COBBLER

YIELD: 16 SERVINGS / **ACTIVE TIME:** 15 MINUTES / **TOTAL TIME:** 1 HOUR

Peach is probably the more traditional choice, but nothing goes with warm biscuits like an in-season blueberry.

1. Preheat the oven to 375°F. Place the blueberries, sugar, cornstarch, salt, lemon zest, lemon juice, and vanilla in a mixing bowl and toss to combine.

2. Transfer the blueberry mixture to a 13 x 9–inch baking dish.

3. Break the dough into large chunks and cover the mixture with them.

4. Brush the chunks of dough with the egg and sprinkle sanding sugar over them.

5. Place the cobbler in the oven and bake until the biscuits are golden brown and the blueberry mixture is bubbling and has thickened, 30 to 35 minutes.

6. Remove from the oven and let the cobbler cool briefly before serving.

INGREDIENTS:

3	PINTS OF FRESH BLUEBERRIES
½	CUP SUGAR
1	TABLESPOON CORNSTARCH
¼	TEASPOON KOSHER SALT
	ZEST AND JUICE OF 1 LEMON
1	TEASPOON PURE VANILLA EXTRACT
	DOUGH FROM BUTTERMILK BISCUITS (SEE PAGE 644)
1	EGG, BEATEN
	SANDING SUGAR, FOR TOPPING

GRANOLA

YIELD: 3 CUPS / **ACTIVE TIME:** 30 MINUTES / **TOTAL TIME:** 3 HOURS

This is a stock recipe that can be tailored to your own whims quite easily.

1. Preheat the oven to 250°F and line a 26 x 18–inch baking sheet with parchment paper. Place the oats, pumpkin seeds, almonds, pistachios, and coconut in a mixing bowl and stir to combine.

2. Combine the remaining ingredients in a small saucepan and bring to a boil, stirring to dissolve.

3. Pour the hot syrup over the oat-and-nut mixture and fold the mixture until it is thoroughly combined.

4. Spread the granola on the baking sheet in an even layer, place it in the oven, and bake until it is crispy and golden brown, about 2 hours. Remove a bit of the granola, let it cool for 5 minutes, and then taste it to see if it is as crispy as you want it to be. If not, continue baking until it is, testing every 15 minutes.

5. Remove the granola from the oven and let it cool before enjoying. The granola will keep at room temperature in an airtight container for up to 1 month.

INGREDIENTS:

1½	CUPS ROLLED OATS
¼	CUP PUMPKIN SEEDS
½	CUP SLICED ALMONDS
¼	CUP PISTACHIOS
¼	CUP SWEETENED SHREDDED COCONUT
1.5	OZ. HONEY
1.5	OZ. REAL MAPLE SYRUP
½	OZ. DARK BROWN SUGAR
1	OZ. UNSALTED BUTTER
½	TEASPOON KOSHER SALT
1	TEASPOON CINNAMON

MUFFINS, SCONES, BAGELS & SAVORY CROISSANTS

These recipes will make your morning, no matter your default orientation to it. Go-getters will have a host of options that they can enjoy without missing a step, and others that allow them to take a step back and gather their thoughts. And those who dread the morning gain a handful of means to get through it, a collection of oases in what, for them, is an otherwise barren landscape.

While each of the preparations within will look great on the breakfast table or as part of a brunch spread, it is the bagel recipes that we believe will be truly eye-opening for the motivated home baker. Thought forever to be restricted to all but the most practiced hands, this group of recipes will show you what it takes to stretch, boil, and bake your way to regularly turning out line-around-the-block-worthy bagels.

BLUEBERRY MUFFINS

YIELD: 12 MUFFINS / **ACTIVE TIME:** 20 MINUTES / **TOTAL TIME:** 1 HOUR

Soft and sweet muffins that are bursting with fresh blueberries.

1. Preheat the oven to 375°F. Line a 12-well muffin pan with paper liners.

2. Place the flour, baking powder, and salt in a mixing bowl and whisk to combine. Set the mixture aside.

3. In the work bowl of a stand mixer fitted with the paddle attachment, cream the butter and sugar on medium until light and fluffy, about 5 minutes. Add the eggs and beat until incorporated. Add the dry mixture, reduce the speed to low, and beat until the mixture comes together as a smooth batter. Add the sour cream and beat until incorporated. Gradually add the milk and beat to incorporate. Add the blueberries, reduce the speed to low, and beat until evenly distributed.

4. Pour ½ cup of muffin batter into each well and top each muffin with approximately 2 tablespoons of the Streusel Topping.

5. Place the pan in the oven and bake the muffins until a cake tester inserted into the center of each comes out clean, 20 to 25 minutes.

6. Remove from the oven, place the pan on a wire rack, and let the muffins cool completely before enjoying.

INGREDIENTS:

20	OZ. ALL-PURPOSE FLOUR
1	TABLESPOON BAKING POWDER
1½	TEASPOONS KOSHER SALT
8	OZ. UNSALTED BUTTER, SOFTENED
10	OZ. SUGAR
6	EGGS
½	CUP SOUR CREAM
11	OZ. MILK
2	CUPS FRESH BLUEBERRIES
	STREUSEL TOPPING (SEE PAGE 698)

DOUGHNUT SHOP MUFFINS

YIELD: 12 MUFFINS / **ACTIVE TIME:** 20 MINUTES / **TOTAL TIME:** 1 HOUR

Taking the coating of a classic cinnamon doughnut and transferring it to a lighter muffin is a surefire way to get the day started off right.

1. Preheat the oven to 375°F. Coat a 12-well muffin pan with non-stick cooking spray.

2. Place the flour, baking powder, salt, and nutmeg in a mixing bowl and whisk to combine. Set the mixture aside.

3. In the work bowl of a stand mixer fitted with the paddle attachment, cream the 6 oz. of butter and the sugar on medium until light and fluffy, about 5 minutes. Add the eggs and beat until incorporated. Add the dry mixture, reduce the speed to low, and beat until the mixture comes together as a smooth batter. Gradually add the milk and beat until incorporated.

4. Pour ½ cup of muffin batter into each well. Place the pan in the oven and bake the muffins until a cake tester inserted into the center of each comes out clean, 20 to 25 minutes.

5. Remove from the oven, place the pan on a wire rack, and let the muffins cool for 10 minutes.

6. Dip the muffins in the 8 oz. of melted butter, toss them in the Cinnamon Sugar until coated, and enjoy.

INGREDIENTS:

- 1 LB. ALL-PURPOSE FLOUR
- 1 TABLESPOON BAKING POWDER
- ½ TEASPOON KOSHER SALT
- ½ TEASPOON FRESHLY GRATED NUTMEG
- 6 OZ. UNSALTED BUTTER, SOFTENED; PLUS 8 OZ., MELTED
- 8 OZ. SUGAR
- 2 EGGS
- 1 CUP MILK

CINNAMON SUGAR (SEE PAGE 43)

CRANBERRY & ORANGE MUFFINS

YIELD: 12 MUFFINS / **ACTIVE TIME:** 20 MINUTES / **TOTAL TIME:** 1 HOUR

These wonderfully tart muffins carry eye-opening flavor.

1. Preheat the oven to 375°F. Line a 12-well muffin pan with paper liners.

2. Place the flour, baking powder, and salt in a mixing bowl and whisk to combine. Set the mixture aside.

3. In the work bowl of a stand mixer fitted with the paddle attachment, cream the butter, sugar, and orange zest on medium until light and fluffy, about 5 minutes. Add the eggs and beat until incorporated. Add the dry mixture, reduce the speed to low, and beat until the mixture comes together as a smooth batter. Add the sour cream and beat until incorporated. Gradually add the milk and beat to incorporate. Add the cranberries, reduce the speed to low, and beat until evenly distributed.

4. Pour ½ cup of muffin batter into each well and sprinkle some sanding sugar over the top of each muffin.

5. Place the pan in the oven and bake the muffins until a cake tester inserted into the center of each comes out clean, 20 to 25 minutes.

6. Remove from the oven, place the pan on a wire rack, and let the muffins cool completely before enjoying.

INGREDIENTS:

20	OZ. ALL-PURPOSE FLOUR
1	TABLESPOON BAKING POWDER
1½	TEASPOONS KOSHER SALT
8	OZ. UNSALTED BUTTER, SOFTENED
10	OZ. SUGAR
	ZEST OF 2 ORANGES
6	EGGS
½	CUP SOUR CREAM
11	OZ. MILK
2	CUPS FRESH OR FROZEN CRANBERRIES
	SANDING SUGAR, FOR TOPPING

MORNING GLORY MUFFINS

YIELD: 12 MUFFINS / **ACTIVE TIME:** 20 MINUTES / **TOTAL TIME:** 1 HOUR

By turning a rich carrot cake batter into muffins, you can transform a simple Sunday brunch into an event.

1. Preheat the oven to 375°F. Line a 12-well muffin pan with paper liners.

2. Place the flour, sugar, brown sugar, baking soda, and cinnamon in a mixing bowl and whisk to combine. Set the mixture aside.

3. In the work bowl of a stand mixer fitted with the paddle attachment, beat the eggs, canola oil, vanilla, carrots, raisins, apple, and coconut on medium for 3 minutes. Add the dry mixture, reduce the speed to low, and beat until the mixture comes together as a smooth batter.

4. Pour ½ cup of muffin batter into each well and sprinkle some sanding sugar over the top of each muffin.

5. Place the pan in the oven and bake the muffins until a cake tester inserted into the center of each comes out clean, 20 to 25 minutes.

6. Remove from the oven, place the pan on a wire rack, and let the muffins cool completely before enjoying.

INGREDIENTS:

8	OZ. ALL-PURPOSE FLOUR
4	OZ. SUGAR
2	OZ. DARK BROWN SUGAR
2	TEASPOONS BAKING SODA
1½	TEASPOONS CINNAMON
3	EGGS
½	CUP CANOLA OIL
1	TEASPOON PURE VANILLA EXTRACT
7	OZ. CARROTS, SHREDDED
3	OZ. DARK RAISINS
1	HONEYCRISP APPLE, GRATED
2	OZ. SWEETENED SHREDDED COCONUT
	SANDING SUGAR, FOR TOPPING

BANANA & CHOCOLATE CHIP MUFFINS

YIELD: 12 MUFFINS / **ACTIVE TIME**: 20 MINUTES / **TOTAL TIME**: 1 HOUR

The pronounced notes of vanilla that ripe bananas carry are an ideal complement to rich chocolate.

1. Preheat the oven to 350°F. Line a 12-well muffin pan with paper liners.

2. Place the flour, baking soda, cinnamon, nutmeg, and salt in a mixing bowl and whisk to combine. Set the mixture aside.

3. In the work bowl of a stand mixer fitted with the paddle attachment, beat the bananas, brown sugar, sugar, and butter on medium for 5 minutes. Add the oil, eggs, and vanilla and beat until incorporated. Add the dry mixture, reduce the speed to low, and beat until the mixture comes together as a smooth batter. Add the sour cream and chocolate chips and beat until incorporated.

4. Pour ½ cup of muffin batter into each well, place the pan in the oven, and bake the muffins until a cake tester inserted into the center of each comes out clean, 20 to 22 minutes.

5. Remove from the oven, place the pan on a wire rack, and let the muffins cool completely before enjoying.

INGREDIENTS:

2	CUPS ALL-PURPOSE FLOUR
1	TEASPOON BAKING SODA
¼	TEASPOON CINNAMON
¼	TEASPOON FRESHLY GRATED NUTMEG
½	TEASPOON KOSHER SALT
3	RIPE BANANAS
4	OZ. LIGHT BROWN SUGAR
6	OZ. SUGAR
2	OZ. UNSALTED BUTTER, SOFTENED
½	CUP EXTRA-VIRGIN OLIVE OIL
2	EGGS
1½	TEASPOONS PURE VANILLA EXTRACT
2	TABLESPOONS SOUR CREAM
1	CUP SEMISWEET CHOCOLATE CHIPS

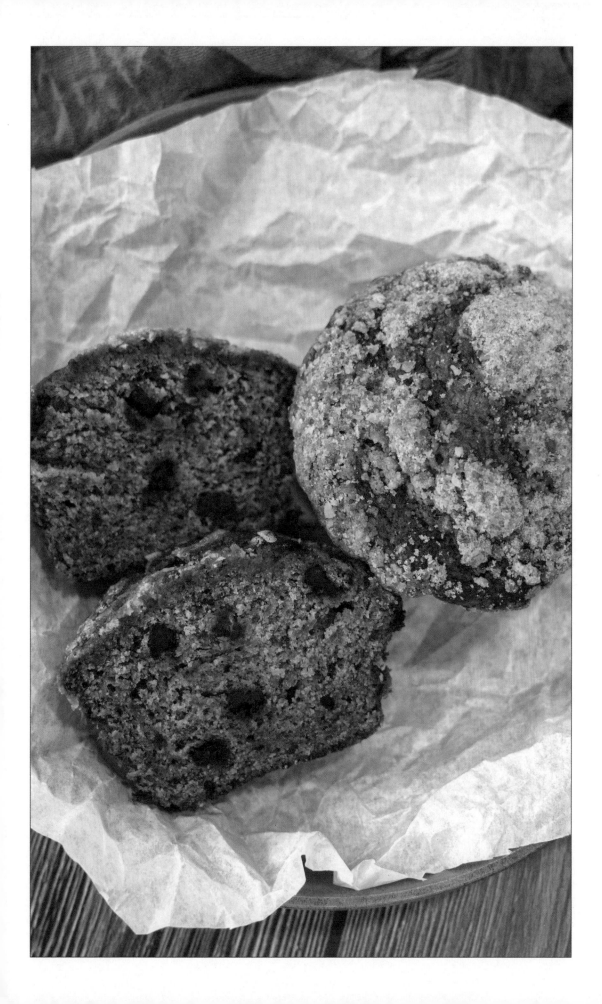

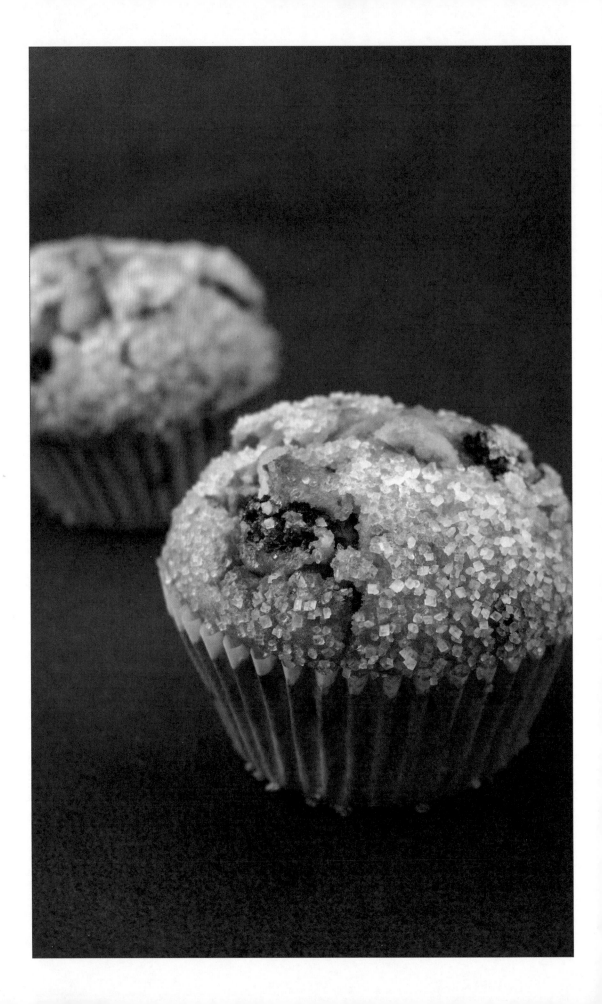

BLACKBERRY & CORN MUFFINS

YIELD: 12 MUFFINS / **ACTIVE TIME:** 20 MINUTES / **TOTAL TIME:** 1 HOUR

Two of the late summer's brightest stars team up in this magical preparation.

1. Preheat the oven to 375°F. Line a 12-well muffin pan with paper liners.

2. Place the flour, cornmeal, baking powder, and salt in a mixing bowl and whisk to combine. Set the mixture aside.

3. In the work bowl of a stand mixer fitted with the paddle attachment, cream the butter and sugar on medium until light and fluffy, about 5 minutes. Add the eggs and beat until incorporated. Add the dry mixture, reduce the speed to low, and beat until the mixture comes together as a smooth batter. Gradually add the milk and beat until incorporated. Add the blackberries and corn kernels and beat on low until evenly distributed, making sure to not overmix the batter.

4. Pour ½ cup of muffin batter into each well and top each muffin with approximately 2 tablespoons of the Corn Muffin Topping.

5. Place the pan in the oven and bake the muffins until a cake tester inserted into the center of each comes out clean, 20 to 25 minutes.

6. Remove from the oven, place the pan on a wire rack, and let the muffins cool completely before enjoying.

INGREDIENTS:

1	LB. ALL-PURPOSE FLOUR
8	OZ. CORNMEAL
1	TABLESPOON BAKING POWDER, PLUS 1 TEASPOON
1	TABLESPOON KOSHER SALT
8	OZ. UNSALTED BUTTER, SOFTENED
7	OZ. SUGAR
4	EGGS
2	CUPS MILK
1	PINT OF FRESH BLACKBERRIES, SLICED LENGTHWISE
1	CUP FRESH CORN KERNELS
	CORN MUFFIN TOPPING (SEE PAGE 697)

WHITE CHOCOLATE & MACADAMIA MUFFINS

YIELD: 12 MUFFINS / *ACTIVE TIME:* 30 MINUTES / *TOTAL TIME:* 1 HOUR AND 20 MINUTES

Toasting the macadamia nuts makes the most of their decadent qualities.

1. Preheat the oven to 375°F. Line a 12-well muffin pan with paper liners.

2. Place the macadamia nuts on a baking sheet, place them in the oven, and toast until they are golden brown, about 10 minutes. Remove the nuts from the oven and let them cool.

3. Place the flour, baking powder, and salt in a mixing bowl and whisk to combine. Set the mixture aside.

4. In the work bowl of a stand mixer fitted with the paddle attachment, cream the butter and sugar on medium until light and fluffy, about 5 minutes. Add the eggs and beat until incorporated. Add the dry mixture, reduce the speed to low, and beat until the mixture comes together as a smooth batter. Add the sour cream and beat until incorporated. Gradually add the milk and beat to incorporate. Add the toasted nuts and chocolate chips and beat until evenly distributed.

5. Pour ½ cup of muffin batter into each well and top each muffin with approximately 2 tablespoons of the Streusel Topping.

6. Place the pan in the oven and bake the muffins until a cake tester inserted into the center of each comes out clean, 20 to 25 minutes.

7. Remove from the oven, place the pan on a wire rack, and let the muffins cool completely before enjoying.

INGREDIENTS:

1	CUP MACADAMIA NUTS
20	OZ. ALL-PURPOSE FLOUR
1	TABLESPOON BAKING POWDER
1½	TEASPOONS KOSHER SALT
8	OZ. UNSALTED BUTTER, SOFTENED
10	OZ. SUGAR
6	EGGS
½	CUP SOUR CREAM
11	OZ. MILK
1	CUP WHITE CHOCOLATE CHIPS
	STREUSEL TOPPING (SEE PAGE 698)

CLASSIC SCONES

YIELD: 10 SCONES / **ACTIVE TIME:** 15 MINUTES / **TOTAL TIME:** 1 HOUR AND 15 MINUTES

Enjoy these as is, or add 2 cups of your favorite fruit or nut to the egg mixture.

1. Line a baking sheet with parchment paper.

2. Place the eggs and 3 oz. of the heavy cream in a measuring cup and whisk to combine. Set the mixture aside.

3. Place the flour, sugar, butter, baking powder, and salt in the work bowl of a stand mixer fitted with the paddle attachment and beat the mixture until it comes together as a crumbly dough where the butter has been reduced to pea-sized pieces. Take care not to overmix the dough.

4. Transfer the dough to a mixing bowl, add the egg mixture, and gently fold the mixture until it is a smooth batter.

5. Drop 4-oz. portions of the batter onto the baking sheet, making sure to leave enough space between the portions. Brush the top of each portion with the remaining cream and sprinkle a bit of pearl sugar over each one.

6. Place the scones in the refrigerator and chill for 20 minutes. Preheat the oven to 375°F.

7. Place the pan in the oven and bake until the scones are golden brown and a cake tester inserted into the center of each scone comes out clean, 22 to 25 minutes.

8. Remove from the oven and place the pan on a wire rack. Let the scones cool slightly before serving.

INGREDIENTS:

3	EGGS
3	OZ. HEAVY CREAM, PLUS 2 OZ.
1	LB. ALL-PURPOSE FLOUR
3	OZ. SUGAR
8	OZ. UNSALTED BUTTER, CHILLED AND CUBED
1½	TABLESPOONS BAKING POWDER
1½	TEASPOONS KOSHER SALT
	PEARL OR SANDING SUGAR, FOR TOPPING

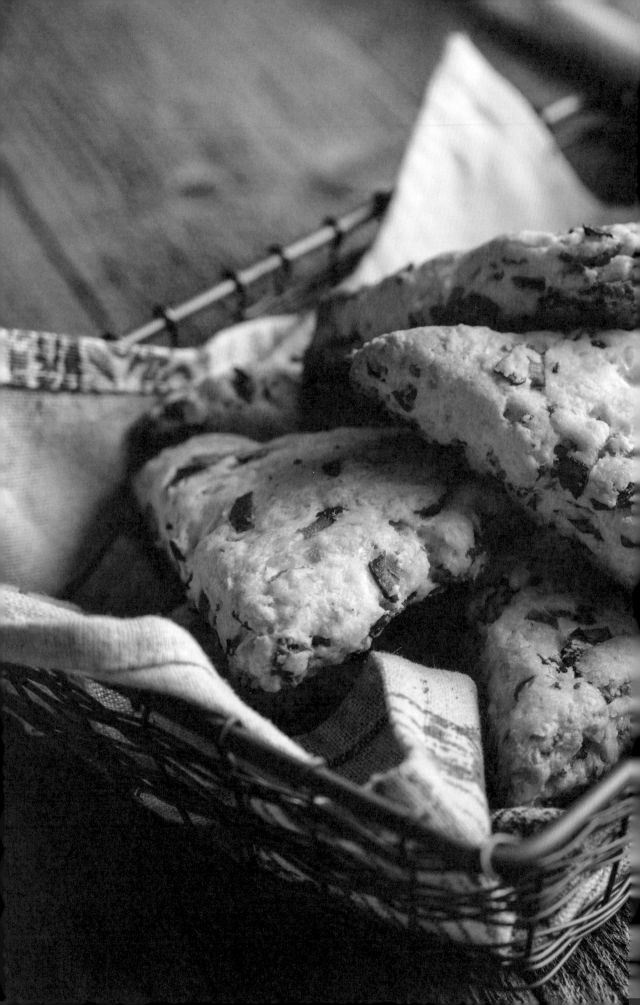

WILD BLUEBERRY SCONES

YIELD: 10 SCONES / **ACTIVE TIME:** 15 MINUTES / **TOTAL TIME:** 1 HOUR AND 15 MINUTES

There's almost nothing better for breakfast than the sweet-tart flavor of blueberries—unless it's a blueberry scone.

1. Line a baking sheet with parchment paper.

2. Place the eggs and 3 oz. of the heavy cream in a measuring cup and whisk to combine. Set the mixture aside.

3. Place the flour, sugar, butter, baking powder, and salt in the work bowl of a stand mixer fitted with the paddle attachment and beat the mixture until it comes together as a crumbly dough where the butter has been reduced to pea-sized pieces. Take care not to overmix the dough.

4. Transfer the dough to a mixing bowl, add the egg mixture and the blueberries, and gently fold the mixture until it is a smooth batter.

5. Drop 4-oz. portions of the batter onto the baking sheet, making sure to leave enough space between the portions. Brush the top of each portion with the remaining cream and sprinkle a bit of pearl sugar over each one.

6. Place the scones in the refrigerator and chill for 20 minutes. Preheat the oven to 375°F.

7. Place the pan in the oven and bake until they are golden brown and a cake tester inserted into the center of each scone comes out clean, 22 to 25 minutes.

8. Remove from the oven and place the pan on a wire rack. Let the scones cool slightly before serving.

INGREDIENTS:

3	EGGS
3	OZ. HEAVY CREAM, PLUS 2 OZ.
1	LB. ALL-PURPOSE FLOUR
3	OZ. SUGAR
8	OZ. UNSALTED BUTTER, CHILLED AND CUBED
1½	TABLESPOONS BAKING POWDER
1½	TEASPOONS KOSHER SALT
2	CUPS FRESH WILD BLUEBERRIES
	PEARL OR SANDING SUGAR, FOR TOPPING

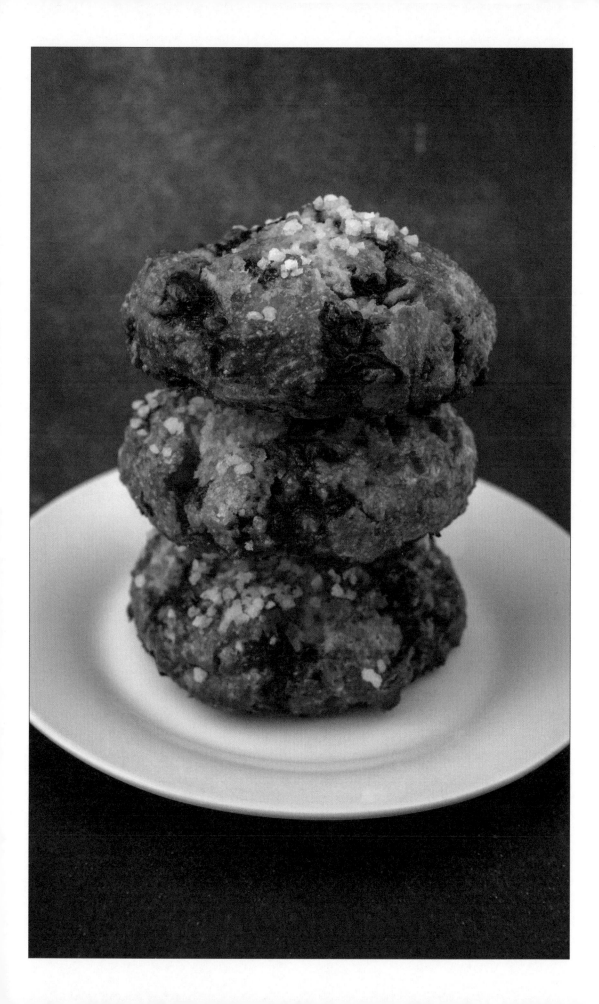

LEMON & GINGER SCONES

YIELD: 10 SCONES / **ACTIVE TIME:** 15 MINUTES / **TOTAL TIME:** 1 HOUR AND 15 MINUTES

Spicy, bright, and with just the right amount of tartness, these scones will touch every single tastebud.

1. Line a baking sheet with parchment paper.

2. Place the eggs and 3 oz. of the heavy cream in a measuring cup and whisk to combine. Set the mixture aside.

3. Place the flour, sugar, butter, baking powder, salt, and lemon zest in the work bowl of a stand mixer fitted with the paddle attachment and beat the mixture until it comes together as a crumbly dough where the butter has been reduced to pea-sized pieces. Take care not to overmix the dough.

4. Transfer the dough to a mixing bowl, add the egg mixture and ginger, and gently fold the mixture until it is a smooth batter.

5. Drop 4-oz. portions of the batter onto the baking sheet, making sure to leave enough space between them. Brush the top of each portion with the remaining cream and sprinkle a bit of pearl sugar over each one.

6. Place the scones in the refrigerator and chill for 20 minutes. Preheat the oven to 375°F.

7. Place the pan in the oven and bake until they are golden brown and a cake tester inserted into the center of each scone comes out clean, 22 to 25 minutes.

8. Remove from the oven and place the pan on a wire rack. Let the scones cool slightly before serving.

INGREDIENTS:

3	EGGS
3	OZ. HEAVY CREAM, PLUS 2 OZ.
1	LB. ALL-PURPOSE FLOUR
3	OZ. SUGAR
8	OZ. UNSALTED BUTTER, CHILLED AND CUBED
1½	TABLESPOONS BAKING POWDER
1½	TEASPOONS KOSHER SALT
	ZEST OF 2 LEMONS
2	CUPS DICED CRYSTALLIZED GINGER
	PEARL OR SANDING SUGAR, FOR TOPPING

EVERYTHING SPICE SCONES

YIELD: 10 SCONES / **ACTIVE TIME:** 15 MINUTES / **TOTAL TIME:** 1 HOUR AND 15 MINUTES

A savory scone that brings the best out of the bagel shop's finest invention.

1. Line a baking sheet with parchment paper.

2. Place the eggs and 3 oz. of the heavy cream in a measuring cup and whisk to combine. Set the mixture aside.

3. Place the flour, sugar, butter, baking powder, salt, and the ½ cup of seasoning in the work bowl of a stand mixer fitted with the paddle attachment and beat the mixture until it comes together as a crumbly dough where the butter has been reduced to pea-sized pieces. Take care not to overmix the dough.

4. Transfer the dough to a mixing bowl, add the egg mixture, and gently fold the mixture until it is a smooth batter.

5. Drop 4-oz. portions of the batter onto the baking sheet, making sure to leave enough space between them. Brush the top of each portion with the remaining cream. Sprinkle the remaining seasoning over the scones and gently press down on it so that it adheres.

6. Place the scones in the refrigerator and chill for 20 minutes. Preheat the oven to 375°F.

7. Place the pan in the oven and bake until they are golden brown and a cake tester inserted into the center of each scone comes out clean, 22 to 25 minutes.

8. Remove from the oven and place the pan on a wire rack. Let the scones cool slightly before serving.

INGREDIENTS:

3 EGGS

3 OZ. HEAVY CREAM, PLUS 2 OZ.

1 LB. ALL-PURPOSE FLOUR

3 OZ. SUGAR

8 OZ. UNSALTED BUTTER, CHILLED AND CUBED

1½ TABLESPOONS BAKING POWDER

1½ TEASPOONS KOSHER SALT

½ CUP EVERYTHING SEASONING (SEE PAGE 738), PLUS ¼ CUP FOR TOPPING

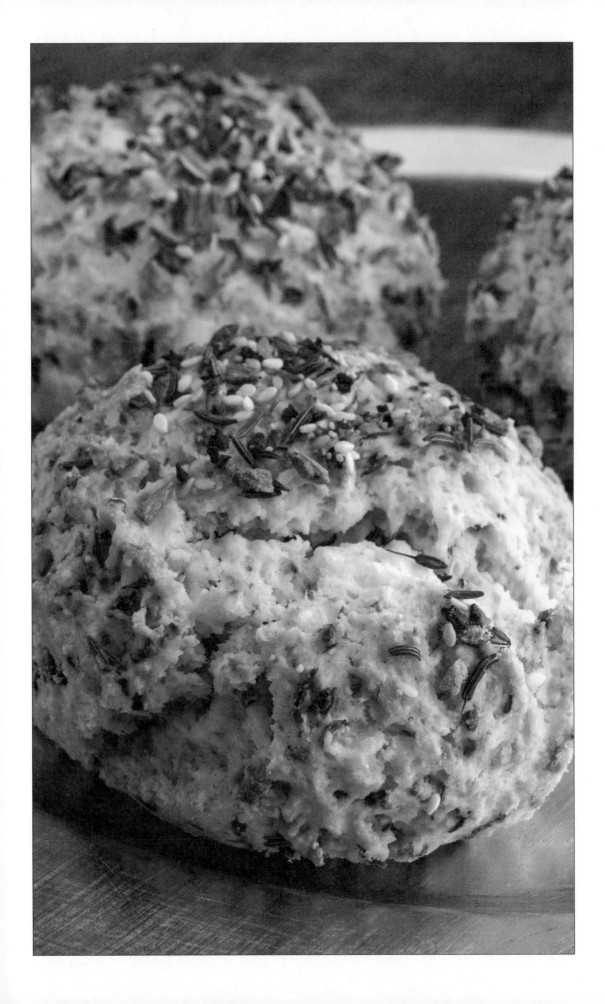

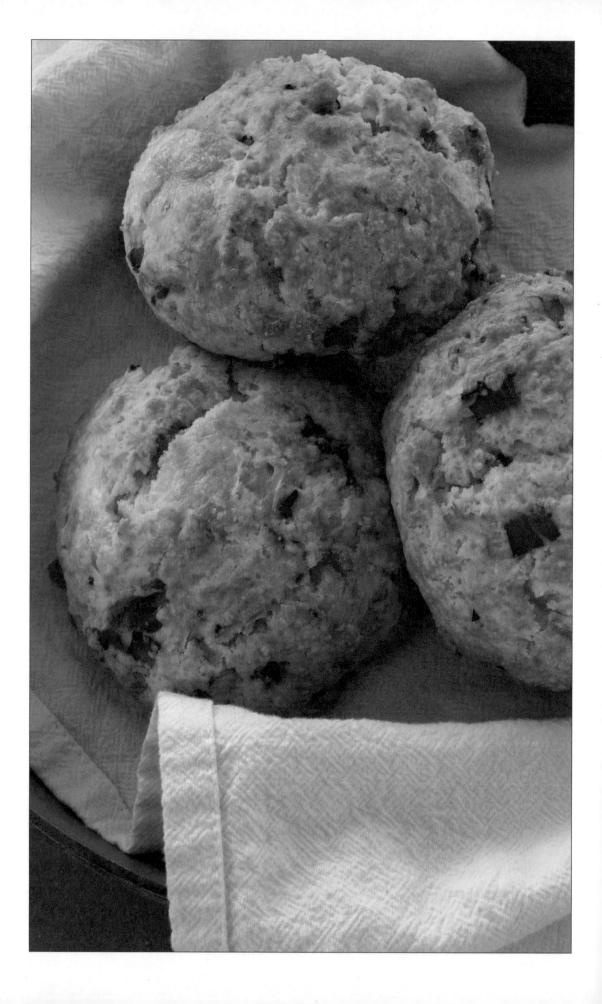

HAM & CHEESE SCONES

YIELD: 10 SCONES / **ACTIVE TIME**: 15 MINUTES / **TOTAL TIME**: 1 HOUR AND 15 MINUTES

Swiss and gouda are other cheeses that will work well in these rich scones.

1. Line a baking sheet with parchment paper.

2. Place the eggs and 3 oz. of the heavy cream in a measuring cup and whisk to combine. Set the mixture aside.

3. Place the flour, sugar, butter, baking powder, salt, and garlic powder in the work bowl of a stand mixer fitted with the paddle attachment and beat the mixture until it comes together as a crumbly dough where the butter has been reduced to pea-sized pieces. Take care not to overmix the dough.

4. Transfer the dough to a mixing bowl, add the egg mixture, ham, cheese, and chives, and gently fold the mixture until it is a smooth batter.

5. Drop 4-oz. portions of the batter onto the baking sheet, making sure to leave enough space between them. Brush the top of each portion with the remaining cream.

6. Place the scones in the refrigerator and chill for 20 minutes. Preheat the oven to 375°F.

7. Place the pan in the oven and bake until they are golden brown and a cake tester inserted into the center of each scone comes out clean, 22 to 25 minutes.

8. Remove from the oven and place the pan on a wire rack. Let the scones cool slightly before serving.

INGREDIENTS:

3 EGGS

3 OZ. HEAVY CREAM, PLUS 2 OZ.

1 LB. ALL-PURPOSE FLOUR

3 OZ. SUGAR

8 OZ. UNSALTED BUTTER, CHILLED AND CUBED

1½ TABLESPOONS BAKING POWDER

1½ TEASPOONS KOSHER SALT

1 TEASPOON GARLIC POWDER

1 CUP DICED HAM

1 CUP SHREDDED CHEDDAR CHEESE

2 TABLESPOONS FINELY CHOPPED FRESH CHIVES

GINGERBREAD SCONES

YIELD: 10 SCONES / **ACTIVE TIME**: 15 MINUTES / **TOTAL TIME**: 1 HOUR AND 15 MINUTES

A holiday-inspired treat that will keep you warm all winter long.

1. Line a baking sheet with parchment paper.

2. Place the eggs, maple syrup, molasses, and ⅓ cup of the heavy cream in a measuring cup and whisk to combine. Set the mixture aside.

3. Place the flour, butter, cinnamon, cloves, ginger, salt, and baking powder in the work bowl of a stand mixer fitted with the paddle attachment and beat the mixture until it comes together as a crumbly dough where the butter has been reduced to pea-sized pieces. Take care not to overmix the dough.

4. Transfer the dough to a mixing bowl, add the egg mixture, and gently fold the mixture until it is a smooth batter.

5. Drop 4-oz. portions of the batter onto the baking sheet, making sure to leave enough space between them. Brush the top of each portion with the remaining cream.

6. Place the scones in the refrigerator and chill for 20 minutes. Preheat the oven to 375°F.

7. Place the pan in the oven and bake until they are golden brown and a cake tester inserted into the center of each scone comes out clean, 22 to 25 minutes.

8. Remove from the oven and place the pan on a wire rack. Let the scones cool slightly before serving.

INGREDIENTS:

2	EGGS
⅓	CUP REAL MAPLE SYRUP
⅓	CUP MOLASSES
⅓	CUP HEAVY CREAM, PLUS ¼ CUP
15	OZ. ALL-PURPOSE FLOUR
8	OZ. UNSALTED BUTTER, CHILLED AND CUBED
½	TEASPOON CINNAMON
½	TEASPOON GROUND CLOVES
¾	TEASPOON GROUND GINGER
¾	TEASPOON KOSHER SALT
1	TABLESPOON BAKING POWDER

MOCHA SCONES

YIELD: 10 SCONES / **ACTIVE TIME:** 15 MINUTES / **TOTAL TIME:** 1 HOUR AND 15 MINUTES

A warm and buttery scone that marries the miraculous worlds of coffee and chocolate.

1. Line a baking sheet with parchment paper.

2. Place the eggs and 3 oz. of the heavy cream in a measuring cup and whisk to combine. Set the mixture aside.

3. Place the flour, sugar, butter, baking powder, espresso powder, cocoa powder, and salt in the work bowl of a stand mixer fitted with the paddle attachment and beat the mixture until it comes together as a crumbly dough where the butter has been reduced to pea-sized pieces. Take care not to overmix the dough.

4. Transfer the dough to a mixing bowl, add the egg mixture and the semisweet chocolate chips, and gently fold the mixture until it is a smooth batter.

5. Drop 4-oz. portions of the batter onto the baking sheet, making sure to leave enough space between them. Brush the top of each portion with the remaining cream and sprinkle a bit of pearl sugar over each one.

6. Place the scones in the refrigerator and chill for 20 minutes. Preheat the oven to 375°F.

7. Place the pan in the oven and bake until they are golden brown and a cake tester inserted into the center of each scone comes out clean, 22 to 25 minutes.

8. Remove from the oven and place the pan on a wire rack. Let the scones cool slightly before serving.

INGREDIENTS:

3	EGGS
3	OZ. HEAVY CREAM, PLUS 2 OZ.
1	LB. ALL-PURPOSE FLOUR
3	OZ. SUGAR
8	OZ. UNSALTED BUTTER, CHILLED AND CUBED
1½	TABLESPOONS BAKING POWDER
2	TABLESPOONS ESPRESSO POWDER
2	TABLESPOONS COCOA POWDER
1½	TEASPOONS KOSHER SALT
2	CUPS SEMISWEET CHOCOLATE CHIPS
	PEARL OR SANDING SUGAR, FOR TOPPING

MONTREAL-STYLE BAGELS

YIELD: 6 BAGELS / **ACTIVE TIME:** 1 HOUR / **TOTAL TIME:** 6 HOURS

Montreal occupies a sweeter space in the bagel world than New York, which most recognize as its capital.

1. To begin preparations for the dough, place the water, honey, egg white, and canola oil in the work bowl of a stand mixer fitted with the dough hook and whisk to combine. Add the flour, yeast, sugar, and salt and work the mixture for 1 minute on low. Raise the speed to medium and knead the mixture until it comes together as a smooth dough and pulls away from the side of the work bowl, about 10 minutes.

2. Place the dough on a flour-dusted work surface and shape it into a ball. Return the dough to the work bowl, cover it with plastic wrap, and let the dough rise at room temperature until it has doubled in size.

3. Divide the dough into six 5 oz. pieces and form each one into a ball.

4. Coat an 18 x 13–inch sheet pan with nonstick cooking spray. Place the pieces of dough on the pan, cover them with plastic wrap, and let them rise until they have doubled in size.

5. Use your fingers to make a small hole in the center of each ball of dough. Place both of your index fingers in each hole and, working in a rotating motion, slowly stretch each piece of dough into a 4-inch-wide bagel. Place the bagels on the sheet pan, cover them with plastic wrap, and let them sit for 30 minutes.

6. Preheat the oven to 350°F. To prepare the bath, place the ingredients in a wide saucepan and bring to a boil.

7. Gently place the bagels in the boiling water and poach them on each side for 30 seconds.

8. Place the bagels back on the sheet pan. Brush them with the egg and sprinkle them with any topping you desire.

9. Place the bagels in the oven and bake until they are a deep golden brown, 20 to 25 minutes.

10. Remove the pan from the oven, place the bagels on a cooling rack, and let them cool before enjoying.

INGREDIENTS:

FOR THE DOUGH

6	OZ. WATER
¼	CUP HONEY
1	EGG WHITE
1	TABLESPOON CANOLA OIL
19	OZ. BREAD FLOUR, PLUS MORE AS NEEDED
2	TEASPOONS ACTIVE DRY YEAST
1.5	OZ. SUGAR
1½	TEASPOONS KOSHER SALT
1	EGG, BEATEN

FOR THE BATH

12	CUPS WATER
½	CUP HONEY

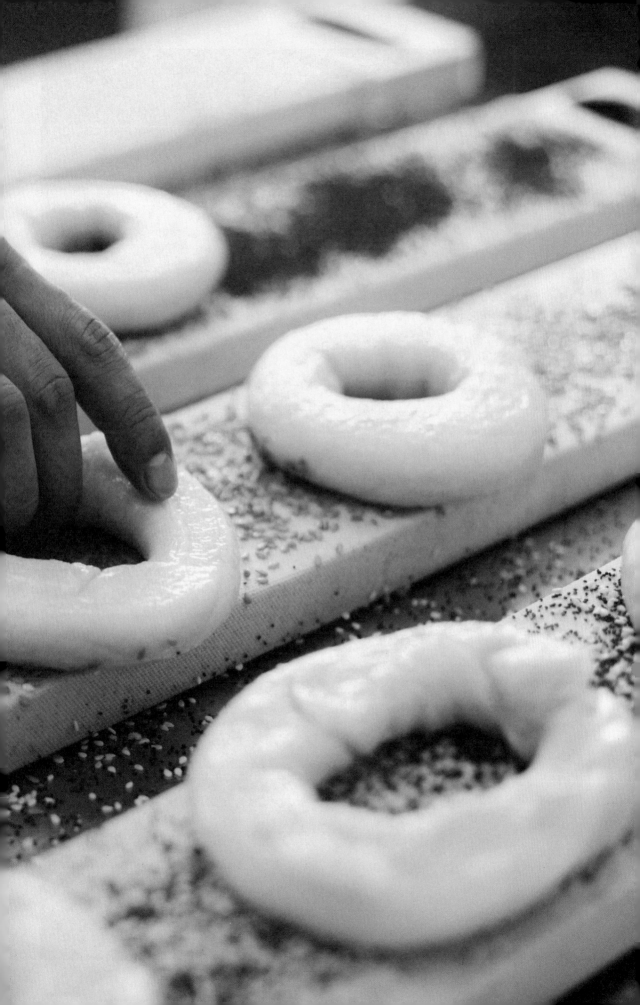

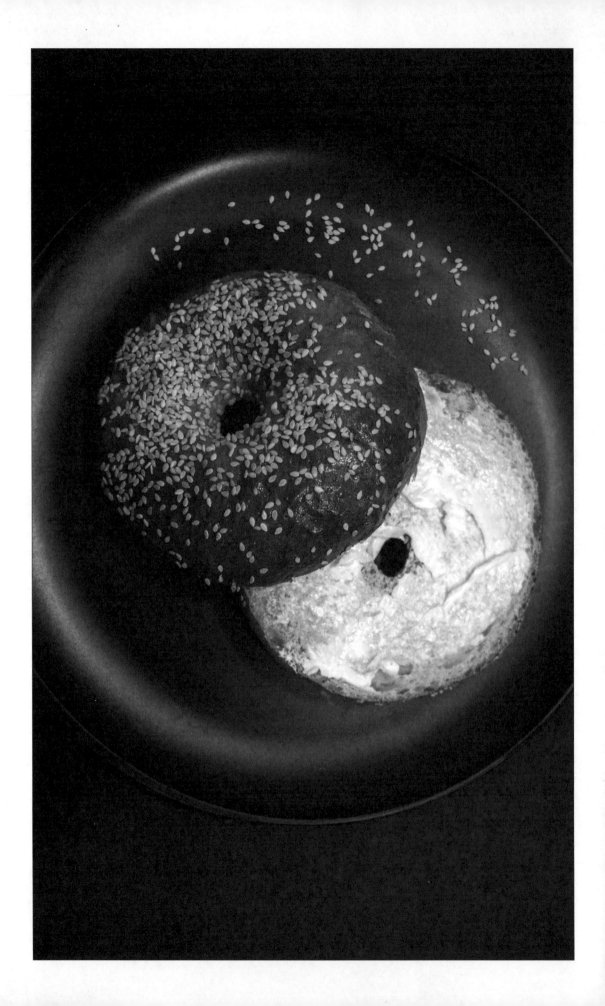

TOASTED SESAME BAGELS

YIELD: 6 BAGELS / **ACTIVE TIME:** 1 HOUR / **TOTAL TIME:** 6 HOURS

Using sesame oil adds a wonderful nutty flavor to these bagels.

1. To begin preparations for the dough, place the water, honey, egg white, and sesame oil in the work bowl of a stand mixer fitted with the dough hook and whisk to combine. Add the flour, yeast, sugar, and salt and work the mixture for 1 minute on low. Raise the speed to medium and knead the mixture until it comes together as a smooth dough and pulls away from the side of the work bowl, about 10 minutes. This dough takes a bit longer to come together, due to the honey.

2. Place the dough on a flour-dusted work surface and shape it into a ball. Return the dough to the work bowl, cover it with plastic wrap, and let the dough rise at room temperature until it has doubled in size.

3. Divide the dough into six 5 oz. pieces and form each one into a ball.

4. Coat an 18 x 13–inch sheet pan with nonstick cooking spray. Place the pieces of dough on the pan, cover them with plastic wrap, and let them rise until they have doubled in size.

5. Use your fingers to make a small hole in the center of each ball of dough. Place both of your index fingers in the holes and, working in a rotating motion, slowly stretch the pieces of dough into 4-inch-wide bagels. Place the bagels on the sheet pan, cover them with plastic wrap, and let them sit for 30 minutes.

6. Preheat the oven to 350°F. To prepare the bath, place the ingredients in a wide saucepan and bring to a boil.

7. Gently place the bagels in the boiling water and poach them on each side for 30 seconds.

8. Place the bagels back on the sheet pan. Brush them with the egg and sprinkle the sesame seeds over the top.

9. Place the bagels in the oven and bake until they are a deep golden brown, 20 to 25 minutes.

10. Remove the pan from the oven, place the bagels on a cooling rack, and let them cool before enjoying.

INGREDIENTS:

FOR THE DOUGH

6	OZ. WATER
¼	CUP HONEY
1	EGG WHITE
1	TABLESPOON SESAME OIL
19	OZ. BREAD FLOUR, PLUS MORE AS NEEDED
2	TEASPOONS ACTIVE DRY YEAST
1.5	OZ. SUGAR
1½	TEASPOONS KOSHER SALT
1	EGG, BEATEN
¼	CUP WHITE SESAME SEEDS, TOASTED

FOR THE BATH

12	CUPS WATER
½	CUP HONEY

WASABI BAGELS

YIELD: 6 BAGELS / **ACTIVE TIME:** 1 HOUR / **TOTAL TIME:** 6 HOURS

The perfect mixture of savory, sweet, and heat. Furikake is a Japanese seasoning normally made of dried fish, sesame seeds, seaweed, sugar, and salt, and it adds a wonderful, umami-laden crunch anywhere it is utilized.

1. To begin preparations for the dough, place the water, honey, egg white, and canola oil in the work bowl of a stand mixer fitted with the dough hook and whisk to combine. Add the flour, yeast, wasabi powder, sugar, and salt and work the mixture for 1 minute on low. Raise the speed to medium and knead the mixture until it comes together as a smooth dough and pulls away from the side of the work bowl, about 10 minutes. This dough takes a bit longer to come together, due to the honey.

2. Place the dough on a flour-dusted work surface and shape it into a ball. Return the dough to the work bowl, cover it with plastic wrap, and let the dough rise at room temperature until it has doubled in size.

3. Divide the dough into six 5 oz. pieces and form each one into a ball.

4. Coat an 18 x 13–inch sheet pan with nonstick cooking spray. Place the pieces of dough on the pan, cover them with plastic wrap, and let them rise until they have doubled in size.

5. Use your fingers to make a small hole in the center of each ball of dough. Place both of your index fingers in each hole and, working in a rotating motion, slowly stretch each piece of dough into a 4-inch-wide bagel. Place the bagels on the sheet pan, cover them with plastic wrap, and let them sit for 30 minutes.

6. Preheat the oven to 350°F. To prepare the bath, place the ingredients in a wide saucepan and bring to a boil.

7. Gently place the bagels in the boiling water and poach them on each side for 30 seconds.

8. Place the bagels back on the sheet pan. Brush them with the beaten egg and generously sprinkle the furikake seasoning over the top.

9. Place the bagels in the oven and bake until they are a deep golden brown, 20 to 25 minutes.

10. Remove the pan from the oven, place the bagels on a cooling rack, and let them cool before enjoying.

INGREDIENTS:

FOR THE DOUGH

6	OZ. WATER
¼	CUP HONEY
1	EGG WHITE
1	TABLESPOON CANOLA OIL
19	OZ. BREAD FLOUR, PLUS MORE AS NEEDED
2	TEASPOONS ACTIVE DRY YEAST
2	TABLESPOONS WASABI POWDER
1.5	OZ. SUGAR
1½	TEASPOONS KOSHER SALT
1	EGG, BEATEN
	FURIKAKE SEASONING, TO TASTE

FOR THE BATH

12	CUPS WATER
½	CUP HONEY

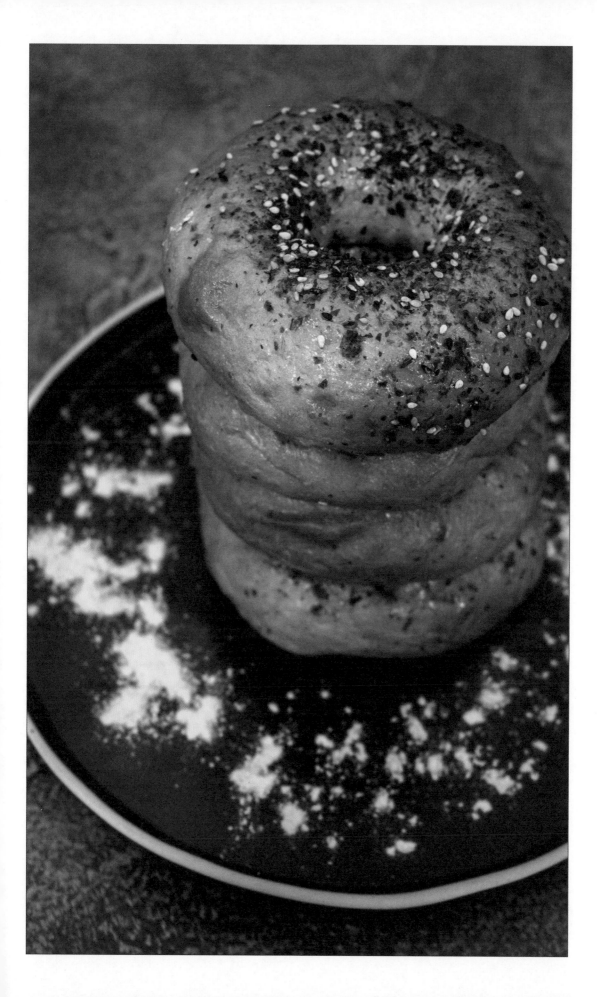

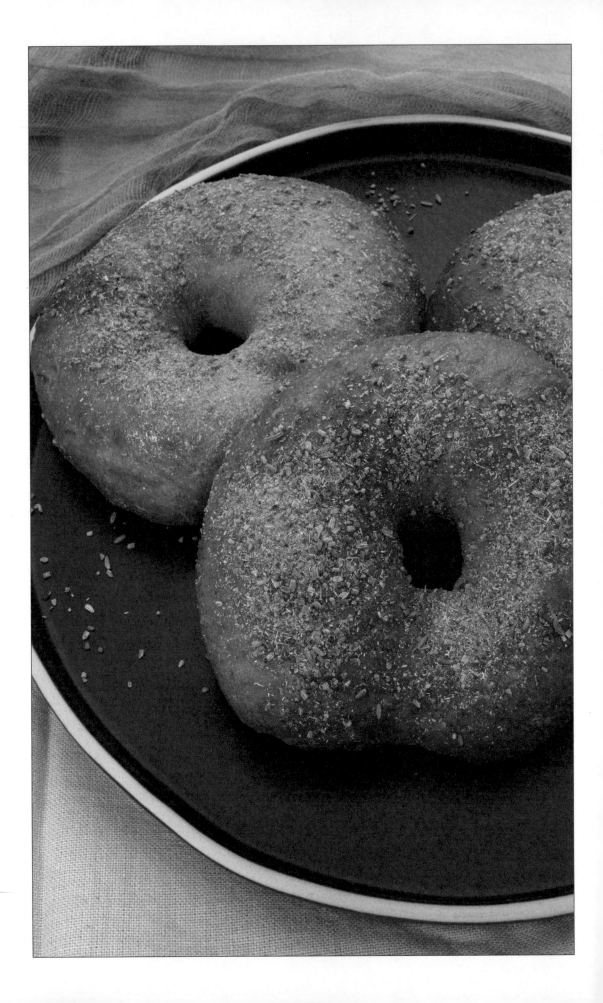

FENNEL & ONION BAGELS

YIELD: 6 BAGELS / **ACTIVE TIME:** 1 HOUR / **TOTAL TIME:** 6 HOURS

Fennel pollen can be found in specialty markets or online.

1. To begin preparations for the dough, place the water, honey, egg white, and sesame oil in the work bowl of a stand mixer fitted with the dough hook and whisk to combine. Add the flour, yeast, onion flakes, onion powder, fennel fronds, sugar, and salt and work the mixture for 1 minute on low. Raise the speed to medium and knead the mixture until it comes together as a smooth dough and pulls away from the side of the work bowl, about 10 minutes. This dough takes a bit longer to come together, due to the honey.

2. Place the dough on a flour-dusted work surface and shape it into a ball. Return the dough to the work bowl, cover it with plastic wrap, and let the dough rise at room temperature until it has doubled in size.

3. Divide the dough into six 5 oz. pieces and form each one into a ball.

4. Coat an 18 x 13–inch sheet pan with nonstick cooking spray. Place the pieces of dough on the pan, cover them with plastic wrap, and let them rise until they have doubled in size.

5. Use your fingers to make a small hole in the center of each ball of dough. Place both of your index fingers in each hole and, working in a rotating motion, slowly stretch each piece of dough into a 4-inch-wide bagel. Place the bagels on the sheet pan, cover them with plastic wrap, and let them sit for 30 minutes.

6. Preheat the oven to 350°F. To prepare the bath, place the ingredients in a wide saucepan and bring to a boil.

7. Gently place the bagels in the boiling water and poach them on each side for 30 seconds.

8. Place the bagels back on the sheet pan. Brush them with the beaten egg and sprinkle the fennel pollen over the top.

9. Place the bagels in the oven and bake until they are a deep golden brown, 20 to 25 minutes.

10. Remove the pan from the oven, place the bagels on a cooling rack, and let them cool before enjoying.

INGREDIENTS:

FOR THE DOUGH

6	OZ. WATER
¼	CUP HONEY
1	EGG WHITE
1	TABLESPOON SESAME OIL
19	OZ. BREAD FLOUR, PLUS MORE AS NEEDED
2	TEASPOONS ACTIVE DRY YEAST
2	TABLESPOONS ONION FLAKES
1	TABLESPOON ONION POWDER
1	TABLESPOON FINELY CHOPPED FENNEL FRONDS
1.5	OZ. SUGAR
1½	TEASPOONS KOSHER SALT
1	EGG, BEATEN
	FENNEL POLLEN, FOR TOPPING

FOR THE BATH

12	CUPS WATER
½	CUP HONEY

PUMPERNICKEL BAGELS

YIELD: 6 BAGELS / **ACTIVE TIME:** 1 HOUR / **TOTAL TIME:** 6 HOURS

The rich, earthy flavor and aroma of pumpernickel were made to be captured in a homemade bagel.

1. To begin preparations for the dough, place the water, molasses, egg white, and sesame oil in the work bowl of a stand mixer fitted with the dough hook and whisk to combine. Add the flour, yeast, rye flour, caraway seeds, cocoa powder, sugar, and salt and work the mixture for 1 minute on low. Raise the speed to medium and knead the mixture until it comes together as a smooth dough and pulls away from the side of the work bowl, about 10 minutes.

2. Place the dough on a flour-dusted work surface and shape it into a ball. Return the dough to the work bowl, cover it with plastic wrap, and let the dough rise at room temperature until it has doubled in size.

3. Divide the dough into six 5 oz. pieces and form each one into a ball.

4. Coat an 18 x 13–inch sheet pan with nonstick cooking spray. Place the pieces of dough on the pan, cover them with plastic wrap, and let them rise until they have doubled in size.

5. Use your fingers to make a small hole in the center of each ball of dough. Place both of your index fingers in each hole and, working in a rotating motion, slowly stretch each piece of dough into a 4-inch-wide bagel.

6. Place the bagels on the sheet pan, cover them with plastic wrap, and let them sit for 30 minutes.

7. Preheat the oven to 350°F. To prepare the bath, place the ingredients in a wide saucepan and bring to a boil. Gently place the bagels in the boiling water and poach them on each side for 30 seconds.

8. Place the bagels back on the sheet pan and brush them with the beaten egg.

9. Place the bagels in the oven and bake until they are a deep golden brown, 20 to 25 minutes.

10. Remove the pan from the oven, place the bagels on a cooling rack, and let them cool before enjoying.

INGREDIENTS:

FOR THE DOUGH

6	OZ. WATER
¼	CUP MOLASSES
1	EGG WHITE
1	TABLESPOON SESAME OIL
1	LB. BREAD FLOUR, PLUS MORE AS NEEDED
2	TEASPOONS ACTIVE DRY YEAST
2	OZ. RYE FLOUR
2	TABLESPOONS CARAWAY SEEDS, TOASTED
1	TABLESPOON COCOA POWDER
1.5	OZ. SUGAR
1½	TEASPOONS KOSHER SALT
1	EGG, BEATEN

FOR THE BATH

12	CUPS WATER
½	CUP HONEY

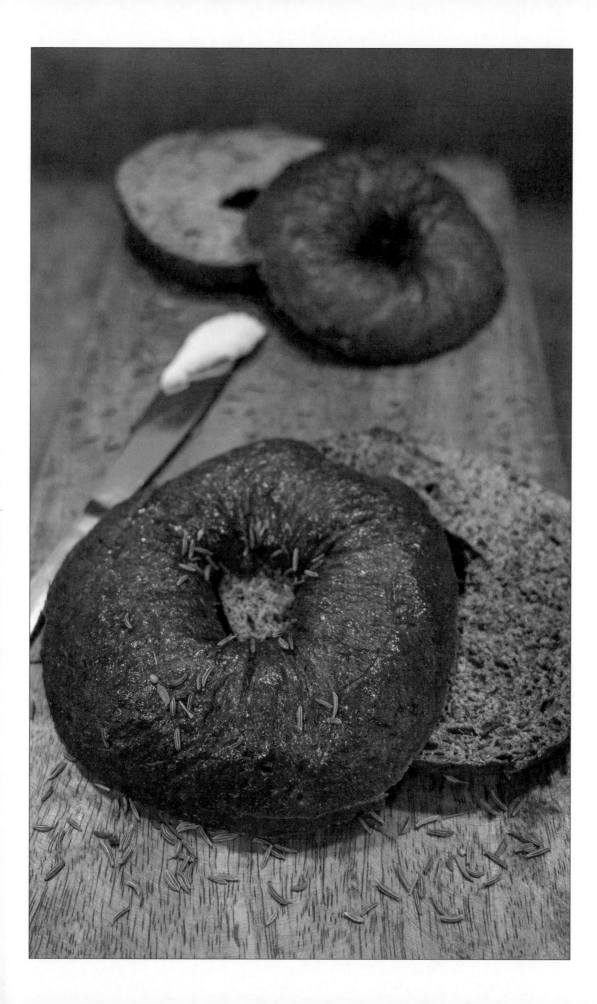

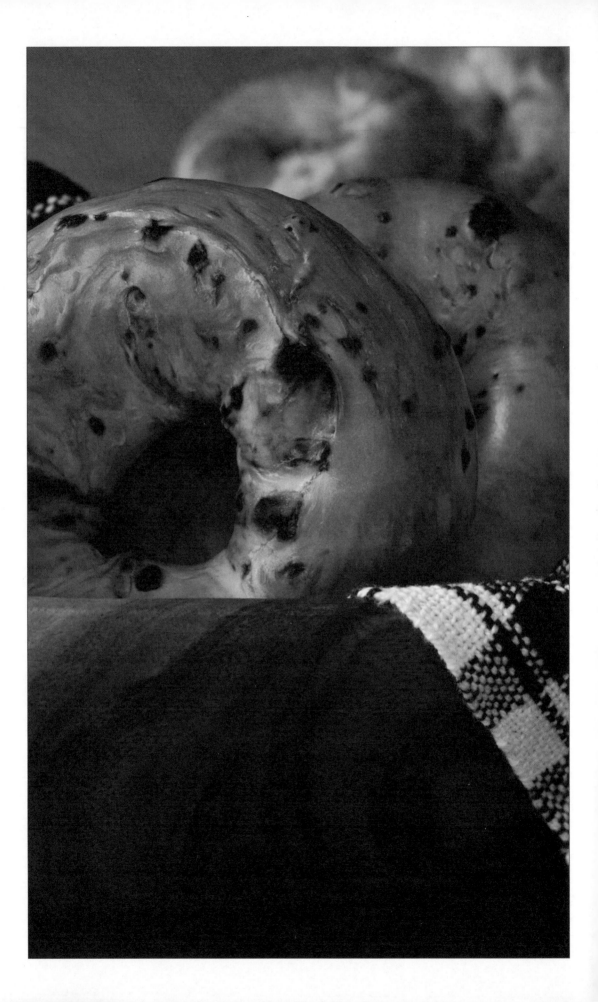

BLUEBERRY BAGELS

YIELD: 6 BAGELS / **ACTIVE TIME:** 1 HOUR / **TOTAL TIME:** 6 HOURS

The key to getting those enticing blue streaks in your bagels is using frozen berries.

1. To begin preparations for the dough, place the water, honey, egg white, and canola oil in the work bowl of a stand mixer fitted with the dough hook and whisk to combine. Add the flour, yeast, sugar, blueberries, and salt and work the mixture for 1 minute on low. Raise the speed to medium and knead the mixture until it comes together as a smooth dough and pulls away from the side of the work bowl, about 10 minutes.

2. Place the dough on a flour-dusted work surface and shape it into a ball. Return the dough to the work bowl, cover it with plastic wrap, and let the dough rise at room temperature until it has doubled in size.

3. Divide the dough into six 5 oz. pieces and form each one into a ball.

4. Coat an 18 x 13–inch sheet pan with nonstick cooking spray. Place the pieces of dough on the pan, cover them with plastic wrap, and let them rise until they have doubled in size.

5. Use your fingers to make a small hole in the center of each ball of dough. Place both of your index fingers in each hole and, working in a rotating motion, slowly stretch each piece of dough into a 4-inch-wide bagel.

6. Place the bagels on the sheet pan, cover them with plastic wrap, and let them sit for 30 minutes.

7. Preheat the oven to 350°F. To prepare the bath, place the ingredients in a wide saucepan and bring to a boil. Gently place the bagels in the boiling water and poach them on each side for 30 seconds.

8. Place the bagels back on the sheet pan and brush them with the beaten egg.

9. Place the bagels in the oven and bake until they are a deep golden brown, 20 to 25 minutes.

10. Remove the pan from the oven, place the bagels on a cooling rack, and let them cool before enjoying.

INGREDIENTS:

FOR THE DOUGH

6	OZ. WATER
¼	CUP HONEY
1	EGG WHITE
1	TABLESPOON CANOLA OIL
19	OZ. BREAD FLOUR, PLUS MORE AS NEEDED
2	TEASPOONS ACTIVE DRY YEAST
1.5	OZ. SUGAR
⅓	CUP DRIED BLUEBERRIES
⅓	CUP FROZEN BLUEBERRIES
1½	TEASPOONS KOSHER SALT
1	EGG, BEATEN

FOR THE BATH

12	CUPS WATER
½	CUP HONEY

GINGER & MISO BAGELS

YIELD: 6 BAGELS / **ACTIVE TIME:** 1 HOUR / **TOTAL TIME:** 6 HOURS

Red miso has a stronger flavor and higher salt content than the white variety, making it a natural for these shockingly deep bagels.

1. To begin preparations for the dough, place the water, honey, egg white, miso, and canola oil in the work bowl of a stand mixer fitted with the dough hook and whisk to combine. Add the flour, yeast, sugar, candied ginger, and salt and work the mixture for 1 minute on low. Raise the speed to medium and knead the mixture until it comes together as a smooth dough and pulls away from the side of the work bowl, about 10 minutes.

2. Place the dough on a flour-dusted work surface and shape it into a ball. Return the dough to the work bowl, cover it with plastic wrap, and let the dough rise at room temperature until it has doubled in size.

3. Divide the dough into six 5 oz. pieces and form each one into a ball.

4. Coat an 18 x 13–inch sheet pan with nonstick cooking spray. Place the pieces of dough on the pan, cover them with plastic wrap, and let them rise until they have doubled in size.

5. Use your fingers to make a small hole in the center of each ball of dough. Place both of your index fingers in each hole and, working in a rotating motion, slowly stretch each piece of dough into a 4-inch-wide bagel.

6. Place the bagels on the sheet pan, cover them with plastic wrap, and let them sit for 30 minutes.

7. Preheat the oven to 350°F. To prepare the bath, place the ingredients in a wide saucepan and bring to a boil. Gently place the bagels in the boiling water and poach them on each side for 30 seconds.

8. Place the bagels back on the sheet pan and brush them with the beaten egg.

9. Place the bagels in the oven and bake until they are a deep golden brown, 20 to 25 minutes.

10. Remove the pan from the oven, place the bagels on a cooling rack, and let them cool before enjoying.

INGREDIENTS:

FOR THE DOUGH

6	OZ. WATER
¼	CUP HONEY
1	EGG WHITE
¼	CUP RED MISO PASTE
1	TABLESPOON CANOLA OIL
19	OZ. BREAD FLOUR, PLUS MORE AS NEEDED
2	TEASPOONS ACTIVE DRY YEAST
1.5	OZ. SUGAR
½	CUP CANDIED GINGER, FINELY CHOPPED
½	TEASPOON KOSHER SALT
1	EGG, BEATEN

FOR THE BATH

12	CUPS WATER
½	CUP HONEY

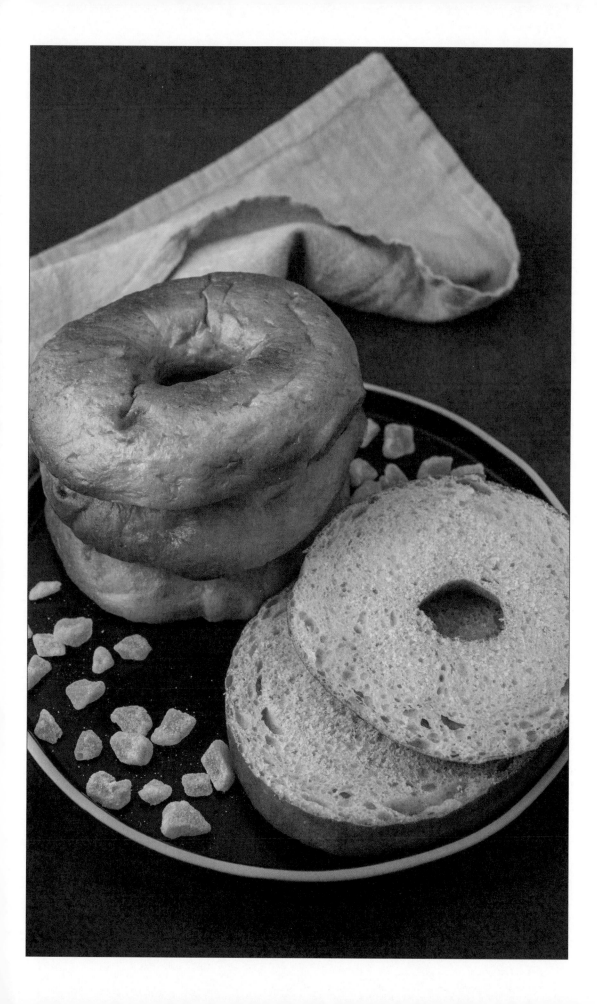

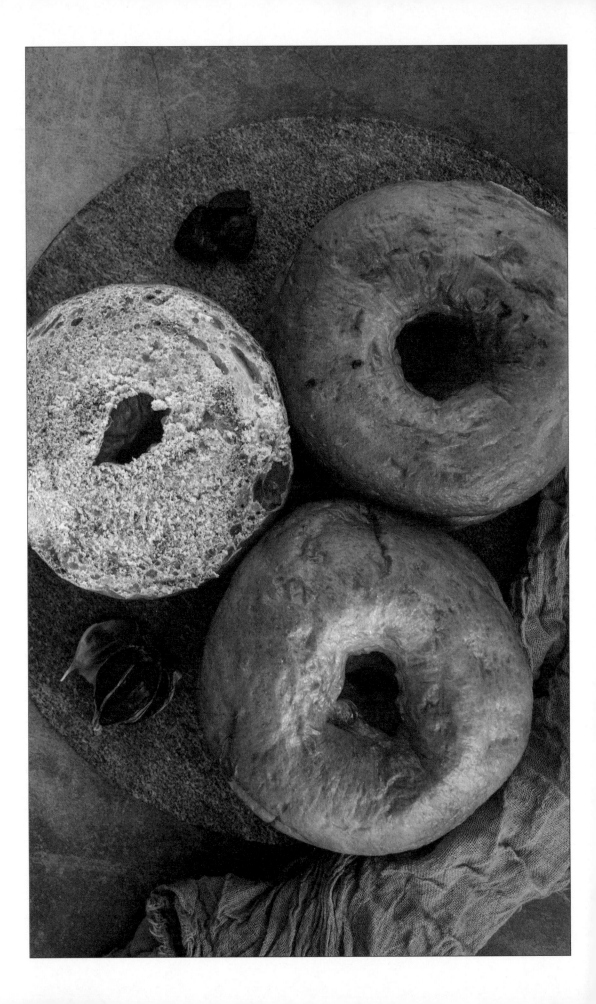

BLACK GARLIC BAGELS

YIELD: 6 BAGELS / **ACTIVE TIME**: 1 HOUR / **TOTAL TIME**: 6 HOURS

Black garlic is produced by heating whole bulbs over the course of several weeks. The process yields a sweet, powerful taste sprinkled with notes of tamarind.

1. To begin preparations for the dough, place the water, honey, egg white, and canola oil in the work bowl of a stand mixer fitted with the dough hook and whisk to combine. Add the flour, yeast, sugar, black garlic cloves, and salt and work the mixture for 1 minute on low. Raise the speed to medium and knead the mixture until it comes together as a smooth dough and pulls away from the side of the work bowl, about 10 minutes.

2. Place the dough on a flour-dusted work surface and shape it into a ball. Return the dough to the work bowl, cover it with plastic wrap, and let the dough rise at room temperature until it has doubled in size.

3. Divide the dough into six 5 oz. pieces and form each one into a ball.

4. Coat an 18 x 13–inch sheet pan with nonstick cooking spray. Place the pieces of dough on the pan, cover them with plastic wrap, and let them rise until they have doubled in size.

5. Use your fingers to make a small hole in the center of each ball of dough. Place both of your index fingers in each hole and, working in a rotating motion, slowly stretch each piece of dough into a 4-inch-wide bagel.

6. Place the bagels on the sheet pan, cover them with plastic wrap, and let them sit for 30 minutes.

7. Preheat the oven to 350°F. To prepare the bath, place the ingredients in a wide saucepan and bring to a boil. Gently place the bagels in the boiling water and poach them on each side for 30 seconds.

8. Place the bagels back on the sheet pan and brush them with the beaten egg.

9. Place the bagels in the oven and bake until they are a deep golden brown, 20 to 25 minutes.

10. Remove the pan from the oven, place the bagels on a cooling rack, and let them cool before enjoying.

INGREDIENTS:

FOR THE DOUGH

6	OZ. WATER
¼	CUP HONEY
1	EGG WHITE
1	TABLESPOON CANOLA OIL
19	OZ. BREAD FLOUR, PLUS MORE AS NEEDED
2	TEASPOONS ACTIVE DRY YEAST
1.5	OZ. SUGAR
½	BULB OF BLACK GARLIC, CLOVES PEELED AND LEFT WHOLE
½	TEASPOON KOSHER SALT
1	EGG, BEATEN

FOR THE BATH

12	CUPS WATER
½	CUP HONEY

CINNAMON RAISIN BAGELS

YIELD: 6 BAGELS / **ACTIVE TIME:** 1 HOUR / **TOTAL TIME:** 6 HOURS

The flavors of childhood, elevated slightly by these delicately sweet bagels.

1. To begin preparations for the dough, place the water, honey, egg white, and canola oil in the work bowl of a stand mixer fitted with the dough hook and whisk to combine. Add the flour, yeast, sugar, cinnamon, raisins, and salt and work the mixture for 1 minute on low. Raise the speed to medium and knead the mixture until it comes together as a smooth dough and pulls away from the side of the work bowl, about 10 minutes.

2. Place the dough on a flour-dusted work surface and shape it into a ball. Return the dough to the work bowl, cover it with plastic wrap, and let the dough rise at room temperature until it has doubled in size.

3. Divide the dough into six 5 oz. pieces and form each one into a ball.

4. Coat an 18 x 13–inch sheet pan with nonstick cooking spray. Place the pieces of dough on the pan, cover them with plastic wrap, and let them rise until they have doubled in size.

5. Use your fingers to make a small hole in the center of the balls of dough. Place both of your index fingers in the holes and, working in a rotating motion, slowly stretch each piece of dough into a 4-inch-wide bagel.

6. Place the bagels on the sheet pan, cover them with plastic wrap, and let them sit for 30 minutes.

7. Preheat the oven to 350°F. To prepare the bath, place the ingredients in a wide saucepan and bring to a boil. Gently place the bagels in the boiling water and poach them on each side for 30 seconds.

8. Place the bagels back on the sheet pan and brush them with the beaten egg.

9. Place the bagels in the oven and bake until they are a deep golden brown, 20 to 25 minutes.

10. Remove the pan from the oven, place the bagels on a cooling rack, and let them cool before enjoying.

INGREDIENTS:

FOR THE DOUGH

6	OZ. WATER
¼	CUP HONEY
1	EGG WHITE
1	TABLESPOON CANOLA OIL
19	OZ. BREAD FLOUR, PLUS MORE AS NEEDED
1	TABLESPOON ACTIVE DRY YEAST
1.5	OZ. SUGAR
1	TABLESPOON CINNAMON, PLUS 1 TEASPOON
½	CUP RAISINS
½	TEASPOON KOSHER SALT
1	EGG, BEATEN

FOR THE WATER

12	CUPS WATER
½	CUP HONEY

HAM & CHEESE CROISSANTS

YIELD: 16 CROISSANTS / **ACTIVE TIME:** 30 MINUTES / **TOTAL TIME:** 2 HOURS

A wonderful breakfast option for those on the go.

1. Line two baking sheets with parchment paper. Place the dough on a flour-dusted work surface and roll it into an 8 x 20–inch rectangle. Using a pizza cutter or a chef's knife, cut the dough horizontally in the center so that you have two 4 x 20–inch rectangles. Cut each rectangle vertically into strips that are 5 inches wide.

2. Cut each rectangle diagonally, yielding 16 triangles. Gently roll out each triangle until it is 8 inches long.

3. Spread 2 teaspoons of the mustard toward the wide side of each triangle. Lay a slice of ham over the mustard and top it with a slice of cheese, making sure to leave 1 inch of dough uncovered at the tip.

4. Roll the croissants up tight, moving from the wide side of the triangle to the tip. Tuck the tips under the croissants. Place eight croissants on each of the baking sheets.

5. Cover the baking sheets with plastic wrap and let the croissants rest at room temperature for 1 hour.

6. Preheat the oven to 400°F.

7. Remove the plastic wrap and brush the croissants with the beaten egg.

8. Place the croissants in the oven and bake until they are golden brown, 20 to 22 minutes.

9. Remove the croissants from the oven and place them on wire racks. Let the croissants cool slightly before enjoying.

INGREDIENTS:

CROISSANT DOUGH (SEE PAGE 294)

ALL-PURPOSE FLOUR, AS NEEDED

½ CUP DIJON MUSTARD

16 SLICES OF SMOKED HAM

16 SLICES OF SWISS CHEESE

1 EGG, BEATEN

EVERYTHING CROISSANTS

YIELD: 16 CROISSANTS / **ACTIVE TIME:** 30 MINUTES / **TOTAL TIME:** 2 HOURS

For those mornings when you want a bagel, but need something lighter.

1. Line two baking sheets with parchment paper. Place the cream cheese in a piping bag and set aside.

2. Place the dough on a flour-dusted work surface and roll it into an 8 x 20–inch rectangle. Using a pizza cutter or chef's knife, cut the dough horizontally in the center so that you have two 4 x 20–inch rectangles. Cut each rectangle vertically into strips that are 5 inches wide.

3. Cut each rectangle diagonally, yielding 16 triangles. Gently roll out each triangle until it is 8 inches long.

4. Cut a hole in the piping bag and pipe about 3 tablespoons of cream cheese toward the wide side of each triangle. Spread the cream cheese out a bit with an offset spatula.

5. Roll the croissants up tight, moving from the wide side of the triangle to the tip. Tuck the tips under the croissants. Place eight croissants on each of the baking sheets.

6. Cover the baking sheets with plastic wrap and let the croissants rest at room temperature for 1 hour.

7. Preheat the oven to 400°F.

8. Remove the plastic wrap and brush the croissants with the beaten egg. Sprinkle some of the seasoning over each of the croissants.

9. Place the croissants in the oven and bake until they are golden brown, 20 to 22 minutes.

10. Remove the croissants from the oven and place them on wire racks. Let the croissants cool slightly before enjoying.

INGREDIENTS:

1 **LB. CREAM CHEESE**

 CROISSANT DOUGH (SEE PAGE 294)

 ALL-PURPOSE FLOUR, AS NEEDED

1 **EGG, BEATEN**

 EVERYTHING SEASONING (SEE PAGE 738), FOR TOPPING

SPINACH & FETA CROISSANTS

YIELD: 16 CROISSANTS / **ACTIVE TIME:** 45 MINUTES / **TOTAL TIME:** 2 HOURS AND 30 MINUTES

Fans of spanakopita get the flavors that they want, in a package that's much easier to prepare and handle.

1. Place the olive oil in a large skillet and warm it over medium heat. Add the garlic and cook for 1 minute, stirring frequently.

2. Add the spinach, salt, and pepper and cook until the spinach has wilted, about 1 minute. Transfer the mixture to a colander and let it drain and cool.

3. Line two baking sheets with parchment paper. Place the Croissant Dough on a flour-dusted work surface and roll it into an 8 x 20–inch rectangle. Using a pizza cutter or chef's knife, cut the dough horizontally in the center so that you have two 4 x 20–inch rectangles. Cut each rectangle vertically into strips that are 5 inches wide.

4. Cut each rectangle diagonally, yielding 16 triangles. Gently roll out each triangle until it is 8 inches long.

5. Place 2 tablespoons of the spinach mixture toward the wide side of each triangle. Sprinkle 1 tablespoon of the feta over the spinach.

6. Roll the croissants up tight, moving from the wide side of the triangle to the tip. Tuck the tips under the croissants. Place eight croissants on each of the baking sheets.

7. Cover the baking sheets with plastic wrap and let the croissants rest at room temperature for 1 hour.

8. Preheat the oven to 400°F.

9. Remove the plastic wrap and brush the croissants with the beaten egg.

10. Place the croissants in the oven and bake until they are golden brown, 20 to 22 minutes.

11. Remove the croissants from the oven and place them on wire racks. Let the croissants cool slightly before enjoying.

INGREDIENTS:

1	TEASPOON EXTRA-VIRGIN OLIVE OIL
2	GARLIC CLOVES, MINCED
1	LB. FRESH SPINACH
½	TEASPOON KOSHER SALT
¼	TEASPOON BLACK PEPPER
	CROISSANT DOUGH (SEE PAGE 294)
	ALL-PURPOSE FLOUR, AS NEEDED
8	OZ. FETA CHEESE, CRUMBLED
1	EGG, BEATEN

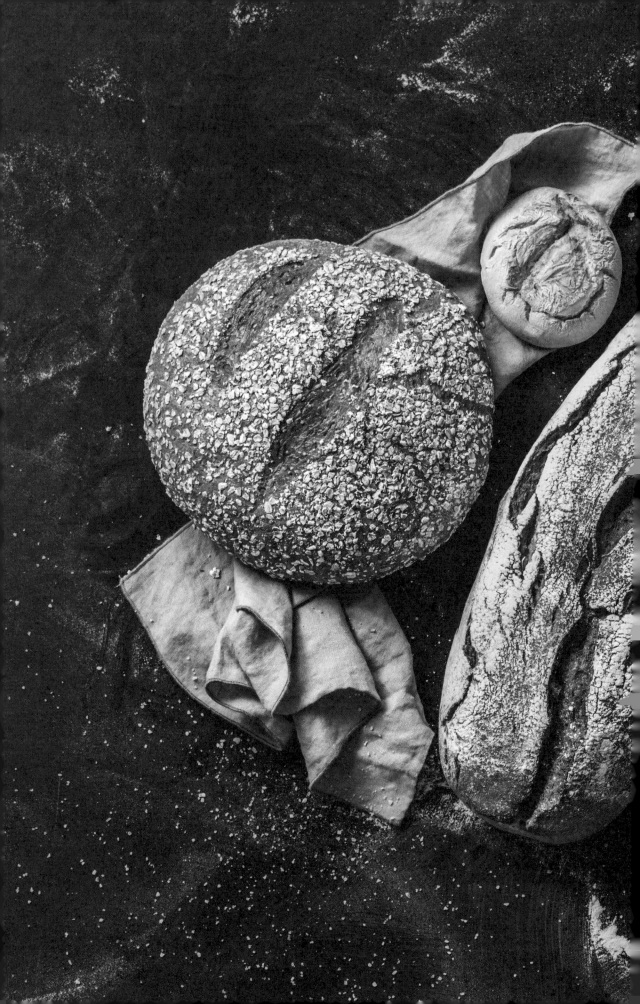

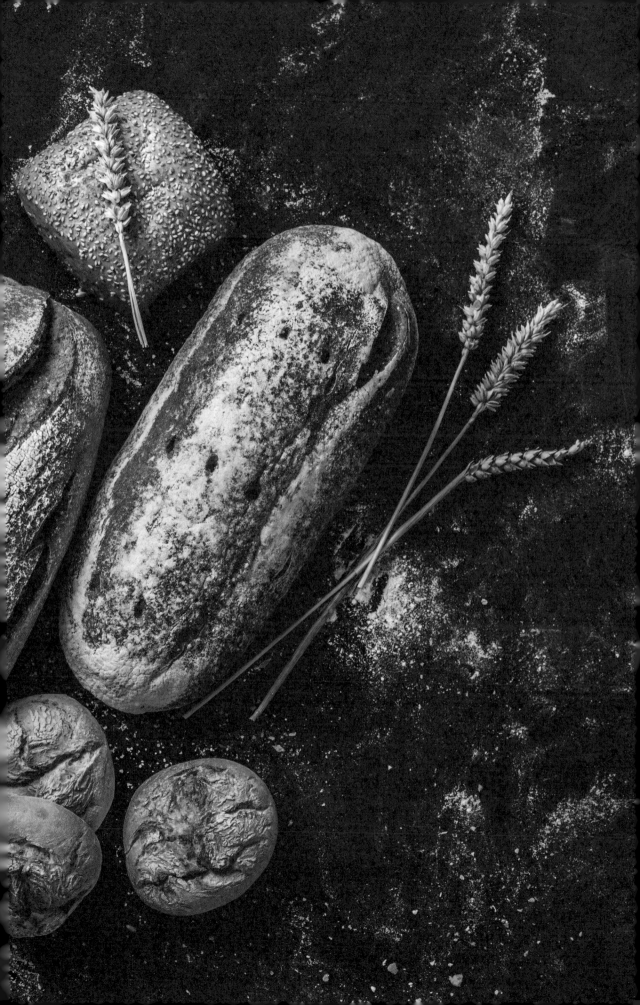

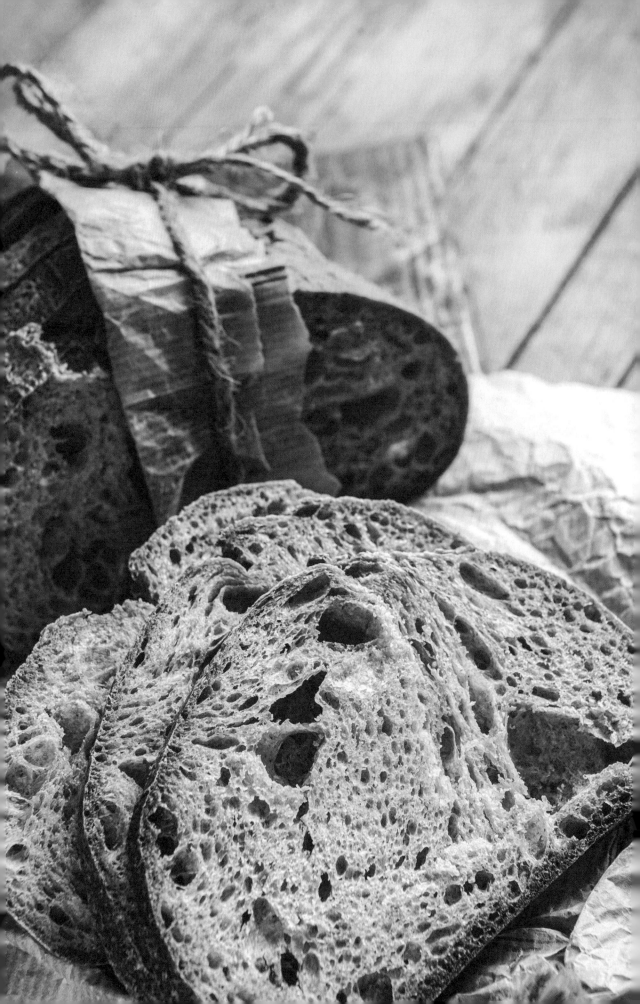

BREADS, ROLLS & BUNS

*H*aving provided the sustenance needed to take civilization into the modern era, and formed the foundation every artisan baker builds their career upon, much of what makes baking such a vital craft is contained within this section.

From building a sourdough starter that will put a unique signature on every loaf that comes out of your oven to quickbreads that will serve as a catchall for the odds and ends that you accumulate during other preparations, from crispy crackers that will round out a cheese board to legendary dinner rolls and the very best breads from countries and cuisines around the world, from using preferments such as biga and poolish to the proper technique for braiding a challah, the passionate baker could happily spend the rest of their life working through this chapter.

SOURDOUGH STARTER

YIELD: 2 CUPS / **ACTIVE TIME:** 2 HOURS / **TOTAL TIME:** 2 WEEKS

The key to baking naturally leavened bread, and the delicious, slightly sour taste that sourdough loaves are known for. One thing to remember: the starter must be left out at room temperature the day before baking to ensure that its enzymes will be active.

1. Place the water and flour in a large jar (the jar should be at least 1 quart). Combine the ingredients by hand, cover the jar, and let it stand in a sunny spot at room temperature for 24 hours.

2. Place 1 cup of the starter in a bowl, add 1 cup of water and 2 cups of all-purpose flour, and stir until thoroughly combined. Discard the remainder of the starter. Place the new mixture back in the jar and let it sit at room temperature for 24 hours. Repeat this process every day until you notice bubbles forming in the starter. This should take approximately 14 days.

3. Once the starter begins to bubble, it can be used in recipes. The starter can be stored at room temperature or in the refrigerator. If the starter is kept at room temperature, it must be fed once a day; if the starter is refrigerated, it can be fed every 3 days. The starter can be frozen for up to a month without feeding.

4. To feed the starter, place 1 cup of the starter in a bowl, add 1 cup of flour and 1 cup of water, and work the mixture with your hands until combined. Discard the remainder of the starter. When baking bread, it is recommended that you feed the starter 6 to 8 hours before making the bread.

INGREDIENTS:

1 CUP WATER, AT ROOM TEMPERATURE, PLUS MORE DAILY

2 CUPS ALL-PURPOSE FLOUR, PLUS MORE DAILY

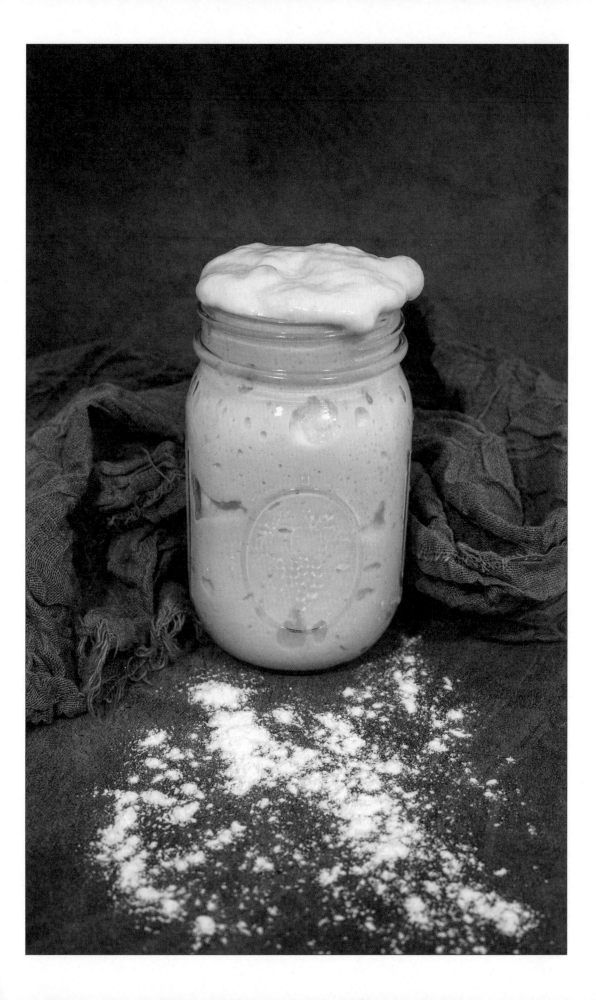

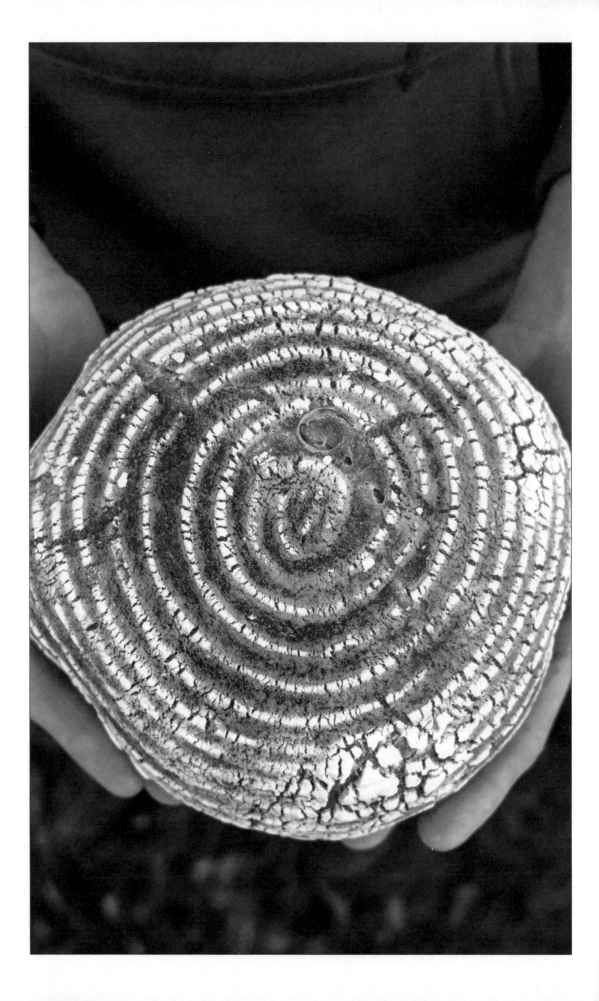

SOURDOUGH BREAD

YIELD: 1 BOULE / **ACTIVE TIME:** 1 HOUR AND 30 MINUTES / **TOTAL TIME:** 24 HOURS

A foundational recipe that will have the tangy taste and crispy crust everyone wants in a sourdough.

1. Place the water and flours in the work bowl of a stand mixer fitted with the dough hook and work the mixture on low for 6 minutes. Remove the bowl from the mixer and cover it with plastic wrap. Let the dough sit at room temperature for 1 hour to allow the dough to autolyse.

2. Place the work bowl back on the mixer and add the starter and salt. Knead the mixture at low speed until the dough starts to come together, about 2 minutes. Increase the speed to medium and knead until the dough is elastic and pulls away from the side of the bowl.

3. Dust a 9-inch banneton (proofing basket) with bread flour. Shape the dough into a ball and place it in the proofing basket, seam side down. Cover the bread with plastic wrap and let it sit on the counter for 2 hours.

4. Place the basket in the refrigerator and let it rest overnight.

5. Preheat the oven to 450°F and place a baking stone on a rack positioned in the middle.

6. Dust a peel with bread flour and gently turn the bread onto the peel so that the seam is facing up.

7. With a very sharp knife, carefully score the dough just off center. Make sure the knife is at a 45-degree angle to the dough.

8. Gently slide the sourdough onto the baking stone. Spray the oven with 5 spritzes of water and bake the bread for 20 minutes.

9. Open the oven, spray the oven with 5 more spritzes, and bake until the crust is golden brown, about 20 minutes. The internal temperature of the bread should be at minimum 210°F.

10. Remove the bread from the oven, place it on a wire rack, and let it cool completely before slicing.

INGREDIENTS:

1 CUP WATER, AT ROOM TEMPERATURE

3⅓ CUPS BREAD FLOUR, PLUS MORE AS NEEDED

⅓ CUP WHOLE WHEAT FLOUR

1 CUP SOURDOUGH STARTER (SEE PAGE 494)

2 TEASPOONS KOSHER SALT

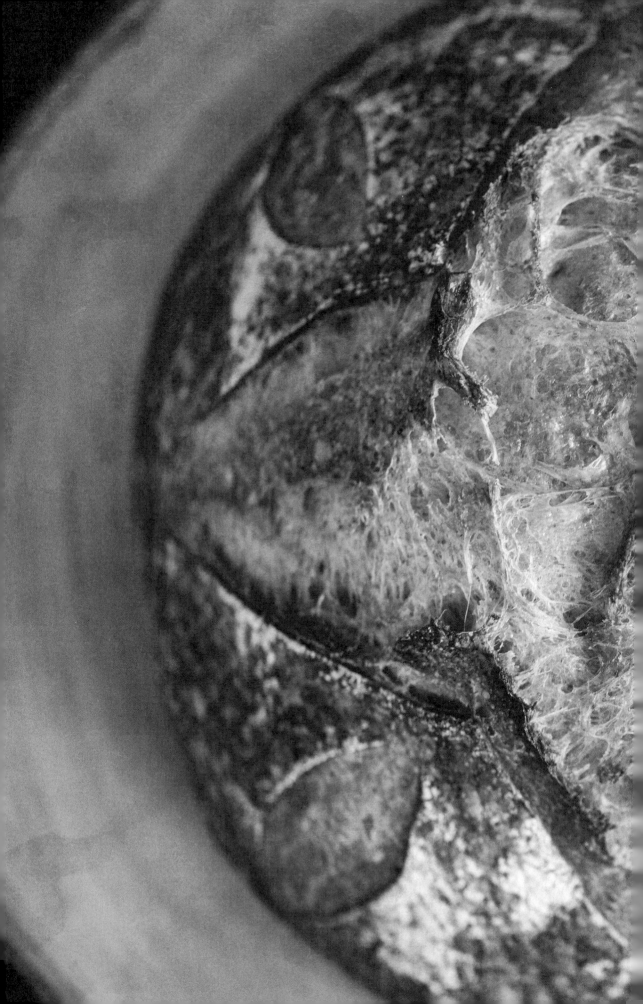

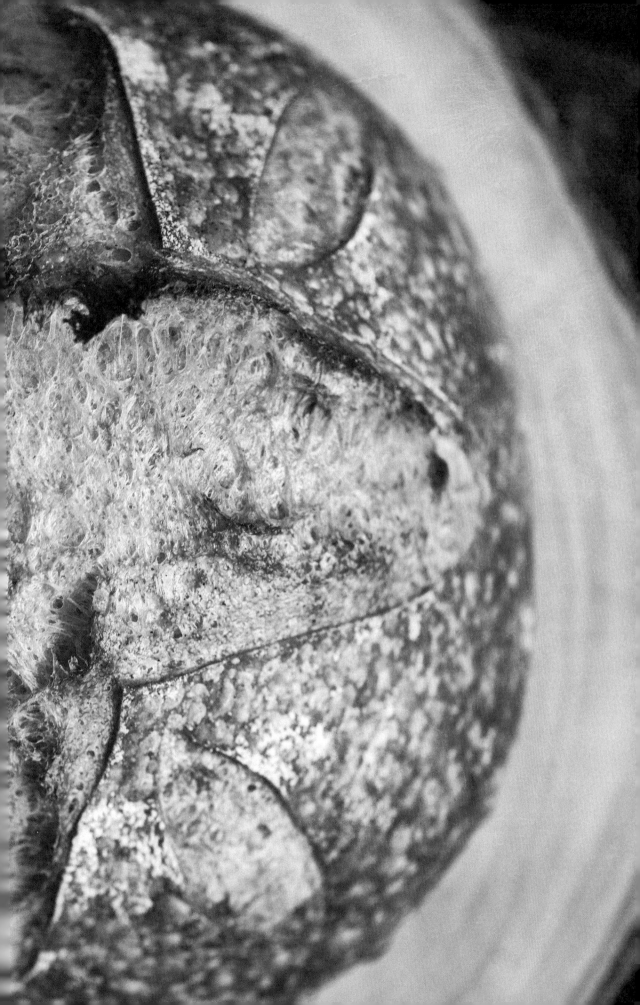

HARVEST SOURDOUGH BREAD

YIELD: 1 BOULE / **ACTIVE TIME:** 1 HOUR AND 30 MINUTES / **TOTAL TIME:** 24 HOURS

Good in just about any situation, but sublime as the base of a sandwich filled with Thanksgiving leftovers.

1. Place the water and flours in the work bowl of a stand mixer fitted with the dough hook and work the mixture on low for 6 minutes. Remove the bowl from the mixer and cover it with plastic wrap. Let the dough sit at room temperature for 1 hour to allow the dough to autolyse.

2. Place the work bowl back on the mixer and add the cranberries, seeds, starter, and salt. Knead the mixture at low speed until the dough starts to come together, about 2 minutes. Increase the speed to medium and knead until the dough is elastic and pulls away from the side of the bowl.

3. Combine the seeds for topping on a plate. Shape the dough into a ball and spray the seam side with water. Roll the top of the dough in the mixture until coated.

4. Dust a 9-inch banneton (proofing basket) with bread flour. Place the dough in the proofing basket, seeded side down. Cover the bread with plastic wrap and let it sit on the counter for 2 hours.

5. Place the basket in the refrigerator and let it rest overnight.

6. Preheat the oven to 450°F and place a baking stone on a rack positioned in the middle.

7. Dust a peel with bread flour and gently turn the bread onto the peel so that the seam is facing up.

8. With a very sharp knife, carefully score the dough just off center. Make sure the knife is at a 45-degree angle to the dough.

9. Gently slide the sourdough onto the baking stone. Spray the oven with 5 spritzes of water and bake the bread for 20 minutes.

10. Open the oven, spray the oven with 5 more spritzes, and bake until the crust is golden brown, about 20 minutes. The internal temperature of the bread should be at minimum 210°F.

11. Remove the bread from the oven, place it on a wire rack, and let it cool completely before slicing.

INGREDIENTS:

1 CUP WATER, AT ROOM TEMPERATURE

3⅓ CUPS BREAD FLOUR, PLUS MORE AS NEEDED

⅓ CUP WHOLE WHEAT FLOUR

¼ CUP DRIED CRANBERRIES

2 TABLESPOONS PUMPKIN SEEDS, PLUS MORE FOR TOPPING

2 TABLESPOONS SUNFLOWER SEEDS, PLUS MORE FOR TOPPING

2 TABLESPOONS POPPY SEEDS, PLUS MORE FOR TOPPING

2 TABLESPOONS CHIA SEEDS, PLUS MORE FOR TOPPING

1 CUP SOURDOUGH STARTER (SEE PAGE 494)

2 TEASPOONS KOSHER SALT

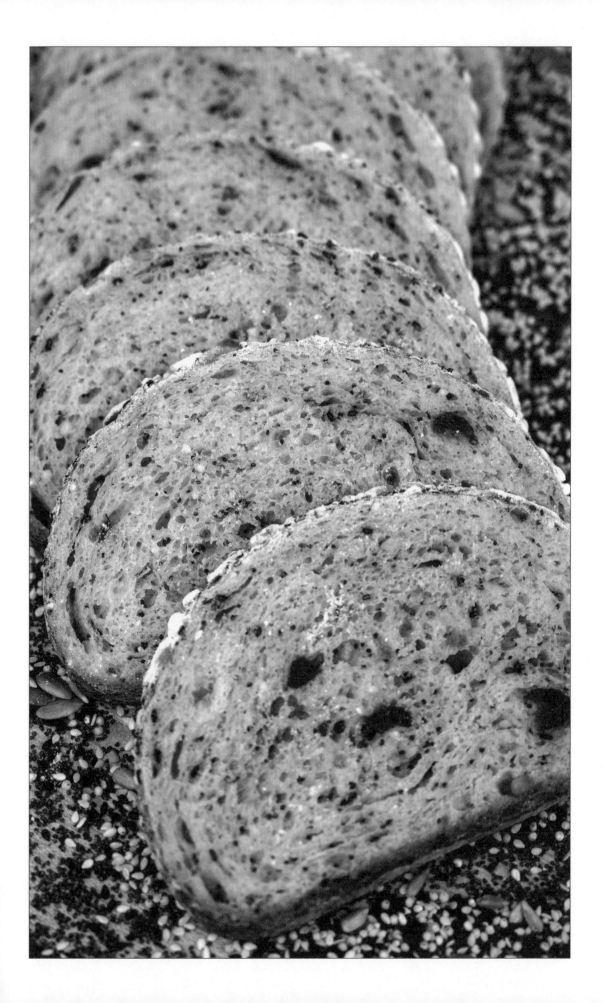

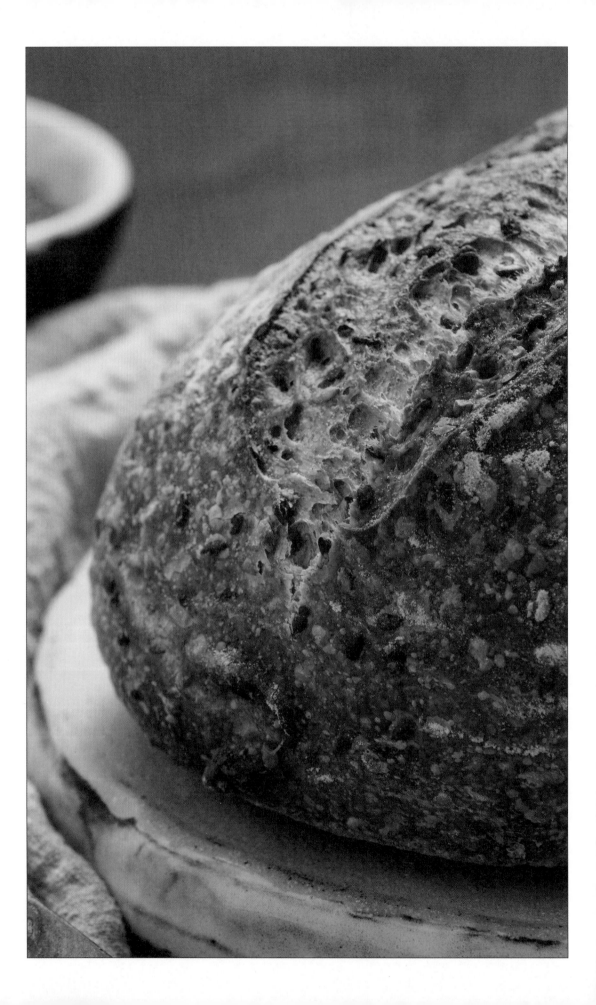

MULTIGRAIN SOURDOUGH BREAD

YIELD: 1 BOULE / **ACTIVE TIME:** 1 HOUR AND 30 MINUTES / **TOTAL TIME:** 24 HOURS

The texture provided by the oats and seeds is the drawing card here.

1. Place the water and flours in the work bowl of a stand mixer fitted with the dough hook and work the mixture on low for 6 minutes. Remove the bowl from the mixer and cover it with plastic wrap. Let the dough sit at room temperature for 1 hour to allow the dough to autolyse.

2. Place the work bowl back on the mixer and add the oats, seeds, starter, and salt. Knead the mixture at low speed until the dough starts to come together, about 2 minutes. Increase the speed to medium and knead until the dough is elastic and pulls away from the side of the bowl.

3. Place more oats on a plate. Shape the dough into a ball and spray the seam side with water. Roll the top of the dough in the oats until coated.

4. Dust a 9-inch banneton (proofing basket) with bread flour. Place the dough in the proofing basket, oat side down. Cover the bread with plastic wrap and let it sit on the counter for 2 hours.

5. Place the basket in the refrigerator and let it rest overnight.

6. Preheat the oven to 450°F and place a baking stone on a rack positioned in the middle.

7. Dust a peel with bread flour and gently turn the bread onto the peel so that the seam is facing up.

8. With a very sharp knife, carefully score the dough just off center. Make sure the knife is at a 45-degree angle to the dough.

9. Gently slide the sourdough onto the baking stone. Spray the oven with 5 spritzes of water and bake the bread for 20 minutes.

10. Open the oven, spray the oven with 5 more spritzes, and bake until the crust is golden brown, about 20 minutes. The internal temperature of the bread should be at minimum 210°F.

11. Remove the bread from the oven, place it on a wire rack, and let it cool completely before slicing.

INGREDIENTS:

1	CUP WATER, AT ROOM TEMPERATURE
3⅓	CUPS BREAD FLOUR, PLUS MORE AS NEEDED
⅓	CUP WHOLE WHEAT FLOUR
1	CUP ROLLED OATS, PLUS MORE FOR TOPPING
¼	CUP SUNFLOWER SEEDS
¼	CUP MILLET SEEDS
1	CUP SOURDOUGH STARTER (SEE PAGE 494)
2	TEASPOONS KOSHER SALT

STOUT SOURDOUGH BREAD

YIELD: 1 BOULE / **ACTIVE TIME:** 1 HOUR AND 30 MINUTES / **TOTAL TIME:** 24 HOURS

The stout adds still another layer of fermented flavor to the bread, plus a bit of sweetness.

1. Place the beer, water, and flours in the work bowl of a stand mixer fitted with the dough hook and work the mixture on low for 6 minutes. Remove the bowl from the mixer and cover it with plastic wrap. Let the dough sit at room temperature for 1 hour to allow the dough to autolyse.

2. Place the work bowl back on the mixer and add the starter and salt. Knead the mixture at low speed until the dough starts to come together, about 2 minutes. Increase the speed to medium and knead until the dough is elastic and pulls away from the side of the bowl.

3. Shape the dough into a ball and spray the seam side with water. Dust a 9-inch banneton (proofing basket) with bread flour. Place the dough in the proofing basket, seam side down. Cover the bread with plastic wrap and let it sit on the counter for 2 hours.

4. Place the basket in the refrigerator and let it rest overnight.

5. Preheat the oven to 450°F and place a baking stone on a rack positioned in the middle.

6. Dust a peel with bread flour and gently turn the bread onto the peel so that the seam is facing up.

7. With a very sharp knife, carefully score the dough just off center. Make sure the knife is at a 45-degree angle to the dough.

8. Gently slide the sourdough onto the baking stone. Spray the oven with 5 spritzes of water and bake the bread for 20 minutes.

9. Open the oven, spray the oven with 5 more spritzes, and bake until the crust is golden brown, about 20 minutes. The internal temperature of the bread should be at minimum 210°F.

10. Remove the bread from the oven, place it on a wire rack, and let it cool completely before slicing.

INGREDIENTS:

½ CUP DARK STOUT

½ CUP WATER, AT ROOM TEMPERATURE

3⅓ CUPS BREAD FLOUR, PLUS MORE AS NEEDED

⅓ CUP WHOLE WHEAT FLOUR

1 CUP SOURDOUGH STARTER (SEE PAGE 494)

2 TEASPOONS KOSHER SALT

CARAMELIZED ONION SOURDOUGH BREAD

YIELD: 1 BOULE / **ACTIVE TIME:** 1 HOUR AND 30 MINUTES / **TOTAL TIME:** 24 HOURS

The sweetness of caramelized onions cuts beautifully against sourdough's celebrated tang.

1. Place the olive oil in a large skillet and warm it over medium heat. Add the onion and sugar, reduce the heat to medium-low, and cook the onion, stirring frequently, until it starts to caramelize, about 30 minutes. Remove the pan from heat and let the onion cool.

2. Place the water and flours in the work bowl of a stand mixer fitted with the dough hook and work the mixture on low for 6 minutes. Remove the bowl from the mixer and cover it with plastic wrap. Let the dough sit at room temperature for 1 hour to allow the dough to autolyse.

3. Place the work bowl back on the mixer and add the caramelized onion, starter, and salt. Knead the mixture at low speed until the dough starts to come together, about 2 minutes. Increase the speed to medium and knead until the dough is elastic and pulls away from the side of the bowl.

4. Place the sesame seeds on a plate. Shape the dough into a ball and spray the seam side with water. Roll the top of the dough in the sesame seeds until coated.

5. Dust a 9-inch banneton (proofing basket) with bread flour. Place the dough in the proofing basket, seeded side down. Cover the bread with plastic wrap and let it sit on the counter for 2 hours.

6. Place the basket in the refrigerator and let it rest overnight.

7. Preheat the oven to 450°F and place a baking stone on a rack positioned in the middle.

8. Dust a peel with bread flour and gently turn the bread onto the peel so that the seeded side is facing up.

9. With a very sharp knife, carefully score the dough just off center. Make sure the knife is at a 45-degree angle to the dough.

10. Gently slide the sourdough onto the baking stone. Spray the oven with 5 spritzes of water and bake the bread for 20 minutes.

11. Open the oven, spray the oven with 5 more spritzes, and bake until the crust is golden brown, about 20 minutes. The internal temperature of the bread should be at minimum 210°F.

12. Remove the bread from the oven, place it on a wire rack, and let it cool completely before slicing.

INGREDIENTS:

1	TEASPOON EXTRA-VIRGIN OLIVE OIL
1	WHITE ONION, SLICED THIN
1	TABLESPOON SUGAR
1	CUP WATER, AT ROOM TEMPERATURE
3⅓	CUPS BREAD FLOUR, PLUS MORE AS NEEDED
⅓	CUP WHOLE WHEAT FLOUR
1	CUP SOURDOUGH STARTER (SEE PAGE 494)
2	TEASPOONS KOSHER SALT
1	CUP WHITE SESAME SEEDS

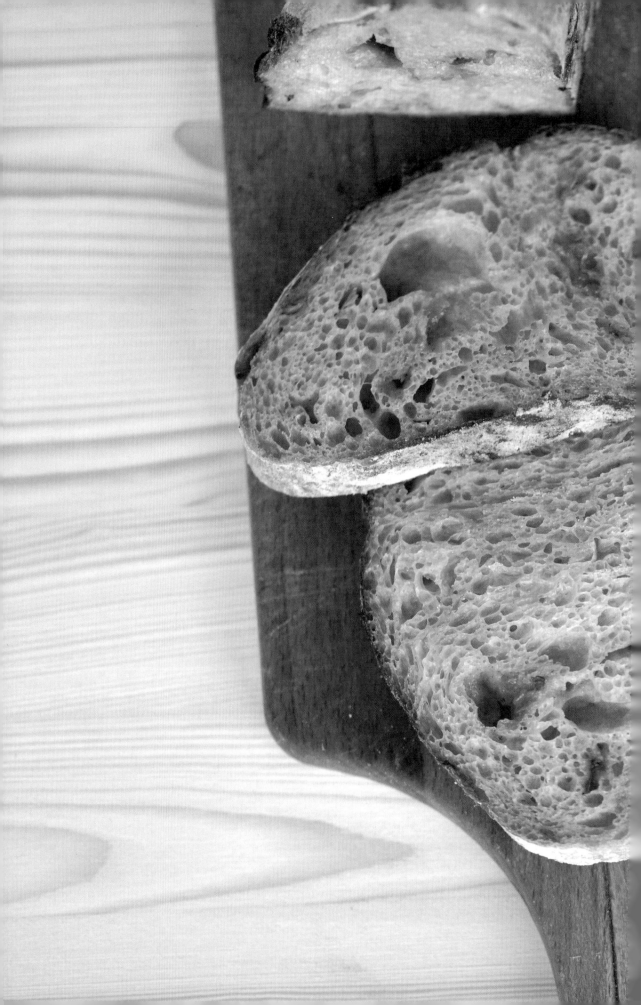

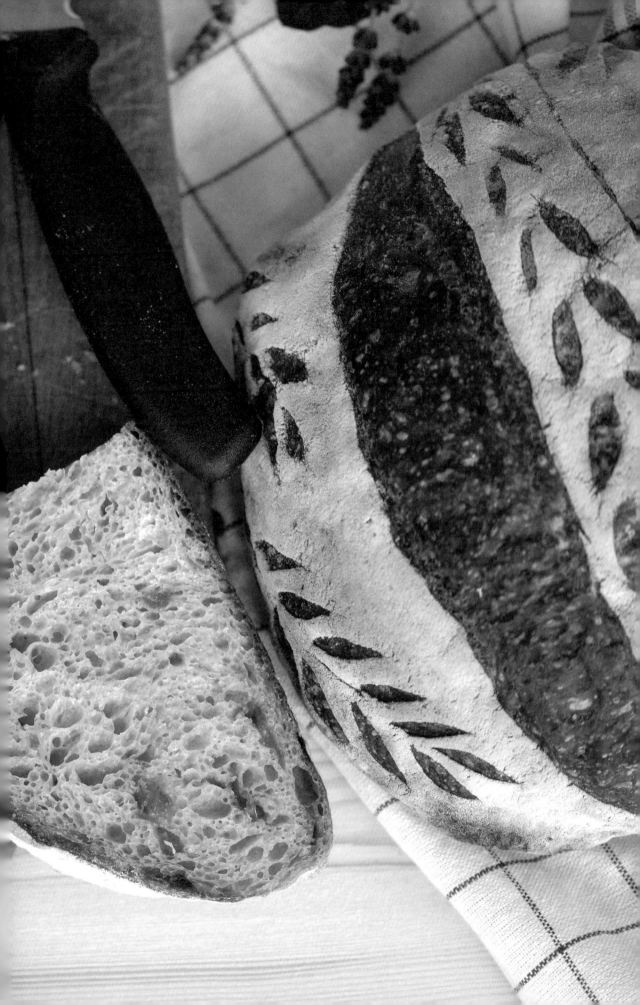

BLACK SESAME SOURDOUGH BREAD

YIELD: 1 BOULE / **ACTIVE TIME:** 1 HOUR AND 30 MINUTES / **TOTAL TIME:** 24 HOURS

Black tahini lends this bread plenty of earthiness, plus an eye-catching smoky look.

1. Place the water and flours in the work bowl of a stand mixer fitted with the dough hook and work the mixture on low for 6 minutes. Remove the bowl from the mixer and cover it with plastic wrap. Let the dough sit at room temperature for 1 hour to allow the dough to autolyse.

2. Place the work bowl back on the mixer and add the black tahini paste, starter, and salt. Knead the mixture at low speed until the dough starts to come together, about 2 minutes. Increase the speed to medium and knead until the dough is elastic and pulls away from the side of the bowl.

3. Place the sesame seeds on a plate. Shape the dough into a ball and spray the seam side with water. Roll the top of the dough in the sesame seeds until coated.

4. Dust a 9-inch banneton (proofing basket) with bread flour. Place the dough in the proofing basket, seeded side down. Cover the bread with plastic wrap and let it sit on the counter for 2 hours.

5. Place the basket in the refrigerator and let it rest overnight.

6. Preheat the oven to 450°F and place a baking stone on a rack positioned in the middle.

7. Dust a peel with flour and gently turn the bread onto the peel so that the seeded side is facing up.

8. With a very sharp knife, carefully score the dough just off center. Make sure the knife is at a 45-degree angle to the dough.

9. Gently slide the sourdough onto the baking stone. Spray the oven with 5 spritzes of water and bake the bread for 20 minutes.

10. Open the oven, spray the oven with 5 more spritzes, and bake until the crust is golden brown, about 20 minutes. The internal temperature of the bread should be at minimum 210°F.

11. Remove the bread from the oven, place it on a wire rack, and let it cool completely before slicing.

INGREDIENTS:

1 CUP WATER, AT ROOM TEMPERATURE

3⅓ CUPS BREAD FLOUR, PLUS MORE AS NEEDED

⅓ CUP WHOLE WHEAT FLOUR

½ CUP BLACK TAHINI PASTE

1 CUP SOURDOUGH STARTER (SEE PAGE 494)

2 TEASPOONS KOSHER SALT

1 CUP BLACK SESAME SEEDS

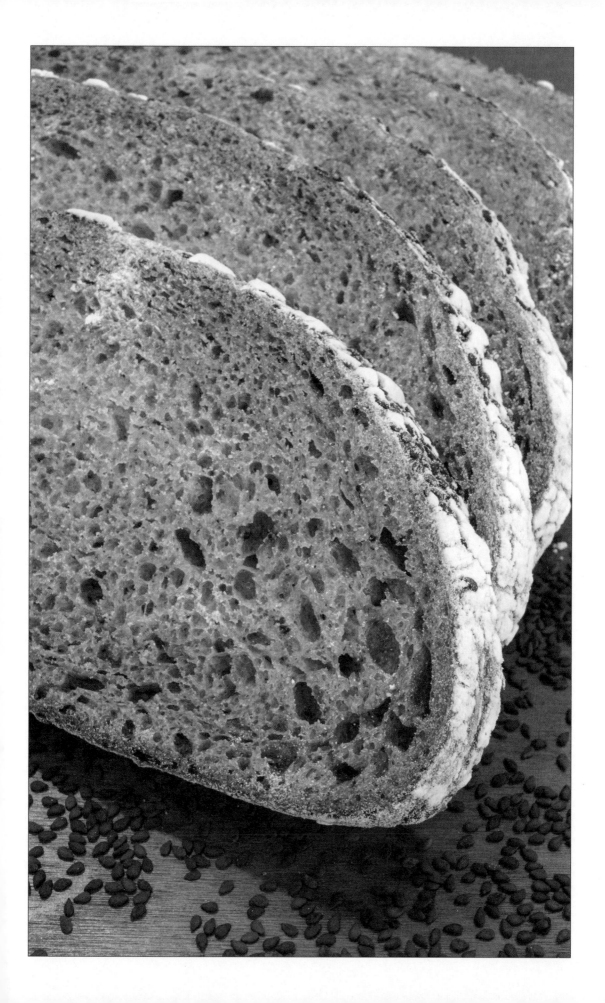

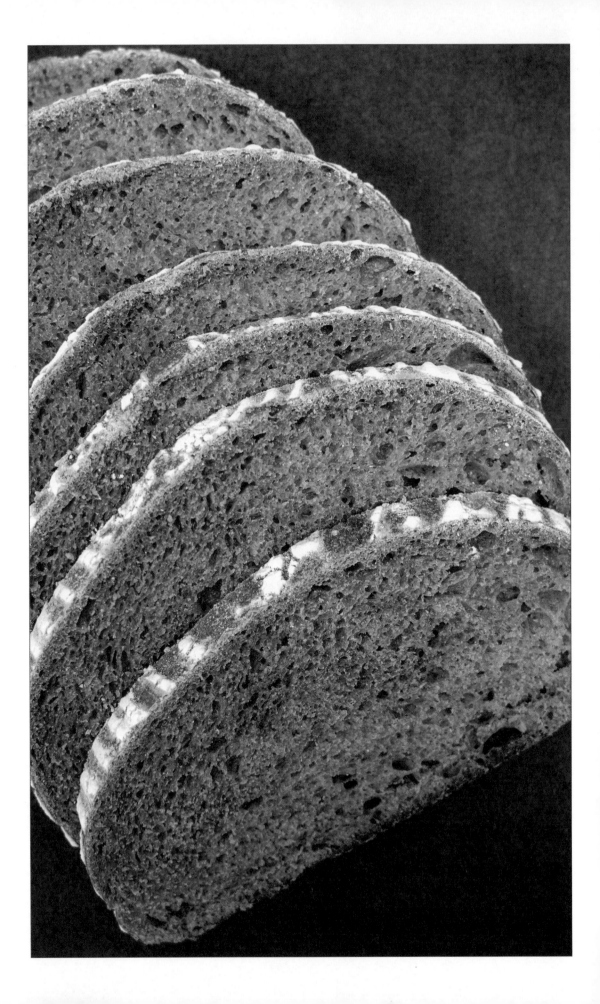

BLUE PEA FLOWER SOURDOUGH BREAD

YIELD: 1 BOULE / **ACTIVE TIME:** 1 HOUR AND 30 MINUTES / **TOTAL TIME:** 24 HOURS

Due to the high acidity of sourdough, the blue pea flower powder will actually produce a loaf that is closer to purple. It's a unique bread—both in terms of looks and taste.

1. Place the water, flours, and blue pea flower powder in the work bowl of a stand mixer fitted with the dough hook and work the mixture on low for 6 minutes. Remove the bowl from the mixer and cover it with plastic wrap. Let the dough sit at room temperature for 1 hour to allow the dough to autolyse.

2. Place the work bowl back on the mixer and add the starter and salt. Knead the mixture at low speed until the dough starts to come together, about 2 minutes. Increase the speed to medium and knead until the dough is elastic and pulls away from the side of the bowl.

3. Shape the dough into a ball and spray the seam side with water. Dust a 9-inch banneton (proofing basket) with bread flour. Place the dough in the proofing basket, seam side down. Cover the bread with plastic wrap and let it sit on the counter for 2 hours.

4. Place the basket in the refrigerator and let it rest overnight.

5. Preheat the oven to 450°F and place a baking stone on a rack positioned in the middle.

6. Dust a peel with flour and gently turn the bread onto the peel so that the seam is facing up.

7. With a very sharp knife, carefully score the dough just off center. Make sure the knife is at a 45-degree angle to the dough.

8. Gently slide the sourdough onto the baking stone. Spray the oven with 5 spritzes of water and bake the bread for 20 minutes.

9. Open the oven, spray the oven with 5 more spritzes, and bake until the crust is golden brown, about 20 minutes. The internal temperature of the bread should be at minimum 210°F.

10. Remove the bread from the oven, place it on a wire rack, and let it cool completely before slicing.

INGREDIENTS:

1	CUP WATER, AT ROOM TEMPERATURE
3⅓	CUPS BREAD FLOUR, PLUS MORE AS NEEDED
⅓	CUP WHOLE WHEAT FLOUR
¼	CUP BLUE PEA FLOWER POWDER
1	CUP SOURDOUGH STARTER (SEE PAGE 494)
2	TEASPOONS KOSHER SALT

RYE SOURDOUGH BREAD

YIELD: 1 BOULE / **ACTIVE TIME:** 1 HOUR AND 30 MINUTES / **TOTAL TIME:** 24 HOURS

The rye flour brings a little spice and a little fruitiness to the proceedings.

1. Place the caraway seeds in a dry skillet and toast over medium heat until fragrant, shaking the pan frequently. Remove the pan from heat and let the seeds cool.

2. Place the water and flours in the work bowl of a stand mixer fitted with the dough hook and work the mixture at low for 6 minutes. Remove the bowl from the mixer and cover it with plastic wrap. Let the dough sit at room temperature for 1 hour to allow the dough to autolyse.

3. Place the work bowl back on the mixer and add the toasted caraway seeds, starter, and salt. Knead the mixture on low speed until the dough starts to come together, about 2 minutes. Increase the speed to medium and knead until the dough is elastic and pulls away from the side of the bowl.

4. Shape the dough into a ball and spray the seam side with water. Dust a 9-inch banneton (proofing basket) with rye flour. Place the dough in the proofing basket, seam side down. Cover the bread with plastic wrap and let it sit on the counter for 2 hours.

5. Place the basket in the refrigerator and let it rest overnight.

6. Preheat the oven to 450°F and place a baking stone on a rack positioned in the middle.

7. Dust a peel with rye flour and gently turn the bread onto the peel so that the seam is facing up.

8. With a very sharp knife, carefully score the dough just off center. Make sure the knife is at a 45-degree angle to the dough.

9. Gently slide the sourdough onto the baking stone. Spray the oven with 5 spritzes of water and bake the bread for 20 minutes.

10. Open the oven, spray the oven with 5 more spritzes, and bake until the crust is golden brown, about 20 minutes. The internal temperature of the bread should be at minimum 210°F.

11. Remove the bread from the oven, place it on a wire rack, and let it cool completely before slicing.

INGREDIENTS:

2 TABLESPOONS CARAWAY SEEDS

1 CUP WATER, AT ROOM TEMPERATURE

3⅓ CUPS BREAD FLOUR

⅓ CUP DARK RYE FLOUR, PLUS MORE AS NEEDED

1 CUP SOURDOUGH STARTER (SEE PAGE 494)

2 TEASPOONS KOSHER SALT

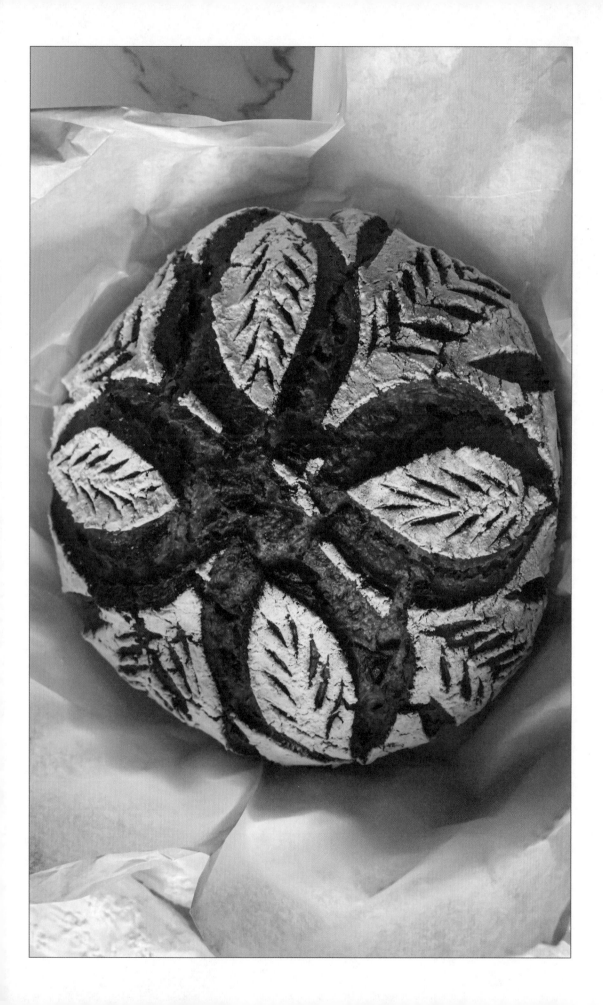

WILD BLUEBERRY SOURDOUGH BREAD

YIELD: 1 BOULE / **ACTIVE TIME:** 1 HOUR AND 30 MINUTES / **TOTAL TIME:** 24 HOURS

If you're craving French toast, make this sourdough the night before.

1. Place the water and flours in the work bowl of a stand mixer fitted with the dough hook and work the mixture on low for 6 minutes. Remove the bowl from the mixer and cover it with plastic wrap. Let the dough sit at room temperature for 1 hour to allow the dough to autolyse.

2. Place the work bowl back on the mixer and add the blueberries, starter, and salt. Knead the mixture at low speed until the dough starts to come together, about 2 minutes. Increase the speed to medium and knead until the dough is elastic and pulls away from the side of the bowl.

3. Shape the dough into a ball and spray the seam side with water. Dust a 9-inch banneton (proofing basket) with bread flour. Place the dough in the proofing basket, seam side down. Cover the bread with plastic wrap and let it sit on the counter for 2 hours.

4. Place the basket in the refrigerator and let it rest overnight.

5. Preheat the oven to 450°F and place a baking stone on a rack positioned in the middle.

6. Dust a peel with bread flour and gently turn the bread onto the peel so that the seam is facing up.

7. With a very sharp knife, carefully score the dough just off center. Make sure the knife is at a 45-degree angle to the dough.

8. Gently slide the sourdough onto the baking stone. Spray the oven with 5 spritzes of water and bake the bread for 20 minutes.

9. Open the oven, spray the oven with 5 more spritzes, and bake until the crust is golden brown, about 20 minutes. The internal temperature of the bread should be at minimum 210°F.

10. Remove the bread from the oven, place it on a wire rack, and let it cool completely before slicing.

INGREDIENTS:

1	CUP WATER, AT ROOM TEMPERATURE
3⅓	CUPS BREAD FLOUR, PLUS MORE AS NEEDED
⅓	CUP WHOLE WHEAT FLOUR
½	CUP FROZEN WILD BLUEBERRIES
½	CUP DRIED BLUEBERRIES
1	CUP SOURDOUGH STARTER (SEE PAGE 494)
2	TEASPOONS KOSHER SALT

BLACK GARLIC SOURDOUGH BREAD

YIELD: 1 BOULE / **ACTIVE TIME:** 1 HOUR AND 30 MINUTES / **TOTAL TIME:** 24 HOURS

Adding the beguiling flavor of black garlic to sourdough's unique tang will cause all who encounter this bread to savor it in complete silence.

1. Place the water and flours in the work bowl of a stand mixer fitted with the dough hook and work the mixture on low for 6 minutes. Remove the bowl from the mixer and cover it with plastic wrap. Let the dough sit at room temperature for 1 hour to allow the dough to autolyse.

2. Place the work bowl back on the mixer and add the black garlic, garlic, starter, and salt. Knead the mixture at low speed until the dough starts to come together, about 2 minutes. Increase the speed to medium and knead until the dough is elastic and pulls away from the side of the bowl.

3. Shape the dough into a ball and spray the seam side with water. Dust a 9-inch banneton (proofing basket) with bread flour. Place the dough in the proofing basket, seam side down. Cover the bread with plastic wrap and let it sit on the counter for 2 hours.

4. Place the basket in the refrigerator and let it rest overnight.

5. Preheat the oven to 450°F and place a baking stone on a rack positioned in the middle.

6. Dust a peel with bread flour and gently turn the bread onto the peel so that the seam is facing up.

7. With a very sharp knife, carefully score the dough just off center. Make sure the knife is at a 45-degree angle to the dough.

8. Gently slide the sourdough onto the baking stone. Spray the oven with 5 spritzes of water and bake the bread for 20 minutes.

9. Open the oven, spray the oven with 5 more spritzes, and bake until the crust is golden brown, about 20 minutes. The internal temperature of the bread should be at minimum 210°F.

10. Remove the bread from the oven, place it on a wire rack, and let it cool completely before slicing.

INGREDIENTS:

1	CUP WATER
3⅓	CUPS BREAD FLOUR, PLUS MORE AS NEEDED
⅓	CUP WHOLE WHEAT FLOUR
1	BULB OF BLACK GARLIC, PEELED
2	GARLIC CLOVES, MINCED
1	CUP SOURDOUGH STARTER (SEE PAGE 494)
2	TEASPOONS KOSHER SALT

ALL THE SEEDS SOURDOUGH BREAD

YIELD: 1 BOULE / **ACTIVE TIME:** 1 HOUR AND 30 MINUTES / **TOTAL TIME:** 24 HOURS

A strong collection of seeds lend this bread texture, nuttiness, and complex flavor.

1. Place the water and flours in the work bowl of a stand mixer fitted with the dough hook and work the mixture on low for 6 minutes. Remove the bowl from the mixer and cover it with plastic wrap. Let the dough sit at room temperature for 1 hour to allow the dough to autolyse.

2. Place the work bowl back on the mixer and add the seeds, starter, and salt. Knead the mixture at low speed until the dough starts to come together, about 2 minutes. Increase the speed to medium and knead until the dough is elastic and pulls away from the side of the bowl.

3. Combine the sesame seeds and poppy seeds on a plate. Shape the dough into a ball and spray the seam side with water. Roll the top of the dough in the seed mixture until coated.

4. Dust a 9-inch banneton (proofing basket) with bread flour. Place the dough in the proofing basket, seeded side down. Cover the bread with plastic wrap and let it sit on the counter for 2 hours.

5. Place the basket in the refrigerator and let it rest overnight.

6. Preheat the oven to 450°F and place a baking stone on a rack positioned in the middle.

7. Dust a peel with bread flour and gently turn the bread onto the peel so that the seeded side is facing up.

8. With a very sharp knife, carefully score the dough just off center. Make sure the knife is at a 45-degree angle to the dough.

9. Gently slide the sourdough onto the baking stone. Spray the oven with 5 spritzes of water and bake the bread for 20 minutes.

10. Open the oven, spray the oven with 5 more spritzes, and bake until the crust is golden brown, about 20 minutes. The internal temperature of the bread should be at minimum 210°F.

11. Remove the bread from the oven, place it on a wire rack, and let it cool completely before slicing.

INGREDIENTS:

1	CUP WATER, AT ROOM TEMPERATURE
3⅓	CUPS BREAD FLOUR, PLUS MORE AS NEEDED
⅓	CUP WHOLE WHEAT FLOUR
2	TABLESPOONS SUNFLOWER SEEDS
2	TABLESPOONS BLACK SESAME SEEDS
2	TABLESPOONS WHITE SESAME SEEDS, PLUS MORE FOR TOPPING
2	TABLESPOONS CHIA SEEDS
2	TABLESPOONS MILLET SEEDS
2	TABLESPOONS PUMPKIN SEEDS
2	TABLESPOONS POPPY SEEDS, PLUS MORE FOR TOPPING
1	CUP SOURDOUGH STARTER (SEE PAGE 494)
2	TEASPOONS KOSHER SALT

SUMMER BERRY SOURDOUGH

YIELD: 1 BOULE / **ACTIVE TIME:** 1 HOUR AND 30 MINUTES / **TOTAL TIME:** 24 HOURS

Once your freezer is filled up, this is a wonderful spot for some of your berry-picking haul.

1. Place the water, flours, and lavender in the work bowl of a stand mixer fitted with the dough hook and work the mixture on low for 6 minutes. Remove the bowl from the mixer and cover it with plastic wrap. Let the dough sit at room temperature for 1 hour to allow the dough to autolyse.

2. Place the work bowl back on the mixer and add the berries, starter, and salt. Knead the mixture at low speed until the dough starts to come together, about 2 minutes. Increase the speed to medium and knead until the dough is elastic and pulls away from the side of the bowl.

3. Shape the dough into a ball and spray the seam side with water. Dust a 9-inch banneton (proofing basket) with bread flour. Place the dough in the proofing basket, seam side down. Cover the bread with plastic wrap and let it sit on the counter for 2 hours.

4. Place the basket in the refrigerator and let it rest overnight.

5. Preheat the oven to 450°F and place a baking stone on a rack positioned in the middle.

6. Dust a peel with bread flour and gently turn the bread onto the peel so that the seam is facing up.

7. With a very sharp knife, carefully score the dough just off center. Make sure the knife is at a 45-degree angle to the dough.

8. Gently slide the sourdough onto the baking stone. Spray the oven with 5 spritzes of water and bake the bread for 20 minutes.

9. Open the oven, spray the oven with 5 more spritzes, and bake until the crust is golden brown, about 20 minutes. The internal temperature of the bread should be at minimum 210°F.

10. Remove the bread from the oven, place it on a wire rack, and let it cool completely before slicing.

INGREDIENTS:

1	CUP WATER, AT ROOM TEMPERATURE
3⅓	CUPS BREAD FLOUR, PLUS MORE AS NEEDED
⅓	CUP WHOLE WHEAT FLOUR
2	TABLESPOONS LAVENDER BUDS
¼	CUP FROZEN BLUEBERRIES
¼	CUP FROZEN RASPBERRIES
¼	CUP FROZEN BLACKBERRIES
1	CUP SOURDOUGH STARTER (SEE PAGE 494)
2	TEASPOONS KOSHER SALT

SPINACH & HERB SOURDOUGH BREAD

YIELD: 1 BOULE / **ACTIVE TIME:** 1 HOUR AND 30 MINUTES / **TOTAL TIME:** 24 HOURS

A beautiful and fresh-tasting sourdough that will lift any sandwich.

1. Prepare an ice bath, and bring water to a boil in a small saucepan. Place the spinach in the pan and cook it for 30 seconds. Transfer the spinach to the ice bath to shock it. When cool, drain the spinach and squeeze it to remove as much water as possible.

2. Place the spinach and 1 cup of water in a blender and puree until smooth.

3. Place the puree and flours in the work bowl of a stand mixer fitted with the dough hook and work the mixture on low for 6 minutes. Remove the bowl from the mixer and cover it with plastic wrap. Let the dough sit at room temperature for 1 hour to allow the dough to autolyse.

4. Place the work bowl back on the mixer and add the herbs, starter, and salt. Knead the mixture at low speed until the dough starts to come together, about 2 minutes. Increase the speed to medium and knead until the dough is elastic and pulls away from the side of the bowl.

5. Shape the dough into a ball and spray the seam side with water. Dust a 9-inch banneton (proofing basket) with bread flour. Place the dough in the proofing basket, seam side down. Cover the bread with plastic wrap and let it sit on the counter for 2 hours.

6. Place the basket in the refrigerator and let it rest overnight.

7. Preheat the oven to 450°F and place a baking stone on a rack positioned in the middle.

8. Dust a peel with bread flour and gently turn the bread onto the peel so that the seam is facing up.

9. With a very sharp knife, carefully score the dough just off center. Make sure the knife is at a 45-degree angle to the dough.

10. Gently slide the sourdough onto the baking stone. Spray the oven with 5 spritzes of water and bake the bread for 20 minutes.

11. Open the oven, spray the oven with 5 more spritzes, and bake until the crust is golden brown, about 20 minutes. The internal temperature of the bread should be at minimum 210°F.

12. Remove the bread from the oven, place it on a wire rack, and let it cool completely before slicing.

INGREDIENTS:

1	CUP SPINACH
3⅓	CUPS BREAD FLOUR, PLUS MORE AS NEEDED
⅓	CUP WHOLE WHEAT FLOUR
1	TABLESPOON FRESH THYME
1	TABLESPOON FINELY CHOPPED FRESH SAGE
1	TABLESPOON FINELY CHOPPED FRESH ROSEMARY
1	TABLESPOON FINELY CHOPPED FRESH BASIL
1	CUP SOURDOUGH STARTER (SEE PAGE 494)
2	TEASPOONS KOSHER SALT

SOURDOUGH BAGUETTES

YIELD: 2 BAGUETTES / **ACTIVE TIME:** 1 HOUR AND 30 MINUTES / **TOTAL TIME:** 24 HOURS

These are a bit more involved than a standard baguette, but the additional effort will be well worth it.

1. Place the water and flours in the work bowl of a stand mixer fitted with the dough hook and work the mixture on low for 6 minutes. Remove the bowl from the mixer and cover it with plastic wrap. Let the dough sit at room temperature for 1 hour to allow the dough to autolyse.

2. Place the work bowl back on the mixer and add the starter and salt. Knead the mixture at low speed until the dough starts to come together, about 2 minutes. Increase the speed to medium and knead until the dough is elastic and pulls away from the side of the bowl.

3. Shape the dough into a ball and spray the seam side with water. Dust a 9-inch banneton (proofing basket) with bread flour. Place the dough in the proofing basket, seam side down. Cover the bread with plastic wrap and let it sit on the counter for 2 hours.

4. Place the dough on a flour-dusted work surface, divide it in half, and shape each piece into a ball. Cover the dough with a moist linen towel and let it sit on the counter for 15 minutes.

5. Punch down the dough balls until they are rough ovals. Working with one piece at a time, take the side of the dough closest to you and roll it away. Starting halfway up, fold in the corners and roll the dough into a rough baguette shape.

6. Place both hands over one piece of dough. Gently roll the dough while moving your hands back and forth over it and lightly pressing down until it is about 16 inches.

7. Place the baguettes on a baguette pan, cover them with plastic wrap, and place them in the refrigerator overnight.

8. Remove the dough from the refrigerator, place it in a naturally warm spot, and let it sit for 2 hours.

9. Preheat the oven to 450°F.

10. Using a very sharp knife, cut four slits at a 45-degree angle along the length of each baguette.

11. Place the baguettes in the oven, spray the oven with 5 spritzes of water, and bake until the baguettes are a deep golden brown, 20 to 30 minutes.

12. Remove the baguettes from the oven, place them on a wire rack, and let them cool slightly before slicing.

INGREDIENTS:

5 OZ. WATER

11.5 OZ. BREAD FLOUR, PLUS
 MORE AS NEEDED

½ OZ. WHOLE WHEAT FLOUR

1 TEASPOON SUGAR

1 CUP SOURDOUGH STARTER
 (SEE PAGE 494)

1 TABLESPOON KOSHER SALT

SESAME COUNTRY BUNS

YIELD: 8 BUNS / **ACTIVE TIME:** 45 MINUTES / **TOTAL TIME:** 4 HOURS

A go-to preparation whether you're looking for dinner rolls or hamburger buns.

1. Place the water in the work bowl of a stand mixer. Sprinkle the yeast over the water, gently whisk, and let the mixture sit for 10 minutes.

2. Add the flour, sugar, and salt and fit the mixer with the dough hook. Work the mixture on low until it just starts to come together as a dough, about 1 minute.

3. Add the butter, raise the speed to medium, and work the dough until it comes away clean from the side of the work bowl and is elastic.

4. Spray a mixing bowl with nonstick cooking spray. Transfer the dough to a flour-dusted work surface and knead it until it is extensible. Shape the dough into a ball, place it in the bowl, and cover the bowl with a kitchen towel. Place the dough in a naturally warm spot and let it rise until doubled in size, 1 to 2 hours.

5. Preheat the oven to 350°F. Line an 18 x 13–inch sheet pan with parchment paper.

6. Portion the dough into 8 pieces that are each about 3.5 oz and form them into rounds. Place the rounds on the pan, cover them with plastic wrap, and place them in a naturally warm spot. Let the rolls rise until they have doubled in size.

7. Gently brush the rolls with the beaten egg and sprinkle the sesame seeds over them.

8. Place the rolls in the oven and bake until they are golden brown, about 20 minutes. Remove from the oven and let the rolls cool on a wire rack before enjoying.

INGREDIENTS:

9	OZ. LUKEWARM WATER (90°F)
1	TABLESPOON ACTIVE DRY YEAST
1	LB. BREAD FLOUR, PLUS MORE AS NEEDED
1	TEASPOON SUGAR
1	TABLESPOON KOSHER SALT
2	TABLESPOONS UNSALTED BUTTER, SOFTENED
1	EGG, BEATEN
	WHITE SESAME SEEDS, FOR TOPPING

SCALI BREAD

YIELD: 1 LOAF / **ACTIVE TIME:** 45 MINUTES / **TOTAL TIME:** 4 HOURS

This crusty loaf with the soft interior is a staple in Italian American homes in the Boston area.

1. Place the water in the work bowl of a stand mixer. Sprinkle the yeast over the water, gently whisk, and let the mixture sit for 10 minutes.

2. Add the flour, sugar, and salt and fit the mixer with the dough hook. Work the mixture on low until it just starts to come together as a dough, about 1 minute.

3. Add the butter, raise the speed to medium, and work the dough until it comes away clean from the side of the work bowl and is elastic.

4. Spray a mixing bowl with nonstick cooking spray. Transfer the dough to a flour-dusted work surface and knead it until it is extensible. Shape the dough into a ball, place it in the bowl, and cover the bowl with a kitchen towel. Place the dough in a naturally warm spot and let it rise until doubled in size, 1 to 2 hours.

5. Preheat the oven to 350°F. Line an 18 x 13–inch sheet pan with parchment paper.

6. Place the dough on a flour-dusted work surface and flatten it into a rough rectangle that is about 6 inches across. Starting from a near end, roll the dough up while tucking in the sides, so that the dough becomes shaped like a football. Pinch the seam to seal, and place the dough on the sheet pan, seam side down. Cover the dough with plastic wrap, place it in a naturally warm spot, and let it rise until doubled in size.

7. Brush the dough with the beaten egg and sprinkle the sesame seeds over the top. Using a very sharp knife, cut a seam on the top of the bread at a 45-degree angle. Place the dough in the oven and spray the oven with water to add a bit of humidity. Bake the bread until it is golden brown, about 20 minutes. The internal temperature of the bread should be 190°F.

8. Remove the bread from the oven, place it on a cooling rack, and let it cool before slicing.

INGREDIENTS:

½ CUP LUKEWARM WATER (90°F), PLUS 1 TABLESPOON

1½ TEASPOONS ACTIVE DRY YEAST

8 OZ. BREAD FLOUR, PLUS MORE AS NEEDED

2 TEASPOONS SUGAR

1½ TEASPOONS KOSHER SALT

1 TABLESPOON UNSALTED BUTTER, SOFTENED

1 EGG, BEATEN

WHITE SESAME SEEDS, FOR TOPPING

BRIOCHE

YIELD: 2 LOAVES / **ACTIVE TIME:** 45 MINUTES / **TOTAL TIME:** 4 HOURS

Generous amounts of eggs and butter create the rich and soft crumb in this classic French bread.

1. To prepare the sponge, place all of the ingredients in the work bowl of a stand mixer. Cover it with plastic wrap and let the mixture sit until it starts to bubble, about 30 minutes.

2. To begin preparations for the dough, add the 4 unbeaten eggs to the sponge and whisk until incorporated.

3. Add the sugar, flour, and salt, fit the mixer with the dough hook, and knead the mixture on low for 5 minutes.

4. Over the course of 2 minutes, add the butter a little at a time with the mixer running. When all of the butter has been added, knead the mixture on low for 5 minutes.

5. Raise the speed to medium and knead the dough until it begins to pull away from the sides, about 6 minutes. Cover the bowl with a kitchen towel, place the dough in a naturally warm spot, and let it rise until it has doubled in size, about 1 hour.

6. Preheat the oven to 350°F. Coat two 8 x 4–inch loaf pans with nonstick cooking spray.

7. Divide the dough into two equal pieces and flatten each one into a rectangle the width of a loaf pan. Tuck in the sides to form the dough into loaf shapes and place one in each pan, seam side down.

8. Cover the pans with plastic wrap and let the dough rise until it has crested over the top of the pans.

9. Brush the loaves with the beaten egg, place them in the oven, and bake until they are golden brown, 35 to 45 minutes. The loaves should reach an internal temperature of 200°F.

10. Remove from the oven, place the pans on a wire rack, and let them cool before enjoying.

INGREDIENTS:

FOR THE SPONGE

½	CUP MILK, WARMED
4½	TEASPOONS ACTIVE DRY YEAST
2	TABLESPOONS HONEY
4	OZ. BREAD FLOUR

FOR THE DOUGH

5	EGGS, 1 BEATEN
2	OZ. SUGAR
1	LB. BREAD FLOUR
2	TEASPOONS KOSHER SALT
4	OZ. UNSALTED BUTTER, SOFTENED

SEEDED BRIOCHE

YIELD: 2 LOAVES / **ACTIVE TIME:** 45 MINUTES / **TOTAL TIME:** 4 HOURS

A delicious twist on the French classic, adding a bit of crunch to the famed softness.

1. To prepare the sponge, place all of the ingredients in the work bowl of a stand mixer. Cover it with plastic wrap and let the mixture sit until it starts to bubble, about 30 minutes.

2. To begin preparations for the dough, add the 4 unbeaten eggs to the sponge and whisk until incorporated.

3. Add the sugar, flour, salt, and all of the seeds, fit the mixer with the dough hook, and knead the mixture on low for 5 minutes.

4. Over the course of 2 minutes, add the butter a little at a time with the mixer running. When all of the butter has been added, knead the mixture on low for 5 minutes.

5. Raise the speed to medium and knead the dough until it begins to pull away from the sides, about 6 minutes. Cover the bowl with a kitchen towel, place the dough in a naturally warm spot, and let it rise until it has doubled in size, about 1 hour.

6. Preheat the oven to 350°F. Coat two 8 x 4–inch loaf pans with nonstick cooking spray.

7. Divide the dough into two equal pieces and flatten each one into a rectangle the width of a loaf pan. Tuck in the sides to form the dough into loaf shapes and place one in each pan, seam side down.

8. Cover the pans with plastic wrap and let the dough rise until it has crested over the top of the pans.

9. Brush the loaves with the beaten egg, place them in the oven, and bake until they are golden brown, 35 to 45 minutes. The loaves should reach an internal temperature of 200°F.

10. Remove from the oven, place the pans on a wire rack, and let them cool before enjoying.

INGREDIENTS:

FOR THE SPONGE

½ CUP MILK, WARMED

4½ TEASPOONS ACTIVE DRY YEAST

2 TABLESPOONS HONEY

4 OZ. BREAD FLOUR

FOR THE DOUGH

5 EGGS, 1 BEATEN

2 OZ. SUGAR

1 LB. BREAD FLOUR

2 TEASPOONS KOSHER SALT

¼ CUP SUNFLOWER SEEDS

¼ CUP MILLET SEEDS

¼ CUP POPPY SEEDS

¼ CUP WHITE SESAME SEEDS

¼ CUP POPPY SEEDS

4 OZ. UNSALTED BUTTER, SOFTENED

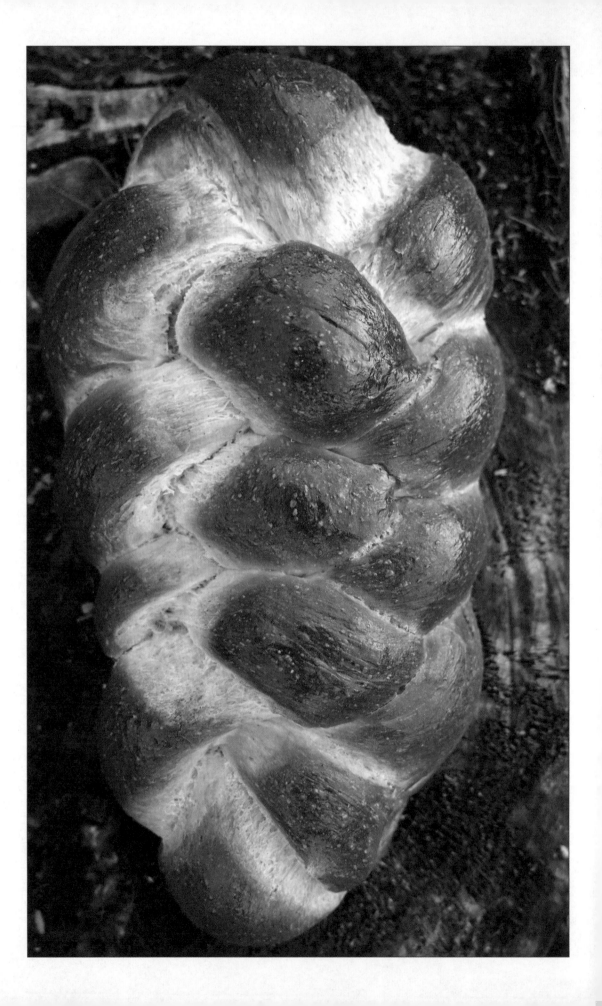

CHALLAH

YIELD: 1 LOAF / **ACTIVE TIME:** 1 HOUR / **TOTAL TIME:** 5 HOURS

A braided bread with a taste and texture that matches the elegance of its looks.

1. Place the water and yeast in the work bowl of a stand mixer and gently whisk to combine. Let the mixture sit until it starts to foam, about 10 minutes.

2. Fit the mixer with the dough hook, add the 3 unbeaten eggs, oil, flour, sugar, and salt to the work bowl, and work the mixture on low until it comes together as a dough, about 2 minutes.

3. Raise the speed to medium and knead until the dough becomes elastic and starts to pull away from the side of the bowl, about 6 minutes.

4. Cover the mixing bowl with a kitchen towel, place it in a naturally warm spot, and let the dough rise until it has doubled in size.

5. Place the dough on a flour-dusted work surface and punch it down. Divide the dough into four pieces that are each 12.7 oz. Shape each piece into an oval, cover the pieces with linen towels, and let them rest for 15 to 30 minutes.

6. Preheat the oven to 350°F. Line a baking sheet with parchment paper.

7. Using the palms of your hands, gently roll the dough into strands that are about 2 feet long.

8. Take the strands and fan them out so that one end of each of them is touching. Press down on the ends where they are touching. Take the right-most strand (Strand 1) and cross it over to the left so that it is horizontal. Take the left-most strand (Strand 2) and cross it over to the right so that it is horizontal.

9. Move Strand 1 between the two strands that have yet to move. Move the strand to the right of Strand 1 to the left so that it is horizontal. This will be known as Strand 3.

10. Move Strand 2 between Strand 1 and Strand 4. Move strand 4 to the right so that it is horizontal.

INGREDIENTS:

1½	**CUPS LUKEWARM WATER (90°F)**
1	**TABLESPOON ACTIVE DRY YEAST, PLUS 2 TEASPOONS**
4	**EGGS, 1 BEATEN**
¼	**CUP EXTRA-VIRGIN OLIVE OIL**
7	**CUPS BREAD FLOUR, PLUS MORE AS NEEDED**
¼	**CUP SUGAR**
1½	**TABLESPOONS KOSHER SALT**

Continued . . .

11. Repeat moving the horizontal strands to the middle and replacing them with the opposite, outer strands until the entire loaf is braided. Pinch the ends of the loaf together and tuck them under the bread.

12. Brush the dough with the beaten egg. If you want to top the bread with poppy seeds, sesame seeds, or herbs, now is the time to sprinkle them over the top.

13. Place the bread in the oven and bake until it is golden brown, about 30 minutes. The cooked challah should have an internal temperature of 210°F.

14. Remove from the oven, place the challah on a wire rack, and let it cool completely.

MARBLED CHALLAH

YIELD: 1 LOAF / **ACTIVE TIME:** 1 HOUR / **TOTAL TIME:** 5 HOURS

The contrasting colors and flavors of the doughs are sure to set off a swirl of emotions.

1. Place the water and yeast in the work bowl of a stand mixer and gently whisk to combine. Let the mixture sit until it starts to foam, about 10 minutes.

2. Fit the mixer with the dough hook, add the 3 unbeaten eggs, oil, flour, sugar, and salt to the work bowl, and work the mixture on low until it comes together as a dough, about 2 minutes.

3. Raise the speed to medium and knead until the dough becomes elastic and starts to pull away from the side of the bowl, about 6 minutes.

4. Remove half of the dough, place it in a mixing bowl, and set aside. Add the cocoa powder, caraway seeds, and molasses to the remaining dough and knead until incorporated, about 5 minutes.

5. Cover the bowls with linen towels, place them in a naturally warm spot, and let them rise until doubled in size.

6. Place the dough on a flour-dusted work surface and punch it down. Divide the dough into four pieces that are each 12.7 oz. Shape each piece into an oval, cover the pieces with linen towels, and let them rest for 15 to 30 minutes.

7. Preheat the oven to 350°F. Line a baking sheet with parchment paper.

8. Using the palms of your hands, gently roll the dough into strands that are about 2 feet long.

9. Take the strands and fan them out, alternating light and dark strands, so that one end of each of them is touching. Press down on the ends where they are touching. Take the right-most strand (Strand 1) and cross it over to the left so that it is horizontal. Take the left-most strand (Strand 2) and cross it over to the right so that it is horizontal.

10. Move Strand 1 between the two strands that have yet to move. Move the strand to the right of Strand 1 to the left so that it is horizontal. This will be known as Strand 3.

INGREDIENTS:

1½	CUPS LUKEWARM WATER (90°F)
1	TABLESPOON ACTIVE DRY YEAST, PLUS 2 TEASPOONS
4	EGGS, 1 BEATEN
¼	CUP EXTRA-VIRGIN OLIVE OIL
2	LBS. BREAD FLOUR, PLUS MORE AS NEEDED
¼	CUP SUGAR
1½	TABLESPOONS KOSHER SALT
2	TEASPOONS COCOA POWDER
1	TEASPOON CARAWAY SEEDS
2	TABLESPOONS MOLASSES

Continued . . .

11. Move Strand 2 between Strand 1 and Strand 4. Move strand 4 to the right so that it is horizontal.

12. Repeat moving the horizontal strands to the middle and replacing them with the opposite, outer strands until the entire loaf is braided. Pinch the ends of the loaf together and tuck them under the bread.

13. Place the dough on the baking sheet, cover it with plastic wrap, place it in a naturally warm spot, and let it rise until it has doubled in size.

14. Brush the dough with the beaten egg.

15. Place the bread in the oven and bake until it is golden brown, about 30 minutes. The cooked challah should have an internal temperature of 210°F.

16. Remove from the oven, place the challah on a wire rack, and let it cool completely.

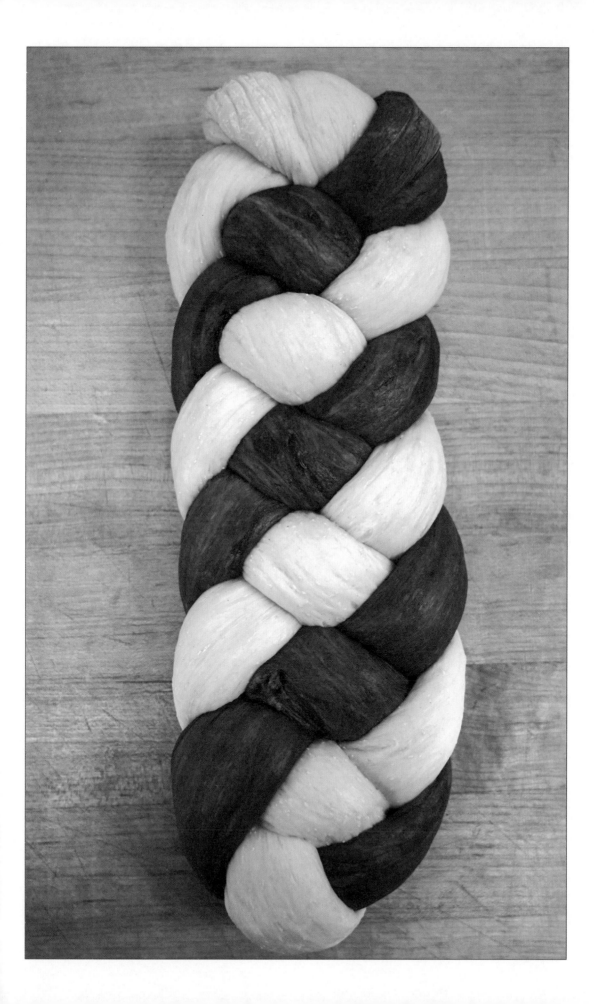

FALL HARVEST LOAF

YIELD: 1 LOAF / **ACTIVE TIME:** 45 MINUTES / **TOTAL TIME:** 4 HOURS

I f you can't get enough of the smell of freshly baked bread, this loaf resides at a whole new olfactory level.

1. Place the water in the work bowl of a stand mixer. Sprinkle the yeast over the water, gently whisk, and let the mixture sit for 10 minutes.

2. Add the unbeaten egg, egg yolk, olive oil, and sugar and fit the mixer with the dough hook. Add the flour, cloves, cinnamon, cranberries, pumpkin seeds, and salt. Work the mixture on low until it just starts to come together as a dough, about 1 minute.

3. Raise the speed to medium and work the dough until it comes away clean from the side of the work bowl and is elastic, about 6 minutes.

4. Spray a mixing bowl with nonstick cooking spray. Transfer the dough to a flour-dusted work surface and knead it until it is extensible. Shape the dough into a ball, place it in the bowl, and cover the bowl with a kitchen towel. Place the dough in a naturally warm spot and let it rise until doubled in size, 1 to 2 hours.

5. Preheat the oven to 350°F. Spray an 8 x 4–inch loaf pan with nonstick cooking spray.

6. Place the dough on a flour-dusted work surface and roll it into a tight round. Pinch the ends together and place the dough in the loaf pan, seam side down. Cover the dough with plastic wrap, place it in a naturally warm spot, and let it rise until doubled in size.

7. Brush the dough with the beaten egg. Using a very sharp knife, cut a seam on the top of the bread for its entire length. Place the dough in the oven and bake until it is golden brown, 35 to 45 minutes. The internal temperature of the bread should be 200°F.

8. Remove the bread from the oven, place it on a cooling rack, and let it cool before slicing.

INGREDIENTS:

6	OZ. LUKEWARM WATER (90°F)
1	TABLESPOON ACTIVE DRY YEAST
2	EGGS, 1 BEATEN
1	EGG YOLK
1	OZ. EXTRA-VIRGIN OLIVE OIL
1	OZ. SUGAR
15	OZ. BREAD FLOUR, PLUS MORE AS NEEDED
1	TEASPOON GROUND CLOVES
1	TABLESPOON CINNAMON
1	CUP DRIED CRANBERRIES
½	CUP PUMPKIN SEEDS, TOASTED
2	TEASPOONS KOSHER SALT

WINTER HARVEST LOAF

YIELD: 1 LOAF / **ACTIVE TIME:** 45 MINUTES / **TOTAL TIME:** 4 HOURS

Aloaf for those times when the cold and bleak world outside starts to wear you down.

1. Place the water in the work bowl of a stand mixer. Sprinkle the yeast over the water, gently whisk, and let the mixture sit for 10 minutes.

2. Add the unbeaten egg, egg yolk, olive oil, sugar, and molasses and fit the mixer with the dough hook. Add the flour, cocoa powder, millet seeds, rolled oats, caraway seeds, fennel seeds, and salt. Work the mixture on low until it just starts to come together as a dough, about 1 minute.

3. Raise the speed to medium and work the dough until it comes away clean from the side of the work bowl and is elastic, about 6 minutes.

4. Spray a mixing bowl with nonstick cooking spray. Transfer the dough to a flour-dusted work surface and knead it until it is extensible. Shape the dough into a ball, place it in the bowl, and cover the bowl with a kitchen towel. Place the dough in a naturally warm spot and let it rise until doubled in size, 1 to 2 hours.

5. Preheat the oven to 350°F. Spray an 8 x 4–inch loaf pan with nonstick cooking spray.

6. Place the dough on a flour-dusted work surface and roll it into a tight round. Pinch the ends together and place the dough in the loaf pan, seam side down. Cover the dough with plastic wrap, place it in a naturally warm spot, and let it rise until doubled in size.

7. Brush the dough with the beaten egg. Using a very sharp knife, cut a seam on the top of the bread for its entire length. Place the dough in the oven and bake until it is golden brown, 35 to 45 minutes. The internal temperature of the bread should be 200°F.

8. Remove the bread from the oven, place it on a cooling rack, and let it cool before slicing.

INGREDIENTS:

6	OZ. LUKEWARM WATER (90°F)
1	TABLESPOON ACTIVE DRY YEAST
2	EGGS, 1 BEATEN
1	EGG YOLK
1	OZ. EXTRA-VIRGIN OLIVE OIL
1	OZ. SUGAR
1	TABLESPOON MOLASSES
15	OZ. BREAD FLOUR, PLUS MORE AS NEEDED
4	TEASPOONS COCOA POWDER
½	CUP MILLET SEEDS
¼	CUP ROLLED OATS, PLUS MORE FOR TOPPING
2	TABLESPOONS CARAWAY SEEDS, TOASTED
1	TABLESPOON FENNEL SEEDS, TOASTED
2	TEASPOONS KOSHER SALT

HAWAIIAN SWEET BREAD

YIELD: 1 LOAF / **ACTIVE TIME:** 45 MINUTES / **TOTAL TIME:** 4 HOURS

The crushed pineapple turns this bread into a sweeter and even softer version of brioche.

1. Place the water in the work bowl of a stand mixer. Sprinkle the yeast over the water, gently whisk, and let the mixture sit for 10 minutes.

2. Add the pineapple, brown sugar, eggs, egg yolk, and vanilla, whisk to combine, and fit the mixer with the dough hook. Add the flour and salt and work the mixture on low until it just starts to come together as a dough, about 2 minutes.

3. Gradually add the softened butter and continue to knead on low until all of the butter has been incorporated.

4. Raise the speed to medium and work the dough until it comes away clean from the side of the work bowl and is elastic, about 6 minutes. Cover the work bowl with a linen towel and let the dough rise until doubled in size, 1 to 2 hours.

5. Preheat the oven to 350°F. Spray a round 8-inch cake pan with nonstick cooking spray.

6. Place the dough, which will be sticky, on a flour-dusted work surface and gently knead it until it is extensible. Form it into a large round and place it in the pan, seam side down. Cover the dough with plastic wrap, place it in a naturally warm spot, and let it rise until doubled in size.

7. Brush the dough with the melted butter. Place the dough in the oven and bake until it is golden brown, 35 to 45 minutes. The internal temperature of the bread should be 210°F.

8. Remove the bread from the oven, brush it with more melted butter, place it on a wire rack, and let it cool before slicing.

INGREDIENTS:

2 TABLESPOONS LUKEWARM WATER (90°F)

2½ TEASPOONS ACTIVE DRY YEAST

¾ CUP CRUSHED PINEAPPLE

1½ CUPS LIGHT BROWN SUGAR

2 EGGS

1 EGG YOLK

1 TABLESPOON PURE VANILLA EXTRACT

4 CUPS BREAD FLOUR, PLUS MORE AS NEEDED

2 TEASPOONS KOSHER SALT

2 OZ. UNSALTED BUTTER, SOFTENED; PLUS MELTED BUTTER AS NEEDED

CIABATTA

YIELD: 1 LOAF / **ACTIVE TIME:** 1 HOUR / **TOTAL TIME:** 24 HOURS

An Italian bread that bears the mark of the culinary genius native to that country.

1. To prepare the poolish, place all of the ingredients in a mixing bowl and whisk to combine. Cover the bowl with a linen towel and let it sit at room temperature overnight.

2. To begin preparations for the dough, place the poolish in the work bowl of a stand mixer fitted with the dough hook. Add the water, yeast, and honey and whisk to combine. Add the flour and work the mixture on low for 1 minute. Raise the speed to medium and knead the mixture for 5 minutes. Turn off the mixer and let it rest for 5 minutes.

3. Add the salt and knead the mixture on low for 1 minute. Raise the speed to medium and knead the dough until it is very well developed and starts to pull away from the side of the work bowl, about 8 minutes.

4. Spray a 13 x 9–inch baking pan with nonstick cooking spray. Place the dough in the pan, cover it with plastic wrap, and let it rise for 45 minutes.

5. Take one end of the dough and fold a third of it over the other dough. Take the other end of the dough and fold over this third. Turn the pan 90 degrees and gently flip the dough over so that the fresh fold is facing down. Cover the pan and let the dough rise for 45 minutes. After 45 minutes, repeat the folding and resting process twice more.

6. Line a baking sheet with parchment paper. Place the dough on a flour-dusted surface and repeat the folding process used in Step 5. Place the dough on the baking sheet and let it rise for 45 minutes.

7. Preheat the oven to 400°F.

8. Place the bread in the oven and spray the oven generously with water to increase the humidity. Bake for 10 minutes, open the oven, and generously spray it with water. Bake for another 10 minutes, open the oven, and spray it generously with water one last time.

9. Close the oven and let the ciabatta bake until it is golden brown and crispy, about 20 minutes. The internal temperature of the bread should be 210°F.

10. Remove the ciabatta from the oven, place it on a wire rack, and let it cool before enjoying.

INGREDIENTS:

FOR THE POOLISH

7.5 OZ. LUKEWARM WATER

¼ TEASPOON ACTIVE DRY YEAST

2¼ CUPS ALL-PURPOSE FLOUR

FOR THE DOUGH

¾ CUP WATER

¾ TEASPOON ACTIVE DRY YEAST

2 TEASPOONS HONEY

12.5 OZ. BREAD FLOUR, PLUS MORE AS NEEDED

2¼ TEASPOONS KOSHER SALT

FOCACCIA

YIELD: 18 x 13-INCH FOCACCIA / **ACTIVE TIME:** 45 MINUTES / **TOTAL TIME:** 4 HOURS

The origins of pizza reside within this Italian flatbread, and the moment you taste it, you'll wonder why anyone even bothered to mess with it.

1. To prepare the poolish, place all of the ingredients in a mixing bowl and whisk to combine. Cover the bowl with a linen towel and let it sit at room temperature for 30 minutes.

2. To begin preparations for the dough, place the poolish in the work bowl of a stand mixer fitted with the dough hook. Add all of the remaining ingredients, except for the olive oil and cheese, and work the mixture on low for 1 minute. Raise the speed to medium and knead the mixture until it comes together as a smooth dough, about 5 minutes. Cover the bowl with a linen towel and let the dough rise until it has doubled in size.

3. Preheat the oven to 350°F.

4. Coat an 18 x 13–inch sheet pan with olive oil and place the dough on the pan. Use your fingers to gradually stretch the dough until it fills the entire pan and is as even as possible. If the dough is difficult to stretch, let it rest for 10 minutes before resuming.

5. Cover the dough with plastic wrap and let it rise at room temperature until it has doubled in size.

6. Use your fingertips to gently press down on the dough and make dimples all over it. The dimples should go about halfway down. Drizzle about 1 cup of olive oil over the focaccia and sprinkle the Parmesan on top.

7. Place the focaccia in the oven and bake until it is a light golden brown, 20 to 30 minutes.

8. Remove the focaccia from the oven and brush it generously with the remaining olive oil. Let it cool slightly before slicing and serving.

INGREDIENTS:

FOR THE POOLISH

3¼	CUPS WATER
2	TABLESPOONS ACTIVE DRY YEAST
½	CUP SUGAR
½	CUP EXTRA-VIRGIN OLIVE OIL, PLUS 2 TABLESPOONS

FOR THE DOUGH

28	OZ. BREAD FLOUR
20	OZ. ALL-PURPOSE FLOUR
2	TABLESPOONS FINELY CHOPPED FRESH ROSEMARY
1	TABLESPOON FINELY CHOPPED FRESH THYME
2	TABLESPOONS FINELY CHOPPED FRESH BASIL
3	TABLESPOONS KOSHER SALT
1½	TEASPOONS BLACK PEPPER
1½	CUPS EXTRA-VIRGIN OLIVE OIL, PLUS MORE AS NEEDED
1	CUP FRESHLY SHAVED PARMESAN CHEESE, FOR TOPPING

BALSAMIC & PLUM FOCACCIA

YIELD: 18 x 13–INCH FOCACCIA / **ACTIVE TIME:** 45 MINUTES / **TOTAL TIME:** 4 HOURS

The plums bring a mellow tartness to this flatbread, plus a sweetness that pairs well with the balsamic.

1. Preheat the oven to 350°F. To prepare the poolish, place all of the ingredients in a mixing bowl and whisk to combine. Cover the bowl with a linen towel and let it sit at room temperature for 30 minutes.

2. To begin preparations for the dough, place the poolish in the work bowl of a stand mixer fitted with the dough hook. Add all of the remaining ingredients, except for the olive oil, and work the mixture on low for 1 minute. Raise the speed to medium and knead the mixture until it comes together as a smooth dough, about 5 minutes. Cover the bowl with a linen towel and let the dough rise until it has doubled in size.

3. To begin preparations for the topping, place all of the ingredients in a mixing bowl and toss until the plums are coated. Place the mixture in a baking pan, place it in the oven, and roast until the plums are tender, about 15 minutes.

4. Remove from the oven, remove the plums from the pan, and transfer the juices to a saucepan. Warm over low heat until it has reduced by half. Remove the pan from heat and set aside.

5. Coat an 18 x 13–inch sheet pan with olive oil and place the dough on the pan. Use your fingers to gradually stretch the dough until it fills the entire pan and is as even as possible. If the dough is difficult to stretch, let it rest for 10 minutes before resuming.

6. Cover the dough with plastic wrap and let it rise at room temperature until it has doubled in size.

7. Use your fingertips to gently press down on the dough and make dimples all over it. The dimples should go about halfway down. Drizzle about 1 cup of olive oil over the focaccia, and evenly distribute the roasted plums on top.

8. Place the focaccia in the oven and bake until it is a light golden brown, 20 to 30 minutes.

9. Remove the focaccia from the oven, brush it generously with the remaining olive oil, and drizzle the reduction over the top. Let it cool slightly before slicing and serving.

INGREDIENTS:

FOR THE POOLISH

3¼	CUPS WATER
2	TABLESPOONS ACTIVE DRY YEAST
½	CUP SUGAR
½	CUP EXTRA-VIRGIN OLIVE OIL, PLUS 2 TABLESPOONS

FOR THE DOUGH

28	OZ. BREAD FLOUR
20	OZ. ALL-PURPOSE FLOUR
2	TABLESPOONS FINELY CHOPPED FRESH ROSEMARY
1	TABLESPOON FINELY CHOPPED FRESH THYME
2	TABLESPOONS FINELY CHOPPED FRESH BASIL
3	TABLESPOONS KOSHER SALT
1½	TEASPOONS BLACK PEPPER
1½	CUPS EXTRA-VIRGIN OLIVE OIL, PLUS MORE AS NEEDED

FOR THE TOPPING

1	LB. PLUMS, PITTED AND QUARTERED
2	TABLESPOONS LIGHT BROWN SUGAR
½	CUP BALSAMIC VINEGAR
1	TEASPOON PURE VANILLA EXTRACT
¼	CUP AMARETTO

CARAMELIZED ONION FOCACCIA

YIELD: 18 X 13–INCH FOCACCIA / **ACTIVE TIME:** 45 MINUTES / **TOTAL TIME:** 4 HOURS

When paired with a light salad, this focaccia is an ideal dinner in the summer.

1. Preheat the oven to 350°F. To prepare the poolish, place all of the ingredients in a mixing bowl and whisk to combine. Cover the bowl with a linen towel and let it sit at room temperature for 30 minutes.

2. To begin preparations for the dough, place the poolish in the work bowl of a stand mixer fitted with the dough hook. Add all of the remaining ingredients, except for the olive oil, and work the mixture on low for 1 minute. Raise the speed to medium and knead the mixture until it comes together as a smooth dough, about 5 minutes. Cover the bowl with a linen towel and let the dough rise until it has doubled in size.

3. To prepare the caramelized onions, place the olive oil in a large skillet and warm it over medium-low heat. Add the onions, sugar, and salt and cook, stirring continuously, until the onions are a deep golden brown, about 30 minutes.

4. Coat an 18 x 13–inch sheet pan with olive oil and place the dough on the pan. Use your fingers to gradually stretch the dough until it fills the entire pan and is as even as possible. If the dough is difficult to stretch, let it rest for 10 minutes before resuming.

5. Cover the dough with plastic wrap and let it rise at room temperature until it has doubled in size.

6. Use your fingertips to gently press down on the dough and make dimples all over it. The dimples should go about halfway down. Drizzle about 1 cup of olive oil over the focaccia, and evenly distribute the caramelized onions on top.

7. Place the focaccia in the oven and bake until it is a light golden brown, 20 to 30 minutes.

8. Remove the focaccia from the oven and brush it generously with the remaining olive oil. Let it cool slightly before slicing and serving.

INGREDIENTS:

FOR THE POOLISH

3¼	CUPS WATER
2	TABLESPOONS ACTIVE DRY YEAST
½	CUP SUGAR
½	CUP EXTRA-VIRGIN OLIVE OIL, PLUS 2 TABLESPOONS

FOR THE DOUGH

28	OZ. BREAD FLOUR
20	OZ. ALL-PURPOSE FLOUR
2	TABLESPOONS FINELY CHOPPED FRESH ROSEMARY
1	TABLESPOON FINELY CHOPPED FRESH THYME
2	TABLESPOONS FINELY CHOPPED FRESH BASIL
3	TABLESPOONS KOSHER SALT
1½	TEASPOONS BLACK PEPPER
1½	CUPS EXTRA-VIRGIN OLIVE OIL, PLUS MORE AS NEEDED

FOR THE CARAMELIZED ONIONS

2	TABLESPOONS EXTRA-VIRGIN OLIVE OIL
4	LARGE YELLOW ONIONS, SLICED THIN
1	TABLESPOON SUGAR
1	TEASPOON KOSHER SALT

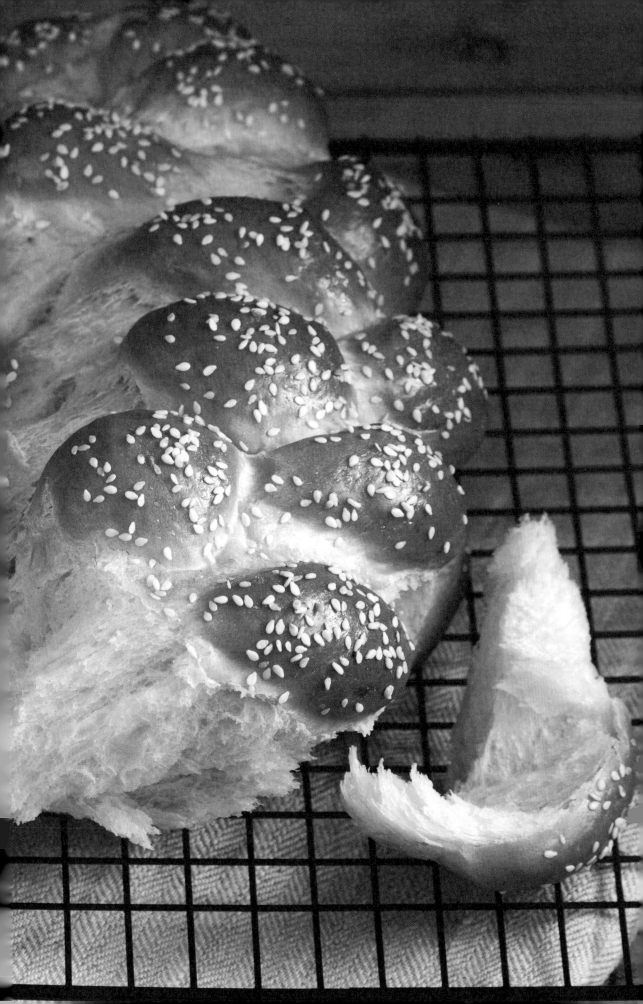

BLACK OLIVE FOCACCIA

YIELD: 18 X 13–INCH FOCACCIA / **ACTIVE TIME:** 45 MINUTES / **TOTAL TIME:** 4 HOURS

Kalamata olives are going to be the easiest to procure for this focaccia, but if you can locate Taggiasca olives, snap them up immediately.

1. Preheat the oven to 350°F. To prepare the poolish, place all of the ingredients in a mixing bowl and whisk to combine. Cover the bowl with a linen towel and let it sit at room temperature for 30 minutes.

2. To begin preparations for the dough, place the poolish in the work bowl of a stand mixer fitted with the dough hook. Add all of the remaining ingredients, except for the olive oil, olives, and oregano, and work the mixture on low for 1 minute. Raise the speed to medium and knead the mixture until it comes together as a smooth dough, about 5 minutes. Cover the bowl with a linen towel and let the dough rise until it has doubled in size.

3. Coat an 18 x 13–inch sheet pan with olive oil and place the dough on the pan. Use your fingers to gradually stretch the dough until it fills the entire pan and is as even as possible. If the dough is difficult to stretch, let it rest for 10 minutes before resuming.

4. Cover the dough with plastic wrap and let it rise at room temperature until it has doubled in size.

5. Use your fingertips to gently press down on the dough and make dimples all over it. The dimples should go about halfway down. Drizzle about 1 cup of olive oil over the focaccia and evenly distribute the black olives on top.

6. Place the focaccia in the oven and bake until it is a light golden brown, 20 to 30 minutes.

7. Remove the focaccia from the oven and brush it generously with the remaining olive oil. Sprinkle the oregano over the focaccia and let it cool slightly before slicing and serving.

INGREDIENTS:

FOR THE POOLISH

3¼	CUPS WATER
2	TABLESPOONS ACTIVE DRY YEAST
½	CUP SUGAR
½	CUP EXTRA-VIRGIN OLIVE OIL, PLUS 2 TABLESPOONS

FOR THE DOUGH

28	OZ. BREAD FLOUR
20	OZ. ALL-PURPOSE FLOUR
2	TABLESPOONS FINELY CHOPPED FRESH ROSEMARY
1	TABLESPOON FINELY CHOPPED FRESH THYME
2	TABLESPOONS FINELY CHOPPED FRESH BASIL
3	TABLESPOONS KOSHER SALT
1½	TEASPOONS BLACK PEPPER
1½	CUPS EXTRA-VIRGIN OLIVE OIL, PLUS MORE AS NEEDED
1	CUP BLACK OLIVES, PITTED AND HALVED
2	TABLESPOONS FINELY CHOPPED FRESH OREGANO, FOR TOPPING

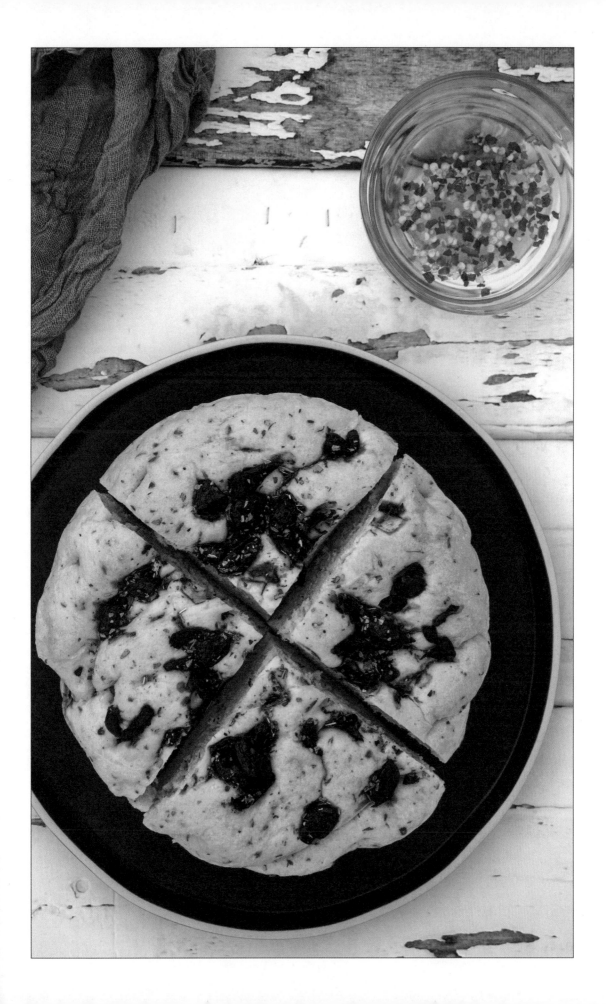

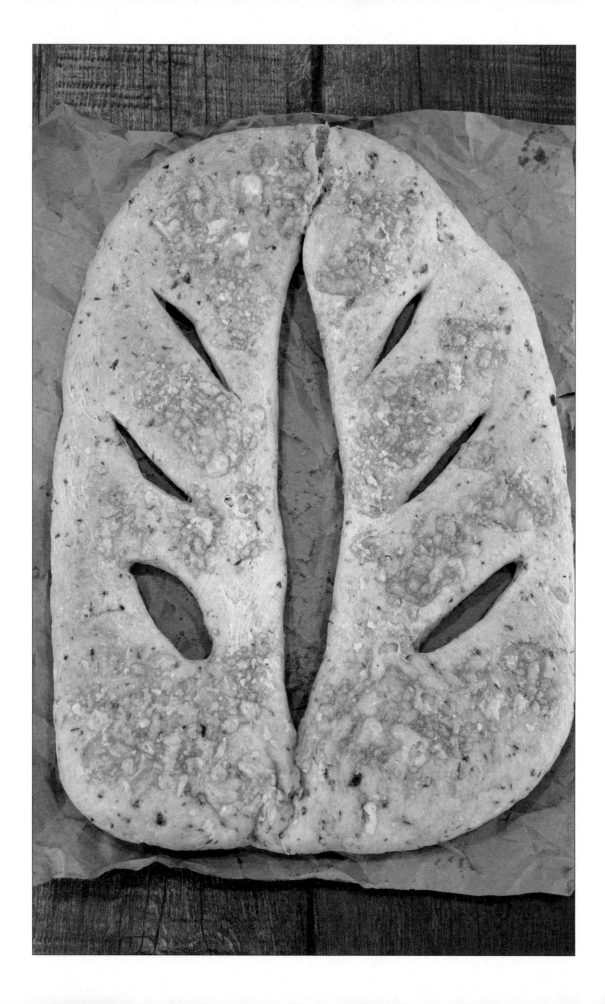

FOUGASSE

YIELD: 1 LOAF / **ACTIVE TIME:** 30 MINUTES / **TOTAL TIME:** 3 HOURS

This classic, leaf-shaped bread hails from the region of Provence, France.

1. In the work bowl of a stand mixer fitted with the paddle attachment, add the water and yeast, gently whisk to combine, and let the mixture sit for 10 minutes.

2. Add the oil, flour, basil, garlic, and salt and work the mixture on low for 1 minute. Raise the speed to medium and work the mixture until it comes together as a smooth dough, about 5 minutes.

3. Remove the dough from the work bowl, place it on a flour-dusted work surface, and knead it until it is elastic. Shape the dough into a ball, return it to the work bowl, and cover it with plastic wrap. Place the dough in a naturally warm spot and let it rise until it has doubled in size.

4. Turn the dough out onto a flour-dusted surface. Lightly flour the top of the dough. Using a rolling pin, roll the dough outward by starting in the middle of the dough and rolling toward you until it is an approximately 10 x 6–inch oval.

5. Preheat the oven to 350°F. Coat an 18 x 13–inch sheet pan with olive oil. Carefully place the dough in the center of the pan.

6. Using a pizza cutter, cut a lengthwise line in the center of the oval, leaving an inch uncut at each end so that the dough remains one piece. Make three small, angled slices to the left of the center cut. Do the same to the right of the center cut.

7. The bread should resemble a leaf. Lightly brush the dough with olive oil, cover the pan with plastic wrap, and let it rise until it has doubled in size.

8. Preheat the oven to 350°F.

9. Sprinkle the Parmesan over the bread, place it in the oven, and bake until it is golden brown, 20 to 30 minutes.

10. Remove the fougasse from the oven and brush it with more olive oil. Transfer it to a wire rack and let it cool before enjoying.

INGREDIENTS:

9	OZ. WATER
2½	TEASPOONS ACTIVE DRY YEAST
3	TABLESPOONS EXTRA-VIRGIN OLIVE OIL, PLUS MORE AS NEEDED
15	OZ. BREAD FLOUR, PLUS MORE AS NEEDED
1	TABLESPOON DRIED BASIL, PLUS 1 TEASPOON
2	GARLIC CLOVES, MINCED
1	TABLESPOON KOSHER SALT
¼	CUP FRESHLY SHAVED PARMESAN CHEESE

FARMHOUSE FOUGASSE

YIELD: 1 LOAF / **ACTIVE TIME:** 30 MINUTES / **TOTAL TIME:** 3 HOURS

Enriching a fougasse with vegetables somehow makes this loaf even more fun and delicious.

1. In the work bowl of a stand mixer fitted with the paddle attachment, add the water and yeast, gently whisk to combine, and let the mixture sit for 10 minutes.

2. Add the oil, flour, chopped herbs, garlic, and salt and work the mixture on low for 1 minute. Raise the speed to medium and work the mixture until it comes together as a smooth dough, about 5 minutes.

3. Remove the dough from the work bowl, place it on a flour-dusted work surface, and knead it until it is elastic. Shape the dough into a ball, return it to the work bowl, and cover it with plastic wrap. Place the dough in a naturally warm spot and let it rise until it has doubled in size.

4. Turn the dough out onto a flour-dusted surface. Lightly flour the top of the dough. Using a rolling pin, roll the dough outward by starting in the middle of the dough and rolling toward you until it is an approximately 10 x 6–inch oval.

5. Preheat the oven to 350°F. Coat an 18 x 13–inch sheet pan with olive oil. Carefully place the dough in the center of the pan.

6. Using a pizza cutter, cut a lengthwise line in the center of the oval, leaving an inch uncut at each end so that the dough remains one piece. Make three small, angled slices to the left of the center cut. Do the same to the right of the center cut.

7. The bread should resemble a leaf. Distribute the cauliflower, squash, and bell pepper over the dough, brush the vegetables and dough with olive oil, and sprinkle salt over the vegetables. Cover the pan with plastic wrap and let the dough rise until it has doubled in size.

8. Preheat the oven to 350°F.

9. Sprinkle the Parmesan over the bread, place it in the oven, and bake until it is golden brown, 20 to 30 minutes.

10. Remove the fougasse from the oven and brush it with more olive oil. Transfer it to a wire rack and let it cool before enjoying.

INGREDIENTS:

9	OZ. WATER
2½	TEASPOONS ACTIVE DRY YEAST
3	TABLESPOONS EXTRA-VIRGIN OLIVE OIL, PLUS MORE AS NEEDED
2½	TEASPOONS ACTIVE DRY YEAST
15	OZ. BREAD FLOUR, PLUS MORE AS NEEDED
1	TABLESPOON FINELY CHOPPED FRESH MINT
1	TABLESPOON FINELY CHOPPED FRESH PARSLEY
1	TABLESPOON FINELY CHOPPED FRESH DILL
2	GARLIC CLOVES, MINCED
1	TABLESPOON KOSHER SALT, PLUS MORE TO TASTE
½	CUP CHOPPED PURPLE CAULIFLOWER
1	SUMMER SQUASH, SLICED
½	BELL PEPPER, SLICED THIN
¼	CUP FRESHLY SHAVED PARMESAN CHEESE

BULKIE ROLLS

YIELD: 8 ROLLS / **ACTIVE TIME:** 45 MINUTES / **TOTAL TIME:** 4 HOURS

A New England staple for sandwiches, and not too shabby when it comes to burger buns.

1. Place the water, yeast, unbeaten egg, egg yolk, olive oil, and sugar in the work bowl of a stand mixer fitted with the dough hook and whisk to combine. Add the flour and salt and knead on low for 1 minute. Raise the speed to medium and knead the mixture until it comes together as a smooth dough and begins to pull away from the side of the work bowl, 6 to 8 minutes.

2. Coat a mixing bowl with nonstick cooking spray. Remove the dough from the work bowl, place it on a flour-dusted work surface, and shape it into a ball. Place the dough in the bowl, cover it with plastic wrap, place it in a naturally warm spot, and let it rise until doubled in size.

3. Line an 18 x 13–inch sheet pan with parchment paper. Place the dough on a flour-dusted work surface and divide it into 3.5-oz. portions. Roll the portions into tight balls. Place the balls on the pan, cover the pan with plastic wrap, and place it in a naturally warm spot. Let the dough rise until it has doubled in size.

4. Preheat the oven to 350°F.

5. Brush the balls with the beaten egg. Using a sharp knife, score an X on top of each ball.

6. Place the pan in the oven and bake until the rolls they are golden brown, 20 to 25 minutes. The internal temperature of the rolls should be 190°F.

7. Remove from the oven, transfer the rolls to a wire rack, and let them cool completely before enjoying.

INGREDIENTS:

6	OZ. WATER
1½	TEASPOONS ACTIVE DRY YEAST
2	EGGS, 1 BEATEN
1	EGG YOLK
1	OZ. EXTRA-VIRGIN OLIVE OIL
1	OZ. SUGAR
15	OZ. BREAD FLOUR, PLUS MORE AS NEEDED
1	TEASPOON KOSHER SALT

BAGUETTES

YIELD: 3 BAGUETTES / **ACTIVE TIME:** 45 MINUTES / **TOTAL TIME:** 4 HOURS

The true test of a baker's patience, skill, and steadiness. Do not give up on them after just one try.

1. In the work bowl of a stand mixer fitted with the paddle attachment, combine all of the ingredients. Knead on low until the mixture comes together as a dough. Raise the speed to medium and knead the dough until it is smooth, about 5 minutes.

2. Place the dough on a flour-dusted surface and knead it into a ball. Return it to the work bowl, cover it with plastic wrap, and let it rise at room temperature until it has doubled in size.

3. Divide the dough into three 12-oz. portions and form them into balls. Coat an 18 x 13–inch sheet pan with nonstick cooking spray. Place the balls of dough on the pan and cover them with plastic wrap. Let the dough rise at room temperature until doubled in size.

4. Punch down the balls of dough until they are rough ovals. Take the side of the dough closest to you and roll it away. Starting halfway up, fold in the corners and roll the dough into a rough baguette shape.

5. Place both hands over one piece of dough. Gently roll the dough while moving your hands back and forth over it and lightly pressing down until it is about 16 inches.

6. Place the baguette on the sheet pan and repeat with the remaining pieces of dough. When all of the dough has been rolled out, place the baguettes on the sheet pan, cover them with plastic wrap, and let them rise until they have doubled in size.

7. Preheat the oven to 450°F.

8. Using a very sharp knife, cut four slits at a 45-degree angle along the length of each baguette.

9. Place the baguettes in the oven, spray the oven with 5 spritzes of water, and bake until the baguettes are a deep golden brown, 20 to 30 minutes.

10. Remove the baguettes from the oven, place them on a wire rack, and let them cool slightly before slicing.

INGREDIENTS:

- 18 OZ. WATER, AT ROOM TEMPERATURE
- 2 LBS. BREAD FLOUR, PLUS MORE AS NEEDED
- 2 TABLESPOONS ACTIVE DRY YEAST
- 2 TABLESPOONS KOSHER SALT

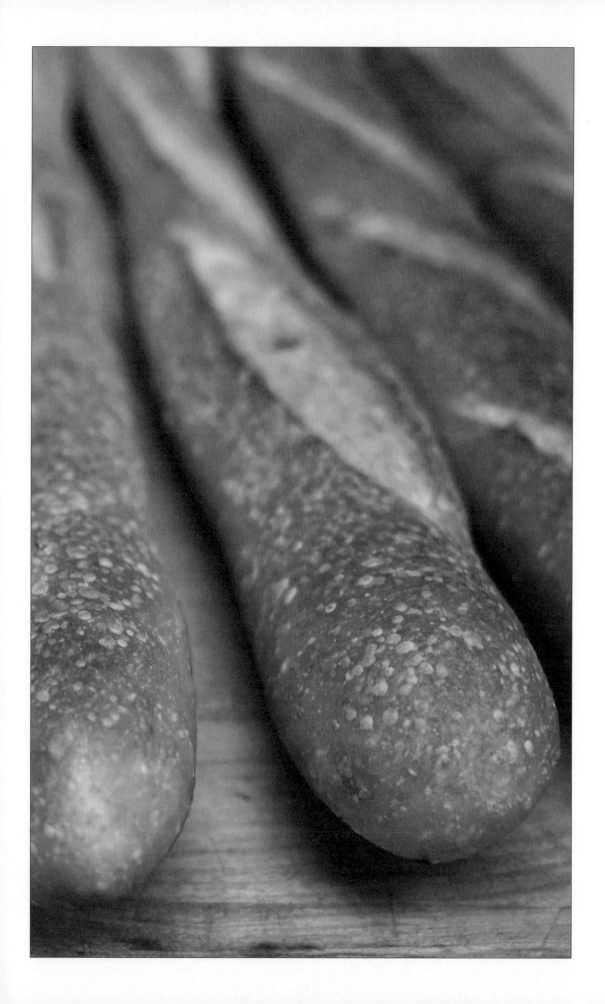

CINNAMON ROLLS

YIELD: 12 ROLLS / **ACTIVE TIME:** 1 HOUR / **TOTAL TIME:** 4 HOURS AND 30 MINUTES

Not a preparation one can enjoy every day, but each encounter with it will prove memorable.

1. To prepare the filling, place all of the ingredients in the work bowl of a stand mixer fitted with a paddle attachment and beat on medium until the mixture is light and fluffy. Transfer to a mixing bowl and set aside. Wipe out the work bowl.

2. To prepare the glaze, place all of the ingredients in a mixing bowl and whisk to combine. Cover it with plastic wrap and set aside.

3. To begin preparations for the dough, place the water and yeast in the work bowl of the stand mixer, gently stir, and let the mixture sit until foamy, about 10 minutes.

4. Add the eggs, oil, flour, sugar, and salt, fit the mixer with the dough hook, and work the mixture on low until the dough starts to come together, about 2 minutes. Raise the speed to medium and knead until the dough is elastic and pulls away from the side of the bowl. Cover the bowl with plastic wrap, place it in a naturally warm spot, and allow the dough to rise until it has doubled in size.

5. Turn the dough out onto a flour-dusted work surface. Use a rolling pin to roll the dough into a rectangle that is about 24 x 12 inches.

6. Spread the filling evenly across the dough, leaving an inch of dough uncovered on the wide side closest to yourself. Sprinkle sugar lightly over the filling. This will help provide friction and allow for a tight roll.

7. Take the side farthest away and roll the dough into a tight spiral. Pinch the seam to seal the roll closed.

8. Cut the roll into twelve 2-inch-wide pieces.

9. Spray a large, rectangular baking dish with nonstick cooking spray. Place the 12 rolls in the pan in an even layer. Cover the rolls with plastic wrap, place them in a naturally warm spot, and let them rise until doubled in size.

10. Preheat the oven to 350°F.

11. Place the rolls in the oven and bake until their internal temperature is 210°F, 20 to 30 minutes.

12. Remove from the oven and pour the glaze over the rolls. Let them cool slightly before enjoying.

INGREDIENTS:

FOR THE FILLING

8	OZ. UNSALTED BUTTER, SOFTENED
8	OZ. SUGAR, PLUS MORE TO TASTE
8	OZ. DARK BROWN SUGAR
1	TEASPOON PURE VANILLA EXTRACT
2	TABLESPOONS CINNAMON

FOR THE GLAZE

1	LB. CONFECTIONERS' SUGAR
4	OZ. WATER
1	TEASPOON PURE VANILLA EXTRACT
	PINCH OF KOSHER SALT

FOR THE DOUGH

12	OZ. LUKEWARM WATER (90°F)
1	TABLESPOON ACTIVE DRY YEAST, PLUS 2 TEASPOONS
3	EGGS
¼	CUP EXTRA-VIRGIN OLIVE OIL
2	LBS. BREAD FLOUR, PLUS MORE AS NEEDED
¼	CUP SUGAR, PLUS MORE TO TASTE
1½	TABLESPOONS KOSHER SALT

SCHNECKEN

YIELD: 12 ROLLS / ACTIVE TIME: 1 HOUR / TOTAL TIME: 4 HOURS AND 30 MINUTES

German for "snails," these take the cinnamon roll to the next level.

1. Preheat the oven to 350°F. To begin preparations for the topping, place the pecans on a baking sheet and toast for 10 minutes. Remove from the oven and let the pecans cool. When cool enough to handle, chop them and set aside.

2. To begin preparations for the dough, whisk together the milk, melted butter, yeast, egg, and egg yolk in the work bowl of a stand mixer fitted with the dough hook. Add the flour, sugar, and salt and work the mixture on low for 1 minute. Raise the speed to medium and knead the mixture until it comes together as a dough and pulls away from the side of the bowl.

3. Place the dough on a flour-dusted work surface, form it into a ball, and return it to the work bowl. Cover it with plastic wrap and let it rise until doubled in size.

4. While the dough is rising, resume preparations for the topping. Place the butter, dark brown sugar, and corn syrup in a small saucepan and bring the mixture to a boil. Pour the mixture into a 13 x 9–inch baking pan and spread it into an even layer. Sprinkle the pecans evenly over the mixture.

5. To prepare the filling, combine all of the ingredients in a mixing bowl and set aside.

6. Turn the dough out onto a flour-dusted work surface. Use a rolling pin to roll the dough into a rectangle that is about 24 x 12 inches.

7. Spread the filling evenly across the dough, leaving an inch of dough uncovered on the wide side closest to yourself.

8. Take the side farthest away and roll the dough into a tight spiral. Pinch the seam to seal the roll closed.

9. Cut the roll into twelve 2-inch-wide pieces. Place the 12 rolls in the pan in an even layer. Cover the rolls with plastic wrap, place them in a naturally warm spot, and let them rise until doubled in size.

INGREDIENTS:

FOR THE TOPPING

1	CUP PECANS
6	OZ. UNSALTED BUTTER
4	OZ. DARK BROWN SUGAR
½	CUP CORN SYRUP

FOR THE DOUGH

1	CUP MILK, AT ROOM TEMPERATURE
4	OZ. UNSALTED BUTTER, MELTED
1	TABLESPOON ACTIVE DRY YEAST
1	EGG
1	EGG YOLK
1	LB. BREAD FLOUR, PLUS MORE AS NEEDED
2	OZ. SUGAR
1½	TEASPOONS KOSHER SALT

FOR THE FILLING

2	OZ. UNSALTED BUTTER, MELTED
1	CUP SUGAR
1	TABLESPOON CINNAMON

Continued . . .

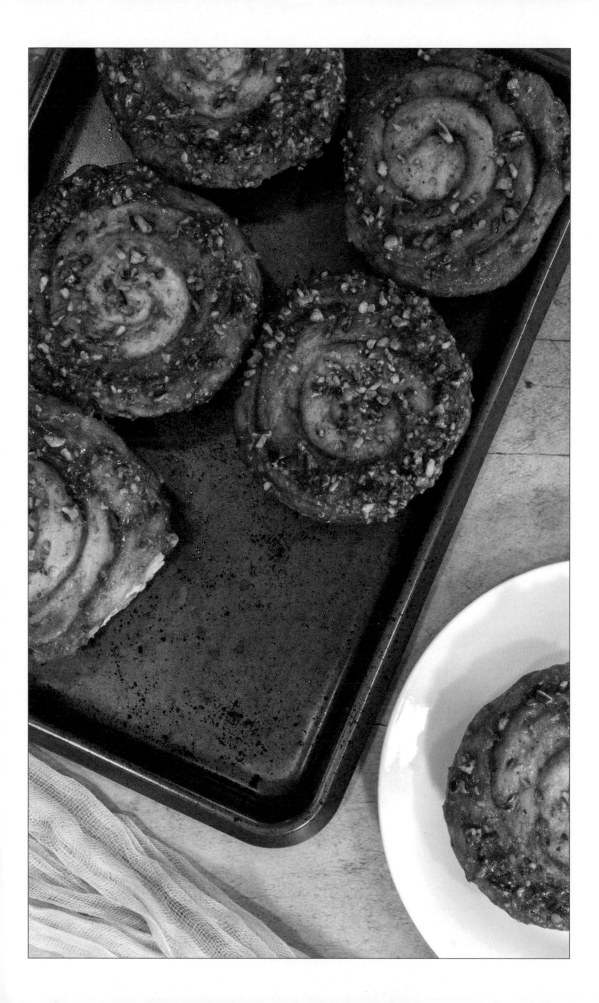

10. Preheat the oven to 350°F.

11. Place the rolls in the oven and bake until their internal temperature is 210°F, 20 to 30 minutes.

12. Remove from the oven and place an 18 x 13–inch sheet pan over the baking pan, face down. Carefully invert the rolls so that the caramel-and-pecan mixture is on top. Let the rolls cool slightly before enjoying.

PUMPKIN STICKY BUNS

YIELD: 12 BUNS / **ACTIVE TIME:** 1 HOUR / **TOTAL TIME:** 4 HOURS AND 30 MINUTES

With their rich flavor and gorgeous golden hue, these are guaranteed to become a fall favorite.

1. To prepare the filling, place all of the ingredients in a stand mixer fitted with a paddle attachment and beat on medium until the mixture is light and fluffy. Transfer to a mixing bowl and set aside. Wipe out the work bowl.

2. To begin preparations for the dough, place the milk and yeast in the work bowl of the stand mixer, gently stir, and let the mixture sit until foamy, about 10 minutes.

3. Add the melted butter, egg, egg yolk, and pumpkin puree and whisk to combine. Fit the mixer with the dough hook, add the flour, dark brown sugar, and salt, and work the mixture on low until the dough starts to come together, about 2 minutes. Raise the speed to medium and knead until the dough is elastic and pulls away from the side of the bowl.

4. Place the dough on a flour-dusted work surface, form it into a ball, and return it to the work bowl. Cover the bowl with plastic wrap, place it in a naturally warm spot, and allow the dough to rise until it has doubled in size.

5. Spread 1 cup of the filling over the bottom of a 13 x 9–inch baking pan.

6. Turn the dough out onto a flour-dusted work surface. Use a rolling pin to roll the dough into a rectangle that is about 24 x 12 inches.

7. Spread the remaining filling evenly across the dough, leaving an inch of dough uncovered on the wide side closest to yourself.

8. Take the side farthest away and roll the dough into a tight spiral. Pinch the seam to seal the roll closed.

9. Cut the roll into twelve 2-inch-wide pieces.

10. Place the 12 buns in the pan in an even layer. Cover them with plastic wrap, place them in a naturally warm spot, and let them rise until doubled in size.

INGREDIENTS:

FOR THE FILLING

8	OZ. UNSALTED BUTTER, SOFTENED
8	OZ. SUGAR
8	OZ. DARK BROWN SUGAR
1	TEASPOON PURE VANILLA EXTRACT
2	TABLESPOONS CINNAMON
1	TABLESPOON FRESHLY GRATED NUTMEG
1	TEASPOON GROUND GINGER
1	TEASPOON CARDAMOM
½	TEASPOON GROUND CLOVES

FOR THE DOUGH

1	CUP MILK
1	TABLESPOON ACTIVE DRY YEAST
4	OZ. UNSALTED BUTTER, MELTED
1	EGG
1	EGG YOLK
6	OZ. PUMPKIN PUREE
24	OZ. BREAD FLOUR, PLUS MORE AS NEEDED
2	OZ. DARK BROWN SUGAR
1½	TEASPOONS KOSHER SALT

Continued . . .

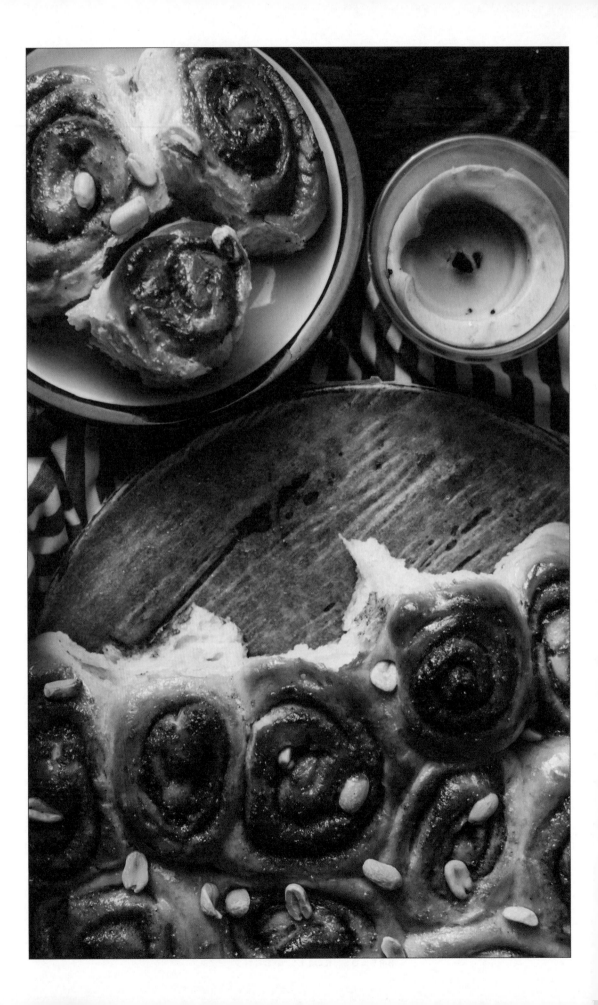

11. Preheat the oven to 350°F.

12. Place the buns in the oven and bake until their internal temperature is 210°F, 20 to 30 minutes.

13. Remove from the oven and place an 18 x 13–inch sheet pan over the baking pan, face down. Carefully invert the buns so that the filling is on top. Let them cool slightly before enjoying.

HOT CROSS BUNS

YIELD: 12 BUNS / **ACTIVE TIME:** 45 MINUTES / **TOTAL TIME:** 4 HOURS

A traditional Easter bread, its distinct look comes from its white cross over the top. These buns are commonly made with assorted dried fruits and candied citrus.

1. Place the apple juice, milk, egg, egg yolk, and brown sugar in the work bowl of a stand mixer fitted with the dough hook and whisk to combine.

2. Add the remaining ingredients and work the mixture on low until the dough starts to come together, about 2 minutes. Raise the speed to medium and knead until the dough is elastic and pulls away from the side of the bowl.

3. Place the dough on a flour-dusted work surface, form it into a ball, and return it to the work bowl. Cover the bowl with plastic wrap, place it in a naturally warm spot, and allow the dough to rise until it has doubled in size.

4. Spray a 13 x 9–inch baking pan with nonstick cooking spray. Place the dough on a flour-dusted work surface and divide it into twelve 3-oz. portions. Form those portions into balls and place them in the pan in an even layer. It is OK if the balls are touching slightly. Cover them with plastic wrap and let them rise until doubled in size.

5. Preheat the oven to 350°F.

6. Place the buns in the oven and bake until they are golden brown, about 30 minutes.

7. Remove the buns from the oven, brush them with the melted butter, and let them cool to room temperature.

8. Place the glaze in a piping bag and cut a small hole in the bag. Pipe the glaze onto each bun in a cross and let it set for 15 minutes before enjoying.

INGREDIENTS:

- ¼ CUP APPLE JUICE
- 1¼ CUPS MILK, AT ROOM TEMPERATURE
- 1 EGG
- 1 EGG YOLK
- 2 TABLESPOONS LIGHT BROWN SUGAR
- 1 LB. BREAD FLOUR, PLUS MORE AS NEEDED
- 2 TEASPOONS ACTIVE DRY YEAST
- 1 TEASPOON CINNAMON
- ¼ TEASPOON FRESHLY GRATED NUTMEG
- ¼ TEASPOON ALLSPICE
- 2 TEASPOONS KOSHER SALT
- 1 TABLESPOON BAKING POWDER
- ¼ CUP RAISINS
- ¼ CUP DRIED CURRANTS
- 3 OZ. UNSALTED BUTTER, SOFTENED; PLUS MELTED BUTTER AS NEEDED
- VANILLA GLAZE (SEE PAGE 682)

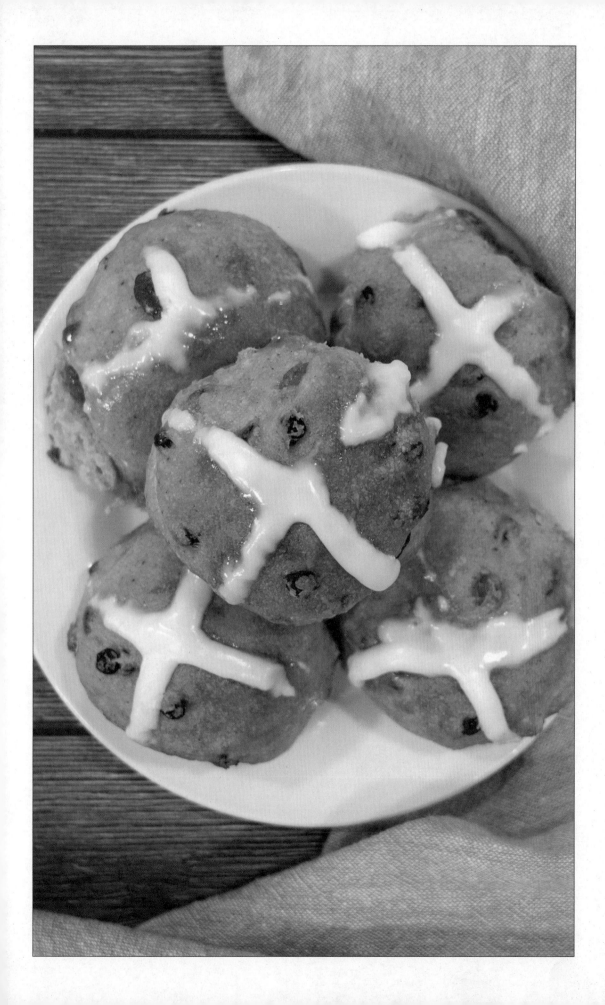

IRISH SODA BREAD

YIELD: 1 LOAF / **ACTIVE TIME:** 30 MINUTES / **TOTAL TIME:** 1 HOUR AND 30 MINUTES

Irish soda bread is an older style of bread that is not made with yeast. It is well balanced, with a light sweetness and a bit of earthiness coming from the caraway. Soda bread is great toasted and finished with some butter.

1. Preheat the oven to 350°F. Coat a round 6-inch cake pan with nonstick cooking spray.

2. Place the flour, sugar, baking powder, baking soda, salt, raisins, and caraway seeds in the work bowl of a stand mixer fitted with the paddle attachment and whisk to combine.

3. Combine the egg, buttermilk, and sour cream. With the mixer running on low, gradually pour in the wet mixture and beat the mixture until it comes together as a smooth dough.

4. Transfer the dough to the pan and spread it into an even layer. Using a flour-dusted paring knife, cut an X in the center of the dough.

5. Place the bread in the oven and bake until a cake tester inserted into the center comes out clean, 35 to 45 minutes.

6. Remove from the oven and let the bread cool completely before slicing and serving.

INGREDIENTS:

7	OZ. ALL-PURPOSE FLOUR, PLUS MORE AS NEEDED
1	OZ. SUGAR
½	TEASPOON BAKING POWDER
¼	TEASPOON BAKING SODA, PLUS ⅛ TEASPOON
¼	TEASPOON KOSHER SALT
5	OZ. RAISINS
1	TEASPOON CARAWAY SEEDS
1	EGG
⅓	CUP BUTTERMILK
⅓	CUP SOUR CREAM

BROWN BREAD

YIELD: 1 LOAF / **ACTIVE TIME:** 15 MINUTES / **TOTAL TIME:** 1 HOUR

A dense, chewy bread with a flavor something like a souped-up loaf of pumpernickel.

1. Preheat the oven to 350°F. Coat an 8 x 4–inch loaf pan with nonstick cooking spray.

2. In the work bowl of a stand mixer fitted with the paddle attachment, combine the milk and molasses. Add the remaining ingredients and beat until the mixture comes together as a smooth batter, about 2 minutes.

3. Pour the batter into the pan, place it in the oven, and bake until a cake tester inserted into the center comes out clean, 45 minutes to 1 hour.

4. Remove from the oven and let the bread cool slightly. Remove it from the pan, place it on a cooling rack, and let it cool slightly before serving.

INGREDIENTS:

11	OZ. MILK
½	CUP MOLASSES
2	TABLESPOONS LIGHT BROWN SUGAR
5	OZ. ALL-PURPOSE FLOUR
2.5	OZ. CORNMEAL
5	OZ. WHOLE WHEAT FLOUR
2	TEASPOONS BAKING POWDER
¾	TEASPOON BAKING SODA
5	OZ. RAISINS

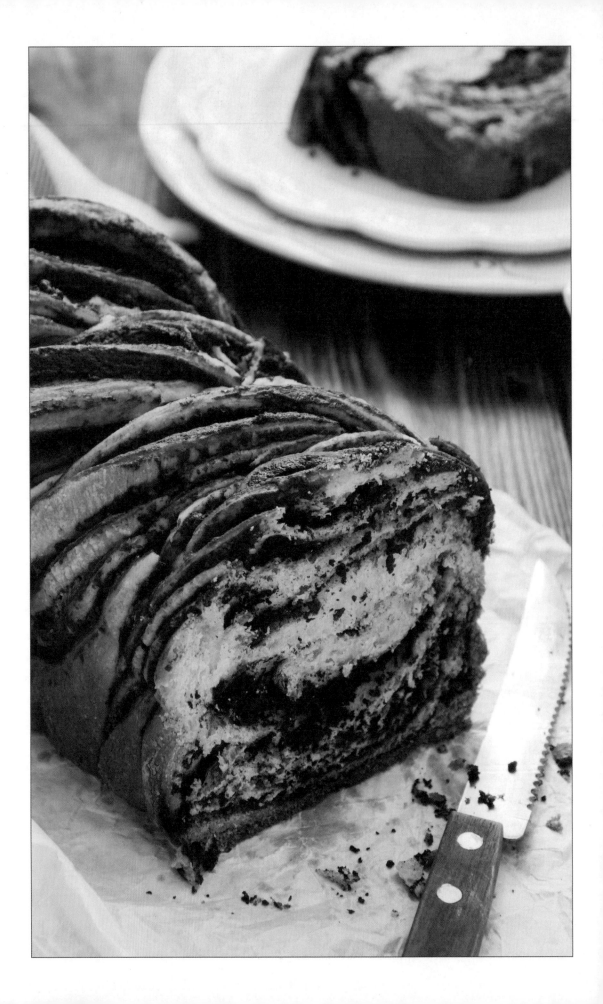

CHOCOLATE BABKA

YIELD: 2 LOAVES / **ACTIVE TIME:** 45 MINUTES / **TOTAL TIME:** 4 HOURS

A rich, moist bread with a crumb similar to challah, but enriched with a luscious, dark chocolate filling.

1. To prepare the filling, fill a small saucepan halfway with water and bring it to a gentle simmer. In a heatproof bowl, combine the dark chocolate and butter. Place the bowl over the simmering water and stir until the mixture is melted and smooth. Remove the bowl from heat, add the confectioners' sugar and cocoa powder, and whisk until thoroughly combined. Set the mixture aside.

2. To begin preparations for the dough, whisk together the water, yeast, eggs, and olive oil in the work bowl of a stand mixer fitted with the dough hook. Add the flour, sugar, and salt and work the mixture on low for 1 minute. Raise the speed to medium and knead the mixture until it comes together as a dough and pulls away from the side of the bowl.

3. Place the dough on a flour-dusted work surface, form it into a ball, and return it to the work bowl. Cover it with plastic wrap and let it rise until doubled in size.

4. Turn the dough out onto a flour-dusted work surface and divide it in half. Use a rolling pin to roll each piece into a rectangle that is about 8 x 6 inches.

5. Spread ½ cup of the filling evenly across the pieces of dough, leaving an inch of dough uncovered on the wide side closest to yourself.

6. Take the side farthest away and roll the pieces of dough into tight spirals. Using a bench scraper, cut the rolls of dough in half lengthwise. Turn the rolls of dough so that the centers are facing out. Carefully twist the dough to form 3 full turns. Pinch the ends to seal.

7. Spray two 8 x 4–inch loaf pans with nonstick cooking spray and place a piece of dough in each one.

8. Cover the loaves with plastic wrap and let them rise until they crest above the edges of the pans.

9. Preheat the oven to 350°F.

10. Place the loaves in the oven and bake until their internal temperature is 210°F, 45 to 55 minutes.

11. Remove from the oven and transfer the babka to a wire rack. Let them cool completely before serving.

INGREDIENTS:

FOR THE FILLING
- 6 OZ. DARK CHOCOLATE (55 TO 65 PERCENT)
- 6 OZ. UNSALTED BUTTER
- 3 OZ. CONFECTIONERS' SUGAR
- 2 OZ. COCOA POWDER

FOR THE DOUGH
- 1½ CUPS LUKEWARM WATER (90°F)
- 1 TABLESPOON ACTIVE DRY YEAST, PLUS 2 TEASPOONS
- 3 EGGS
- ¼ CUP EXTRA-VIRGIN OLIVE OIL
- 2 LBS. BREAD FLOUR, PLUS MORE AS NEEDED
- ¼ CUP SUGAR
- 1½ TABLESPOONS KOSHER SALT

HERBED FOCACCIA

YIELD: 18 X 13-INCH FOCACCIA / **ACTIVE TIME:** 30 MINUTES / **TOTAL TIME:** 3 HOURS

A great variation on the traditional focaccia. A very herbaceous bread with a striking green color.

1. Preheat the oven to 350°F. Bring water to a boil in a large saucepan, and prepare an ice bath. Add the spinach to the pan, boil for 30 seconds, and transfer it to the ice bath.

2. Place the water in a blender, drain the spinach, and squeeze it to remove as much water as possible. Add it to the blender and puree until smooth.

3. Place the puree in the work bowl of a stand mixer fitted with the dough hook. Add the yeast, gently whisk, and let the mixture sit until it starts to foam, about 10 minutes.

4. Add the sugar, salt, garlic, fresh herbs, and flour to the work bowl and knead the mixture on low for 1 minute. Raise the speed to medium and knead the mixture until it comes together as a dough, about 5 minutes. Cover the bowl with plastic wrap and let the dough rise at room temperature until doubled in size.

5. Coat an 18 x 13–inch sheet pan with nonstick cooking spray. Place the dough in the pan and gently spread it to the edges of the pan. If the dough is difficult to stretch, let it rest for 10 minutes before resuming.

6. Cover the dough with plastic wrap and let it rise at room temperature until it has doubled in size.

7. Use your fingertips to gently press down on the dough and make dimples all over it. The dimples should go about halfway down. Drizzle about ¾ cup of olive oil over the focaccia and sprinkle the Parmesan on top.

8. Place the focaccia in the oven and bake until it is a light golden brown, 20 to 30 minutes.

9. Remove the focaccia from the oven and brush it with the remaining olive oil. Let it cool slightly before slicing and serving.

INGREDIENTS:

4	OZ. SPINACH
2	CUPS WATER
2½	TEASPOONS ACTIVE DRY YEAST
1	TABLESPOON SUGAR
1	TABLESPOON KOSHER SALT
2	GARLIC CLOVES, MINCED
½	OZ. FRESH PARSLEY, CHOPPED
½	OZ. FRESH BASIL, CHOPPED
¼	OZ. FRESH MINT, CHOPPED
22	OZ. BREAD FLOUR
1	CUP EXTRA-VIRGIN OLIVE OIL, PLUS MORE AS NEEDED
1	CUP GRATED PARMESAN CHEESE, FOR TOPPING

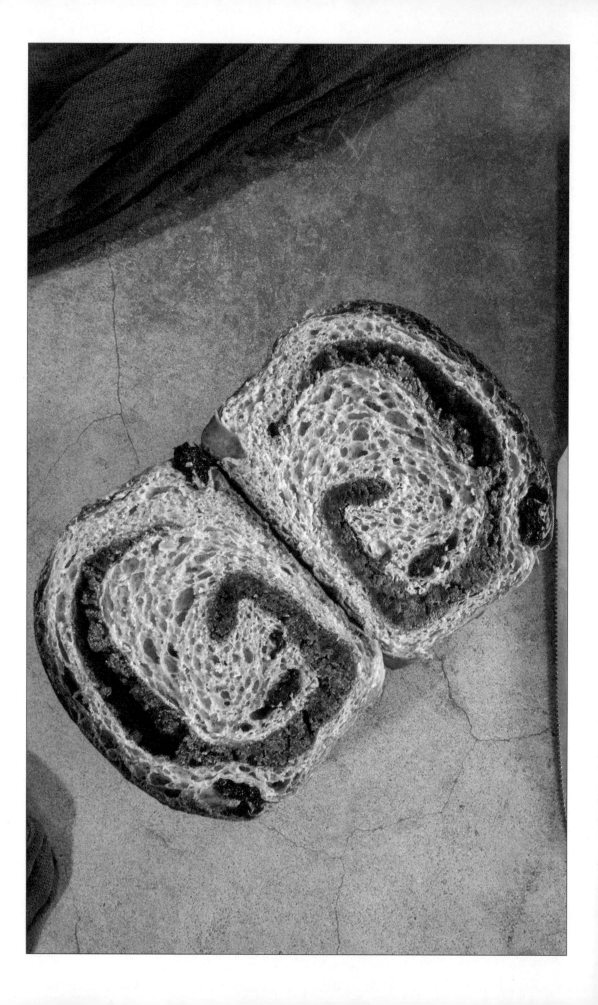

CINNAMON RAISIN BREAD

YIELD: 2 LOAVES / **ACTIVE TIME:** 45 MINUTES / **TOTAL TIME:** 4 HOURS

The bread that provided everyone's favorite childhood toast.

1. To begin preparations for the dough, whisk together the water, milk, melted butter, and yeast, and the unbeaten egg in the work bowl of a stand mixer fitted with the dough hook. Add the flour, sugar, salt, cinnamon, and raisins and work the mixture on low for 1 minute. Raise the speed to medium and knead the mixture until it comes together as a dough and pulls away from the side of the bowl.

2. Transfer the dough to a bowl, cover it with plastic wrap, and let it rise until doubled in size.

3. Wipe out the work bowl of the stand mixer and prepare the filling. Add all of the ingredients, fit the mixer with the paddle attachment, and beat the mixture until it is a crumbly meal, about 5 minutes. Set the mixture aside.

4. Turn the dough out onto a flour-dusted work surface and divide it in half. Use a rolling pin to roll each piece into a rectangle that is about 8 x 6 inches.

5. Spread 1 cup of the filling evenly across each piece of dough, leaving an inch of dough uncovered on the wide side closest to yourself.

6. Take the side farthest away and roll the pieces of dough up tightly. Pinch the seam and ends to seal the rolls.

7. Spray two 8 x 4–inch loaf pans with nonstick cooking spray and place a piece of dough in each one.

8. Cover the loaves with plastic wrap and let them rise until they crest above the edges of the pans.

9. Preheat the oven to 350°F.

10. Brush both loaves with the beaten egg. Place them in the oven and bake until the internal temperature of the loaves is 190°F, 40 to 45 minutes.

11. Remove from the oven, place the pans on a wire rack, and let them cool completely before slicing.

INGREDIENTS:

FOR THE DOUGH

3	OZ. WATER
3	OZ. MILK
4	OZ. UNSALTED BUTTER, MELTED
5	TEASPOONS ACTIVE DRY YEAST
2	EGGS, 1 BEATEN
15	OZ. BREAD FLOUR, PLUS MORE AS NEEDED
2	OZ. SUGAR
1	TABLESPOON KOSHER SALT
1½	TEASPOONS CINNAMON
5	OZ. RAISINS

FOR THE FILLING

4	OZ. LIGHT BROWN SUGAR
5	OZ. ALL-PURPOSE FLOUR
1½	TEASPOONS CINNAMON
3	OZ. UNSALTED BUTTER, SOFTENED
¼	TEASPOON KOSHER SALT
¾	TEASPOON COCOA POWDER

POTATO ROLLS

YIELD: 12 ROLLS / **ACTIVE TIME:** 1 HOUR / **TOTAL TIME:** 5 HOURS

With just the starch of one potato, you can transform white bread into a moist, spongy marvel.

1. Place the water and 2 tablespoons of the salt in a saucepan and bring it to a boil. Add the potato and cook until very tender, 20 to 25 minutes. Reserve ½ cup of the cooking liquid and then drain the potato.

2. Place the potato in a small bowl and mash it with a fork until smooth.

3. Let the reserved liquid and potato cool to 90°F.

4. In the work bowl of a stand mixer fitted with the dough hook, combine the reserved liquid and yeast, gently stir, and let the mixture sit until foamy, about 10 minutes.

5. Add the sugar, egg, ⅔ cup of the potato, flour, and 1½ teaspoons of the salt and knead the mixture on low for 1 minute. Raise the speed to medium and knead until it comes together as a smooth dough.

6. Transfer the dough to a flour-dusted bowl and cover it with plastic wrap. Let the dough rise on the countertop until doubled in size, about 1½ hours.

7. Place the dough on a flour-dusted work surface, divide it into 12 pieces, and shape them into small balls.

8. Line an 18 x 13–inch sheet pan with parchment paper and coat it with nonstick cooking spray. Place the rolls on the pan, dust them with flour, and cover them with plastic wrap. Place the pan in a naturally warm spot and let the rolls rise until doubled in size.

9. Preheat the oven to 350°F.

10. Place the rolls in the oven and bake until they are golden brown, 20 to 25 minutes.

11. Remove the rolls from the oven and let them cool slightly before enjoying.

INGREDIENTS:

4	CUPS WATER
2	TABLESPOONS KOSHER SALT, PLUS 1½ TEASPOONS
1	LARGE RUSSET POTATO, PEELED AND DICED
1¾	TEASPOONS ACTIVE DRY YEAST
3	TABLESPOONS SUGAR, PLUS 1½ TEASPOONS
1	EGG
12	OZ. BREAD FLOUR, PLUS MORE AS NEEDED

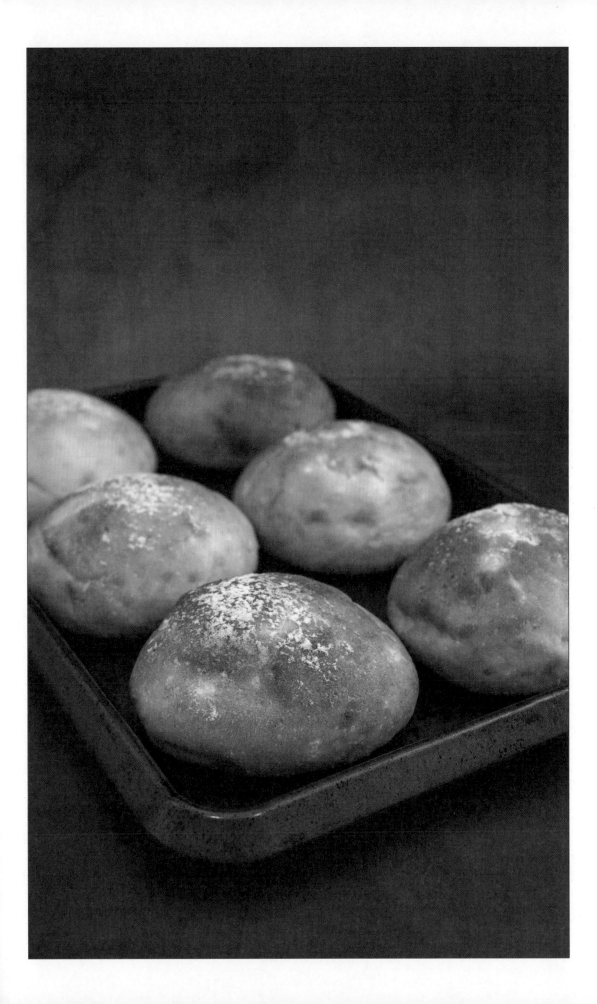

ROSEMARY POTATO BREAD

YIELD: 1 LOAF / **ACTIVE TIME:** 1 HOUR / **TOTAL TIME:** 5 HOURS

Biga is a preferment featured in many Italian breads.

1. Preheat the oven to 350°F.

2. Place the water and 2 tablespoons of the salt in a saucepan and bring it to a boil. Add the potato and cook until very tender, 20 to 25 minutes. Reserve ½ cup of the cooking liquid and then drain the potato.

3. Place the potato in a small bowl and mash it with a fork until smooth.

4. Let the reserved liquid and potato cool to 90°F.

5. In the work bowl of a stand mixer fitted with the dough hook, combine the reserved liquid, Biga, and yeast, gently stir, and let the mixture sit until foamy, about 10 minutes.

6. Add the reserved oil, flour, white pepper, Roasted Garlic, 1 teaspoon of the salt, and rosemary and knead the mixture on low for 1 minute. Raise the speed to medium and knead until it comes together as a smooth dough.

7. Transfer the dough to a flour-dusted bowl and cover it with plastic wrap. Let the dough rise on the countertop until doubled in size, about 1½ hours.

8. Coat an 8 x 4–inch loaf pan with nonstick cooking spray. Place the dough on a flour-dusted work surface and punch it down. Form it into a tight ball and place it in the pan, seam side down. Cover it with plastic wrap and let the dough rise until doubled in size.

9. Preheat the oven to 350°F.

10. Place the bread in the oven and bake until they are golden brown, 45 to 50 minutes. The bread should have an internal temperature of 190°F.

11. Remove the bread from the oven, remove it from the pan, and transfer it to a wire rack. Brush it with some more reserved oil and let it cool completely before slicing and serving.

INGREDIENTS:

4	CUPS WATER
2	TABLESPOONS KOSHER SALT, PLUS 1 TEASPOON
1	LARGE RUSSET POTATO, PEELED AND DICED
5	OZ. BIGA (SEE RECIPE)
1	TEASPOON ACTIVE DRY YEAST
2	TEASPOONS OIL FROM ROASTED GARLIC, PLUS MORE AS NEEDED
9.5	OZ. BREAD FLOUR, PLUS MORE AS NEEDED
⅛	TEASPOON WHITE PEPPER
	ROASTED GARLIC (SEE RECIPE)
1	TABLESPOON FINELY CHOPPED FRESH ROSEMARY

BIGA

4	OZ. BREAD FLOUR
¼	TEASPOON ACTIVE DRY YEAST
⅓	CUP LUKEWARM WATER (90°F)

ROASTED GARLIC

1	CUP EXTRA-VIRGIN OLIVE OIL
4	GARLIC CLOVES

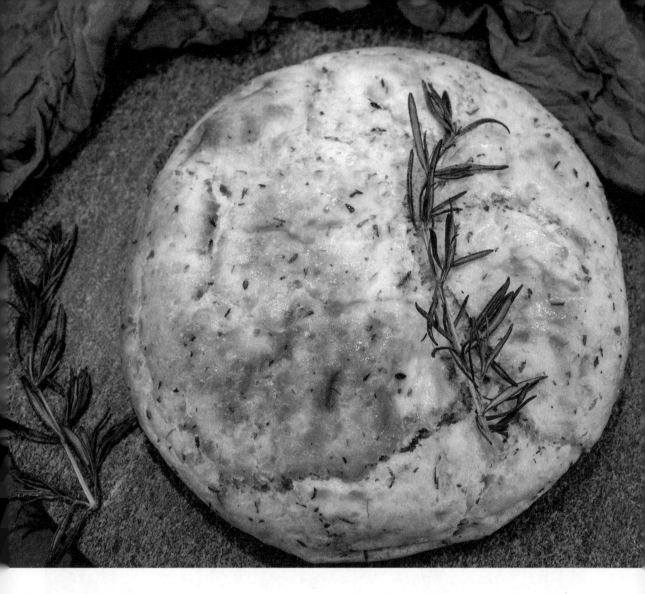

BIGA

1. Place all of the ingredients in a small stainless steel bowl and whisk to combine. Cover the bowl with plastic wrap and let the mixture sit for at least 2 hours.

ROASTED GARLIC

1. Preheat the oven to 350°F. Place the olive oil and garlic in a small baking dish. Make sure there is enough oil to completely cover the garlic. Add more if needed.

2. Place in the oven and roast until the garlic is soft when poked with a knife, about 45 minutes. Remove from the oven and let the cloves cool.

3. Strain the garlic, reserving the oil. Peel the cloves and use as desired.

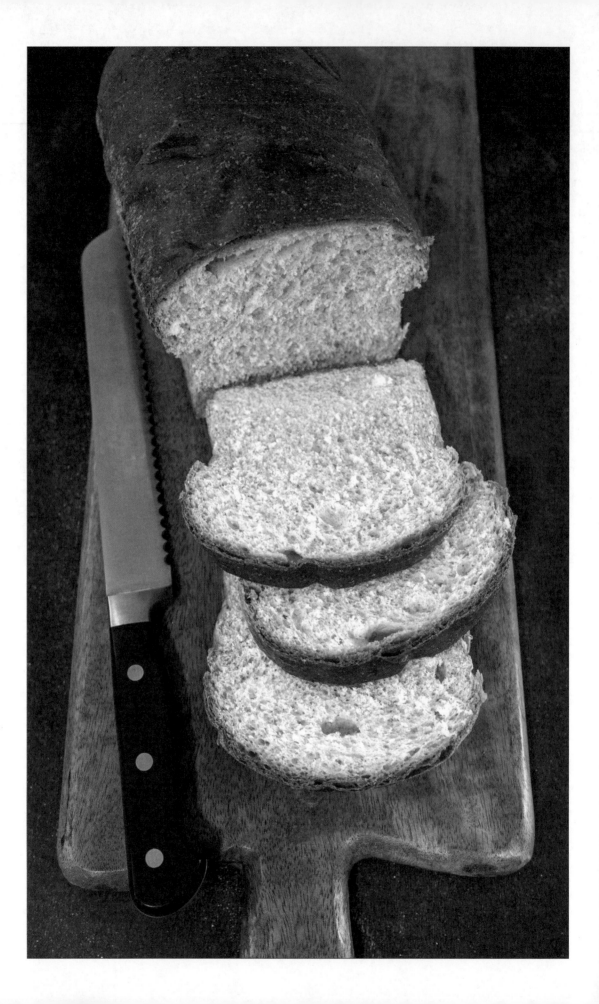

COUNTRY WHOLE WHEAT BREAD

YIELD: 1 LOAF / **ACTIVE TIME:** 45 MINUTES / **TOTAL TIME:** 4 HOURS

Great for sandwiches, or toasted with a bit of homemade jam.

1. Place the water in the work bowl of a stand mixer. Sprinkle the yeast over the water, gently whisk, and let the mixture sit for 10 minutes.

2. Add the flours, sugar, and salt and fit the mixer with the dough hook. Work the mixture on low until it just starts to come together as a dough, about 1 minute.

3. Add the butter, raise the speed to medium, and work the dough until it comes away clean from the side of the work bowl and is elastic.

4. Spray a mixing bowl with nonstick cooking spray. Transfer the dough to a flour-dusted work surface and knead it until it is extensible. Shape the dough into a ball, place it in the bowl, and cover the bowl with a kitchen towel. Place the dough in a naturally warm spot and let it rise until doubled in size, 1 to 2 hours.

5. Preheat the oven to 350°F. Coat an 8 x 4–inch loaf pan with nonstick cooking spray.

6. Place the dough on a flour-dusted work surface and form it into a tight round. Place it in the pan, seam side down, cover it with plastic wrap, and place it in a naturally warm spot. Let the dough rise until doubled in size.

7. Place the pan in the oven and bake until it is golden brown, 35 to 45 minutes. Remove from the oven and let the bread cool on a wire rack before enjoying.

INGREDIENTS:

8	OZ. LUKEWARM WATER (90°F)
2	TEASPOONS ACTIVE DRY YEAST
10	OZ. BREAD FLOUR, PLUS MORE AS NEEDED
2	OZ. WHOLE WHEAT FLOUR
1	TABLESPOON SUGAR, PLUS 1 TEASPOON
1½	TEASPOONS KOSHER SALT
1.5	OZ. UNSALTED BUTTER, SOFTENED

PÃO DE QUEIJO

YIELD: 12 BUNS / **ACTIVE TIME:** 20 MINUTES / **TOTAL TIME:** 45 MINUTES

A delicious gluten-free bread that is revered in Brazil.

1. Preheat the oven to 350°F. Line an 18 x 13–inch sheet pan with parchment paper. Place the tapioca starch in the work bowl of a stand mixer fitted with the paddle attachment.

2. Place the milk, butter, and salt in a small saucepan and warm over medium heat until the butter has melted and the mixture is simmering.

3. Turn the mixer on low and slowly pour the milk mixture into the work bowl. Raise the speed to medium and work the mixture until it has cooled considerably.

4. Add the eggs one at a time and knead to incorporate. Add the grated cheese and knead the mixture until incorporated.

5. Scoop twelve 2-oz. portions of the dough onto the pan, making sure to leave enough space between them.

6. Place the pan in the oven and bake until the buns are puffy and light golden brown, 15 to 20 minutes.

7. Remove from the oven and enjoy immediately.

INGREDIENTS:

11	OZ. TAPIOCA STARCH
1	CUP MILK
4	OZ. UNSALTED BUTTER
1	TEASPOON KOSHER SALT
2	EGGS
1½	CUPS GRATED PARMESAN CHEESE

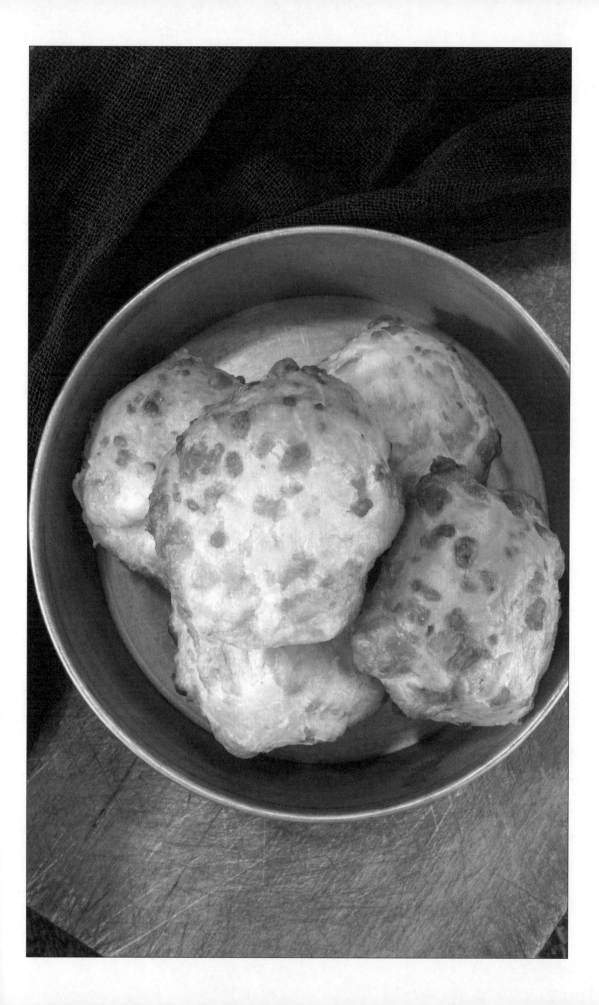

JAPANESE MILK BREAD

YIELD: 1 LOAF / **ACTIVE TIME:** 45 MINUTES / **TOTAL TIME:** 4 HOURS

This springy loaf is made with a unique technique known as *tangzhong*, which uses a paste of water and flour.

1. To prepare the tangzhong mixture, place the water and flour in a small saucepan and whisk to combine. Cook over medium-low heat until the mixture thickens and starts to bubble, about 2 minutes. Pour the mixture into a small bowl and let it cool completely. If done correctly, the mixture will thicken significantly as it cools.

2. To begin preparations for the dough, place the tangzhong mixture, milk, egg, egg yolk, sugar, and yeast in the work bowl of a stand mixer fitted with the dough hook and whisk to combine. Add the flour, salt, and butter and knead on low for 1 minute. Raise the speed to medium and knead the mixture until it comes together as a smooth dough and begins to pull away from the side of the work bowl, 6 to 8 minutes.

3. Coat a mixing bowl with nonstick cooking spray. Remove the dough from the work bowl, place it on a flour-dusted work surface, and shape it into a ball. Place the dough in the bowl, cover it with plastic wrap, place it in a naturally warm spot, and let it rise until doubled in size.

4. Coat an 8 x 4–inch loaf pan with nonstick cooking spray. Place the dough on a flour-dusted work surface and roll it into a tight ball. Place the dough in the pan, seam side down, cover it with plastic wrap, and place it in a naturally warm spot. Let the dough rise until it has doubled in size.

5. Preheat the oven to 350°F.

6. Place the pan in the oven and bake until the bread is golden brown, 35 to 45 minutes. The internal temperature of the loaf should be 190°F.

7. Remove from the oven, remove the loaf from the pan, and place it on a cooling rack. Let it cool completely before enjoying.

INGREDIENTS:

FOR THE TANGZHONG MIXTURE

2.5	OZ. WATER
2	TABLESPOONS BREAD FLOUR

FOR THE DOUGH

3	OZ. MILK
1	EGG
1	EGG YOLK
3	TABLESPOONS SUGAR
1	TABLESPOON ACTIVE DRY YEAST
10	OZ. BREAD FLOUR, PLUS MORE AS NEEDED
1½	TEASPOONS KOSHER SALT
1.5	OZ. UNSALTED BUTTER, SOFTENED

PORTUGUESE SWEET ROLLS

YIELD: 10 ROLLS / **ACTIVE TIME:** 45 MINUTES / **TOTAL TIME:** 4 HOURS

Serve these alongside a spicy or smoky protein.

1. Place the water, yeast, eggs, and sugar in the work bowl of a stand mixer fitted with the dough hook and whisk to combine. Add the flour, salt, and softened butter and knead on low for 1 minute. Raise the speed to medium and knead the mixture until it comes together as a smooth dough and begins to pull away from the side of the work bowl, 6 to 8 minutes.

2. Coat a mixing bowl with nonstick cooking spray. Remove the dough from the work bowl, place it on a flour-dusted work surface, and shape it into a ball. Place the dough in the bowl, cover it with plastic wrap, place it in a naturally warm spot, and let it rise until doubled in size.

3. Line an 18 x 13–inch sheet pan with parchment paper. Place the dough on a flour-dusted work surface and divide it into ten 3.5-oz. portions. Roll the portions into tight balls. Place the balls on the pan, cover them with plastic wrap, and place them in a naturally warm spot. Let them rise until they have doubled in size.

4. Preheat the oven to 350°F.

5. Place the pan in the oven and bake until the rolls are golden brown, 20 to 25 minutes. The internal temperature of the rolls should be 190°F.

6. Remove from the oven, transfer the rolls to a wire rack, and brush them with the melted butter. Let them cool completely before enjoying.

INGREDIENTS:

8	OZ. WATER
2	TABLESPOONS ACTIVE DRY YEAST
2	EGGS
5	OZ. SUGAR
23	OZ. BREAD FLOUR, PLUS MORE AS NEEDED
1	TABLESPOON KOSHER SALT, PLUS 1 TEASPOON
4	OZ. UNSALTED BUTTER, SOFTENED; PLUS 2 OZ., MELTED

PIZZA DOUGH

YIELD: 3 BALLS OF DOUGH / **ACTIVE TIME:** 30 MINUTES / **TOTAL TIME:** 3 HOURS

This can be made ahead of time and kept in the freezer tightly wrapped for up to 3 months.

1. Place the water and yeast in the work bowl of a stand mixer, gently stir, and let the mixture sit until it foams, about 10 minutes. Stir in the oil, flour, and salt and fit the mixer with the dough hook. Knead the dough on low for 1 minute. Increase the speed to medium and knead the mixture until it comes together as a smooth dough and begins to pull away from the side of the work bowl.

2. Coat a mixing bowl with nonstick cooking spray. Place the dough on a flour-dusted work surface and form it into a ball. Place the dough in the bowl, cover it with plastic wrap, place it in a naturally warm spot, and let it rise until doubled in size.

3. If you are cooking pizza immediately after making the dough, preheat the oven to 500°F and place a baking stone on the center rack.

4. Coat a baking sheet with nonstick cooking spray. Place the dough on a flour-dusted work surface and divide it into 6-oz. pieces. Form the pieces into tight rounds, place them on the pan, and cover them with plastic wrap. Let the dough rest for 30 minutes.

5. If you are making the dough ahead of time, place each ball in a plastic bag and store the dough in the freezer for up to 3 months.

6. Dust a work surface with semolina flour. Place the balls of dough on the surface and roll them into 8-inch disks.

7. To bake the pizzas, add sauce and toppings as desired, use a pizza peel to transfer the pizza onto the baking stone, and bake until the crust is crispy and golden brown, 8 to 10 minutes. Remove from the oven and let the pizzas cool slightly before slicing and serving.

INGREDIENTS:

8.5 OZ. WATER

1¾ TEASPOONS ACTIVE DRY YEAST

1 TABLESPOON EXTRA-VIRGIN OLIVE OIL

15 OZ. BREAD FLOUR, PLUS MORE AS NEEDED

2 TEASPOONS KOSHER SALT

SEMOLINA FLOUR, AS NEEDED

WHOLE WHEAT CRACKERS

YIELD: 40 CRACKERS / **ACTIVE TIME:** 20 MINUTES / **TOTAL TIME:** 45 MINUTES

This whole wheat cracker is a great addition to your repertoire. Perfect to pair with a cheese board, or simply enjoy them as a snack.

1. Preheat the oven to 400°F. Line an 18 x 13–inch sheet pan with parchment paper. Place the flour, sugar, kosher salt, and butter in a food processor and pulse until combined and the butter has been reduced to pea-sized pieces.

2. While the food processor is running, add the water and blitz until incorporated.

3. Tip the mixture onto a lightly floured work surface and knead it until it comes together as a soft, smooth dough. Place the dough in a small bowl, cover it with plastic wrap, and let it rest for 10 minutes.

4. Place the dough on a flour-dusted work surface and divide it in half. Roll each half until it is ⅛ inch thick, brush it with the olive oil, and cut it into forty 2-inch squares. Place the squares on the pan and sprinkle the sea salt over them.

5. Place the pan in the oven and bake until the crackers are crispy and lightly golden brown, 8 to 10 minutes. Remove from the oven and let the crackers cool on the pan before enjoying.

INGREDIENTS:

5.5 OZ. WHOLE WHEAT FLOUR, PLUS MORE AS NEEDED

1 OZ. SUGAR

½ TEASPOON KOSHER SALT

2 OZ. BUTTER, CHILLED AND CUBED

2 OZ. WATER

EXTRA-VIRGIN OLIVE OIL, AS NEEDED

MALDON SEA SALT, FOR TOPPING

GRISSINI STICKS

YIELD: 24 STICKS / **ACTIVE TIME:** 30 MINUTES / **TOTAL TIME:** 3 HOURS

To get these breadsticks to the pictured thinness, a pasta maker or stand mixer attachment is necessary.

1. Place the milk, water, and yeast in the work bowl of a stand mixer fitted with the dough hook, gently stir to combine, and let the mixture sit until it starts to foam, about 10 minutes.

2. Add the butter, flour, salt, and oregano and knead on low for 1 minute. Raise the speed to medium and knead the mixture until it comes together as a smooth dough and begins to pull away from the side of the work bowl, about 5 minutes.

3. Coat a mixing bowl with nonstick cooking spray. Remove the dough from the work bowl, place it on a flour-dusted work surface, and shape it into a ball. Place the dough in the bowl, cover it with plastic wrap, place it in a naturally warm spot, and let it rise until doubled in size.

4. Preheat the oven to 400°F.

5. Line two baking sheets with parchment paper. Place the dough on a flour-dusted work surface and divide it in half. Roll each piece out until it is ¼ inch thick, and cut the pieces into ⅛-inch-wide ribbons.

6. Place the ribbons on the baking sheets, brush them with the olive oil, and sprinkle the salt over them. Place them in the oven and bake until they are golden brown, 10 to 15 minutes.

7. Remove from the oven and let the grissini sticks cool slightly before enjoying.

INGREDIENTS:

4.5 OZ. MILK

1 OZ. WATER

2 TEASPOONS ACTIVE DRY YEAST

1 OZ. UNSALTED BUTTER, MELTED

9 OZ. ALL-PURPOSE FLOUR, PLUS MORE AS NEEDED

2 TEASPOONS KOSHER SALT, PLUS MORE TO TASTE

1 TABLESPOON DRIED OREGANO

EXTRA-VIRGIN OLIVE OIL, AS NEEDED

PRETZEL BUNS

YIELD: 10 BUNS / **ACTIVE TIME:** 45 MINUTES / **TOTAL TIME:** 4 HOURS

The beautifully burnished outside and powerful flavor of these buns are a result of the alkaline solution.

1. To begin preparations for the dough, place the water and yeast in the work bowl of a stand mixer fitted with the dough hook, gently stir to combine, and let the mixture sit until it starts to foam, about 10 minutes.

2. Add the brown sugar, flour, and salt and knead on low for 1 minute. Raise the speed to medium and knead the mixture until it comes together as a smooth dough and begins to pull away from the side of the work bowl, about 6 to 8 minutes.

3. Coat a mixing bowl with nonstick cooking spray. Remove the dough from the work bowl, place it on a flour-dusted work surface, and shape it into a ball. Place the dough in the bowl, cover it with plastic wrap, place it in a naturally warm spot, and let it rise until doubled in size.

4. Preheat the oven to 350°F. Line an 18 x 13–inch sheet pan with parchment paper.

5. To prepare the alkaline solution, place the ingredients in a small saucepan and bring to a boil. Remove the pan from heat and set aside.

6. Place the dough on a flour-dusted work surface and divide it into ten 3.5-oz. portions. Form each one into a ball and place the balls on the pan. Cover them with plastic wrap, place them in a naturally warm spot, and let them rise until doubled in size.

7. Brush the buns with the alkaline solution and score a small X on the top of each one.

8. Place the buns in the oven and bake until they are golden brown, 20 to 25 minutes. The internal temperature of the buns should be 190°F.

9. Remove them from the oven, transfer them to a wire rack, and let them cool before enjoying.

INGREDIENTS:

FOR THE DOUGH

12 OZ. LUKEWARM WATER (90°F)

1½ TEASPOONS ACTIVE DRY YEAST

2 OZ. DARK BROWN SUGAR

18 OZ. BREAD FLOUR, PLUS MORE AS NEEDED

2 TEASPOONS KOSHER SALT

FOR THE ALKALINE SOLUTION

2 CUPS WATER

2 TABLESPOONS BAKING SODA

LAVASH

YIELD: 4 LAVASH / **ACTIVE TIME:** 30 MINUTES / **TOTAL TIME:** 1 HOUR AND 30 MINUTES

A thin flatbread that is a regular guest upon dinner tables throughout central Asia and the Mediterranean region.

1. Combine the flour, water, and salt in the work bowl of a stand mixer fitted with the dough hook. Knead the mixture on low until it comes together as a smooth dough, about 5 minutes. If the dough is too dry, add a small amount of water. If the dough is too sticky, add a little bit of flour.

2. Place the dough on a flour-dusted work surface and knead it for 1 minute. Coat a mixing bowl with nonstick cooking spray, place the dough in the bowl, and cover it with plastic wrap. Let the dough sit at room temperature for 1 hour.

3. Preheat the oven to 500°F and place a baking stone on the center rack of the oven.

4. Remove the dough from the bowl and place it on a flour-dusted work surface. Divide the dough into four equal pieces and roll them out into ¼-inch-thick ovals.

5. Working with one lavash at a time, use a pizza peel to carefully transfer the dough to the baking stone. Bake until the lavash begins to puff up and brown, 4 to 5 minutes.

6. Remove from the oven and immediately brush the lavash with olive oil. Place the cooked lavash in a basket, cover, and continue cooking the remaining lavash. Serve warm.

INGREDIENTS:

- 18 OZ. ALL-PURPOSE FLOUR, PLUS MORE AS NEEDED
- 14 OZ. WATER, TEPID
- 1 TEASPOON KOSHER SALT
- EXTRA-VIRGIN OLIVE OIL, AS NEEDED

ST. LUCIA BUNS

YIELD: 10 BUNS / ACTIVE TIME: 45 MINUTES / TOTAL TIME: 4 HOURS

Also known in Sweden as Lussekatter, a name inspired by the way these swirled buns resemble a cat's tail.

1. Place the milk and yeast in the work bowl of a stand mixer fitted with the dough hook, gently stir to combine, and let the mixture sit until it starts to foam, about 10 minutes.

2. Add the butter, unbeaten egg, saffron, sugar, flour, and salt and knead on low for 1 minute. Raise the speed to medium and knead the mixture until it comes together as a smooth dough and begins to pull away from the side of the work bowl, about 6 to 8 minutes.

3. Coat a mixing bowl with nonstick cooking spray. Remove the dough from the work bowl, place it on a flour-dusted work surface, and shape it into a ball. Place the dough in the bowl, cover it with plastic wrap, place it in a naturally warm spot, and let it rise until doubled in size.

4. Preheat the oven to 350°F. Line an 18 x 13–inch sheet pan with parchment paper.

5. Place the dough on a flour-dusted work surface and divide it into ten 5-oz. portions. Form each one into a ball and then use your hands to roll the balls out into 14-inch-long strands. Curl the ends of the strands in opposite directions so that each strand forms an S. Place the buns on the pan, cover them with plastic wrap, place them in a naturally warm spot, and let them rise until doubled in size.

6. Brush the buns with the beaten egg. Drain the raisins and place one in the middle of each curl.

7. Place the buns in the oven and bake until they are golden brown, 15 to 20 minutes. The internal temperature of the buns should be 190°F.

8. Remove the buns from the oven, place them on a cooling rack, and let them cool before enjoying.

INGREDIENTS:

- 2 OZ. MILK
- 1 TABLESPOON ACTIVE DRY YEAST
- 6 OZ. UNSALTED BUTTER, MELTED
- 2 EGGS, 1 BEATEN
- PINCH OF SAFFRON
- 6.5 OZ. SUGAR
- 2 LBS. BREAD FLOUR, PLUS MORE AS NEEDED
- ½ TEASPOON KOSHER SALT
- ½ CUP RAISINS, SOAKED IN HOT WATER

BENNE BUNS

YIELD: 12 BUNS / **ACTIVE TIME:** 45 MINUTES / **TOTAL TIME:** 4 HOURS

Benne seeds are the forebearers of white sesame seeds, and they lend a nutty, honeyed flavor to these buns.

1. Place the water and yeast in the work bowl of a stand mixer fitted with the dough hook, gently stir to combine, and let the mixture sit until it starts to foam, about 10 minutes.

2. Add the sugar, butter, eggs, flours, salt, and benne seeds and knead on low for 1 minute. Raise the speed to medium and knead the mixture until it comes together as a smooth dough and begins to pull away from the side of the work bowl, about 6 to 8 minutes.

3. Coat a mixing bowl with nonstick cooking spray. Remove the dough from the work bowl, place it on a flour-dusted work surface, and shape it into a ball. Place the dough in the bowl, cover it with plastic wrap, place it in a naturally warm spot, and let it rise until doubled in size.

4. Preheat the oven to 350°F. Line an 18 x 13–inch sheet pan with parchment paper.

5. Place the dough on a flour-dusted work surface and divide it into twelve 3.5-oz. portions. Place the buns on the pan, cover them with plastic wrap, place them in a naturally warm spot, and let them rise until doubled in size.

6. Place the buns in the oven and bake until they are golden brown, 20 to 25 minutes. The internal temperature of the buns should be 190°F.

7. Remove the buns from the oven, place them on a cooling rack, and let them cool before enjoying.

INGREDIENTS:

8	OZ. LUKEWARM WATER (90°F)
4	TEASPOONS ACTIVE DRY YEAST
5	OZ. SUGAR
4	OZ. UNSALTED BUTTER, MELTED
2	EGGS
20	OZ. ALL-PURPOSE FLOUR, PLUS MORE AS NEEDED
4	OZ. BENNE SEED FLOUR OR SESAME SEED FLOUR
1	TABLESPOON KOSHER SALT
1.5	OZ. BENNE SEEDS, TOASTED

PARATHA

YIELD: 8 SERVINGS / **ACTIVE TIME:** 30 MINUTES / **TOTAL TIME:** 1 HOUR

An Indian flatbread that is perfect for sopping up curries and soups.

1. Place the flours and salt in the work bowl of a stand mixer fitted with the paddle attachment. Turn on low and slowly add the warm water. Mix until incorporated and then slowly add the olive oil. When the oil has been incorporated, place the dough on a lightly floured work surface and knead until it is quite smooth, about 8 minutes.

2. Divide the dough into 8 small balls and dust them with flour. Use your hands to roll each ball into a long rope, and then coil each rope into a large disk. Use a rolling pin to flatten the disks until they are no more than ¼ inch thick. Lightly brush each disk with a small amount of olive oil.

3. Place a cast-iron skillet over very high heat for about 4 minutes. Brush the surface with some of the ghee or melted butter and place a disk of the dough on the surface. Cook until it is blistered and brown, about 1 minute. Turn over and cook the other side. Transfer the cooked paratha to a plate and repeat with the remaining disks. Serve warm or at room temperature.

NOTE: If you want to freeze any extras, make sure to place parchment paper between them to prevent them from melding together in the freezer.

INGREDIENTS:

- 8 OZ. PASTRY FLOUR, PLUS MORE AS NEEDED
- 5 OZ. WHOLE WHEAT FLOUR
- ¼ TEASPOON KOSHER SALT
- 1 CUP WARM WATER (110°F)
- 5 TABLESPOONS EXTRA-VIRGIN OLIVE OIL, PLUS MORE AS NEEDED
- 5 TABLESPOONS GHEE OR MELTED UNSALTED BUTTER

ENGLISH MUFFINS

YIELD: 8 MUFFINS / **ACTIVE TIME:** 30 MINUTES / **TOTAL TIME:** 3 HOURS

Nothing beats freshly baked, homemade English muffins. The ideal vehicles for butter and jam in the morning.

1. Place the water and yeast in the work bowl of a stand mixer fitted with the dough hook, gently stir to combine, and let the mixture sit until it starts to foam, about 10 minutes.

2. Add the butter, sugar, egg, bread flour, and salt and knead on low for 1 minute. Raise the speed to medium and knead the mixture until it comes together as a smooth dough and begins to pull away from the side of the work bowl, about 5 minutes.

3. Coat a mixing bowl with nonstick cooking spray. Remove the dough from the work bowl, place it on a flour-dusted work surface, and shape it into a ball. Place the dough in the bowl, cover it with plastic wrap, place it in a naturally warm spot, and let it rise until doubled in size.

4. Line an 18 x 13–inch sheet pan with parchment paper.

5. Place the dough on a flour-dusted work surface and divide it into eight 2.5-oz. portions. Flatten each ball into a 3½-inch circle and place the circles on the pan. Cover the muffins with plastic wrap, place them in a naturally warm spot, and let them rest for 30 minutes.

6. Warm a stovetop griddle over low heat and lightly sprinkle the semolina flour on the griddle. Place the muffins on the griddle and cook until they are golden brown on both sides, 12 to 20 minutes. The internal temperature of the muffins should be 190°F. If the muffins browned too quickly and are not cooked through in the center, bake them in a 350°F oven for 5 to 10 minutes.

7. Let the muffins cool before slicing and enjoying.

INGREDIENTS:

7	OZ. WATER
1	TEASPOON ACTIVE DRY YEAST
4½	TEASPOONS UNSALTED BUTTER, SOFTENED
1	TABLESPOON SUGAR
1	EGG
10	OZ. BREAD FLOUR, PLUS MORE AS NEEDED
1	TEASPOON KOSHER SALT
	SEMOLINA FLOUR, AS NEEDED

CHOCOLATE BRIOCHE

YIELD: 1 LOAF / **ACTIVE TIME:** 45 MINUTES / **TOTAL TIME:** 4 HOURS

Less a dessert than a great way to add contrast to a charcuterie board, or to complement a bit of foie gras.

1. Place the water and yeast in the work bowl of a stand mixer fitted with the dough hook, gently stir, and let the mixture sit until it starts to foam, about 10 minutes.

2. Add the sugar, flour, cocoa powder, and salt and knead the mixture on low for 1 minute.

3. Add the butter a little at a time with the mixer running. When all of the butter has been added, raise the speed to medium and knead the dough until it begins to pull away from the sides, about 6 minutes.

4. Add the chocolate chips and work the mixture until they are evenly distributed. Coat a mixing bowl with nonstick cooking spray. Remove the dough from the work bowl, place it on a flour-dusted work surface, and shape it into a ball. Place the dough in the bowl, cover it with plastic wrap, place it in a naturally warm spot, and let it rise until doubled in size, 1 to 2 hours.

5. Preheat the oven to 350°F. Coat an 8 x 4–inch loaf pan with nonstick cooking spray.

6. Place the dough on a flour-dusted work surface and form it into a tight round. Tuck in the sides to form the dough into a loaf shape and place it in the pan, seam side down.

7. Cover the pan with plastic wrap and let the dough rise until it has doubled in size.

8. Place the brioche in the oven and bake until it is golden brown, 35 to 45 minutes. The brioche should reach an internal temperature of 200°F.

9. Remove from the oven, place the pan on a wire rack, and let it cool before enjoying.

INGREDIENTS:

- 8 OZ. LUKEWARM WATER (90°F)
- 3½ TEASPOONS ACTIVE DRY YEAST
- ⅓ CUP SUGAR
- 12 OZ. ALL-PURPOSE FLOUR, PLUS MORE AS NEEDED
- ¼ CUP COCOA POWDER
- 1 TEASPOON KOSHER SALT
- 1 OZ. UNSALTED BUTTER, SOFTENED
- 3 OZ. CHOCOLATE CHIPS

MOLASSES WHEAT BREAD

YIELD: 1 LOAF / **ACTIVE TIME:** 45 MINUTES / **TOTAL TIME:** 4 HOURS

A hearty bread with a wonderful balance of sweet and earthy flavor.

1. Place the water and yeast in the work bowl of a stand mixer fitted with the dough hook, gently stir, and let the mixture sit until it starts to foam, about 10 minutes.

2. Add the sugar, honey, molasses, flours, oats, cocoa powder, and salt and knead the mixture on low for 1 minute.

3. Add the butter a little at a time with the mixer running. When all of the butter has been added, raise the speed to medium and knead the dough until it begins to pull away from the sides, about 6 minutes.

4. Coat a mixing bowl with nonstick cooking spray. Remove the dough from the work bowl, place it on a flour-dusted work surface, and shape it into a ball. Place the dough in the bowl, cover it with plastic wrap, place it in a naturally warm spot, and let it rise until doubled in size, 1 to 2 hours.

5. Preheat the oven to 350°F. Coat an 8 x 4–inch loaf pan with nonstick cooking spray.

6. Place the dough on a flour-dusted work surface and form it into a tight round. Tuck in the sides to form the dough into a loaf shape and place it in the pan, seam side down.

7. Cover the pan with plastic wrap and let the dough rise until it has doubled in size.

8. Brush the dough with the beaten egg and sprinkle additional oats on top. Using a sharp knife, cut a slit that runs the length of the entire loaf down the center.

9. Place the bread in the oven and bake until it is golden brown, 35 to 45 minutes. The bread should reach an internal temperature of 190°F.

10. Remove from the oven, place the pan on a wire rack, and let it cool before enjoying.

INGREDIENTS:

5	OZ. LUKEWARM WATER (90°F)
2	TEASPOONS ACTIVE DRY YEAST
¾	TEASPOON SUGAR
1	OZ. HONEY
1	OZ. MOLASSES
5	OZ. ALL-PURPOSE FLOUR, PLUS MORE AS NEEDED
3.5	OZ. WHOLE WHEAT FLOUR
1	OZ. ROLLED OATS, PLUS MORE FOR TOPPING
1	TEASPOON COCOA POWDER
1	TEASPOON KOSHER SALT
½	OZ. UNSALTED BUTTER, SOFTENED
1	EGG, BEATEN

GLUTEN-FREE BRIOCHE

YIELD: 1 LOAF / **ACTIVE TIME:** 30 MINUTES / **TOTAL TIME:** 2 HOURS AND 30 MINUTES

Guaranteed to be one of the best gluten-free breads you've ever had. Make sure you check your chosen gluten-free mix before adding the xanthan gum, as some will already include it.

1. Place the water and yeast in the work bowl of a stand mixer fitted with the whisk attachment, gently stir, and let the mixture sit until it starts to foam, about 10 minutes.

2. Add the sugar, eggs, butter, flour, xanthan gum, and salt and whip the mixture on medium for 10 minutes until it is a smooth batter.

3. Coat an 8 x 4–inch loaf pan with nonstick cooking spray. Pour the batter into the pan and bang the pan on the countertop to remove any air bubbles. Cover the pan tightly with plastic wrap, place it in a naturally warm spot, and let it rise until it reaches the lip of the pan, about 1 hour.

4. Preheat the oven to 350°F.

5. Place the pan in the oven and bake until the bread is golden brown, 35 to 45 minutes. The bread should reach an internal temperature of 190°F. Make sure you do not open the oven at any point, as this will cause the bread to collapse.

6. Remove from the oven, place the pan on a wire rack, and let the bread cool completely before enjoying.

INGREDIENTS:

3	OZ. LUKEWARM WATER (90°F)
4½	TEASPOONS ACTIVE DRY YEAST
3.5	OZ. SUGAR
6	EGGS
4	OZ. UNSALTED BUTTER, MELTED
9	OZ. GLUTEN-FREE ALL-PURPOSE FLOUR MIX
1	TABLESPOON XANTHAN GUM
1½	TEASPOONS KOSHER SALT

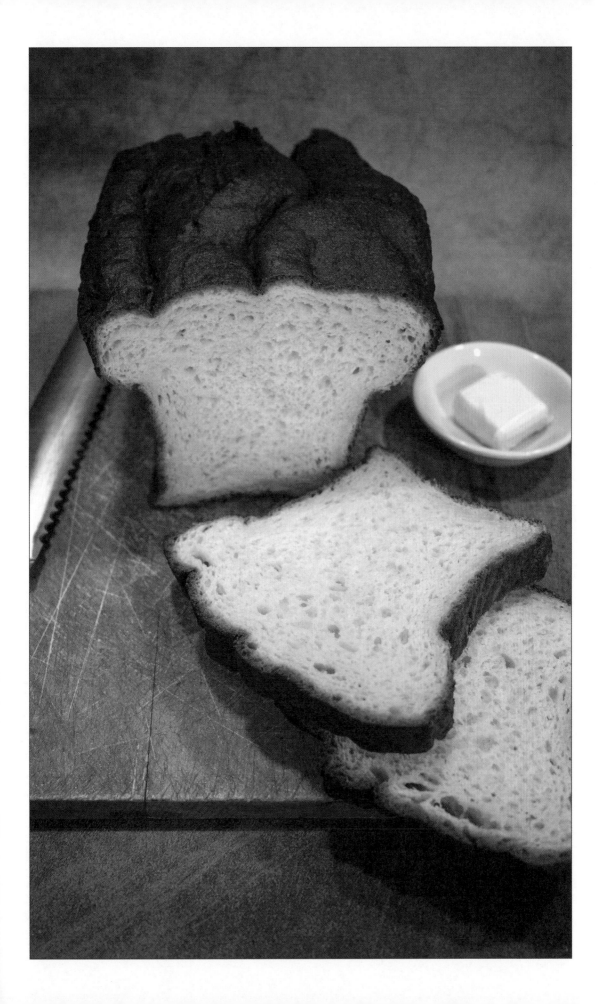

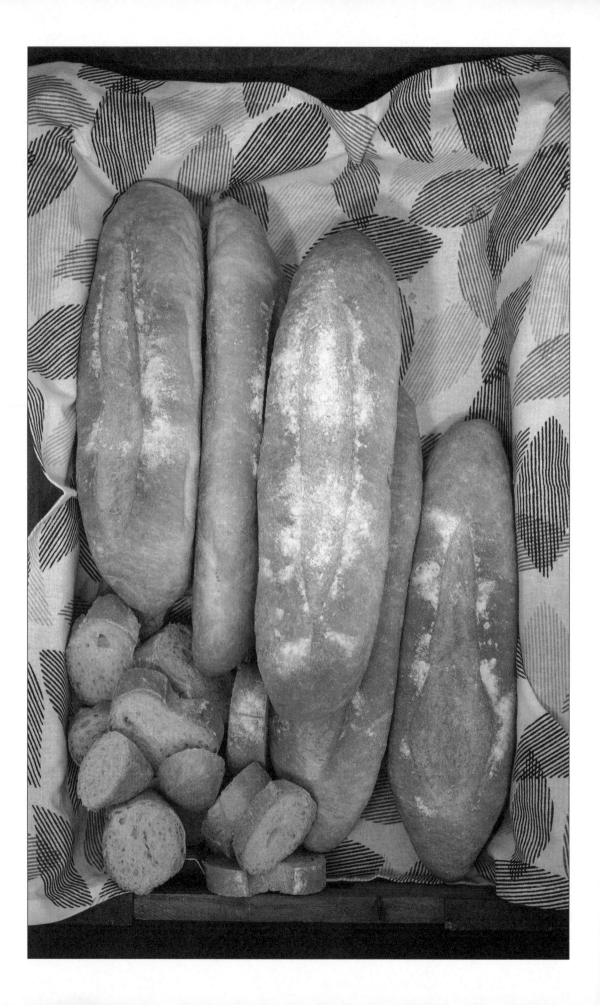

PAN CUBANO

YIELD: 3 LOAVES / ACTIVE TIME: 1 HOUR / TOTAL TIME: 5 HOURS

A traditional Cuban bread that is in the style of a French baguette, but crispier and more flavorful, thanks to the use of lard in the dough.

1. Place the water and yeast in the work bowl of a stand mixer fitted with the dough hook, gently stir, and let the mixture sit until it starts to foam, about 10 minutes.

2. Add the remaining ingredients and knead on low until the mixture comes together as a dough. Raise the speed to medium and knead the dough until it is smooth, about 8 minutes.

3. Place the dough on a flour-dusted surface and knead it into a ball. Return it to the work bowl, cover it with plastic wrap, and let it rise at room temperature until it has doubled in size.

4. Divide the dough into three 12-oz. portions and form them into balls. Coat an 18 x 13–inch sheet pan with nonstick cooking spray. Place the balls of dough on the pan and cover them with plastic wrap. Let the dough rise at room temperature until doubled in size.

5. Punch down one ball of dough until it is a rough oval. Take the side of the dough closest to you and roll it away. Starting halfway up, fold in the corners and roll the dough into a rough baguette shape.

6. Place both hands over the dough. Gently roll the dough while moving your hands back and forth over it and lightly pressing down until it is the length of the baguette pan (about 16 inches).

7. Place the bread on the sheet pan and repeat with the remaining pieces of dough. When all of the dough has been rolled out, place the pieces on the sheet pan, cover them with plastic wrap, and let them rise until they have doubled in size.

8. Preheat the oven to 450°F. Coat a baguette pan with nonstick cooking spray.

9. Using a very sharp knife, cut four slits at a 45-degree angle along the length of each loaf.

10. Place the bread in the oven, spray the oven with 5 spritzes of water, and bake until the bread is a deep golden brown, 20 to 30 minutes.

11. Remove the loaves from the oven, place them on a wire rack, and let them cool slightly before slicing.

INGREDIENTS:

8	OZ. LUKEWARM WATER (90°F)
1	TABLESPOON ACTIVE DRY YEAST
2	TEASPOONS SUGAR
2	OZ. LARD, MELTED
½	OZ. EXTRA-VIRGIN OLIVE OIL
6	OZ. ALL-PURPOSE FLOUR
6	OZ. BREAD FLOUR, PLUS MORE AS NEEDED
1	TABLESPOON KOSHER SALT

HONEY OAT BREAD

YIELD: 1 LOAF / **ACTIVE TIME:** 45 MINUTES / **TOTAL TIME:** 4 HOURS

Wildflower honey, with its potent flavor and subtle floral notes, is recommended for this particular recipe.

1. Place the milk, water, and yeast in the work bowl of a stand mixer fitted with the dough hook, gently stir, and let the mixture sit until it starts to foam, about 10 minutes.

2. Add the ¼ cup of honey, flour, oats, and salt and knead the mixture on low for 1 minute.

3. Add the butter a little at a time with the mixer running. When all of the butter has been added, raise the speed to medium and knead the dough until it begins to pull away from the sides, about 6 minutes.

4. Coat a mixing bowl with nonstick cooking spray. Remove the dough from the work bowl, place it on a flour-dusted work surface, and shape it into a ball. Place the dough in the bowl, cover it with plastic wrap, place it in a naturally warm spot, and let it rise until doubled in size, 1 to 2 hours.

5. Preheat the oven to 350°F. Coat an 8 x 4–inch loaf pan with nonstick cooking spray.

6. Place the dough on a flour-dusted work surface and form it into a tight round. Tuck in the sides to form the dough into a loaf shape and place it in the pan, seam side down.

7. Cover the pan with plastic wrap and let the dough rise until it has doubled in size.

8. Brush the dough with the warmed honey. Using a sharp knife, cut a slit that runs the length of the entire loaf down the center.

9. Place the bread in the oven and bake until it is golden brown, 35 to 45 minutes. The bread should reach an internal temperature of 190°F.

10. Remove from the oven, remove the bread from the pan, place it on a wire rack, and let it cool before enjoying.

INGREDIENTS:

6	OZ. MILK
1	OZ. WATER
2¼	TEASPOONS ACTIVE DRY YEAST
¼	CUP HONEY; PLUS ¼ CUP FOR BRUSHING, WARMED
10	OZ. BREAD FLOUR, PLUS MORE AS NEEDED
1.5	OZ. ROLLED OATS
1	TEASPOON KOSHER SALT
1	OZ. UNSALTED BUTTER, SOFTENED

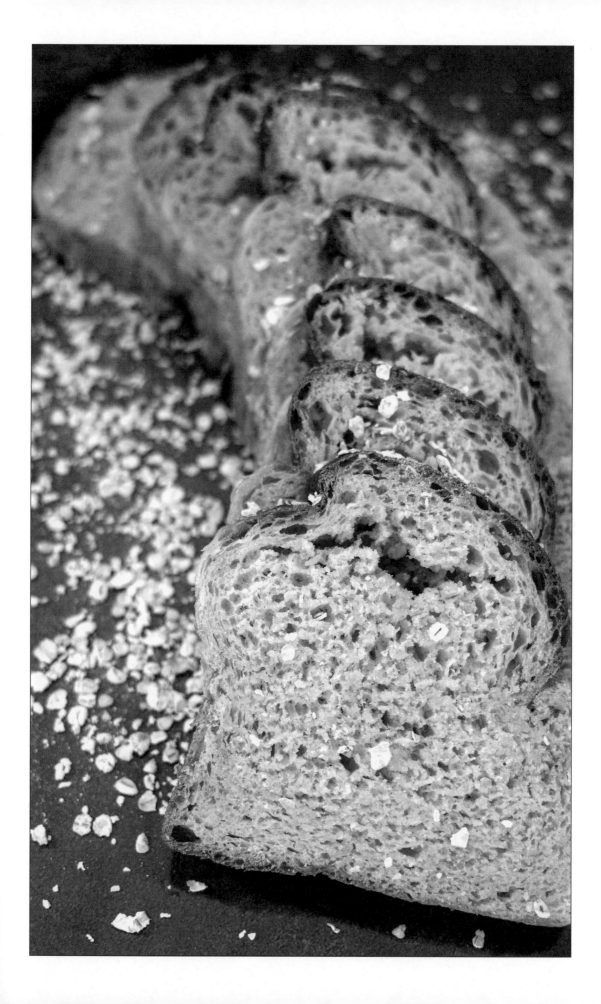

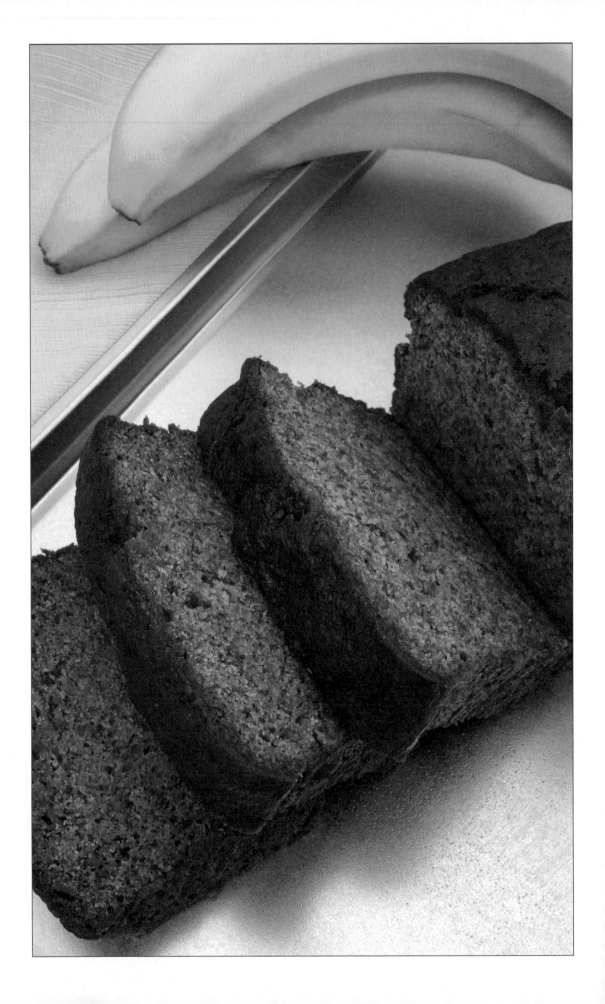

BANANA BREAD

YIELD: 1 LOAF / **ACTIVE TIME:** 15 MINUTES / **TOTAL TIME:** 1 HOUR AND 30 MINUTES

This batter can also be used to make banana muffins.

1. Preheat the oven to 350°F. Coat an 8 x 4–inch loaf pan with nonstick cooking spray.

2. Place the flour, baking soda, cinnamon, nutmeg, ginger, and salt in a mixing bowl and whisk to combine. Set aside.

3. In the work bowl of a stand mixer fitted with the paddle attachment, cream the bananas, brown sugar, sugar, and butter on medium for 5 minutes. Add the oil, eggs, and vanilla and beat until incorporated. Add the dry mixture, reduce the speed to low, and beat until the mixture comes together as a smooth batter. Add the sour cream and beat to incorporate.

4. Pour the batter into the prepared loaf pan, place it in the oven, and bake until a cake tester inserted into the center of the banana bread comes out clean, 60 to 70 minutes.

5. Remove the pan from the oven and place it on a wire rack to cool completely.

INGREDIENTS:

2	CUPS ALL-PURPOSE FLOUR
1	TEASPOON BAKING SODA
¼	TEASPOON CINNAMON
¼	TEASPOON FRESHLY GRATED NUTMEG
	PINCH OF GROUND GINGER
½	TEASPOON KOSHER SALT
3	RIPE BANANAS
4	OZ. LIGHT BROWN SUGAR
6	OZ. SUGAR
2	OZ. UNSALTED BUTTER, SOFTENED
½	CUP EXTRA-VIRGIN OLIVE OIL
2	EGGS
1½	TEASPOONS PURE VANILLA EXTRACT
2	TABLESPOONS SOUR CREAM

RUM & CARAMELIZED BANANA BREAD

YIELD: 1 LOAF / **ACTIVE TIME:** 30 MINUTES / **TOTAL TIME:** 2 HOURS

This is not a typical banana bread. The caramelized bananas and rum intensify the sweetness and flavor.

1. Preheat the oven to 350°F. Coat an 8 x 4–inch loaf pan with nonstick cooking spray.

2. Place the flour, baking soda, cinnamon, allspice, and salt in a mixing bowl and whisk to combine. Set aside.

3. Place the butter in a large skillet and melt it over medium heat. Add the bananas and brown sugar and cook, stirring occasionally, until the bananas start to brown, about 3 minutes. Remove the pan from heat, stir in the rum, and let the mixture steep for 30 minutes.

4. In the work bowl of a stand mixer fitted with the paddle attachment, cream the caramelized banana mixture, sugar, olive oil, eggs, and vanilla on medium for 5 minutes. Add the dry mixture, reduce the speed to low, and beat until the mixture comes together as a smooth batter. Add the crème fraîche and beat to incorporate.

5. Pour the batter into the prepared loaf pan, place it in the oven, and bake until a cake tester inserted into the center of the loaf comes out clean, 60 to 70 minutes.

6. Remove the pan from the oven and place it on a wire rack to cool completely.

INGREDIENTS:

2	CUPS ALL-PURPOSE FLOUR
1	TEASPOON BAKING SODA
¼	TEASPOON CINNAMON
¼	TEASPOON ALLSPICE
½	TEASPOON KOSHER SALT
2	OZ. UNSALTED BUTTER, SOFTENED
3½	RIPE BANANAS, SLICED
4	OZ. LIGHT BROWN SUGAR
2	TABLESPOONS SPICED RUM
6	OZ. SUGAR
½	CUP EXTRA-VIRGIN OLIVE OIL
2	EGGS
1½	TEASPOONS PURE VANILLA EXTRACT
2	TABLESPOONS CRÈME FRAÎCHE

PUMPKIN BREAD

YIELD: 1 LOAF / **ACTIVE TIME:** 15 MINUTES / **TOTAL TIME:** 1 HOUR AND 30 MINUTES

Try enriching this batter with a splash of spiced rum or bourbon. The alcohol will cook off in the oven, but the flavor will be noticeably enhanced.

1. Preheat the oven to 350°F. Coat an 8 x 4–inch loaf pan with nonstick cooking spray.

2. Place the flour, sugar, baking soda, baking powder, cinnamon, ginger, cloves, and salt in a mixing bowl and whisk to combine. Set aside.

3. In the work bowl of a stand mixer fitted with the whisk attachment, whip the pumpkin puree, eggs, and vanilla until combined. Add the dry mixture, reduce the speed to low, and whip until the mixture comes together as a smooth batter.

4. Pour the batter into the prepared loaf pan, place it in the oven, and bake until a cake tester inserted into the center of the loaf comes out clean, 65 to 75 minutes.

5. Remove the pan from the oven and place it on a wire rack to cool completely.

INGREDIENTS:

10	OZ. ALL-PURPOSE FLOUR
13	OZ. SUGAR
2¼	TEASPOONS BAKING SODA
½	TEASPOON BAKING POWDER
2¼	TEASPOON CINNAMON
2¼	TEASPOONS GROUND GINGER
¼	TEASPOON GROUND CLOVES
¼	TEASPOON KOSHER SALT
15	OZ. PUMPKIN PUREE
3	EGGS
1½	TEASPOONS PURE VANILLA EXTRACT

CLASSIC GINGERBREAD

YIELD: 1 LOAF / **ACTIVE TIME:** 15 MINUTES / **TOTAL TIME:** 1 HOUR AND 30 MINUTES

Softer and moister than the cookie most people picture when they hear the term, this gingerbread is a serious threat to become your favorite winter tradition.

1. Preheat the oven to 350°F. Coat an 8 x 4–inch loaf pan with nonstick cooking spray.

2. Place the flour, salt, baking soda, ginger, cinnamon, nutmeg, cloves, and allspice in a mixing bowl and whisk to combine. Set aside.

3. Combine the molasses and sour cream in a measuring cup and set the mixture aside.

4. In the work bowl of a stand mixer fitted with the paddle attachment, cream the butter and brown sugar on medium until light and fluffy, about 5 minutes. Add half of the dry mixture and beat until incorporated. Add half of the molasses mixture, beat until incorporated, and then add the remaining dry mixture. Beat to incorporate, add the remaining molasses mixture, and beat until the mixture comes together as a smooth batter.

5. Pour the batter into the prepared loaf pan, place it in the oven, and bake until a cake tester inserted into the center of the loaf comes out clean, 50 to 60 minutes.

6. Remove the pan from the oven and place it on a wire rack to cool completely.

INGREDIENTS:

7.4	OZ. ALL-PURPOSE FLOUR
½	TEASPOON KOSHER SALT
⅛	TEASPOON BAKING SODA
2½	TEASPOONS GROUND GINGER
1½	TEASPOONS CINNAMON
1	TEASPOON FRESHLY GRATED NUTMEG
½	TEASPOON GROUND CLOVES
½	TEASPOON ALLSPICE
¼	CUP MOLASSES
¼	CUP SOUR CREAM
8	OZ. UNSALTED BUTTER, SOFTENED
8	OZ. DARK BROWN SUGAR
4	EGGS

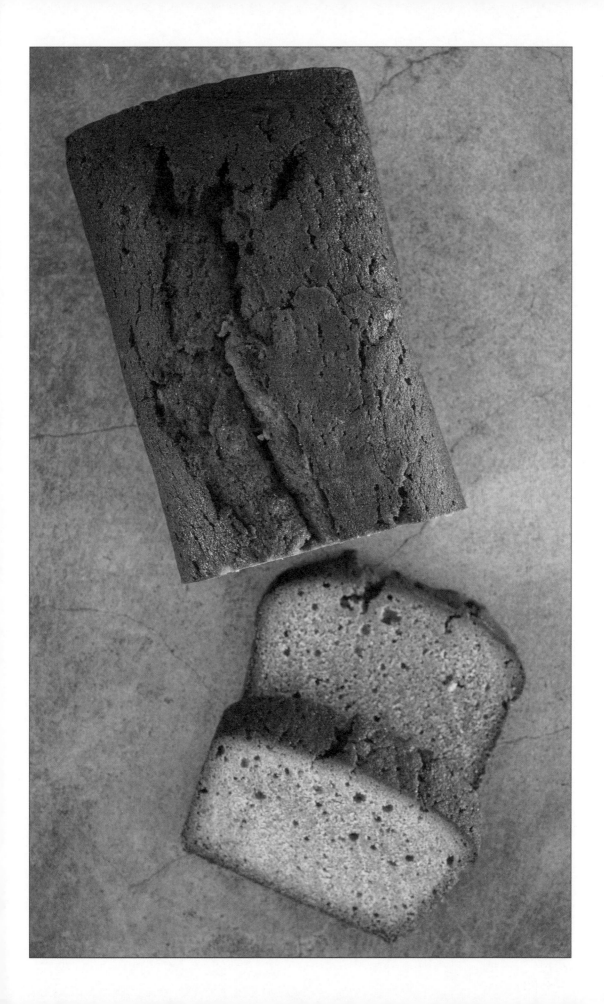

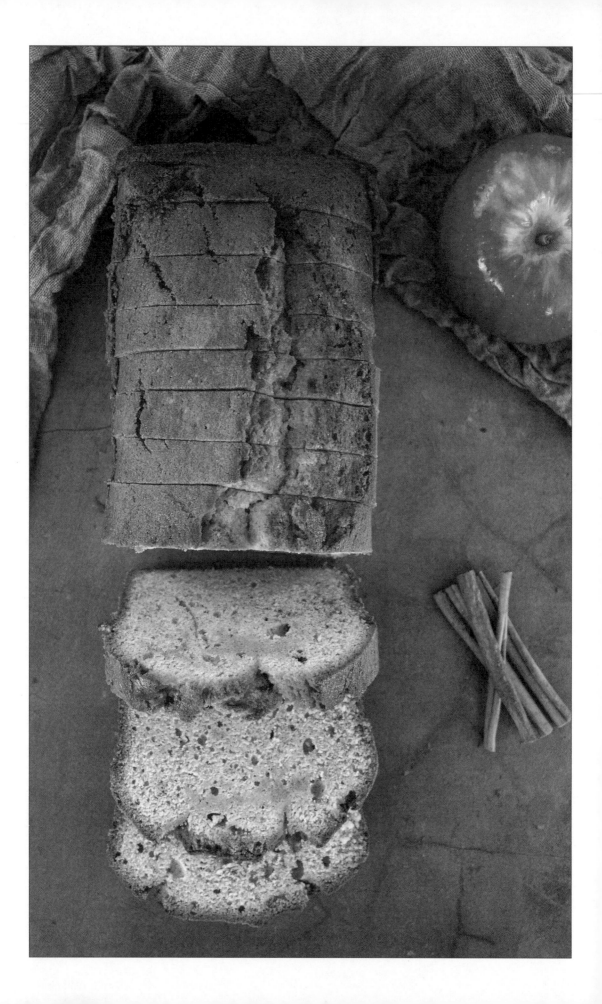

APPLE BREAD

YIELD: 1 LOAF / **ACTIVE TIME:** 15 MINUTES / **TOTAL TIME:** 1 HOUR AND 30 MINUTES

The applesauce and honey syrup add a sweet and moist decadence to this seemingly standard loaf.

1. Preheat the oven to 350°F. Coat an 8 x 4–inch loaf pan with nonstick cooking spray.

2. Place the flour, cinnamon, ginger, cloves, baking soda, and salt in a mixing bowl and whisk to combine. Set aside.

3. In the work bowl of a stand mixer fitted with the paddle attachment, cream the butter, sugar, brown sugar, canola oil, and vanilla on medium until light and fluffy, about 5 minutes. Add the eggs and applesauce and beat to incorporate. Add half of the dry mixture and beat until incorporated. Add half of the milk, beat to incorporate, and then add the remaining dry mixture. Beat to incorporate, add the remaining milk, and beat until the mixture comes together as a smooth batter.

4. Pour the batter into the prepared loaf pan, place it in the oven, and bake until a cake tester inserted into the center of the loaf comes out clean, 50 to 60 minutes.

5. Remove the pan from the oven and place it on a wire rack to cool slightly.

6. Brush the bread with the syrup and let the bread cool completely before slicing and enjoying.

HONEY SYRUP

1. Place the water and honey in a small saucepan and bring the mixture to a boil, stirring to dissolve the honey. Remove the pan from heat and let the syrup cool completely before using or storing.

INGREDIENTS:

26.7	OZ. ALL-PURPOSE FLOUR
4	TEASPOONS CINNAMON
1	TEASPOON GROUND GINGER
½	TEASPOON GROUND CLOVES
4	TEASPOONS BAKING SODA
1	TEASPOON KOSHER SALT
8	OZ. UNSALTED BUTTER, SOFTENED
20	OZ. SUGAR
7	OZ. DARK BROWN SUGAR
½	CUP CANOLA OIL
1	TABLESPOON PURE VANILLA EXTRACT
6	EGGS
2	OZ. APPLESAUCE
1½	CUPS MILK
	HONEY SYRUP (SEE RECIPE)

HONEY SYRUP

½	CUP WATER
½	CUP HONEY

BUTTERMILK BISCUITS

YIELD: 12 BISCUITS / **ACTIVE TIME:** 30 MINUTES / **TOTAL TIME:** 1 HOUR

If you can track it down, the White Lily brand of flour is what helps the South be recognized as the home of great biscuits.

1. Preheat the oven to 425°F. Line a baking sheet with parchment paper.

2. Place the 2 cups of the buttermilk and the honey in a measuring cup and whisk to combine. Set the mixture aside.

3. Place the flour, salt, baking powder, and chilled butter in the work bowl of a stand mixer fitted with the paddle attachment and beat the mixture until combined and the butter has been reduced to pea-sized pieces, 5 to 10 minutes. Gradually add the buttermilk mixture and beat the mixture until it comes together as a slightly crumbly dough.

4. Transfer the dough to a flour-dusted work surface. Working with generously flour-dusted hands and a roller, roll the dough into a ¾-inch-thick rectangle.

5. Using a bench scraper, cut the dough into thirds and stack them on top of each other. Roll the dough out again into a ¾ inch-thick rectangle.

6. Cut the dough into twelve 3-inch squares and arrange them on the baking sheet. Brush the tops of the biscuits with the ½ cup of buttermilk.

7. Place the biscuits in the oven and bake until they are golden brown, 15 to 17 minutes.

8. Remove from the oven and place the biscuits on a wire rack to cool slightly. Brush them with the melted butter and enjoy warm.

INGREDIENTS:

- **2** CUPS BUTTERMILK, PLUS ½ CUP
- **¼** CUP HONEY
- **26** OZ. ALL-PURPOSE FLOUR, PLUS MORE AS NEEDED
- **1** TABLESPOON KOSHER SALT
- **3** TABLESPOONS BAKING POWDER
- **8** OZ. UNSALTED BUTTER, CHILLED AND CUBED; PLUS ¼ CUP, MELTED

ZUCCHINI BREAD

YIELD: 1 LOAF / **ACTIVE TIME:** 15 MINUTES / **TOTAL TIME:** 1 HOUR AND 30 MINUTES

Perhaps the best way to use up zucchini fresh from the garden during the summer.

1. Preheat the oven to 350°F. Coat an 8 x 4–inch loaf pan with nonstick cooking spray.

2. Place the flour, baking soda, baking powder, salt, and cinnamon in a mixing bowl and whisk to combine. Set aside.

3. In the work bowl of a stand mixer fitted with the whisk attachment, beat the zucchini, olive oil, sugar, brown sugar, and eggs on medium for 5 minutes. Add the dry mixture, reduce the speed to low, and beat until it comes together as a batter.

4. Pour the batter into the prepared loaf pan, place it in the oven, and bake until a cake tester inserted into the center of the loaf comes out clean, 45 to 55 minutes.

5. Remove the pan from the oven and place it on a wire rack to cool completely.

INGREDIENTS:

14	OZ. ALL-PURPOSE FLOUR
1	TEASPOON BAKING SODA
1	TEASPOON BAKING POWDER
1	TEASPOON KOSHER SALT
1	TABLESPOON CINNAMON
2	ZUCCHINI, GRATED
1	CUP EXTRA-VIRGIN OLIVE OIL
8	OZ. SUGAR
8	OZ. LIGHT BROWN SUGAR
3	EGGS

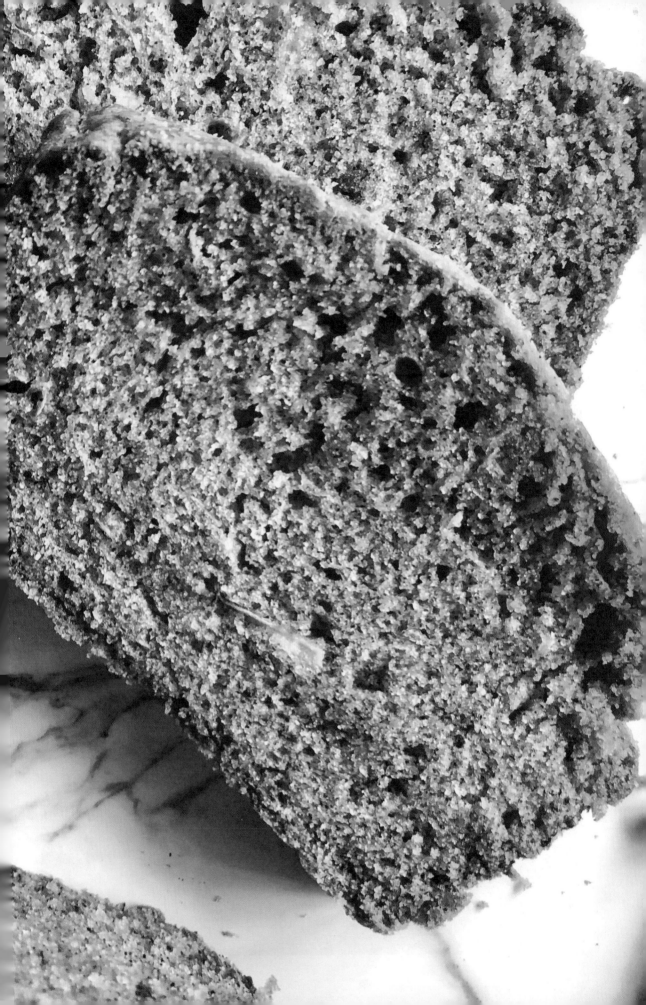

HONEY CORNBREAD

YIELD: 12 SERVINGS / **ACTIVE TIME:** 20 MINUTES / **TOTAL TIME:** 1 HOUR

The honey-and-butter spread gives this recipe all the warmth, comfort, and sweetness one expects from homemade cornbread.

1. Preheat the oven to 350°F. Coat a 13 x 9–inch baking pan with nonstick cooking spray.

2. Place the honey and 4 oz. of the butter in a small saucepan and warm over medium heat until the butter has melted. Whisk to combine, and set the mixture aside.

3. Place the flour, cornmeal, baking powder, and salt in a mixing bowl and whisk to combine. Set the mixture aside.

4. In the work bowl of a stand mixer fitted with the paddle attachment, cream the remaining butter and the sugar on medium until light and fluffy, about 5 minutes. Add the eggs and beat until incorporated. Add the dry mixture, reduce the speed to low, and beat until the mixture comes together as a smooth batter. Gradually add the milk and beat until incorporated.

5. Pour the batter into the pan, place the pan in the oven, and bake until a cake tester inserted into the center of the cornbread comes out clean, 25 to 30 minutes.

6. Remove from the oven and place the pan on a wire rack. Brush the cornbread with the honey butter and serve it warm.

INGREDIENTS:

½	CUP HONEY
12	OZ. UNSALTED BUTTER, SOFTENED
1	LB. ALL-PURPOSE FLOUR
8	OZ. CORNMEAL
1	TABLESPOON BAKING POWDER, PLUS 1 TEASPOON
1	TABLESPOON KOSHER SALT
7	OZ. SUGAR
4	EGGS
2	CUPS MILK

JALAPEÑO & CHEDDAR CORNBREAD

YIELD: 12 SERVINGS / ACTIVE TIME: 20 MINUTES / TOTAL TIME: 1 HOUR

A gooey and spicy cornbread that is the perfect balance of sweet, savory, and spicy.

1. Preheat the oven to 350°F. Coat a 13 x 9–inch baking pan with nonstick cooking spray.

2. Place the flour, cornmeal, baking powder, salt, jalapeños, and cheese in a mixing bowl and whisk to combine. Set the mixture aside.

3. In the work bowl of a stand mixer fitted with the paddle attachment, cream the butter and sugar on medium until light and fluffy, about 5 minutes. Add the eggs and beat until incorporated. Add the dry mixture, reduce the speed to low, and beat until the mixture comes together as a smooth batter. Gradually add the milk and beat until incorporated.

4. Pour the batter into the pan, place the pan in the oven, and bake until a cake tester inserted into the center of the cornbread comes out clean, 25 to 30 minutes.

5. Remove from the oven and place the pan on a wire rack. Let the cornbread cool slightly before slicing and serving.

INGREDIENTS:

1	LB. ALL-PURPOSE FLOUR
8	OZ. CORNMEAL
1	TABLESPOON BAKING POWDER, PLUS 1 TEASPOON
1	TABLESPOON KOSHER SALT
3	JALAPEÑO CHILE PEPPERS, STEMMED, SEEDED, AND DICED
2	CUPS SHREDDED CHEDDAR CHEESE
8	OZ. UNSALTED BUTTER, SOFTENED
7	OZ. SUGAR
4	EGGS
2	CUPS MILK

CHEDDAR & CHIVE BISCUITS

YIELD: 12 BISCUITS / ACTIVE TIME: 30 MINUTES / TOTAL TIME: 1 HOUR

The bright, onion-y taste of chives positions these biscuits to function as an ideal partner for numerous entrees.

1. Preheat the oven to 425°F. Line a baking sheet with parchment paper.

2. Place the 2 cups of buttermilk and the honey in a measuring cup and whisk to combine. Set the mixture aside.

3. Place the flour, salt, baking powder, chilled butter, chives, and cheese in the work bowl of a stand mixer fitted with the paddle attachment and beat the mixture until combined and the butter has been reduced to pea-sized pieces, 5 to 10 minutes. Gradually add the buttermilk mixture and beat the mixture until it comes together as a slightly crumbly dough.

4. Transfer the dough to a flour-dusted work surface. Working with generously flour-dusted hands and a roller, roll the dough into a ¾-inch-thick rectangle.

5. Using a bench scraper, cut the dough into thirds and stack them on top of each other. Roll the dough out again into a ¾-inch-thick rectangle.

6. Cut the dough into twelve 3-inch squares and arrange them on the baking sheet. Brush the tops of the biscuits with the ½ cup of buttermilk.

7. Place the biscuits in the oven and bake until they are golden brown, 15 to 17 minutes.

8. Remove from the oven and place the biscuits on a wire rack to cool slightly. Brush them with the melted butter and enjoy warm.

INGREDIENTS:

2	CUPS BUTTERMILK, PLUS ½ CUP
¼	CUP HONEY
26	OZ. ALL-PURPOSE FLOUR, PLUS MORE AS NEEDED
1	TABLESPOON KOSHER SALT
3	TABLESPOONS BAKING POWDER
8	OZ. UNSALTED BUTTER, CHILLED AND CUBED; PLUS ¼ CUP, MELTED
2	TABLESPOONS FINELY CHOPPED FRESH CHIVES
2	CUPS SHREDDED CHEDDAR CHEESE

GRAHAM CRACKERS

YIELD: 20 CRACKERS / **ACTIVE TIME:** 30 MINUTES / **TOTAL TIME:** 2 HOURS

Almost every graham cracker is great. But this homemade version has no weaknesses, avoiding the overly dry quality that can stop an indulgence in its tracks.

1. Place the honey, milk, and vanilla in a measuring cup and whisk to combine.

2. Place the flour, brown sugar, baking soda, salt, and butter in the work bowl of a stand mixer fitted with the paddle attachment and beat the mixture until combined and the butter has been reduced to pea-sized pieces, 5 to 10 minutes.

3. Gradually add the milk mixture and beat until the mixture comes together as a soft dough. Cover the dough in plastic wrap and chill it in the refrigerator for at least 1 hour.

4. Preheat the oven to 350°F. Line a 26 x 18–inch sheet pan with parchment paper.

5. Place the dough on a flour-dusted work surface and roll it out to ¼ inch thick. Cut the dough into twenty 2 x 5–inch rectangles, transfer them to the baking sheet, and use a fork to poke holes in each one.

6. Place the crackers in the oven and bake them until they are the desired level of crispness, 10 to 12 minutes.

7. Remove the crackers from the oven, place the pan on a wire rack, and let them cool completely.

INGREDIENTS:

½	CUP HONEY
5	TABLESPOONS MILK
2	TABLESPOONS PURE VANILLA EXTRACT
15	OZ. ALL-PURPOSE FLOUR, PLUS MORE AS NEEDED
1	CUP LIGHT BROWN SUGAR
1	TEASPOON BAKING SODA
½	TEASPOON KOSHER SALT
3.5	OZ. UNSALTED BUTTER, CHILLED AND CUBED

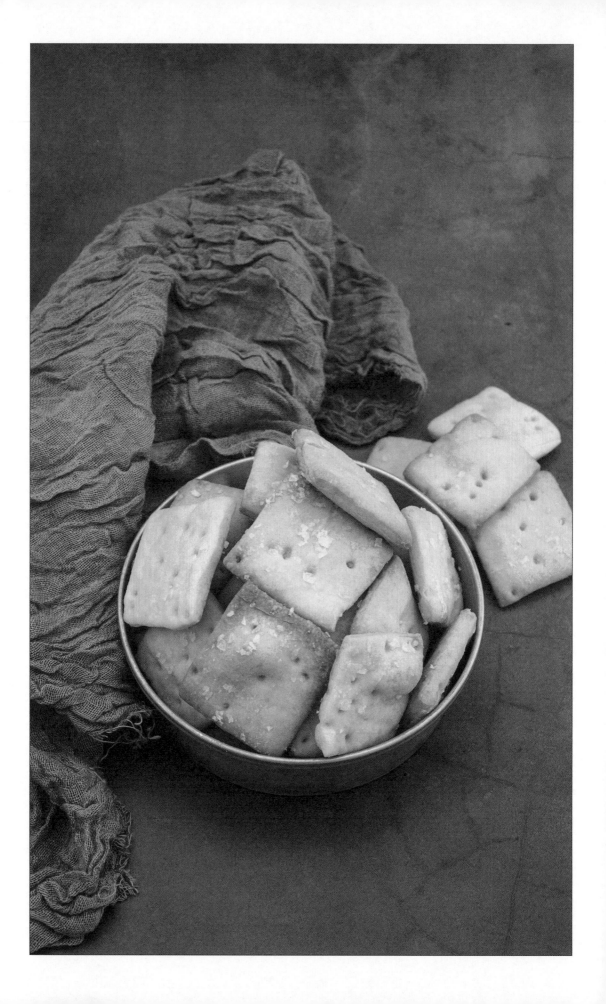

SALTINES

YIELD: 30 CRACKERS / **ACTIVE TIME:** 30 MINUTES / **TOTAL TIME:** 2 HOURS

A bit of cultured butter on these makes for one of the simplest, and best, treats civilization has devised thus far.

1. Place the water and yeast in the work bowl of a stand mixer, gently stir, and let the mixture sit until it starts to foam, about 10 minutes.

2. Add the olive oil to the work bowl and beat the mixture on medium for 1 minute. Add the flour and kosher salt and beat the mixture until it comes together as a soft dough. Cover the dough in plastic wrap and chill it in the refrigerator for at least 1 hour.

3. Preheat the oven to 350°F. Line a 26 x 18–inch sheet pan with parchment paper.

4. Place the dough on a flour-dusted work surface and roll it out to ⅛ inch thick. Cut the dough into thirty 2-inch squares, transfer them to the baking sheet, and use a fork to poke holes in each one. Sprinkle the sea salt over the crackers.

5. Place the crackers in the oven and bake them until the edges are golden brown, 12 to 15 minutes.

6. Remove the crackers from the oven, place the pan on a wire rack, and let them cool completely.

INGREDIENTS:

12.5 OZ. WATER, AT ROOM TEMPERATURE

1 TABLESPOON ACTIVE DRY YEAST

½ CUP EXTRA-VIRGIN OLIVE OIL

2 LBS. BREAD FLOUR, PLUS MORE AS NEEDED

1 TABLESPOON KOSHER SALT

MALDON SEA SALT, FOR TOPPING

STOUT GINGERBREAD

YIELD: 1 LOAF / ACTIVE TIME: 15 MINUTES / TOTAL TIME: 1 HOUR AND 30 MINUTES

If you can find one of the marshmallow stouts that some craft breweries are now turning out, that will add yet another layer of flavor to this lovely gingerbread.

1. Preheat the oven to 350°F. Coat an 8 x 4–inch loaf pan with nonstick cooking spray.

2. Place the flour, baking powder, ginger, cinnamon, cloves, nutmeg, and salt in a mixing bowl and whisk to combine. Set aside.

3. Combine the molasses and stout in a small saucepan and bring it to a simmer over medium heat. Remove the pan from heat and whisk in the baking soda. Set the mixture aside.

4. In the work bowl of a stand mixer fitted with the paddle attachment, beat the eggs, sugar, dark brown sugar, and canola oil on medium until light and fluffy, about 5 minutes. Add the molasses mixture, beat until incorporated, and then add the dry mixture. Reduce the speed to low and beat until the mixture comes together as a smooth batter.

5. Pour the batter into the prepared loaf pan, place it in the oven, and bake until a cake tester inserted into the center of the loaf comes out clean, 50 to 60 minutes.

6. Remove the pan from the oven and place it on a wire rack to cool completely.

INGREDIENTS:

10	OZ. ALL-PURPOSE FLOUR
1½	TEASPOONS BAKING POWDER
2	TABLESPOONS GROUND GINGER
½	TEASPOON CINNAMON
½	TEASPOON GROUND CLOVES
¼	TEASPOON FRESHLY GRATED NUTMEG
¼	TEASPOON KOSHER SALT
1	CUP MOLASSES
1	CUP STOUT
1½	TEASPOONS BAKING SODA
3	EGGS
4	OZ. SUGAR
4	OZ. DARK BROWN SUGAR
¾	CUP CANOLA OIL

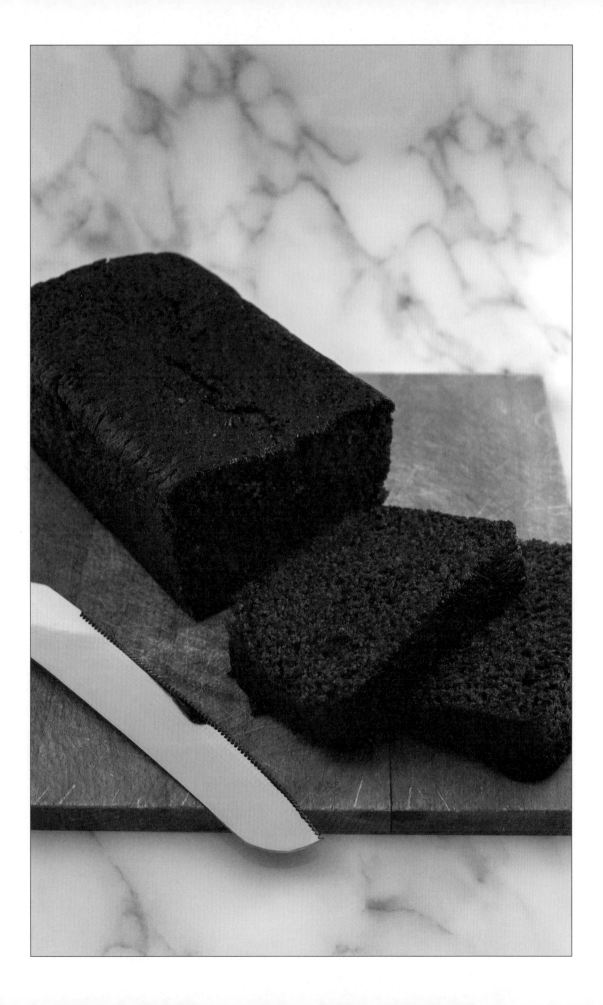

ESSENTIAL ACCOMPANIMENTS

Although the most important pieces of the book are now past, the preparations in this chapter are crucial enhancements that will enable you to add contrasting flavors, decorative flourishes, and much more. Yes, you can easily purchase many of these cornerstones at your local grocery store, but we're certain you'll feel better tackling tough preparations and serving them to your loved ones if you get in the habit of whipping them up yourself.

While these recipes are meant to form partnerships with the other recipes, a number of them—such as the Butterscotch Pastry Cream (see page 675) and Milk Chocolate Crémeux (see page 706)—are treats in their own right, able to delight with nothing further required.

CHOCOLATE GANACHE

YIELD: 1½ CUPS / **ACTIVE TIME:** 10 MINUTES / **TOTAL TIME:** 15 MINUTES

The key to adding a bit of chocolate and beauty to your cakes and pies. This preparation will work with any chocolate.

1. Place the chocolate in a heatproof mixing bowl and set aside.

2. Place the heavy cream in a small saucepan and bring to a simmer over medium heat.

3. Pour the cream over the chocolate and let the mixture rest for 1 minute.

4. Gently whisk the mixture until thoroughly combined. Use immediately if you are drizzling over a cake or serving with fruit. Let the ganache cool for 2 hours if you are piping. The ganache will keep in the refrigerator for up to 5 days.

INGREDIENTS:

8	OZ. CHOCOLATE
1	CUP HEAVY CREAM

BUTTERFLUFF FILLING

YIELD: 4 CUPS / **ACTIVE TIME:** 10 MINUTES / **TOTAL TIME:** 10 MINUTES

A go-to filling for cakes, whoopie pies, and cookie sandwiches.

1. In the work bowl of a stand mixer fitted with the paddle attachment, cream the marshmallow creme and butter on medium until the mixture is light and fluffy, about 5 minutes.

2. Add the confectioners' sugar, vanilla, and salt, reduce the speed to low, and beat for 2 minutes. Use immediately, or store in the refrigerator for up to 1 month.

INGREDIENTS:

- 8 OZ. MARSHMALLOW CREME
- 10 OZ. UNSALTED BUTTER, SOFTENED
- 11 OZ. CONFECTIONERS' SUGAR
- 1½ TEASPOONS PURE VANILLA EXTRACT
- ¾ TEASPOON KOSHER SALT

CHANTILLY CREAM

YIELD: 2 CUPS / **ACTIVE TIME:** 5 MINUTES / **TOTAL TIME:** 5 MINUTES

Chantilly Cream is a sweet, vanilla-infused whipped cream that transforms a simple dessert into an event.

1. In the work bowl of a stand mixer fitted with the whisk attachment, whip the heavy cream, sugar, and vanilla on high until the mixture holds soft peaks.

2. Use immediately, or store in the refrigerator for up to 3 days.

INGREDIENTS:

2 CUPS HEAVY CREAM

3 TABLESPOONS SUGAR

1 TEASPOON PURE VANILLA EXTRACT

PASTRY CREAM

YIELD: 2½ CUPS / **ACTIVE TIME:** 20 MINUTES / **TOTAL TIME:** 2 HOURS AND 30 MINUTES

A delightful, straightforward custard that can be used to fill cream puffs, doughnuts, eclairs, and much more.

1. Place the sugar, egg yolks, and cornstarch in a small bowl and whisk until the mixture is a pale yellow.

2. Place the milk in a medium saucepan and bring it to a boil over medium heat. Remove the pan from heat and gradually add the milk to the egg yolk mixture while whisking continually.

3. Place the tempered egg yolks in the saucepan and warm them over medium-low heat until they thicken and begin to bubble, whisking continually. Remove the pan from heat and whisk in the salt, vanilla, and butter.

4. Strain the custard through a fine mesh strainer into a small bowl.

5. Place plastic wrap directly on the custard to prevent a skin from forming.

6. Place in the refrigerator and chill for at least 2 hours before using. The custard will keep in the refrigerator for up to 5 days.

INGREDIENTS:

½	CUP SUGAR
6	EGG YOLKS
3	TABLESPOONS CORNSTARCH
2	CUPS MILK
¼	TEASPOON KOSHER SALT
1½	TEASPOONS PURE VANILLA EXTRACT
2	OZ. UNSALTED BUTTER, SOFTENED

AUTUMN-SPICED PASTRY CREAM

YIELD: 2½ CUPS / **ACTIVE TIME:** 30 MINUTES / **TOTAL TIME:** 2 HOURS AND 30 MINUTES

A spiced, creamy custard that provides the finishing touch to any holiday dessert.

1. In a mixing bowl, add the sugar, cornstarch, and egg yolks and whisk until combined, about 2 minutes. Set the mixture aside.

2. Place the milk, cinnamon, nutmeg, ginger, and cloves in a saucepan and bring to a simmer over medium heat. Remove the pan from heat.

3. Slowly pour half of the hot milk mixture into the egg mixture and stir until incorporated. Add the salt and vanilla, stir to incorporate, and pour the tempered egg mixture into the saucepan. Cook, while stirring constantly, until the mixture is very thick and about to come to a boil.

4. Remove the pan from heat, add the butter, and stir until thoroughly incorporated.

5. Strain the custard through a fine-mesh strainer into a small bowl.

6. Place plastic wrap directly on the surface to prevent a skin from forming. Refrigerate for about 2 hours. This will keep in the refrigerator for up to 5 days.

INGREDIENTS:

½	CUP SUGAR
3	TABLESPOONS CORNSTARCH
6	EGG YOLKS
2	CUPS WHOLE MILK
1½	TEASPOONS CINNAMON
1	TEASPOON FRESHLY GRATED NUTMEG
½	TEASPOON GROUND GINGER
⅛	TEASPOON GROUND CLOVES
¼	TEASPOON KOSHER SALT
1½	TEASPOONS PURE VANILLA EXTRACT
2	OZ. UNSALTED BUTTER, SOFTENED

BUTTERSCOTCH PASTRY CREAM

YIELD: 2½ CUPS / **ACTIVE TIME:** 30 MINUTES / **TOTAL TIME:** 2 HOURS AND 30 MINUTES

A rich custard with deep notes of caramelized sugar and butter. This can be used as a filling, or stand on its own as butterscotch pudding.

1. In a small bowl, combine the cornstarch and egg yolks and whisk for 2 minutes. Set the mixture aside.

2. Place the brown sugar and water in a saucepan, fit the pan with a candy thermometer, and cook over high heat until the thermometer reads 290°F.

3. Remove the pan from the heat. While whisking, slowly add the milk to the sugar. Be careful, as the mixture will most likely splatter. Place the pan over high heat and bring the mix back to a simmer. Remove the pan from heat.

4. Slowly pour half of the hot milk mixture into the egg mixture and stir until incorporated. Add the salt and vanilla extract, stir to incorporate, and pour the tempered egg mixture into the saucepan. Cook, while stirring constantly, until the mixture is very thick and about to come to a boil. Remove the pan from heat.

5. Add the salt, vanilla, and butter and whisk until fully incorporated.

6. Strain the pastry cream through a fine-mesh strainer into a small bowl.

7. Place plastic wrap directly on the surface to prevent a skin from forming. Refrigerate for about 2 hours. This will keep in the refrigerator for up to 5 days.

INGREDIENTS:

- 3 TABLESPOONS CORNSTARCH
- 6 EGG YOLKS
- ½ CUP LIGHT BROWN SUGAR
- 2 TABLESPOONS WATER
- 2 CUPS MILK
- ¼ TEASPOON KOSHER SALT
- 1½ TEASPOONS PURE VANILLA EXTRACT
- 2 OZ. UNSALTED BUTTER, SOFTENED

SUMMER BERRY COMPOTE

YIELD: 2 CUPS / **ACTIVE TIME:** 20 MINUTES / **TOTAL TIME:** 1 HOUR

Use this as a filling in fruit tarts, or to top parfaits and cakes.

1. Place the berries, lemon zest, lemon juice, and sugar in a medium saucepan and cook over medium heat until the berries begin to burst and release their liquid, about 10 minutes.

2. Stir in the cornstarch, salt, and vanilla and reduce the heat to medium-low. Cook, stirring occasionally, until the mixture thickens slightly.

3. Remove the pan from the heat and let the compote cool completely before storing in an airtight container. The compote can be served warm or chilled. It will keep in the refrigerator for up to 1 week.

INGREDIENTS:

4 PINTS OF ASSORTED FRESH BERRIES

 ZEST AND JUICE OF 1 LEMON

1 CUP SUGAR

3 TABLESPOONS CORNSTARCH

¼ TEASPOON KOSHER SALT

2 TEASPOONS PURE VANILLA EXTRACT

CINNAMON CHANTILLY CREAM

YIELD: 2 CUPS / **ACTIVE TIME:** 5 MINUTES / **TOTAL TIME:** 5 MINUTES

Use this spiced whipped cream to add a bit of flair to any autumn-inclined dessert.

1. In the work bowl of a stand mixer fitted with the whisk attachment, whip the heavy cream, sugar, cinnamon, and vanilla on high until the mixture holds soft peaks.

2. Use immediately, or store in the refrigerator for up to 3 days.

INGREDIENTS:

2 CUPS HEAVY CREAM

¼ CUP CONFECTIONERS' SUGAR

1 TABLESPOON CINNAMON

1 TEASPOON PURE VANILLA EXTRACT

HONEY GLAZE

YIELD: 1½ CUPS / **ACTIVE TIME:** 5 MINUTES / **TOTAL TIME:** 5 MINUTES

That sweet taste of Sunday mornings that we all remember from childhood.

1. In a mixing bowl, combine all of the ingredients and whisk well.

2. If the glaze is too thick, incorporate tablespoons of milk until it reaches the desired consistency. If too thin, incorporate tablespoons of confectioners' sugar. Use immediately, or store in the refrigerator for up to 5 days.

INGREDIENTS:

½ CUP MILK, PLUS MORE AS NEEDED

1 TABLESPOON HONEY

¼ TEASPOON KOSHER SALT

1 LB. CONFECTIONERS' SUGAR, PLUS MORE AS NEEDED

APRICOT GLAZE

YIELD: 2 CUPS / **ACTIVE TIME:** 10 MINUTES / **TOTAL TIME:** 40 MINUTES

Essential for bestowing an eye-catching sheen on your danish and other pastries.

1. Place the apricot jam and water in a saucepan and warm over medium heat until it is about to come to a simmer, stirring occasionally.

2. Strain the mixture through a fine mesh strainer and let it cool until just above room temperature before using or storing in the refrigerator, where it will keep for up to 2 weeks. If storing in the refrigerator, add a little water and warm it in a saucepan before using.

INGREDIENTS:

2 CUPS APRICOT JAM (SEE PAGE 721)

¼ CUP WATER

VANILLA GLAZE

YIELD: 1½ CUPS / **ACTIVE TIME:** 5 MINUTES / **TOTAL TIME:** 5 MINUTES

This is intended for the doughnuts in this book, but it's equally delightful on cakes and cookies.

1. In a mixing bowl, whisk all of the ingredients until combined.

2. If the glaze is too thick, incorporate tablespoons of milk until it reaches the desired consistency. If too thin, incorporate tablespoons of confectioners' sugar. Use immediately, or store in the refrigerator for up to 5 days.

INGREDIENTS:

½ CUP MILK, PLUS MORE AS NEEDED

¼ TEASPOON PURE VANILLA EXTRACT

1 LB. CONFECTIONERS' SUGAR, PLUS MORE AS NEEDED

CREAM CHEESE GLAZE

YIELD: 1½ CUPS / **ACTIVE TIME:** 10 MINUTES / **TOTAL TIME:** 10 MINUTES

A great match for any of the cake doughnuts in this book, and it's just as good on muffins.

1. In the work bowl of a stand mixer fitted with the paddle attachment, cream the butter and cream cheese on medium until the mixture is thoroughly combined and smooth.

2. Add the confectioners' sugar and beat until incorporated.

3. Add the vanilla extract and milk and beat until incorporated.

4. Use immediately or store in the refrigerator, where it will keep for up to 5 days.

INGREDIENTS:

6　OZ. CREAM CHEESE

3　OZ. UNSALTED BUTTER, SOFTENED

1　LB. CONFECTIONERS' SUGAR

½　TEASPOON PURE VANILLA EXTRACT

¼　CUP MILK

DARK CHOCOLATE GLAZE

YIELD: 3 CUPS / **ACTIVE TIME:** 15 MINUTES / **TOTAL TIME:** 15 MINUTES

The perfect finish to any cake or pastry for an earthy dark chocolate flavor.

1. Fill a small saucepan halfway with water and bring it to a gentle simmer. Combine the butter and dark chocolate in a heatproof bowl and place it over the simmering water. Heat it, stirring occasionally, until the mixture is melted and smooth.

2. Remove the pan from heat and whisk in the corn syrup, vanilla, and salt.

3. Use immediately or store in the refrigerator for up to 2 weeks.

INGREDIENTS:

4 OZ. UNSALTED BUTTER, SOFTENED

8 OZ. DARK CHOCOLATE (55 TO 65 PERCENT)

1 OZ. LIGHT CORN SYRUP

¼ TEASPOON PURE VANILLA EXTRACT

 PINCH OF KOSHER SALT

WHITE CHOCOLATE GLAZE

YIELD: 3 CUPS / **ACTIVE TIME:** 15 MINUTES / **TOTAL TIME:** 15 MINUTES

For those times when you need just a little something more than a standard vanilla- or honey-centered glaze.

1. Fill a small saucepan halfway with water and bring it to a gentle simmer. Place the white chocolate in a heatproof bowl and place it over the simmering water. Heat it, stirring occasionally, until melted and smooth.

2. Remove the pan from heat and whisk in the corn syrup and salt.

3. Use immediately or store in the refrigerator for up to 2 weeks.

INGREDIENTS:

8 OZ. WHITE CHOCOLATE

1 OZ. LIGHT CORN SYRUP

 PINCH OF KOSHER SALT

STRAWBERRY PRESERVES

YIELD: 2 CUPS / **ACTIVE TIME:** 30 MINUTES / **TOTAL TIME:** 2 HOURS AND 30 MINUTES

Because the taste of a hand-picked strawberry is too wonderful to be restricted to the short growing season. And, for those wondering: absolutely any berry can be preserved in this way.

1. Place all of the ingredients in a large saucepan and warm it over low heat, using a wooden spoon to occasionally fold the mixture. Cook until the sugar has dissolved and the strawberries are starting to collapse, about 15 minutes.

2. Remove the pan from heat. If you are canning the preserves, see the sidebar on the opposite page. If you are not going to can the preserves, transfer them to a sterilized mason jar and let them cool at room temperature for 2 hours before enjoying or storing in the refrigerator, where they will keep for up to 1 month.

INGREDIENTS:

1 LB. STRAWBERRIES, HULLED

1 LB. SUGAR

ZEST AND JUICE OF 1 LEMON

SEEDS AND POD OF 1 VANILLA BEAN

¼ TEASPOON KOSHER SALT

RASPBERRY JAM

YIELD: 2 CUPS / **ACTIVE TIME:** 30 MINUTES / **TOTAL TIME:** 3 HOURS

Like all fruit, raspberries contain pectin. But theirs seems to react stronger to the jam-making process, making it exceptionally easy to work with.

1. Place the ingredients in a large saucepan fitted with a candy thermometer and cook it over medium-high heat until the mixture is 220°F. Stir the jam occasionally as it cooks.

2. Pour the jam into jars and let it cool completely. Cover the jars and store the jam in the refrigerator, where it will keep for up to 1 month.

INGREDIENTS:

1 LB. FRESH RASPBERRIES

1 LB. SUGAR

ZEST AND JUICE OF 1 LEMON

APPLE BUTTER

YIELD: 4 CUPS / **ACTIVE TIME:** 40 MINUTES / **TOTAL TIME:** 3 HOURS

Apple butter is cooked longer than applesauce, creating a thick, smooth, and heavenly spread which can be used on toast or to fill pastries.

1. Place the apples, apple cider, water, lemon zest, and lemon juice in a medium saucepan, cover the pan, and cook over low heat until the apples start to break down, about 30 minutes.

2. Remove the pan from heat, place the mixture in a blender, and puree until smooth.

3. Return the mixture to the saucepan and stir in the sugar, cinnamon, nutmeg, and cloves. Cook over low heat until the apple butter is thick, velvety, and a deep brown, about 1 hour. Stir the apple butter with a wooden spoon occasionally to keep it from burning.

4. Transfer the apple butter into jars and let it cool completely before storing in the refrigerator, where it will keep for up to 2 weeks.

INGREDIENTS:

- 2 LBS. GRANNY SMITH APPLES, PEELED, QUARTERED, AND CORED
- ¾ CUP APPLE CIDER
- ¼ CUP WATER
- ZEST AND JUICE OF 1 LEMON
- 8 OZ. SUGAR
- 1 TEASPOON CINNAMON
- ¼ TEASPOON FRESHLY GRATED NUTMEG
- ⅛ TEASPOON GROUND CLOVES

PUMPKIN BUTTER

YIELD: 4 CUPS / **ACTIVE TIME:** 30 MINUTES / **TOTAL TIME:** 2 HOURS

For a spicier result, try switching the bourbon out for rye whiskey.

1. Combine the pumpkin puree, apple cider, brown sugar, cinnamon, ginger, nutmeg, allspice, and lemon juice in a saucepan and cook over medium-high heat while stirring.

2. When the mixture begins to bubble, reduce the heat to low and simmer until it has thickened and is smooth, about 30 minutes, stirring occasionally.

3. Remove the pan from heat and stir in the bourbon.

4. Transfer the pumpkin butter into jars and let it cool completely before storing in the refrigerator, where it will keep for up to 2 weeks.

INGREDIENTS:

30	OZ. PUMPKIN PUREE
1	CUP APPLE CIDER
8	OZ. DARK BROWN SUGAR
1	TABLESPOON CINNAMON
1	TEASPOON GROUND GINGER
1	TEASPOON FRESHLY GRATED NUTMEG
½	TEASPOON ALLSPICE
	JUICE OF 1 LEMON
1	TABLESPOON BOURBON

PEAR & CARDAMOM BUTTER

YIELD: 4 CUPS / **ACTIVE TIME:** 30 MINUTES / **TOTAL TIME:** 3 HOURS

Similar to apple butter, but with floral notes thanks to the cardamom and pears.

1. Place the apples, lemon juice, lemon zest, orange juice, orange zest, and water in a medium saucepan, cover the pan, and cook over low heat until the pears start to break down, about 30 minutes.

2. Remove the pan from heat, place the mixture in a blender, and puree until smooth.

3. Return the mixture to the saucepan and stir in the sugar, honey, cardamom, and ginger. Cook over low heat until the pear butter is thick, velvety, and a deep brown, about 1 hour. Stir the apple butter with a wooden spoon occasionally to keep it from burning.

4. Transfer the butter into jars and let it cool completely before storing in the refrigerator, where it will keep for up to 2 weeks.

INGREDIENTS:

2.5	LBS. BOSC PEARS, PEELED, QUARTERED, AND CORED
	ZEST AND JUICE OF 2 LEMONS
	ZEST AND JUICE OF 1 ORANGE
2	CUPS WATER
1	LB. SUGAR
¼	CUP HONEY
½	TEASPOON CARDAMOM
½	TEASPOON GROUND GINGER

CORN MUFFIN TOPPING

YIELD: 3 CUPS / **ACTIVE TIME:** 10 MINUTES / **TOTAL TIME:** 10 MINUTES

Don't let the name limit you—this is as good on blueberry muffins as it is on corn muffins.

1. In the work bowl of a stand mixer fitted with the paddle attachment, add the flour, cornmeal, sugar, brown sugar, oats, and salt and beat on low until combined.

2. Turn off the mixer and add the butter. Raise the speed to medium and beat until the mixture is crumbly and the butter is being absorbed by the dry mixture. Take care not to overwork the mixture—you want it to be crumbly, not creamy.

3. Use as desired or store in the refrigerator, where it will keep for up to 1 week.

INGREDIENTS:

6	OZ. ALL-PURPOSE FLOUR
3	OZ. CORNMEAL
6	OZ. SUGAR
6	OZ. LIGHT BROWN SUGAR
4	OZ. ROLLED OATS
¾	TEASPOON KOSHER SALT
8	OZ. UNSALTED BUTTER, CHILLED AND CUBED

STREUSEL TOPPING

YIELD: 3 CUPS / **ACTIVE TIME**: 10 MINUTES / **TOTAL TIME**: 10 MINUTES

Great on top of pies, fruit bars, a crumble, or muffins.

1. In the work bowl of a stand mixer fitted with the paddle attachment, beat the flour, sugar, brown sugar, oats, cinnamon, and salt on low until combined.

2. Turn off the mixer and add the butter.

3. Raise the speed to medium and beat the mixture until the mixture is crumbly and the butter has been absorbed by the dry ingredients. Make sure not to overwork the mixture.

4. Store in the refrigerator for a week and place on muffins before baking.

INGREDIENTS:

9 OZ. ALL-PURPOSE FLOUR

6 OZ. SUGAR

6 OZ. LIGHT BROWN SUGAR

4 OZ. ROLLED OATS

2¼ TEASPOONS CINNAMON

¾ TEASPOON KOSHER SALT

8 OZ. UNSALTED BUTTER, CHILLED AND DIVIDED INTO TABLESPOONS

COFFEE CAKE TOPPING

YIELD: 3 CUPS / **ACTIVE TIME:** 10 MINUTES / **TOTAL TIME:** 10 MINUTES

A spicy and sugary crumble that plays a major role in providing coffee cake its beloved flavor and texture.

1. In the work bowl of a stand mixer fitted with the paddle attachment, add the flour, brown sugar, salt, and cinnamon and beat until the mixture is combined.

2. Turn off the mixer and add the butter. Raise the speed to medium and beat until the mixture is crumbly and the butter is being absorbed by the dry mixture. Take care not to overwork the mixture—you want it to be crumbly, not creamy.

3. Use as desired or store in the refrigerator, where it will keep for up to 1 week.

INGREDIENTS:

7 OZ. ALL-PURPOSE FLOUR

9 OZ. LIGHT BROWN SUGAR

¼ TEASPOON KOSHER SALT

¾ TEASPOON CINNAMON

6 OZ. UNSALTED BUTTER, CHILLED AND CUBED

CARAMEL SAUCE

YIELD: 2 CUPS / **ACTIVE TIME:** 15 MINUTES / **TOTAL TIME:** 1 HOUR AND 30 MINUTES

The perfect caramel sauce for cakes, topping ice cream, or just dipping.

1. Place the sugar and water in a small saucepan and bring to a boil over high heat. Resist the urge to whisk the mixture; instead, swirl the pan occasionally.

2. Once the mixture turns a dark amber, turn off the heat and, whisking slowly, drizzle in the heavy cream. Be careful, as the mixture may splatter.

3. When all of the cream has been incorporated, add the butter, salt, and vanilla and whisk until smooth. Pour the hot caramel into mason jars to cool. The caramel sauce can be stored for 1 week at room temperature.

INGREDIENTS:

1	CUP SUGAR
¼	CUP WATER
½	CUP HEAVY CREAM
3	OZ. UNSALTED BUTTER, SOFTENED
½	TEASPOON KOSHER SALT
½	TEASPOON PURE VANILLA EXTRACT

CARAMELIZED WHITE CHOCOLATE

YIELD: 1 CUP / **ACTIVE TIME:** 25 MINUTES / **TOTAL TIME:** 1 HOUR AND 30 MINUTES

This is a game-changer. Caramelizing the milk solids in white chocolate yields an incredibly aromatic and caramel-flavored chocolate.

1. Preheat the oven to 250°F.

2. Line a rimmed 18 x 13–inch baking sheet with a silicone baking mat.

3. Chop the white chocolate into small pieces and spread them over the baking sheet. Add the salt and oil and stir to coat the chocolate pieces.

4. Place the baking sheet in the oven and cook for 10 minutes.

5. Use a rubber spatula to spread the chocolate until it covers the entire silicone mat. Place back in the oven and bake until the chocolate has caramelized to a deep golden brown, about 30 to 50 minutes, removing to stir every 10 minutes.

6. Carefully pour the caramelized chocolate into a heatproof container. Store at room temperature for up to 1 month.

INGREDIENTS:

1 LB. WHITE CHOCOLATE

 PINCH OF FINE SEA SALT

2 TABLESPOONS CANOLA OIL

MILK CHOCOLATE CRÉMEUX

YIELD: 4 CUPS / ACTIVE TIME: 30 MINUTES / TOTAL TIME: 24 HOURS

Meaning "creamy" and "mousse-like" a crémeux is incredibly versatile, and can be used as a cake filling, spread on scones, or enjoyed on its own.

1. Place the gelatin sheets in a small bowl and add 1 cup of ice and enough cold water that the sheets are completely covered. Set aside.

2. Place the chocolate in a heatproof mixing bowl.

3. Place half of sugar and the egg yolks in a small bowl and whisk for 2 minutes. Set the mixture aside.

4. In a small saucepan, combine the milk, heavy cream, and remaining sugar and bring to a simmer over medium heat.

5. Slowly pour half of the hot milk mixture into the egg mixture and stir until incorporated. Add the salt and vanilla extract, stir to incorporate, and pour the tempered egg mixture into the saucepan. Cook, while stirring constantly, until the mixture thickens and is about to come to a full simmer (if you have an instant-read thermometer, 175°F). Remove the pan from heat.

6. Remove the bloomed gelatin from the ice water. Squeeze to remove as much water as possible from the sheets. Add the sheets to the hot milk mixture and whisk until they have completely dissolved.

7. Pour the hot milk mixture over the chocolate and let the mixture sit for 1 minute. Whisk to combine, transfer to a heatproof container, and let it cool to room temperature.

8. Refrigerate overnight before using.

INGREDIENTS:

2	SHEETS OF SILVER GELATIN
10.7	OZ. MILK CHOCOLATE
¼	CUP SUGAR
4	EGG YOLKS
¾	CUP MILK
¾	CUP HEAVY CREAM

GIANDUJA CRÉMEUX

YIELD: 1 QUART / **ACTIVE TIME:** 30 MINUTES / **TOTAL TIME:** 24 HOURS

Gianduja is a sweet chocolate that contains 30 percent hazelnut paste. If it proves difficult to find in stores, turn to the internet.

1. Place the gelatin sheets in a small bowl and add 1 cup of ice and enough cold water that the sheets are completely covered. Set aside.

2. Place the chocolate in a heatproof mixing bowl.

3. Place half of sugar and the egg yolks in a small bowl and whisk for 2 minutes. Set the mixture aside.

4. In a small saucepan, combine the milk, heavy cream, and remaining sugar and bring to a simmer over medium heat.

5. Slowly pour half of the hot milk mixture into the egg mixture and stir until incorporated. Add the salt and vanilla extract, stir to incorporate, and pour the tempered egg mixture into the saucepan. Cook, while stirring constantly, until the mixture thickens and is about to come to a full simmer (if you have an instant-read thermometer, 175°F). Remove the pan from heat.

6. Remove the bloomed gelatin from the ice water. Squeeze to remove as much water as possible from the sheets. Add the sheets to the hot milk mixture and whisk until they have completely dissolved.

7. Pour the hot milk mixture over the chocolate and let the mixture sit for 1 minute. Whisk to combine, transfer to a heatproof container, and let it cool to room temperature.

8. Refrigerate overnight before using.

INGREDIENTS:

2	SHEETS OF SILVER GELATIN
12	OZ. GIANDUJA CHOCOLATE, CHOPPED
¼	CUP SUGAR
4	EGG YOLKS
¾	CUP MILK
¾	CUP HEAVY CREAM

CARAMELIZED WHITE CHOCOLATE CRÉMEUX

YIELD: 4 CUPS / **ACTIVE TIME:** 30 MINUTES / **TOTAL TIME:** 24 HOURS

Just one of the numerous recipes where the exceptional flavor of the Caramelized White Chocolate can be utilized.

1. Place the gelatin sheets in a small bowl and add 1 cup of ice and enough cold water that the sheets are completely covered. Set aside.

2. Place the Caramelized White Chocolate in a mixing bowl.

3. Place half of sugar and the egg yolks in a small bowl and whisk for 2 minutes. Set the mixture aside.

4. In a small saucepan, combine the milk, heavy cream, and remaining sugar and bring to a simmer over medium heat.

5. Slowly pour half of the hot milk mixture into the egg mixture and stir until incorporated. Pour the tempered egg mixture into the saucepan. Cook, while stirring constantly, until the mixture thickens and is about to come to a full simmer (if you have an instant-read thermometer, 175°F). Remove the pan from heat.

6. Remove the bloomed gelatin from the ice water. Squeeze to remove as much water as possible from the sheets. Add the sheets to the hot milk mixture base and whisk until they have completely dissolved.

7. Pour the hot milk mixture over the Caramelized White Chocolate and let the mixture sit for 1 minute. Whisk to combine, transfer to a heatproof container, and let it cool to room temperature.

8. Store in the refrigerator overnight before using.

INGREDIENTS:

2	SHEETS OF SILVER GELATIN
6	OZ. MILK
6	OZ. HEAVY CREAM
¼	CUP SUGAR
4	EGG YOLKS
13	OZ. CARAMELIZED WHITE CHOCOLATE (SEE PAGE 705)

COATING CHOCOLATE

Coating chocolate is a quick and simple way to add a crackly layer of chocolate to ice cream or a chocolate-dipped dessert.

1. Combine all of the ingredients in a small saucepan and place it over low heat.

2. Stir constantly until the chocolate has melted and the mixture is smooth. Use immediately.

INGREDIENTS:

8	OZ. DARK CHOCOLATE (55 TO 65 PERCENT)
4	OZ. COCONUT OIL
½	TEASPOON PURE VANILLA EXTRACT
⅛	TEASPOON KOSHER SALT

AMERICAN BUTTERCREAM

YIELD: 3 CUPS / **ACTIVE TIME:** 10 MINUTES / **TOTAL TIME:** 10 MINUTES

A simple but delicious frosting that will soon become your go-to.

1. In the work bowl of a stand mixer fitted with the paddle attachment, combine the butter, confectioners' sugar, and salt and beat on low until the sugar starts to be incorporated into the butter. Raise the speed to high and beat until the mixture is smooth and fluffy, about 5 minutes.

2. Reduce the speed to low, add the heavy cream and vanilla, and beat until incorporated. Use immediately, or store in the refrigerator for up to 2 weeks. If refrigerating, return to room temperature before using.

INGREDIENTS:

1 LB. UNSALTED BUTTER, SOFTENED

2 LBS. CONFECTIONERS' SUGAR

⅛ TEASPOON KOSHER SALT

¼ CUP HEAVY CREAM

½ TEASPOON PURE VANILLA EXTRACT

ITALIAN BUTTERCREAM

YIELD: 3 CUPS / **ACTIVE TIME:** 20 MINUTES / **TOTAL TIME:** 30 MINUTES

A more elegant frosting—not as sweet as the American iteration, quite versatile, and absolutely gorgeous.

1. Place the sugar and water in a small saucepan, fit it with a candy thermometer, and bring the mixture to a boil.

2. While the syrup is coming to a boil, place the egg whites and salt in the work bowl of a stand mixer fitted with the whisk attachment and whip on medium until the mixture holds stiff peaks.

3. Cook the syrup until the thermometer reads 245°F. Immediately remove the pan from the heat and once the syrup stops bubbling let it stand for an additional 30 seconds.

4. Reduce the speed of the mixer to medium-low and slowly pour the syrup down the side of the mixing bowl until all of it has been incorporated. Raise the speed to high and whip until the meringue is glossy and holds stiff peaks.

5. Add the butter 4 oz. at a time and whip until the mixture has thickened.

6. Reduce the speed to medium, add the vanilla, and beat until incorporated.

7. Use immediately, or store in the refrigerator for up to 2 weeks. If refrigerating, return to room temperature before using.

INGREDIENTS:

2 CUPS SUGAR

½ CUP WATER

8 EGG WHITES

¼ TEASPOON FINE SEA SALT

1.5 LBS. UNSALTED BUTTER, SOFTENED

1 TEASPOON PURE VANILLA EXTRACT

CREAM CHEESE FROSTING

YIELD: 3 CUPS / **ACTIVE TIME:** 10 MINUTES / **TOTAL TIME:** 10 MINUTES

The quintessential frosting for carrot and red velvet cakes, as well as any confection where you're looking to add creaminess.

1. In the work bowl of a stand mixer fitted with the paddle attachment, combine the butter, cream cheese, confectioners' sugar, and salt and beat on low until the sugar starts to be incorporated into the butter. Raise the speed to high and beat until the mixture is smooth and fluffy, about 5 minutes.

2. Reduce the speed to low, add the heavy cream and vanilla extract, and beat until incorporated. Use immediately, or store in the refrigerator for up to 2 weeks. If refrigerating, return to room temperature before using.

INGREDIENTS:

- 8 OZ. UNSALTED BUTTER, SOFTENED
- 8 OZ. CREAM CHEESE SOFTENED
- 2 LBS. CONFECTIONERS' SUGAR
- ⅛ TEASPOON KOSHER SALT
- ¼ CUP HEAVY CREAM
- ½ TEASPOON PURE VANILLA EXTRACT

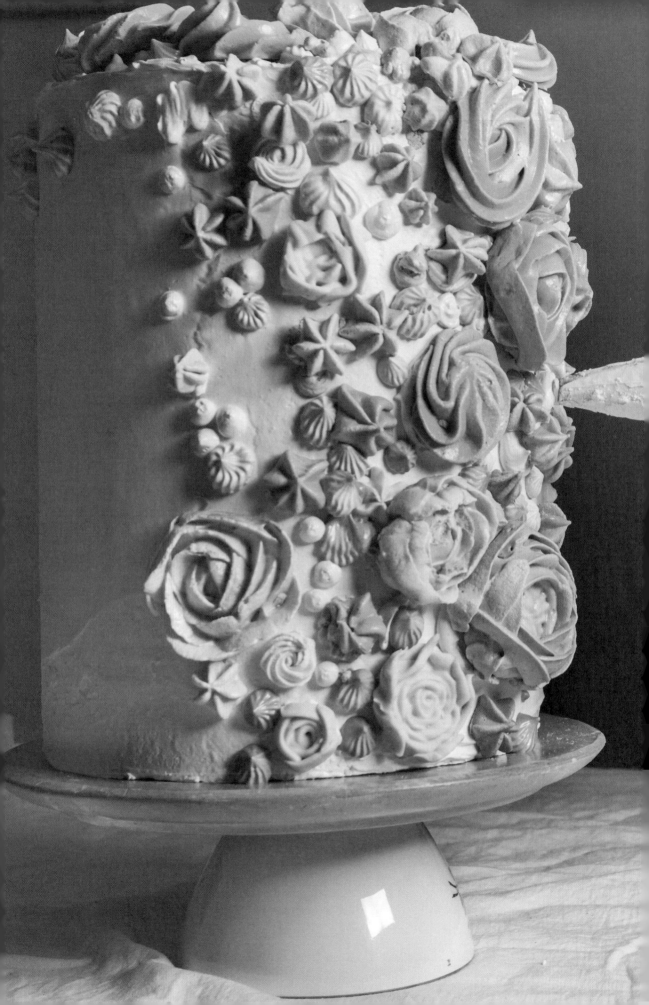

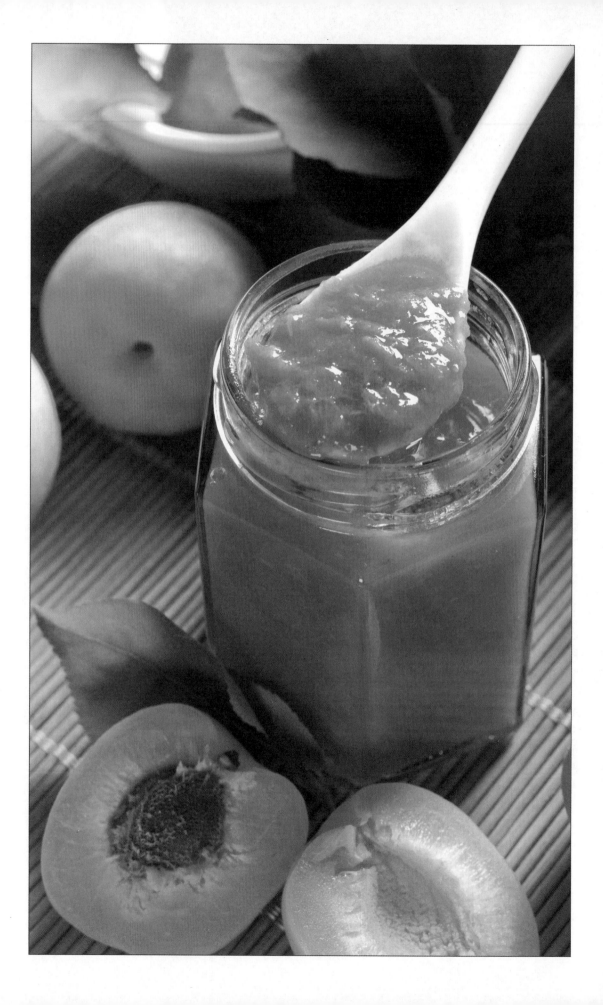

APRICOT JAM

YIELD: 3 CUPS / **ACTIVE TIME:** 1 HOUR / **TOTAL TIME:** 24 HOURS

Best on a baguette or croissant that's just been removed from the oven.

1. Place the apricots, sugar, lemon zest, and lemon juice in a mixing bowl and toss to coat the fruit.

2. Cover the bowl with plastic wrap and refrigerate overnight. This allows the sugar to break down the fibers of the fruit and draw out its natural sugars.

3. Place the ingredients in a large saucepan fitted with a candy thermometer and cook over medium-high heat until it comes to a boil.

4. Stir in the butter and continue cooking until the mixture is 220°F. Stir the jam occasionally as it cooks.

5. Pour the jam into jars and let it cool completely. Cover the jars and store the jam in the refrigerator, where it will keep for up to 2 weeks.

INGREDIENTS:

1.75 LBS. APRICOTS, PITTED AND QUARTERED

18 OZ. SUGAR

ZEST AND JUICE OF 1 LEMON

1½ TEASPOONS UNSALTED BUTTER

CAJETA

YIELD: 1½ CUPS / **ACTIVE TIME:** 1 HOUR / **TOTAL TIME:** 5 HOURS

The Mexican version of dulce de leche, but it's made with goats' milk, which gives it a slightly tangy finish. Traditionally, cajeta is served over ice cream or fried dough, but it's pretty dang good on anything.

1. Place the goats' milk, sugar, cinnamon stick, and salt in a medium saucepan and bring to a simmer over medium-low heat.

2. In a small bowl, combine the baking soda and water. Whisk the mixture into the saucepan.

3. Continue to simmer for 1 to 2 hours, stirring frequently.

4. When the mixture turns a caramel color and is thick enough to coat the back of a wooden spoon, remove the pan from the heat and let the sauce cool for 1 hour.

5. Transfer to mason jars and refrigerate until set. This will keep in the refrigerator for up to 1 month.

INGREDIENTS:

4	CUPS GOATS' MILK
1	CUP SUGAR
1	CINNAMON STICK
⅛	TEASPOON KOSHER SALT
¼	TEASPOON BAKING SODA
1½	TEASPOONS WATER

BOURBON TOFFEE SAUCE

YIELD: 4 CUPS / **ACTIVE TIME:** 10 MINUTES / **TOTAL TIME:** 20 MINUTES

This uber-sweet, velvety sauce is unbeatable on a warm cobbler made from fresh summer fruit, on your favorite ice cream.

1. Place the butter, brown sugar, maple syrup, heavy cream, and salt in a medium saucepan and bring the mixture to a boil over medium heat.

2. Let the mixture boil for 30 seconds, while continually whisking.

3. Remove the pan from heat and whisk in the bourbon.

4. Use immediately, or store in the refrigerator for up to 1 month. If storing in the refrigerator, reheat before using.

INGREDIENTS:

7	OZ. UNSALTED BUTTER
¾	CUP PACKED LIGHT BROWN SUGAR
¾	CUP MAPLE SYRUP
¼	CUP HEAVY CREAM
¼	TEASPOON KOSHER SALT
2	TABLESPOONS BOURBON

CARAMELIZED ONION & APRICOT CHUTNEY

YIELD: 2 CUPS / **ACTIVE TIME:** 25 MINUTES / **TOTAL TIME:** 2 HOURS

A quick way to add depth to any cheeseboard. This chutney is also a good partner for freshly baked sourdough.

1. Place the olive oil in a large saucepan and warm it over medium heat. Add the onion and salt and cook until the onion is golden brown, about 10 minutes, stirring occasionally.

2. Add the remaining ingredients and cook over medium heat until the chutney has thickened to your liking, 20 to 30 minutes. Taste and adjust the seasoning as necessary.

3. Place the chutney in a jar and let it cool completely before using or storing in the refrigerator, where it will keep for up to 2 weeks.

INGREDIENTS:

1	TABLESPOON EXTRA-VIRGIN OLIVE OIL
1	YELLOW ONION, FINELY DICED
1	TEASPOON KOSHER SALT
¾	CUP DRIED APRICOTS
¼	CUP SUGAR
¾	CUP DRY WHITE WINE
¼	CUP GRAINY DIJON MUSTARD
1	TABLESPOON WHITE WINE VINEGAR
1	TEASPOON HOT SAUCE

ROYAL ICING

YIELD: 3 CUPS / **ACTIVE TIME:** 5 MINUTES / **TOTAL TIME:** 5 MINUTES

The beautiful and rich icing that is attached to so many warm memories around the holidays.

1. Place the egg whites, vanilla, and confectioners' sugar in a mixing bowl and whisk until the mixture is smooth.

2. If desired, add food coloring. If using immediately, place the icing in a piping bag. If making ahead of time, store in the refrigerator, where it will keep for 5 days.

INGREDIENTS:

6 EGG WHITES

1 TEASPOON PURE VANILLA EXTRACT

2 LBS. CONFECTIONERS' SUGAR

1-2 DROPS OF GEL FOOD COLORING (OPTIONAL)

CREAM CHEESE DANISH FILLING

YIELD: 4 CUPS / **ACTIVE TIME:** 20 MINUTES / **TOTAL TIME:** 20 MINUTES

Mixing a little almond paste and sugar into cream cheese is one of the best and easiest ways to guarantee that your danish are decadent.

1. Place the almond paste in the work bowl of a stand mixer fitted with the paddle attachment and beat it on medium until it has softened, about 5 minutes.

2. Add the sugar and cream the mixture for 5 minutes.

3. Add the cream cheese, vanilla, and salt and cream until the mixture is very smooth, about 10 minutes.

4. Use immediately or store in the refrigerator, where it will keep for up to 2 weeks.

INGREDIENTS:

8	OZ. ALMOND PASTE
1	CUP SUGAR
1	LB. CREAM CHEESE, SOFTENED
1½	TEASPOONS PURE VANILLA EXTRACT
½	TEASPOON KOSHER SALT

SPICED CRANBERRY CHUTNEY

YIELD: 4 CUPS / **ACTIVE TIME:** 25 MINUTES / **TOTAL TIME:** 2 HOURS

The next time the holidays come around, lose the canned sauce and replace it with this sweet-tart spread.

1. Place the olive oil in a large saucepan and warm it over medium heat. Add the onion and salt and cook until the onion is golden brown, about 10 minutes, stirring occasionally.

2. Add the remaining ingredients and cook over medium heat until the chutney has thickened to your liking, 20 to 30 minutes. Taste and adjust the seasoning as necessary.

3. Place the chutney in a jar and let it cool completely before using or storing in the refrigerator, where it will keep for up to 2 weeks.

INGREDIENTS:

- 1 TABLESPOON EXTRA-VIRGIN OLIVE OIL
- 1 YELLOW ONION, FINELY DICED
- 1 TEASPOON KOSHER SALT
- 12 OZ. DRIED CRANBERRIES
- ½ CUP GOLDEN RAISINS
- 1¼ CUP SUGAR
- ½ CUP APPLE CIDER
- 1 CUP CRANBERRY JUICE
- ½ CUP DRY RED WINE
- ½ TEASPOON GROUND CLOVES
- 1 TEASPOON CINNAMON
- 1 TEASPOON GROUND GINGER
- 1 GRANNY SMITH APPLE, DICED
- ZEST AND JUICE OF 1 ORANGE

FRANGIPANE

YIELD: 4 CUPS / **ACTIVE TIME:** 10 MINUTES / **TOTAL TIME:** 10 MINUTES

A sweet almond concoction that serves as the filling for almond croissants, and also finds its way into many fruit tarts.

1. In the work bowl of a stand mixer fitted with the paddle attachment, cream the almond paste, butter, and salt on medium until the mixture is light and fluffy, about 5 minutes.

2. Reduce the speed to low, add the eggs one at a time, and beat until incorporated, again scraping down the work bowl as needed. Add the flour and beat until incorporated. Use immediately or store in the refrigerator for up to 2 weeks.

INGREDIENTS:

12	OZ. ALMOND PASTE
4	OZ. UNSALTED BUTTER, SOFTENED
¼	TEASPOON KOSHER SALT
4	EGGS
1.75	OZ. ALL-PURPOSE FLOUR

FRENCH MERINGUE

YIELD: 4 CUPS / **ACTIVE TIME:** 10 MINUTES / **TOTAL TIME:** 10 MINUTES

The lightest and fastest of the three types of meringues, but also the least stable.

1. In the work bowl of a stand mixer fitted with the whisk attachment, whip the egg whites and salt on medium until soft peaks form.

2. Add the sugar 1 tablespoon at a time and whisk to incorporate. Wait about 10 seconds between additions.

3. When all of the sugar has been incorporated, whip until the mixture holds stiff peaks. Use immediately.

INGREDIENTS:

4 EGG WHITES

 PINCH OF KOSHER SALT

½ CUP SUGAR

SWISS MERINGUE

YIELD: 3 CUPS / **ACTIVE TIME:** 20 MINUTES / **TOTAL TIME:** 20 MINUTES

This meringue is fluffy, shiny, and almost cloudlike, making it good for topping cakes and pies, and also as a filling for macarons.

1. Fill a small saucepan halfway with water and bring it to a gentle simmer.

2. Place the egg whites, sugar, and salt in the work bowl of a stand mixer. Place the bowl over the simmering water and whisk until the mixture reaches 115°F.

3. Return the bowl to the stand mixer and fit it with the whisk attachment. Whip on high until the meringue is shiny, glossy, and holds stiff peaks, about 5 minutes. For best results, use the meringue the day you make it.

INGREDIENTS:

4 EGG WHITES

 PINCH OF KOSHER SALT

1 CUP SUGAR

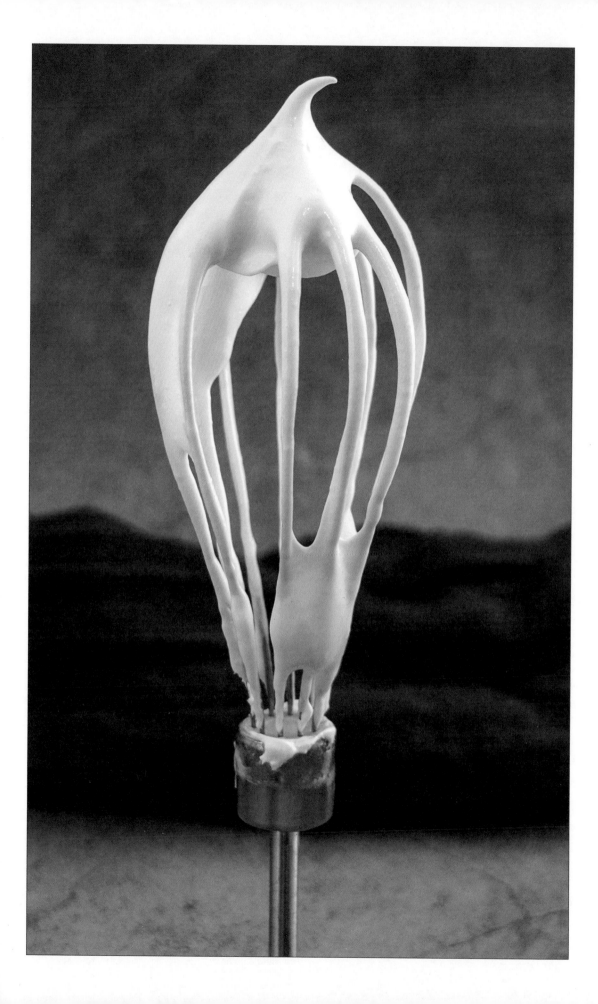

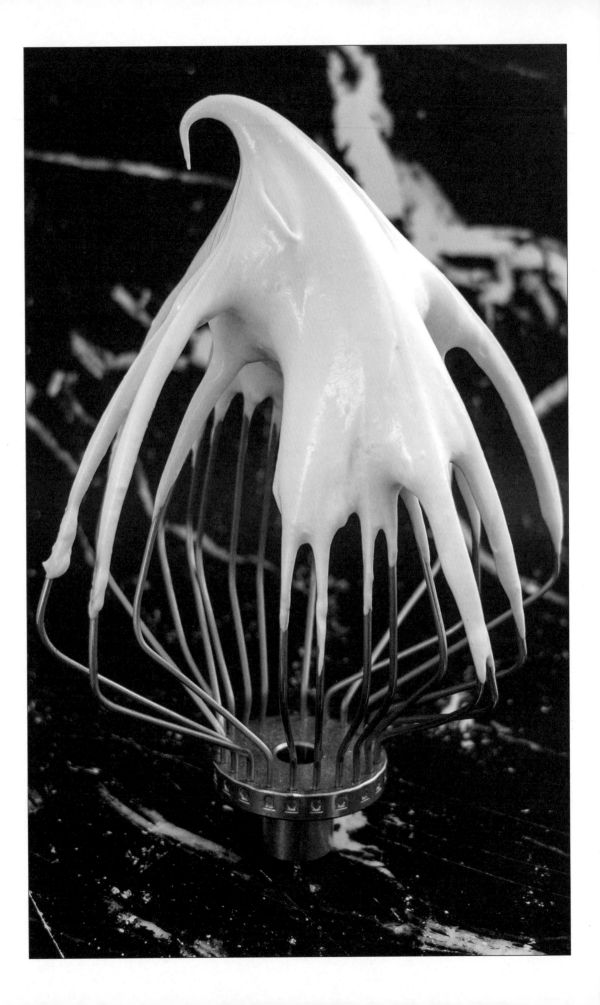

ITALIAN MERINGUE

YIELD: 3 CUPS / **ACTIVE TIME:** 15 MINUTES / **TOTAL TIME:** 30 MINUTES

The most involved of all the meringues, but also the most versatile and reliable.

1. Place the sugar and water in a small saucepan that is fit with a candy thermometer and bring the mixture to a boil.

2. While the syrup is coming to a boil, place the egg whites and salt in the work bowl of a stand mixer fitted with the whisk attachment and whip on medium until the mixture holds stiff peaks.

3. Cook the syrup until the thermometer reads 245°F. Immediately remove the pan from the heat once the syrup stops bubbling and let it sit for 30 seconds.

4. Reduce the speed of the mixer to medium-low and slowly pour the syrup down the side of the mixing bowl until all of it has been incorporated. Raise the speed to high and whip until the meringue is glossy and holds stiff peaks.

INGREDIENTS:

1	CUP SUGAR
¼	CUP WATER
4	EGG WHITES
	PINCH OF KOSHER SALT

EVERYTHING SEASONING

YIELD: ½ CUP / **ACTIVE TIME:** 5 MINUTES / **TOTAL TIME:** 5 MINUTES

Bad news for the local bagel shop—this recipe makes it a cinch to prepare their secret weapon.

1. Place all of the ingredients in a small bowl and stir to combine. Store in an airtight container for up to 3 months.

INGREDIENTS:

2 TABLESPOONS POPPY
 SEEDS

1 TABLESPOON FENNEL
 SEEDS

1 TABLESPOON ONION
 FLAKES

1 TABLESPOON GARLIC
 FLAKES

1 TABLESPOON WHITE
 SESAME SEEDS

1 TABLESPOON BLACK
 SESAME SEEDS

1 TEASPOON KOSHER SALT

INDUSTRY INSIDERS

*A*fter working your way through this book, you may be feeling confident in your ability to crank out baked goods that are well above-average. Cocky, even.

But there is always another level above, no matter how good you get. These folks are proof of just that. From the genius that is required to master specialties like Neapolitan pizza to the uncompromising devotion one needs to cultivate heritage grains, these folks have ascended to the top of the culinary world, and have been kind enough to share some of the discoveries, secrets, and recipes that powered this climb.

SWEET ANNIE'S OF MAINE

Manchester, ME

Annie of Sweet Annie's of Maine is of the firm belief that cupcakes and cake should both taste and look incredible. That extends to all forms of treats, from wedding cakes to birthday cakes or "I deserve it" cakes. Based out of her home kitchen in Manchester, Maine, Annie seeks to use only the freshest local ingredients she can find. Occasionally, she grows produce herself, using canned rhubarb for cakes, mint for mint chocolate chip cupcakes, and of course, wild Maine blueberries.

KEY LIME PIE CUPCAKES

YIELD: 24 CUPCAKES / **ACTIVE TIME:** 1 HOUR / **TOTAL TIME:** 24 HOURS

These light and fluffy cupcakes have the perfect balance of tart and sweet.

1. Prepare the cream cheese filling at least a day in advance so that it has time to harden in the refrigerator. To do this, beat the softened cream cheese in a large bowl until smooth, add the sweetened condensed milk, and then slowly add the lime juice to avoid splattering.

2. To prepare the crust, completely crush the graham crackers in a large resealable bag with a rolling pin. Place crumbs in a large bowl and add the sugar, mixing to incorporate. Next, add the melted butter and mix until you've achieved a graham cracker paste. Prepare a large, 24-cup muffin tin with cupcake liners and spoon the graham cracker paste into each one until evenly divided. Press the graham cracker crumbs down in each well to form a crust.

3. To make the cupcakes, combine the flour, baking powder, and salt in a medium bowl. Whisk together for 20 seconds with a fork. In a large bowl, add the granulated sugar and softened butter. Beat on low with a stand or handheld mixer, adding the eggs, vegetable oil, and sour cream. Once smooth, alternate adding the flour mixture with the milk and lime juice until the flour and liquid have all been incorporated. Using an ice cream scoop, fill each muffin tin well nearly completely full and bake at 325°F for 15 to 17 minutes.

4. Once baked, remove from the oven and let the cupcakes cool for 15 minutes before removing from the tin. The cake is still cooking the first few minutes after it comes out and it is fragile until completely cooled. Please note that the center of the cupcakes will seem uncooked and won't be firm to the touch; this is normal. Once the cupcake centers are cored in the next step, you will be left with a perfectly baked cupcake. If you were to bake the cupcakes until the centers were firm, the outer part that remains after coring would be too dry.

5. Core the cooled cupcakes with a cupcake corer (or a spoon, but you'll get a cleaner core with the corer), and fill with the cream cheese filling, placing it either in a pastry bag or a large resealable bag with a hole cut on one of the bottom corners.

INGREDIENTS:

FOR THE FILLING

8	OZ. CREAM CHEESE, SOFTENED
1	(14 OZ.) CAN SWEETENED CONDENSED MILK
⅔	CUP FRESH LIME JUICE

FOR THE GRAHAM CRACKER CRUST

2	(4.8 OZ.) PACKAGES OF GRAHAM CRACKERS
2	TABLESPOONS SUGAR
8	OZ. UNSALTED BUTTER, MELTED

FOR THE CUPCAKES

12.5	OZ. ALL-PURPOSE FLOUR
5	TEASPOONS BAKING POWDER
1	TEASPOON FINE SEA SALT
10.5	OZ. SUGAR
4	OZ. UNSALTED BUTTER, SOFTENED
4	EGGS
½	CUP VEGETABLE OIL
½	CUP SOUR CREAM
⅔	CUP WHOLE MILK, AT ROOM TEMPERATURE
⅔	CUP FRESH LIME JUICE, AT ROOM TEMPERATURE

Continued . . .

6. To make the buttercream, gradually add the confectioners' sugar to the softened butter in a stand mixer while beating on low. If it's too messy, alternate adding the confectioners' sugar with the lime juice, or simply add the lime juice after the confectioners' sugar if the sugar is not flying out of the bowl. Using a zester, zest the lime, mixing the buttercream on low so that the lime zest is evenly distributed. If you'd like to tint the buttercream, add the tiniest amount of green gel food coloring until a delicate lime green has been achieved.

7. Spread the buttercream over the cooled core and filled cupcakes with a knife, or use a pastry bag and a piping tip. At the very end, I like to top the cupcakes with clear sugar crystals.

8. Refrigerate any leftovers. They will keep for roughly 3 to 4 days if they are stored in an airtight container.

INGREDIENTS:

FOR THE LIME BUTTERCREAM

1 LB. CONFECTIONERS' SUGAR

8 OZ. UNSALTED BUTTER, SOFTENED

¼ CUP FRESH LIME JUICE

 ZEST OF 1 LIME

1-2 DROPS OF GREEN GEL FOOD COLORING (OPTIONAL)

BAMBAM BAKERY

Portland, ME

BamBam is a dedicated 100 percent gluten-free facility. That means it's celiac friendly and there is no risk of cross-contamination. Some say that eating gluten free is fad diet but many non-celiacs benefit from a gluten-free diet for many different health reasons. Some people just eat gluten free because they feel a lot better. BamBam provides delicious gluten-free treats in either case. Owner Tina Cromwell says that "The best part of this job is when kids come in and they are told that they can have anything in the store. When people ask 'Do you have anything that's gluten free?' We get to say 'Yes! Everything.'" BamBam doesn't claim to be a health food store. What they try to do is provide treats that taste as good as their gluten counterparts and dream up new delights to accommodate dietary needs.

GLUTEN-FREE SPICY CHOCOLATE COOKIES

YIELD: 12 COOKIES / **ACTIVE TIME:** 35 MINUTES / **TOTAL TIME:** 1 HOUR AND 45 MINUTES

Get the best of both worlds with the spicy cayenne and the sweet chocolate. These delicious cookies are dairy-, nut-, and soy-free.

1. Preheat oven to 325°F.

2. Mix the flour, cocoa powder, xanthan gum, baking soda, cinnamon, and cayenne pepper together in a bowl and set aside.

3. Mix the eggs, sugar, canola oil, and vanilla extract in a stand mixer until well combined.

4. Add the dry ingredients. Mix on low for 5 minutes, then fold in the chocolate chips.

5. Let dough chill for 1 hour in the refrigerator.

6. Scoop the dough into 1.5-oz. balls and place on cookie sheet.

7. Bake for 12 minutes.

INGREDIENTS:

- 3.2 OZ. GLUTEN-FREE ALL-PURPOSE FLOUR
- 2.6 OZ. COCOA POWDER
- ½ TEASPOON XANTHAN GUM (IF MISSING FROM ALL-PURPOSE FLOUR)
- 1 TEASPOON BAKING SODA
- 2 TEASPOONS CINNAMON
- ½ TEASPOON CAYENNE PEPPER
- 2 LARGE EGGS
- 7 OZ. SUGAR
- ½ CUP CANOLA OIL
- 1 TABLESPOON PURE VANILLA EXTRACT
- 1 CUP CHOCOLATE CHIPS (DAIRY- OR SOY-FREE IF DESIRED)

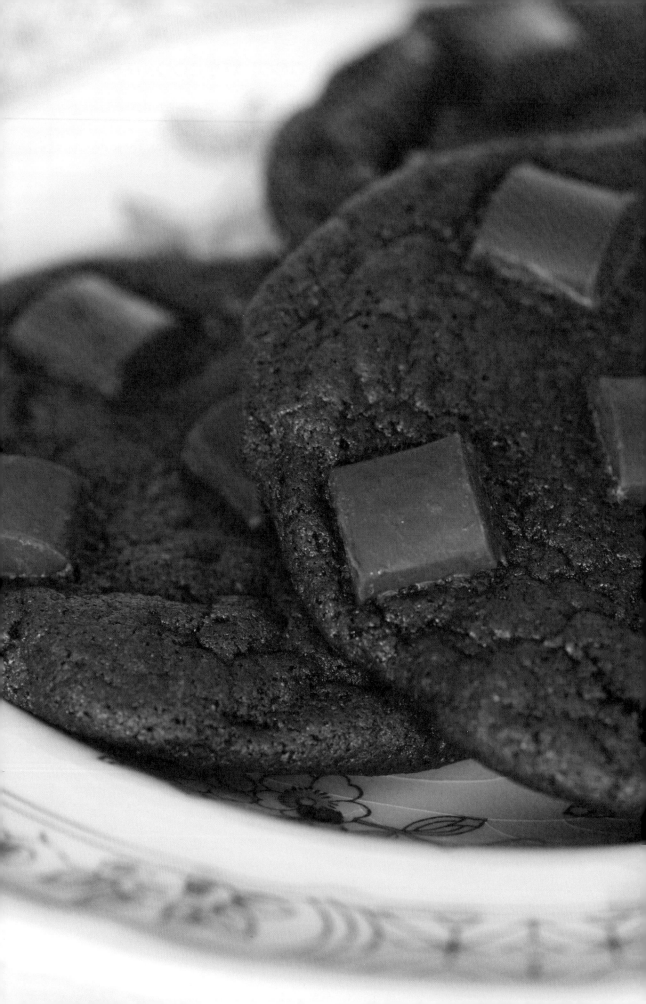

GLUTEN-FREE COCONUT BREAD

YIELD: 1 LOAF / **ACTIVE TIME:** 20 MINUTES / **TOTAL TIME:** 1 HOUR AND 50 MINUTES

Gluten-free recipes like this one benefit from a blend of flours so you can get the taste and texture just right.

1. Preheat oven to 325°F. Coat a standard loaf pan with nonstick cooking spray.

2. Lightly toast 1 cup of the coconut flakes for about 5 minutes. Let them cool.

3. Mix together the flours, tapioca starch, xanthan gum, baking powder, baking soda, and salt. Set aside.

4. Combine the sugars, canola oil, vanilla and coconut extracts, and coconut milk in a stand mixer fitted with the whisk attachment. Add eggs one at a time until combined.

5. Add in dry ingredients and let mix for 5 minutes, then fold in toasted coconut. Mix together.

6. Fill the loaf pan with batter to about three-quarters of the way full. Any leftover batter makes great cupcakes!

7. Top the loaf with untoasted coconut flakes for decoration.

8. Bake for 1 hour and 20 minutes.

9. Let it cool in the pan for 10 minutes and then turn out onto a cooling rack. Let the bread cool completely before enjoying.

TIP: If you're using the coconut bread for strawberry shortcake, slice the coconut bread, brush with olive oil, and broil until toasted. Macerate strawberries with a splash of vanilla and sugar. Top with choice of whipped cream (dairy-free, if desired).

INGREDIENTS:

- 1 CUP SWEETENED COCONUT FLAKES, PLUS MORE TO TASTE
- 8.4 OZ. WHITE RICE FLOUR
- 3.2 OZ. SORGHUM FLOUR
- 3.2 OZ. TAPIOCA STARCH
- ½ TEASPOON XANTHAN GUM
- 1½ TEASPOONS BAKING POWDER
- 1 TEASPOON BAKING SODA
- ¾ TEASPOON KOSHER SALT
- 7 OZ. SUGAR
- 3.5 OZ. BROWN SUGAR
- ¾ CUP CANOLA OIL
- 1 TEASPOON VANILLA EXTRACT
- 1 TEASPOON COCONUT EXTRACT
- 1½ CUPS UNSWEETENED COCONUT MILK
- 4 EGGS

TEATOTALLER

Somersworth, NH

Twice named "Best of New Hampshire" in *New Hampshire Magazine*, Teatotaller is best described as a queer, hipster oasis of tea, coffee, and pastry goodness. Teatotaller is a café, teahouse, bakery, and venue located in Historic Downtown Somersworth, New Hampshire. Drawing inspiration from flavors around the world, Teatotaller's kitchen makes everything from scratch—loose-leaf tea blends, hand-crafted tea and espresso drinks, and pastries for any palate. Teatotaller has garnered attention for its cheeky billboards, vibrant venue, and eccentric flavors, including being named "Most Instagrammable Restaurant in America" by *Food Network Magazine.* Emmet Soldati opened Teatotaller to create vibrancy in his one-road downtown, just one block away from his childhood lemonade stand.

GINGER MOLASSES COOKIES

YIELD: 15 COOKIES / **ACTIVE TIME:** 30 MINUTES / **TOTAL TIME:** 1 HOUR

These delicious cookies are dairy-free.

1. Preheat oven to 325°F.

2. To begin preparations for the cookies, cream the margarine and sugar with an electric mixer.

3. In a separate bowl, mix together the remaining dry ingredients.

4. Add eggs and molasses into electric mixer. Slowly add the dry ingredient mixture in and mix until it forms a dough.

5. Roll dough into 1-oz. balls and then roll in a bowl of sugar. Place on a parchment lined baking sheet with plenty of room between each ball.

6. Chill in the refrigerator for 15 minutes.

7. Bake 12 minutes, turning the baking sheet halfway through. The cookies should be spread out with cracks. Even if the center looks slightly wet, remove from the oven because the cookies will finish baking on a wire rack. Let them cool completely and then transfer to the refrigerator.

8. To prepare the filling, place all of the ingredients in a mixing bowl and whip until combined.

9. Place 1 tablespoon of cream filling between two cookies, bottom side in, and gently twist and press together until cream gets to edge. Chill until ready to serve.

INGREDIENTS:

FOR THE COOKIES

3.2	OZ. MARGARINE
7.7	OZ. SUGAR, PLUS MORE AS NEEDED
6.7	OZ. BROWN SUGAR
11.6	OZ. ALL-PURPOSE FLOUR
2	TEASPOONS BAKING SODA
½	TEASPOON FINE SEA SALT
1	TEASPOON GROUND GINGER
1	TEASPOON CINNAMON
2	EGGS
2.5	OZ. MOLASSES

FOR THE CREAM FILLING

7	OZ. FLUFF
8.8	OZ. CONFECTIONERS' SUGAR
5.3	OZ. MARGARINE
2.1	OZ. COCONUT OIL
1	TABLESPOON COCONUT MILK

LEMON POLENTA CAKE

YIELD: 1 CAKE / **ACTIVE TIME:** 15 MINUTES / **TOTAL TIME:** 1 HOUR AND 30 MINUTES

This simple lemon polenta cake is sure to become a family favorite.

1. Preheat oven to 325°F.

2. Beat together the oil and sugar until fluffy.

3. In a separate bowl, combine the dry ingredients and add to the sugar mixture, alternating with the eggs.

4. Add the lemon zest to the mixture.

5. Cut a circle of parchment paper to the size of an 8" or 9" spring-form pan. Spray the pan with nonstick cooking spray and place the parchment paper on the bottom.

6. Pour the batter into the pan and bake for 50 minutes, turning the pan halfway through. Bake until a cake tester inserted into the center comes out clean. Remove and let it cool before serving.

INGREDIENTS:

7	OZ. COCONUT OIL OR BUTTER
7	OZ. SUGAR
7	OZ. ALMOND FLOUR
3.5	OZ. POLENTA OR CORNMEAL
1½	TEASPOONS BAKING POWDER
3	EGGS
	ZEST OF 2 LEMONS

FLOUR BAKERY

Boston and Cambridge, MA

It's nearly impossible to talk about the New England baking scene without going on a tangent about Flour Bakery + Café, Joanne Chang's highly acclaimed chain. Chang, a true culinary star, has been featured or reviewed in too many publications to count—from *Zagat* to *Food & Wine* to dozens of Boston outlets. In 2007, she beat celebrity chef Bobby Flay on *Food Network*'s "Throwdown with Bobby Flay," besting his sticky bun with her own now-famous recipe. And she won the James Beard Foundation's award for Outstanding Baker in 2016. In other words: Joanne Chang is a busy woman.

Incredibly, all of this could have never happened had Chang ignored her gut. After graduating from Harvard with a degree in Applied Math and Economics, she began her career as a management consultant at The Monitor Group in Cambridge. Thus began two years of spreadsheets and meetings that never quite suited Chang, despite the respect she held for her bosses. And so, she began applying for work at Boston's top restaurants. Chef Lydia Shire gave her a start at the bottom of the totem pole at Biba, where she worked for a year before leaving to work with Rick Katz at his bakery in Newton Center. Before long, Chang was working at Payard Patisserie with legendary pastry chef Francois Payard.

"He was the stereotypical French chef. He yelled a lot in French and English, threw things at times, was such a perfectionist." I spent a year with him working from 4 a.m. to 7 p.m., 6 days a week. I'm not exaggerating. We all worked this hard—it was sort of like boot camp. Of course, I learned so much! But I also realized that no one can work those hours and stay sharp and strong. It was while I was in NYC that I started thinking about opening a bakery of my own. I had loved working with Rick and all of the personal touches we were able to give our customers, and I dreamed of opening a place back in Boston in which we would make everything from scratch and we would give the best service ever. We would be like the bakery version of Cheers."

Chang realized her dream in 2000, opening the first Flour Bakery + Café in Boston's South End. She has soared since then, but the bakeries' collective mission statement has remained unchanged: "total unwavering commitment to excellence in every way." The aforementioned sticky buns are perhaps the best in the country, but everything baked at Flour is reliably delicious and fresh—so much, in fact, that you may have to prepare for a (well worth it) line!

Today, Chang owns seven Flour locations in addition to their "Breadquarters" (where Flour's offices and baking classes can be found) and Myers + Chang, a sit-down restaurant she operates with chef Karen Akunowicz and co-owns with her husband, Chris Myers. If this all sounds like too much, don't worry; Chang has been so successful at every level that it's fair to wonder if she's just getting started.

FLOUR'S FAMOUS BANANA BREAD

YIELD: 19-INCH LOAF / **ACTIVE TIME:** 45 MINUTES / **TOTAL TIME:** 2 HOURS

Joanne Chang: "I remember grocery shopping with my mom and toting home large bags of overripe bananas when we found them on special for ten cents a pound. My mom would encourage my brother, my dad, and me to 'have a banana!' every time we were near the kitchen. My brother and I began to avoid the kitchen for fear of being accosted by Mom and her banana entreaties. In time, I developed this banana bread as a protection device for us."

1. Position a rack in the center of the oven and heat the oven to 325°F. Butter a 9 x 5–inch loaf pan.

2. In a bowl, sift together the flour, baking soda, cinnamon, and salt. Set aside.

3. Using a stand mixer fitted with the whip attachment or a hand-held mixer, beat together the sugar and eggs on medium for about 5 minutes, or until light and fluffy. (If you use a handheld mixer, this same step will take about 8 minutes.)

4. On low, slowly drizzle in the oil. Don't pour the oil in all at once. Add it slowly so it has time to incorporate into the eggs and doesn't deflate the air you have just beaten into the batter. Adding it should take about 1 minute. Add the bananas, crème fraîche, and vanilla and continue to mix on low just until combined.

5. Using a rubber spatula, fold in the flour mixture and the nuts just until thoroughly combined. No flour streaks should be visible, and the nuts should be evenly distributed. Pour the batter into the prepared loaf pan and smooth the top.

6. Bake for 1 to 1¼ hours, or until golden brown on top and the center springs back when you press it. If your finger sinks when you poke the bread, it needs to bake a little longer. Let it cool in the pan on a wire rack for at least 30 minutes, and then pop it out of the pan to finish cooling.

7. The banana bread can be stored tightly wrapped in plastic wrap at room temperature for up to 3 days. Or, it can be well wrapped in plastic wrap and frozen for up to 2 weeks; thaw overnight at room temperature for serving

INGREDIENTS:

1½	CUPS UNBLEACHED ALL-PURPOSE FLOUR
1	TEASPOON BAKING SODA
¼	TEASPOON GROUND CINNAMON
½	TEASPOON KOSHER SALT
1	CUP PLUS 2 TABLESPOONS SUGAR
2	EGGS
½	CUP CANOLA OIL
3½	VERY RIPE, MEDIUM BANANAS, PEELED AND MASHED (1 CUP MASHED)
2	TABLESPOONS CRÈME FRAÎCHE OR SOUR CREAM
1	TEASPOON PURE VANILLA EXTRACT
¾	CUP WALNUT HALVES, TOASTED AND CHOPPED

KOUIGN-AMANN

YIELD: 12 SMALL CAKES / **ACTIVE TIME:** 2 HOURS / **TOTAL TIME:** 5½ HOURS

" A specialty of Brittany, the small, rich kouign-amann, literally "butter cake," is possibly the most extraordinary pastry of all time. Imagine a flaky croissant–type pastry filled with layers of butter and sugar, and then more butter and sugar, and baked until the sugar caramelizes into a marvelously sticky, crispy coating. The first time I had one—in Paris, of course—I knew I had to make it at Flour. It remains for me the most delicious pastry I've ever eaten. Nicole, our executive pastry chef, spent hours perfecting the recipe to make sure it has the right balance of sugar to butter to dough, and then tweaked it so that it could be baked in a muffin tin rather than ring molds. Read through the recipe a few times to make sure you understand the directions. If you've made laminated doughs of any kind before (puff pastry, croissant), you'll have no problem with this one. If you haven't, it is not difficult to make, but you'll need to familiarize yourself with the simple technique of folding and turning the dough, explained in the recipe. These small cakes are more of an after-party treat or decadent breakfast than an opulent plated dessert, although if you were to serve them with some ice cream and berries, I guarantee that you would be showered with compliments."

1. In the stand mixer, mix together the yeast and water until the yeast dissolves. Add the flour, salt, and 1 tablespoon of the melted butter and mix on low for 3 to 4 minutes, or until the dough comes together and is smooth. (If the dough is too wet, add 2 to 3 tablespoons flour; if it is too dry, add 2 to 3 teaspoons of water.) The dough should be soft and supple and should come away from the sides of the work bowl when the mixer is on. To make the dough by hand, in a medium bowl, dissolve the yeast in 1 cup water as directed and stir in the flour, salt, and melted butter with a wooden spoon until incorporated. Then turn the dough out onto a floured worksurface and knead by hand for 8 to 10 minutes, or until the dough is soft, smooth, and supple.

2. Transfer the dough to the baking sheet and cover with plastic wrap. Leave in a warm place for 1 hour to allow the dough to proof. Then transfer the dough to the refrigerator and leave it for another hour.

3. Transfer the dough from the refrigerator to a generously floured work surface. Roll it into a rectangle about 16 inches wide and 10 in from top to bottom. With your fingers, press or smear the room-temperature butter directly over the right half of the dough, spreading it in a thin, even layer to cover the entire right half. Fold the left half of the dough over the butter and press down to seal the butter between the dough layers. Turn the dough 90 degrees clockwise so that the rectangle is about 10 inches wide and 8 inches top to bottom, and generously flour the underside and top of the dough.

INGREDIENTS:

1⅛ TEASPOONS ACTIVE DRY YEAST, OR 3 TEASPOONS FRESH CAKE YEAST

1 CUP WATER, TEPID

13.75 OZ. ALL-PURPOSE FLOUR

1¼ TEASPOONS KOSHER SALT

8 OZ. UNSALTED BUTTER, SOFTENED; PLUS 1 TABLESPOON, MELTED

10.5 OZ. SUGAR, PLUS MORE FOR ROLLING AND COATING

4. Press the dough down evenly with the palms of your hands, flattening it out before you start to roll it out. Slowly begin rolling the dough from side to side into a rectangle about 24 inches wide and 12 inches from top to bottom. The dough might be a little sticky, so, again, be sure to flour the dough and the work surface as needed to prevent the rolling pin from sticking. Using the bench scraper or a knife, lightly score the rectangle vertically into thirds. Each third will be about 8 inches wide and 12 inches from top to bottom. Brush any loose flour off the dough. Lift the right third of the dough and flip it over onto the middle third. Then lift the left third of the dough and flip it on top of the middle and right thirds (like folding a business letter). The dough should now be about 8 inches wide, 12 inches from top to bottom, and about 1½ inches thick. Rotate the dough clockwise 90 degrees; it will now be 12 inches wide and 8 inches from top to bottom, with the folded seam on top. The process of folding in thirds and rotating is called turning the dough.

5. Repeat the process once more: patiently and slowly roll the dough into a long rectangle, flipping it upside down as needed as you roll it back and forth, and then fold the dough into thirds. The dough will be a bit tougher to roll out and a bit more elastic.

6. Return the dough to the baking sheet and cover it completely with plastic wrap, tucking the plastic wrap under the dough as if you are tucking it into bed. Refrigerate the dough for about 30 minutes. This will relax the dough so that you'll be able to roll it out again and give it more turns. Don't leave the dough in the refrigerator much longer than 30 minutes, or the butter will harden too much and it won't roll out properly.

7. Remove the dough from the refrigerator and place it on a well-floured work surface with a long side of the rectangle facing you and the seam on top. Again, roll the dough into a rectangle about 24 inches wide and 12 inches from top to bottom. Sprinkle ½ cup of the sugar over the dough and use the rolling pin to gently press it in. Give the dough another fold into thirds and turn as directed previously. The sugar may spill out a bit. That's okay, just scoop it back in.

8. Once again roll the dough into a rectangle 24 inches wide and 12 inches from top to bottom. Sprinkle the remaining sugar over the dough and use the rolling pin to press the sugar gently into the dough. Give the dough one last fold into thirds and turn. Return the dough to the baking sheet, cover again with plastic wrap, and refrigerate for another 30 minutes.

9. Meanwhile, liberally butter the cups of the muffin tin and set aside.

10. Remove the dough from the refrigerator. Sprinkle your work surface generously with sugar, place the dough on the sugar, and sprinkle

the top with more sugar. Roll the dough into a long rectangle 24 inches wide and 8 inches from top to bottom. The sugar will make the dough gritty and sticky, but it will also make the dough easier to roll out. Using a chef's knife, cut the dough in half lengthwise. You should have two strips of dough, each 24 inches wide and 4 inches from top to bottom. Cut each strip into six 4-inch squares.

11. Working with one square at a time, fold the corners of the square into the center and press down so they stick in place. Shape and cup the dough into a little circle, and press the bottom and the top into more sugar so that the entire pastry is evenly coated with sugar. Place the dough circle, folded side up, into a cup of the prepared muffin tin. It will just barely fit. Repeat with the remaining squares. Cover the tin with plastic wrap and let the cakes proof in a warm place (78 to 82°F is ideal) for 1 hour to 1 hour and 20 minutes, or until the dough has puffed up.

12. About 20 minutes before you are ready to bake, preheat the oven to 400°F and place a rack in the center of the oven.

13. When the dough is ready, place the muffin tin in the oven, reduce the heat to 325°F, and bake for 30 to 40 minutes, or until the cakes are golden brown. Remove the cakes from the oven and let them cool just until you can handle them, then gently pry them out of the muffin tin onto a wire rack and leave them to cool upside down. They are extremely sticky and will stick to the muffin tin if you don't pop them out while they are still warm. Let them cool completely before serving.

SPACCA NAPOLI PIZZERIA

Chicago, IL

Chicago's Spacca Napoli Pizzeria produces not only some of the best Neapolitan pizza in that city, but some of the best in the world, thanks to certified pizzaiolo Jonathan Goldsmith. Recommended by the Michelin Guide and celebrated by local and international pizza aficionados, Goldsmith's reverence for tradition comes through in his team's commitment to turning out delicious uncut pies with beautifully blistered crusts. When he is not busy running the restaurant, Goldsmith is dedicated to educating aspiring pizza makers about why this culinary art form elicits so much passion.

What type of oven do you use to cook your pizzas? What temperature do you cook at?

We have two wood-burning ovens. Both built on-site by the Agliarulo family of Naples, fourth- and fifth-generation oven builders. The first oven built by the family is circa 1870 somewhere in Naples. The normal temperature range is 850 to 900°F (454 to 482°C).

If you use a wood-burning oven, what type of wood do you burn? Why?

We use locally kiln-dried oak. We have played with imported beech, as both give a clean, hot burn. Were we in Connecticut, we would be using beech. In Colorado or Arizona, something else.

What flour(s) do you use for your doughs?

Our principal flour producer is Molino Caputo of Naples. Our daily mix consists of Caputo Red, Caputo Blue, and a touch of *tipo uno*. We also use Caputo's gluten-free mix and one with a special selection of grains and seeds such as sunflower, rye, flax, barley, sesame, and

wheat for our *cuor di cereal* (heart of cereal) dough. Focaccia is new for us, but fun. A much wetter dough with 70 percent hydration; our usual hydration is 62.5 percent. We sometimes go out of the box, using a biga and incorporating quinoa, chia, and cracked wheat. Our usual method is more direct.

Do you primarily use locally sourced ingredients, or a combination of imported ingredients and local ones?

Produce is primarily local and from elsewhere around the US. During the warmer months in Chicago, we purchase as much as possible from the surrounding farms: tomatoes, peppers, beets, and squash blossoms come to mind. From Italy, we bring in tomatoes, olives, olive oils, vinegars, prosciutto, beans, anchovies, capers, salt, Vesuvian peaches and apricots, select beers and sodas, and all of our wines. The wines we offer are all from Campania, representing all of the region and all of its terroir. A few years back, we let go of marinated white anchovies, as some products are best enjoyed

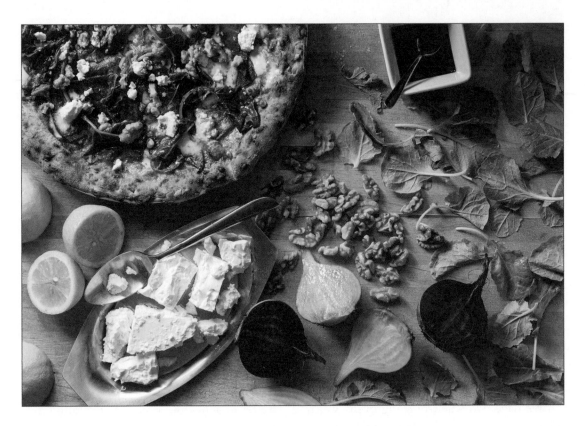

where they are produced. There is no comparison between anchovies fresh out of the water and those packed in brine for six months.

A big move we made a few years back was our bringing in a mozzarella for our pizza (though not for our antipasti) that is working great. It's a blend of 85 percent cow's milk and 15 percent *bufala* milk. Less moisture, and lovely, gentle acidity. We are also making more use of a burrata we bring in from Puglia.

What's the most important factor to keep in mind when making pizza?

YOU HAVE TO MIND THE DOUGH. IF YOU HAVE NO DOUGH, YOU HAVE NO PIZZA! Some say the pizza maker is most important. Maybe so in a small shop where the pizza maker is doing everything—from making the dough, preparing ingredients, and opening, extending, and baking a pie. When you are a big operation, you are an ensemble with many moving parts—each one being important. I am the *arrangiatore*, the conductor, as well as the dough maker, menu planner, visionary,

etc. I would be lost without my pizza makers, salad station staff, runners, wait, bus, and dish staff, managers, hosts, and office administrator. Everyone is important!

Before you thought about being a pizza maker, and before you thought about entering the hospitality industry, you were fascinated by Italy. Why? What made you want to spend so much time in Italy?

Art brought my wife, Ginny, and me to Italy in 1988. We lived in Florence for 3½ years. My wife, who is a painter and mixed media artist, studied at the Cecil Graves atelier. I was the atelier's janitor in exchange for Ginny's tuition, and I was also dedicated to our daughter's care. Not a bad life, to be a househusband in Florence. Three of our four summers were in Puglia. There, I was a *bagnino* on the beach. Our daughter, 20 months old when we arrived, was our passport to goodwill. We were embraced by our local communities, we were not tourists passing through. We were lucky to have had this opportunity early in our adult years.

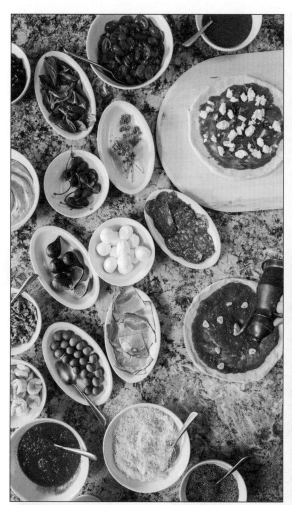
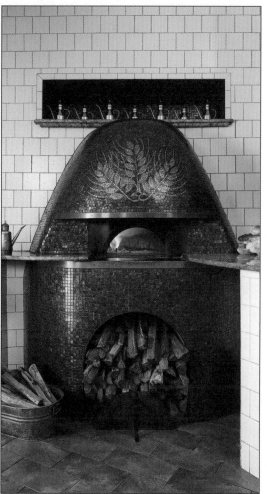

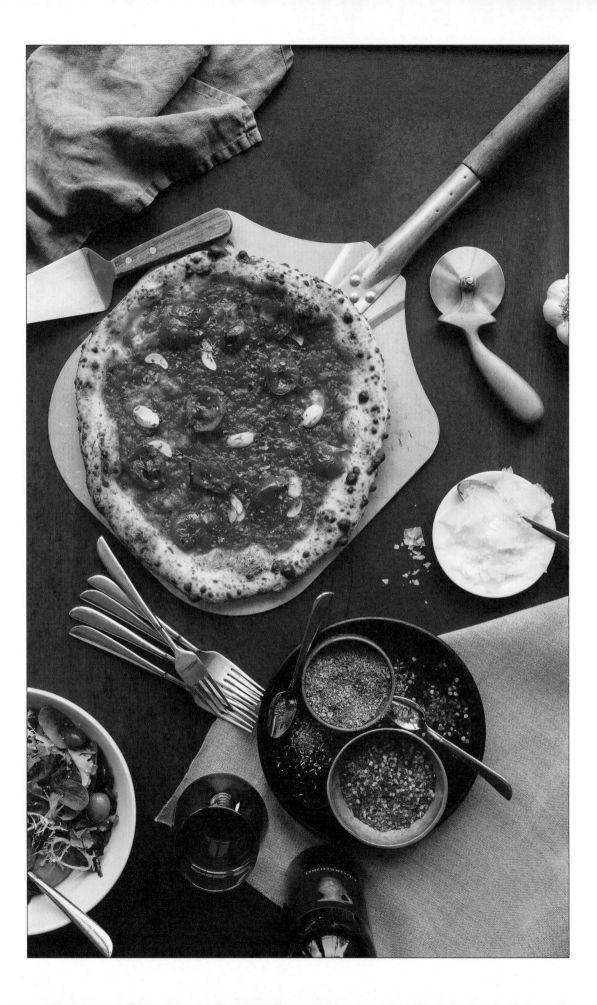

We enjoyed the rhythm of daily life, the local culture and customs, shopping in the neighborhood, the spontaneous generosity and hospitality of new friends as well as strangers, the magic of a simple tomato with good olive oil and salt. We were surrounded by art, architecture, fashion, the beautiful countryside, artisans, and *contadini* (farmers).

The transition home was not easy, it took many years to settle back in. I longed for Italy. Luckily, we were able to continue our summers in the south, in Rodi Garganico. By the grace of a chance encounter, the pizza idea was born, and that renewed my connection to Italy. Through pizza we try to share all of the joy, wonder, simplicity, and generosity we experienced in Italy. We are a *terzo posto*, a third place, somewhere between home and work, that nourishes the soul as well as the stomach.

You are very involved with educating others about making pizza. What about your craft inspires you to share your knowledge with others? So many restaurants keep certain recipes and techniques closely guarded, but it seems you are happy to share all your pizza making "secrets."

There are many who keep their craft close to their vest. Not me. I learned, and continue to learn, through others sharing with me. I did not invent this craft, but I can celebrate it. When we first opened, I would get nervous when I learned of a new place in town, but I soon realized that I would go crazy if I worried whether someone else's pizza was better than mine. I focus on my own work. More importantly, I realized that pizzerias can have the same formula, the same product, the same oven, but each one can produce a pizza and a culture that is unique unto itself, and that is a great thing for all of us.

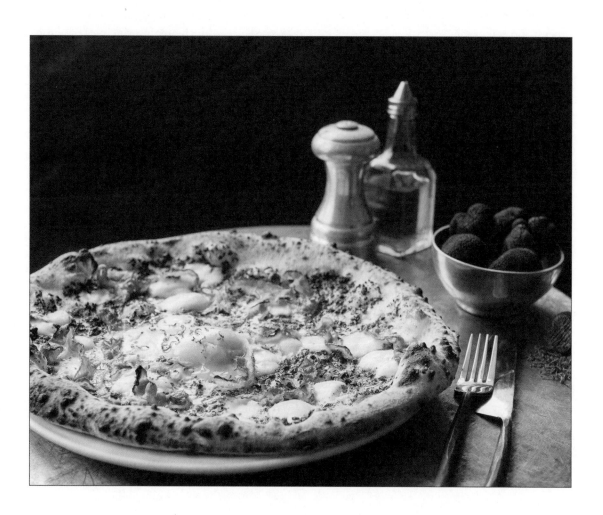

PAYSANBIO SEMENCES PAYSANNES FARM

Aquitaine, France

Under the guidance of Philippe Guichard, Paysanbio has become a force for the whole heritage grains' movement in France, providing high-quality flours to several French bakeries and restaurants. Phillippe has developed his own landraces of wheat and grows them together, following an evolutionary approach that allows the plants to select themselves, rather than being selected by agronomists. We spoke with Phillippe to take a closer look at his process and philosophy.

What is your story? How did you become a wheat farmer and miller?

My father was a farmer, and always cultivated wheat. My maternal grandfather was a farmer and a miller, and my paternal grandmother made bread for the entire family. So, the sowing and harvesting of wheat at the family farm was the backdrop to my childhood. After I learned more and more about it, I listened to the call of the earth and decided to become a farmer.

I did not want to take over my father's family farm because at the time he had a negative opinion about organic farming, so I went out on my own a couple of decades ago. I became an organic farmer and began to work with old wheat varieties around 1991. Very few people were interested in organic farming at that time, and even fewer were interested in heritage seeds or old varieties of wheat.

However, I soon became convinced that these old varieties of wheat were among the

tools that I needed to succeed as a farmer. I have been cultivating a mix of about a hundred different heritage varieties of wheat for a long time, and I have been selling the milled flour of my unique heritage wheats mix across France.

Is wheat the only thing you farm?

No, on an organic farm, cultivating exclusively wheat does not make sense and is not sustainable. A coherent organic farm that is in accordance with the main principles of agronomy and ecology must include the cultivation of several species and varieties. For my farm, which does not have animals, I have chosen a variety of legumes, which work well in rotation and add a lot of nitrogen to the soil. This in turn makes the soil more fertile and guarantees a good wheat harvest. Depending on the year and on the condition of the crops, I grow alfalfa, fava beans, protein peas, lentils, chickpeas, and soybeans as well.

What keeps you motivated?

I am passionate about my work, and constantly have new things to learn, observe, and experiment with. The recognition from my customers, who rave about the products I make and transform, also keeps me motivated.

What do you think you do different from other farmers?

I think I am much more concerned than some other farmers about the final quality of my product. I have always been very demand-

ing with myself as well as those who work with me, so that the product is as close to perfect as possible. This high standard has contributed to the recognition of the quality of my products, both in the world of agriculture and in that of gastronomy and baking.

Do you use your own seeds or do you buy them from another company?

I produce 90 percent of the seeds I grow.

Why are heritage wheat varieties so important?

To me the main reason to grow heritage wheat is the soil! In fact, these varieties of wheat, with their high stems, allow for a replenishment of the soil through their straws, and guarantee that enough nitrogen is present. This ensures that the soil maintains its fertility without the need of organic fertilizers. My second reason is sentimental: they are the seeds that have been cultivated by my ancestors, who were also farmers like me. The third reason there is the current demand for these old varieties.

Are your methods 100 percent organic?

Yes, the farm has been 100 percent organic for over 25 years.

Do you think organic farming is more sustainable than conventional farming?

Of course! Without any doubt this is obvious. The best indicator of the sustainability of an agricultural system is its dependence on external input. On my farm, with a turnover of about €65,000 per year, the expenses for materials and supplies external to the farm represent less than €10,000 per year, energy expenses for electricity and fuel included.

Do you have much competition? What are the greatest challenges for independent wheat farmers?

Yes, there is competition, but it is not a real competition. As no legislation regulates the pro-

duction of old varieties of wheat, many millers can claim to produce flours from heritage wheat varieties. Often, they even have a farmer who cultivates an old wheat variety for them. They put this one single grain in their mix and then say that they are selling heritage wheat flour. They often deceive bakers and consumers without the knowledge to recognize flour made from older wheat varieties. There are also farmers who might claim to cultivate ancient wheat but deceive their buyers.

Over time, by educating consumers and showing pictures of our cultivated fields and wheat, we can help distinguish the truth from the false. But one has to spend a lot of time explaining everything.

Another challenge to the industry is businesses with lots of money that contract farmers to cultivate old wheat varieties and then resell them at a very high price, profiting from the work of others.

How do you envision the future of wheat farming in the face of climate change? Will we still have bread on our tables in 500 years from now?

Yes, as long as there is still wheat and people to cultivate it! Old varieties will always be present because they possess great capabilities to adapt to changes in climate. They are much more adaptable than humans, for sure!

What can people do to support small-scale millers and farmers?

Sharing our work and its importance. We do not necessarily need to sell massive amounts of produce; we just need to sell it regularly. It is my farm (rather than my income) that suffers most because of inconsistent sales. Some months, I sell a lot of flour, to such a point that the mill runs incessantly. Other months, it barely runs. The production rhythms are often not regular enough to allow for the development of long-term projects or investments at the farm.

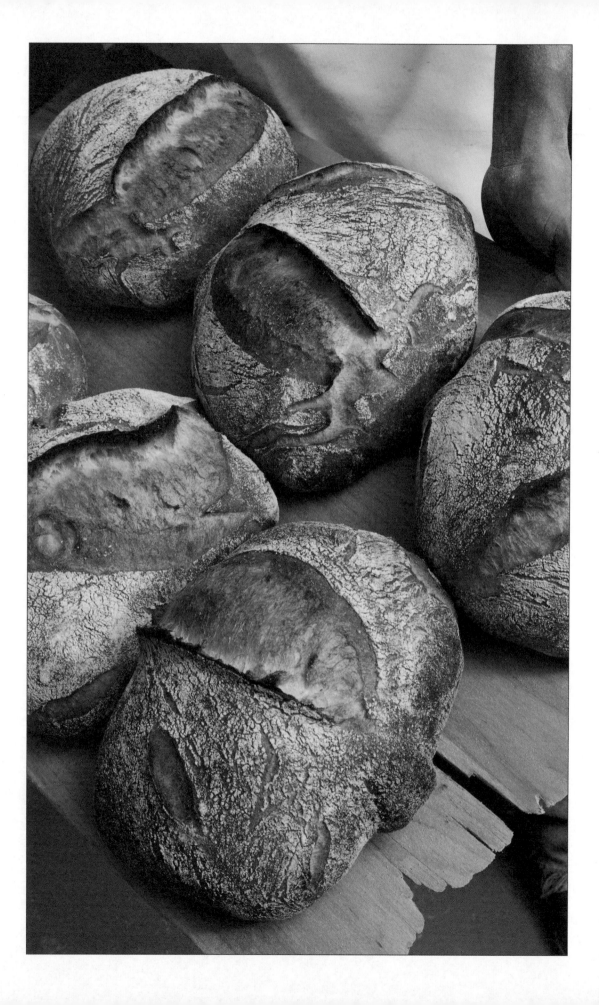

SEVEN STARS BAKERY

Providence, RI

When Lynn and Jim Williams met in California in the late 1990s, baking was already an established part of their lives. Lynn longed to return to the Northeast and open her own bakery; Jim had already worked in the now-closed Bread Garden of Berkeley, California, and remained an avid follower of baking and fermentation processes. Eventually, they found a space they liked on Hope Street in Providence—and their customers are glad they did.

Their enterprise grew quickly. It wasn't long before two new locations had opened, and after a visit to Dave Miller's Bakery, Miller's Bake House, Jim and Lynn purchased their first flour mill. For Jim, it was a long road from making Sunday morning waffles as a child. "I have no formal cooking or baking education, but I worked in lots of bakeries learning the craft. Baking is all about repetition. You have to put in the time and do the work."

Known for its flavorful breads and friendly service, Seven Stars does not skip steps. Their fermentation process is rigid, but worthwhile; the bakery uses four different types of preferments, and each loaf they bake requires at least one of them. These recipes are time-tested and made entirely in-house—and it shows in the bread. Between their businesses and breadmaking, the couple is extremely busy, but Jim was kind enough to take some time to speak with us.

Who inspired you to bake? Who inspires you now?

I had always been interested in cooking and baking growing up. I had a tremendous interest in bread and brewing beer. In 1993, two very inspirational books, *Bread Alone* by Daniel Leader and *The Village Baker* by Joe Ortiz, were published on European-style, long-fermented breads. I dove in headfirst, and realized that this is what I wanted to do with my life.

What is your golden rule for baking?

Time and temperature are everything. Control those two variables, and you control the final product.

What does Seven Stars Bakery represent to you?

We take pride in offering an outstanding product, while giving our employees an excellent place of employment, all the while providing excellent customer service. The three add up to what makes Seven Stars the special place that it is.

What is your favorite thing to bake? Least favorite thing to bake?

My favorite thing would be freshly milled, long-fermented, whole-grain breads from one single variety of wheat. Wheat is no different than grapes, hops, or even cows! There are thousands of different varieties of wheat to explore—all with different flavors and fermentation profiles. I have a lot of respect for the

sweet bakers of the world, but I'm not one of them!

Where do you get your tools/materials? What non-essential items should every baker have?

Large equipment, like ovens and mixers come from equipment companies. Any smaller items like scrapers, scoops, and buckets, can be found at any restaurant supply store.

The most important nonessential item—though I would argue it *is* essential—would be a good plastic scraper! I like them made of hard, rigid plastic. Flexible scrapers just don't work as well.

What book(s) go on your required reading list for bakers?

For the home and professional baker, *Bread* by Jeffrey Hamelman. *Advanced Bread and Pastry*, by Michel Suas, for the professional baker.

What outlets/periodicals/newspapers do you read or consult regularly, if any?

Instagram has a very good bread community. Also, the Bread Bakers Guild of America is an excellent organization for both home and professional bakers. They offer events throughout the year, and a quarterly newsletter that is worth the membership alone.

Tell me about your most memorable collaboration with another chef.

It's not exactly a collaboration, but my first visit to Dave Miller's bakery, Miller's Bake House, changed the way I think about bread, grains, and milling. That visit led to a new mentor, friendship, and direction, both for myself

as a baker and for Seven Stars. Shortly after that visit, we purchased our first flour mill to start milling the Northeast-sourced local grains we had previously been purchasing as flour. It led to Seven Stars becoming one of the leaders in the country in sourcing regional grains and milling them into whole grain flour.

Brag about yourself a bit. What are your highest achievements and/or proudest moments as a chef?

Bakers tend to be quiet types with not much to say about themselves. I'm proud of the work we do daily at Seven Stars and the work I've done with single-variety wheats. I believe that Seven Stars is a great place to work. I wish I worked in a place like ours when I was starting out!

You mill in-house. What inspired you to make that choice, and how has it benefitted the bakery?

After that first visit to Dave's I just knew milling was the next logical step. We jumped right in headfirst, and I couldn't see us going back to dead flour in a bag. Fresh milled flour has an aroma that you want to do everything you can to capture. We do our best to do that in our breads every day. One of the nicest side effects to milling in house is the interest generated by our staff. Of course, some people couldn't care less, but there are those that might have thought I was crazy at first. Not anymore. I can guarantee that there are a handful of bakers on our team that wouldn't think twice about adding a mill to their own bakery if they were to ever venture out on their own. Once you do it, it becomes what you do. There are no other options.

BOULTED BREAD

Raleigh, NC

"Initially, Boulted Bread was a pretty selfish endeavor; a means to explore our own ideas of bread and pastry while indulging our own creativity, but that self-indulgence vanished pretty quickly once we opened our doors," said Joshua Bellamy, who owns and operates Boulted Bread with Fulton Forde and Sam Kirkpatrick, during an interview about his approach and practice.

The bakery's original focus may have been experimentation, but Boulted has a new priority these days: "Doing right by the people who sustain it: our customers and our employees. This is the fundamental obligation of any bakery," says Josh, and it ties in nicely with their original goal. "Our products aren't pigeonholed by rigid morality, other than this quest for taste. We want our customers to be shocked at and to revel in the fertility of flavor in everything we make. This ambition toward a nebulous ideal keeps us honest and driven." In other words: creativity is still encouraged.

Boulted got its start in 2014, when Fulton and Josh met at the Asheville Bread Festival. They immediately recognized one another as "like-minded idiots," and it wasn't long before Fulton and his longtime friend Sam reached out to Josh with their plans to open a bakery; all three men are Raleigh natives, and felt it was important to bake for the community they knew and loved. Boulted was soon up and running, establishing itself as a part of the community just as quickly. With its loaves, both chewy and crunchy, and its buttery pastries, it's not hard to see why.

How and when did you get your start baking?

I've worked at bakeries and coffee shops since high school, but my first real urge to bake came later in life, after college. At the time, I was running an afterschool program for at-risk middle school students, and it was a lot. I started baking bread at home to relieve the stress of it, and things snowballed pretty rapidly from there.

Who inspired you to bake? Who inspires you now?

Initially, my curiosity was piqued by Peter Reinhart's books. They gave me a window into a world of which I had such limited understanding, and I knew pretty quickly that I wanted to explore more.

Currently, no baker inspires me more than Jim Lahey of Sullivan Street Bakery. His continued evolution as a baker proves his persistent curiosity, which I find deeply impressive.

What is your golden rule for baking?

My only "golden rule" for baking is that I only bake things I'd like to eat. Does it taste good? Despite other moral and ethical proclamations, I believe that's really the essential goal of baking.

What is your favorite thing to bake? Least favorite?

Baguettes are the ultimate challenge for me: the purest expression of a baker's proficiency, focus, and ethos. A perfect baguette requires so many distinct skills and such precise execution. If you're even fractionally off your game, the

whole thing can fall apart. For the same reason, baguettes are also my least favorite thing to bake. Nothing has caused me more stress, grief, and sleepless nights.

Where do you get your baking tools? What nonessential items should every baker have?

We purchased almost all of our equipment secondhand. We also did most of the build-out ourselves, asking friends and family to pitch in when our construction skills were found lacking.

Bountiful, high-quality bench scrapers are an absolute must for us! We use these orange, hard plastic scrapers from King Arthur Flour exclusively. They're amazing.

What book(s) go on your required reading list for bakers?

Bread Builders by Daniel Wing and Alan Scott and all of the *Tartine* books played a role in informing our overall ethos toward baking. For technical knowledge, nothing beats *Advanced Bread and Pastry* by Michel Suas and *Bread* by Jeffrey Hamelman. *Practical Milling* by B. W. Dedrick is also great for an informative trip into the history and mechanics of milling.

What outlets/periodicals/newspapers do you read or consult regularly, if any?

The online forum for the Bread Baker's Guild of America offers an amazing, ongoing conversation on all things bread- and pastry-related.

Where did you learn to cook? Please tell me about your education and apprenticeships.

After struggling to unlock some bread-baking mysticism at home, I moved to Vermont and got a Certificate of Professional Baking from the New England Culinary Institute. It was a short and wonderful experience. I worked with some really talented instructors, learned all the important fundamentals, and got a great taste of what it would be like to work in a production setting.

I completed my apprenticeship at Elmore Mountain Bread in Wolcott, Vermont, with Blair Marvin and Andrew Heyn. They were gracious enough to let me stick around after the internship and gave me an immense wealth of knowledge, ethics, and skills with which to grow my career. I am forever in their debt, and I'm lucky to count them as my friends.

Tell me about your milling process. How long have you been using a stone mill in-house? Why do you prefer it?

Our stone mill has been the focal point of our bakery, both physically and ethically, since our inception. It was designed and built by our very own Fulton Forde, as part of New American Stone Mills.

We try to stay loose with our milling dogma and avoid sacrificing product integrity, identity, and flavor for the sake of fresh milling. That being said, milling most of our flour in-house gives us a number of distinct benefits. We have access to a wide variety of grain, directly from the farm, and the fresh flour has a sweeter aroma and fattier flavor than conventionally milled grains. We use our mill, in conjunction with several other techniques, as a tool to elevate and deepen the flavors in our products.

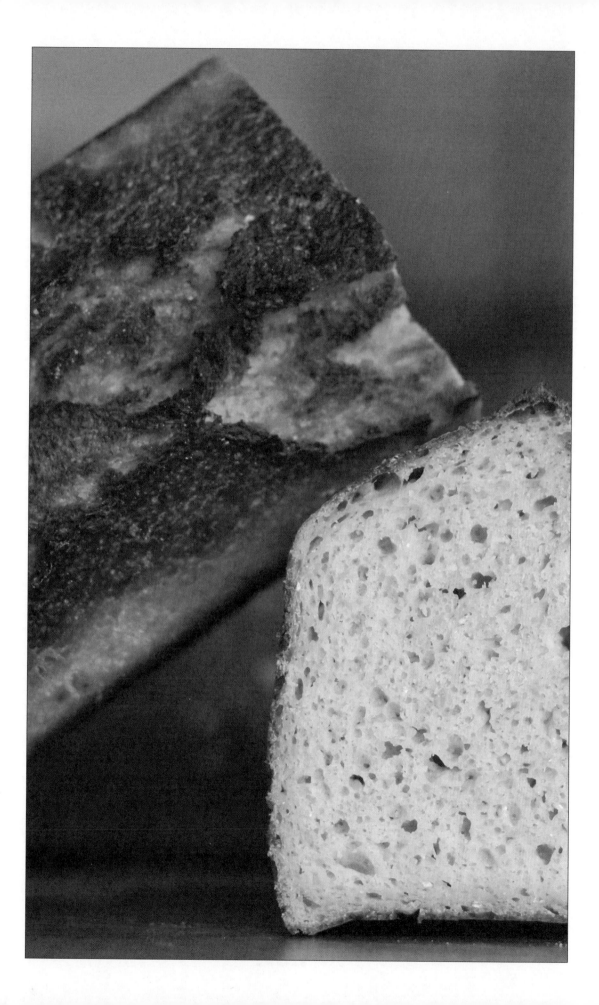

GRITS BREAD

YIELDS: 1 LOAF / ACTIVE TIME: 4 HOURS / TOTAL TIME: 20 HOURS

An especially delicious cousin of cornbread courtesy of the team at Boulted.

1. About 12 hours before you will begin to mix the dough, begin preparations for the dough. Place the grits and water in a medium saucepan and let the mixture sit at room temperature.

2. About 8 hours prior to mixing, prepare the soaker. Combine the ingredients in a mixing bowl, cover the bowl, and let it sit at room temperature.

3. Prepare the levain right after preparing the soaker. Combine the ingredients in a mixing bowl, cover the bowl, and let it sit at room temperature.

4. About two hours prior to mixing, bring the grits and water to a boil. Reduce the heat so that the grits simmer and cook, gently stirring occasionally, until the grits are tender. Stir in the butter, season the grits with salt to taste, remove the pan from heat, and let the grits cool.

5. Place 1¾ cups of the cooked grits, the soaker, the levain, the buttermilk, salt, and flours in the work bowl of a stand mixer fitted with the dough hook and work the mixture on low until it comes together as a rough, shaggy dough.

6. Cover the mixing bowl with plastic wrap and place it in a naturally warm location. Let the dough rise for 4 hours, folding all of the sides of the dough into the center every 45 minutes.

7. Coat an 8 x 4–inch loaf pan with nonstick cooking spray and transfer the dough into it. Cover the dough with a linen towel and let it in a naturally warm spot until it is about about ½ inch from the lip of the pan.

8. Preheat the oven to 450°F. Place a small baking sheet on the bottom rack of the oven.

9. Fill the baking sheet with water. Place the loaf pan on the top rack of the oven and bake until the top is a deep golden brown, about 1 hour. Remove the bread from the oven, place the pan on a wire rack, and let it cool completely before enjoying.

INGREDIENTS:

FOR THE DOUGH

⅔	CUP GRITS, RINSED
17	OZ. WATER
4	OZ. UNSALTED BUTTER
2½	CUPS BUTTERMILK
1½	TABLESPOONS KOSHER SALT, TO TASTE
18.2	OZ. BREAD FLOUR
3.75	OZ. WHOLE WHEAT FLOUR

FOR THE SOAKER

2¾	CUPS CORNMEAL
1¾	CUPS BUTTERMILK

FOR THE LEVAIN

½	CUP COLD WATER
½	CUP WHOLE WHEAT FLOUR

ZINGERMAN'S BAKEHOUSE

Ann Arbor, MI

For bread enthusiasts in the Midwest, it's impossible to hear the words *rye bread* without immediately thinking of Zingerman's. Michiganders know the deli for its overflowing sandwiches, made with corned beef, pastrami, and several other traditional favorites. But the real magic happens at the Bakehouse nearby, where head baker Amy Emberling, managing partner Frank Carollo, and their crack team turn out exquisite loaves and pastries from all over the world. Everything at Zingerman's is delicious, but among their many standouts, the rye has received special attention. *Saveur* named it "America's best deli rye . . . no contest." *The Atlantic* champions their rye as well, calling it "one of the best" in the country. And the list of accolades only continues from there.

Of course, the bread from Zingerman's Bakehouse is not literally magic. Like all breads, it must be built, cared after, and baked to perfection—and that's where Emberling and partner Frank Carollo come in. Making delicious loaves since 1992, the Bakehouse has a singular goal: make the best bread possible. Carollo, who started the bakery with the support of Zingerman's founders Ari Weinzweig and Paul Saginaw, was lucky enough to hire Emberling as one of the shop's original eight bakers, and the rest was history.

Emberling was kind enough to join us for a look at her own history, as well as Zingerman's.

How and when did you get your start baking?

I started baking at about age 10. I loved dessert. My mother hated to bake and we didn't have a traditional bakery in my hometown, so I decided to try it out myself. Even at 10, I loved looking through recipe books and daydreaming about what this list of ingredients and set of instructions would create. It all seemed mysterious and intriguing. I used recipes from *The Joy of Cooking* and from *McCall's* magazine. They had a section at the back of the magazine every month, and sometimes I was lucky, and it was something baked. That was the beginning.

Who inspired you to bake?

I had many inspirations before I turned 20, somewhat because I was very drawn to anyone who engaged with food and baking and would let me participate. My Nanny, my father's mother, was a very good cook and baker. She was a typical self-taught baker who didn't measure anything—so challenging to learn from, but inspiring nonetheless. My other grandmother, my New York Grandma, only bought cakes and cookies. They were inspiring though because they introduced me to my first experience of professional baking. I was fascinated by checkerboard cakes. I remember wondering, "How did they do that?" And I loved the names—"Charlotte Russe," so fancy! And then there was our Italian babysitter/housekeeper, Elva Pezzarello, who made special cookies for

us, and pizzas on Friday. She introduced me to yeast for the first time. The list goes on, but I have to come back to my mother. Although she was a reluctant baker, she did it from time to time. I now realize that some of her reluctance may have come from her perfectionism. If you're a perfectionist, baking can either make you very happy, or very crazy. Well, it made her crazy. But she inspired me to be more of a perfectionist (I'm not one by nature) because it's a valuable trait when you're trying to make truly great baked items, every time. Thanks Mom!

Who inspires you now?

I am super-appreciative of the many bakers and baking instructors in America (famous and little known) who do what looks like the same thing every day but continue to learn about the process and make their bread better and better. Examples of famous people are Jeffrey Hammelman, Frank Carollo (my partner at Zingerman's Bakehouse), Peter Reinhart, and Chad Robertson. They go deep in their study of bread making and bring progress to the field in important ways. I'm more drawn to different cuisines around the world, and educating the public on breads that are not well known, or on the verge of being forgotten. The work these other bakers do educates me and enables me to make better versions of these breads. I'm not so drawn to exploring the intricacies, but am happy to learn them from those who are and then spread the word.

What is your golden rule for baking?

These are some of my rules:

1. Bake in a neat and clean environment. I'm addicted to order and need it in my work environment. For me it allows for the possibility of a well-executed recipe. Disorder clutters my mind, distracts me, and leads to mistakes.

2. Weigh ingredients. A scale is a must in my baking. Volume measures introduce too much variation.

3. Measure everything prior to starting the process. This sets the stage for success. No missed items. No unexpected ingredients or disorder because all of the bags and boxes can be put away where they belong prior to starting the work.

4. Do a double-check. Everything measured? Measured correctly?

5. Always do a recipe as written the first time through and then start to change it.

What does a bakery represent to you?

At Zingerman's Bakehouse, we're very clear about what a bakery means. It's a community of people working toward an agreed upon and documented mission and vision. Our mission statement, created in 1994, is, "At Zingerman's Bakehouse, we are passionately committed to the relentless pursuit of being the best bakery we can imagine." As part of this "best," we are deeply engaged in our greater community. We are in daily conversations with our customers about what's going well and not so well, receiving at least 100 points of feedback every week.

Favorite thing to bake? Least favorite thing to bake?

I love baking things that have very few ingredients, but an involved process. That's where the skill of a baker comes into play for me. I find it super-rewarding when the seemingly simple, nondescript ingredients are transformed into a tasty and multi-textured treat. Examples of this are French baguettes and palmiers. They both use five ingredients or fewer and are amazing in their complex end results.

On the other side, I like to stay clean when I bake and there are some steps that can make that difficult, like using cocoa powder or cinnamon in large quantities. I'm a small person and am usually quite close to the mixing bowls when I work, so it's easy to get enveloped by the clouds of items like this as they enter the bowl. So, if they're in the recipe, I won't love that particular mix.

Where do you get your tools/materials?

Oh, they come from all over our state, the

country, and the world. We are most interested in great flavor and choose our ingredients based on that. We are fortunate to live in a state with a large agricultural community so we are able to get great-tasting and fresh dairy, eggs, fruit, and vegetables. Grains are obviously critical to our bakery. We can get local rye and oats, and we're working on developing wheat with some local farmers. We then travel farther away when we want to use items not created here, like Parmigiano Reggiano cheese or vanilla.

CONVERSION TABLE

WEIGHTS

1 oz. = 28 grams

2 oz. = 57 grams

4 oz. (¼ lb.) = 113 grams

8 oz. (½ lb.) = 227 grams

16 oz. (1 lb.) = 454 grams

VOLUME MEASURES

⅛ teaspoon = 0.6 ml

¼ teaspoon = 1.23 ml

½ teaspoon = 2.5 ml

1 teaspoon = 5 ml

1 tablespoon (3 teaspoons) = ½ fluid oz. = 15 ml

2 tablespoons = 1 fluid oz. = 29.5 ml

¼ cup (4 tablespoons) = 2 fluid oz. = 59 ml

⅓ cup (5 ⅓ tablespoons) = 2.7 fluid oz. = 80 ml

½ cup (8 tablespoons) = 4 fluid oz. = 120 ml

⅔ cup (10 ⅔ tablespoons) = 5.4 fluid oz. = 160 ml

¾ cup (12 tablespoons) = 6 fluid oz. = 180 ml

1 cup (16 tablespoons) = 8 fluid oz. = 240 ml

TEMPERATURE EQUIVALENTS

°F	°C	Gas Mark
225	110	¼
250	130	½
275	140	1
300	150	2
325	170	3
350	180	4
375	190	5
400	200	6
425	220	7
450	230	8
475	240	9
500	250	10

LENGTH MEASURES

1/16 inch = 1.6 mm

⅛ inch = 3 mm

¼ inch = 1.35 mm

½ inch = 1.25 cm

¾ inch = 2 cm

1 inch = 2.5 cm

IMAGE CREDITS

ACKNOWLEDGMENTS

All the love and gratitude to Caitlyn, Nick, our family, and our friends who have supported us through this magical endeavor. Thank you for loving us through all the late nights, believing in our ideas, and above all, accepting our passion.

ABOUT THE AUTHORS

DAN CREAN

Immersed in food and driven to create delicious confections, Chef Dan Crean's devotion for integrating classic desserts and breads into the modern era are the key to his success. Cooking in kitchens all over Boston for over 10 years, Crean found his passion in the pastry arts world. His drive began as a Bakery Manager at the illustrious Black Bird Donuts, Production Manager at Union Square Donuts, and pastry work at Alden & Harlow and Waypoint. Crean took his large step as the Pastry Sous Chef at the highly anticipated Cultivar in the Ames Hotel, contributing to an in-house bread program and a top-of-the-line selection of poetic desserts that helped Cultivar earn the distinction of Boston's Best New Restaurant 2018. Today, Crean is the Assistant Culinary Manager at the Concord Market, leading the bakery department team, which focuses on scratch-made confections and an artisan bread program.

ROBERT GONZALEZ

Chef Robert Gonzalez first entered the culinary world as an intern at Tuyo while studying at the Miami Culinary Institute. There he soon achieved the position of Head Pastry Chef, developing his imaginative dessert skills and receiving local recognition for his achievements. Gonzalez made his Boston debut at the esteemed Bistro du Midi, bringing his unique talent to bread and dessert offerings while working alongside Executive Chef Robert Sisca. He was recognized as an *Eater* Young Guns Semi-Finalist for his magnificent creations, and also received rave reviews from Boston's food scene critics. Gonzalez then joined the inaugural team at Cultivar, running the pastry department. The highly anticipated opening of Cultivar at the Ames Hotel featured an in-house bread program and selection of rotating, produce-driven desserts to complement New England seasonal foods. Gonzalez currently helms the culinary team at the Concord Market as the Culinary Manager, where he focuses on bringing customers the absolute best confections, breads, and foods with locally sourced ingredients. Inspired to create desserts that are as unique and visually stunning as they are delicious, Gonzalez's confections are designed to capture the heart and imagination of every guest.

INDEX

ABOUT CIDER MILL PRESS BOOK PUBLISHERS

Good ideas ripen with time. From seed to harvest, Cider Mill Press brings fine reading, information, and entertainment together between the covers of its creatively crafted books. Our Cider Mill bears fruit twice a year, publishing a new crop of titles each spring and fall.

"Where Good Books Are Ready for Press"

Visit us online at
cidermillpress.com

501 Nelson Place
Nashville, Tennessee 37214

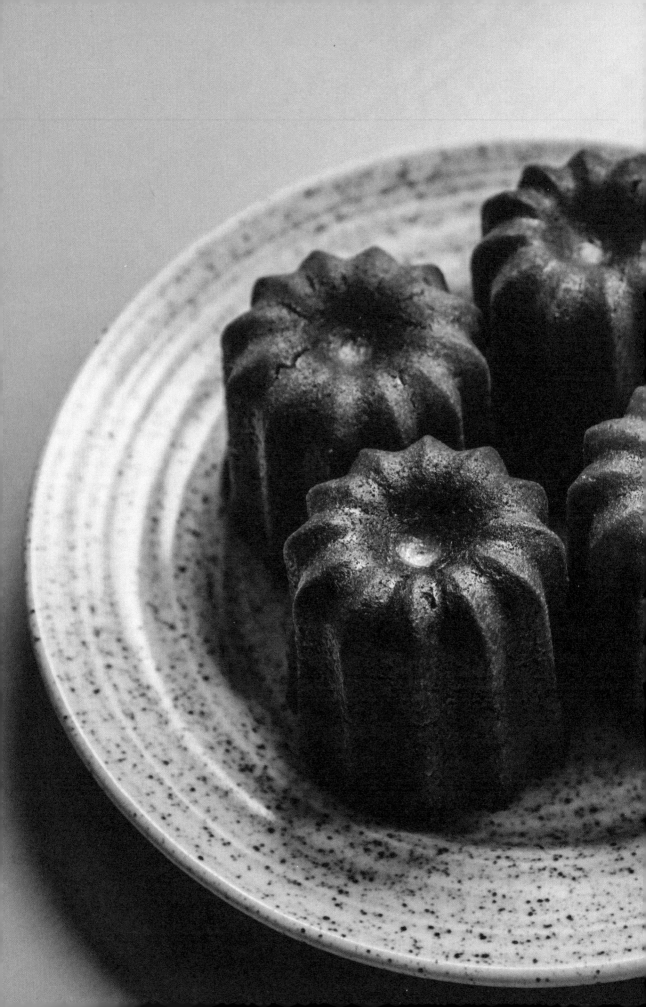